CW00750148

Rainer W. Schlegelmilch
Hartmut Lehbrink
Jochen von Osterroth

PORSCHE

h.f.ullmann

Contents · Inhalt · Sommaire

Walter Röhrl: Foreword · Vorwort · Préface

In motor sport I have always preferred the straight line—to go where I had to go without any frills and ado, the shortest possible way in the shortest possible time. As far as my cars were concerned, there were invariably a couple of parameters that made them good or bad for me: weight, traction, roadholding and power. It was the stopwatch that had the final say with regard to their quality.

When I was a young man it appeared quite natural to me to save every penny for four years to buy my first Porsche in 1970. It was a secondhand 356. The engine was contributed by my elder brother, who had also said: "Don't purchase a motor vehicle until you have scraped together the money for a decent one. For a Porsche."

In that year I also made my first acquaintance with a 911 prepared for rallying. That automobile was entirely in keeping with the picture I had of a sports car. Apart from that, I was instantly in love with the sound of its engine and the beautiful lines of its bodywork.

Then there were first encounters with Porsche people. I soon realized that the way they fine-honed their cars resembled the way I fine-honed my ideal line. We have stayed in touch ever since. The friendships that connect us will always mean a lot to me.

When I married Monika in 1978, we treated ourselves to a Turbo, and up to the present day there has always been a Porsche in our garage. Long before there were official ties to the marque, we would meet or somehow communicate time and again. I have fond memories, for instance, of test drives with Professor Bott. He called me before the 1982 Monte Carlo Rally and mysteriously suggested that he had a very special four-wheel-driven 911 somewhere up there at Turrach, as well as an Audi Quattro for the sake of comparison. What he was talking about was the 959, and I was even lucky enough to possess a lightweight specimen.

As Porsche was not involved in the World Rally Championship, there were only a few shared appearances in professional terms, albeit spectacular ones. A definite highlight was the 1981 San Remo Rally. Before we were forced to retire it looked for quite a time as if we were able to cope in a 911 with the Audi Quattros which reigned supreme on gravel.

But only in 1993 did I ink a contract as a representative and development driver for Porsche. After so many years of working with Porsche AG, I am fairly familiar with the company and its successful development. Zuffenhausen and Weissach are homes away from home for me now. That is so because of the people there, with their passion for thoroughbred sports cars and their obsession to do a perfect job.

I like that and I also like their products which, even in a day and age of overregulation, are technically advanced, fascinating, prepared for superb performance and an aesthetic feat to boot. That combination is certainly hard to beat.

Die direkte Linie war mir im Motorsport immer die liebste: ohne Firlefanz und ohne Umweg auf dem kürzesten Weg in der kürzesten Zeit dahin, wo es hingehen sollte. Was meine Autos anging, gab es ein paar Eckpunkte, die sie in meinen Augen gut oder schlecht machten: Gewicht, Traktion, Straßenlage, Kraft. Die Stoppuhr sagte Entscheidendes über die Qualität eines Autos aus.

Es erschien mir als ganz junger Mann nur natürlich, vier Jahre lang jeden Groschen zu sparen, um 1970 meinen ersten Porsche zu kaufen. Es war ein gebrauchter 356. Den Motor steuerte mein älterer Bruder bei, der mir auch gesagt hatte: „Kauf dir kein Auto, bevor du das Geld für einen anständigen Wagen zusammen hast. Für einen Porsche."

Meine erste Bekanntschaft mit einem Rallye-911 machte ich im selben Jahr. Dieser Elfer entsprach meiner Vorstellung von einem Sportwagen – siehe oben – ganz genau. Davon abgesehen, war ich begeistert vom Klang des Motors und von der unvergleichlichen Linie der Karosserie.

Es gab erste Treffen mit den Menschen bei Porsche. Mir wurde klar: So, wie ich an meiner Ideallinie schleife, arbeiten die an ihren Autos. Das gefiel mir. Unsere Verbindung blieb seit dieser Zeit immer lebendig. Ich schloss Freundschaften, die mir wichtig waren und sind.

Zur Hochzeit mit Monika 1978 leisteten wir uns einen Turbo, und es gab kein Jahr, in dem nicht ein Porsche in unserer Garage gestanden hätte. Auch wenn ich mit Porsche noch nicht offiziell verbunden war, blieben wir immer im Kontakt. Gerne erinnere ich mich beispielsweise an die Testfahrten mit Professor Bott, der mich vor der Rallye Monte Carlo 1982 anrief und geheimnisvoll andeutete, er hätte da auf der Turrach einen besonderen 911 mit Allradantrieb und als Referenz einen Audi Quattro ... Es ging weiter mit dem 959, von dem ich sogar ein Leichtbauexemplar besitzen durfte.

Da Porsche sich nicht in der Rallye-Weltmeisterschaft engagierte, blieb es auf professionellem Feld bei einzelnen gemeinsamen Auftritten, die allerdings spektakulär ausfielen. Ein Höhepunkt war die San Remo Rallye 1981, als es bis zu unserem Ausfall lange Zeit so aussah, als könnten wir mit einem 911 die auf Schotter übermächtigen Audi Quattro besiegen.

Schließlich war es 1993 soweit: Ich unterschrieb meinen Vertrag als Repräsentant und Entwicklungsfahrer für Porsche. Nach so vielen Jahren Zusammenarbeit kenne ich die Porsche AG und ihre erfolgreiche Entwicklung ziemlich gut, und ich fühle mich in Zuffenhausen und Weissach wie zu Hause. Das liegt an den Menschen dort, an ihrer Leidenschaft für Vollblutsportwagen und an ihrer Sucht, Arbeit von hoher Qualität zu leisten. Das passt mir.

Es passt mir genau so wie ihre Sportwagen, die auch im Zeitalter gesetzlicher Überregulierung technisch wegweisend, faszinierend, durch

En compétition, j'ai toujours préféré la ligne droite : sans fioritures ni détours, le plus court chemin jusqu'à destination, sans perte de temps. Quant aux voitures, quelques critères suffisent à mes yeux pour séparer les bonnes des mauvaises : le poids, la motricité, la tenue de route, le punch. Et le verdict du chronomètre est toujours sans appel quant à la qualité d'une voiture.

Quand j'étais jeune, j'ai sans regret économisé le moindre sou quatre ans durant pour pouvoir m'acheter ma première Porsche, en 1970. Il s'agissait d'une 356 d'occasion. Le moteur, c'est mon frère qui me l'a payé, lui qui m'a toujours dit : « N'achète rien tant que tu n'as pas assez d'argent pour t'offrir une voiture correcte. Une Porsche. »

La même année, j'ai essayé une 911 de rallye. Elle incarnait pour moi la voiture de sport par excellence – répondant parfaitement à tous les critères précités. J'étais de plus emballé par la sonorité de son moteur et les lignes incomparables de sa carrosserie.

Puis, j'ai rencontré des gens de chez Porsche. J'ai tout de suite été convaincu : ils travaillent sur leurs voitures comme je peaufine ma trajectoire. Cela m'a plu. Depuis ce moment-là, j'ai gardé contact avec eux et leur amitié m'est essentielle.

Quand je me suis marié avec Monika, en 1978, nous nous sommes offert une Turbo et, depuis, il y a toujours eu une Porsche dans notre garage. Bien avant que je sois officiellement lié à la marque, je rencontrais ou discutais régulièrement avec des gens de chez Porsche. C'est avec un grand plaisir que je me rappelle, par exemple, les essais réalisés avec le professeur Bott. Il m'appela avant le rallye de Monte-Carlo de 1982 et me déclara, tel un conjurateur, qu'il avait là, à Turrach, une 911 un peu particulière à transmission intégrale et, comme référence, une Audi Quattro ... Il parlait de la future 959, dont j'ai eu l'honneur de posséder un exemplaire à la construction allégée.

Porsche ne s'engageant pas dans le Championnat du Monde des Rallyes, nous nous sommes contentés de quelques apparitions communes ponctuelles dans le domaine professionnel, mais d'autant plus spectaculaires. Le rallye de San Remo de 1981 fut un moment inoubliable. Jusqu'à notre abandon, nous avons longtemps donné l'impression de pouvoir battre, avec notre 911, une Audi Quattro – pourtant impériale sur la terre.

Ce n'est qu'en 1993 que j'ai signé mon contrat de représentant et de pilote de développement pour Porsche. Après tant d'années de collaboration, je connais plutôt bien Porsche AG et les succès accumulés au fil des ans, et je me sens comme chez moi à Zuffenhausen et à Weissach. Grâce aux gens qui travaillent ici, à leur passion pour les voitures de sport considérées comme de véritables purs-sangs et à leur très haute exigence de qualité.

J'aime leur caractère et j'aime leurs voitures de sport qui, même à notre époque où prolifèrent réglementations et interdictions, ne cessent d'innover sur le plan technique, de rester fascinantes, dédiées corps et âme à la puissance,

I am quite sure that Rainer W. Schlegelmilch's attitude to Porsche is not much different from mine. Hardly ever have I seen him in cars of a different make. Unlike myself, he doesn't only drive Porsches but he also photographs their beauty in his own inimitable style.

I wish you much joy looking at his pictures and reading the informative text.

Yours truly,

und durch auf Leistung getrimmt sowie ein ästhetischer Genuss sind. Das muss denen erstmal einer nachmachen.

Ich denke, Rainer W. Schlegelmilch empfindet für Porsche ganz ähnlich wie ich. Jedenfalls habe ich ihn selten in anderen Fahrzeugen gesehen. Anders als ich kann er die Porsche nicht nur fahren, er kann ihre Schönheit auch in seinen unverwechselbaren Fotos einfangen.

Ich wünsche Ihnen viel Freude beim Bilderschauen und beim Lesen.

Herzlich, Ihr

sans négliger pour autant un authentique plaisir esthétique. Cherchez-en d'ailleurs une autre qui puisse rivaliser avec elles !

Je pense que Rainer W. Schlegelmilch a pour Porsche des sentiments très similaires aux miens. D'ailleurs, je l'ai rarement vu au volant d'une voiture d'une autre marque. Contrairement à moi, il n'a pas seulement le loisir de piloter des Porsche, il a aussi le plaisir d'en capter toute la beauté dans ses photos dont lui seul a le secret.

Je vous souhaite beaucoup de plaisir à la lecture de ce livre.

Cordialement,

Portrait of a Premium Marque
Porträt einer Premiummarke
Portrait d'une marque de luxe

Porsche—that name has obviously long since become synonymous with the product, a brilliant sports car, fostered, above all, by almost six decades of the 356 and 911 model ranges' presence on the roads of the world. But initially it stood for an almost inexhaustible variety of ideas cast into the "Dr. Ing. h.c. F. Porsche GmbH, Konstruktion und Beratung für Motoren- und Fahrzeugbau" (a design and consultancy company for engine and vehicle construction) form of organization in 1931, almost at the height of the world economic crisis. It was to become a limited partnership (KG) in 1937 and eventually changed into a joint-stock corporation in 1972. Its garrison has always been Stuttgart, apart from an interlude in Carinthian Gmünd between 1944 and 1950, after perpetual allied air raids meant that a period of exile in the Austrian province seemed advisable.

In those years Porsche was a huge showcase full of technical delicatessen, in which the possible and the feasible blended into a mosaic of universal dimensions. There were aircraft engines with 16 or 32 combustion units, air-cooled V10 and 16-cylinder diesel motors with direct injection and turbocharging and the concept of a gas turbine for the propulsion of a tank; there was torsion bar suspension, the patent of which was applied for on 10 August 1931, a swing axle for the British ERA racing stable, and a wind power plant; and there were the water turbines, cable winches, ski lifts and diverse types of tractors with which "Porsche-Konstruktionenbüro", amidst makeshift premises, endeared itself to its Gmünd interim home.

On 22 June 1934, the company had been entrusted with designing and building a German

Porsche – der Begriff ist längst zum Synonym mit dem Produkt geworden, dem Klassesportwagen, unterfüttert vor allem durch die sechs Jahrzehnte während und wirkende Präsenz der Baureihen 356 und 911 auf den Straßen der Welt. Ursprünglich jedoch stand er für schier unerschöpflich sprudelnde Ideenvielfalt, im Jahr der Krise 1931 in die Organisationsform der „Dr. Ing. h.c. F. Porsche GmbH, Konstruktion und Beratung für Motoren- und Fahrzeugbau" gegossen. 1937 wurde diese zur Kommanditgesellschaft umgewidmet und 1972 in den Status einer Aktiengesellschaft überführt. Standort war stets Stuttgart, abgesehen von einem Intermezzo im Kärntner Gmünd zwischen 1944 und 1950, nachdem anhaltender alliierter Bombenhagel ein Exil in der österreichischen Provinz hatte ratsam erscheinen lassen.

Porsche – das war damals ein Schaukasten voller technischer Delikatessen, in dem sich Mögliches und Machbares zu einem Mosaik von universaler Größe zusammenfanden. Flugmotoren mit 16 und 32 Verbrennungseinheiten, luftgekühlte V10- und sechzehnzylindrige Dieseltriebwerke mit direkter Einspritzung und Turboaufladung sowie der Entwurf einer Gasturbine zum Antrieb eines Panzers waren ebenso darin ausgestellt wie die am 10. August 1931 zum Patent angemeldete Drehstabfederung, eine Schwingachse für den englischen Rennstall ERA, eine Windkraftanlage oder die Wasserturbinen, Seilwinden, Skilifte sowie diverse Schleppertypen, mit denen sich das „Porsche-Konstruktionenbüro" in seine Gmünder Interims-Heimat einschmiegte.

Am 22. Juni 1934 war man vom „Reichsverband der deutschen Automobilindustrie" (RDA) mit

Porsche – s'il est un nom qui, depuis longtemps, incarne à la perfection un produit, c'est bien celui de cette voiture de sport élitaire. Un statut confirmé par les soixante ans de présence durable et active des 356 et 911 toutes générations confondues sur les routes du monde entier. À l'origine, il évoquait pourtant un foisonnement d'idées littéralement inépuisables en cette année de crise de 1931 sous la raison sociale « Dr. Ing. h.c. F. Porsche GmbH, Konstruktion und Beratung für Motoren- und Fahrzeugbau ». En 1937, celle-ci devient une société à commandite avant d'obtenir, en 1972, le statut de société anonyme. Son siège a toujours été à Stuttgart, si l'on fait abstraction d'un bref passage à Gmünd, en Carinthie, entre 1944 et 1950, les bombardements alliés récurrents ayant fait paraître judicieux ce court exil aux fins fonds de cette province autrichienne.

Porsche – c'était alors un kaléidoscope de raffinements techniques dans lequel s'associaient le possible et le réalisable en une mosaïque à l'ampleur universelle. Des moteurs d'avion à 16 et 32 cylindres, des diesels V10 ou seize-cylindres refroidis par air à injection directe et suralimentation, le projet d'une turbine à gaz destinée à motoriser un blindé en ont fait partie, tout comme une suspension à barre de torsion brevetée le 10 août 1931, un essieu oscillant pour l'écurie de course anglaise ERA, une centrale à éoliennes ou des turbines hydrauliques, des treuils, des remonte-pentes, ou encore divers types de tracteurs avec lesquels le Bureau d'études Porsche s'est intégré à la perfection à sa patrie intérimaire de Gmünd.

Le 22 juin 1934, la « Fédération du Reich pour l'industrie automobile allemande », la RDA, chargea ce bureau d'études de concevoir et construire la future Volkswagen (VW), la Voiture du peuple.

Les administrateurs du Reich s'étaient vite rendu compte quelles étaient les ressources du filon à exploiter sous la renommée de Porsche. La conception complète de chars d'assaut comme la « Souris » et le « Tigre » en est le témoignage, de même que les nombreux dérivés militaires de l'automobile KdF (la force par la joie) de VW.

Mais il y avait aussi et surtout la compétition automobile, depuis toujours le péché mignon et domaine de prédilection pour l'esprit innovateur du génial fanatique de la technique qu'était Ferdinand Porsche. Son charisme rayonnait au point de masquer même des rivalités ancestrales cultivées avec acharnement : le 17 mars 1933,

Already in its first year, 1931, the Porsche design office causes a stir with the introduction of the torsion bar suspension.

Bereits in ihrem ersten Arbeitsjahr 1931 glänzt die Porsche GmbH mit der Pioniertat Drehstabfederung.

Dès sa première année, en 1931, le bureau d'études Porsche GmbH s'illustre avec une création innovante, la suspension à barre de torsion.

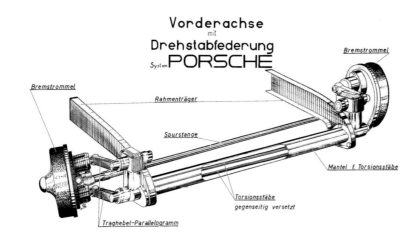

Vorderachse
mit
Drehstabfederung
System PORSCHE

Bremstrommel

Bremstrommel

Rahmenträger

Spurstange

Mantel f. Torsionsstäbe

Torsionsstäbe gegenseitig versetzt

Traghebel-Parallelogramm

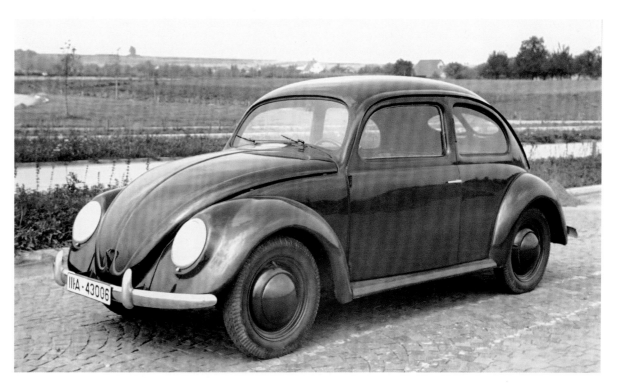

In winter 1935 the first roadworthy prototype of the Volkswagen (code V1) is put through extensive tests. The 1938 version already resembles the VW "Beetle".

Im Winter 1935 wird der erste fahrfertige Prototyp des Volkswagens (Code V1) extensiven Tests unterzogen. 1938 ist das Modell schon zum richtigen Käfer gereift.

Durant l'hiver 1935, le premier prototype roulant de la Volkswagen (code V1) subit des tests approfondis. En 1938, le modèle a déjà donné naissance à la vraie Coccinelle.

people's car by "Reichsverband der deutschen Automobilindustrie" (RDA), the German Reich's automobile industry association. In any case, it had not gone unnoticed with the Nazi big shots that considerable resources could be tapped under the Porsche name. Complete battle tanks such as "Maus" (mouse) and "Tiger" bore testimony to that, as did a lot of warlike derivatives of the Volkswagen. And then there was racing, of course, which had always been close to the heart of Ferdinand Porsche and a testing ground for his innovative ideas. His charisma outshone even time-honored and well-preserved rivalries: on 17 March 1933, a contract was signed with the Auto Union automotive group to build a grand prix car that complied with the

Konstruktion und Bau des deutschen Volkswagens betraut worden.

Überhaupt waren den Verwesern des Reichs natürlich die Ressourcen nicht entgangen, die sich unter dem guten Namen Porsche anzapfen ließen. Komplette Kampfpanzer wie „Maus" und „Tiger" zeugten davon, aber auch die zahlreichen kriegsverwendungsfähigen Derivate des KdF (Kraft durch Freude)-Mobils VW.

Immer aber war da der Rennsport, für den genialen Technikgelehrten Ferdinand Porsche seit jeher Herzensanliegen und Spielwiese innovativen Gedankenguts. Sein Charisma überstrahlte selbst eingefahrene und sorgsam gehegte Rivalitäten: Am 17. März 1933 einigte man sich mit der Auto Union über den Bau eines Mittelmotor-

il conclut avec Auto Union un accord sur la construction d'une voiture de course à moteur central pour la future formule 750 kg. Et, quatre ans plus tard, Daimler-Benz AG lui passe commande de la voiture de record T80 destinée à battre le record de vitesse sur terre. Enfin, le double compresseur pour la monoplace de Grand Prix W154 de l'année 1938 est, lui aussi, né sur la planche à dessin du professeur.

En septembre 1938, il s'attaque en marge de ses activités à la type 64, la propre création de Porsche pour la course d'endurance Berlin-Rome qu'il envisage de disputer douze mois plus tard avec un moteur boxer de VW modifié et une carrosserie à l'aérodynamique raffinée. Au printemps 1939, trois coupés sont prêts à prendre

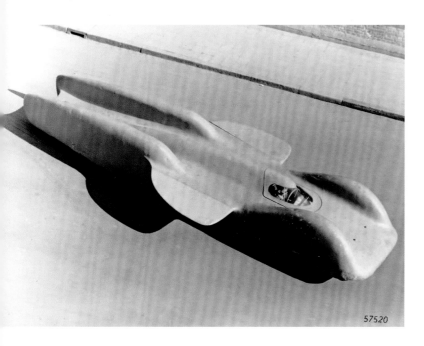

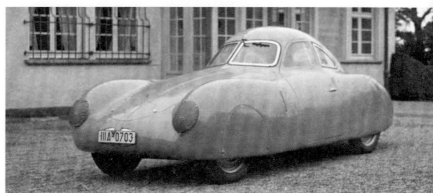

Commissioned work from 1937 for Mercedes, the T80 and the "Berlin–Rome car" Type 64 of 1939. Both Porsche-conceived vehicles were never put to their proper use.

Porsche-Auftragswerk T80 von 1937 für Mercedes und der „Berlin–Rom-Wagen" Typ 64 von 1939. Beide wurden nie ihrer eigentlichen Bestimmung zugeführt.

De bonnes commandes pour Porsche – la T80 de 1937, pour Mercedes, et la « Berlin–Rome », la Type 64, de 1939. Mais aucune ne prendra réellement la route.

oncoming 750-kg formula. Four years later it was Daimler-Benz AG's turn to commission Porsche with the monstrous Type 80 so as to eclipse the existing world land speed record. The two-stage supercharger incorporated into the V12 of the 1938 W154 grand prix monoposto was also credited to the professor.

In September of that year the Type 64, Porsche's own contribution to the Berlin-Rome long-distance race planned for September 1939, took shape on the drawing-board. It featured a modified VW flat-four and streamlined bodywork. Three coupés were ready by spring 1939 but then history set different priorities. The Porsche sports car had been born, though. Genes of the 64 could visibly be found on the miniature model of a four-seater code-named Type 352 requested for by Swiss client Rupprecht von Senger and constructed in Gmünd in 1946, and also on the very first 356, ready for the road on 8 June 1948. It was to be the ancestor of a whole dynasty.

But then the Porsche vision of "driving in its most beautiful form" took shape quickly. In 1951, more than 200 highly motivated employees produced 1364 specimens of the Type 356. In 1954, a staff of 500 was busy manufacturing 1853 vehicles. In 1964—the nearby Reutter bodyshop, part and parcel of the production since 1949 and employing 1000 people, had been fully integrated and rechristened "Karosseriewerk Porsche

Rennwagens für die künftige 750-kg-Formel, vier Jahre später gab die Daimler-Benz AG den Rekordwagen T80 in Auftrag, mit dem man den Geschwindigkeitsrekord zu Lande zu brechen gedachte. Und auch der Doppelkompressor für den Grand-Prix-Monoposto W154 anno 1938 stammte vom Reißbrett des Professors.

Im September jenes Jahres nahm man überdies den Typ 64 in Angriff, Porsches eigene Züchtung für das Langstreckenrennen Berlin–Rom, das zu einem Termin zwölf Monate später angesetzt war, mit einem modifizierten VW-Boxer-Aggregat und einem Aufbau von windschlüpfiger Glätte. Drei Coupés harrten im Frühjahr 1939 auf ihren Einsatz. Aber dann setzte die Geschichte andere Prioritäten. Gleichwohl war der Porsche-Sportwagen geboren. Gene des 64 fanden sich sichtbar im Miniatur-Modell für das Opus 352, einen Viersitzer, den man 1946 in Gmünd für den Schweizer Rupprecht von Senger konstruierte, und vor allem am Ur-356, am 8. Juni 1948 einsatzbereit und Stammvater einer ganzen Dynastie.

Dann aber verschaffte sich die Vision vom „Fahren in seiner schönsten Form" zügig Raum. 1951 stellten über 200 engagierte Mitarbeiter 1364 Exemplare des Typs 356 auf die Räder. 1954 waren mit der Produktion von 1853 Fahrzeugen 500 Porsche-Bedienstete betraut. 1964 – das benachbarte Karosseriewerk Reutter, seit 1949 in die Fertigung eingebunden, war am 1. März

le départ. Mais l'Histoire en décide autrement. La voiture de sport de Porsche n'en est pas moins bel et bien née. Des gènes de la 64 se retrouvent de façon flagrante dans la maquette de la 352, une quatre-places que Porsche construit en 1946 à Gmünd pour le Suisse Rupprecht von Senger, et, surtout, sur l'ancêtre de la 356, prête à entrer dans les annales le 8 juin 1948 et à l'origine de toute une dynastie.

Mais le concept de la «Conduite sous la forme la plus belle» devient vite une réalité. En 1951, plus de 200 collaborateurs débordant d'enthousiasme fabriquent 1364 exemplaires de la 356. En 1954, ce sont 500 ouvriers de chez Porsche qui sont chargés de produire les 1853 voitures. Entre-temps, Reutter, l'usine de carrosserie voisine qui assurait la fabrication depuis 1949 est rebaptisée «Karosseriewerk Porsche GmbH» avec ses 1000 salariés. En 1964, ce sont 10368 voitures qui sortent des chaînes où travaillent 2415 employés de Porsche, pour un chiffre d'affaires de 156 millions de marks. Le 16 mars 1956, un toast est porté en l'honneur du numéro 10000, un coupé de la gamme 356A, sorti par un heureux hasard à l'occasion du 25e anniversaire de la firme. À partir de l'exercice 1960, 653 ateliers agréés dans le monde entier se chargent d'entretenir et de réparer la diva de Zuffenhausen. La 50000e sort des chaînes le 3 avril 1962. Et, le 21 décembre 1966, la police du Land du Bade-Wurtemberg s'offre

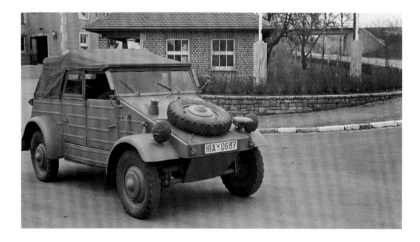

Being a seemingly inexhaustible think tank the Porsche engineering office contributed a wide spectrum of paraphernalia to the Wehrmacht's equipment, such as the Type 82, known as the VW "Kübelwagen". Built in large numbers in the VW plant instead of the Volkswagen itself, it was to become the German forces' standard off-road vehicle, sturdy and utterly reliable. The Type 166 amphibious version, pictured during an inspection in 1942, was a close relative. In the category exceeding 50 tonnes, the Type 101 "Tiger" tank never made it to the battlefields.

Aus gegebenem Anlass steuerte Porsche ein ganzes Spektrum von Kriegsgerät zur Ausrüstung der Wehrmacht bei. Dazu zählte der Typ 82 „Kübelwagen", der anstelle des Volkswagens in großen Stückzahlen im VW-Werk hergestellt und zum genügsamen und unverwüstlichen Standard-Geländefahrzeug der deutschen Truppen im Zweiten Weltkrieg wurde. Beim Schwimmwagen Typ 166, hier bei der Abnahme im Mai 1942, handelte es sich um einen nahen Verwandten. Der schwere Panzer Typ 101 („Tiger") kam über das Versuchsstadium nicht hinaus.

Porsche a été l'auteur de toute une armada d'engins de guerre qui ont équipé la Wehrmacht. Dont la Type 82 «Kübelwagen», qu'il fabrique, à la place de la Volkswagen, en grand nombre à l'usine VW et qui devient un véhicule tout-terrain standard aussi sobre que robuste pour les troupes allemandes durant la Seconde Guerre mondiale. Quant à la voiture amphibie, la 166, ici lors de son homologation en mai 1942, il s'agit d'une proche parente. Le char lourd Type 101 («Tigre») ne dépassera jamais le stade expérimental.

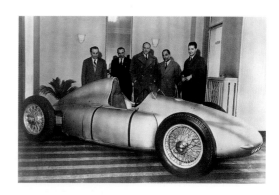

Production of the first Porsche 356 Coupé at Gmünd in 1948, Erwin Komenda (left) and plant manager Otto Husslein looking on. In the same year the Porsche Type 360 ("Cisitalia") for Piero Dusio (center) was completed.

Produktion des 356/2 Coupés 1948 in Gmünd, hinten links: Erwin Komenda, rechts: Betriebsleiter Otto Husslein. Im gleichen Jahr wurde der Porsche Typ 360 („Cisitalia") hergestellt. In der Mitte Piero Dusio.

La production de la 356/2 Coupé, en 1948 à Gmünd ; à gauche : Erwin Komenda ; à droite : le directeur d'usine Otto Husslein. La même année la Porsche Type 360 (« Cisitalia ») de Piero Dusio (au centre) est terminée.

GmbH" on 1 March—the workforce totaled 2415, taking care of 10,368 units and a turnover of 156 million marks. Porsche number 10,000, a 356A Coupé, had been celebrated on 16 March 1956, which happily coincided with the firm's 25th anniversary. In the 1960 fiscal year, there was a customer service organization consisting of 653 authorized Porsche workshops worldwide. Car number 50,000 rolled off the assembly line on 3 April 1962, while on 21 December 1966 the 100,000th Porsche, a specially equipped Type 912 Targa, was incorporated into the autobahn fleet of the Baden-Wuerttemberg state police.

At the same time, export rates were soaring, above all in the important United States market. In 1950, Swiss journalist Max Troesch had initiated an historical meeting between Ferdinand Porsche and wheeler-dealer American importer Maxie Hoffman, who promptly presented the 356 in New York before that year's end and took over its distribution. Five years later, an independent network under the name of "Porsche of America Corporation" (POAC) was built up, which from 1959 was solely responsible for sales, service and marketing on behalf of Porsche KG. As in the foundation years, emphasis was further placed on diversification and various commissions. Among the latter was the Type 597 "Jagdwagen", constructed in 1953 in response to a Bundeswehr invitation to tender for an amphibious four-wheel-drive vehicle. Only a pre-production run of 71 were made since the public contract was, for one reason or another, eventually awarded to DKW.

The former comprised "Porsche-Diesel-Motorenbau GmbH Friedrichshafen a.B.", a branch that produced an impressive 120,000 tractors between 1956 and 1963, as well as the Type 729 boat power plant of 1958 and the aircraft engine program of 1959 which, however, was not very successful. The punchy in-house magazine *Christophorus*, in which intrepid racing driver and eloquent journalist Richard von Frankenberg indefatigably promoted the Porsche philosophy and enthused about the joys of jerkily applying the accelerator while cornering on the limit and sawing at the steering wheel, proved to be an instant hit in 1952, the ever-increasing Porsche community flashing their lights at one another conspiratorially when they happened to meet on the roads. Of course, there was plenty to talk about, for instance the metamorphoses and new models, countless racing successes and the

mit 1000 Werksangehörigen umgeflaggt worden zum „Karosseriewerk Porsche GmbH" – nahmen bei einem Umsatz von 156 Millionen Mark unter den Händen von 2415 Porsche-Schaffenden 10368 Einheiten Gestalt an. Auf Numero 10000, ein Coupé der Modellreihe 356A, hatte man, fein abgestimmt auf das 25-jährige Firmenjubiläum, am 16. März 1956 angestoßen. Im Geschäftsjahr 1960 kümmerten sich weltweit 653 autorisierte Werkstätten um Wartung und Pflege der schönen Schnellen aus Zuffenhausen. Nummer 50000 rollte am 3. April 1962 vom Band. Am 21. Dezember 1966 verleibte die Landespolizei Baden-Württemberg ihrem Fuhrpark den 100000. Porsche ein, einen speziell für den Autobahndienst aufbereiteten 912 Targa.

pour son parc la 100000e Porsche, une 912 Targa préparée spécialement pour patrouiller sur les autoroutes.

Simultanément, Porsche fait un tabac à l'export, tout spécialement aux États-Unis, marché capital pour la marque. En 1950, le journaliste suisse Max Troesch avait, en effet, organisé une rencontre qui allait être essentielle pour l'avenir entre Ferdinand Porsche et Maxie Hoffman. L'infatigable importateur américain présenta immédiatement la 356 à New York et en assuma également la distribution. En 1955 est créé un réseau indépendant de distributeurs sous la raison sociale « Porsche of America Corporation » (POAC) qui assume, en 1959, la vente, le service et le marketing. Comme lors

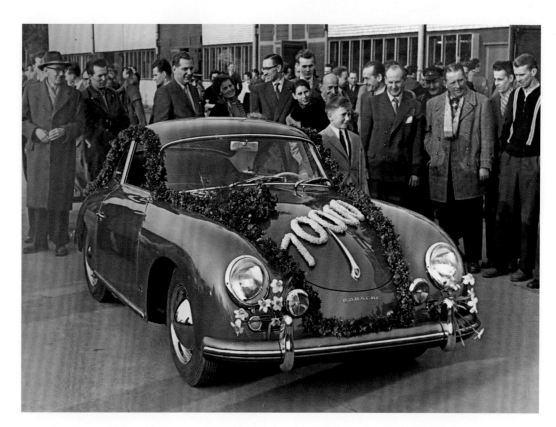

Together with its 25th birthday the company celebrated the 10,000th Porsche sports car, a Coupé, on 16 March 1956. In the 1956 fiscal year, the 356A Coupés, Cabriolets and Speedsters set a new sales record.

Zusammen mit dem 25. Jubiläum der Firma feiert man am 16. März 1956 Exemplar 10000 des Erfolgstyps 356, ein Coupé. Die Coupés, Cabriolets und Speedster 356A erzielen in jenem Jahr einen Verkaufsrekord.

Le 25e anniversaire de la société coïncide, le 16 mars 1956, avec le 10000e exemplaire de son *best-seller*, la 356, un Coupé. Cette année-là, Coupés, Cabriolets et Speedster 356A battent des records de vente.

North American importer Maximilian E. Hoffman is sitting at the wheel of a Glöckler-Porsche. Among other feats, Hoffman triggered the conception of the Speedster.

Der amerikanische Importeur Maximilian E. Hoffman 1951 am Lenkrad eines Glöckler-Porsche. Hoffman stößt unter anderem die Konzeption des Speedsters an.

L'importateur américain Maximilian E. Hoffman au volant d'une Glöckler-Porsche, en 1951. C'est ce même Hoffman qui a été à l'origine, en particulier, de la conception du Speedster.

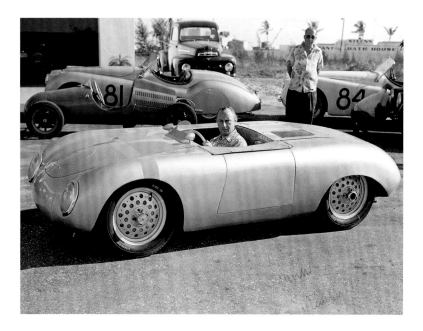

des premières années qui ont suivi sa création, le constructeur souabe joue aussi la carte de la diversification et des développements sur commande. Parmi ces derniers, la « Jagdwagen » (voiture de chasse) Type 597, un véhicule amphibie conçu dans le cadre d'un appel d'offres de l'Armée fédérale allemande. Il n'en sera fabriqué que 71 modèles de présérie, DKW ayant obtenu le marché pour différents motifs. Quant à la diversification, elle s'illustre au travers de la société « Porsche-Diesel-Motorenbau GmbH Friedrichshafen a.B. », qui aura vendu aux agriculteurs pas moins de 120 000 tracteurs entre 1956 et 1963. Mais aussi, par exemple, du moteur de bateau 729, en 1958, ou du programme de moteurs d'avion de 1959 qui ne connaîtra pas un succès mémorable.

Le magazine maison, *Christophorus*, à la maquette sportive, prend vite le statut de revue culte. À partir de 1952, le téméraire pilote de course et journaliste Richard von Frankenberg

Fighters' Cabriolet

The Type 597 "Jagdwagen" was intended for use in the German Bundeswehr. In conceiving it, Porsche could hark back to experiences with the VW "Kübelwagen" and its amphibious derivatives. The completed product was presented in 1954, with the 1.6-liter four-cylinder unit of the 356, switch-off four-wheel drive and amphibian capabilities, though without its own propulsion. Though very well received, the lot went to somebody else.

Cabrio für Kämpfer

Für die Bundeswehr gedacht war der „Jagdwagen" Typ 597, bei dessen Konzeption man in Zuffenhausen auf Erfahrungen mit dem VW „Kübel"- und Schwimmwagen zurückgreifen konnte. Schon Ende 1954 stellte man das fertige Produkt vor, mit dem 1,6-Liter-Vierzylinder aus dem 356, abschaltbarem Allradantrieb und schwimmfähig ohne eigenen Antrieb. Leistungen und Rezeption waren glänzend, den Zuschlag erhielt jemand anders.

L'ancêtre du Cayenne

La « Jagdwagen » Type 597 a bénéficié des expériences tirées des VW « Kübel » et amphibies. Elle était destinée à la Bundeswehr. La voiture est présentée dès 1954, avec le quatre-cylindres de 1,6 litre de la 356, transmission intégrale débrayable et amphibie sans sa propre propulsion. Si les performances et l'accueil sont flatteurs, c'est un autre constructeur qui obtient le marché.

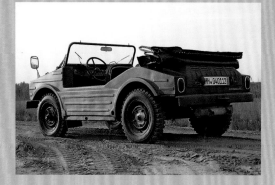

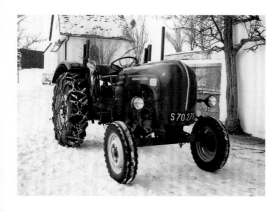

The Porsche "Standard" tractor, pictured in 1970 in front of the family-owned "Schüttgut" in Austrian Zell am See.

Der Porsche-Schlepper „Standard", 1970 aufgenommen vor dem familieneigenen „Schüttgut" in Zell am See.

Le tracteur Porsche «Standard», photographié en 1970 devant la propriété familiale du «Schüttgut», à Zell am See.

Star journalist and racing driver Richard von Frankenberg, famous for his intrepid driving style.

Starjournalist und Rennfahrer Richard von Frankenberg, genannt der „Schreckensteiner".

Le journaliste et pilote de course Richard von Frankenberg, bien connu pour son style de conduite intrépide.

activities of the numerous clubs modeled upon the initial Porsche Club Hohensyburg founded in 1952. And, after all, there were remarkable fringe benefits, such as a monthly pension payable from age 65 introduced in 1956, the year from which the Porsche Foundation also provided financial help to staff who had fallen on hard times through no fault of their own, or the fact that Porsche employees were entitled to sick pay and a full month's salary as a Christmas bonus, both achievements of the year 1960. From 1954, the Stuttgart brand's pride in their attractive product was sported in the shape of the heraldically pretty Porsche coat of arms adorning the hood of every vehicle, an amalgam of the firm's logo as designed in 1951, the prancing Stuttgart stallion and the Baden-Wuerttemberg emblem. Ferry Porsche himself had lent a hand in creating it.

It was he who broke new ground for the future development division of the marque on 16 October 1961, on a site in Weissach 15 miles from the

Zugleich boomte der Export, vor allem in die als Markt ungemein wichtigen USA. 1950 hatte der Schweizer Journalist Max Troesch ein zukunftsträchtiges Treffen von Ferdinand Porsche mit dem rührig-umtriebigen amerikanischen Importeur Maxie Hoffman eingefädelt, der den 356 prompt in New York vorstellte und auch den Vertrieb übernahm. 1955 baute man ein unabhängiges Händlernetz auf in Gestalt der „Porsche of America Corporation" (POAC), die 1959 zu 100 Prozent für Verkauf, Service und Marketing zuständig wurde. Wie bereits in den Gründerjahren setzte man überdies auf Diversifikation und Auftragsentwicklungen. Zu letzteren zählte der „Jagdwagen" Typ 597, ein schwimmfähiges Allradfahrzeug, im Rahmen einer Ausschreibung der Bundeswehr auf die Räder gestellt. Es blieb bei 71 Vorserienwagen, nachdem DKW aus vielerlei Gründen den Zuschlag erhalten hatte. Erstere umspannte die „Porsche-Diesel-Motorenbau GmbH Friedrichshafen a.B.", die zwischen 1956 und 1963 immerhin 120 000 Schlepper unter das Landvolk brachte, aber auch beispielsweise den Bootsmotor 729 von 1958 oder das eher minder erfolgreiche Flugmaschinen-Programm von 1959.

Kultstatus fiel alsbald dem flott aufgemachten Magazin Christophorus zu, in dem sich seit 1952 der überaus unerschrockene Rennfahrer und wortgewaltige Journalist Richard von Frankenberg als Chefredakteur und Exeget der Porsche-Philosophie äußerte und unermüdlich von den Freuden des „Tipperns" (stoßweisen Umgangs mit dem Gaspedal) und „Sägens" (mit dem Lenkrad) kündete und auch vom Zusammenhalt der großen Porsche-Familie, die sich bei Begegnungen im Straßenverkehr verschwörerisch anblinkte. Zu berichten gab es genug, von Metamorphosen und neuen Modellen, schier unzähligen Rennerfolgen sowie dem Wesen und Wirken der Markenclubs nach dem Vorbild des im Mai 1952 gegründeten Porsche Clubs Hohensyburg. Oder auch von Sozialleistungen zum Vorzeigen, wie der betrieblichen Altersversorgung in Form eines monatlichen Ruhegelds ab 1956, der Lohnfortzahlung im Krankheitsfall und dem vollen Monatsgehalt als Weihnachtsgratifikation, Errungenschaften des Jahres 1960. Den Stolz der Stuttgarter auf ihr attraktives Erzeugnis belegte ab 1954 das heraldisch hübsche Porsche-Wappen auf der Fronthaube jedes Wagens, ein Amalgam aus dem seit 1951 eingebürgerten Firmen-Schriftzug, dem tänzelnden Stuttgarter Hengst und dem württembergischen Landeswappen. Bei seinem Design hatte auch Ferry Porsche die Hand im Spiel gehabt.

Am 16. Oktober 1961 führte dieser auf einem 25 Kilometer von Zuffenhausen entfernten Baugrundstück der Gemeinde Weissach den ersten Spatenstich zum künftigen Porsche-Entwicklungszentrum aus, vom Sommer 1971 an eine erste Adresse für Aufträge aus aller Welt. Am 20. September 1974 waren die Arbeiten am zweiten Bauabschnitt abgeschlossen, und Laboratorien, Prüfstände und Werkstätten wurden eingeweiht. Wieder bediente man

en devient le rédacteur en chef. Ennemi de la langue de bois et exégète de la philosophie Porsche, il y prend la parole pour y professer infatigablement le plaisir de la conduite à petits coups d'accélérateur consécutifs accompagnés de « coups de scie » donnés avec le volant. Entre-temps, les membres de la – désormais – grande famille Porsche ont appris à manifester leur sentiment d'appartenance, quand ils se croisent dans la circulation de tous les jours, par un discret coup de clignotant entre initiés. Ce ne sont pas les sujets de conversation qui manquent, des remises à jour aux tout nouveaux modèles ou de l'accumulation inimaginable de succès en course aux activités de toute nature des clubs de marque à l'exemple du Porsche Club Hohensyburg fondé en mai 1952. Ou, aussi, des prestations sociales qui feront date, par exemple la prévoyance vieillesse de l'entreprise sous la forme d'une rente mensuelle à partir de 1956, du maintien du paiement du salaire en cas de maladie et du

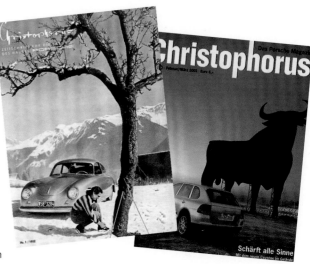

Since 1952 the Christophorus magazine has been the main organ of the sworn Porsche community.

Zentralorgan der großen verschworenen Porsche-Gemeinde ist seit 1952 der Christophorus.

Depuis 1952, la revue Christophorus est l'organe incontournable de la chapelle d'irréductibles de Porsche.

versement d'un 13e mois comme prime de Noël : tous acquis sociaux de l'année 1960. La fierté que les Stuttgartois ressentent envers leur déjà mythique voiture se manifeste à partir de 1954 au travers du blason Porsche, une création d'inspiration héraldique réussie qui orne le capot avant de chaque voiture, un amalgame du logo de la firme qui a fait son apparition en 1951, de la jument cabrée de Stuttgart et des armoiries du Land du Wurtemberg. Ferry Porsche se serait bien évidemment aussi immiscé dans son design.

Le 16 octobre 1961, celui-ci donne le premier coup de pioche sur un terrain de la commune de Weissach, à 25 km de Zuffenhausen, site du futur centre de développement de Porsche qui sera, à partir de l'été 1971, la meilleure adresse pour les commandes provenant du monde entier. Le

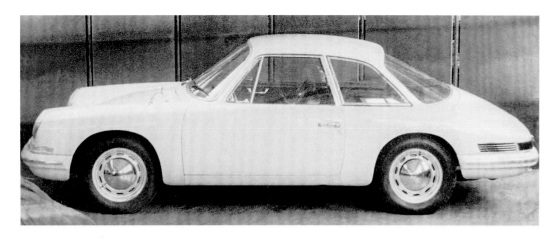

The four-seater 754 T7 is the first roadworthy precursor of the 911, whose basic shape it anticipates. It takes to the road for the first time in November 1960.

Der erste fahrbare Vorläufer des 911 ist der Viersitzer 754 T7. Die formalen Anklänge sind unverkennbar. Im November 1960 rollt er zur Premiere auf die Straße.

Le premier précurseur roulant de la 911 est la 754 T7 à quatre places. La parenté visuelle est incontestable. En novembre 1960, elle prend la route pour la première fois.

original Zuffenhausen plant. From 1971 onwards, it was to be a first-class address for orders from all over the world. On 20 September 1974, work on the second building phase had come to an end, with test rigs, laboratories and workshops being officially inaugurated. Again, apart from the domestic requirements of the noble house itself, a wide range of wishes was catered for. So, among other things, the Weissach think tank was the cradle of a complete subcompact for the Soviet state-owned company Lada, the "Extended Life Car Research Project" which caused quite a stir at the 1973 Frankfurt IAA, the innovative SAVE (abbreviating the German equivalent of Rapid Outpatient Preclinical First Aid) ambulance of 1975, the Porsche double-clutch gearbox for seamless shifting introduced in 1981, the same year in which a new generation of Weissach designed Linde fork trucks saw the light of day.

Following the company's conversion into a joint-stock corporation, which was endorsed

neben dem Eigenbedarf des noblen Hauses ein buntes Spektrum von Wünschen. So wurde die Weissacher „Denkfabrik" unter anderem Wiege eines kompletten Kleinwagens der sowjetischen Staatsmarke Lada, der Fahrzeugstudie FLA (Forschungsprojekt Langzeit-Auto), die auf der Frankfurter IAA 1973 viel Staub aufwirbelte, des innovativen Rettungsautos SAVE (Schnelle Ambulante Vorklinische Erstversorgung) von 1975, des Porsche-Doppelkupplungsgetriebes PDK zum Schalten ohne Zugkraftunterbrechung anno 1981 und einer neuen Generation von Linde-Gabelstaplern im nämlichen Jahr.

Vorsitzer des Aufsichtsrats wurde nach der 1973 faktisch durchgeführten Umwandlung von der KG zur AG Ferry Porsche, Sprecher des Vorstands Ernst Fuhrmann, der ihm am 6. November 1976 im Amt nachfolgte. In dessen Ägide fielen die beiden frohen Botschaften des Jahres 1977: Der 250 000. Porsche erhielt am 3. Juni den letzten Schliff, das Geschäftsjahr

20 septembre 1974, les travaux de la deuxième section sont achevés et l'on inaugure laboratoires, bancs d'essais et ateliers. Une fois de plus, outre les besoins personnels de la prestigieuse maison, on y satisfera aussi les désirs d'une vaste clientèle. Ainsi « l'usine à cerveaux » de Weissach est-elle notamment le berceau d'une compacte totalement conçue sur place pour la marque d'État soviétique Lada, du prototype d'un véhicule FLA (Projet de recherche de voiture durable), qui a fait sensation à l'IAA de Francfort en 1973, de l'innovante automobile de secours SAVE (Premiers soins précliniques ambulatoires rapides), en 1975, de la boîte à double embrayage Porsche PDK permettant de changer de rapport sans interruption du couple, en 1981, et d'une nouvelle génération de chariots élévateurs Linde, la même année.

Après la transformation de facto de la société en commandite en une société anonyme, en 1973, Ferry Porsche devient président du conseil de surveillance, le porte-parole du directoire étant Ernst Fuhrmann, qui en reprendra les fonctions le 6 novembre 1976. Sous son règne se produisent les deux heureux événements de l'année 1977 : la 250 000e Porsche sort des chaînes le 3 juin, et l'exercice comptable 1976–1977 est clôturé avec un chiffre d'affaires d'un milliard de marks. Fuhrmann ne restera pas longtemps aux commandes puisqu'il sera remplacé, plus tard, par le Germano-Américain Peter W. Schutz. La moitié restante de la filiale « VW-Porsche-Vertriebsgesellschaft mbH », joint-venture fondé en avril 1969 pour la commercialisation de la 914, tombe dans le giron de Porsche AG le 31 juillet 1974. Tout n'est pas un long fleuve tranquille aux États-Unis non plus. Dans ce pays, « Porsche-Audi Division of Volkswagen of America Inc. » reprend les activités de la société « Porsche of America Corporation » qui a été dissoute vers la fin de l'année 1969. Le contrat conclu avec cette société arrivant à expiration le 31 août 1984, « Porsche Cars North America, Inc. » se charge donc, à partir du 1er septembre, de l'importation des voitures dans ce pays où rien ne semble impossible.

En 1978, forte du rayonnement que dégage son nom prestigieux, Porsche commence à s'engager aussi dans le mécénat sportif : lors du premier Porsche Tennis Grand Prix des Dames organisé en octobre de cette année-là, Tracy Austin, Américaine tout juste âgée de 15 ans, remporte le jeu, le set et la victoire ainsi qu'une prime de 35 000 dollars. Tandis que le tournoi de Filderstadt devient une date phare du circuit féminin, le rythme des revirements et des retournements s'accélère au sein de la société elle-même. À partir de 1988, c'est Heinz Branitzki qui préside aux destinées de Porsche comme successeur de P. W. Schutz, avant de céder lui-même la place, le 10 mars 1990, à Arno Bohn. Le 1er août 1993, le conseil de surveillance nomme Wendelin Wiedeking président du directoire et inaugure ainsi ce qui allait devenir une ère de continuité et d'essor. Le nouveau responsable du style est, depuis le 1er avril 1989, le Hollandais Harm Lagaay, qui est monté en grade au sein de l'équipe

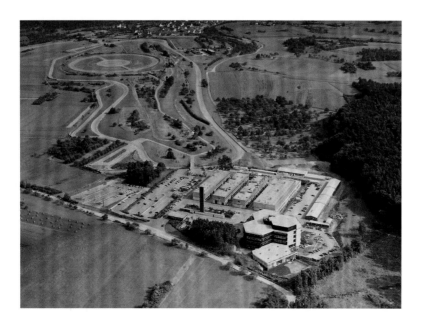

Aerial view of Porsche's Plant 8 in Weissach, taken in July 1975. Work on the second building phase had been completed on 20 September 1974.

Luftbild des Porsche-Werks 8 in Weissach, aufgenommen im Juli 1975. Die Arbeiten des zweiten Bauabschnitts waren am 20. September 1974 beendet worden.

Photo aérienne de l'usine Porsche n° 8, à Weissach, prise en juillet 1975. Les travaux de la deuxième section de bâtiments ont été achevés le 20 septembre 1974.

on 1 March 1973 by officially entering the name "Dr. Ing. h.c. F. Porsche AG" in the trade register, Ferry Porsche took over as Chairman of the Board, while Ernst Fuhrmann was appointed spokesman of the Board of Management, succeeding Porsche on 6 November 1976. His aegis was crowned by the good tidings the year 1977 held in store: the company celebrated the completion of its 250,000th car on 3 June, and the 1976/77 fiscal year was concluded with a turnover of one billion marks. Nevertheless, Fuhrmann was superseded as CEO after just over four years by Peter W. Schutz, an American of German ancestry. In April 1969, the "VW-Porsche-Vertriebsgesellschaft mbH" had been founded to sell the Type 914. On 31 July 1974, the remaining half of that branch was acquired by Porsche AG. Things also carried on moving in the United States. There the "Porsche-Audi Division of Volkswagen of America" took over the activities of "Porsche of America Corporation" which had been wound up at the end of 1969. The contract expired on 31 August 1984, and from 1 September "Porsche Cars North America, Inc." looked after the import of the Zuffenhausen sports cars into the land of limitless opportunity.

From 1978, the charisma of the Porsche name was also brought to bear in sport sponsoring. At the first Porsche Tennis Grand Prix for women players, the 15-year-old American girl Tracy Austin secured victory as well as 35,000 US dollars in prize money. But while the Filderstadt tournament quickly turned into a highly regarded constant, musical chairs prevailed as far as the firm's management was concerned. From 1988, the man at the helm was Schutz's successor Heinz Branitzki, followed by Arno Bohn on 10 March 1990. On 1 August 1993, the Supervisory Board appointed Wendelin Wiedeking as Chief Executive Officer, ushering in a phase of continuity and fresh impetus.

On 1 April 1989, Dutchman Harm Lagaay took over management of the styling department from Anatole Lapine, who had held this position since 1969, with Lagaay winning his spurs in his

This Linde fork-lift truck was designed by the Porsche development center in Weissach.

Das Design dieses Linde-Gabelstaplers stammt aus dem Porsche-Entwicklungszentrum Weissach.

Le design de ce chariot élévateur Linde est aussi une création du centre de développement de Weissach.

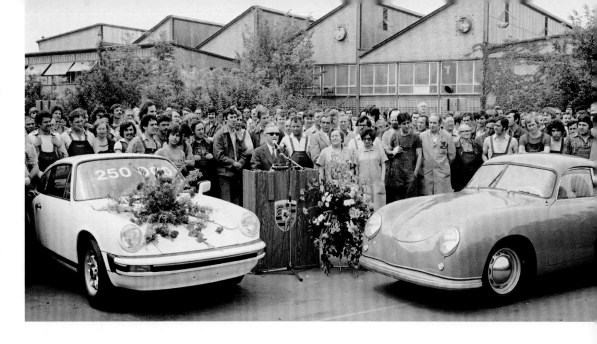

Almost three decades after the first sports car of the marque was built, number 250,000 is celebrated in 1977. Ferry Porsche delivers the ceremonial address.

Fast drei Dekaden nach der Herstellung des ersten Porsche-Sportwagens feiert man 1977 die Nummer 250 000. Die Ansprache hält Ferry Porsche.

Près de 30 ans après la fabrication de la première voiture de sport chez Porsche, on fête, en 1977, son 250 000e exemplaire. Ferry Porsche est au micro.

1976/77 konnte mit einem Umsatz von einer Milliarde Mark abgeschlossen werden. Gleichwohl wurde Fuhrmann nach knapp über vier Jahren Verweildauer von dem Deutsch-Amerikaner Peter W. Schutz abgelöst. Im April 1969 war die „VW-Porsche-Vertriebsgesellschaft mbH" zur Vermarktung des Joint Ventures Typ 914 gegründet, am 31. Juli 1974 die verbleibende Hälfte dieses Tochterunternehmens der Porsche AG einverleibt worden. In Bewegung blieben auch die Dinge in den Vereinigten Staaten. Dort übernahm die „Porsche-Audi Division of Volkswagen of America Inc." die Aktivitäten der gegen Jahresende 1969 aufgelösten „Porsche of America Corporation". Nachdem am 31. August 1984 der Vertrag mit dieser ausgelaufen war, besorgte ab dem 1. September die „Porsche Cars North America, Inc." den Import ins Land der unbegrenzten Möglichkeiten.

1978 begann man die Strahlkraft des Hochwertworts Porsche auch im Sport-Sponsoring einzusetzen: Beim ersten Porsche Tennis Grand Prix der Damen im Oktober jenes Jahres holte sich die 15-jährige Amerikanerin Tracy Austin Spiel, Satz, Sieg und 35 000 Dollar Preisgeld. Während das Filderstädter Turnier zur allseits geschätzten Konstante gedieh, beschleunigte sich in der Firma selbst das Tempo von Revirement und Rochade. Ihre Geschicke lagen ab 1988 in den Händen von Schutz-Nachfolger Heinz Branitzki, den am 10. März 1990 Arno Bohn beerbte. Am 1. August 1993 ernannte der Aufsichtsrat Wendelin Wiedeking zum Vorsitzenden des Vorstands und läutete damit eine Phase von Kontinuität und Aufschwung ein. Nach Styling-Fragen schaute seit dem 1. April 1989 der Holländer Harm Lagaay, der sich im Team seines Vorgängers Anatole Lapine, Designchef seit 1969, die Sporen verdient hatte.

dirigée par son prédécesseur Anatole Lapine, chef-designer depuis 1969. Simultanément se multiplient les filiales de Porsche, dont un grand nombre s'établit dans le «Global Village». Tel est le cas, en 1986, de «Porsche Aviation Products, Inc.», à Washington (Illinois), chargée de la distribution des moteurs d'avion de la marque, tandis que «Porsche Leasing GmbH» se voit confier, en avril 1989, les relations avec les clients, acheteurs de voitures neuves ou d'occasion. La société «Porsche Financial Management Services Ltd.», qui a son siège social à Dublin, en Irlande, depuis 1991, voit naître la même année «K.K. Porsche Engineering Japan». À partir du mois d'août 1994, «Porsche Consulting GmbH» propose à quiconque le désire de partager ses expériences glanées lors de la restructuration de sa propre société ainsi que d'entreprises étrangères et, à l'IAA, à l'automne 1995, «Porsche Travel Club» présente pour la première fois aux amateurs une multitude de voyages de découverte dans le monde entier. À partir de 1996, «Porsche Engineering Services GmbH», à Bietigheim, prépare la voie, avec un braintrust de 120 ingénieurs, à l'usine à cerveaux de Weissach.

Mais l'automobile reste malgré tout au cœur de toutes les activités – même si celle-ci est parfois d'une marque étrangère. Ainsi une commande passée par Mercedes-Benz porte-t-elle sur le développement et le montage d'une rapide berline à hautes performances, la 500 E, en 1990, qui a été rejointe, en octobre 1993, par la fabrication d'une autre coproduction de la même veine, l'Audi Avant RS2. Porsche se voit également confier le développement du minivan compact Zafira, d'Opel, selon un concept présenté au Salon de Paris en 1998. Porsche augmente la valeur intrinsèque et l'espérance de vie de ses propres

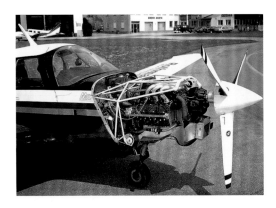

A Mooney M20 with the paint scheme of sponsor Rothmans, powered by the Porsche PFM 3200 engine.

In den Farben des Rennsport-Sponsors Rothmans lackierte Mooney M20 mit Porsche-Motor PFM 3200.

Un Mooney M20 avec moteur Porsche PFM 3200 peint aux couleurs du sponsor, le cigarettier Rothmans.

predecessor's team. The same period saw the rapid spread of Porsche subsidiaries, quite a few being resident in the global village. There was, from 1986, "Porsche Aviation Products, Inc." in Washington, Illinois as a sales enterprise for the company's aero engine, whereas "Porsche Leasing GmbH" looked after owners of new and used cars from April 1989. "Porsche Financial Management Services Ltd.", with head offices in Dublin, Ireland since 1991, was followed in the same year by "K.K. Porsche Engineering Japan". From August 1994, "Porsche Consulting GmbH" provided other companies with the experiences gathered when Porsche AG itself had been restructured, and at the Frankfurt IAA in fall 1995 "Porsche Travel Club" for the first time offered a plethora of international experience and adventure tours. From 1996, "Porsche Engineering Services GmbH" at Bietigheim did some of the groundwork for the Weissach think tank, with a brain trust of 120 engineers.

But, of course, the motor car was always center stage, though not necessarily a Porsche. Development work, body-in-white construction and assembly of the swift 500 E sedan in 1990 was a commissioned work for Untertürkheim-based Mercedes-Benz AG. From October 1993, it was supplemented by the manufacture of the equally fast co-production Audi Avant RS2. Yet another Porsche achievement was the development of the compact Opel Zafira van as presented at the Paris salon in 1998, complying with a concept laid down by the Rüsselsheim company itself. Value and life expectancy of Porsche's own products were continually increased by warranties against rust penetration: six years in 1975, seven in 1980, and ten in 1985. In 1991, Porsche was the first manufacturer to equip all its vehicles with airbags for driver and front passenger, as well as introducing eco-friendly water-based paints.

On 15 July 1996, the one-millionth Porsche left the assembly line and, like specimen number 100,000 thirty years before, was delivered to the autobahn police of Baden-Wuerttemberg. At that

Zugleich mehrten sich die Porsche-Töchter, nicht wenige von ihnen im Global Village ansässig. Da war ab 1986 die „Porsche Aviation Products, Inc." in Washington/Illinois zum Vertrieb des Flugmotors der Marke, während die „Porsche Leasing GmbH" sich seit April 1989 fürsorglich um Gebraucht- und Neuwagenkunden kümmerte. Der seit 1991 in Dublin/Irland beheimateten „Porsche Financial Management Services Ltd." folgte im gleichen Jahr die „K.K. Porsche Engineering Japan". Von August 1994 an stellte die „Porsche Consulting GmbH" die Erfahrungen bei der Umstrukturierung des eigenen auch fremden Unternehmen zur Verfügung, und auf der IAA im Herbst 1995 bot der „Porsche Travel Club" erstmalig eine Fülle von Erlebnisreisen in alle Welt feil. Ab 1996 arbeitete die „Porsche Engineering Services GmbH" in Bietigheim mit einem Braintrust von 120 Ingenieuren der Weissacher Denkfabrik zu.

Im Zentrum jedoch stand stets das Automobil – manchmal auch das fremde. Um einen Auftrag des Nachbarn Mercedes-Benz handelte es sich bei Entwicklung und Montage der flinken Reiselimousine 500 E im Jahre 1990, ab Oktober 1993 flankiert von der Herstellung der nicht weniger hurtigen Koproduktion Audi Avant RS2. Ebenfalls in die Hände von Porsche gelegt wurde die Entwicklung des kompakten Opel-Vans Zafira nach einem vorgegebenen Konzept, präsentiert auf dem Pariser Salon 1998. Wertigkeit und Lebenserwartung des eigenen Produkts erhöhte man durch eine stetig erweiterte Langzeitgarantie gegen Rostschäden, 1975 von sechs, 1980 von sieben und 1985 von zehn Jahren. 1991 stattete Porsche als erster Hersteller sämtliche Fahrzeuge mit Airbags für Fahrer und Beifahrer aus und führte umweltfreundliche Lacke auf Wasserbasis ein.

Als am 15. Juli 1996 der millionste Porsche vom Band lief und sinnigerweise wie Exemplar 100 000 vor 30 Jahren an Baden-Württembergs Autobahnpolizei überstellt wurde, waren An-, Um- und Neubau längst zum Normalzustand geworden. Seit dem Juni 1986 verfügte das Entwicklungszentrum Weissach über einen Windkanal auf dem letzten Stand der Dinge und wurde ein Jahr später mit einer modernen Crash-Anlage ausgestattet. Am 25. August 1988 versammelte man sich, um ein neues Karosseriewerk in Zuffenhausen zu eröffnen, Kapazität: 120 Aufbauten am Tag.

1996 erkoren die Wochenzeitschrift *Produktion* und die Unternehmensberatung A.T. Kearney Porsche zur „Fabrik des Jahres". Als der Aufsichtsrat in seiner Sitzung vom 15. November gleichen Jahres feststellte, das Konzernergebnis vor Steuern sei auf einen Rekordwert (2,110 gegenüber den 1,238 Milliarden Euro für 2004/2005) geklettert, geschah dies bereits zum zwölften Male hintereinander. Für weitere fünf Jahre im Amt bestätigt wurde Star-Manager Wendelin Wiedeking, der unter anderen erfreulichen Aktivitäten am 7. Februar 2000 den ersten Spatenstich zum Porsche-Werk Leipzig getan und 2004 einen Jahresabsatz von mehr als 75 000 Fahrzeugen vorhergesagt hatte – eine weitere Premiere.

Neue Ufer hatte man etwa mit der Gründung der „Porsche Middle East" 1999 oder des

produits en ne cessant de proroger la garantie de longue durée contre les dommages causés par la corrosion : de six ans en 1975 à sept en 1980, puis dix ans en 1985. En 1991, Porsche est le premier constructeur automobile à équiper la totalité de ses voitures d'airbags conducteur et passager, avant d'introduire en pionnier des peintures respectueuses de l'environnement.

Quand, le 15 juillet 1996, la millionième Porsche sort des chaînes et – heureux hasard de circonstance, comme la 100 000e il y a trente ans – est livrée à la police autoroutière du Bade-Wurtemberg, les mesures d'agrandissement et de transformation et les nouvelles constructions sont depuis longtemps achevées. Depuis juin 1986, le centre de développement de Weissach possède une soufflerie aérodynamique dernier cri, complétée, un an plus tard, par une moderne installation de tests de collisions. Le 25 août 1988, Porsche inaugure une usine de carrosserie à Zuffenhausen, d'une capacité de 120 superstructures par jour.

En 1996, l'hebdomadaire *Produktion* et la société de conseil aux entreprises A.T. Kearney élisent Porsche « Usine de l'année ». Quand le conseil de surveillance fait remarquer, lors de sa réunion du 15 novembre 2006, que le résultat du groupe avant impôts a atteint une valeur record (2,11 milliards d'euros par rapport à 1,238 milliard d'euros pour l'exercice 2004–2005), ceci se produit déjà pour la douzième fois consécutive. Le manager vedette, Wendelin Wiedeking, est confirmé dans ses fonctions pour cinq années supplémentaires, une autre première. À son crédit : le premier coup de pioche de l'usine Porsche de Leipzig, le 7 février 2000, et l'annonce pour 2004 d'un volume de ventes annuel de plus de 75 000 véhicules.

Le constructeur de Stuttgart voit de nouveaux horizons s'ouvrir à lui avec, par exemple, la création de « Porsche Middle East », en 1999, ou du « Porsche Center Beijing », en 2001, soit une deuxième tête de pont sur le marché porteur qu'est la Chine, après la succursale de Hong Kong. En août 2005, le directoire et le conseil de surveillance reprennent une idée échafaudée dans les années 1960 et annonce l'arrivée, en 2009, d'un coupé Porsche à quatre places, la Panamera, destiné aux disciples de la marque désireux – ou contraints – d'abandonner la confidentialité intimiste d'un cockpit à deux places. Orchestrées par des bénéfices record consécutifs, le 26 juin 2007 les activités d'exploitation de Porsche AG furent regroupées en une filiale unique et l'accord de contrôle ainsi que le contrat de transfert des bénéfices conclus entre celle-ci et la future « Porsche Automobil Holding SE » furent signés. Le nouveau musée a ouvert ses portes le 31 janvier 2009. Son architecture audacieuse est remplie d'un passé glorieux.

La tentative de reprise de Volkswagen a été moins glorieuse. Les dettes accumulées par cette opération forcèrent Wiedeking à la retraite. Retournement de situation, Porsche, qui avait pendant des années été le fabricant automobile le plus rentable, devint la dixième marque reprise par le groupe Volkswagen et contribue

moment, continuous enlargement of the firm's premises, as well as reconstruction and the setting-up of new buildings had long since become the normal run of things. From 1986, the Weissach development center was equipped with a state-of-the-art wind tunnel and was provided with a modern crash-test installation a year later. On 25 August 1988, a new coachwork construction plant took up its work in Zuffenhausen, with a capacity of 120 bodies per day.

In 1996, the weekly magazine *Produktion* and the A.T. Kearney business consultancy awarded the title of "Industrial Plant of the Year" to Porsche AG. When the Supervisory Board announced in its session on 15 November that year that the group's pre-tax result had risen to a record value (2.110 as compared to the 1.238 billion euros in the 2004/2005 fiscal year), it was the twelfth time running that had happened. Star manager Wendelin Wiedeking was confirmed in office for another five years. Among other encouraging activities, he had turned the first sod for the new Porsche plant in Leipzig on 7 February 2000 and forecast in 2004 that annual vehicle sales were about to exceed 75,000 for the first time.

Fresh ground was broken with founding "Porsche Middle East" in 1999 or "Porsche Center Beijing" in 2001 in addition to Hong Kong, as a second basis from which to gain access to the Chinese market of the future. In August 2005, the Supervisory and Management Boards fell back on a scheme that had already been harbored in the sixties, announcing the four-seater Porsche coupé Panamera for 2009, for all the disciples of the marque that were prepared to start a family or had already done so but were not willing to forgo Porsche ambience. On the strength of yet more record sales, on 26 June 2007 the operational business of Porsche AG was hived off into a 100 percent subsidiary, and a control and profit transfer agreement between the company and the future "Porsche Automobil Holding SE" was concluded. On 31 January 2009 the new museum opened its doors: it was boldly designed, and packed with beautiful items from a glorious past.

A somewhat less glorious moment was the attempt to take over Volkswagen—a move that led to debts so high, Wiedeking was forced to step down. In the resulting countermaneuver, Porsche—which had been the most profitable automobile manufacturer for many years—became the tenth brand to be absorbed into the Volkswagen Group, where it has been helping to plug the gaps ever since. Matthias Müller, Porsche CEO from 2010 to 2015, took on the same position in the new parent company and was tasked with righting the ship following the turmoil of the diesel scandal.

After the company far exceeded its sales target for 2018—200,000 vehicles sold per year—as early as 2015, plans were made for further growth under the Strategy 2025. This included a particular focus on the new engine plant in Zuffenhausen, which is intended to supply all the group's future premium models with not only V8 gas engines, but also powerful electric motors once Porsche's Mission E has generated substantial expertise in this area.

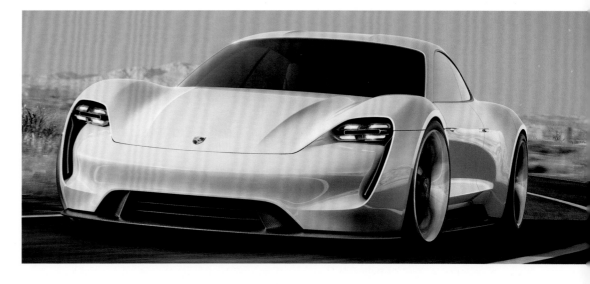

With the Mission E—a project that has cost a billion euros to develop—Porsche has begun the journey to an electric future.

Mit dem Mission E – Entwicklungskosten eine Milliarde Euro – hat bei Porsche die Elektro-Zukunft schon begonnen.

Avec la Mission E – dont les coûts de développement se montent à un milliard d'euros –, chez Porsche le futur électrique a déjà commencé.

„Porsche Center Beijing" anno 2001 als zweitem Standbein auf dem Zukunftsmarkt China neben der Niederlassung in Hongkong im Visier. Im August 2005 griffen Vorstand und Aufsichtsrat einen bereits in den Sechzigern gehegten Gedanken wieder auf und avisierten für 2009 das viersitzige Porsche-Coupé Panamera, für alle diejenigen Jünger der Marke, die den Status trauter Zweisamkeit aufgegeben hatten oder dies zu tun gedachten. Orchestriert von immer neuen Rekorderträgen wurden am 26. Juni 2007 das operative Geschäft der Porsche AG in eine 100-prozentige Tochtergesellschaft ausgegliedert und die Verabschiedung eines Beherrschungs- und Gewinnabführungsvertrags zwischen dieser und der künftigen „Porsche Automobil Holding SE" beschlossen. Am 31. Januar 2009 öffnete das neue Museum seine Pforten, von kühner Baulichkeit, dekorativ angefüllt mit glorioser Vergangenheit.

Weniger glorios verlief der Versuch, Volkswagen zu übernehmen. Die dadurch angehäuften Schulden zwangen Wiedeking zum Rücktritt. Im Gegenzug wurde Porsche, seit Jahren profitabelster Automobilhersteller, als zehnte Marke in den Volkswagen-Konzern übernommen und hilft dort seither, Löcher zu stopfen. Und Matthias Müller, Porsche-Vorstandsvorsitzender von 2010 bis 2015, wechselte auf den gleichen Posten beim Mutterkonzern, um dort die durch den Diesel-Skandal entstandene Schräglage wieder zu richten.

Nachdem das Absatzziel für 2018 – jährlich 200 000 verkaufte Fahrzeuge – bereits 2015 deutlich übertroffen worden war, setzte man mit der Strategie 2025 auf weiteres Wachstum. Besonders im Fokus: das neue Motorenwerk in Zuffenhausen, das künftig alle Premium-Modelle des Konzerns nicht nur mit V8-Benzinern sondern auch mit leistungsfähigen Elektromotoren beliefern soll, nachdem sich Porsche mit dem Mission E viel E-Know-how angeeignet hat.

depuis à combler ses lacunes. Et Matthias Müller, président-directeur général de Porsche de 2010 à 2015, fut nommé au même poste à la maison-mère pour redresser la situation suite au scandale du diesel.

Étant donné que les objectifs de vente pour 2018 – 200 000 voitures par an – avaient déjà été largement dépassés en 2015, la stratégie à l'horizon 2025 mise sur la croissance. En ligne de mire : la nouvelle usine de moteurs de Zuffenhausen, qui est destinée à livrer tous les modèles haut de gamme du groupe, non seulement avec des moteurs à essence V8 mais aussi avec des moteurs électriques surpuissants, puisque Porsche a engrangé un grand savoir-faire grâce à la Mission E.

Proud anniversary: after almost 54 years of history, on 11 May 2017, the millionth 911 rolled off the production line.

Stolzes Jubiläum: Am 11. Mai 2017 lief der Millionste 911er, eine fast 54 Jahre alte Baureihe, vom Band.

Anniversaire mémorable : la millionième 911, une série qui a presque 54 ans d'âge, a démarré le 11 mai 2017.

A Multifront Offensive
Offensiv an allen Fronten
Offensive sur tous les fronts

Porsche and sport—there is more to that than just pleasant assonance. The 356 model range did not just flaunt its manifest sportiness, but translated it into action from the very outset. For 1954 alone, the firm's chronicle reported 206 rally and 214 race wins. Two years later, racing success number 400 was entered into it. A lot of them were credited to the affluent gentleman driver. For European aristocracy, indulging in a late renaissance of motorized knighthood, for instance, the appeal of the nimble Zuffenhausen cars seemed to be irresistible. Some entry lists looked like an excerpt from the Gotha register of German nobility, comprising the likes of Prince Paul Metternich, Count Wittigo Einsiedel, Count Konstantin Berckheim, Count Wolfgang Berghe von Trips, Baron Huschke von Hanstein, Count Egon Westerholt or Richard von Frankenberg, editor-in-chief of the Porsche magazine *Christophorus*.

Favorite battlefields were the four classics Le Mans, Targa Florio, Mille Miglia and the Nürburgring 1000-Kilometer-Races. As far as the Sarthe marathon was concerned, Porsche in its attractive and relished underdog role virtually had a monopoly on class victories, ever since French importer and main agent Auguste Veuillet and his compatriot Edmond Mouche had for the first time drawn the racing world's attention to the marque's potential, securing first place in

Porsche und Sport – nie blieb es da bei bloßer dekorativer Assonanz. Bereits die Modellreihe 356 trug ihre manifeste Sportlichkeit nicht nur zur Schau, sondern setzte sie gewissermaßen entschlossen in die Tat um. Allein für 1954 vermeldete die Firmenchronik 206 Rallye- und 214 Rennsiege, zwei Jahre später wurde Rennerfolg Nummer 400 verbucht. Viele davon gingen auf das Konto des gut betuchten Privatfahrers. Schier unwiderstehlich wirkten die Zuffenhausener Nobel-Produkte auf die europäische Nobilität, die sich in den Fünfzigern zu einer späten motorisierten Ritterlichkeit aufschwang. Manche Starterlisten lasen sich wie ein Auszug aus dem Gotha-Adelsregister: Paul Fürst Metternich, Wittigo Graf Einsiedel, Konstantin Graf Berckheim, Wolfgang Graf Berghe von Trips, Baron Huschke von Hanstein, Egon Graf Westerholt oder *Christophorus*-Chefredakteur Richard von Frankenberg, Kriegername: der „Schreckensteiner", seien willkürlich herausgegriffen.

Forum und Feld der Bewährung wurden vor allem die vier Klassiker Le Mans, Targa Florio, Mille Miglia und das 1000-km-Rennen auf dem Nürburgring. Was das Sarthe-Marathon anbelangt, war Porsche in der gefälligen und auch durchaus goutierten Rolle des Underdogs förmlich auf Klassensiege abonniert, nachdem der französische Importeur und Generalvertreter Auguste Veuillet zusammen mit seinem Landsmann Edmond

Porsche et le sport – cela n'a jamais été qu'une simple association d'idées. La gamme 356, déjà, ne s'est pas contentée d'afficher une sportivité évidente, elle est immédiatement passée à l'acte. Pour la seule année 1954, la chronique de la marque fait état de pas moins de 206 victoires en rallye et de 214 en circuit, le 400e succès en course étant glané deux ans plus tard. Beaucoup de ces victoires ont été obtenues par des pilotes privés aisés. Les prestigieuses berlinettes de Zuffenhausen ont toujours exercé un attrait irrésistible sur la noblesse européenne qui, au cours des années 1950, s'est en quelque sorte métamorphosée en une chevalerie motorisée du XXe siècle. À la lecture de certaines grilles de départ, tout le gotha de la noblesse européenne semble s'être donné rendez-vous. Pour n'en citer que quelques uns : prince Paul Metternich, comte Wittigo Einsiedel, comte Konstantin Berckheim, comte Wolfgang Berghe von Trips, baron Huschke von Hanstein, comte Egon Westerholt ou le rédacteur en chef de *Christophorus* Richard von Frankenberg, avec son nom de guerre : « Schreckensteiner », le téméraire.

Ce sont surtout les quatre grandes classiques – Le Mans, la Targa Florio, les Mille Miglia et les 1000 kilomètres du Nürburgring – qui lui auront servi d'arènes pour en découdre et se couvrir de succès. En ce qui concerne le marathon de la Sarthe, Porsche, dans le rôle plaisant et toujours apprécié de l'*underdog*, possédait littéralement un abonnement aux victoires de classe. Notamment à partir du moment où l'importateur et concessionnaire général français Auguste Veuillet, avec son compatriote Edmond Mouche comme coéquipier, ont, pour la première fois, attiré de façon durable l'attention sur la marque en plein essor avec leur première place remportée en 1951 dans la catégorie allant jusqu'à 1100 cm³ au volant d'un coupé en aluminium. Victoire réitérée un an plus tard, pour enfoncer le clou. En 1970, alors que David s'est métamorphosé en Goliath en dévoilant sa stupéfiante 917 qui imposait la crainte et le respect, c'est une autre mélodie qu'a entonné Porsche avec la victoire au classement général de Hans Herrmann et Richard Attwood. Une mélodie qui devait encore résonner trente ans plus tard.

Les choses se présentaient tout à fait différemment dans le labyrinthe escarpé des Madonie, en Sicile, où les coupés allemands, vifs comme l'éclair, se sont retrouvés plus souvent à la première place que les autres marques.

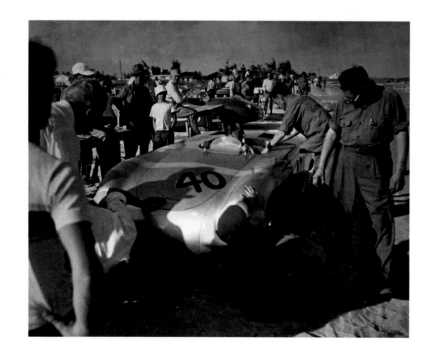

A Glöckler Spyder with 1.5 liters at a sports car race in Palm Beach in December 1951. There were seven specimens.

Ein Glöckler-Spyder mit 1,5 Litern bei einem Rennen im Dezember 1951 in Palm Beach. Es gab sieben Exemplare.

Une Glöckler-Spyder de 1,5 litre lors d'une course à Palm Beach en décembre 1951. Elle a été construite à sept exemplaires.

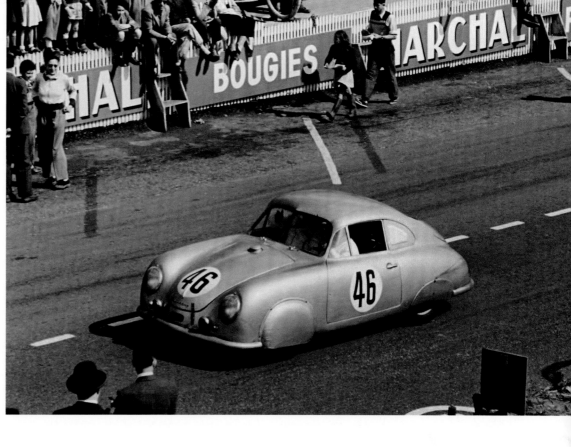

This aluminum Coupé with a 1.1-liter engine won its class at the Le Mans 24 Hours on 23 and 24 June 1951. In the overall classification it finished 20th, with Frenchmen Auguste Veuillet and Edmond Mouche at the wheel.

Dieses Aluminium-Coupé mit einem 1,1-Liter-Triebwerk wurde Klassensieger bei den 24 Stunden von Le Mans am 23. und 24. Juni 1951. In der Gesamtwertung kam es auf Rang 20. Fahrer waren Auguste Veuillet und Edmond Mouche.

Ce coupé en aluminium mu par un moteur de 1,1 litre a remporté une victoire de classe aux 24 Heures du Mans, le 23 et 24 juin 1951. Elle a terminé 20e au classement général, pilotée par Auguste Veuillet et Edmond Mouche.

the 1100 cc category for themselves and their aluminum coupé in 1951, repeating that feat a year later to corroborate their achievement. In 1970 the David had mutated into a Goliath in the form of the mighty Type 917, the overall victory of Hans Herrmann and Dickie Attwood ushering in an impressive string of crushing Porsche triumphs at the French endurance race.

Things were completely different in the sinuous labyrinth of the Sicilian Madonie where the swift and compact cars from Swabia scored more overall wins than any other brand, for the first time in 1956 by a 550 A Spyder in the expert hands of works driver Umberto Maglioli and then in 1959, 1960, 1963, 1964, 1966, 1967, 1968, 1969, 1970 and 1973. An armada of 18 Porsche sports cars from six countries lined up at the start of the 20th Mille Miglia in April 1953, all of them reaching the finish in Brescia again, securing victories in the 1300 cc class (Hans Leo von Hoesch/Werner Engel) and, as in the preceding year by the two fast counts Berckheim and Giovanni Lurani, in the 1500 cc category (Hans Herrmann/ Erwin Bauer). In 1952, the 1100 cc class had been won by the illustrious Metternich/ Einsiedel combo, a partnership that was renewed again and again until the 1967 Targa Florio, where the twosome participated in a

Mouche 1951 durch den ersten Rang in der Kategorie bis 1100 cm³ mit einem Leichtmetall-Coupé zum erstenmal nachhaltig auf die aufstrebende Marke aufmerksam gemacht und seinen Sieg ein Jahr später wie zur Bekräftigung wiederholt hatte. 1970, als der David zum Goliath in Gestalt des Furcht und Respekt einflößenden Typs 917 mutiert war, schlug man mit dem Gesamterfolg von Hans Herrmann und Dickie Attwood neue Töne an. Sie sollten in den folgenden drei Jahrzehnten mächtig widerhallen.

Ganz anders lagen die Dinge im Kurven-labyrinth der sizilianischen Madonie, wo sich die behänden Kompakten aus dem Schwabenland häufiger als irgendeine andere Marke auf Rang eins wiederfanden, zum erstenmal 1956 durch Umberto Maglioli mit dem 550 A Spyder und dann 1959, 1960, 1963, 1964, 1966, 1967, 1968, 1969, 1970 und 1973. An den Start der 20. Mille Miglia im April 1953 ging eine Armada von 18 Porsche-Sportwagen aus sechs Ländern und traf auch wieder vollzählig am Ziel in Brescia ein, nicht ohne erste Plätze bei den Dreizehn-hundertern (Hans Leo von Hoesch/Werner Engel) und, wie schon im Jahr zuvor durch die beiden schnellen Grafen Berckheim und Giovanni Lurani, bei den Fünfzehn-hundertern (Hans Herrmann/Erwin Bauer) eingesammelt zu haben. Die Kategorie bis 1100 cm³ hatte sich 1952 die Aristokraten-Riege Metternich/Einsiedel geholt, einander bis zu einem letzten gemeinsamen Einsatz in einem Mini Cooper bei der Targa Florio 1967 in Treue fest verbunden. In diesem Sinne ging es bis zur letzten Mille Miglia 1957 weiter. In jenem Jahr sorgte Umberto Maglioli in einem 550 RS als Fünfter für die beste Platzierung eines Porsche-Piloten im Gesamtklassement

Pour la première fois en 1956, avec Umberto Maglioli au volant de la 550 A Spyder, puis en 1959, 1960, 1963, 1964, 1966, 1967, 1968, 1969, 1970 et, enfin, en 1973. Une armada de dix-huit Porsche en provenance de six pays s'aligne au départ des 20es Mille Miglia, en avril 1953, et elles franchissent toutes au grand complet le drapeau à damier à Brescia, non sans avoir remporté une première place en catégorie 1300 cm³ (Hans Leo von Hoesch/Werner Engel) et, comme l'année précédente déjà, avec les deux rapides barons Berckheim et Giovanni Lurani, en 1500 cm³ (Hans Herrmann/Erwin Bauer). En 1952, ce sont aussi deux aristocrates, Metternich et Einsiedel, qui remportent la catégorie allant jusqu'à 1100 cm³; un équipage inséparable qui restera fidèle jusqu'à sa dernière course en commun, avec une Mini Cooper, lors de la Targa Florio 1967. Et cela se poursuit jusqu'aux ultimes Mille Miglia, en 1957. Cette année-là, Umberto Maglioli et sa 550 RS finissent à la 5e place. C'est le meilleur résultat jamais obtenu par un pilote de Porsche au classement général de ce tour d'Italie couvert à bride abattue. Trois ans plus tôt, Hans Herrmann a livré l'une de ces anecdotes qui sont entrées pour toujours dans l'histoire et que seules les courses sur route de l'acabit des 1000 Milles de Brescia peuvent générer: se rapprochant d'un passage à niveau fermé, il enfonce d'un coup de poing le casque de son co-pilote Herbert Linge dans le cockpit de la 550 Spyder et glisse sans hésiter son bolide sous les barrières. Avec une 3e place au classement général de la Carrera Panamericana, en novembre 1954, l'intrépide et infatigable pilote de Stuttgart donne une note d'exotisme à ce bilan précoce.

À domicile, à la course des 1000 kilomètres de l'ADAC, les Porsche ont toujours fait partie

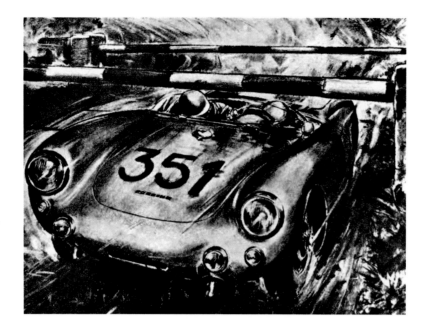

Famous episode: at the 1954 Mille Miglia Herrmann/Linge in their Spyder pass below a grade crossing barrier.

Berühmte Episode: Bei der Mille Miglia 1954 unterqueren Herrmann/Linge mit ihrem Spyder eine Bahnschranke.

Un épisode célèbre : lors des Mille Miglia de 1954, Herrmann/Linge et leur Spyder franchissent un passage à niveau abaissé.

Mini Cooper. Thus, a standard pattern had evolved that was to last until the final Mille Miglia in 1957. In that year, Maglioli, in third position with a 550 RS, grabbed the best result ever for a Porsche driver in the gigantic loop through Italy that had roused millions of *tifosi* since 1927 and had come to a horrific end on that day with the death of the brilliant Marquis Fon de Portago and his co-driver Ed Nelson. Three years before, Hans Herrmann had gone down in legend through one of those incidents that were only provided by road racing. While approaching a closed grade crossing barrier he just sank his co-driver Herbert Linge into the depths of his 550 Spyder's cockpit by hitting him on the helmet and sped on below the obstacle. With third place overall at the Carrera Panamericana in that year's November, the indefatigable driver from Stuttgart contributed an exotic dash of color to the firm's early racing history.

At home, at the 1000-Kilometer Races of the ADAC, Porsches always made up a considerable proportion of the fixtures, accounting, as a rule, for class victories, as they did in terms of the German championships for grand touring and sports cars. Favored by retirements and accidents, guest driver Phil Hill led the German round of the World Championship of Makes for the first time for a couple of laps on 19 May 1963, driving the two-liter eight-cylinder 718 GTR. What had been in the air for quite a time materialized in 1967 as a quadruple triumph of the Type 910 in the popular Eifel event, won by Udo Schütz and American Joe Buzzetta. The spell was broken with Swabian efficiency. A year later the Stuttgart outfit landed a double win, a Type 908 under Jo Siffert and Vic Elford leading home a 907, as also happened in 1970, when two specimens of the extremely agile and light 908/3 prevailed over the Ferrari 512Ss, the winning car being driven by Vic Elford and Kurt Ahrens. In 1969, a flotilla of five 908/2s had topped the result sheets, Jo Siffert and Brian Redman taking the spoils of victory in one of the John Wyer entries. There had been a one-two for the

der rasenden Italien-Durchquerung. Drei Jahre zuvor hatte Hans Herrmann eines jener Schmankerl zu ihrer Historie beigesteuert, die nur Straßenrennen vom Schlage der 1000 Meilen von Brescia bereithalten: Bei der Annäherung an eine geschlossene Bahnschranke versenkte er Copilot Herbert Linge mit einem Faustschlag auf den Helm im Cockpit des 550 Spyders und unterquerte zügig das Hindernis. Mit einem dritten Platz gesamt bei der Carrera Panamericana im November jenes Jahres brachte der unermüdliche Stuttgarter einen exotischen Farbklecks in die frühe Bilanz ein.

Daheim, bei den 1000-Kilometer-Rennen des ADAC, bildeten die Porsche stets einen erheblichen Teil des Inventars und machten Klassensiege in aller Regel untereinander aus, ähnlich wie die deutschen Meisterschaften bei den Grand-Tourisme-Fahrzeugen und den Sportwagen. Begünstigt durch Aus- und Unfälle, führte Gastpilot Phil Hill am 19. Mai 1963 den deutschen Lauf zur Markenweltmeisterschaft zum erstenmal für ein paar Runden mit dem Zweiliter-Achtzylinder 718 GTR an. Was lange in der Luft gelegen hatte, verdichtete sich 1967 zu einem Vierfachtriumph des Typs 910 (angeführt von Udo Schütz und Joe Buzzetta) bei dem populären Eifel-Event. Der Bann war gebrochen, gewissermaßen mit schwäbischer Gründlichkeit: Ein Jahr später schloss man mit einem Doppelerfolg (ein Typ 908 unter Jo Siffert und Vic Elford vor einem 907) ab wie auch 1970, als sich zwei Exemplare des handlichen und federleichten 908/3 gegen die Ferrari 512S behaupteten, allen voran das Gespann Vic Elford und Kurt Ahrens. 1969 lagen am Ende fünf 908/2 vorn, angeführt von Jo Siffert und Brian Redman im Wagen des John-Wyer-Teams. Einen Doppelsieg für die Marke hatte es bereits 1960 bei den 12 Stunden von Sebring gegeben, die der Belgier Olivier Gendebien und Hans Herrmann in einem RS60 gewannen. Ab 1968 begann sich dergleichen zu häufen, gipfelnd im Markenchampionat des folgenden Jahres. Im Frühjahr 1969 stellte Porsche auf dem Genfer Automobilsalon den 917 vor. Das große Coupé

des meubles et, en règle générale, se sont partagé les victoires de classe, comme pour les championnats d'Allemagne dans les catégories Grand Tourisme et Voitures de sport. Favorisé par un certain nombre d'abandons et d'accidents, Phil Hill, qui effectue une pige pour Porsche le 19 mai 1963, mène pour la première fois la manche allemande du Championnat du monde des marques pendant quelques tours avec la 718 GTR à moteur à huit cylindres de deux litres. Ce qui s'annonçait depuis longtemps déjà finit par devenir réalité en 1967, avec le trust des quatre premières places des 910 (emmenées par Udo Schütz et Joe Buzzetta) lors de la populaire course de l'Eifel. La glace est rompue, mais – cela va de soi – avec une minutie digne des Souabes : un an plus tard, Porsche signe un doublé (avec une 908 pilotée par Jo Siffert et Vic Elford devant une 907), et en 1970 encore, quand deux exemplaires de la maniable et ultralégère 908/3 parviennent à s'imposer face aux Ferrari 512S, le duo Vic Elford-Kurt Ahrens terminant une fois de plus en tête. En 1969, ce ne sont pas moins de cinq 908/2 qui franchissent en tête la ligne d'arrivée, emmenées par Jo Siffert et Brian Redman dans la voiture de l'écurie de John Wyer. Porsche avait déjà signé un doublé en 1960 aux 12 Heures de Sebring, où le Belge Olivier Gendebien était l'équipier de Hans Herrmann sur

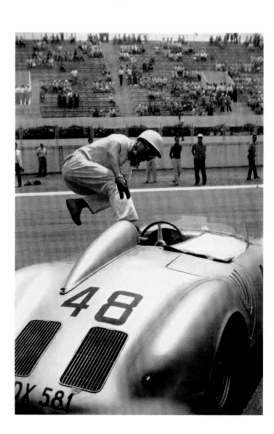

Dynamic entry—Stirling Moss boarding his Spyder at the Buenos Aires 1000-Kilometer Race in 1958.

Dynamischer Einstieg, hier von Stirling Moss beim 1000-Kilometer-Rennen von Buenos Aires 1958.

Débuts dynamiques, ici avec Stirling Moss, lors de la course des 1000 Kilomètres de Buenos Aires, en 1958.

The Porsche four-cylinder of Swede Joakim Bonnier at the non-championship 1961 Formula 1 Solitude Grand Prix.

Der Porsche-Vierzylinder des Schweden Joakim Bonnier beim Grand Prix der Solitude 1961.

La Porsche à quatre cylindres du Suédois Joakim Bonnier, lors du Grand Prix de Formule 1 de Solitude, en 1961.

marque as early as 1960 at the Sebring 12 Hours, where excellent Belgian sports car driver Olivier Gendebien and Hans Herrmann had asserted themselves in an RS60 which was not even a works car. From 1968 onwards, such multiple successes began to abound, culminating in the Championship of Makes being secured by the Zuffenhausen squad in the following year. In spring 1969, however, Porsche presented the Type 917 at the customary Geneva exhibition. The big coupé also embodied both a claim and a threat. The part of the extra, occasionally given the opportunity of playing a leading role, was definitely a thing of the past.

Quite early on, Porsche products had made their presence felt at rallies and rally-like events. First place in the grand touring category up to 1100 cc of the Liège-Rome-Liège long distance race in August 1951 was notched up by Paul von Guilleaume/Count Eckard von der Mühle, whereas a year later at the same event five Porsche 356s could be found among the first ten vehicles. A spectacular second for the Eugen Böhringer/ Rolf Wütherich pair at the 1965 Monte Carlo Rally in a 904GTS, which was certainly unsuited for such a race and had somehow been smuggled past the severe Porsche management by the wily Swabian Böhringer, seemed to act as a time fuse, sparking off a hat trick of the marque between 1968 and 1970, always featuring the 911. In 1968 it was manned by the versatile Vic Elford, partnered by David Stone, in the two other years by the Björn Waldegård/Lars Helmer team. In 1970, the Stuttgart enterprise also managed to gain the Rally Constructors' World Championship.

verkörperte auch einen Anspruch. Der Part des Statisten, der ab und an mal für eine Hauptrolle taugt, war endgültig ausgespielt.

Schon früh hatte man bei Rallyes und verwandten Veranstaltungen kraftvolle Akzente gesetzt. Die Wertung bis 1100 cm³ bei der Fernfahrt Lüttich–Rom–Lüttich im August 1951 gewannen Paul von Guilleaume/Graf Eckard von der Mühle. Ein Jahr später fanden sich unter den ersten Zehn beim gleichen Ereignis fünf Porsche 356. Der zweite Rang der Riege Eugen Böhringer/Rolf Wütherich bei der Rallye Monte Carlo 1965 in einem für solche Gelegenheiten im Grunde genommen herzlich ungeeigneten 904GTS, den der listige Schwabe Böhringer irgendwie an der gestrengen Porsche-Führung vorbeigeschmuggelt hatte, wirkte wie ein Zeitzünder für einen Hattrick der Marke zwischen 1968 und 1970, immer durch den Elfer, 1968 mit dem Mulitalent Vic Elford am Volant, in Begleitung von David Stone, die beiden nächsten Male durch die Mannschaft Björn Waldegård/Lars Helmer. 1970 ging auch der Markentitel im Rallyesport nach Zuffenhausen.

Ausgeprägt war seit den Anfängen der Europa-Bergmeisterschaft 1958 der Hang der Stuttgarter zum Hang. Die ersten neun Jahrgänge wurden allesamt zur Beute von Porsche-Piloten, wobei Edgar Barth (1959, 1963 und 1964) und Gerhard Mitter (1966–1968) durch Dreifach-Championate glänzten. Eher verhalten hingegen verliefen ihre Ausflüge in den Formelsport. Da das Reglement für die Formel 2 dergleichen zuließ, stützte man sich anfänglich noch auf Bewährtes. Sieger dieser Wertung wurde im Rahmen des Großen Preises von Deutschland am 4. August 1957 auf dem Nürburgring Edgar Barth mit dem 550A Spyder, und ein Jahr später schlug der Franzose Jean Behra in Reims die Elite dieser Kategorie in einem 718 RSK mit zentral eingebauter Lenkung. Der Erfolg stieß den Bau des rundlichen Monoposto 718/2 an, mit dem man 1960 den Coupe des Constructeurs errang. Daraufhin gab Geschäftsführer Ferry Porsche grünes Licht für den Einstieg in die auf anderthalb Liter zurechtgestutzte Formel 1 – ab 1961 gleichsam die Fortsetzung der vormaligen Formel 2 mit anderen Mitteln. Medium war zunächst der kaum modifizierte pummelige Einsitzer. Zu Siegen reichte es nicht in einem Jahr erdrückender Ferrari-Hegemonie, nur zu Achtungserfolgen wie den zweiten Rängen für Dan Gurney in Reims, Monza und Watkins Glen. Den Vorstellungen von einem „richtigen" Grand-Prix-Wagen schon viel näher kam der schlanke und glatte Achtzylinder Typ 804 anno 1962. Porsche musste sich indessen – abgesehen von einem Erfolg auf der Solitüde vor der eigenen Haustür – mit dem ersten Platz für Gurney in Rouen am 8. Juli des Jahres bescheiden und dies auch nur, weil die eigentlichen Protagonisten jener Saison auf der Strecke geblieben waren.

Die strahlende Karriere des 917 aber, bis Ende April 1969 zwecks Homologation in einer Population von 25 Exemplaren aufgelegt, begann nach drei Nullnummern mit einem Sieg von Jo Siffert und Kurt Ahrens beim 1000-Kilometer-Rennen auf dem Österreichring am 10. August desselben Jahres. Er

une RS60. Les succès de ce genre se multiplient à partir de 1968, avec un point culminant l'année suivante : le titre de Champion du monde des marques. Au printemps 1969, Porsche dévoile au Salon de l'Automobile de Genève la fameuse 917. Mais l'apparition de cet imposant coupé est lourde de signification. Porsche cesse définitivement de jouer les seconds rôles et brigue désormais la tête d'affiche.

Très tôt déjà, Porsche a eu voix au chapitre en rallye et dans les compétitions apparentées. Ainsi Paul von Guilleaume et le comte Eckard von der Mühle ont-ils remporté, en août 1951, le classement allant jusqu'à 1100 cm³ lors de la course d'endurance Liège-Rome-Liège. Un an plus tard, on trouvait aux dix premières places de cette même course cinq Porsche 356. La deuxième place de l'équipage Eugen Böhringer/ Rolf Wütherich au Rallye de Monte-Carlo de 1965, au volant d'une 904 GTS (a priori totalement inappropriée pour une telle compétition et que l'astucieux souabe Böhringer a réussi à inscrire sans que la sévère direction de Porsche n'en prenne connaissance), a fait l'effet d'une bombe à retardement avec le hat trick signé par la marque de 1968 à 1970, toujours avec la 911 (en 1968 avec le talentueux Vic Elford au volant co-piloté par David Stone, et pour les deux autres éditions par l'équipage Björn Waldegård/Lars Helmer). En

Slim line: the eight-cylinder Type 804 scored just one grand prix victory, at Rouen in 1962.

Schlanke Linie: Dem Achtzylinder Typ 804 war nur ein Grand-Prix-Sieg beschieden, 1962 in Rouen.

Silhouette longiligne : la Type 804 à huit cylindres n'aura remporté qu'une victoire en Grand Prix, en 1962 à Rouen.

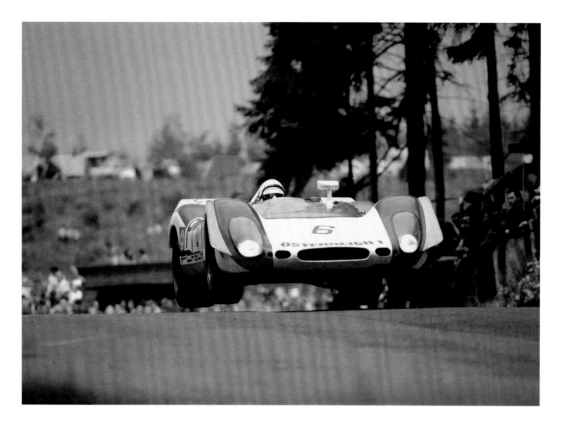

Airborne: a 908/2 entered by Porsche Salzburg, driven by Dickie Attwood at the 1969 Nürburgring 1000 Kilometers.

Leicht abgehoben: ein 908/2 von Porsche Salzburg mit Dickie Attwood am Lenkrad, 1000 km Nürburgring 1969.

Allez hop! Une 908/2 de Porsche Salzbourg, avec Dickie Attwood au volant, aux 1000 Kilomètres du Nürburgring en 1969.

1970, le titre des marques en rallye a aussi été l'apanage de Zuffenhausen.

Dès les débuts du Championnat d'Europe, en 1958, le constructeur de Stuttgart a affiché un goût prononcé pour ce qui est pentu. Les neuf premières années ont sans exception été dominées par les pilotes Porsche, parmi lesquels Edgar Barth (1959, 1963 et 1964) et Gerhard Mitter (1966–1968) se sont particulièrement distingués. Leurs intermèdes en courses de monoplaces n'ont, en revanche, pas remporté le même succès. Le règlement de la Formule 2 autorisant une telle démarche, le constructeur utilise tout d'abord des modèles qui ont fait leurs preuves. Le vainqueur de cette catégorie, dans le cadre du Grand Prix d'Allemagne disputé le 4 août 1957 sur le circuit du Nürburgring, est Edgar Barth avec la 550A Spyder, – succès que réitère, un an plus tard, le Français Jean Behra à Reims, en battant l'élite de cette catégorie au volant d'une 718 RSK à direction centrale. Encouragée par ces succès, Porsche décide de construire la 718/2, une monoplace aux lignes rondelettes pour participer, en 1960, à la Coupe des constructeurs. Ensuite, Ferry Porsche donne son feu vert pour monter en gamme et disputer la Formule 1, dont la cylindrée a été ramenée à 1,5 litre – soit, en quelque sorte, la poursuite de l'ancienne Formule 2 avec d'autres moyens à partir de 1961. Son cheval de bataille est, dans un premier temps, cette même monoplace tout en rondeurs à peine modifiée. Mais elle est incapable de vaincre cette année-là face à la

Noble Toy

This 917 was prepared at Weissach in 1975 for the Italian aristocrat and Porsche sponsor (Martini) Count Gregorio Rossi di Montelera for use on public roads and picked up in person by the proud owner. To circumnavigate the harsh European legislation the spectacular exoticar had been equipped with an Alabama registration, with the proviso that Rossi and the car should show up there occasionally. But his first destination was Paris.

Edles Spielzeug

Dieser 917 wurde 1975 in Weissach für den italienischen Grafen und Porsche-Sponsor (Martini) Gregorio Rossi di Montelera zwecks Gebrauchs auf öffentlichen Straßen vorbereitet und auch persönlich abgeholt. Um die harschen europäischen Gesetze zu umschiffen, verpasste man dem Exoten eine Zulassung des US-Staats Alabama, mit der Auflage, sich da auch mal blicken zu lassen. Der Edelmann verschwand aber erst einmal in Richtung Paris.

Jouet pour un enfant gâté

Weissach a préparé en 1975 cette 917, destinée à l'usage personnel et quotidien du comte italien Gregorio Rossi di Montelera, sponsor de Porsche (Martini). Pour contourner les rigoureuses lois européennes, le bolide est immatriculé en Alabama, sous la promesse d'y séjourner de temps à autre. Mais sa première destination fut Paris.

From the beginnings of the European Championship, first contested in 1958, the Stuttgart outfit had a distinct foible for the hill climb sprint. The titles in the first nine years all fell prey to Porsche drivers, with Edgar Barth (1959, 1963 and 1964) and Gerhard Mitter (1966–1968) standing out with three crowns each. The firm's excursions into formula racing, however, turned out to be much less rewarding. As Formula 2 regulations did not object to such a thing, one initially relied on proven mounts. Victorious in that category on the occasion of the German Grand Prix at the Nürburgring on 4 August 1957 was Edgar Barth in a 550 A Spyder, and a year later Frenchman Jean Behra beat the world's elite at Reims, in a 718 RSK with centrally mounted steering, triggering the decision to build the 718/2 single-seater with which the Coupe des Constructeurs was duly won in 1960. As a consequence, company boss Ferry Porsche gave the go-ahead to enter the Formula 1 arena in 1961, the new rules decreeing a maximum capacity of 1.5 liters so that the former Formula 2 was practically perpetuated with other means. At first, Porsche entered their familiar chubby monoposto, which had scarcely been modified. But there were no victories in a season utterly dominated by the shark-nosed Ferrari 156s, just a couple of runner-up positions for lanky Californian Dan Gurney in Reims, Monza and Watkins Glen. The smooth and slender eight-cylinder Type 804 of 1962 looked much more like a real grand prix car. But apart from a home victory at the Solitude circuit just outside the city gates of Stuttgart, Porsche had to be content with first place for Gurney at Rouen on 8 July, after all the protagonists fighting for that season's title had fallen by the wayside.

The scintillating career of the 917, however, a batch of 25 being built until the end of April 1969 for the sake of homologation, began after three retirements for technical reasons on that year's 10 August when Jo Siffert and Kurt Ahrens snatched victory at the 1000-Kilometer-Race at the majestic Österreichring. It was to remain the outstanding sports car of its era, until new FIA rules for 1972 extinguished the dinosaurs. In 1970, the 908/3 had still been heavily involved in winning the Championship of Makes for Porsche. A year later, the furiously singing 917 coupés practically fought it out between themselves, before a somber backdrop: the John Wyer team's star drivers Pedro Rodriguez and Jo Siffert lost their lives in racing accidents on different battlefields. At Le Mans, winners Gijs van Lennep and Helmut Marko established a record that stands to this day, with an average speed of 138 mph, and a long-tail version howled along the Mulsanne straight at 240 mph.

As a frightened answer to such values, the vehicles in the fleet about to fight for the 1972 title were reduced to a maximum capacity of three liters in analogy to then-current Formula 1. The participants of the Canadian American Challenge Cup (CanAm), however, as well as the patriotic media, grumbled about the invasion of the German "panzers". Indeed the megapotent

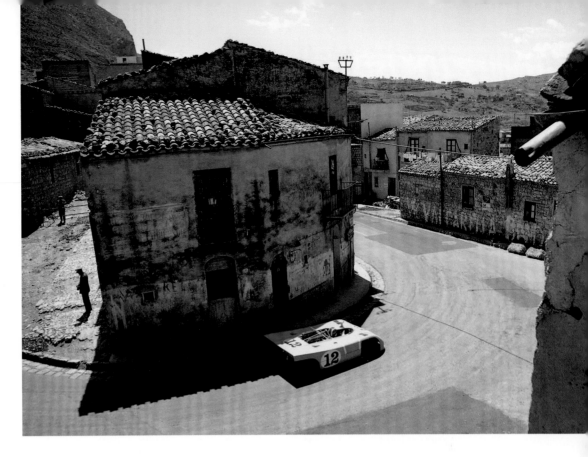

Racing round the corners: Jo Siffert with the ultralight 908/3 of the Wyer Team at the 1970 Targa Florio.
Rasch um die Ecke gebracht: Jo Siffert mit dem federleichten 908/3 des Wyer-Teams bei der Targa Florio 1970.
Ping-pong de virage en virage : Jo Siffert avec la filigrane 908/3 de l'écurie Wyer, lors de la Targa Florio de 1970.

blieb der dominierende Sportwagen seiner Epoche, bis 1972 eine FIA-Götterdämmerung die Dinosaurier dahinraffte. War am Markenchampionat für Porsche 1970 noch der 908/3 maßgeblich beteiligt, machten ein Jahr später die wütend singenden 917-Coupés die Sache praktisch untereinander aus, vor dem düsteren Hintergrund, dass die beiden Star-Fahrer des John-Wyer-Teams Jo Siffert und Pedro Rodriguez auf anderen Kriegsschauplätzen ums Leben kamen. In Le Mans stellten die Sieger Gijs van Lennep und Helmut Marko mit einem Durchschnitt von 222 km/h einen bis heute gültigen Rekord auf, und eine Langheck-Ausführung eilte die Mulsanne-Gerade mit Tempo 387 hinunter.

Während als Antwort auf solche Werte der Fuhrpark der Markenweltmeisterschaft in Analogie zur zeitgenössischen Formel 1 von der bestürzten Rennsport-Legislative FIA auf drei Liter Hubraum umgestellt wurde, beklagte man beim Canadian American Challenge Cup (CanAm) den Einmarsch der deutschen „panzers". In der Tat machten megapotente Spyder-Derivate des 917 mit Turbo-Aufladung wenig Federlesens mit ihrer Konkurrenz, 1972 der 917/10 mit 1000 PS und George Follmer am Lenkrad, 1973 der 1100 PS starke 917/30, von Mark Donohue gefahren – beide im Sold des privaten Penske-Rennstalls. Um die Überlegenheit der schnurrenden Kraftprotze aus Übersee, die sich in beiden Jahren auch den Sieg bei der europäischen Interserie sicherten, in den Griff zu bekommen, änderte man schließlich sogar hastig das CanAm-Reglement.

The mighty 917s and nimble 908/3s of John Wyer Automotive were the class of the field in the 1970 and 1971 Sports Car World Championships. Wyer (center, seated) ran his team professionally and with a rod of iron and was famous for his accurate bookkeeping.

Die mächtigen 917 und flinken 908/3 des John-Wyer-Teams beherrschten die Sportwagenweltmeisterschaft 1970 und 1971. Wyer (sitzend Mitte) lenkte sein Aufgebot professionell und mit eiserner Hand und war bekannt für seine penible Buchführung.

Les puissantes 917 et les virevoltantes 908/3 du team John Wyer dominent le Championnat du monde des voitures de sport en 1970 et 1971. Rigoureux et dur, Wyer (assis, au centre), était aussi un comptable méticuleux.

Racing romance: at the 1971 Le Mans 24 Hours a 917 hurtles towards Tertre Rouge in the morning light.

Rasende Romantik: Beim 24-Stunden-Rennen von Le Mans 1971 eilt ein 917 im Morgenlicht Richtung Tertre Rouge.

Un romantisme effréné : aux 24 Heures du Mans, en 1971, une 917 se dirige vers le Tertre Rouge dans les premières lueurs du jour.

suprématie de Ferrari et ne remporte que des succès d'estime, comme des deuxièmes places avec Dan Gurney à Reims, Monza et Watkins Glen. La mince huit-cylindres 804 de 1962 aux lignes filigranes correspond déjà plus à ce que l'on imagine quand on parle de « vraie » voiture de Grand Prix. Abstraction faite d'un succès sur le circuit de Solitude, autrement dit aux portes de Stuttgart, Porsche doit cependant se contenter de la première place remportée par Dan Gurney à Rouen, le 8 juillet de cette année-là. Et encore, seulement parce que les principaux acteurs de cette saison avaient tous dû jeter l'éponge.

Mais la carrière éblouissante de la 917, qui est dévoilée à 25 exemplaires construits pour l'homologation jusqu'à la fin avril 1969, commence par trois abandons, avant la victoire de Jo Siffert et Kurt Ahrens aux 1000 kilomètres de l'Österreichring, le 10 août de la même année. Cette voiture de sport allait régner en maître jusqu'à ce qu'un édit de la FIA scelle le destin de ces dinosaures en 1972. Si la 908/3 avait encore joué un rôle décisif pour remporter le Championnat des marques pour Porsche en 1970, un an plus tard, ce sont les coupés 917 aux hurlements stridents qui ont pratiquement dit la messe, mais dans une ambiance sinistre, sachant que les deux pilotes vedettes de l'écurie John Wyer, Jo Siffert et Pedro Rodriguez, avaient trouvé la mort sur d'autres théâtres de guerre peu de temps auparavant. Au Mans, les vainqueurs, Gijs van Lennep et Helmut Marko, à une vitesse moyenne de 222 km/h, établissent un record, encore inégalé aujourd'hui, alors qu'une exécution longue queue déboule l'interminable ligne droite de Mulsanne à la vitesse effarante de 387 km/h !

Sidérée par de telles vitesses, la FIA, l'organe législatif qui régit la compétition automobile, décide, à l'instar de la Formule 1 à la même époque, de réduire le cubage des moteurs à 3 litres. Pendant ce temps, les acteurs de la Canadian American Challenge Cup, la fameuse CanAm, se plaignent de l'invasion des « panzers » allemands. En effet, les ultrapuissantes évolutions spyder de la 917 à turbocompresseur ne font pas grand cas de la concurrence, en 1972 avec la 917/10 de 1000 ch et George Follmer au volant ou, en 1973, avec l'étonnante 917/30 de 1100 ch pilotée par Mark Donohue – tous les deux mercenaires de l'écurie privée Penske. Pour mettre un terme à la supériorité dont font preuve, outre-mer, les félins au feulement électrisant qui se sont aussi assuré la victoire à l'Interséries européenne deux années de suite, les responsables en viennent à modifier au pied levé le règlement de la CanAm.

Entre-temps, les métamorphoses de la 911, qui est le fonds de commerce de Zuffenhausen, commencent à laisser entrevoir le potentiel qu'elle renferme. L'ultime Targa Florio, en 1973, est remportée par une 911 Carrera RSR pilotée par Herbert Müller et Gijs van Lennep. Aux 24 Heures du Mans, un an plus tard, la RSR Turbo 2.1 parvient même à décrocher la deuxième place. Fidèle à sa meilleure tradition, Porsche intègre les expériences de la course à sa Turbo de série, la 930, qui donne elle-même naissance, en 1976, à

turbocharged derivatives of the 917 made short work of their competitors, in 1972 the 917/10 with 1000 bhp and George Follmer at the wheel, in 1973 the 1100 bhp 917/30 driven by his compatriot Mark Donohue, both of them in the pay of the private Penske racing stable. In order to get a grip on the purring powerhouses from Germany, the CanAm regulations were changed at short notice.

Meanwhile the metamorphoses of the basic product 911 began to prove what potential was slumbering in it. The last Targa Florio in 1973 was won by a Carrera RSR, the drivers being Herbert Müller and Gijs van Lennep. And at the Le Mans 24 Hours a year later an RSR Turbo 2.1 crossed

Unterdessen begannen Metamorphosen des Basis-Produkts Elfer zu beweisen, welches Potential in ihm schlummerte. Die letzte Targa Florio gewann 1973 ein 911 Carrera RSR, Piloten: Herbert Müller und Gijs van Lennep. Und bis auf Rang zwei arbeitete sich bei den 24 Stunden von Le Mans ein Jahr später der RSR Turbo 2.1 vor. Die Erfahrungen des Rennbetriebs wurden in bester Tradition in den Serien-Turbo Typ 930 eingespeist, aus dem wiederum der 590 PS leistende 935 von 1976 hervorging, Porsches in radikalem Leichtbau gehaltene Reaktion auf das neue Regelwerk für die Gruppe 5. Er wurde prompt Weltmeister bei den Marken wie auch in den folgenden Jahren bis 1980,

1972 CanAm round at Watkins Glen: Roger Penske (white shirt) is standing beside the 917/10 entered by him.

CanAm-Lauf 1972 in Watkins Glen: Roger Penske (helles Hemd) steht vor dem von ihm eingesetzten 917/10.

La CanAm fait étape à Watkins Glen en 1972 : Roger Penske (en chemise claire) devant la 917/10 engagée par son écurie.

the finishing line as runner-up. According to time-honored tradition, racing experiences were instilled into the street-legal Turbo Type 930, from which evolved the 590 bhp 935 of 1976, Porsche's answer to the new Group 5 regulations, notable for its systematic lightweight design. Instantaneously it took the title in the World Championship of Makes, as happened in the subsequent years until 1980 when other makes and in-house opponents began to impinge on its superiority. For the small division up to two liters of the 1977 German Racing Championship was created the Type 935/2.0 "Baby", still delivering 370 bhp, while the 935/78 "Moby Dick" of the following season, with two turbochargers and 845 bhp, was the most powerful scion of the 911 dynasty ever built.

In addition to the Constructors' World Championship, a World Championship for Sports Cars was held in 1976 and 1977. In no time, Porsche responded with the Type 936, which presented the company with a further triumph at the Le Mans 24 Hours—in that year not included in the championship cycle though still boasting a large and first-class entry—as well as with the title. In spite of that, Porsche pulled the plug on the project at the end of the season, but did not fail to score another two 936 Le Mans victories in 1977 and 1981, the second one with 936/81. As in the foundation years, the marque amassed a lot of successes all over the world and in almost every imaginable category, in many cases assisted by its enthusiastic and determined clientele. In 1978, for example, Porsche claimed the titles in the European Sports Car and Hill Climb Championships and the IMSA- and Interseries to boot. In 1980, the Stuttgart squad carried off not only the IMSA and TransAm series trophies with the Types 935 and 911SC, but also three European championship crowns. As in the previous year, only a minor defect denied victory to the 911 Carrera 2.7 of Björn Waldegård and Hans Thorszelius in the 1974 Safari Rally in Kenya, arguably the toughest event of its kind at that time, while after years of drought the French tandem of Jean-Pierre Nicolas and Vincent Laverne managed to score a resounding overall victory at the 1978 Monte Carlo Rally. Quite in keeping with Porsche heritage, the front-engined models also had to prove their worth in the baptism by fire only provided by competition. In 1979, Rudi Lins and Gerhard Plattner bore out the mettle of the 914 Turbo, undertaking a 23,000-mile long-distance run from New York to Vienna. In 1980, all three 924 Carrera GTs premiering at Le Mans saw the chequered flag. And in 1981, again at the Sarthe circuit, Walther Röhrl and Jürgen Barth crowned the debut of the future 944's prototype with class victory.

In 1982 the legendary Type 956 jumped onto the stage, a state-of-the-art sports racer with a monocoque and ground effect technology although, so as to comply with the American IMSA regulations, it was converted into the 962 (in IMSA and C configuration) two years later, with its wheelbase widened from 104.33" to 109.06" and a longer monocoque, the overall length remaining

als ihm bereits andere Fabrikate sowie Rivalen aus dem eigenen Hause zusetzten. Für die kleine Division der Deutschen Rennsportmeisterschaft 1977 wurde der Typ 935/2.0 „Baby" mit noch immer 370 PS geschaffen, während der 935/78 „Moby Dick" im folgenden Jahr mit zwei Turboladern und 845 PS als stärkster Elfer aller Zeiten in die Haus-Historie einging.

Parallel zum Markenchampionat ausge-schrieben wurde für 1976 und 1977 eine Weltmeisterschaft für Sportwagen. In Rekordzeit zauberte man den Typ 936 aus dem Hut, welcher der Firma einen weiteren Triumph beim 24-Stunden-Rennen von Le Mans, in jenem Jahr nicht Teil des Zyklus und dennoch glänzend besetzt, sowie den Titel bescherte. Gleichwohl ließ man es bei 1976 bewenden, sattelte indessen in Le Mans noch zweimal drauf mit Siegen 1977 und 1981, diesmal mit dem 936/81. Wie bereits einst in den Gründerjahren häuften sich die Erfolge in aller Herren Länder und in allen erdenklichen Kategorien, meist unter Mitwirkung einer ebenso passionierten wie entschlossenen Klientel. 1978 zum Beispiel verbuchte Porsche die Titel bei der europäischen Sportwagen- und Bergmeisterschaft sowie der IMSA- und der Interserie. 1980 errang

la 935 de 590 ch. C'est la réponse de Porsche, avec une construction allégée radicale, au nouveau règlement du Groupe 5. Elle décroche immédiatement le titre au Championnat du monde des constructeurs ainsi que les années suivantes jusqu'en 1980, date à partir de laquelle d'autres marques et des rivales issues du sérail commencent à lui faire de l'ombre. Pour la petite division du Deutsche Rennsportmeisterschaft de 1977, Porsche abat comme atout la 935/2.0 « Baby », qui développe tout de même 370 ch, tandis que la 935/78 « Moby Dick », l'année suivante, entre dans l'histoire de la maison comme plus puissante 911 de tous les temps avec ses deux turbocompresseurs et ses 845 ch.

Parallèlement au Championnat des constructeurs, la FIA organise, en 1976 et 1977, un Championnat du monde des voitures de sport. En un temps record, Porsche tire de son chapeau la 936 qui lui assure un nouveau triomphe aux 24 Heures du Mans – qui, cette année-là, ne sont pas inscrites au Championnat et se distinguent pourtant par un plateau magnifique – et, par la même occasion, le titre. Malgré tout, Porsche met un terme à ce projet en 1976, ce qui ne l'empêche pas de remporter deux autres victoires

Porsche garage at Le Mans in 1973. The Carrera RSR number 46 (Müller, van Lennep, Haldi) will finish fourth overall.

Porsche-Garage in Le Mans 1973. Der Carrera RSR mit der Nummer 46 (Müller, van Lennep, Haldi) wird Vierter gesamt.

Le garage Porsche au Mans en 1973. La Carrera RSR avec le numéro de course 46 (Müller, van Lennep, Haldi) terminera quatrième au classement général.

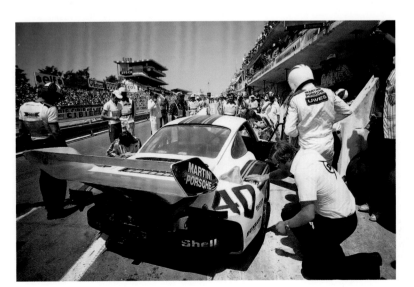

Le Mans 1976: the 935 driven by Schurti, Stommelen, Ickx and van Lennep during a pit stop. It is heading for fourth place.

Le Mans 1976: Der 935 von Schurti, Stommelen, Ickx und van Lennep beim Boxenstopp. Er wird Vierter.

Le Mans 1976 : la 935 de Schurti, Stommelen, Ickx et van Lennep lors d'un arrêt aux stands. Elle remportera la quatrième place.

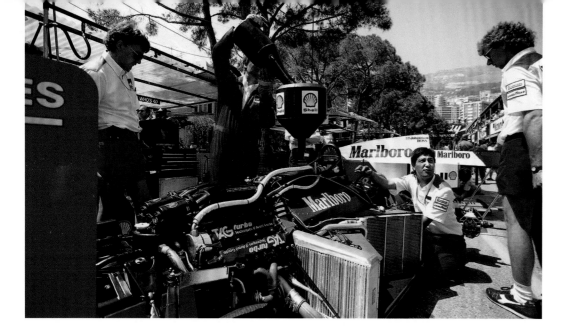

In 1987 the TAG Turbo has run out of victories, with only three successes in Brazil, Belgium and Portugal.

1987 hat der TAG Turbo das Siegen schon ein wenig verlernt: nur noch drei Erfolge, in Brasilien, Belgien und Portugal.

En 1987, le TAG Turbo ne retrouve plus le chemin de la victoire : trois succès seulement, au Brésil, en Belgique et au Portugal.

the same. Between 1982 and 1987, it gained six Le Mans victories and did so in a most convincing way, scoring position one to three in the first year, the first eight places in the second, the first seven in the third—all to the credit of private entrants. In 1994, there was a second helping provided by the Dauer 962 Le Mans GT version, which had been entered by the works in cooperation with smart Frankonian and ex-Formula 2 driver Jochen Dauer. Apart from that, the model managed to take the titles in the World Endurance Championship between 1982 and 1986, while the drivers' crown was secured by Porsche protagonists Jacky Ickx (1982 and 1983), Stefan Bellof (1984) and Derek Bell (1985 and 1986), in the first of the two seasons *ex aequo* with new arrival Hans-Joachim Stuck. As early as 1983, the 956, as if to already pay tribute to its future achievements, had been chosen "Motor Sport Vehicle of the Year". During practice for the 1000-Kilometer Race at the Nürburgring, highly talented Stefan Bellof had taken the dictum "faster than fast" literally and managed to maintain an average speed of more than 124 mph—the first and the only man ever to do so at the Eifel circuit.

In that season Porsche returned to Formula 1, supplying engines to the renowned British racing stable McLaren International. The Dutch Grand Prix at Zandvoort on 28 August saw the debut, in Niki Lauda's McLaren MP4/1-E, of the "TAG Turbo made by Porsche", a turbocharged 1.5-liter V6 which put out up to 1000 bhp, financed by the "Techniques d'Avant Garde" enterprise of Saudi Arabian businessman Mansour Ojjeh and constructed under the supervision of Hans Mezger. That joint venture turned out to be extraordinarily rewarding. In the 1984–1986 grand prix seasons, it brought forth 25 victories, the titles for Lauda (1984) and Alain Prost (1985 and 1986), as well as firsts for McLaren in the constructors' standings in 1984 and 1985. The counterpoint followed in

man mit den Typen 935 und 911SC, neben den IMSA- und TransAm-Meisterschaften drei Europachampionate. Nur ein winziger Defekt warf 1974 bei der Safari-Rallye in Kenia, der schwierigsten jener Zeit, den 911 Carrera 2.7 von Björn Waldegård und Hans Thorszelius auf den zweiten Rang zurück, während das französische Duo Jean-Pierre Nicolas und Vincent Laverne bei der Rallye Monte Carlo 1978 nach Jahren der Dürre mit einem Gesamtsieg aufwartete. Auch die Frontmotormodelle mussten sich nach Art des Hauses im Pulverdampf der Piste behaupten und auch sonst allerlei Schikanen erdulden. 1979 bewiesen Rudi Lins und Gerhard Plattner die Verlässlichkeit des 924 Turbo mit einer Fernfahrt über 37 000 Kilometer von New York nach Wien. 1980 sahen alle drei in Le Mans gestarteten 924 Carrera GT die schwarzweiß karierte Flagge. 1981, wieder auf dem Sarthe-Kurs, krönten Walter Röhrl und Jürgen Barth das Debüt eines Prototyps des künftigen 944 mit einem Klassensieg.

1982 schlug die Stunde des Typs 956, auf dem letzten Stand der Dinge mit einem Monocoque und vom modischen Ground Effect an den Boden gelutscht, wenn auch zwei Jahre später aus Rücksicht auf die amerikanischen IMSA-Regularien zum 962 (in den Versionen IMSA und C) umgewidmet mit einem von 2650 auf 2770 mm erweiterten Radstand und einem längeren Monocoque bei gleicher Gesamtlänge. Er zeichnete verantwortlich für die sechs Le-Mans-Siege 1982 bis 1987, und zwar auf ungemein nachhaltige Weise: Rang eins bis drei im ersten Jahr, die ersten acht Plätze im zweiten, Position eins bis sieben im dritten – alle auf dem Konto privater Rennställe. 1994 gab es einen Nachschlag durch die Version Dauer 962 Le Mans GT, vom Werk in Zusammenarbeit mit dem smarten Franken Jochen Dauer eingesetzt. Zwischen 1982 und 1986 konnte das Modell überdies den Titel bei der Langstreckenweltmeisterschaft für sich

au Mans en 1977 et 1981, mais, cette fois-là, avec la 936/81. Comme lors des premières années suivant la création de la marque, déjà, les succès se multiplient sur les cinq continents et dans toutes les catégories imaginables, le plus souvent grâce au concours d'une clientèle dont la passion n'a d'égale que la détermination. En 1978, par exemple, Porsche engrange le titre aux Championnats européens des voitures de sport et de la montagne ainsi qu'en IMSA et en Interserie. En 1980, avec les versions 935 et 911SC, outre les championnats de l'IMSA et de la TransAm, le constructeur remporte trois Championnats d'Europe. En 1974, au difficile Safari-Rallye du Kenya, un ridicule défaut relègue à la deuxième place la 911 Carrera 2.7 de Björn Waldegård et Hans Thorszelius, pendant que l'équipage français composé de Jean-Pierre Nicolas et Vincent Laverne s'arroge la victoire au classement général du Rallye de Monte-Carlo de 1978 après des années de vaches maigres. De même, les modèles à moteur avant doivent, eux aussi, dans la plus pure tradition de Zuffenhausen, gagner leurs premiers galons en subissant le baptême du feu des circuits et, sinon, endurer les épreuves les plus rudes. En 1979, par exemple, Rudi Lins et Gerhard Plattner prouvent la fiabilité de la 924 Turbo avec une expédition longue de plus de 37 000 km de New York à Vienne. En 1980, les trois 924 Carrera GT inscrites au Mans franchissent la ligne d'arrivée. En 1981, sur ce même circuit de la Sarthe, Walter Röhrl et Jürgen Barth consacrent les débuts d'un prototype de la future 944 avec une victoire de classe.

En 1982 sonne l'heure de la 956 – le *nec plus ultra* des monocoques –, qui colle à la piste grâce à l'effet de sol répandu à cette époque. Voiture qui, deux ans plus tard, pour des raisons de compatibilité avec le règlement américain de l'IMSA, est transformée en 962 (dans les versions IMSA et C) avec un empattement allongé de 2650 à 2770 mm et une monocoque plus longue pour une longueur hors-tout identique. Elle inscrira à son blason les six victoires remportées au Mans de 1982 à 1987, et ce, d'une façon qui restera gravée dans les esprits : avec un triplé pour la première année, les huit premières places pour la deuxième et les places un à sept pour la troisième année – toutes pour le compte d'écuries privées. En 1994, Porsche enfonce le clou avec la version Dauer 962 Le Mans GT, engagée par le rusé homme d'affaires de Franconie, Jochen Dauer. Entre 1982 et 1986, ce modèle parvient même à s'offrir le titre au Championnat du monde d'endurance. Le classement Conducteurs est remporté par les pilotes de Porsche Jacky Ickx (1982 et 1983), Stefan Bellof (1984) et Derek Bell (1985 et 1986), ex-aequo avec Hans-Joachim Stuck pour la première des deux années. Dès 1983, comme si ce sacre était le précurseur de ses mérites futurs, la 956 est élue Voiture de course de l'année. Lors des essais de la course des 1000 Kilomètres, le talentueux pilote de Giessen Stefan Bellof avait, au volant d'une voiture d'usine, pris au mot le terme «vitesse inhabituelle». Il est le premier – et le seul jusqu'à ce jour – à avoir

1991, when the Footwork-Arrows racing team had a late work of Mezger's at its disposal, a 3.5-liter V12, beautiful to behold and a joy to listen to, but too weak, too heavy and hopelessly underfinanced. At the end of the season, the partnership was dissolved prematurely.

In 1988, Porsche entered territory that was equally unknown and mine-infested, with the Type 2708 "Indy" featuring a V8 that produced 750 bhp and an aluminum and plastic monocoque body built by specialist March. The spoils of three years in the American CART scene were poor indeed:

verbuchen. Die Wertung für die Piloten holten sich die Porsche-Fahrer Jacky Ickx (1982 und 1983), Stefan Bellof (1984) und Derek Bell (1985 und 1986), im ersten der beiden Jahre *ex aequo* mit Hans-Joachim Stuck. Schon 1983 hatte man den 956, gleichsam in vorauseilender Würdigung auch künftiger Verdienste, zum „Motorsport-Automobil des Jahres" erkoren. Beim Training zum 1000-Kilometer-Rennen hatte der hoch begabte Gießener Stefan Bellof in einem Werkswagen den Begriff „unheimliche Geschwindigkeit" beim Wort genommen und war als Erster – und Einziger –

couvert un tour du Nürburgring à une moyenne supérieure à 200 km/h.

Cette saison-là, Porsche revient en Formule 1, mais, cette fois-ci, en tant que motoriste pour l'écurie anglaise McLaren International. Le Grand Prix de Hollande, à Zandvoort, le 28 août 1983, est le théâtre des débuts, dans la McLaren MP4/1-E de Niki Lauda, du «TAG Turbo made by Porsche», un V6 de 1,5 litre de cylindrée dont la puissance grimpe jusqu'à 1000 chevaux, un moteur financé par TAG Group (Techniques d'Avant-Garde), une société de l'homme d'affaires saoudien Mansour

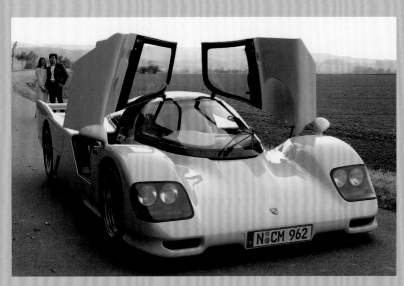

One for the Road

At the 1993 Frankfurt IAA the Franconian team owner and former Formula 2 driver Jochen Dauer created a furore presenting a civilian version of the Porsche 962C. The spectacular one-off cost a hefty 1,725,000 marks. Fully street-legal and with the necessary modifications in terms of its cockpit layout and engine set-up it complied with the GT1 regulations for the 1994 Le Mans 24 Hours. Dauer's GTs scored first and third places.

Dauer-Lösung

Auf der Frankfurter IAA 1993 machte der Nürnberger Team-Eigner und frühere Formel-2-Rennfahrer Jochen Dauer mit einer zivilen Version des Porsche 962C Furore, Kostenpunkt: stramme 1725000 Mark. Mit einer vollen Straßenzulassung und entsprechenden baulichen und technischen Veränderungen passte sie als GT1 genau ins Profil der 24 Stunden von Le Mans 1994. Das Wagnis gelang, belohnt mit Rang eins und drei.

Code civil §962

À l'IAA de 1993, le propriétaire d'écurie et ancien pilote de Formule 2 Jochen Dauer, de Nuremberg, fait un tabac avec une version civile de la Porsche 962C «bradée» au prix de 1725000 marks. Homologuée pour la route après avoir subi les modifications mécaniques et techniques nécessaires, elle respectait parfaitement, en catégorie GT1, le règlement des 24 Heures du Mans de 1994. Elle termine à la 1re et à la 3e place.

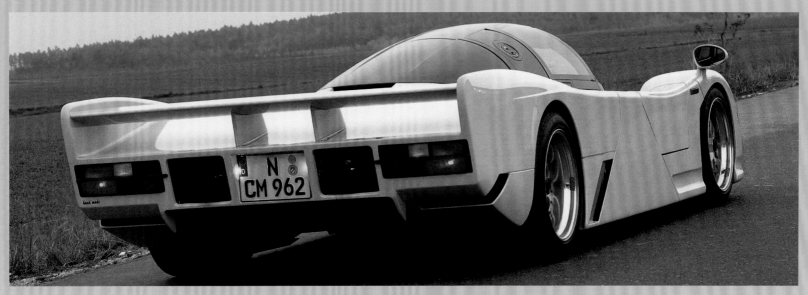

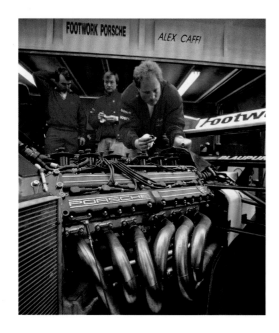

Hans Mezger's V12 in the rear of the 1991 Arrows FA12 turned out to be a flop; beautiful, but too heavy and too weak.

Hans Mezgers V12 im Heck des Arrows FA12 von 1991 geriet zum Flop, schön, aber zu schwer und zu schwach.

Le V12 de Hans Mezger équipant l'Arrows FA12 de 1991 aura été un coûteux flop ; beau, mais trop lourd et trop lymphatique.

just one victory in Mid-Ohio for bald-headed Italian Teo Fabi; otherwise also-ran placings and a feeling of frustration in the end. But Porsche made up for this in difficult terrain. At the prestigious Paris-Dakar Rally in 1984, for instance, a Carrera 4×4 in the colors of sponsor Rothmans prevailed, manned by René Metge and Dominique Lemoyne. Two years later, at the same event, three 959s were entered and all of them not only finished but also took first (with the same team), second and sixth places in the overall rankings. With a first round at the Belgian Zolder circuit on 1 April 1990, the Porsche Carrera Cup was launched, replacing the 944 Turbo Cup, which had been contested since 1986 as an environmentally acceptable race series.

As in the case of the Targa Florio, no other marque could hold a candle to Porsche in terms of its Le Mans balance. Think back to the hat-trick of overall victories between 1996 and 1998, or to outstanding drivers such as Jacky Ickx and Derek Bell. The 1996 and 1997 successes were won by the Type WSC (World Sports Cars) 95 Le Mans, conceived as a two-seater by the British TWR (Tom Walkinshaw Racing) enterprise, with a carbon fiber monocoque. Like the 1994 LM GT, it had a water-cooled flat six of 2994 cc and twin turbochargers, limited to 540 reliable bhp by air restrictors and boost reduction. The WSC 95 had come into being under considerable time pressure as Porsche had been informed by the IMSA (International Motor Sport Association) officials as late as October 1994 that turbo aggregates would be legal in the future. First tests took place in mid-December 1994.

mit einem Schnitt von über 200 km/h über den Nürburgring gepfeilt.

In jener Saison kehrte Porsche in die Formel 1 zurück, diesmal als Motorenlieferant für den englischen Rennstall McLaren International. Beim Großen Preis von Holland in Zandvoort am 28. August debütierte im McLaren MP4/1-E von Niki Lauda der „TAG Turbo made by Porsche", ein bis zu 1000 PS starker 1,5-Liter-V6 mit Abgasaufladung, finanziert vom Unternehmen „Techniques d'Avant Garde" des saudiarabischen Geschäftsmanns Mansour Ojjeh und konstruiert unter Leitung von Hans Mezger. Das Joint Venture erwies sich als überaus ergiebig. In den Grand-Prix-Saisons 1984–1986 erwuchsen daraus 25 Siege, die Titel für Lauda (1984) und Alain Prost (1985 und 1986) sowie Rang eins für McLaren in der Konstrukteurswertung 1984 und 1985. Der Kontrapunkt folgte 1991, als ein Mezger-Spätwerk dem Rennteam Footwork-Arrows zur Verfügung stand, ein 3,5-Liter-V12, bildschön und von prächtiger Melodik, aber zu schwach, zu schwer und hoffnungslos unterfinanziert. Zum Saisonende wurde die Partnerschaft vorzeitig aufgelöst.

Auf ebenso unbekanntes wie minenträchtiges Territorium begab man sich 1988 mit dem Typ 2708 „Indy", mit einem V8 von 750 PS Leistung und einem Aluminium-Kunststoffmonocoque vom Spezialisten March. Die Ausbeute in drei Jahren Verweildauer in der amerikanischen CART-Szene blieb mager: ein Sieg für den kahlhäuptigen Italiener Teo Fabi 1989 in Mid-Ohio, ansonsten Platzierungen unter Ferner liefen, am Ende ein ungutes Gefühl. Dafür hielt man sich in schwerem Gelände schadlos. Bei der Prestige-Rallye Paris–Dakar 1984 etwa siegte ein Carrera 4×4 in den Farben des Sponsors Rothmans, bemannt von René Metge und Dominique Lemoyne, zwei Jahre später erreichten bei der gleichen Veranstaltung alle drei gestarteten Porsche 959 das Ziel und dies auf den Rängen eins (für dasselbe Team), zwei und sechs. Mit einem ersten Lauf im belgischen Zolder wurde am 1. April 1990 der Porsche Carrera Cup aus der Taufe gehoben und zugleich der seit 1986 ausgefochtene 944 Turbo Cup zu Grabe getragen.

Wie einst bei der Targa Florio kann Porsche hinsichtlich der Bilanz der 24 Stunden von Le Mans kein anderes Fabrikat das Wasser reichen. Man erinnere sich nur an den Gesamtsieg-Hattrick von 1996 bis 1998, oder an herausragende Piloten wie Jacky Ickx und Derek Bell. Für die Erfolge 1996 und 1997 zuständig war der Typ WSC (World Sports Cars) 95 Le Mans, mit einem von dem britischen Unternehmen TWR (Tom Walkinshaw Racing) gefertigten Karbon-Monocoque als Zweisitzer ausgelegt. Als Antrieb diente wie bereits im LM GT von 1994 ein wassergekühlter Sechszylinder-Boxer mit 2994 cm³ und Doppelturbo, von Luftrestriktoren und einer Ladedruckbeschränkung auf standfeste 540 PS zur Ader gelassen. Der WSC 95 war unter erheblichem Zeitdruck entstanden, da Porsche erst im Oktober 1994 von den Veranstaltern der IMSA (International Motor Sports Association) informiert worden war, künftig seien auch Turboaggregate statthaft. Im Dezember 1994 fuhr man erste Tests. Etliche Schwierigkeiten waren zu überwinden, so

Ojjeh et construit sous la baguette de Hans Mezger. Le joint-venture s'avère des plus fructueux. En trois saisons de Grands Prix, de 1984 à 1986, il se distingue par 25 victoires avec les titres pour Niki Lauda (en 1984) et Alain Prost (en 1985 et 1986) ainsi que la première place pour McLaren au Championnat des constructeurs en 1984 et 1985. Grande est la désillusion, en 1991, lorsqu'une œuvre tardive de Mezger est mise à la disposition de l'écurie Footwork-Arrows. Il s'agit d'un V12 de 3,5 litres, magnifique et à la mélodie fascinante, mais trop faible, trop lourd et au financement désespérément insuffisant. À la fin de la saison, un terme est mis prématurément à ce partenariat.

C'est sur un terrain aussi inconnu que miné que Porsche s'engage en 1988 avec la 2708 « Indy », propulsée par un V8 de 750 ch dans une monocoque en aluminium et matériaux composites, conçue par le spécialiste March. Le butin à l'issue de trois ans de participation au Championnat américain CART reste maigre : une victoire pour l'Italien aux cheveux rares, Teo Fabi, en 1989 à Mid-Ohio, et, sinon, des classements loin des places d'honneur et, à la fin, un sentiment d'inachevé. La prestation en terrains difficiles est autrement plus brillante. Lors du prestigieux Rallye Paris-Dakar de 1984, par exemple, une Carrera 4×4 portant la casaque du sponsor Rothman et pilotée par René Metge, navigué par Dominique Lemoyne, remporte la victoire alors que, deux ans plus tard, lors de la même épreuve, les trois équipages Porsche 959 qui ont pris le départ voient aussi l'arrivée et, qui plus est, aux places un (pour les mêmes équipiers), deux et six. Avec une première manche organisée à Zolder, en Belgique, la Porsche Carrera Cup est portée sur les fonts baptismaux le 1er avril 1990, ce qui signifie simultanément la fin de la 944 Turbo Cup disputée depuis 1986.

Comme jadis à la Targa Florio, aucun autre constructeur ne peut rivaliser avec Porsche pour le bilan aux 24 Heures du Mans. Il suffit de rappeler le coup du chapeau de 1996 à 1998 et la victoire générale avec des pilotes aussi extraordinaires que Jacky Ickx et Derek Bell. Les deux premiers succès sont à porter à l'actif de la WSC 95 (World Sports Cars) Le Mans, conçue comme biplace avec une monocoque en carbone fabriquée par le préparateur britannique TWR (Tom Walkinshaw Racing). Comme la LM GT de 1994, déjà, elle aussi est propulsée par un six-cylindres à plat à refroidissement liquide de 2994 cm³ et à suralimentation par double turbo, mais d'une puissance ramenée à 540 ch d'une très grande fiabilité grâce à des boîtes à air et une limitation de la pression de suralimentation. La WSC 95 est née avec un échéancier extrêmement serré, Porsche n'ayant été informée qu'en octobre 1994 par les organisateurs de l'IMSA (International Motor Sports Association) que les moteurs suralimentés seraient autorisés à l'avenir. Les premiers tests se déroulent en décembre 1994. Il a fallu résoudre d'innombrables difficultés, à tel point que le projet a été suspendu pendant une année entière. Mais c'est alors que Reinhold Joest achète deux exemplaires de la

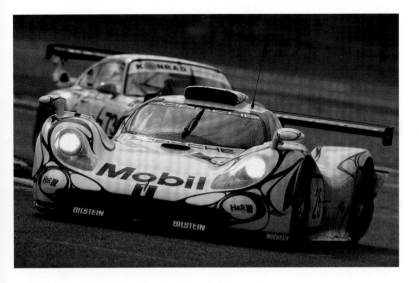

Double victory for the GT1 at Le Mans in 1998. The picture shows the second-placed car of Müller, Alzen and Wollek.

Mission gelungen: Doppelsieg für den GT1 1998 in Le Mans, hier der zweitplatzierte Wagen von Müller, Alzen und Wollek.

Mission réussie : doublé pour la GT1 en 1998 au Mans ; ici, la voiture qui a terminé deuxième avec Müller, Alzen et Wollek.

Porsche 919 Hybrid: overall winner at Le Mans and manufacturers' world champion, 2015 and 2016.

Porsche 919 Hybrid: Gesamtsieger Le Mans und Markenweltmeister 2015 und 2016.

Porsche 919 Hybrid : victoire générale au Mans et champion des constructeurs en 2015 et 2016.

Diverse difficulties had to be overcome, however, so that the project was delayed by a whole year. But then Porsche stalwart Reinhold Joest bought two specimens, securing the support of the factory to eliminate the technical and aerodynamic deficiencies of the model. Before both Le Mans successes these cars had to fend off stiff opposition from in-house rivals in the shape of the GT1 entries. Eventually, in 1998, it was the turn of the swift coupé to grab an historic victory.

Then, for a couple of years, Porsche was conspicuous by its absence on the world racing stage, until the company reported back in style with the prototype RS Spyder in fall 2005 at the American Le Mans Series (ALMS) in Californian Laguna Seca, with pole position, fastest time of the day and class victory in the LMP (Le Mans Prototypes) 2 class. Behind the nostalgic RS Spyder name hid a 750-kg two-seater, again featuring a carbon-fiber monocoque as backbone, propelled by a 3.4-liter V8 whose output had been cut down to 480 bhp by air restrictors. It was entered by Porsche partner Penske Motorsports. Triumph was total: premature win in the constructors' and teams' standings of the LMP2 category at the penultimate round in Road Atlanta, drivers' title for Sascha Maassen and Lucas Luhr, one overall victory over the mighty LMP1 prototypes at the sinuous Mid-Ohio track.

Noblesse oblige, after all—even more so when it has arisen over the course of an entire era. And so it was that the comeback in 2014 was followed by the 919 Hybrid winning the 2015 accolade for this LMP1, then the eighteenth triumph to date in 2016.

dass das Projekt ein Jahr auf Eis lag. Dann jedoch kaufte Reinhold Joest zwei Exemplare und sicherte sich zugleich die Unterstützung des Werks beim Ausräumen von konstruktiven Ungereimtheiten. Bei beiden Le-Mans-Erfolgen musste man sich des GT1 aus dem eigenen Hause erwehren. 1998 setzte sich das hurtige Coupé in einem Doppelsieg durch.

Dann wurde es eine Zeit lang stiller um den Porsche-Sport auf der Weltbühne, bis sich die Marke mit dem Prototyp RS Spyder im Herbst 2005 bei der American Le Mans Series (ALMS) im kalifornischen Laguna Seca zurückmeldete, mit Pole-Position, Rundenrekord und Klassensieg in der Kategorie LMP (Le-Mans-Prototypen) 2. Hinter dem nostalgischen Namen RS Spyder verbarg sich ein 750 kg leichter Zweiplätzer mit dem modischen Kohlefasermonocoque als Rückgrat, befeuert durch einen 3,4-Liter-V8, dessen Leistung durch einen Luftmengenbegrenzer auf 480 PS beschränkt wurde, eingesetzt von Porsche-Partner Penske Motorsports. Der Triumph war total: vorzeitiger Gewinn der Hersteller- und Teamwertung in der Kategorie LMP2 2006 beim vorletzten Lauf in Road Atlanta, Fahrertitel für Sascha Maassen und Lucas Luhr, ein Gesamtsieg auf dem winkligen Kurs von Mid-Ohio.

Adel verpflichtet schließlich, und gewachsener Adel erst recht, und so folgte nach dem Comeback 2014 mit dem 919 Hybrid 2015 der Ritterschlag für diesen LMP1, dem 2016 der bis dato achtzehnte Triumph folgte.

voiture et s'assure ainsi le soutien de l'usine pour éliminer les défauts de conception. Lors des deux succès remportés au Mans avec elle, elle doit se défendre contre une GT1 du sérail. En 1998, le rapide coupé se distingue même par un doublé.

Contre toute attente, débute alors une époque durant laquelle l'on ne parlera plus de Porsche et de compétition sur circuit dans le monde entier pendant longtemps... avant que la marque ne fasse sa réapparition, à l'automne 2005, avec le prototype RS Spyder dans le cadre de l'American Le Mans Series (ALMS) à Laguna Seca, en Californie, en signant la pole position, le record du tour et une victoire de classe en catégorie LMP2 (Le Mans Prototypes) pour son retour en compétition. Derrière la dénomination nostalgique RS Spyder se dissimule une biplace de 750 kg seulement, avec comme épine dorsale l'incontournable monocoque en fibre de carbone, animée par un V8 de 3,4 litres dont la puissance a été ramenée à 480 ch par un limiteur d'alimentation en air, biplace engagée par un partenaire de Porsche, Penske Motorsports. Le triomphe est complet : gain prématuré des classements des constructeurs et des écuries dans la catégorie LMP2 en 2006 lors de l'avant-dernière manche à Road Atlanta, titre pilotes pour Sascha Maassen et Lucas Luhr et une victoire au classement général sur le sinueux circuit de Mid-Ohio.

Noblesse de longue tradition oblige... et c'est ainsi qu'après le retour en 2014 avec la 919 Hybrid, 2015 apporta la consécration à cette LMP1, avec en 2016 son dix-huitième triomphe à ce jour.

The idea came at an inopportune time and did so twice. Soon after pilot production of Ferdinand Porsche's Volkswagen got under way in 1937, he was already reaching for higher aims. During talks with the bosses of the National Socialist organization responsible for the scheme, the stubborn professor reiterated his desire to crown the project with a sporting model based on the VW. His petition was rejected on the grounds that it was the masses who were to be made mobile and not some well-to-do individuals. That changed after a Berlin-Rome long-distance race was announced for September 1939, whetting the Nazi bigwigs' appetites: victory of a VW derivative at such an event would be splendid advertising for the reigning system, not unlike the successes of the Mercedes and Auto Union Silver Arrows. In spring 1939, Dr. Ing. h.c. F. Porsche KG put three Type 64 coupés on their wheels, with wind-cheating aluminum bodies and VW power plants, whose output had been increased to 50 bhp by means of some cautious but efficient steps, installed amidships. These ancestors of future greatness failed to ever hit the tracks, since in September that year sport, seen as a continuation of politics by other means, was replaced by war.

For the first real Porsche the world had to wait until 8 June 1948. It had been built by Porsche-Konstruktionen-Ges.m.b.H., located in Austrian exile in Gmünd, following its Type 64 predecessor in principle and according to initial drawings dated 17 July 1947. Again Fortune did not exactly smile upon the project. But the "VW two-seater sports car", chassis number 356-001, was ideally suited to lightening up post-war gloom and aimlessness, with Ferdinand ("Ferry") Porsche jr. sifting the market as to what the reception of the model would be like. The echo was heartening, particularly in Switzerland, with Porsche and his men wholeheartedly supported by hotelier and car dealer Bernhard Blank and the wealthy Zurich entrepreneur Rupprecht von Senger, who contributed spare parts, sheet metal, as well as finance to the tune of 50,000 Swiss francs.

It was von Senger, too, to whom was delivered the dapper "Gmünd Roadster", scaling 1312 lbs and delivering 35 bhp with a modified 1131 cc engine from the donor VW installed in front of the rear axle, and featuring a tube-type frame. At that moment that particular architecture had already been shelved, as the tubular timberwork was too expensive and needed too much space, as did the mid engine. The four-cylinder had to be resettled into a position behind the axle, the backbone changed into a stiff structure consisting of lateral box-section members and a complete floor. This was already the case on a Cabriolet and a Coupé. By mid-1948 the Carinthian authorities had given their stamp of approval. The cars' aluminum shells were hammered over a wooden model by a Vienna bodywork man. When the Gmünd production expired on 20 March 1951, 44 closed and eight open versions of that primeval 356 had fixed the idea of a Porsche sports car in the heads of many.

Die Idee kam zur Unzeit, und das gleich zweimal. Die Vorserie des von ihm konstruierten Volkswagens war 1937 just angeschoben worden, da strebte Professor Ferdinand Porsche bereits nach Höherem: Er würde gern, regte er bei Gesprächen mit den Bossen der zuständigen nationalsozialistischen Deutschen Arbeitsfront an, das Projekt mit einem sportlichen Fahrzeug auf VW-Basis krönen. Das Gesuch wurde abgeschmettert – man wolle die Massen mobil machen und nicht nur einige wenige Wohlhabende. Anderen Sinnes wurde man, nachdem für den September 1939 eine Fernfahrt Berlin-Rom ausgeschrieben worden war. Der Sieg eines VW-Derivats wäre ein glänzender PR-Coup für das System, ähnlich den Erfolgen der Silberpfeile von Mercedes und Auto Union. Unter der Bezeichnung Typ 64 stellte die Dr. Ing. h.c. F. Porsche KG im Frühjahr 1939 drei Coupés mit windschlüpfigen Aluminiumaufbauten auf die Räder, mittig eingelassen VW-Triebwerke, die durch entsprechende Maßnahmen auf 50 PS erstarkt waren. Zum Einsatz kam dieser Urahn künftiger Größe nie. Denn im September jenes Jahres ersetzte der Krieg den Sport als Fortsetzung der Politik mit anderen Mitteln.

Auf den ersten richtigen Porsche musste die Welt bis zum 8. Juni 1948 warten, gebaut im Exil des österreichischen Gmünd durch die Porsche-Konstruktionen-Ges.m.b.H. auf der Grundlage des Typs 64 und nach Zeichnungen vom 17. Juli 1947. Wieder lächelte keineswegs die Gunst der Stunde über dem Vorhaben. Aber mit dem „VW-Zweisitzer-Sportwagen" Chassisnummer 356-001 heiterte man Wirrwarr und Tristesse der Nachkriegszeit mit einem Traum auf, nicht ohne dass Ferdinand („Ferry") Porsche der Jüngere den Markt vorher auf seine Empfänglichkeit ausgelotet hatte. Energische Ermutigung kam aus der Schweiz, vor allem durch den Hotelier und Autohändler Bernhard Blank und den Zürcher Unternehmer Rupprecht von Senger, der überdies Bleche, Ersatzteile sowie höchst willkommenes Kapital in Höhe von 50000 Franken beisteuerte.

Von Senger bezog auch den schmucken „Roadster Gmünd", 595 kg leicht und 35 PS stark, mit einer modifizierten 1131-cm³-Maschine des Spenders VW vor der Hinterachse und einem Rohrrahmen. Von dieser Architektur war man zu jenem Zeitpunkt bereits wieder abgekommen. Zu teuer war das Rohrgeflecht und verschlang zu viel Platz. Dasselbe galt für den Mittelmotor. Der Vierzylinder musste nach hinten ausgesiedelt werden, als Rückgrat eine steife Struktur mit seitlichen Kastenträgern und durchgehendem Boden herhalten. Dieses war bereits an je einem Cabriolet und einem Coupé der Fall, denen die Kärntner Behörden Mitte 1948 das Zeugnis der Unbedenklichkeit ausstellten. Die Alu-Hüllen hämmerte ein Wiener Spengler über ein Holzmodell. Als die Produktion in Gmünd am 20. März 1951 versiegte, hatten 44 geschlossene und acht offene Versionen des Ur-356 die Idee vom Porsche-Sportwagen nachhaltig in den Köpfen verankert.

À deux reprises, l'idée est venue au mauvais moment... La présérie de la Volkswagen conçue par Ferdinand Porsche vient juste de démarrer, en 1937, que le professeur laisse déjà transparaître son ambition : il aimerait bien, confie-t-il lors d'entretiens avec les éminences grises compétentes du Front national-socialiste allemand du travail, couronner le projet avec un véhicule sportif conçu d'après les VW. Mais sa proposition recueille une fin de non-recevoir – l'objectif étant de permettre au plus grand nombre d'accéder à la mobilité et non de faire plaisir à quelques nantis. Toutefois, les mentalités évoluent et l'organisation d'une course longue distance Berlin–Rome est même annoncée pour septembre 1939. La victoire d'une dérivée de la Volkswagen serait donc spectaculaire et lui donnerait un fabuleux coup de pouce,

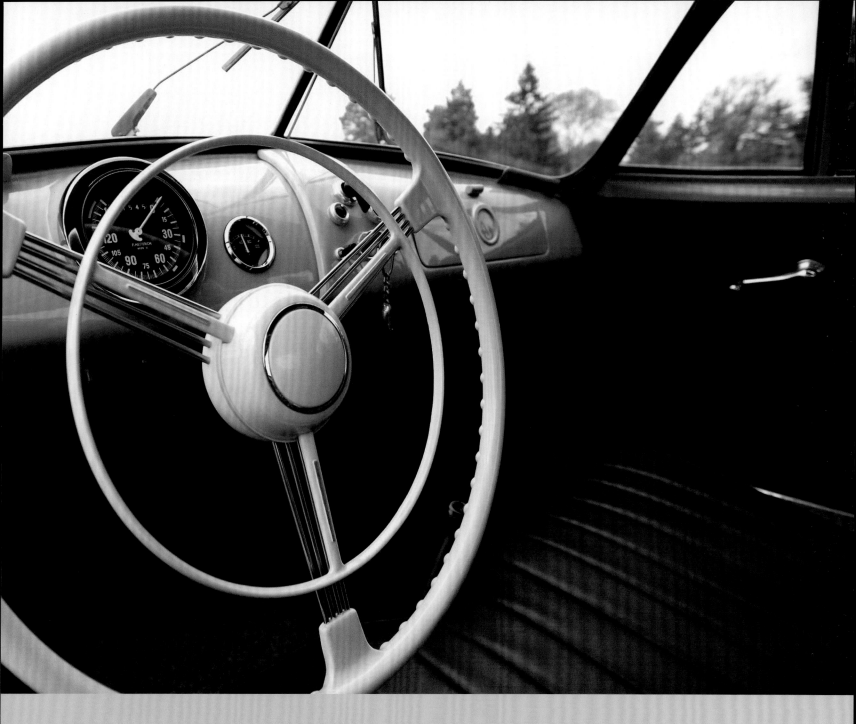

à l'instar des succès remportés par les Flèches d'argent de Mercedes et Auto Union. Sous la désignation Type 64, la société Dr. Ing. h.c. F. Porsche KG dévoile donc, au printemps 1939, trois coupés à carrosserie aluminium aérodynamique avec un moteur VW en position centrale dont on parvient à extraire 50 ch. Issu d'une lignée prestigieuse, ce véhicule n'allait cependant jamais prendre le départ d'une course. En effet, en septembre de cette année-là, la guerre supplante le sport et la politique se poursuit avec d'autres moyens.

Le monde va donc devoir attendre jusqu'au 8 juin 1948 pour voir apparaître la première vraie Porsche, une voiture construite en terre d'exil autrichienne, à Gmünd, par Porsche-Konstruktionen-Ges.m.b.H. sur la base de la 64 et selon des plans achevés le 17 juillet 1947. Mais le projet n'en est pas pour

autant placé sous de meilleurs auspices. Au moins la «voiture de sport VW à deux sièges», avec le numéro de châssis 356-001, aura-t-elle le mérite de redonner un peu de gaieté à la tristesse de l'après-guerre en faisant rêver – sans même que Ferdinand («Ferry») Porsche junior n'ait auparavant sondé le marché quant à sa réceptivité. Ainsi reçoit-il des encouragements enthousiastes en provenance de Suisse, en la personne de l'hôtelier et concessionnaire automobile Bernhard Blank, et de l'industriel zurichois Rupprecht von Senger, qui offre pour le projet des tôles, des pièces de rechange, et des capitaux – 50 000 francs suisses fort bienvenus.

Von Senger s'achète d'ailleurs le joli petit «Roadster Gmünd», un poids plume de 595 kg et 35 ch animé par un moteur de VW modifié de 1131 cm³

et implanté devant le train avant dans un châssis tubulaire. Une architecture pourtant déjà obsolète. En effet, le treillis de tubes s'avère beaucoup trop onéreux et encombrant. Un verdict identique sera réservé au moteur central. Le quatre-cylindres est donc déplacé à l'arrière et inséré dans une structure rigide comme une épine dorsale avec des longerons latéraux et un plancher d'un seul tenant. Une architecture que partagent déjà un Cabriolet et un Coupé, autorisés par les autorités de Carinthie à la mi-1948. Un ferblantier viennois a auparavant martelé sur une maquette en bois leur robe en aluminium. Quand la production cesse à Gmünd, le 20 mars 1951, 44 versions fermées et 8 décapotables de l'ancêtre de toutes les 356 ont déjà profondément enraciné dans les esprits l'idée de la voiture de sport selon Porsche.

356 Alu

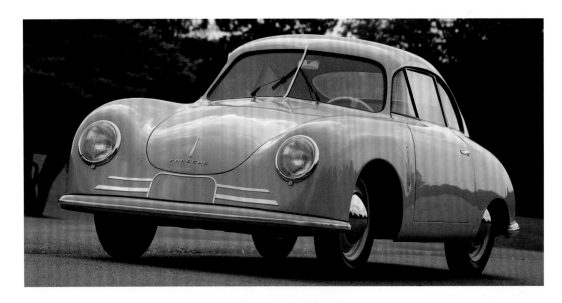

Early brochures speak of the Gmünd Coupé as a "streamlined sedan". But the distinctive 356 shape is already easily recognizable. Most of them are adorned with these two chromed strips.

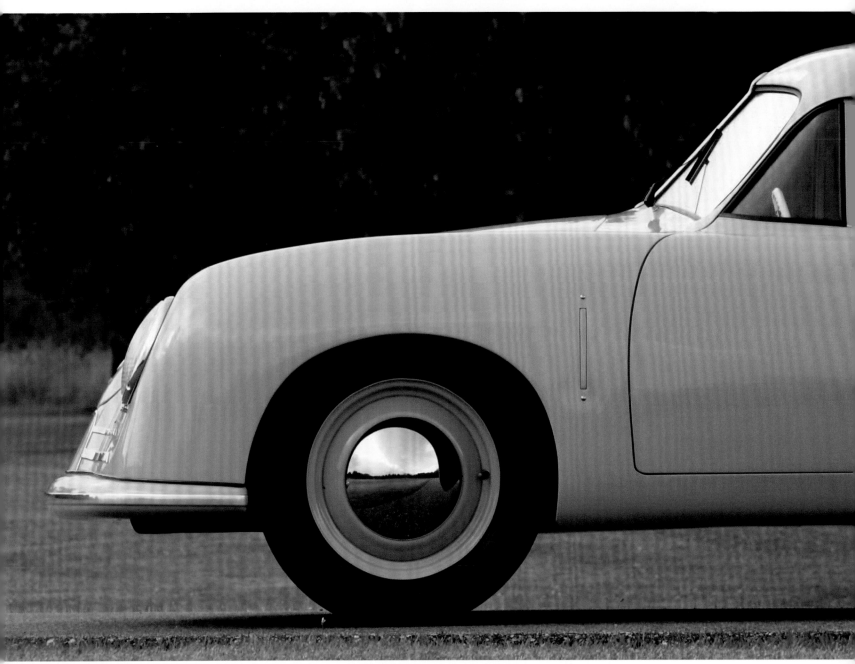

An dieser „Stromlinien-Limousine", als welche die Werbung das Gmünd-Coupé ausweist, ist die typische 356-Form schon deutlich zu erkennen. Die meisten tragen diese beiden Chromleisten zur Zierde auf der Nase.

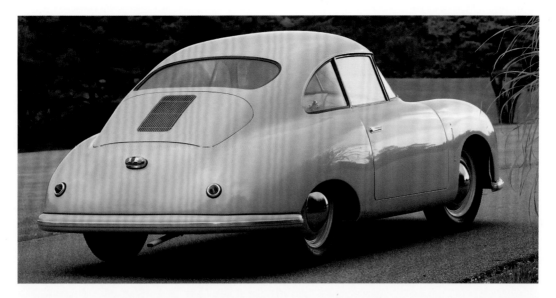

Sur cette «berline aérodynamique» que la publicité nomme Coupé Gmünd, on reconnaît déjà sans ambiguïté la forme typique de la 356. La plupart arborent ces deux barrettes chromées comme décoration sur la proue.

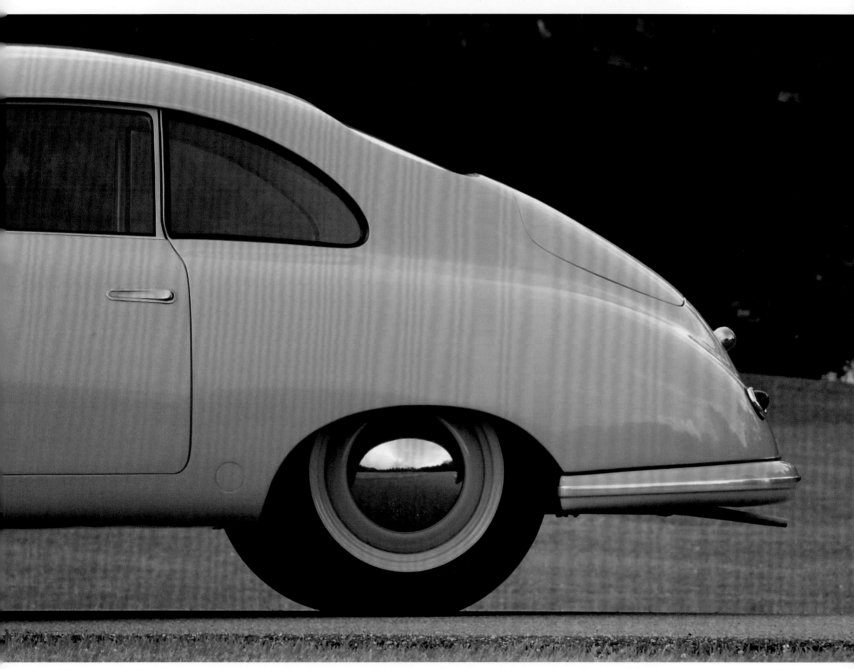

The aluminum coupés manufactured in Austria are real lightweights so that their feeble engines have to cope with fewer pounds. Production tolerances are enormous. Changes in direction are still shown by mechanical indicators.

Die Coupés aus österreichischer Fertigung mit ihren Aluminiumaufbauten sind wirkliche Leichtgewichte. Handarbeit bedingte enorme Fertigungstoleranzen. Noch zeigen Winker an, wo es langgeht.

Les coupés de fabrication autrichienne avec leur carrosserie en aluminium sont vraiment des poids plume. Le travail manuel sous-entendait des tolérances de fabrication énormes. Les indicateurs à levier n'ont pas encore fait place aux clignotants.

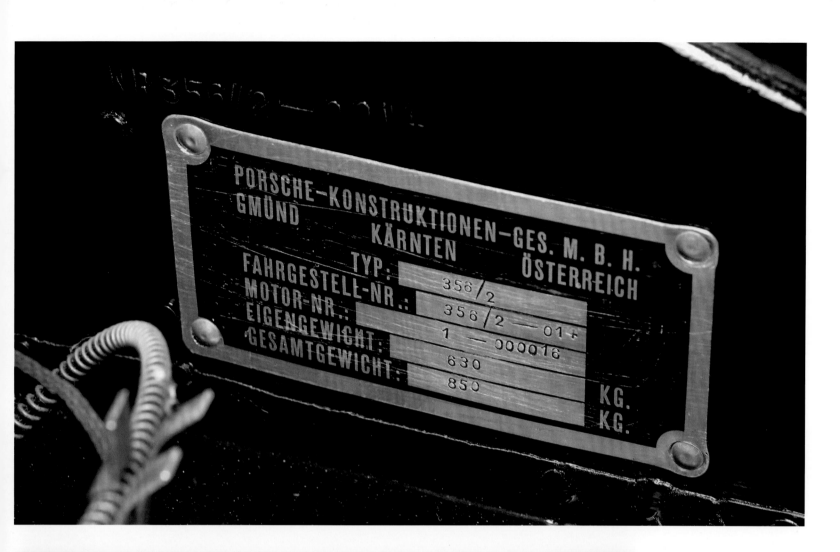

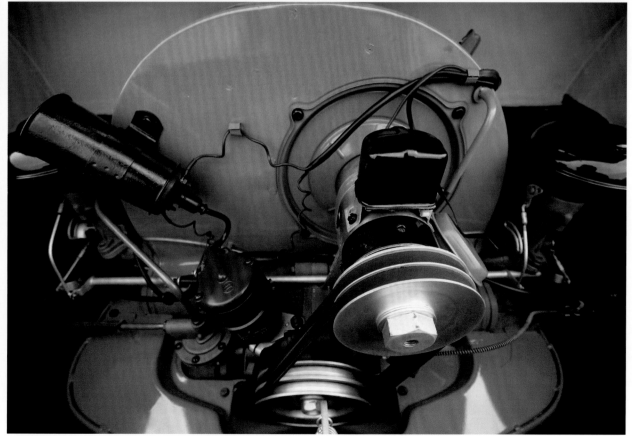

The resemblance to the VW flat-four is obvious, from the round blower housing via gasoline pump and dynamo to the ignition coil.

Die Ähnlichkeiten zum VW-Triebwerk liegen auf der Hand, vom runden Gebläsekasten über Benzinpumpe und Lichtmaschine bis hin zur Zündspule.

Les similitudes avec le moteur VW sont flagrantes, du carénage circulaire de la soufflante à la bobine d'allumage en passant par la pompe à essence et l'alternateur.

The two exhibits unveiled by Porsche-Konstruktionen-Ges.m.b.H. at the Geneva spring show of 17 June 1949, a Coupé and a Cabriolet with bodywork from the Swiss manufacturer Beutler, aroused spontaneous appetite for more. Encouraged by their reception, Porsche rented a 720-sqyd workshop from coachbuilders Reutter & Co. GmbH in Stuttgart-Zuffenhausen. In return, its owner received an order for 500 steel bodies. Over the winter, in-house designer Erwin Komenda smoothed out and honed the shape of the Austrian original, uncovering the basic form of the Porsche 356 in the process, as it were. On Maundy Thursday 1950, the last specks of dust were flicked off the first specimen produced at Zuffenhausen, a Coupé. A black bar divided the windshield into two halves and the bumpers snuggled up to the body-shell, only ending at the wheel cutouts.

Customers did not, however, have to wait long for the first retouches. As early as the 1952 model year, the 356 had been given a one-piece windshield, the bumpers raised and separated from the bodywork, the rectangular tail-lights replaced by round ones the size of the blinkers and the spare wheel placed in an upright position in front of the battery so as to create some additional space for luggage below the front lid.

Transferred from the drawing board almost exclusively by manual labor like the shell itself, the pressed-and-welded steel box-type chassis was in unit with the superstructure. The wheels were sprung independently, the suspension featuring parallel trailing arms with transverse laminated torsion bars at the front, and a rear swing axle with trailing arms and round torsion bars. The air-cooled flat engine behind the rear axle was basically a 1086 cc VW unit, boosted to 40 horsepower, well-fed by two Solex downdraft carburetors.

At once a busy evolution in terms of engine capacity and strength got under way. In spring 1951 the 1300 with 44 bhp became available, as did the 1500 with 60 bhp in October. From September 1952 onwards, a friction-bearing crankshaft rotated in its power plant instead of the former roller-bearing one. That step reduced its output by five bhp. The nickname *"Dame"* ("lady") came into use so as to distinguish the model from the 70 bhp 1500 S (Super) version introduced in October. In November the 356 family was further enlarged, in the form of the 1300 S whose driver was provided with 60 bhp, while at the end of 1954 the production of the 1100 was discontinued.

At the suggestion of the enterprising North American Porsche agent Maxie Hoffman two open lightweight variants had enriched the model range in the intervening time, both equipped with 1488 cc power units exclusively, as Hoffman had lived in the land of unlimited capacities long enough to look down upon any lower displacements. These were the 1334 lb American Roadster, built in a quantity of only 17 from spring 1952, and the slightly less spartan Speedster, which saw the light of day in September 1954.

Die beiden Exponate der Porsche-Konstruktionen-Ges.m.b.H. auf dem Genfer Frühlingssalon ab 17. Juni 1949, ein Coupé und ein von der Schweizer Manufaktur Beutler eingekleidetes Cabriolet, erweckten spontanen Hunger auf mehr. So bestärkt, mietete man in Stuttgart-Zuffenhausen eine 600 m² große Halle an. Deren Besitzer, die Karosseriewerke Reutter, erhielten den Auftrag, 500 Rohkarosserien aus Stahl herzustellen.

Zugleich glättete und rundete Hausdesigner Erwin Komenda die Silhouette des österreichischen Originals im folgenden Winter und legte dabei gewissermaßen die Ur-Form des Porsche 356 frei. Am Gründonnerstag 1950 schnippte man das letzte Stäubchen vom ersten Exemplar mit dem Geburtsort Zuffenhausen. Ein schwarzer Steg gliederte die Windschutzscheibe in zwei Hälften, und die Stoßstangen schmiegten sich bis hin zu den Radausschnitten an den Aufbau an. Die ersten Retuschen ließen gleichwohl nicht lange auf sich warten: Zum Modelljahr 1952 wurden die Frontscheibe einteilig, das Paar der Stoßfänger hoch gesetzt und vom Wagenkörper gesondert, die rechteckigen Rückleuchten durch runde von der Größe der Blinker ersetzt und das Reserverad ganz vorn aufrecht vor die Batterie gestellt, um auch im Bug Platz für ein wenig Gepäck freizuräumen.

Wie dieses fast ausschließlich in Handarbeit vom Reißbrett übertragen, wurde das Chassis mit dem Oberteil fest verbunden, ein gepresster und geschweißter Kastenrahmen. Die Räder waren einzeln aufgehängt, vorn mit zwei Kurbellängslenkern und gebündelten Quertorsionsstabfedern, hinten an einer Pendelachse, geführt durch Längslenker und runde Drehfederstäbe. Bei dem luftgekühlten Vierzylinder-Boxer jenseits der Hinterachse handelte es sich im Grunde genommen um ein VW-Aggregat von 1086 cm³, allerdings von zwei Solex-Fallstromvergasern zu 40 vollzählig vorhandenen PS ermächtigt.

Umgehend setzte eine Evolution des Hubraums und der Stärke ein. Im Frühjahr 1951 wurde der 1300 mit 44 PS verfügbar, im Oktober der 1500 mit 60 PS. In dessen Triebwerk rotierte ab September 1952 eine Kurbelwelle in Gleitlagern anstelle der bisherigen rollengelagerten. Diese Maßnahme schmälerte die Leistung um fünf PS. Die Bezeichnung „Dame" bürgerte sich ein, im Unterschied zum 70 PS starken 1500 S (Super), der im Oktober seine Aufwartung machte. Im November 1953 erweiterte man die Palette um den 1300 S, dessen Lenker über 60 PS gebot, während Ende 1954 der 1100 aus dem Angebot getilgt wurde.

Auf Anregung des rührigen nordamerikanischen Porsche-Importeurs Maxie Hoffman bereicherten unterdessen zwei luftige Exoten das Typen-Spektrum, beide mit den 1488-cm³-Maschinen, da Hoffman im Land der Hubraum-Giganten alles darunter verschmähte: der American Roadster, ein Leichtgewicht von 605 kg in nur 17 Exemplaren ab Frühjahr 1952, und der etwas wohnlicher eingerichtete Speedster, der im September 1954 ins Programm kam.

Les deux modèles exposés par Porsche-Konstruktionen-Ges.m.b.H. au Salon de Genève, le 17 juin 1949 – un Coupé ainsi qu'un Cabriolet, ce dernier habillé par le carrossier suisse Beutler – attirent spontanément l'attention. Confiant en l'avenir, Porsche loue donc, à Stuttgart-Zuffenhausen, un vaste atelier de 600 m². Son propriétaire, le carrossier Reutter, reçoit une commande pour la fabrication de 500 carrosseries blanches en acier.

Auparavant, Erwin Komenda, le styliste maison, lisse et arrondit la silhouette du modèle autrichien d'origine et cisèle ainsi la forme de la première Porsche 356. Le jeudi saint 1950, la dernière touche est mise au premier exemplaire produit à Zuffenhausen. Un petit barreau noir subdivise le pare-brise en deux et les pare-chocs épousent

les contours de la carrosserie jusqu'à frôler les arches de roue. Les premières retouches ne se font cependant pas attendre : pour le millésime 1952, le pare-brise est d'un seul tenant, les deux pare-chocs sont légèrement rehaussés et n'adhèrent plus à la carrosserie, les feux arrière rectangulaires sont remplacés par des optiques circulaires de la taille des clignotants et la roue de secours est placée tout à l'avant, à la verticale devant la batterie, afin de ménager un minimum d'espace pour les bagages, également sous le capot avant.

Transposé de la planche à dessins et élaboré presque exclusivement à la main, comme la carrosserie, le châssis est relié à demeure à la partie supérieure, un cadre à caissons embouti et soudé. Les roues sont à suspension indépendante avec deux bras longitudinaux à manivelle et des ressorts

à barre de torsion transversaux en faisceau à l'avant, et à l'arrière un essieu oscillant, guidé par des bras longitudinaux et des barres circulaires à ressort de torsion. Le quatre-cylindres à plat à refroidissement par air monté derrière le train arrière consiste, dans ses grandes lignes, en un moteur VW de 1086 cm³ auquel deux carburateurs inversés Solex confèrent 40 ch efficaces.

Mais la cylindrée et la puissance ne cessent d'évoluer, évidemment toujours vers le haut. Au printemps 1951, Porsche propose la 1300 de 44 ch puis, en octobre, la 1500 de 60 ch. À partir de septembre 1952, un vilebrequin à paliers lisses remplace l'ancien vilebrequin à paliers à rouleaux. Mais cette mesure sacrifie cinq chevaux sur l'autel de la puissance. Le modèle est affublé d'un quolibet, « La dame », pour le démarquer de la 1500 S (Super)

de 70 ch, qui fait son apparition au mois d'octobre. En novembre 1953, la palette s'enrichit de la 1300 S, avec laquelle le conducteur a 60 ch sous le pied alors que la 1100 disparaît du programme à la fin de l'année 1954.

À la suite d'une suggestion de Maxie Hoffman, l'infatigable importateur Porsche en Amérique du Nord, deux décapotables exotiques viennent entre-temps enrichir la gamme, toutes les deux sont dotées d'un moteur de 1488 cm³. Au pays des grosses cylindrées, Hoffman méprise tout ce qui fait mesquin : la première est l'American Roadster, un poids plume de 605 kg construit en 17 exemplaires seulement à partir de printemps 1952, et la seconde, le Speedster, à l'aménagement un peu plus confortable, qui s'est ajouté au programme en septembre 1954.

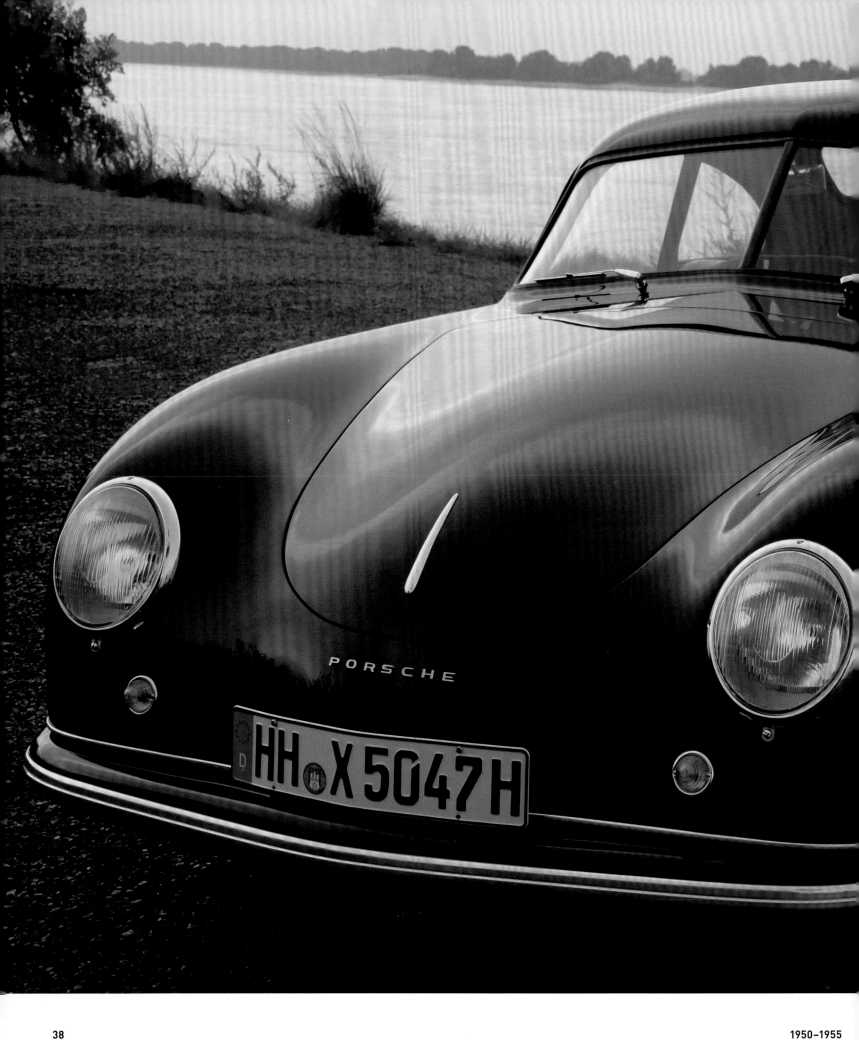

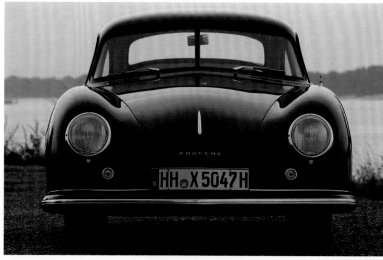

The first steel production 356s still have two-piece ("split") windshields, a black bar clearly separating the halves visually. Their bumpers are integrated flush to the bodywork.

Die Frontscheibe des frühen 356 ist geknickt und durch einen schwarzen Steg auch visuell deutlich geteilt. Seine Stoßstangen sind bündig in die Karosserie integriert.

Le pare-brise des premières 356 est à deux pans que sépare une barrette noire bien visible. Ses pare-chocs sont intégrés sans césure à la carrosserie.

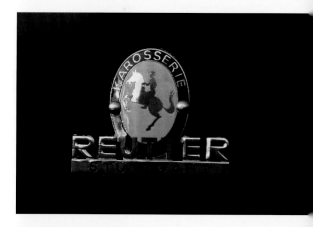

The dashboard unites the most essential information exactly in the driver's field of vision behind the spring-spoke steering wheel, with black and white Veigel units. The mechanical clock in the middle has been replaced by a radio. Time flies anyway when you are having fun in a Porsche.

Das Armaturenbrett hinter dem Federspeichenlenkrad hält die wichtigsten Informationen genau im Blickfeld des Piloten bereit. Noch hat er es weiß auf schwarz. Die Zeituhr in der Mitte hat der Besitzer durch ein Radio ersetzt. Dem glücklichen Porsche-Fahrer schlägt sowieso keine Stunde.

Le tableau de bord derrière le volant filigrane place les informations les plus importantes exactement dans le champ de vision du pilote. Il a tout noir sur blanc devant les yeux. Le propriétaire a remplacé la montre initialement au centre par un autoradio. Dans son bonheur, le pilote de Porsche ignore de toute façon souverainement le temps qui passe.

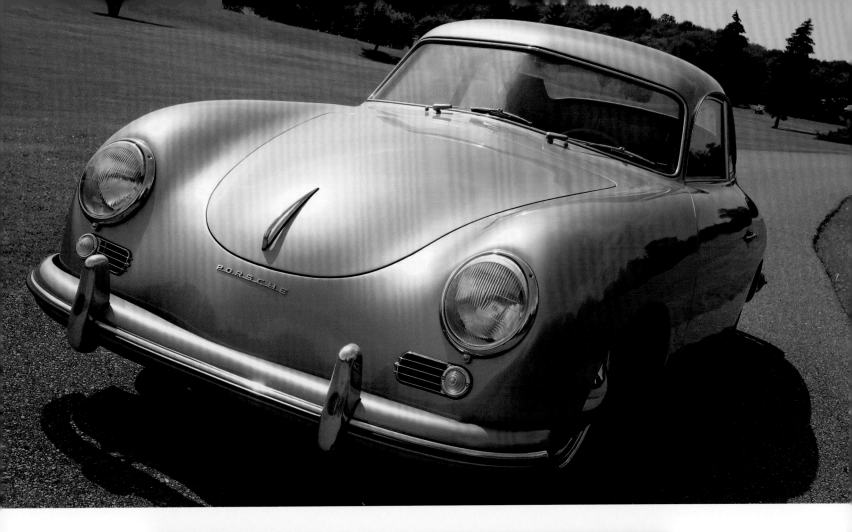

A 1954 vintage 1500
Coupé: in April 1952 the
bipartite windshield was
replaced by a one-piece
"bent" one, while the
bumpers were separated
from the bodyshell.

Ein Coupé 1500 Baujahr
1954: Im April 1952
wurden die zweiteilige
Windschutzscheibe
durch eine geknickte
einteilige ersetzt und
die Stoßfänger vom
Wagenkörper abgesetzt.

Un Coupé 1500 millésime
1954 : en avril 1952, le
pare-brise à deux pans
a été remplacé par un
pare-brise en accent
circonflexe d'un seul
tenant et les pare-
chocs se sont éloignés
de la carrosserie.

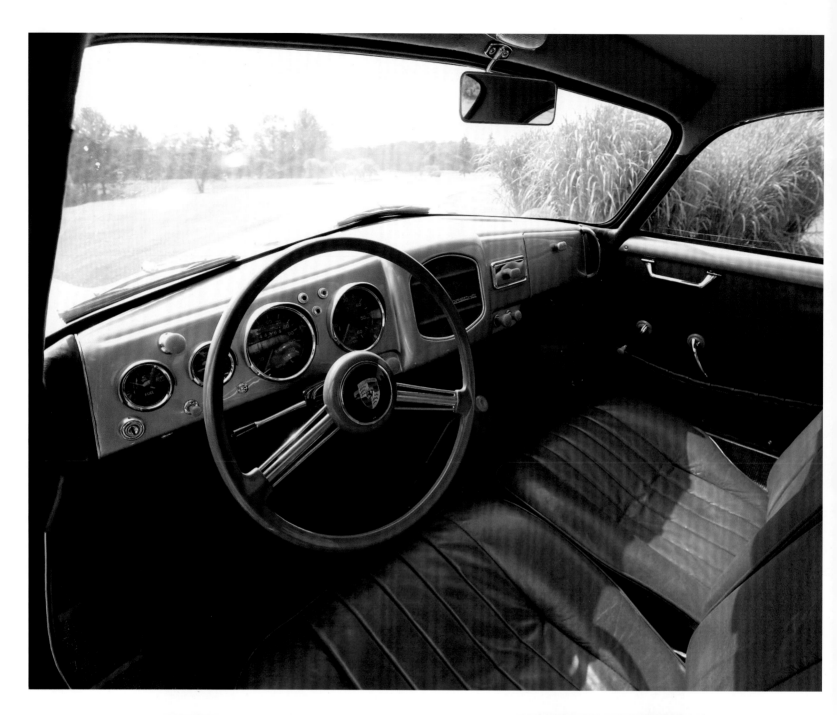

Two-spoke steering wheels were introduced as early as October 1952, while in April 1954 horn grilles inside the blinkers anticipated solutions found on the 356A.

Zweispeichenlenkräder gibt es bereits im Oktober 1952, während die Schallgitter innen neben den Blinkern im April 1954 Detaillösungen am 356A vorwegnehmen.

Les volants à deux branches ont fait leur apparition dès octobre 1952 tandis que les grilles de klaxon accolées aux clignotants annoncent, en avril 1954, certains détails de la 356A.

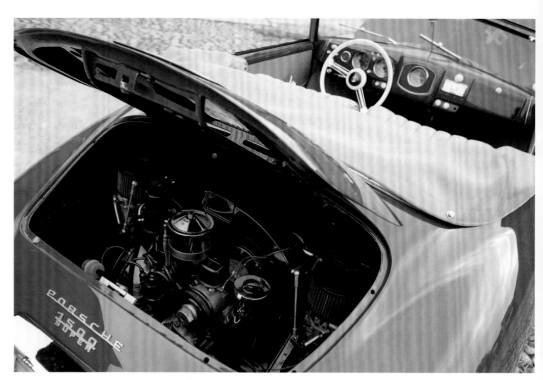

Like all 356s before 1956 this Cabriolet has 16-inch wheels, with white sidewall tires as an option. The engine of the 1500 Super delivers a beefy 70 bhp.

Wie alle 356 vor 1956 hat dieses Cabrio 16-Zoll-Felgen, gegen Aufpreis mit Weißwandreifen. Der Motor des 1500 Super ist 70 PS stark.

Comme toutes les 356 d'avant 1956, ce Cabriolet possède des jantes de 16 pouces, que l'on pouvait habiller, en option, de pneus à flanc. Le moteur de la 1500 Super délivre 70 ch.

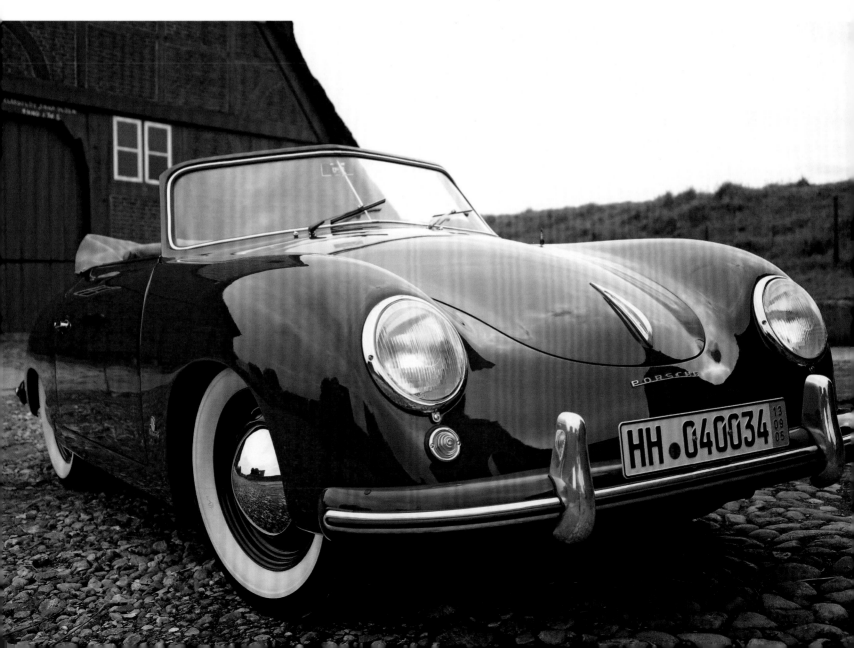

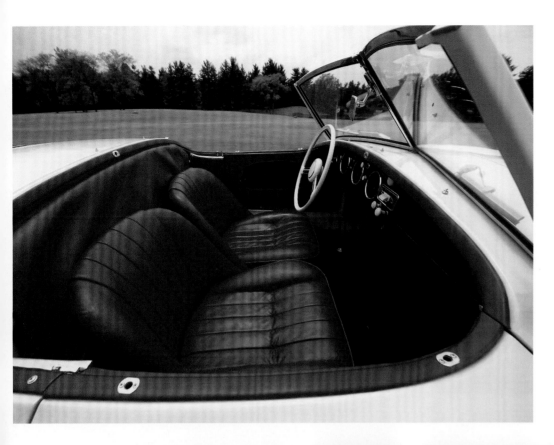

Rare beauty: for the American Roadster various windshields are available, and the canvas roof can be completely removed. Leather straps serve to secure the front lid additionally.

Seltene Schönheit: Für den American Roadster gibt es verschiedene Windschutzscheiben, und das Verdeck aus Segeltuch kann gänzlich entfernt werden. Lederriemchen fixieren die Fronthaube zusätzlich.

Une beauté qui brille par sa rareté : l'American Roadster est proposé avec différentes formes de pare-brise et la capote en toile est totalement amovible. De petites courroies de cuir fixent le capot avant à titre supplémentaire.

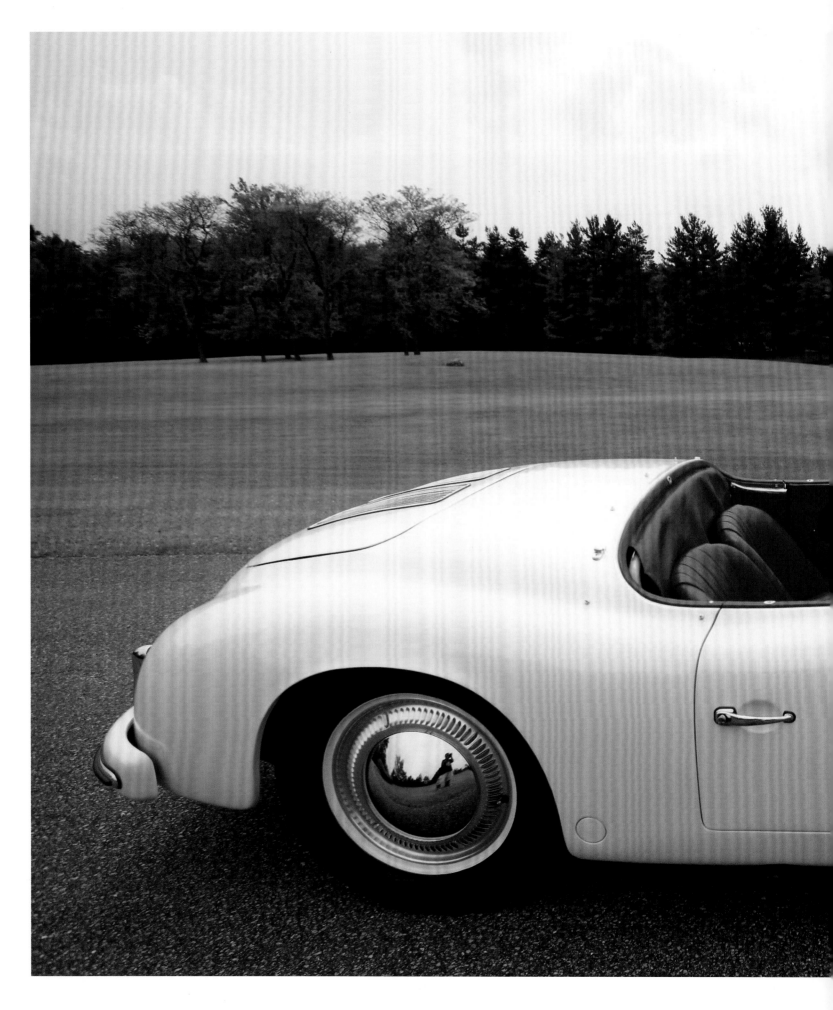

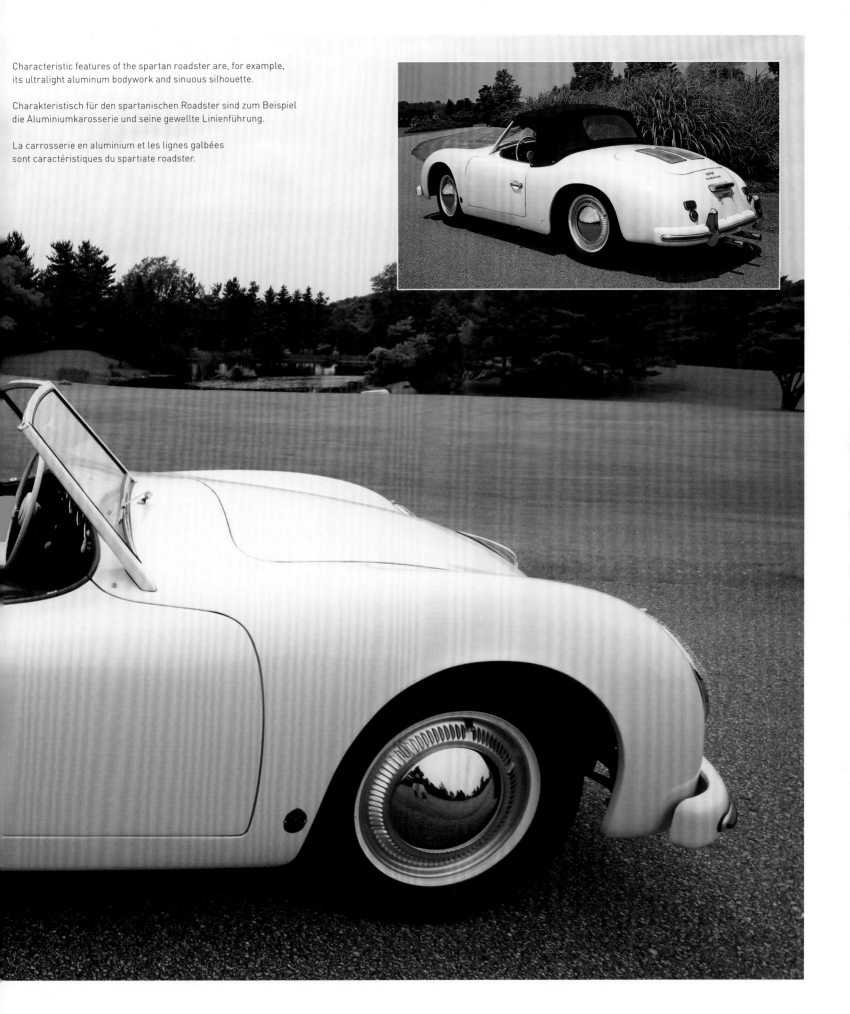

Characteristic features of the spartan roadster are, for example,
its ultralight aluminum bodywork and sinuous silhouette.

Charakteristisch für den spartanischen Roadster sind zum Beispiel
die Aluminiumkarosserie und seine gewellte Linienführung.

La carrosserie en aluminium et les lignes galbées
sont caractéristiques du spartiate roadster.

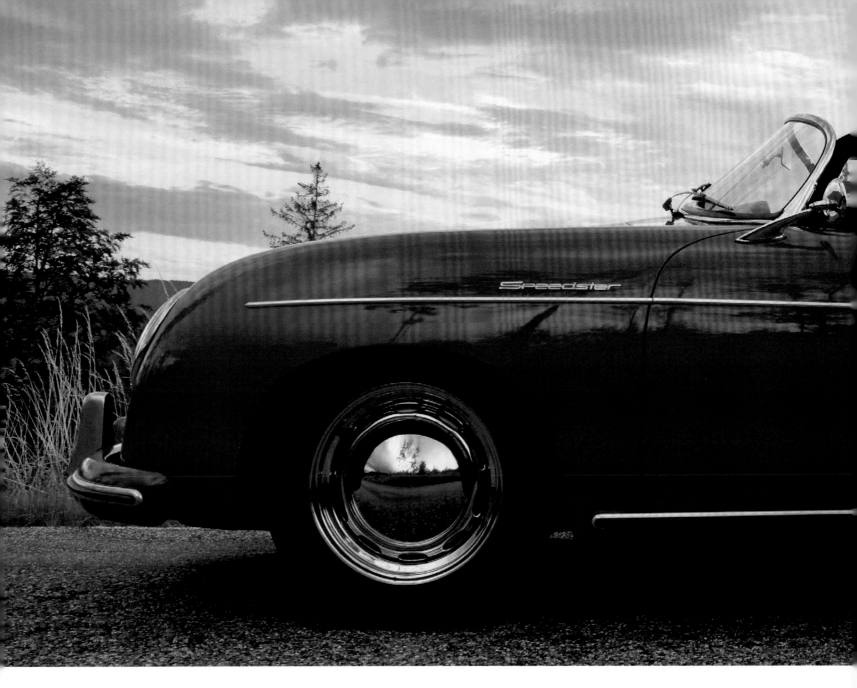

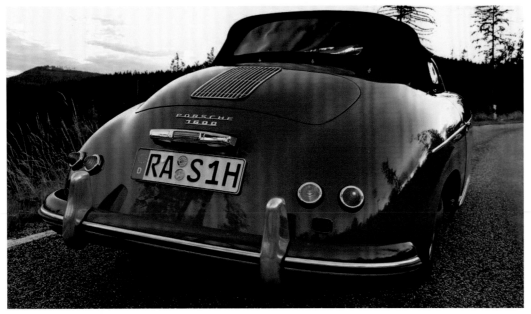

Almost the abstraction of a car, though an
expensive rarity today: the Speedster with its
unlined canvas roof and plug-in windows that
are scratch-prone and grow dull quickly.

Fast schon die Abstraktion eines Autos und dennoch
heute teuer gehandelt: der Speedster, mit seinem
ungefütterten Stoffverdeck und Steckscheiben aus
Kunststoff, der leicht zerkratzt ist und erblindet.

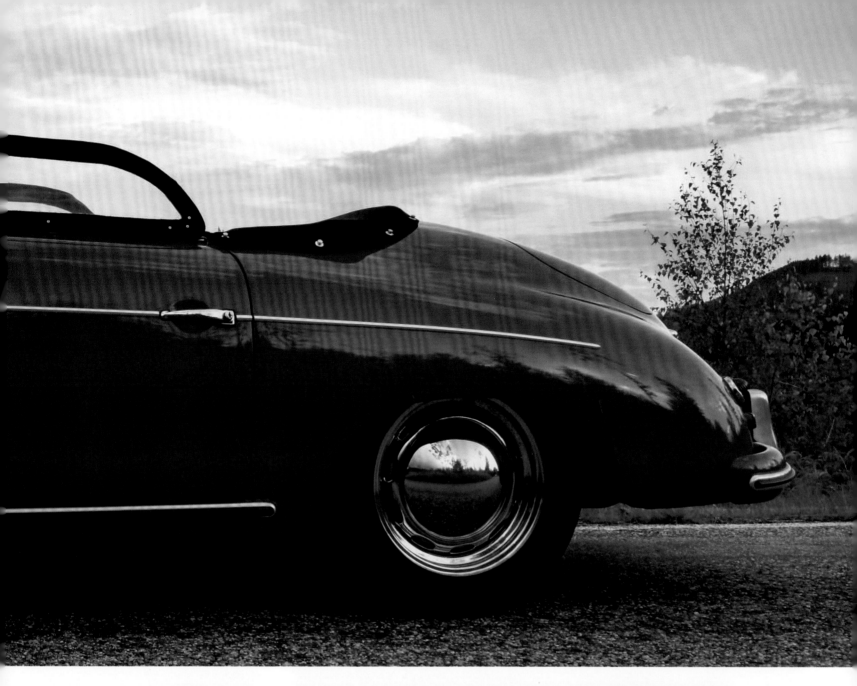

C'est déjà presque l'abstraction d'une voiture et, pourtant, les collectionneurs se l'arrachent aujourd'hui : le Speedster, avec sa capote non capitonnée et les vitres démontables en matière plastique qui se raie facilement et devient mate.

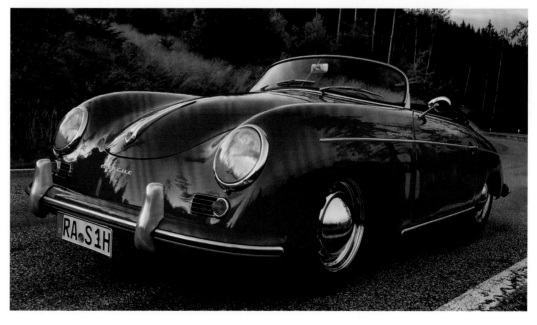

Of Dreaming and Doing
Vom Träumen und Tun
Après le rêve, l'action

Outwardly, Herr Porsche is calm and composed. But look at his eyes! Two abysses full of technical dreams, all striving for realization. Dreaming and doing—that is the essence in the lives of people of his ilk," a shrewd observer once said about him. The year was 1903, Ferdinand Porsche was 28 and already a famous man. As an employee of "K.u.k. Hofkutschenfabrik Jakob Lohner", coach purveyor to the Austrian court in the Viennese suburb of Floridsdorf, he had just contributed his "gasoline-electric mixed car" to the gently flourishing cosmos of automobiles. It was a hybrid derivative of his "Porsche-Lohner-Chaise" which had caused quite a stir at the Paris World Fair in 1900. The amazing feature about it: it was propelled by two electric motors in the front wheel hubs. So it could make do without the complicated mechanism and the inevitable friction losses inherent in any transmission. But charging the battery took days and it was quickly exhausted. As a consequence, Porsche installed a Daimler gasoline unit into the "Chaise", coupling it with

Ferdinand Porsche in 1910 during his period as Technical Director of Austro-Daimler in Wiener Neustadt.

Ferdinand Porsche anno 1910 als Technischer Leiter der Austro-Daimler-Werke in Wiener Neustadt.

Ferdinand Porsche, en 1910, alors directeur technique des usines Austro-Daimler, à Wiener Neustadt.

Herr Porsche ist ruhig und gelassen nach außen. Aber die Augen! Zwei Abgründe voll technischer Träume, die alle nach Realisierung streben. Träumen und Handeln – das ist die Quintessenz des Lebens von Leuten wie er", schrieb einmal ein kluger Beobachter über ihn. Das war 1903, Ferdinand Porsche war 28 Jahre alt und doch schon ein berühmter Mann. Just hatte er als Angestellter der „K.u.k. Hofkutschenfabrik Jakob Lohner & Co." in Wien-Floridsdorf den munter keimenden Kosmos des selbstbeweglichen Fahrzeugs um den „benzin-elektrischen Mischwagen" bereichert. Das war eine hybride Weiterentwicklung seiner „Porsche-Lohner-Chaise", die auf der Pariser Weltausstellung 1900 für beträchtliches Aufsehen gesorgt hatte. Das Tolle daran: Zwei Elektromotoren verrichteten ihre stille Arbeit in den vorderen Radnaben. Dadurch entfielen komplizierte Mechanik und Reibungsverluste der Übertragung. Aber die Batterien aufzuladen dauerte Tage, und sie erschlafften rasch. Folglich pflanzte Porsche ein Daimler-Benzinaggregat in die Chaise und koppelte an dieses einen Dynamo, der die Nabentriebwerke mit Strom belieferte.

Gebürtig war er als Sohn eines Spenglermeisters in dem sudetendeutschen Neiße-Nest Maffersdorf. Es hieß, es gebe dort ebenso viele Fabrikschornsteine wie Häuser. Sein Genie kam gewissermaßen aus dem Nichts, denn über vier Generationen von Porsches einschließlich seiner Geschwister ließ sich von dergleichen keine Spur ausmachen, ganz anders als etwa bei den Tonsetzerfamilien Bach oder Mozart. Ohnehin äußerte sich Ferdinand Porsches Musikalität eher im Komponieren von Metallenem – die Töne stellten sich da von ganz alleine ein.

Ursprünglich hatte er es mehr mit dem Elektrischen. Als seine Eltern eines Abends spät nach Hause kamen, erstrahlte ihr Haus im Licht einer Anlage, die der 17-jährige Ferdinand entworfen und gefertigt hatte – der zweiten in Maffersdorf nach ihrem Pendant bei der mechanischen Teppichweberei Ginzkey und gänzlich ohne von dieser inspiriert worden zu sein. Nicht zuletzt deshalb waren es die Ginzkeys viel mehr als sein Vater, die erkannten, was in ihm schlummerte, ihn förderten und seine Karriere auf die richtige Schiene setzten. Ab 1906 war er als Technischer Direktor für Austro-Daimler tätig, schuf Autos wie den „Maja" (benannt nach der Schwester von Mercedes Jellinek, die dem deutschen Daimler-Mutterhaus ihren Namen spendiert hatte), den 140 km/h schnellen

Monsieur Porsche est calme et impassible, extérieurement. Mais les yeux ! Deux abîmes emplis de rêves techniques qui, tous, aspirent à être réalisés. Rêver et agir – telle est la quintessence de la vie de gens comme lui », écrivait un jour à son sujet un observateur intelligent. C'était en 1903, Ferdinand Porsche était âgé de 28 ans et, pourtant, déjà un homme célèbre. En tant qu'employé de la société K.u.k. Hofkutschenfabrik Jakob Lohner & Co., à Vienne-Floridsdorf, il venait d'enrichir le petit cosmos en pleine ébullition de la locomotion automobile d'une « voiture mixte à essence et électrique ». Il s'agissait d'une extrapolation, hybride avant la lettre, de sa « Chaise Porsche-Lohner » qui avait fait sensation à l'Exposition universelle de Paris, en 1900. Son trait de génie : deux moteurs électriques opéraient dans le plus grand silence dans le moyeu des roues avant. Point, donc, de mécanique compliquée ni de pertes dues à la friction lors de la transmission. Mais recharger les batteries demandait plusieurs jours et elles s'épuisaient rapidement. Par conséquent, Porsche eut l'idée de greffer un moteur à essence Daimler sur son engin et de l'accoupler à une dynamo qui approvisionnait en courant électrique les moteurs de moyeux de roue.

Né dans le petit village de Maffersdorf, sur la Neisse, aux fins fonds des Sudètes allemands, il était le fils d'un tôlier. Selon la légende, il y aurait eu là-bas autant de cheminées d'usines que de maisons. Son génie est né en quelque sorte du néant, car, pendant quatre générations de Porsche, dans toute sa fratrie, aucune trace de ce don n'a jamais été décelée, contrairement à ce qui était le cas, par exemple, dans certaines familles de musiciens comme chez les Bach ou les Mozart. De toute façon, la musicalité de Ferdinand Porsche s'exprimait plutôt par le biais de ses compositions en métal – les sons s'exprimant alors d'eux-mêmes.

À l'origine, c'est plutôt l'électricité qui l'intéressait. De retour très tard un soir, ses parents eurent la surprise de trouver la maison éclairée par une installation que le jeune Ferdinand, âgé de 17 ans, avait conçue et fabriquée – il s'agissait de la deuxième de Maffersdorf, après celle qui équipait l'usine de tissage mécanique de tapis de Ginzkey et qui ne lui avait en aucun cas servi d'inspiration. Ce sont d'ailleurs les Ginzkey, bien avant son père, qui ont reconnu les dons du jeune homme, l'ont encouragé et ont donné à sa carrière la bonne orientation.

a dynamo that supplied the wheel-hub engines with current.

The son of a prosperous metalworker, he was born in the Sudeten German Neisse village of Maffersdorf, which was said to have more smoke stacks than houses. His brilliance virtually came from nowhere, as not a trace of it could be found in four generations of Porsches, including his siblings, quite unlike the way talents were passed on, for instance, in the Bach and Mozart composer families. Anyway, Porsche's musicality voiced itself in his singular ability to compose metallic ingredients—more or less beautiful sounds would follow automatically.

Initially he had been more interested in things electrical. Coming home late one night, his parents were mystified and then elated to find their house festively illuminated, lit by a system 17-year-old Ferdinand had conceived and built— the second lighting system in Maffersdorf after an equivalent used by the local Ginzkey mechanical rug weaving mill and, surprisingly, not at all inspired by it. It was the Ginkeys, rather than his father, who recognized the talents slumbering in the adolescent, furthered them and saw to it that he embarked upon the right career. From 1906, he worked for Austro-Daimler as Technical Director, creating cars like the "Maja" (named after the sister of Mercedes Jellinek, whose first name had been adopted by the German Daimler parent company), as well as the 87 mph "Prinz-Heinrich-Wagen" of 1910 with its aerodynamic "tulip shape". He also drove them in competitions, and did so boldly but ably as reported by contemporaries. Eventually he became General Manager.

Although Ferdinand Porsche then, at the latest, had become a respected citizen in the borderless realm of ideas and visions, he stubbornly stuck to his origins in spite of their middle-class confines and harbored a pronounced sense of family. That is why he presented his future wife Aloisia Johanna Kaes to his beloved ones in Maffersdorf at one of his first excursions with the "gasoline-electric mixed car", and married her there, too. In the year of crisis 1932, he received a call from Russia, combined with the option to further speed up the already dynamic progress prevailing in Stalin's gloomy empire in terms of industry, technology, research and armament, as a sort of chief constructor. He did not fail to have a close look at everything, learned many a secret but made up his mind to stay in Germany. Otherwise, he used to say, he would have had the uneasy feeling of working on the moon, with space separating him from the Blue Planet. At that time, he had already taken up residence in Stuttgart. There, his engineering office had begun work in December 1930 in 24 Kronenstrasse. It certainly appealed to him that the Swabian metropolis is embedded in a beautiful low mountain range not unlike his native region.

Ferdinand Porsche was a typical example of a rough exterior often hiding a heart of gold. He could be rude, grouchy and churlish. But even if it was difficult to cope with for the people concerned, they were mistaken if they took his

A picture that speaks volumes: Porsche in about 1937 in typical pose and typical surroundings.

Durchblick: Das Bild spricht Bände. Porsche 1937 in typischer Pose und in typischer Umgebung.

Un regard d'aigle : Porsche, en 1937, dans une pose aussi typique que son environnement.

Prinz-Heinrich-Wagen von 1910 in strömungs-günstiger „Tulpenform" und den behänden kleinen Sportwagen „Sascha", fuhr sie auch selbst in Rennen, kühn aber beständig, wie es hieß, und avancierte schließlich zum Generaldirektor.

Obwohl Ferdinand Porsche längst als ange-sehener Bürger im grenzenlosen Reich der Ideen und Visionen sesshaft geworden war, zeichneten ihn eine zähe Treue zu seinen Ursprüngen trotz ihrer bürgerlichen Enge und ein ausgeprägter Familiensinn aus. So präsentierte er seine künf-tige Gattin Aloisia Johanna Kaes den Lieben daheim in Maffersdorf auf einer ersten Ausfahrt mit dem „benzin-elektrischen Mischwagen" und heiratete sie auch dort. Im Jahr der Krise 1932 ereilte ihn ein Ruf aus Russland, verbunden mit der Option, gleichsam als eine Art Reichs-konstrukteur den ohnehin dynamischen Aufstieg von Industrie, Technik, Forschung und Rüstung im düsteren Imperium Stalins weiter voranzu-treiben. Er sah sich alles genau an, erfuhr auch so manches Geheimnis, beschloss indessen, in Deutschland zu bleiben. Er hätte sonst, pflegte er zu sagen, das Gefühl gehabt, auf dem Mond zu arbeiten, mit dem Weltraum dazwischen. Wohnsitz war bereits Stuttgart. Dort hatte sein Ingenieursbüro im Dezember 1930 in der Kronenstraße 24 seine Tätigkeit aufgenommen. Ihn heimelte wohl auch an, dass die schwäbi-sche Metropole in eine Mittelgebirgslandschaft nicht unähnlich seiner heimischen Region eingebettet ist.

Ferdinand Porsche passte das viel bemühte Klischee „harte Schale, weicher Kern" wie maßgeschneidert. Er konnte grob, grantig und griesgrämig sein. Wenn es auch schwer fiel: Die einschlägig Betroffenen durften das auf keinen

À partir de 1906, il occupe le poste de directeur technique chez Austro-Daimler, crée des voitures comme la « Maja » (du nom de la sœur de Mercedes Jellinek, qui avait elle-même donné son nom à la maison mère allemande, Daimler), la Prinz-Heinrich, une voiture à la carrosserie aérodynamique « en forme de tulipe » qui atteignait 140 km/h en 1910, et la rapide petite voiture de sport « Sascha », qu'il pilota lui-même en course, avec bravoure et constance, comme on l'écrivit à ce sujet, avant d'être finalement promu directeur général de la firme.

Bien que Ferdinand Porsche ait toujours été considéré comme un citoyen respecté dans l'empire sans limite des vitesses et des visions, il se distinguait par une fidélité à ses origines malgré leur étroitesse bourgeoise et par un esprit de famille caractéristique. Ainsi présenta-t-il sa future épouse Aloisia Johanna Kaes à ses parents restés à Maffersdorf lors d'une première excursion au volant de la « voiture mixte à essence et électrique » et l'épousa-t-il aussi dans ce village.

En 1932, année de crise, il reçoit de Russie une convocation combinée à l'option, en quelque sorte comme constructeur de l'empire, de faire avancer les progrès de l'industrie, de la technique, de la recherche et de l'armement – déjà en plein essor dans le sombre empire de Staline. Après avoir étudié avec attention cette proposition et appris certains secrets au passage, il décide finalement de rester en Allemagne. Il aurait sinon eu, se plaisait-il à dire, le sentiment de travailler sur la lune tout en en étant séparé par l'espace. Son domicile se trouvait déjà à Stuttgart. Dans cette ville, son bureau d'études avait ouvert ses portes en décembre 1930 au 24 de la Kronenstraße. Sans doute s'y plaisait-il tant en raison du fait que la métropole souabe était nichée dans un écrin de

Ferdinand Porsche in 1942 after a test run with the Type 175 "Ostrad" tractor.

Der Lotse geht von Bord: Porsche 1942 nach einem Test mit seinem Opus 175, dem „Ostrad"-Schlepper.

Porsche descend du tracteur « Ostrad » (Type 175), après un essai en 1942.

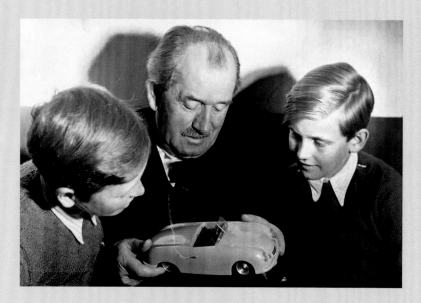

The Professor in 1949, with grandsons Ferdinand Piëch (right) and Ferdinand Alexander ("Butzi") Porsche.

Der Professor 1949 mit seinen Enkeln Ferdinand Piëch (rechts) und Ferdinand Alexander („Butzi") Porsche.

Le professeur, en 1949, avec ses petits-fils Ferdinand Piëch (à droite) et Ferdinand Alexander («Butzi») Porsche.

moods personally. Usually it was the cause that mattered and preoccupied him, maybe a lack or delay of progress that got on his nerves, or a sort of creative impatience that haunted him. Unlike the three scientists Ernesti, Beutler and Möbius, locked away in a madhouse in Friedrich Dürrenmatt's caustic comedy *The Physicists* and forever pondering about the consequences of the lethal weapons they had developed, he would not worry about the threateningly political implications of the tools of war he placed at the disposal of those at the levers of power, all those tanks and super tanks, for example, the gun carriages, jeeps or aircraft power plants. Even Porsche drawings of jet engines have been left, scribbled down long before their concrete equivalents came into being. What really interested him was the technical achievement in question, and inevitably the benchmark he was geared to was perfection and the superlative.

Throughout his life he managed to maintain his no-nonsense straightforwardness, in all the fields of tension and the minefields his existence led him through. In 1923, meanwhile endowed with an honorary doctorate by the Viennese Technical University, he signed up with Daimler (from 1926 Daimler-Benz) in Stuttgart as Technical Director, seeing himself confronted with the odd prejudice as somebody who had bolted from the Austrian bush, as it were. But being the man he was, he soon gained the respect even of his detractors by his input in the 1924 Targa-Florio-winning supercharged two-liter four-cylinder, the majestic 15/70/100 PS and 24/100/140 PS, which were built from 1924 onwards, as well as the legendary S to SSKL model range from 1927. While these mighty cars were heading for automobile immortality however, the Professor's relationship with his environment became ever more strained again. In 1929, Ferdinand Porsche turned his back on the Stuttgart company with the star emblem, politely, but otherwise on the worst of terms. He was a leading light in the Steyr car-building effort for a short time and then rolled up his sleeves setting up his Zuffenhausen business.

Fall persönlich nehmen, denn in aller Regel ging es allein um den Fortschritt der Sache, um schöpferische Ungeduld. Aber darunter verbarg sich ein Mensch, der naiv war, fast kindlich. Im Gegensatz zu den im Tollhaus eingesperrten Wissenschaftlern Ernesti, Beutler und Möbius in Friedrich Dürrenmatts böser Komödie *Die Physiker* machte sich Porsche kaum Gedanken über die politisch-bedrohlichen Implikationen des Kriegswerkzeugs, das er den Männern an den Hebeln der Macht zur Verfügung stellte, Panzer zum Beispiel, Artillerie-Lafetten, Kübelwagen oder Flugmotoren – sogar Zeichnungen von einem Staustrahltriebwerk sind überliefert. Ihm lag vor allem die technische Errungenschaft am Herzen, und dabei orientierte er sich stets an Superlativ und Perfektion als Maß der Dinge.

Seine schnörkellose und unbekümmerte Geradlinigkeit bewahrte er sich Zeit seines Lebens in den Spannungs- und Minenfeldern, in die ihn sein Dasein stellte. 1923, inzwischen mit der Würde eines Ehrendoktors der Technischen Hochschule Wien in der Stammrolle, heuerte er als Technischer Direktor bei Daimler (ab 1926 Daimler-Benz) in Stuttgart an und sah sich gleichsam als Zugereister aus dem österreichischen Busch dem einen oder anderen Vorurteil ausgesetzt. Aber er verschaffte sich bald Respekt, wie das seine Art war, durch seine konstruktiven Beiträge zum Targa-Florio-Sieger von 1924, einem Zweiliter-Vierzylinder mit Kompressor, den majestätischen Modellen 15/70/100 PS und 24/100/140 PS seit 1924, der legendären Baureihe S bis SSKL ab 1927. Aber während diese in die automobile Unsterblichkeit einzog, glitzerten schon wieder Eiskristalle auf dem Zwischenmenschlichen, und 1929 kehrte der Doktor honoris causa Ferdinand Porsche dem Stuttgarter Stern-Konzern in durchaus gespanntem Einvernehmen den Rücken, wirkte kurz bei Steyr und nahm ein Jahr später sein Schicksal in die eigenen Hände.

Bei aller kreativer Universalität gehörte die besondere Liebe des grantelnden Genius dem Rennsport. In Russland hätte er völlig ohne dieses

montagnes de moyenne altitude assez similaire à sa région d'origine.

Le stéréotype usé jusqu'à la corde du «cœur d'or sous une apparence de dureté» allait comme un gant à Ferdinand Porsche. Il pouvait être grossier, grincheux et grognon. Même si cela leur était parfois difficile, ses victimes ne devaient en aucun cas considérer cela comme une attaque personnelle, car, en règle générale, son seul but était de faire avancer les choses, ce qui est la preuve d'une impatience créative. Mais, derrière cette façade, se dissimulait un homme naïf, presque enfantin. Contrairement aux scientifiques Ernesti, Beutler et Möbius enfermés dans la maison de fous de la méchante comédie *Les Physiciens* de Friedrich Dürrenmatt, Porsche ne se perdait guère en réflexions sur les implications politico-menaçantes d'un engin de guerre qu'il mettait à la disposition des hommes détenant les leviers du pouvoir, des blindés, par exemple, des affûts d'artillerie, voitures de commandement ou moteurs d'avion – on connaît même de lui des plans pour un moteur d'avion à réaction. Il avait surtout à cœur les acquis de la technique, avec une seule idée en tête : le superlatif et la perfection comme l'aune de toute chose.

Tout au long de sa vie, sa droiture sans fioritures ni préjugés a dépassé les conflits d'intérêts et les champs de mines auxquels l'a confronté son destin. Docteur *honoris causa* de l'École supérieure technique de Vienne, il est recruté en 1923 comme directeur technique chez Daimler (rebaptisé Daimler-Benz en 1926) à Stuttgart. Immigré des fins fonds de la province autrichienne, il fait l'objet de préjugés. Mais il ne tarde pas à se faire respecter, ce qui était tout à fait dans sa nature, par son apport constructif à la victoire à la Targa Florio de 1924 avec une quatre-cylindres de deux litres à compresseur ou avec les majestueux modèles 15/70/100 PS et 24/100/140 PS, à partir de 1924, ou encore la légendaire gamme des S à SSKL à partir de 1927. Malheureusement, alors même que ses créations entraient dans le panthéon automobile, les premiers cristaux de glace venaient déjà faire craquer les relations humaines : en 1929, le docteur *honoris causa* Ferdinand Porsche tourna le dos au groupe à l'étoile de Stuttgart à l'issue d'une séparation difficile. Il œuvra brièvement chez Steyr puis, un an plus tard, pris en mains son destin.

Nonobstant sa créativité universelle, l'amour tout particulier du génie aux abords rugueux était voué à la compétition automobile. En Russie, il aurait dû végéter en étant totalement privé de cet élixir. C'est d'ailleurs l'une des raisons pour lesquelles il résista vaillamment à cette proposition et au pont d'or qu'on lui déroulait. Il avait en revanche les mains libres chez lui, et ce d'autant plus que les puissants du IIIe Reich firent immédiatement de la compétition une affaire d'État et un faire-valoir idéologique. Ainsi Porsche développa-t-il en 1932 une seize-cylindres qui servit de dot dans le bref mariage scellé contractuellement le 16 mars 1933 avec Auto Union et pour la construction complète de

For all his creative universality, the choleric Bohemian habored a particular fondness for motor racing. In Russia he would have had to do without that elixir vitae, one of the reasons why he resisted the temptation to move there with bag and baggage. But matters went his way at home, the more so as the Third Reich dignitaries immediately recognized the significance of sport for the system. Porsche developed a 16-cylinder power unit in 1932, which he took as a dowry into a brief marriage with Auto Union sealed on 17 March 1933 and which shortly afterwards became part and parcel of the marque's complete mid-engined Type 22 single-seater, designed by him for the oncoming 750-kilogram formula. A successful racing engine had to have as many combustion chambers as possible, he declared, for better cylinder fill and smaller dimensions of the parts in motion. As regards the expenditure, he went on to say, standards were different from mass production aggregates which would ineluctably be questioned by the cost accountants above a certain amount.

Those were explanations asked for, for instance, by Adolf Hitler himself, who Porsche ("my most capable constructor") could call on any time without having to go through the official channels. Inevitably the big question posed itself what his relationship to the top National Socialist was like, in whose presence bowing and scraping and, preferably, a peaked cap as the time-honored symbol of assiduousness were the normal run of things. In that respect again, Porsche was refresheningly frank and forthright, addressing the then Chancellor of the Reich with his Austrian "Grüß Gott, Herr Hitler" instead of the Nazi salute, wearing informal clothing and an English hat.

But after the war he had bitterly to atone for his familiarity with the Reich's greats and his position in the hierarchy they had established. For three months of imprisonment in an American interrogation camp in a castle near Frankfurt, ironically called "Dustbin", he was still allowed to take his own car and his faithful chauffeur Goldinger. Because of charges pressed by Peugeot supremo Jean-Pierre Peugeot, the French, however, blamed the 70-year-old Professor for reprisals on French workers and the French civilian population, even for deportment. Two years of devastating prison conditions, the latter half of which in the provincial prison at Dijon, undermined his health. They were interrupted by an interlude in early summer 1946 when Porsche was employed by Renault to fine-hone their rear-engined "people's" car 4 CV. Only in 1948—his son Ferry and friends had bailed him out paying a hefty amount of francs— was he acquitted of any guilt whatever.

Porsche still experienced the rise and first sporting successes of his beloved opus 356, which, after all, bore his good name. He passed away on 30 January 1951 and was buried in a chapel on the family-owned Schüttgut estate near Zell am See in Austria. There was no doubt at all that Professor Dr. Ing. h.c. Ferdinand Porsche had rendered outstanding services to the car and to the automobile world as a whole.

Elixir auskommen müssen. Das war einer der Gründe, warum er der gut dotierten Verlockung standhielt. Freie Hand hatte er indessen daheim, zumal die Mächtigen des Dritten Reichs den Sport umgehend zu Chefsache und ideologischem Aushängeschild erklärten. So entwickelte Porsche 1932 einen Sechzehnzylinder, der in eine am 16. März 1933 vertraglich besiegelte Kurzehe mit der Auto Union eingebracht wurde und in den Bau des kompletten Mittelmotor-Rennwagens Typ 22 für die künftige 750-Kilogramm-Formel einfloss. So viele Verbrennungseinheiten müssten es schon sein, erklärte er, je mehr desto besser, desto günstiger die Füllung, desto kleiner die Dimensionen der bewegten Teile. Die Kosten? Nun gut, da gälten halt andere Spielregeln als bei der Serienfertigung mit ihren überschaubaren Budgets.

Das waren Erläuterungen, die zum Beispiel Adolf Hitler einforderte, den er jederzeit („mein fähigster Konstrukteur") ohne Einhaltung des Dienstweges sprechen konnte. Womit sich die Gretchenfrage nach seiner Chemie zu dem Top-Nationalsozialisten stellte, in dessen Gegenwart sich Kotau und Katzbuckelei, schneidiger „Deutscher Gruß" und eine Schirmmütze als bewährtes Emblem der Botmäßigkeit empfahlen. Auch hier trat Porsche mit erfrischender Unverblümtheit auf, redete den damaligen Reichskanzler mit einem herzhaft-vertraulichen „Grüß Gott, Herr Hitler" an, bevorzugt in durchaus informeller Kleidung und mit einem englischen Hut auf dem Kopf.

Für seine Nähe zu den Reichs-Größen und seinen Stellenwert im System musste er nach dem Krieg gänzlich unverschuldet bitter büßen. Für drei Monate Gefangenschaft in einem amerikanischen Verhörlager bei Frankfurt, offiziell ironisch „Dustbin" genannt, durfte er sogar noch seinen Dienstwagen nebst Chauffeur Goldinger mitnehmen. Die Franzosen jedoch, auf Grund einer Anzeige, die Peugeot-Chef Jean-Pierre Peugeot lancierte, lasteten dem 70-jährigen Professor Repressalien gegenüber französischen Arbeitern und der französischen Zivilbevölkerung, ja Verschleppung an. Zwei Jahre unter unwürdigen Haftbedingungen, am Ende im Provinzgefängnis von Dijon, unterminierten seine Gesundheit. Unterbrochen wurden sie durch ein Intermezzo im Frühsommer 1946 im Dienst von Renault, wo Porsche dem Heckmotor-Kleinwagen 4 CV („Cremeschnittchen") den letzten Schliff verpasste. Erst 1948 – inzwischen hatten Sohn Ferry und Freunde eine saftige Kaution entrichtet – gab es einen Freispruch erster Klasse.

Er erlebte noch Aufstieg und erste Sporterfolge seines Opus 356, dem er von Herzen zugetan war und das seinen guten Namen tragen durfte. Am 30. Januar 1951 verstarb er und wurde auf dem familieneigenen Schüttgut bei Zell am See bestattet. Professor Dr. Ing. h.c. Ferdinand Porsche, darüber waren sich alle einig, hatte sich um das Automobil verdient gemacht wie kaum ein Zweiter.

la fameuse voiture de course à moteur central type 22 destinée à la future formule 750 kg. Il fallait bien autant de cylindres, assurait-il : plus il y en avait, meilleur était leur remplissage et d'autant plus réduites les dimensions des pièces en mouvement. Mais les coûts ? Euh, eh bien, il fallait, là, appliquer évidemment d'autres règles du jeu que pour la fabrication en série avec ses budgets à taille humaine.

C'est là le genre d'explications qu'exigeait Adolf Hitler (qui l'appelait « mon ingénieur le plus performant »), auquel il pouvait parler à tout moment sans suivre la voie hiérarchique. Ce qui incite inévitablement à questionner ses relations avec les plus hauts dignitaires nazis, en présence desquels obséquiosité et servilité, le martial « salut allemand » et une casquette à visière étaient recommandés comme signes éprouvés de respect de l'autorité. Sur ce plan aussi, Porsche faisait preuve d'une forfanterie rafraîchissante, interpellait le Chancelier du IIIe Reich avec un convivial et cordial « Dieu vous salue, Monsieur Hitler », la plupart du temps vêtu d'un costume informel, avec un chapeau anglais en guise de couvre-chef.

Après la guerre, il a été sévèrement puni – et ce, malgré sa totale innocence – pour sa proximité vis-à-vis des grands du Reich et son statut au sein du système. Prisonnier pendant trois mois dans un camp d'interrogatoire américain proche de Francfort surnommé officiellement, et ironiquement, « Dustbin » (la poubelle), il a quand même eu l'honneur d'emmener avec lui sa voiture de fonction et son chauffeur, le brave Goldinger. Mais les Français, à la suite d'une plainte déposée par Jean-Pierre Peugeot, le patron des usines du même nom, reprochèrent au professeur septuagénaire des mesures de répression contre des ouvriers français et contre la population civile française, voire des déportations. Deux années passées dans des conditions de détention indignes, à la fin dans la prison de Dijon, minèrent définitivement sa santé. Cet emprisonnement fut interrompu par un intermède au début de l'année 1946 au service de Renault, où Porsche donna la dernière touche à la légendaire petite 4 CV à moteur arrière. Ce n'est qu'en 1948 – son fils Ferry et des amis avaient entre-temps versé une lourde caution – qu'il fut complètement blanchi.

Il fut encore le témoin de l'essor de sa firme et des premiers succès remportés en compétition par son chef-d'œuvre, la 356, qu'il adorait et qui eut l'honneur de porter son nom. Décédé le 30 janvier 1951, il est inhumé dans le caveau familial, proche de Zell am See. Le professeur Ferdinand Porsche, tout le monde était unanime sur ce point, avait plus mérité de l'automobile que pratiquement tout autre homme.

One of the most successful racing sports cars in post-war history originated from private initiative in 1949, the "year of need". The courageous man to whom the world owed the Porsche 550 Spyder was Helm Glöckler, a Volkswagen dealer in Frankfurt. He welded together a light space frame, anchored into it a 1086 cc Porsche-VW engine spurred on to 58 bhp by relatively moderate alcohol consumption, had all that clothed sportingly by the Weidhausen bodyshop on the other side of the street, and became the 1950 German champion in the 1100 cc sports car category. The project's progress was followed closely by the Zuffenhausen works which, in winter 1952 and by mutual agreement, set about building their own version. Initially they resorted to the 1500 cc pushrod flat four of the production 1500 S. In the 1953 Le Mans 24 Hours the performance deficit was compensated for by fitting hardtops so as to improve aerodynamics, enough to notch up a class victory.

During practice for a sports car race on the eve of the German Grand Prix, the Spyder appeared with the engine that was to make its creator Professor Dr. Ernst Fuhrmann famous, with four camshafts actuated by vertical shafts, a capacity of 1498 cc and 110 bhp at 7800 rpm. Its first real racing outing at the Mille Miglia on 2 May 1954 did a lot to further the early fame of sixth-placed Porsche driver Hans Herrmann, together with Zuffenhausen stalwart Herbert Linge.

Towards the end of that year the 550 Spyder was also available to private customers, numbering around 100 and including celebrities like star conductor Herbert von Karajan. Its chassis was composed of tubes and combined with the one-shell skin, which suited the wind as well as the beholder's eye because of its sleek contours from the nose, via the pronounced mudguards, to the well-shaped rear. The wheels were sprung independently, with longitudinal trailing arms and two transversely-installed square torsion bars at the front, while the rear swing axle was located by trailing arms and one transversely-mounted round torsion bar on either side. The canvas soft top was foldable and removable, fastened to the upper frame of the single-piece laminated glass windshield by means of two shackles.

The 550 A appeared in 1956, with a space frame three times stiffer and five times more resistant against twisting, and a low-pivot rear swing axle in keeping with Mercedes practice. Its engine, fed by two dual-barrel downdraft Weber 40 DCM carbs rather than the former Solex one, now gave 135 bhp at 7200 rpm, and the most satisfying success so far was achieved by Italian Umberto Maglioli when he snatched victory at the Targa Florio on 10 June. The model owed its cult status both to countless victories and to the death of a legend: on 30 September 1955, film star James Dean was killed at the wheel of his silver specimen in a freak accident in the Californian desert on his way to a race.

Einer der erfolgreichsten Rennsportwagen nach dem Krieg wurzelte in einer privaten Initiative im Jahr der Not 1949. Der mutige Mensch, bei dem sich die Welt für die Existenz des Porsche 550 bedanken durfte, hieß Helm Glöckler und war VW-Händler in Frankfurt. Er schweißte einen leichten Rohrrahmen zusammen, pflanzte ein Porsche-VW-Triebwerk von 1086 cm³, dem sanfter Alkoholismus 58 PS einflößte, in dessen Heck und ließ dem Ganzen bei der Karosseriewerkstatt Weidhausen auf der anderen Straßenseite ein sportliches Trikot verpassen. 1950 wurde Glöckler deutscher Meister bei den Sportwagen bis 1100 cm³.

In Zuffenhausen verfolgte man das Projekt aufmerksam und machte sich im Winter 1952 in gegenseitigem Einvernehmen an den Bau einer eigenen Version. Anfänglich begnügte man sich mit dem Vierzylinder-Stoßstangenboxer von 1500 cm³ des serienmäßigen 1500 S. Bei den 24 Stunden von Le Mans 1953 stülpte man den dort eingesetzten Spydern Hardtops über, um weniger Leistung mit mehr Aerodynamik auszutarieren. Der Eingriff trug durchaus sein Scherflein zu einem Klassensieg bei. Beim Training zu einem Sportwagenlauf vor dem Großen Preis von Deutschland machte der Spyder seine Aufwartung mit dem Meisterstück Professor Dr. Ernst Fuhrmanns. Es schöpfte 110 PS bei 7800/min aus 1498 cm³, und seine vier Nockenwellen wurden von Königswellen zur Arbeit angetrieben. Seine wirkliche Premiere anlässlich der Mille Miglia am 2. Mai 1954 begründete den Ruhm des sechstplatzierten jungen Hans Herrmann, begleitet von Herbert Linge, einem Porsche-Mann der ersten Stunde.

Ende jenes Jahres war der 550 Spyder auch für rund 100 private Kunden verfügbar, unter ihnen Stardirigent Herbert von Karajan. Sein Rohrrahmen fand sich zu einer selbsttragenden Einheit zusammen mit der Außenhaut aus einem Stück, windschlüpfig und schön anzusehen wegen ihrer ausgewogenen Konturen von der schaufelförmigen Nase über die muskulösen Kotflügel bis hin zum wohl geformten Hinterteil. Die Einzelradaufhängung bildeten vorn zwei längs liegende Traghebel und quer angesiedelte Vierkant-Blattfederstäbe und hinten eine durch Längslenker geführte Pendelachse mit je einem runden, quer angebrachten Drehstab. Am oberen Rahmen der einteiligen Windschutzscheibe aus Schichtglas mit zwei Laschen befestigt, ließ sich das leichte Zeltdach zusammenklappen und ganz entfernen.

1956 trat der 550 A mit einem Rahmen an, der fünffach verwindungssteifer war. Seine Pendelachse mit tief gelegtem Drehpunkt folgte Mercedes-Bräuchen. Der Motor leistete nun 135 PS bei 7200/min, ermöglicht durch zwei Weber-Doppel-Fallstromvergaser Typ 40 DCM statt der bisherigen Solex-Zerstäuber. Schönster Sporterfolg bislang war Rang eins Umberto Magliolis bei der Targa Florio am 10. Juni. Der Kultstatus des Modells erwuchs aus unzähligen weiteren Siegen und aus dem Tod einer Legende. Denn am 30. September 1955 starb James Dean auf der Fahrt zu einem Rennen bei einem Verkehrsunfall in der kalifornischen Wüste.

L'une des voitures de sport les plus capées de l'après-guerre est le fruit d'une initiative privée prise en cette année de disette de 1949. L'homme courageux auquel on doit la Porsche 550 s'appelle Helm Glöckler, un concessionnaire VW de Francfort. Il décide de souder un léger châssis tubulaire à l'arrière duquel il greffe un moteur de Porsche VW de 1086 cm³ de cylindrée, assez sobre, d'une puissance de 58 ch et pour lequel il fait tailler une robe sportive dans l'atelier de carrosserie Weidhausen, de l'autre côté de la rue. À son volant, Glöckler est sacré champion d'Allemagne des voitures de sport jusqu'à 1100 cm³ en 1950.

Depuis Zuffenhausen, on observe attentivement le projet et, au cours de l'hiver 1952, d'un commun accord, les compères s'attaquent à la construction d'une version maison. Au début, Porsche se contente

1953–1957

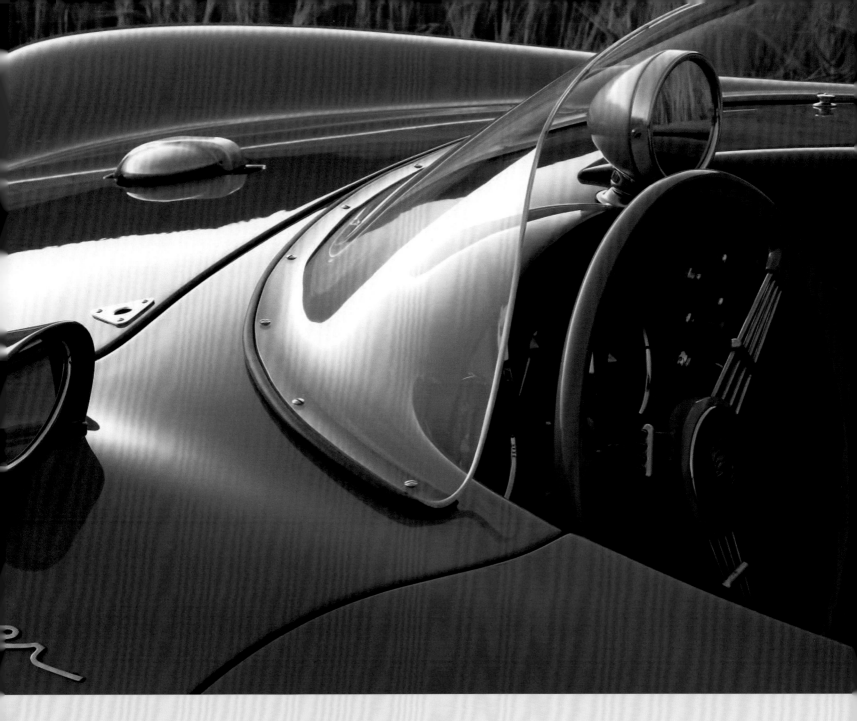

du quatre-cylindres boxer culbuté de 1500 cm³ de la 1500 S de série. Pour les 24 Heures du Mans de 1953, en revanche, les Spyder sont coiffés d'un hard-top afin de compenser leur déficit de puissance par une aérodynamique plus raffinée. Cette intervention aura assurément contribué à la victoire de classe. Lors des essais préliminaires dans le cadre d'une manche pour voitures de sport en lever de rideau du Grand Prix d'Allemagne, le chef-d'œuvre du Professeur Ernst Fuhrmann fait une entrée remarquée. Ce moteur délivre 110 ch à 7800 tr/min à partir de 1498 cm³ et ses quatre arbres à cames sont entraînés par des arbres de renvoi. Sa véritable première course, à l'occasion des Mille Miglia, le 2 mai 1954, assoit la renommée du jeune Hans Herrmann, qui termine à la sixième place, avec comme coéquipier Herbert Linge, un porschiste de la première heure.

Fin 1954, la 550 Spyder est aussi disponible pour une centaine de clients privés, parmi lesquels la star des chefs d'orchestre, Herbert von Karajan. Son châssis tubulaire se combine à la carros-serie d'un seul tenant en une unité autoporteuse aérodynamique, d'une grande beauté en vertu de l'équilibre de ses contours, de son museau offensif, sans oublier ses ailes musculeuses. La suspen-sion à roues indépendantes se compose de deux bras-supports longitudinaux en position horizontale et de ressorts à lames de section carrée en posi-tion transversale à l'avant et à l'arrière, un essieu oscillant guidé par des bras longitudinaux avec une barre de torsion de section circulaire, elle aussi en position transversale, de chaque côté. Sur la partie supérieure du pare-brise d'un seul tenant en verre feuilleté se fixe, avec deux languettes, une

capote extrêmement primitive qui se démonte en quelques secondes.

En 1956 apparaît la 550 A, qui se distingue par un châssis cinq fois plus rigide à la torsion. Son essieu oscillant avec un point de torsion abaissé s'inspire de celui des Mercedes. Le moteur déve-loppe maintenant 135 ch à 7200 tr/min grâce à deux doubles carburateurs inversés Weber de type 40 DCM au lieu des anciens vaporisateurs Solex. Son plus grand succès : la 1re place d'Umberto Maglioli lors de la Targa Florio disputée le 10 juin 1956. Son statut de voiture culte s'obtient par d'innombrables autres victoires, mais aussi et surtout par la dispa-rition d'une légende. En effet, le 30 septembre 1955, James Dean trouve la mort à son volant, lors d'un accident de la circulation à un carrefour dans un désert de Californie.

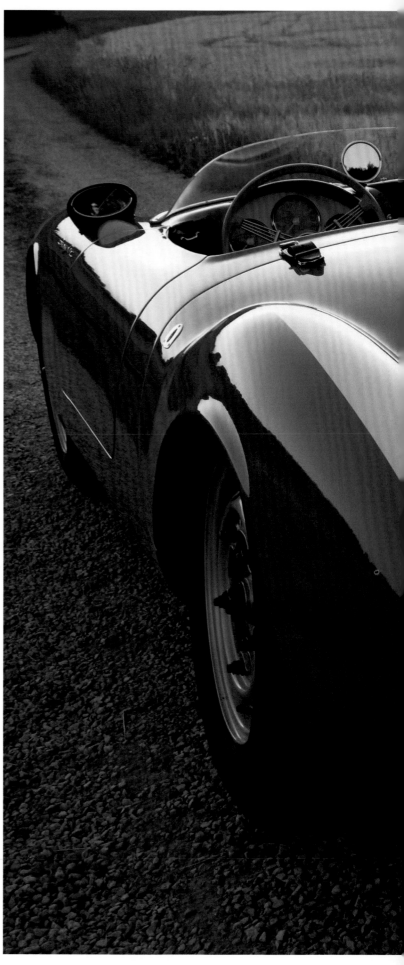

Attractive rear: below the Spyder's body tail menacingly protrudes the Sebring exhaust, through which Ernst Fuhrmann's famous four-camshaft engine gives vent to its wrath. The one-piece windshield consists of plexiglas.

Schöner Rücken: Darunter ragt drohend der Sebring-Auspuff hervor, durch den sich Ernst Fuhrmanns berühmter Königswellenmotor mit mächtigem Bariton Luft macht. Die einteilige Windschutzscheibe ist aus Plexiglas.

Une croupe aguichante : il en émane, menaçant, un pot d'échappement Sebring à travers lequel le célèbre moteur à arbre vertical de commande d'arbre à cames imaginé par l'ingénieur Ernst Fuhrmann s'exprime avec un baryton sonore. Le pare-brise d'un seul tenant est en plexiglas.

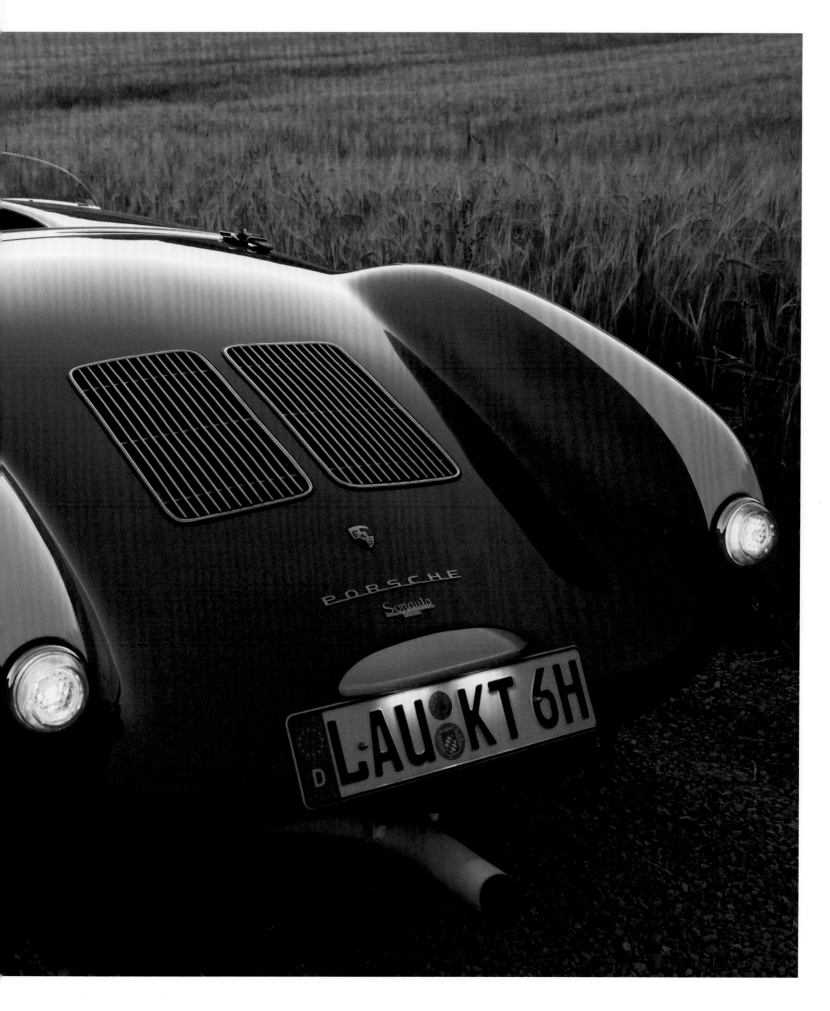

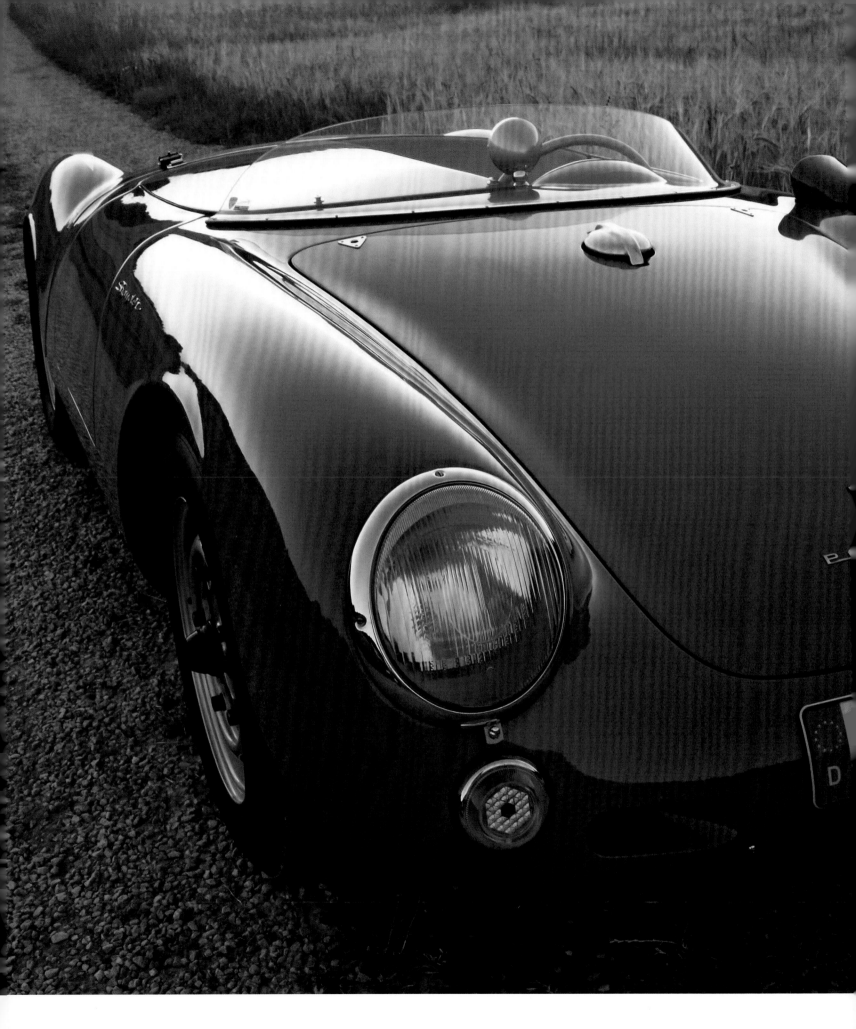

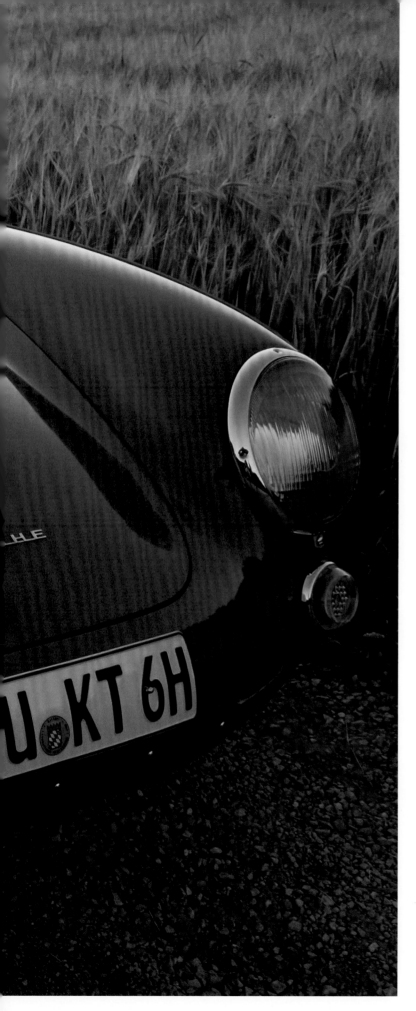

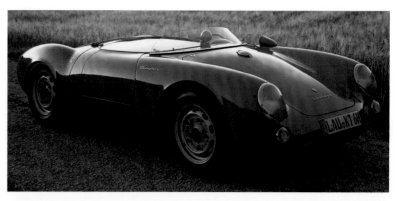

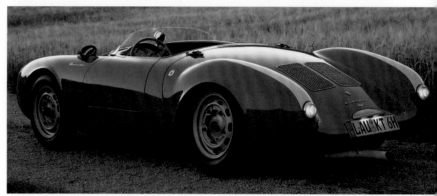

Like its rear counterpart the front lid is pivoted on concealed hinges. At the front a section has been cut out for the filler cap, while the engine hood accommodates the dual ventilation grilles.

Die Bughaube ist wie ihr Gegenstück über dem Heck mit verdeckten Scharnieren angelenkt. Hinten sind die Belüftungsgitter eingeschnitten, vorne wurde eine Öffnung für den Tankdeckel ausgespart.

À l'instar de son homologue à l'avant, le capot moteur, à l'arrière, est articulé par des charnières dissimulées sous la carrosserie. Il comporte une découpe pour les grilles de ventilation tandis qu'une ouverture pour la goulotte de réservoir a été ménagée à l'avant.

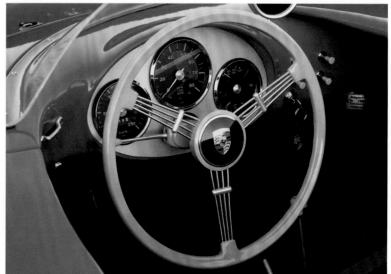

Introduced at the Frankfurt IAA in September 1955, the Porsche 356 armada sailed into the 1956 model year with the 1300 (44 bhp), 1300 S and 1600 (both 60 bhp), and 1600 S (75 bhp). The capacity of the two largest-volume variants had been slightly raised; as far as the top model of the range, the Carrera GS, was concerned, it had been left at 1498 cc. In its rear the mildly detuned power plant of the 550 Spyder, its muscle cut to a still threateningly audible 100 bhp, did its impressive work, with four overhead camshafts actuated by vertical drive shafts.

The list of improvements was long, comprising a bigger and consistently curved one-piece panoramic windshield as well as front blinkers inserted into small horizontal louvers, a bouclé-carpeted floor lowered by 1.4" so as to make access to and sojourn in the Porsche easier and more comfortable, a padded eyebrow protecting the dashboard, as well as a handbrake protruding on the left below the ignition key without endangering the driver's knee. A softer springing was effectuated by front torsion bars that had eight leaves each (previously six top and five bottom leaves) and, at the other end, by lengthening their rear equivalents by 2.9" to 24.7".

Offered from May 1957 in addition to the GS de Luxe (100 bhp) in Coupé and Speedster guise, the Carrera GT boasted 110 bhp, but had to make do without the amenity of its sibling's gasoline-electric heating. As was the case with the 356A's less spectacular brother the VW, model improvement went on continually, as could be seen at that year's Frankfurt IAA. By passing the double exhaust of the two 1600 cc variants through the rear overriders, additional ride height could be gained. The pairs of circular rear lights were replaced by horizontally positioned "teardrop" clusters, while the appropriate illumination was repositioned from above to below the registration plate. The rear window, which had been enlarged for the second time since 1952 on the Cabriolet, was curved spherically.

For the two open-top varieties there were easy-to-mount hardtops. At the bottom end, the range dried up with the demise of the two entry-level 1300s, followed by the Speedster in 1958. More comfort was called for, provided from August that year by the Convertible D (D being the initial of the Drauz body shop at Heilbronn, which fabricated the shells). At the same time, the performance of the top-flight 356, the Carrera, which now with its 1588 cc was quite in keeping with its more urbane pushrod brethren, kept escalating. You could buy it as a comparatively comfortable grand tourer GS de Luxe with 105 bhp or, with ten more horse-power, as the GT, whose rear grill was flanked by six lamellae on either side improving the ventilation of the engine compartment, as already featured on its predecessor. The GT's militant appearance as a potential racing tool was further enhanced by light-alloy doors and lids, leather straps for raising and lowering the side windows, and by dispensing with the overriders. Nevertheless, the noise level was reduced by a friction-bearing crankshaft.

Vorgestellt auf der Frankfurter IAA im September 1955, lief die Armada der Porsche 356 A in das folgende Modelljahr aus mit den Typen 1300 (44 PS), 1300 S und 1600 (beide 60 PS) sowie 1600 S (75 PS). War das Volumen der beiden hubraumstärksten Varianten leicht angehoben worden, ließ man es bei der Krönung der Palette, dem Carrera GS, bei 1498 cm³ bewenden. In seinem Heck waltete 100 PS mächtig und drohend vernehmlich das etwas besänftigte Triebwerk des 550 Spyder mit vier oben liegenden Nockenwellen, ihrerseits durch Königswellen angetrieben, und Doppelzündung.

Lang war die Liste der Novitäten, umspannte eine etwas größere und gleichmäßig gewölbte Panorama-Frontscheibe ebenso wie vordere Blinker, die außen in horizontale Schallgitterchen eingesetzt worden waren, einen um 35 mm abgesenkten, mit Bouclé ausgelegten Wagenboden zwecks besserem Zugang zum und angenehmeren Aufenthalt am Arbeitsplatz, einen gepolsterten Blendschutz über der Armaturentafel sowie eine Stockbremse links unter dem Zündschlüssel. Eine weichere Federung bewirkten vorn Torsionsstäbe aus je acht Blatt (vorher: oben sechs, unten fünf) und am anderen Ende Drehstäbe, die um 74 auf 627 mm verlängert worden waren.

Mit 110 PS ging der Carrera GT ins Rennen, der ab Mai 1957 neben dem GS de Luxe (100 PS) als Coupé und Speedster offeriert wurde und ohne die Annehmlichkeit von dessen benzinelektrischer Heizung auskommen musste. Wie beim bürgerlichen Bruder VW wurde weiter emsig am Detail gefeilt, wie auf der IAA jenes Jahres ersichtlich. Indem man den Doppelauspuff der beiden 1600er durch die Enden der Stoßstangenhörner führte, gewann man Bodenfreiheit. Blinker, Brems- und Schlusslampen waren in einem gemeinsamen tropfenförmigen Gehäuse vereint, während das hintere Kennzeichen nun von unten beleuchtet wurde. Die Heckscheibe, am Cabriolet nach 1952 zum zweiten Mal vergrößert, war sphärisch gewölbt.

Für die beiden offenen Versionen gab es bequem zu montierende Hardtops. Nach unten trocknete das Angebot mit dem Hinscheiden der zwei 1300er aus, und 1958 segnete auch der Speedster das Zeitliche. Mehr Komfort war angesagt, und den bot ab August desselben Jahres das Convertible D (im D fand sich die Initiale der Spenglerei Drauz in Heilbronn wieder, die den Aufbau herstellte). Die Leistung des Top-Typs Carrera, nunmehr mit 1588 cm³ ganz im Einklang mit seinen verbindlicheren Brüdern, eskalierte unterdessen munter weiter. Man konnte ihn als kommoden Reisewagen GS de Luxe mit 105 PS erwerben oder als zehn PS stärkeren GT, dessen Heckgrill wie schon beim Vorgänger von je sechs Lamellen zur Belüftung des Motorabteils flankiert wurde. Zum militanten Auftritt des GT als potentiellem Sportgerät zählten überdies der Verzicht auf Stoßstangenhörner, Türen und Hauben aus Aluminium und Lederriemchen zum Heben und Senken der Seitenscheiben. Gleichwohl mäßigte eine Kurbelwelle in Gleitlagern den Geräuschpegel.

Présentée à l'IAA de Francfort en septembre 1955, l'armada des Porsche 356 A pour le millésime 1956 a fière allure avec les types 1300 (44 ch), 1300 S et 1600 (toutes les deux de 60 ch) ainsi que 1600 S (75 ch). Alors que le cubage des deux variantes à la plus forte cylindrée a été légèrement majoré, pour le porte-drapeau de la gamme, la Carrera GS, il est resté de 1498 cm³. Son compartiment moteur est équipé du groupe motopropulseur du 550 Spyder, légèrement dégonflé avec quatre arbres à cames en tête, actionné par des arbres de renvoi et à double allumage, mais à la puissance imposante de 100 ch et à l'acoustique menaçante.

La liste des nouveautés est impressionnante puisqu'elle englobe un pare-brise panoramique un peu plus grand et au galbe régulier, des clignotants avant placés sur l'extérieur de petits grillages

1955–1959

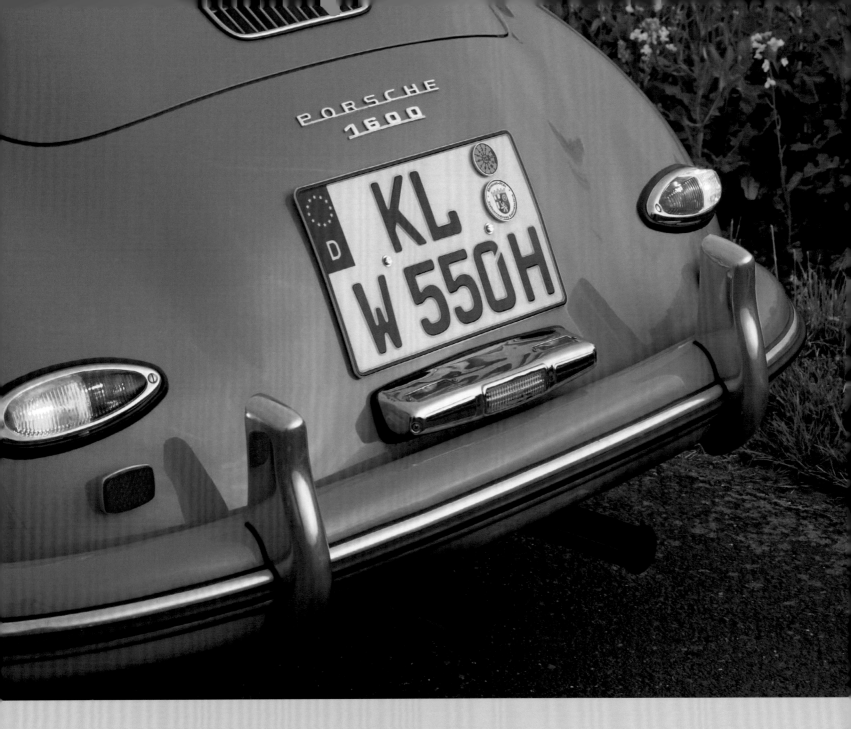

horizontaux, un plancher recouvert de tapis bouclé et abaissé de 35 mm afin de faciliter l'accès à bord et d'offrir un séjour plus agréable aux passagers, un pare-soleil capitonné au-dessus du tableau de bord, ainsi qu'un levier de frein à main placé à gauche sous la clé de contact. À l'avant, les barres de torsion comportent huit lames (contre six en haut et cinq en bas auparavant) et, à l'arrière, elles sont allongées de 74 mm, à 627 mm, l'ensemble procurant une suspension plus souple.

Une Carrera GT de 110 ch fait son apparition en mai 1957, aux côtés de la GS de Luxe de 100 ch, en deux versions, coupé et Speedster, mais doit se passer d'un accessoire aussi agréable que son chauffage électrique à essence. À l'instar de sa cousine, la brave VW, les détails ne cessent de s'améliorer comme on peut le constater à l'IAA de 1957. Ainsi, en plaçant la sortie de l'échappement double des deux 1600 au bas des cornes du pare-chocs, on gagne en garde au sol. Clignotants, feux de frein et feux de position arrière sont réunis dans un boîtier commun en forme de goutte d'eau alors que la plaque d'immatriculation arrière est désormais éclairée d'en bas. La lunette, agrandie pour la deuxième fois depuis 1952 sur le cabriolet, présente un galbe sphérique.

Pour les deux versions décapotables, Porsche propose un hard-top très facile à monter. En bas de l'échelle, le programme s'élague avec la disparition des deux 1300 tandis que le Speedster est, quant à lui, écarté du programme en 1958. Offrir plus de confort devient impératif, ce que propose à partir du mois d'août de cette année-là la Convertible D (D étant l'initiale du carrossier Drauz, à Heilbronn, qui réalise la robe de cette voiture). La puissance du navire amiral, la Carrera, désormais d'une cylindrée de 1588 cm³, identique à celle de ses consœurs moins sportives, ne cesse, en revanche, d'augmenter. On a le choix entre la GS de Luxe, pratique pour les longues distances avec ses 105 ch, ou la GT, plus puissante de 10 chevaux, dont les grilles du capot moteur, comme sur la version précédente déjà, sont ornées de six lamelles sur chaque côté pour aérer le groupe motopropulseur. L'allure martiale de la GT en tant que potentiel engin de compétition est renforcée par le renoncement aux cornes de pare-chocs, par des portières et capots en aluminium ainsi que de petites courroies de cuir pour relever et abaisser les vitres latérales. Dans un autre registre, un vilebrequin à paliers lisses s'efforce de tempérer le niveau acoustique.

356 A

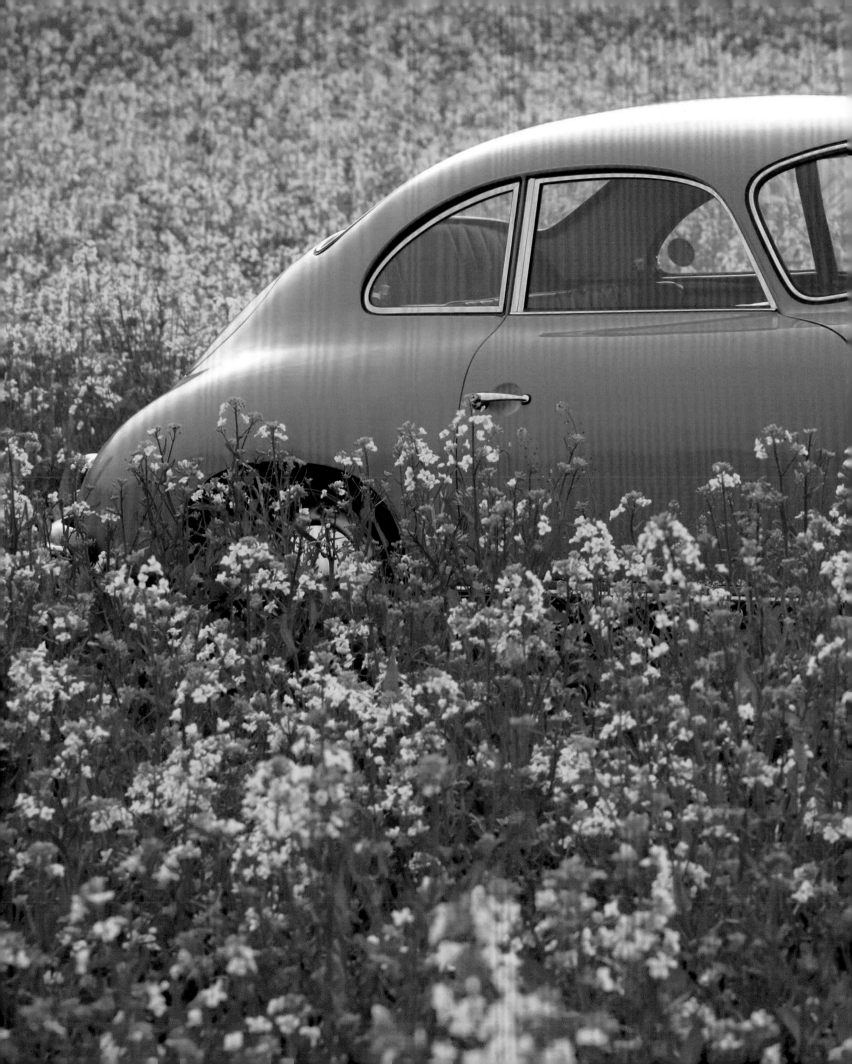

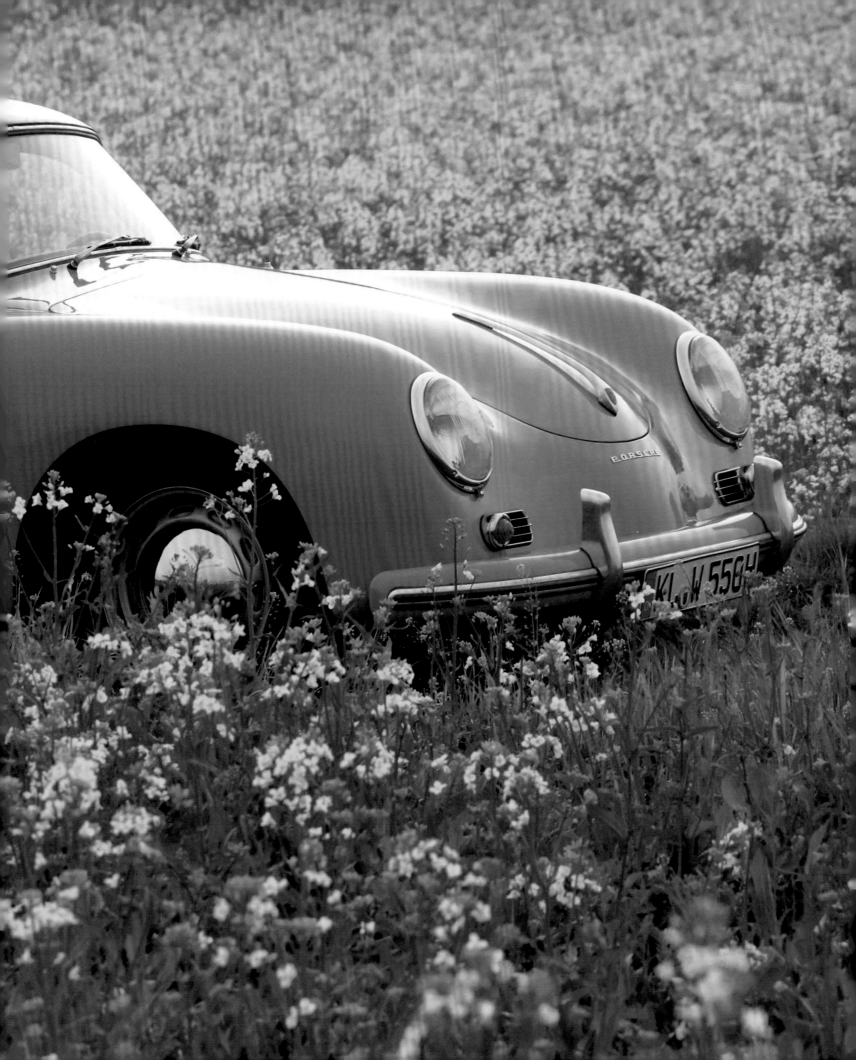

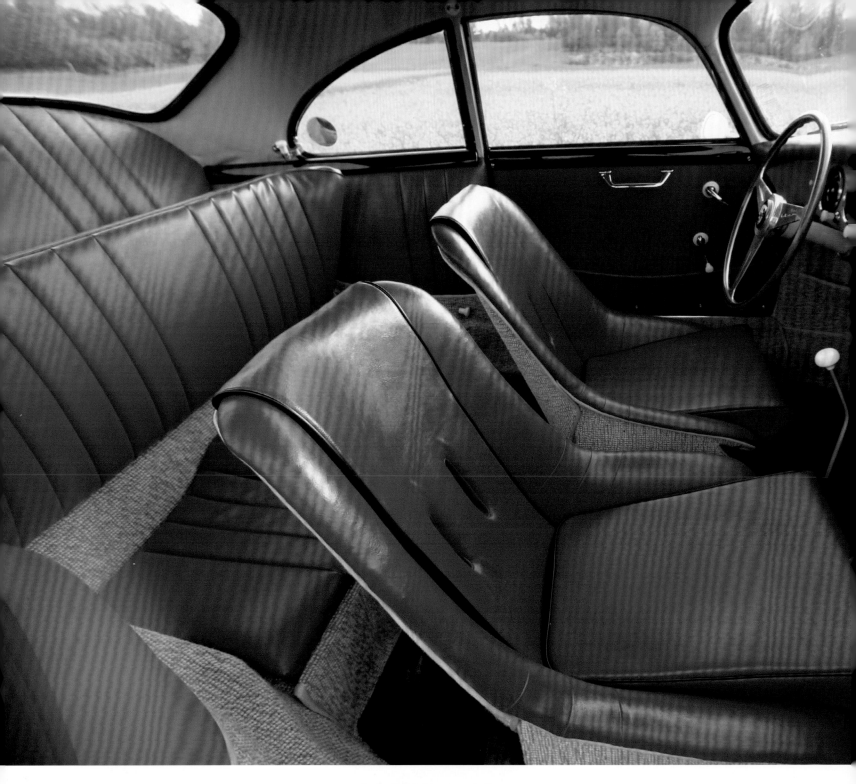

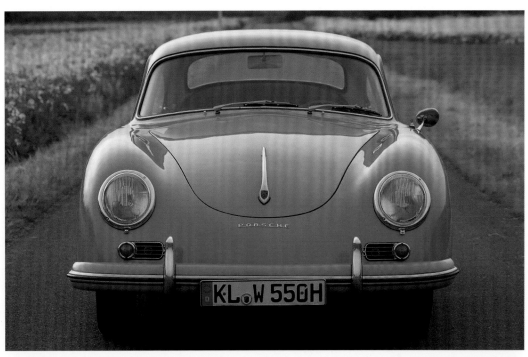

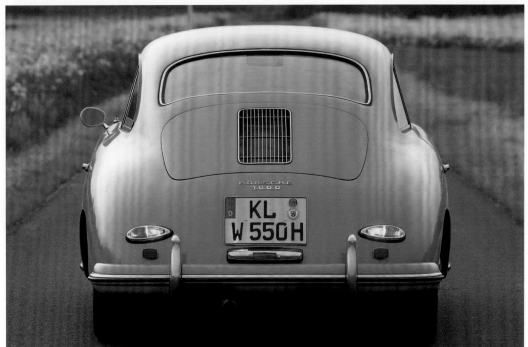

With its 60 bhp, this 1959 model year 1600 Coupé does not necessarily stand in the first row of the Porsche starting grid. But its owner has upgraded it a bit, installing Speedster bucket seats and a Nardi steering wheel.

Mit seinen 60 PS steht dieses Coupé 1600 von 1959 nicht eben in der ersten Reihe des Porsche-Starterfeldes. Dafür hat es sein Besitzer mit Speedster-Schalensitzen und einem Nardi-Lenkrad sportlich aufgemöbelt.

Avec ses 60 ch, ce Coupé 1600 de 1959 ne risque pas de figurer en première ligne d'un plateau de Porsche en compétition. Ceci n'a pas empêché son propriétaire de lui donner une allure sportive avec les sièges baquets Speedster et un volant Nardi.

Those teardrop tail lights appear on the T2 generation from fall 1957, for the benefit of its outer appearance, which is also improved by license-plate lamps that are now installed below the plates themselves.

Die „Tropfen"-Rückleuchten finden sich am Heck der T2-Generation ab Herbst 1957 und werten ihren Auftritt ebenso auf wie die Nummernschildbeleuchtung, die sich nun unterhalb der Kennzeichen findet.

Les feux arrière en « goutte d'eau » ornent la poupe de la génération T2 à partir de l'automne 1957 et lui donnent plus d'allure, au même titre que l'éclairage de plaque minéralogique qui se trouve maintenant sous l'immatriculation.

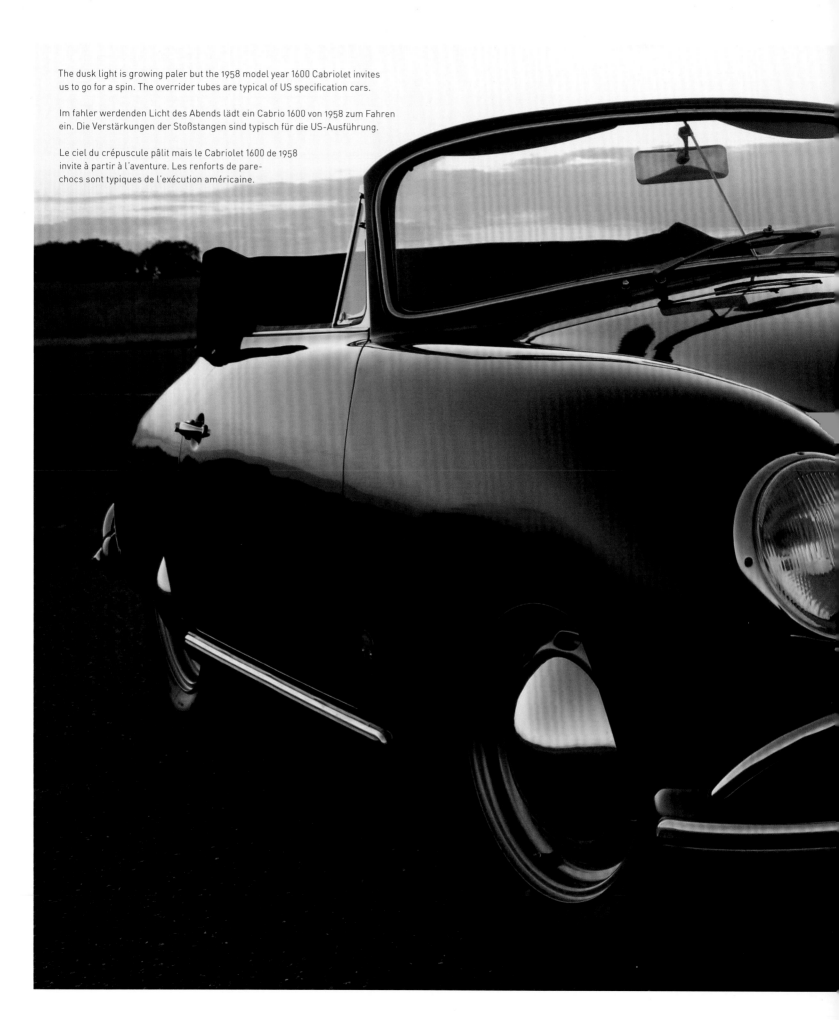

The dusk light is growing paler but the 1958 model year 1600 Cabriolet invites us to go for a spin. The overrider tubes are typical of US specification cars.

Im fahler werdenden Licht des Abends lädt ein Cabrio 1600 von 1958 zum Fahren ein. Die Verstärkungen der Stoßstangen sind typisch für die US-Ausführung.

Le ciel du crépuscule pâlit mais le Cabriolet 1600 de 1958 invite à partir à l'aventure. Les renforts de pare-chocs sont typiques de l'exécution américaine.

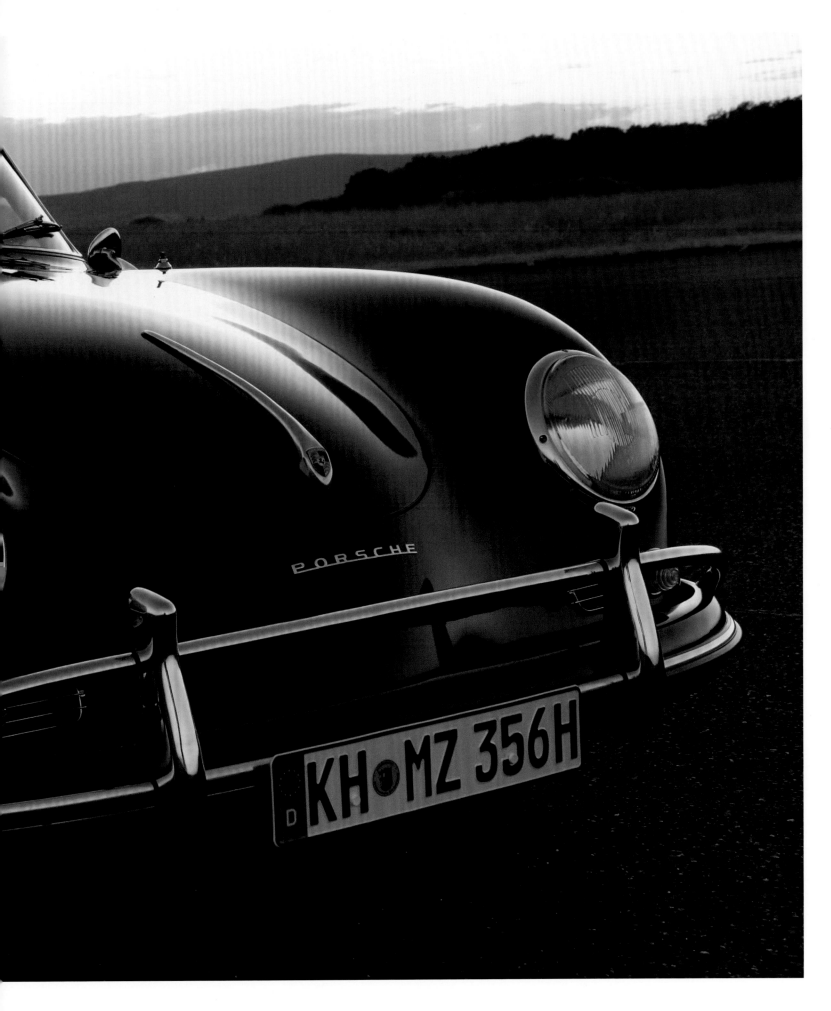

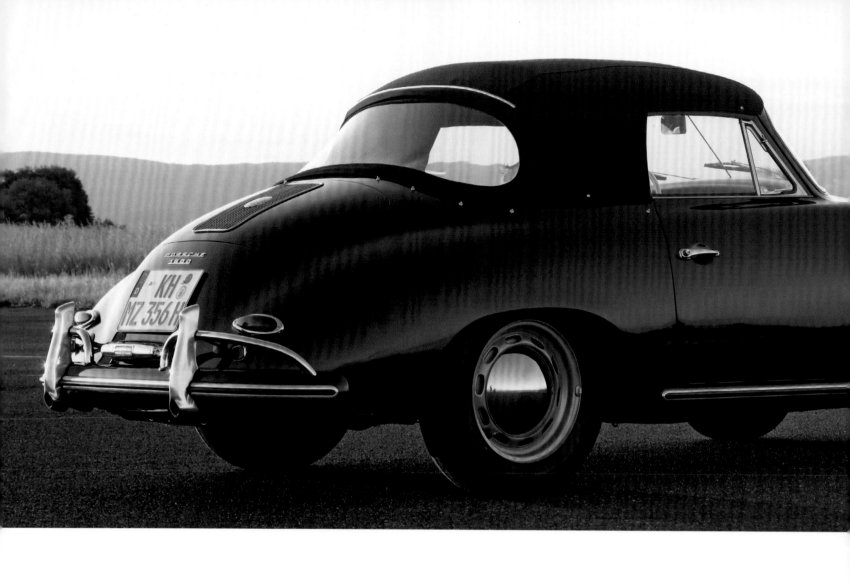

In the T2 version of the 356A model range the speedometer (now moved to the right) and the combination gauge (now without numbered scale) have swapped places.

In der Ausbaustufe T2 der Baureihe 356A haben Kombiinstrument (nun ohne Gradeinteilung für die Öltemperatur) und Tachometer (nun rechts) den Platz getauscht.

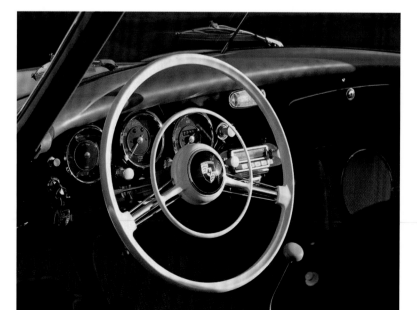

For the sake of better aeration the T2 Cabriolet features vent windows. The trim molding below its backlite has been removed.

Das Cabrio hat erstmalig ausstellbare Dreieckfenster zwecks besserer Belüftung. Die Zierleiste unter der Heckscheibe wurde entfernt.

Le cabriolet possède pour la première fois des déflecteurs triangulaires pour améliorer la ventilation de l'habitacle. La barrette de décoration sous la lunette arrière a disparu.

Dans l'évolution T2 de la gamme 356 A, le combiné d'instruments (maintenant sans graduation pour la température d'huile) et le tachymètre (désormais à droite) ont échangé leur place.

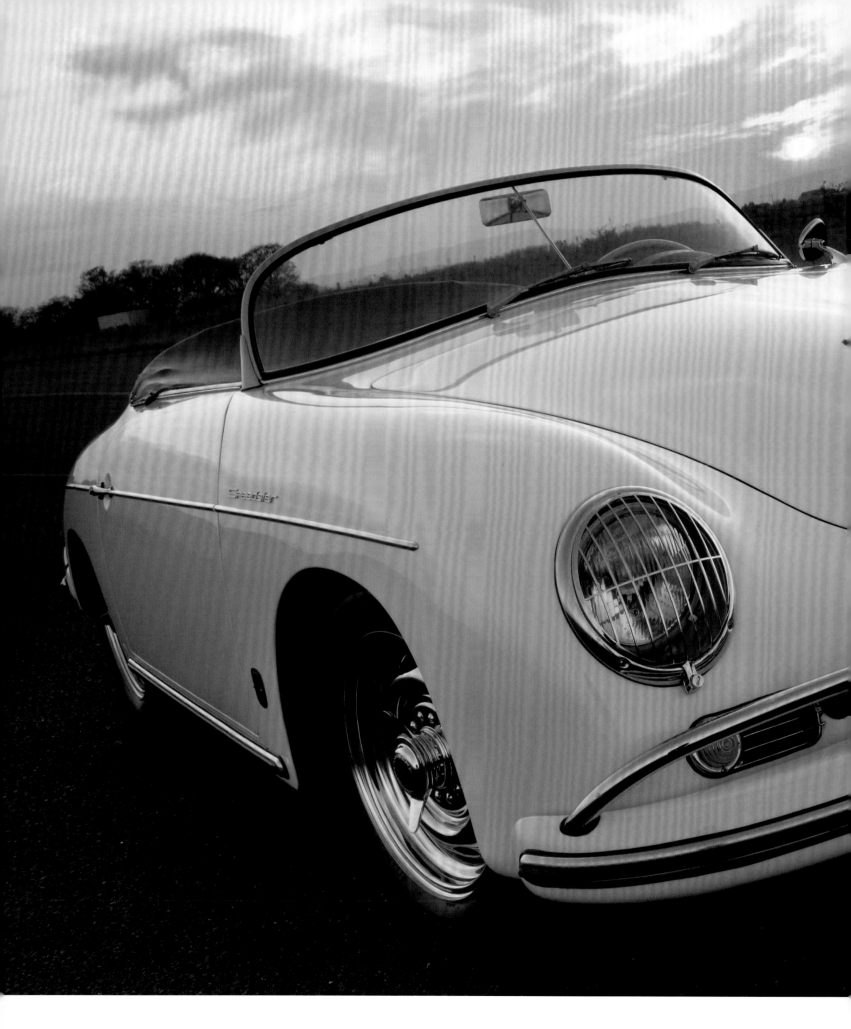

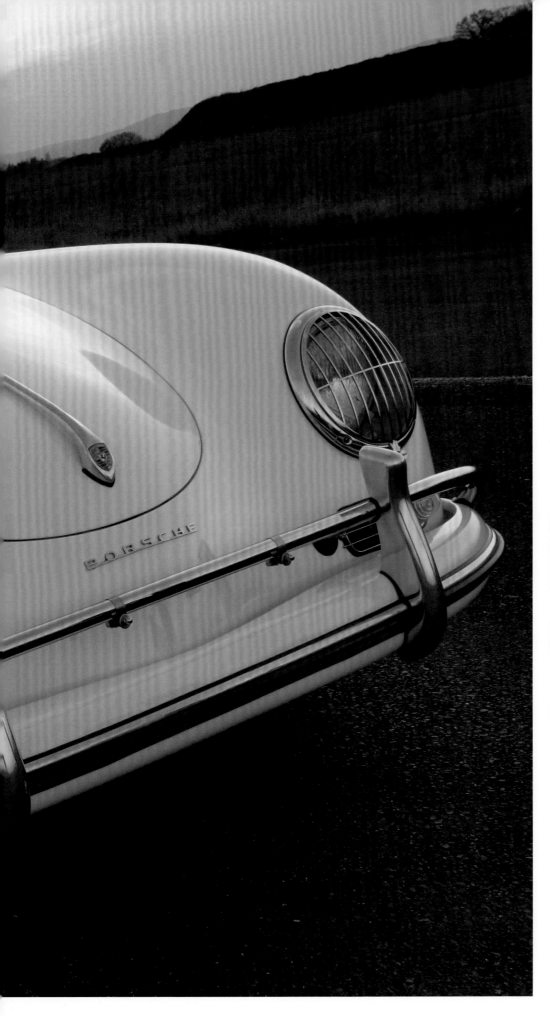

A T2 Speedster in US specification with headlight grilles. The bigger bumpers with their massive curved tubes were necessary to comply with the compulsory height.

Ein T2 Speedster in US-Ausführung mit Scheinwerfergittern. Die Amerika-Stoßstangen mit ihrem massiven gekrümmten Rohr waren erforderlich, um auf die vorgeschriebene Höhe zu kommen.

Un Speedster T2 en exécution américaine avec phares grillagés. Les pare-chocs «américains» avec leurs tubes massifs courbés étaient nécessaires pour respecter la hauteur prescrite outre-Atlantique.

From August 1958 the Convertible D variant is available, with a chromed screwed-on window frame like the Speedster, but about 1.2" higher, which allows an increase in the height of the soft top. This, together with wind-up windows, provides better weather protection.

Ab August 1958 kommt die Variante Convertible D in den Handel, mit einem verchromten aufgeschraubten Fensterrahmen wie der Speedster, aber rund 30 mm höher. Zusammen mit dem höheren Verdeck und Kurbelfenstern sorgt dies für besseren Wetterschutz.

En août 1958 apparaît la variante Convertible D avec un encadrement de fenêtre chromé et vissé comme pour le Speedster, mais d'environ 30 mm plus haut. De concert avec la capote plus élevée et les fenêtres à manivelle, ceci améliore la protection contre les intempéries.

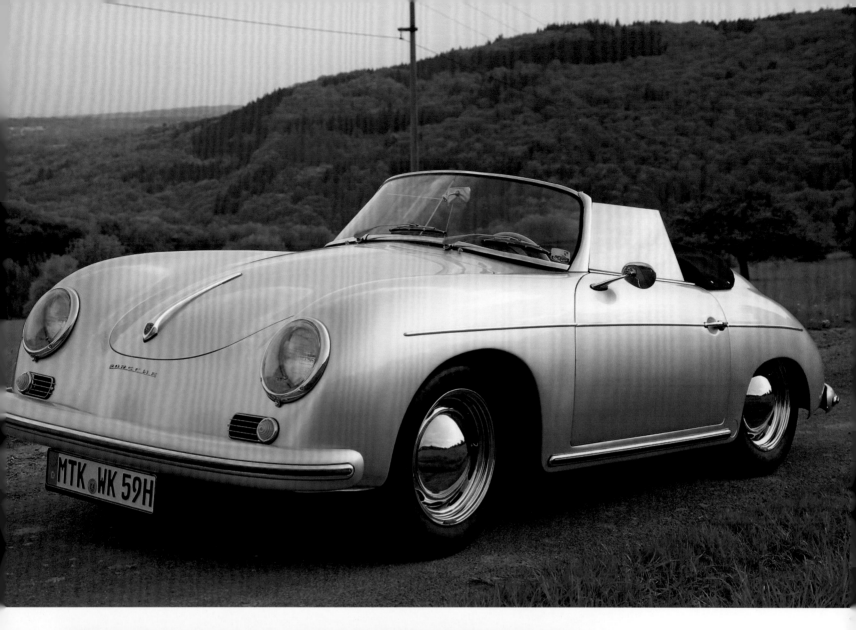

Porsche 356 A

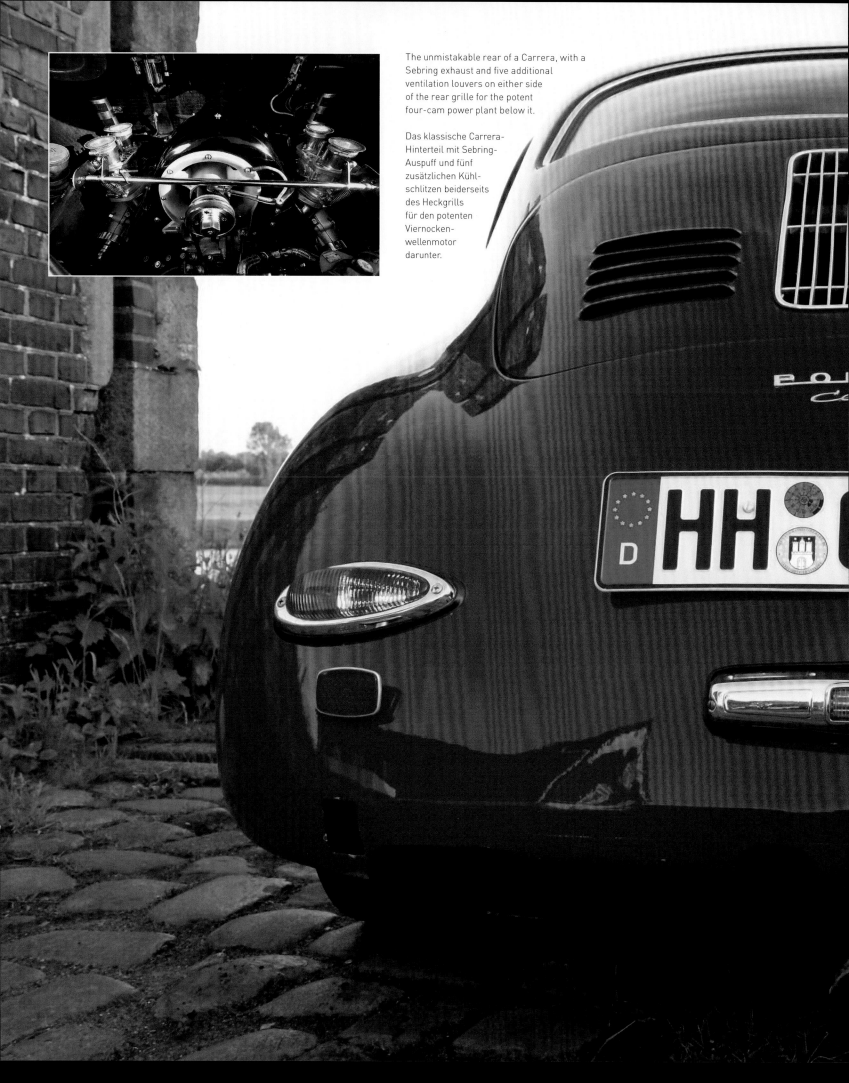

The unmistakable rear of a Carrera, with a Sebring exhaust and five additional ventilation louvers on either side of the rear grille for the potent four-cam power plant below it.

Das klassische Carrera-Hinterteil mit Sebring-Auspuff und fünf zusätzlichen Kühl-schlitzen beiderseits des Heckgrills für den potenten Viernocken-wellenmotor darunter.

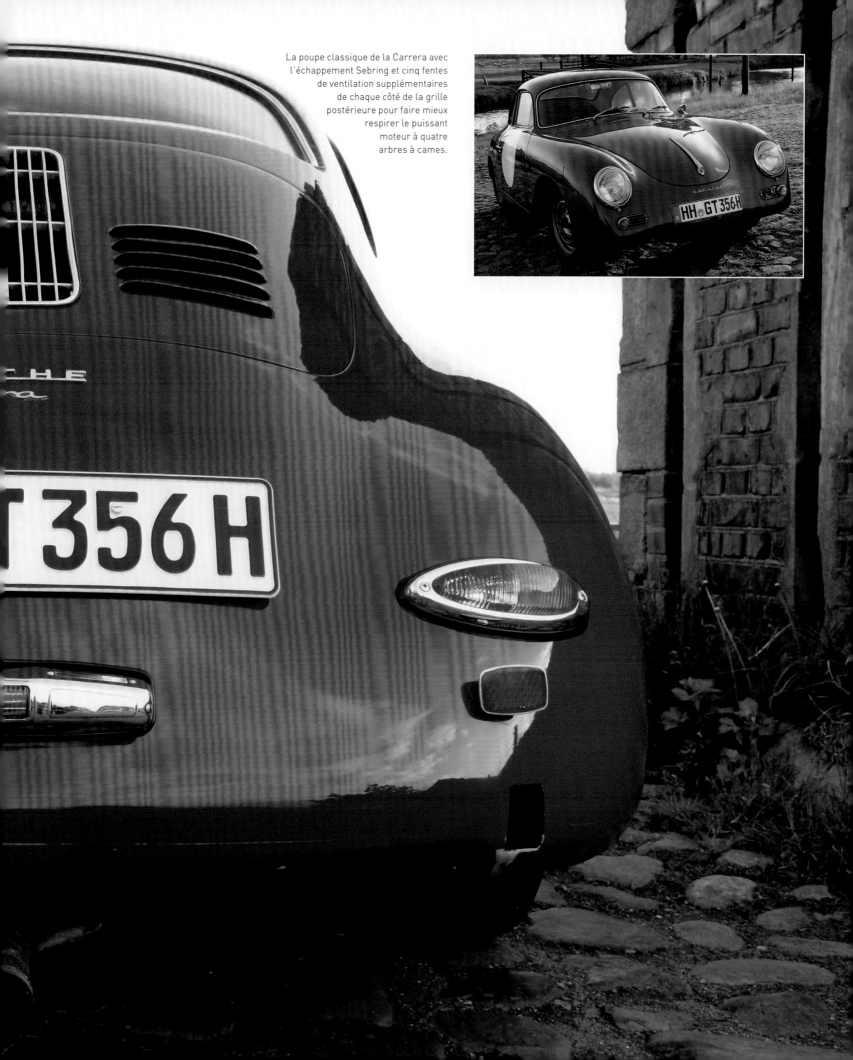

La poupe classique de la Carrera avec l'échappement Sebring et cinq fentes de ventilation supplémentaires de chaque côté de la grille postérieure pour faire mieux respirer le puissant moteur à quatre arbres à cames.

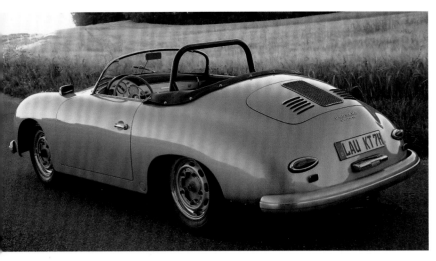

Extremely popular among Porsche's racing clientele: a Carrera Speedster.
The front lid is additionally held in place by two leather straps,
while the rollover bar is standard on the GT version.

Bei Sportfahrern ungemein beliebt: ein Carrera Speedster. Die vordere Haube ist durch
zusätzliche Riemchen gesichert, der Überrollbügel Standard an der GT-Version.

Incroyablement populaire auprès des pilotes sportifs : une Carrera Speedster.
Le capot avant est maintenu par des sangles de cuir supplémentaires
et des arceaux de sécurité équipent en standard la version GT.

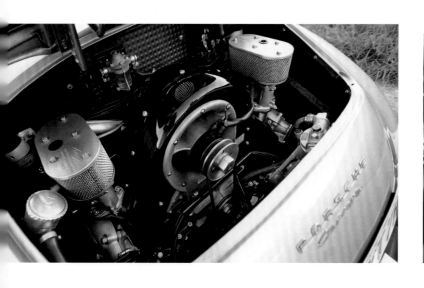

The Indestructible
Der Unzerstörbare
L'indestructible

A man can be destroyed but not defeated. That is the heartening message of Ernest Hemingway's longer short story *The Old Man and the Sea*. Otto Mathé (1907–1995), an Austrian sports idol, a Porsche icon and beacon for all those who tend toward throwing in the towel was such a man.

He worked real wonders at the wheel of racing cars, and with one arm only, his left. He had lost his right one in a terrifying accident at a 1934 Graz dirt track race having just changed from a muscle-driven cycle to a motorized one. With that, he had quickly become a force to be reckoned with. In practice for a Swiss hillclimb event Mathé, an amateur after all, had the same time with his Sunbeam 350 cc motorcycle as rising superstar Bernd Rosemeyer riding a DKW 500 with supercharger. Would he like to drive for him in a Silver Arrow, asked illustrious Mercedes team manager Alfred Neubauer. Mathé would not, however.

On 8 July 1949, the personable man from Innsbruck purchased an index fossil of the firm's history, in the shape of the Berlin–Rome car (Type 64), as well as two second-hand Gmünd coupés from Porsche-Konstruktionen-Ges.m.b.H. in Salzburg. With those he caused quite a stir, as he did with his featherweight Porsche special, called the "Fetzenflieger" (Tearer to Shreds). The

Einen richtigen Kerl kann man vernichten. Aber kleinkriegen lässt er sich nie. Das ist die Moral von Ernest Hemingways Erzählung *Der alte Mann und das Meer*. Otto Mathé (1907–1995), österreichisches Sportidol, Porsche-Ikone und Leuchtfeuer für alle, die am liebsten die Flinte ins Korn werfen würden, war so ein Kerl.

Am Lenkrad von Rennwagen wirkte er wahre Wunder, mit nur einem Arm, dem linken. Den rechten hatte er 1934 in einem schweren Unfall beim Sandbahnrennen von Graz verloren, nachdem er just vom per Muskel getriebenen auf das motorisierte Zweirad umgesattelt hatte. Schon mit dem war Mathé Extraklasse, fuhr zum Beispiel beim Training zu einem Schweizer Bergrennen als Amateur mit seiner Sunbeam-Dreihundertfünfziger die gleiche Zeit wie Bernd Rosemeyer auf einer DKW 500 mit Kompressor. Ob er nicht einmal einen Silberpfeil ausprobieren wolle, fragte Mercedes-Rennleiter Alfred Neubauer an. Mathé wollte nicht.

Am 8. Juli 1949 erstand der freundliche Innsbrucker bei der Porsche-Konstruktionen-Ges.m.b.H. Salzburg in Gestalt des Berlin–Rom-Wagens (Typ 64) ein Leitfossil der Firmengeschichte, dazu zwei gebrauchte Gmünd-Coupés, machte mächtig von sich reden mit diesen und mit seinem winzigen federleichten

Un homme digne de ce nom, un vrai, on peut le détruire. Mais il ne se laisse jamais abattre. Telle est la morale du roman *Le vieil homme et la mer*, d'Ernest Hemingway. Otto Mathé (1907–1995), idole du sport en Autriche, icône de Porsche et exemple à suivre pour tous ceux tentés de jeter l'éponge, était l'un de ces hommes.

Au volant d'une voiture de course, il faisait des miracles. Et il n'avait pourtant qu'un seul bras, le bras gauche. Celui de droite, il l'avait perdu en 1934, lors d'un grave accident durant une course de motos sur terre battue, à Graz, tout juste après avoir abandonné sa petite reine propulsée à la force du mollet pour un autre deux-roues, motorisé celui-là. Sur deux roues déjà, Mathé était un extraterrestre. Un exemple ? Lors des essais d'une course de côte en Suisse, où il s'était inscrit en amateur avec sa Sunbeam de 350 cm³, il a égalé le temps de Bernd Rosemeyer au guidon d'une DKW 500 à compresseur. N'aurait-il pas envie de tester un jour une Flèche d'argent, lui demanda le directeur de course de Mercedes, Alfred Neubauer. Mathé n'en avait pas envie.

Le 8 juillet 1949, le joyeux drille d'Innsbruck a acheté à Salzbourg un modèle Berlin–Rome (Type 64), un fossile antédiluvien de l'histoire de Porsche-Konstruktionen-Ges.m.b.H., ainsi que deux coupés Gmünd. Il fait énormément parler de lui avec ces derniers, comme avec sa minuscule Porsche-Special, un poids plume, la « Fetzenflieger ». Un nom qui était tout un programme, ce mot signifiant « mettre en morceaux ». En 1950, il gagne la Coupe des Alpes autrichienne, une médaille d'or et un edelweiss d'argent à l'occasion de l'Internationale Österreichische Alpenfahrt ; en 1952, ayant remporté 20 victoires en 20 participations, il remporte le Championnat autrichien.

Avec sa « Fetzenflieger », lors d'une course sur glace sur le lac de Zell, il se permet même de battre des champions aussi prestigieux que Hans Stuck senior et Richard von Frankenberg en personne.

Il a su faire oublier son handicap physique en transformant ses voitures avec la direction à droite, ce qui lui permettait de tenir le volant du thorax en virage et de changer de vitesse de la main gauche. Il aimait à parler de sa rencontre avec le Professeur Porsche (« Un homme si agréable… et si bon ! »). Celui-ci s'était déclaré enthousiasmé de la victoire de l'Autrichien Mathé dans la Coupe des Alpes avec l'une de ses voitures. Porsche l'avait alors invité à Stuttgart et avait examiné sous toutes les

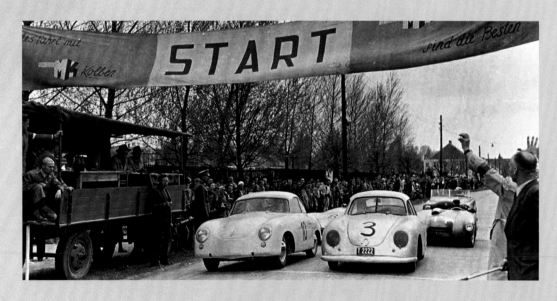

In this photo Otto Mathé (number 3) stands at the start of a smallish field in one of his Gmünd Coupés.

Hier steht Otto Mathé (Nummer 3) mit einem seiner Gmünd-Coupés am Start in einem dünn besetzten Feld.

Ici, Otto Mathé (numéro 3) avec l'un de ses Coupés Gmünd, au départ d'une course au plateau plutôt maigrelet.

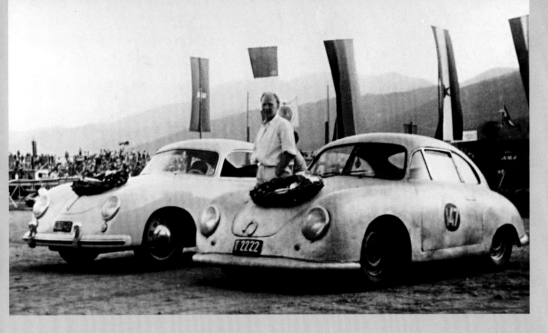

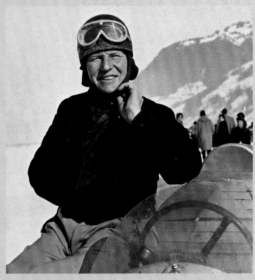

In spite of his serious handicap, Mathé was indefatigably busy racing his various cars, for instance in Abazia in 1954, on the Lake Zell in 1955 or at Krieau in 1953.

Seiner schweren Behinderung zum Trotz ist Mathé unermüdlich im Renntempo unterwegs, etwa 1954 in Abazia, 1955 auf dem Zeller See, 1953 in Krieau.

Malgré son grave handicap, Mathé est incroyablement rapide en course, par exemple en 1954 à Abazia, en 1955 au lac de Zell ou en 1953 à Krieau.

tiny racer's name set the agenda. In 1950, Mathé secured the Alpine Cup, Gold Medal and Silver Edelweiss for victory in the International Alpine Trial, notched up 20 firsts in as many events and became Austrian Champion in 1952, his most successful year. In an ice race on the frozen Lake Zell he beat established racing stars like Hans Stuck sr. and Richard von Frankenberg fair and square with the irrepressible "Fetzenflieger", not the only occasion he did so.

He coped with his physical handicap converting his vehicles to right-hand steering. His method of turning was leaning against the wheel, then shifting with his left hand. He was fond of telling about once meeting Professor Ferdinand Porsche ("Such a nice and affable gentleman"). Porsche had been very happy because, as an Austrian, Mathé had won the Alpine Trial in one of his products. He had invited him to Stuttgart, giving the silver gray Gmünd car a closer look there. Mathé had replaced its mechanical brakes with hydraulic ones. Porsche appreciated his work, saying "Bravo Mathé, I am so sorry that we did not meet earlier."

From 1960 onwards, Otto Mathé slowed his pace a bit. He pulled the plug on racing but remained the jack-of-all-trades he had always been. He patented and made ski bindings that are still being used today, repaired broken crankshafts, earned his shillings with oil and oil additives, went skiing (both water and snow), was an ardent bird watcher and serviced and maintained his fame. What he had once achieved was spectacularly documented by the Berlin–Rome car, exposed to the public eye in a glass-enclosed room of his house a stone's throw away from the Innsbruck railway station. Even his compatriot Niki Lauda, usually not given to idolatry, was a fan.

Porsche-Special, dem „Fetzenflieger". Der Name war Programm. 1950 gewann er den Alpenpokal, Goldmedaille und Silbernes Edelweiß im Rahmen der Internationalen Österreichischen Alpenfahrt, landete 1952 bei 20 Starts 20 Siege und wurde Staatsmeister der Alpenrepublik. Mit dem „Fetzenflieger" beim Eisrennen auf dem Zeller See schlug er Branchengrößen wie Hans Stuck den Älteren und Richard von Frankenberg.

Sein physisches Handicap bekam er in den Griff, indem er seine Autos auf Rechtslenkung umrüstete, das Volant in Kurven mit der Brust festhielt und mit der Linken schaltete. Gern erzählte er von seiner Begegnung mit Professor Porsche („So ein netter und gütiger Mensch!"). Der sei begeistert gewesen, weil sich der Österreicher Mathé den Alpenpokal mit einem seiner Produkte geholt hatte. Porsche habe ihn nach Stuttgart eingeladen und sich den silbergrauen Gmünd-Wagen genau angesehen. Mathé hatte dessen mechanische Bremsen durch hydraulische ersetzt. Das habe der alte Herr voller Anerkennung zur Kenntnis genommen: „Bravo, Mathé! Wären Sie mir nur schon früher über den Weg gelaufen!"

Ab 1960 ging er die Dinge gemütlicher an, hängte den Sturzhelm an den Nagel, blieb aber ein Hansdampf in mancherlei Gassen. Er hatte sich eine Skibindung patentieren lassen, die bis auf den heutigen Tag aktuell ist, fertigte diese auch, reparierte kaputte Kurbelwellen, verdiente seine Schillinge mit Öl und Ölzusätzen, war passionierter Skifahrer und Hobby-Ornithologe, wartete und pflegte seinen Ruhm. Für jedermann sichtbar kündete davon der Berlin–Rom-Wagen in einem von gläsernen Wänden umschlossenen Raum seines Hauses unweit des Innsbrucker Bahnhofs. Selbst der kühle Niki Lauda war Fan.

coutures le coupé Gmünd gris métallisé. Mathé en avait remplacé les freins mécaniques par un circuit hydraulique. Ce dont le vieil homme aurait pris connaissance avec beaucoup d'admiration : « Bravo, Mathé ! Dommage que nos routes ne se soient pas croisées plus tôt ! »

À partir de 1960, il préfère ralentir l'allure après avoir raccroché son casque, sans que cela affecte sa bonne humeur légendaire. Il a breveté et fabriqué une fixation de ski qui est encore utilisée aujourd'hui, s'est mis à réparer des vilebrequins cassés, a gagné sa vie avec de l'huile et des additifs de lubrifiants, est resté un skieur et un ornithologue amateur passionné, entretenant et cultivant sa célébrité. Sa voiture Berlin–Rome, témoin de son succès, est d'ailleurs exposée à la vue de tous dans une pièce vitrée de sa maison, à un jet de pierre de la gare d'Innsbruck. Même son compatriote Niki Lauda, pourtant peu enclin à l'idolâtrie, se réclamait fan.

The basic shape of the 356 had been untouched for about a decade: for this very reason, the changes it had been subject to were all the more striking at the Frankfurt IAA in September 1959. The robust bumpers of its B generation, protected by long and massive overriders, were installed higher and closer to the shell. Gills in the front apron served to cool the aluminum brake drums. The styling of the small louvers on the inside of the reshaped blinkers had been simplified, whereas the headlights had been allocated a higher position in the fender tips, and low-beam illumination of the roadway was also improved by asymmetrical headlights. Vent windows, to be found on the Cabriolet since 1957, were now standard.

Again the customer, long since a member of the sworn Porsche community, had the choice of a wide spectrum of models. The Coupé and the Cabriolet, also available with a removable hardtop, had been joined by a rare variant whose hardtop was in unit with the rest of the coachwork, built by the Karmann coachmaker in Osnabrück. After a brief life span, the Convertible, which had taken over from the Speedster in 1958, made way for the equally short-lived Roadster. It combined prominent features of both, with wind-up windows, a relatively big windshield and a thin canvas roof, for rudimentary protection against the vicissitudes of the northern climate.

With a displacement of exclusively 1600 cc, Porsche had nestled cosily into a niche provided by the international framework of categories motor sport's rule makers had established. In doing so, the Zuffenhausen marque slipped into the worthwhile role of the proverbial underdog, enabling it to be the first among the Davids and to occasionally threaten the Goliaths of the race track. In any case, there was power enough: 60 bhp in the case of the *"Dame"* ("the lady") as the weakest member of the family, 75 bhp for the Super and, from March 1960, 90 bhp for the Super 90, whose pushrod engine did not necessarily like longer bouts of full throttle.

While the lot of the Carrera de Luxe was reduced to that of a pitiable wallflower, its GT sibling, armed with 115 bhp from 1588 cc, enjoyed the universal esteem of private racers, who scored countless class and even overall wins with the nimble Swabian coupés. Introduced as early as fall 1961, the Carrera 2 broke new ground from spring 1962 onwards. Its 130 bhp (140 and 155 bhp in GT version) were produced by an even more torquey two-liter variety of the four-camshaft power plant. It had disk brakes as already put to the test on a Coupé at the Nürburgring 1000 Kilometers in 1959. Built in a circulation of just 436, it nevertheless crowned the 356 range.

Again at the Frankfurt IAA, the 356 B was displayed in 1961 with some conspicuous retouches which suited well what had become a true classic. Behind the rear window, a double grill looked after the ventilation of the flat-four. The boot lid, rounded elliptically up to then, had been flattened, and the tank filler nozzle was found below a small lid in the right front fender.

Gerade weil seine Grundform seit rund einer Dekade unangetastet war, fielen die Änderungen am Typ 356 auf der Frankfurter IAA im September 1959 erst recht ins Auge. Die robusteren Stoßstangen der Generation B, bewehrt mit massiven und längeren Hörnern, lagerten sich höher und enger an den Wagenkörper an. Zwecks Kühlung der Bremstrommeln durchbrachen Kiemen die vordere Schürze. Die Schallgitter innen neben den neu gestalteten Blinkleuchten waren simpler gestylt, und die Scheinwerfer lugten höher aus den Spitzen der Kotflügel hervor und leuchteten die Fahrbahn mit asymmetrischem Abblendlicht besser aus als zuvor. Ausstellfenster, am Cabriolet bereits 1957 zu finden, waren Standard.

Wieder hatte der Kunde, längst Angehöriger einer verschworenen Porsche-Gemeinde, die Qual der Wahl. Zu Coupé und Cabriolet, auch mit einem abnehmbaren Festdach verfügbar, gesellte sich eine rare Variante, deren Hardtop mit dem restlichen Aufbau verquickt war und die bei Karmann in Osnabrück gefertigt wurde. Das Convertible, das 1958 den Speedster abgelöst hatte, machte nach knapper Verweildauer dem ebenfalls kurzlebigen Roadster Platz. Er vereinigte markante Merkmale beider in sich, mit Kurbelfenstern sowie einer relativ großen Frontscheibe und einem dünnen Stoffdach als rudimentärem Schutz gegen die Schikanen nordischer Witterung.

Mit einem Motorvolumen von durchweg 1600 cm³ hatte man sich wohnlich in einer Nische eingerichtet, welche die internationalen Rennsport-Regularien vorsahen. Die Rolle, die den Zuffenhausenern dadurch zufiel, war durchaus dankbar: der Erste zu sein unter den Davids, gelegentlich eine Bedrohung darzustellen für die Goliaths der Piste. Kraft war in jedem Falle genug da, 60 PS im Falle der „Dame" als schwächstem Glied der Familie, 75 PS für den Super und, ab März 1960, 90 PS für den nicht unbedingt drehzahlfesten Super 90.

Eher ein Mauerblümchendasein blieb dem Carrera de Luxe beschieden, während sich der Carrera GT, mit 1588 cm³ und 115 PS glänzend gerüstet, bei den Sportfahrern großer Beliebtheit erfreute.

Bereits Ende 1961 vorgestellt, brach im Frühjahr 1962 der Carrera 2 zu neuen Ufern auf. Denn seine 130 PS (140 bzw. 155 PS als GT) wurden von einer ungemein elastisch zu Werke gehenden Zweiliter-Spielart des grollenden Viernockenwellentriebwerks bereitgestellt. Er hatte Scheibenbremsen, wie sie schon 1959 beim 1000-Kilometer-Rennen auf dem Nürburgring an einem Coupé erprobt worden waren. In lediglich 436 Exemplaren aufgelegt, krönte er gleichwohl die klug gefächerte Palette der Stuttgarter.

Wiederum auf der Frankfurt IAA zeigte sich der 356 B 1961 mit auffälligen Retuschen, die ihm gut zu Gesicht standen. Im Anschluss an die größere Heckscheibe besorgte ein Doppelgrill Beatmung und Kühlung des Boxermotors. Der Kofferraumdeckel, vorher elliptisch gerundet, war nun abgeflacht, und der Tankstutzen fand sich neuerdings rechts vorn im Kotflügel unter einer kleinen Klappe.

Les modifications apportées à la 356 à l'occasion de l'IAA de Francfort, en septembre 1959, sont d'autant plus frappantes que ses lignes générales n'avaient pas changé depuis une bonne dizaine d'années. Les pare-chocs plus fortement dimensionnés de la génération B, ornés de cornes massives et plus longues, sont positionnés plus haut et plus près de la carrosserie. Pour mieux refroidir les tambours de frein, des ouïes sont apparues sous le tablier avant. Les petits grillages contigus aux clignotants redessinés sont d'une forme simplifiée et les phares ont grimpé un peu plus haut sur les ailes, éclairant mieux la route qu'auparavant avec des feux de croisement asymétriques. Les déflecteurs, qui ont fait leur apparition sur le cabriolet en 1957 déjà, sont désormais de série.

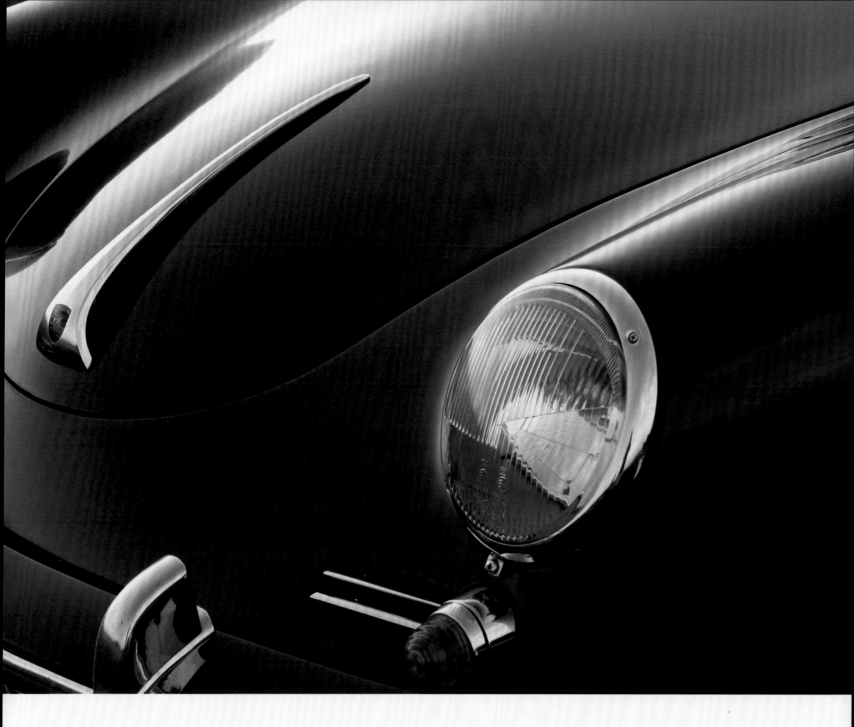

Une fois de plus, le client n'a que l'embarras du choix. Au coupé et au cabriolet (ce dernier disponible aussi avec un *hard-top* amovible) s'est jointe une variante rare dont le hard-top est fixé de façon permanente au reste de la carrosserie fabriquée chez Karmann, à Osnabrück. La Convertible, qui a supplanté le Speedster en 1958, cède à son tour la place, après un bref intermède, au Roadster, qui ne restera pas lui non plus longtemps au catalogue. Ce dernier réunit quelques caractéristiques marquantes de ses deux prédécesseurs, comme les fenêtres à manivelle, le pare-brise de relativement grande dimension et une mince capote offrant une protection rudimentaire contre les aléas de la météorologie septentrionale.

Les moteurs ont désormais tous une cylindrée de 1600 cm³, Porsche ayant investi un créneau établi par les règlements internationaux de la compétition automobile. Le rôle qu'endosse dès lors le constructeur de Zuffenhausen est des plus gratifiants : être le premier parmi les David et, occasionnellement, représenter une menace pour les Goliath des circuits. La puissance est, dans tous les cas, suffisante : 60 ch pour la fameuse « Dame » (le maillon faible de la dynastie), 75 ch pour la Super et, à partir de mars 1960, 90 ch pour la Super 90 (qui tolère toutefois très mal les hauts régimes). Par rapport à elles, la Carrera de Luxe joue un rôle plutôt discret, tandis que la Carrera GT, parfaitement armée avec ses 1588 cm³ et 115 ch, fait le bonheur des pilotes amateurs de compétition.

La Carrera 2, présentée dès fin 1961, ouvre un nouveau chapitre au printemps 1962. En effet, ses 130 ch (140 ou 155 ch en version GT) proviennent d'une variante de deux-litres du hargneux moteur à quatre arbres à cames qui se distingue par une extrême souplesse. Elle possède des freins à disque testés en compétition en 1959 sur un coupé lors de la mythique course des 1000 kilomètres du Nürburgring. Fabriquée à 436 exemplaires seulement, elle incarne le meilleur de la gamme des 356. À l'IAA de Francfort, la 356 B fait sa réapparition en 1961, avec des retouches frappantes qui lui vont fort bien. Juste en dessous de la lunette arrière de plus grande dimension, une double grille améliore la ventilation et le refroidissement du moteur boxer. Le couvercle de malle, jusqu'ici elliptique et arrondi, s'est maintenant aplati et la goulotte du réservoir d'essence se trouve désormais à l'avant, dans l'aile droite, sous un petit couvercle.

356 B

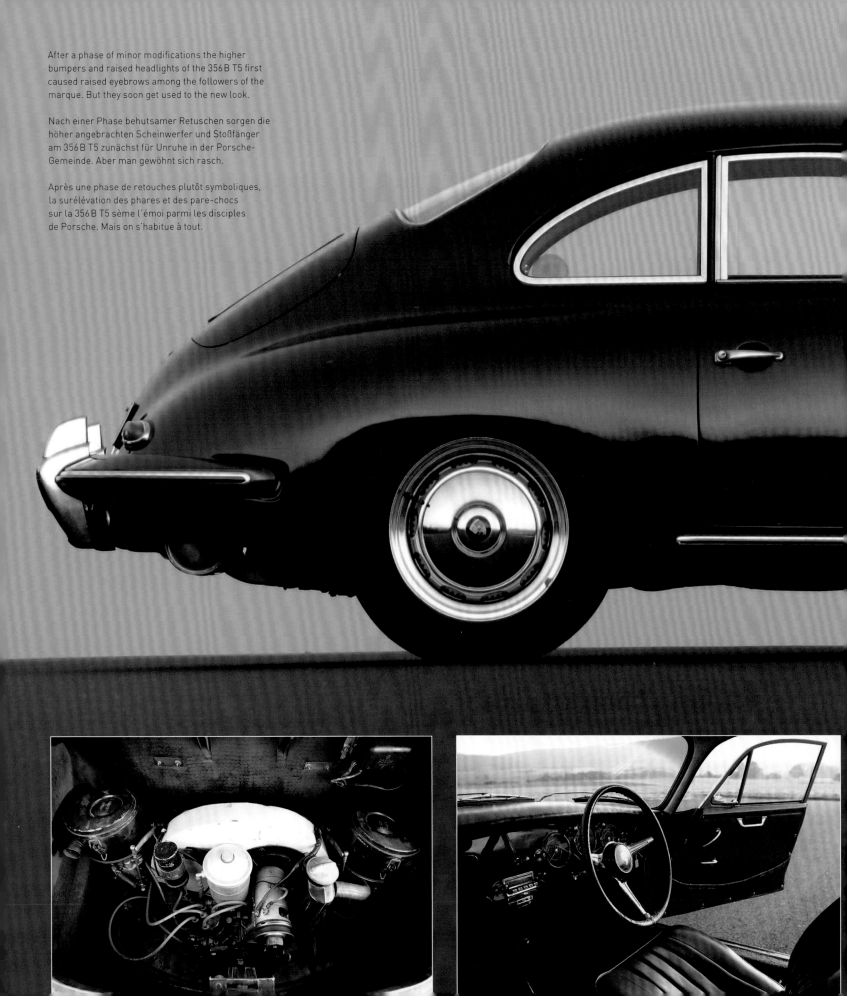

After a phase of minor modifications the higher bumpers and raised headlights of the 356 B T5 first caused raised eyebrows among the followers of the marque. But they soon get used to the new look.

Nach einer Phase behutsamer Retuschen sorgen die höher angebrachten Scheinwerfer und Stoßfänger am 356 B T5 zunächst für Unruhe in der Porsche-Gemeinde. Aber man gewöhnt sich rasch.

Après une phase de retouches plutôt symboliques, la surélévation des phares et des pare-chocs sur la 356 B T5 sème l'émoi parmi les disciples de Porsche. Mais on s'habitue à tout.

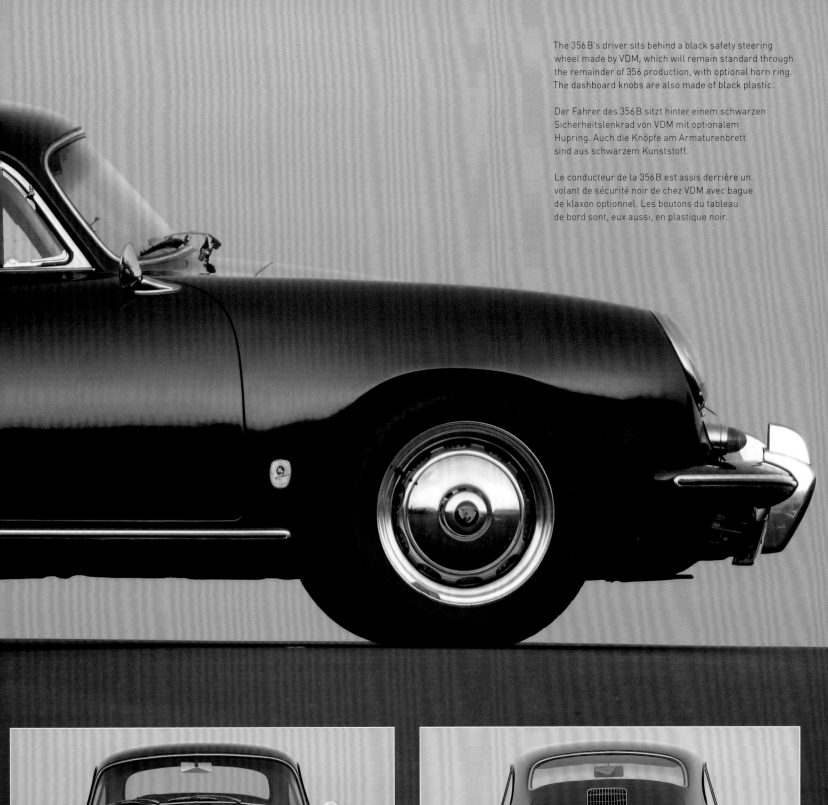

The 356B's driver sits behind a black safety steering wheel made by VDM, which will remain standard through the remainder of 356 production, with optional horn ring. The dashboard knobs are also made of black plastic.

Der Fahrer des 356B sitzt hinter einem schwarzen Sicherheitslenkrad von VDM mit optionalem Hupring. Auch die Knöpfe am Armaturenbrett sind aus schwarzem Kunststoff.

Le conducteur de la 356B est assis derrière un volant de sécurité noir de chez VDM avec bague de klaxon optionnel. Les boutons du tableau de bord sont, eux aussi, en plastique noir.

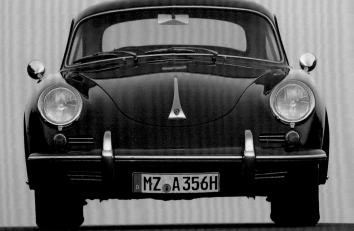

Its lavishly lined fabric hood makes the B Cabriolet a good partner in winter, too. With light-alloy cylinders and two Solex carburetors 40 PII-4 the engine of the Super 90 has been prepared for its additional power. But it is not necessarily full-throttle resistant.

Sein dick gefüttertes Stoffverdeck macht das B-Cabriolet zu einem guten Partner auch im Winter. Das Triebwerk des Super 90 ist mit Leichtmetallzylindern und zwei Solex-Vergasern 40 PII-4 auf seine höhere Leistung eingestimmt, aber nicht unbedingt vollgasfest.

Sa capote à l'épais capitonnage fait du Cabriolet B un compagnon de route fidèle même en hiver. Le moteur de la Super 90 développe une puissance supérieure grâce aux cylindres en aluminium et aux deux carburateurs Solex 40 PII-4, mais il est préférable de ne pas le pousser trop longtemps dans ses derniers retranchements.

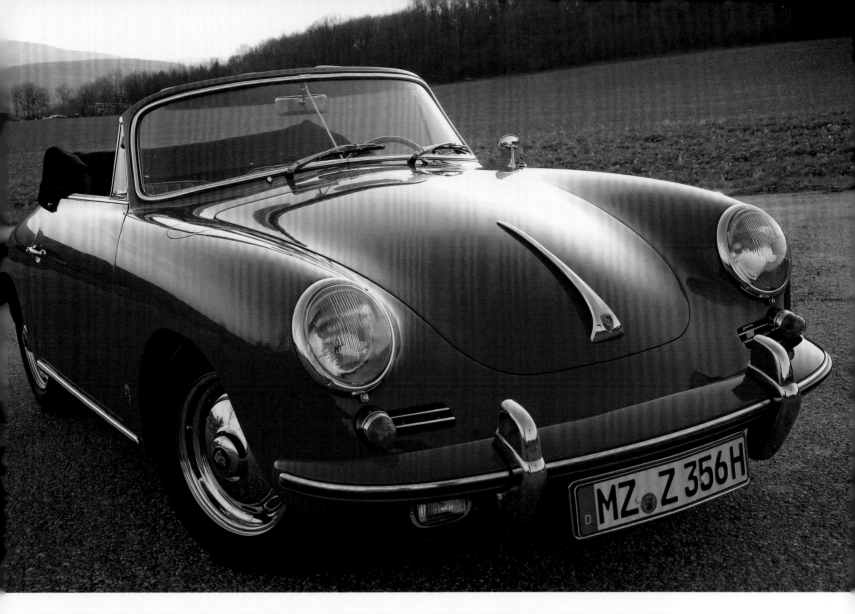

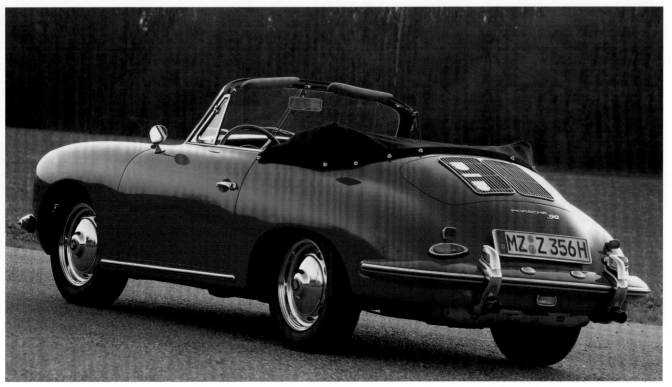

Porsche 356 B

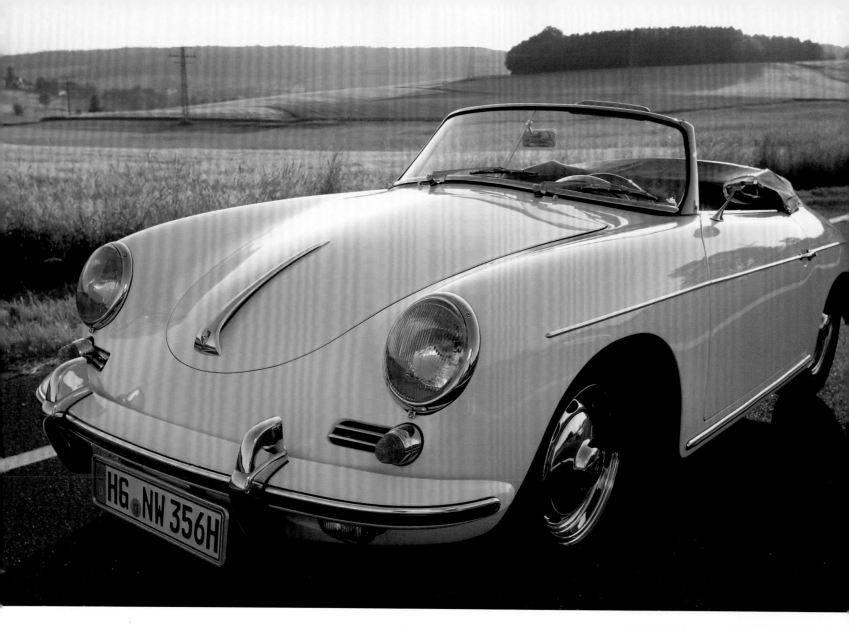

The spartan Roadster version with its low silhouette and the striking chromium-plated windshield frame, bolted onto the bodywork. It has a thin canvas roof only. Fueling the B-Type still necessitated opening the front lid.

Der spartanische Roadster mit seiner geduckten Linienführung und dem markanten, mit der Karosserie verschraubten Chromrahmen der Frontscheibe. Zum Betanken des B-Typs muss man noch immer den vorderen Deckel öffnen.

La spartiate version Roadster à la silhouette surbaissée, avec le typique jonc de décoration chromé de la baie de pare-brise vissé à la carrosserie. Elle ne possède qu'une mince capote. Pour remplir le réservoir de la type B, il faut encore ouvrir le capot avant.

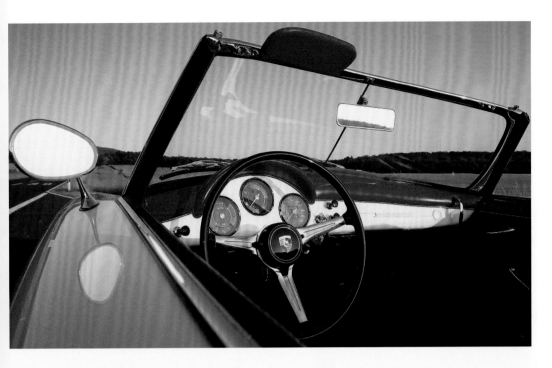

The austere dashboard of the Roadster is characterized by the arch vaulting above the three large round gages, with the rev counter sitting in the driver's prime field of vision.

Charakteristisch für die karge Armaturentafel des Roadsters ist der Rundbogen, unter dem der Drehzahlmesser zuoberst im Blickfeld des Fahrers angesiedelt ist.

Une caractéristique de l'austère tableau de bord du Roadster est l'arc de cercle sous lequel le compte-tours s'expose bien dans le champ de vision du conducteur.

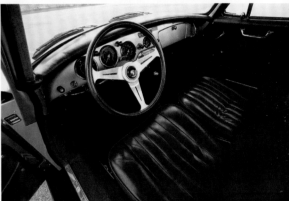

Not to everybody's liking and a rarity at that: the Hardtop-Coupé built at Karmann in Osnabrück. With the appearance of the T6 metamorphosis in summer 1961 the Super 90 designation is reduced to a mere 90.

Nicht jedermanns Geschmack und eine Seltenheit dazu: das Hardtop-Coupé, gebaut bei Karmann in Osnabrück. Mit dem Erscheinen des T6 im Sommer 1961 bleibt vom Super-90-Schriftzug nur die 90.

Il n'est pas du goût de chacun, mais, en revanche, absolument rarissime : le coupé hard-top construit chez Karmann, à Osnabrück. Avec l'apparition de la T6, durant l'été 1961, seul subsiste, du monogramme Super 90, le chiffre 90.

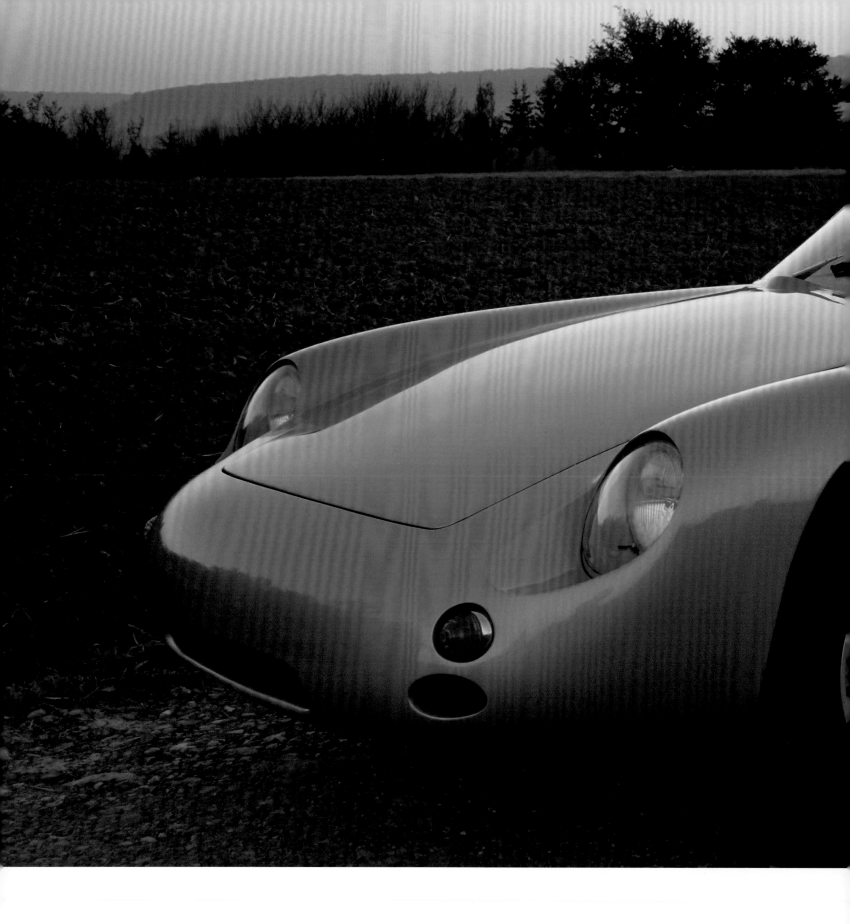

The Carrera GTL Abarth is based upon the 356 B. Its aerodynamic aluminum skin, longer, lower and equipped with larger windows, stems from Carlo Abarth of Torino.

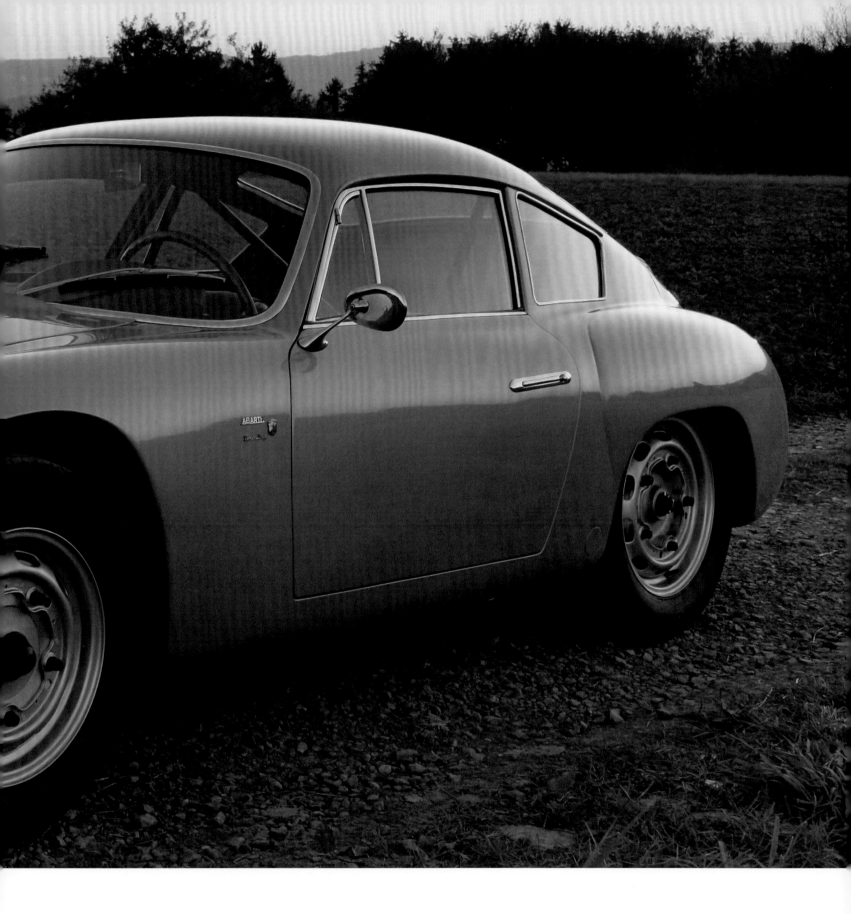

Der Carrera GTL Abarth fußt auf der Basis des 356 B.
Seine aerodynamische Aluminium-Außenhaut, länger,
flacher und mit voluminöserer Verglasung, stammt von
Carlo Abarth in Turin.

La Carrera GTL Abarth dérive de la 356 B. Sa carrosserie
aérodynamique en aluminium – plus longue, plus basse
et aux surfaces vitrées plus généreuses – est l'œuvre du
Turinois Carlo Abarth.

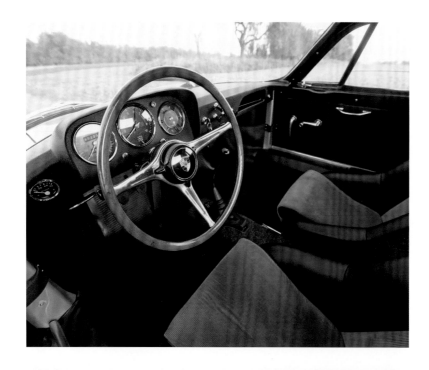

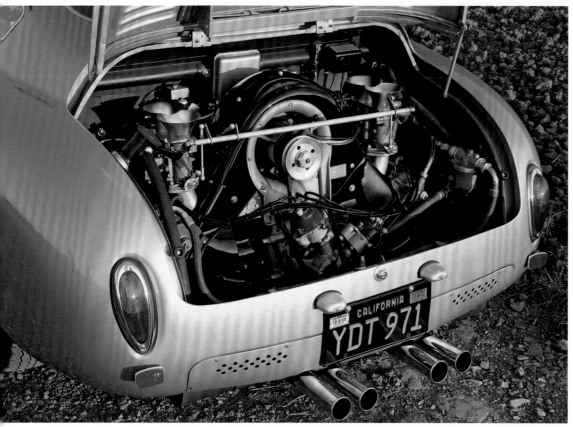

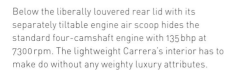

Below the liberally louvered rear lid with its separately tiltable engine air scoop hides the standard four-camshaft engine with 135 bhp at 7300 rpm. The lightweight Carrera's interior has to make do without any weighty luxury attributes.

Unter der vielfach durchbrochenen Heckhaube mit ihrer separat abklappbaren Lufthutze verbirgt sich der Viernockenwellenmotor mit 135 PS bei 7300/min. Der Innenraum muss ohne gewichtigen Luxus auskommen.

Sous le capot moteur aux multiples fentes avec sa prise d'air rabattable séparément se dissimule le moteur à quatre arbres à cames de 135 ch à 7300 tr/min. L'habitacle renonce à tout luxe superflu.

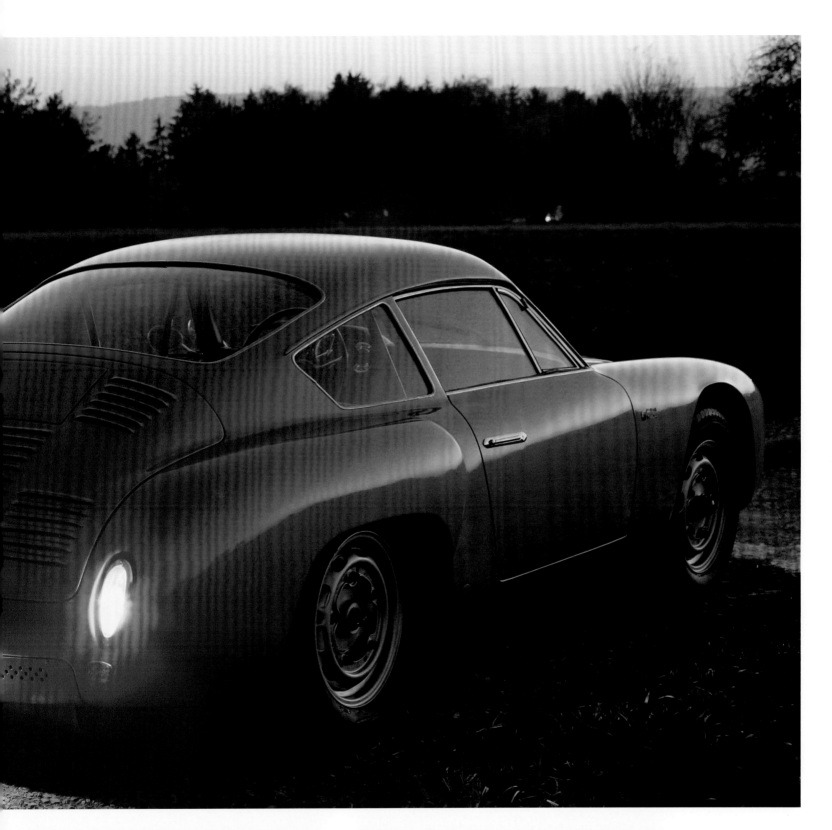

The third letter of the 356 ABC became topical in July 1963, the latest and last evolutionary stage of the Zuffenhausen classic being presented at the Frankfurt IAA a couple of weeks later. With the final scion of the family became obvious what was perfectly suited as a Porsche mantra for the future: even the seemingly consummate can be improved. To start with, the range was streamlined by pensioning off the traditional "Dame" ("lady") entry model with its mild 60 bhp, as well as the comparatively youthful Roadster. Porsche now concentrated on the Coupé, the Cabriolet and the so-called Hardtop version featuring a fixed roof welded in place, whose production had been outsourced to Karmann, the Osnabrück coachbuilder.

The superstructures of the B predecessor, in its revised form as of fall 1961, were carried over without any major changes. However, the cabin and, above all, the driver's workplace had been retouched, as usual. That the dashboard had grown a vertical protuberance was compensated by a shorter gear lever. Formerly a couple of turns at a knurled button were necessary to control the heating, while now it could be quickly regulated via a lever on the center tunnel; the rear window was ventilated by means of two vents. Retouches were much more radical in terms of driving safety and comfort. Characteristically, the feedback from the firm's racing cars had left its mark everywhere. Flat hubcaps on new 15-inch rims with smaller hole circles visually betrayed the presence of four disk brakes. They came from a supplier named ATE (Alfred Teves), complying with the Dunlop system, while the competition cars of the make and the Carrera 2 were equipped with the more expensive variety of Porsche's own manufacture. One extra millimeter strengthened the front stabilizer, and, along with softer and preloaded round torsion bars at the rear axle, this made for the 356 C's better roadholding, while a supplementary rubber spring elastically limited suspension travel so as to nip shock absorber damage in the bud. A compensating spring, which had been standard on the B-Type, was available as an option.

Engine wizard Hans Mezger had taught even better manners to the remaining pushrod engines with 75 bhp (in the 1600 C) and 95 bhp (in the top-of-the-range 1600 SC, formerly known as Super 90). This had been effectuated by a different shape of the piston heads and modifications to valve timing, spring caps, inlet and exhaust ports, crankcase ventilation, air and idling jets, as well as the crankshaft and main bearings. The powerful SC engine had to be handled with care, nevertheless, as even the works themselves pointed out. While the valve gear had no problem at all with revs beyond the red line at 5500 rpm, the bearings could not cope with the pressures that then occurred.

The last of 16,668 Porsche 356 Cs, a white Cabriolet, rolled off the assembly line in April 1965. Altogether 76,302 specimens had demonstrated Professor Ferdinand Porsche's idea number 356 to happy owners all over the world. But now the time was ripe for something new.

Die dritte Stufe im ABC der Baureihe 356 wurde im Juli 1963 gezündet und bald darauf auf der IAA zu Frankfurt gezeigt. Zugleich klang an, was sich trefflich als Porsche-Mantra für die Zukunft eignen würde: Selbst das perfekt Scheinende lässt sich noch perfektionieren.

Zunächst einmal straffte man das Sortiment, sonderte das traditionelle Einstiegsmodell „Dame" mit seinen sanften 60 PS ebenso aus wie den vergleichsweise jugendfrischen Roadster. Es verblieben Coupé, Cabriolet und die auswärts bei Karmann in Osnabrück hergestellte Hardtop-Variante mit integriertem Festdach.

Ohne wesentliche Retuschen übernahm man die Karosserien der Variante B in der Ausbaustufe vom Herbst 1961. Gleichwohl war wie üblich der Wohn- und Arbeitstrakt überarbeitet worden. Dass die Armaturentafel in der Mitte eine Protuberanz nach unten angesetzt hatte, fing man mit einem kürzeren Schalthebel auf. Wo früher etliche Drehungen an einem Rändelknopf gefragt gewesen waren, ließ sich die Heizung nun zügig über einen Hebel auf dem Mitteltunnel regulieren, und die Heckscheibe wurde über zwei Ausströmöffnungen mit Warmluft beschickt.

Entschiedenere Eingriffe betrafen Fahrsicherheit und -komfort. Wie immer war ihnen ein lebhafter Dialog mit den Rennmodellen der Marke vorhergegangen. Flache Radkappen auf den neuen 15-Zoll-Felgen mit kleineren Lochkränzen bezeugten visuell die Anwesenheit von vier Scheibenbremsen. Sie gingen nach dem System Dunlop zu Werke und wurden bezogen vom Zulieferer ATE (Alfred Teves), während die Wettbewerbswagen und der Carrera 2 mit den teureren Anlagen aus eigener Fertigung ausgestattet waren. Ein um einen Millimeter verstärkter Stabilisator vorn sowie weichere und vorgespannte Drehstäbe an der Hinterachse taten der Straßenlage des 356 C gut, während eine Zusatzfeder aus Gummi den Federweg elastisch begrenzte und Stoßdämpferschäden vereitelte. Eine Ausgleichsfeder, beim B noch Standard, war nur noch auf Sonderwunsch erhältlich.

Den verbleibenden Stoßstangenmotoren mit 75 PS (im 1600 C) und 95 PS (im 1600 SC, vormals Super 90) hatte Triebwerks-Guru Hans Mezger verbindlichere Manieren beigebogen. Verändert wurden die Form der Kolbenböden, die Steuerzeiten, Federteller, Ein- und Auslasskanäle, die Entlüftung des Kurbelgehäuses, Luft- und Leerlaufdüsen sowie Kurbelwelle und Hauptlager. Die mögliche Leistung des SC war gleichwohl mit Vorsicht zu genießen, worauf sogar das Werk vorsorglich aufmerksam machte. Zwar steckte der Ventiltrieb selbst Drehzahlen im roten Bereich jenseits von 5500/min locker weg, aber die Lager waren den Drücken nicht gewachsen, die dann auftraten.

Der letzte von 16 668 Porsche 356 C, ein mit einem hübschen Blumenbukett geschmücktes weißes Cabriolet, rollte im April 1965 vom Band. 76 302 Exemplare insgesamt hatten die Botschaft Nummer 356 des Professors Ferdinand Porsche in alle Welt hinausgetragen. Aber nun war die Zeit reif für etwas Neues.

Porsche continue de décliner la gamme 356. Après la A et la B, la C fait son apparition en juillet 1963, et elle est présentée quelques semaines plus tard à l'IAA de Francfort. Elle est la preuve que même ce qui semble parfait peut toujours être perfectionné: un exemple judicieux pour Porsche à l'avenir.

Dans un premier temps, le programme est élagué avec le retrait du marché du modèle d'entrée de gamme, la « Dame » avec ses dociles 60 ch, puis du Roadster pourtant encore tout jeune. Il reste donc le coupé, le cabriolet et la variante hard-top à toit rigide intégré, dont la fabrication est délocalisée chez Karmann à Osnabrück.

La carrosserie de la variante B est reprise sans modifications notables pour le modèle de l'automne 1961. Comme d'habitude, cockpit et mécanique ont

1963–1965

été revus et corrigés. Un pommeau de vitesses plus court permet de compenser une protubérance qui a fait son apparition sous le tableau de bord. Le chauffage se règle dorénavant instantanément à l'aide d'un levier au-dessus du tunnel de transmission maintenant qu'a disparu l'ancienne molette qu'il fallait tourner interminablement. Quant à la lunette arrière, deux aérateurs permettent de la désembuer avec de l'air chaud.

Des modifications plus importantes améliorent la sécurité et le confort de conduite. Comme toujours, la marque tire des enseignements de la compétition, où elle s'engage de plus en plus. Les enjoliveurs de roue plats sur les nouvelles jantes de 15 pouces avec une couronne de trous de plus petit diamètre trahissent visuellement la présence de quatre freins à disque. Ils reprennent le principe

Dunlop, mais sont fournis par l'équipementier ATE (Alfred Teves), contrairement aux voitures de course et à la Carrera 2, qui sont dotées d'un système de freinage plus onéreux de fabrication maison. Une barre antiroulis au diamètre accru d'un millimètre à l'avant ainsi que des barres de torsion plus souples et prétendues pour le train arrière améliorent la tenue de route de la 356C, tandis qu'un ressort supplémentaire en caoutchouc limite élastiquement le débattement, empêchant ainsi d'endommager les amortisseurs. Le ressort de compensation encore proposé en série sur la B n'est maintenant plus disponible qu'en option.

Les derniers moteurs culbutés de 75 ch (sur la 1600C) et 95 ch (sur la 1600SC, l'ancienne Super 90) font maintenant preuve d'un comportement plus civil depuis l'intervention du gourou des moteurs

Hans Mezger. Celui-ci a modifié la forme des têtes de piston, la distribution, les coupelles de ressorts, les tubulures d'aspiration et d'échappement, la ventilation de l'embiellage, les tuyères d'air et de ralenti ainsi que le vilebrequin et les paliers principaux. La distribution des soupapes tolère aisément des régimes dans la zone rouge au-delà de 5500 tr/min, mais ce sont les paliers qui ne sont pas en mesure de résister aux pressions qui surviennent alors.

La dernière des 16668 Porsche 356C, un cabriolet blanc orné d'un joli bouquet de fleurs, est sorti des chaînes en avril 1965. Au total, 76302 exemplaires ont véhiculé le numéro 356 du Professeur Ferdinand Porsche dans le monde entier. Mais le temps est maintenant venu pour un modèle résolument nouveau.

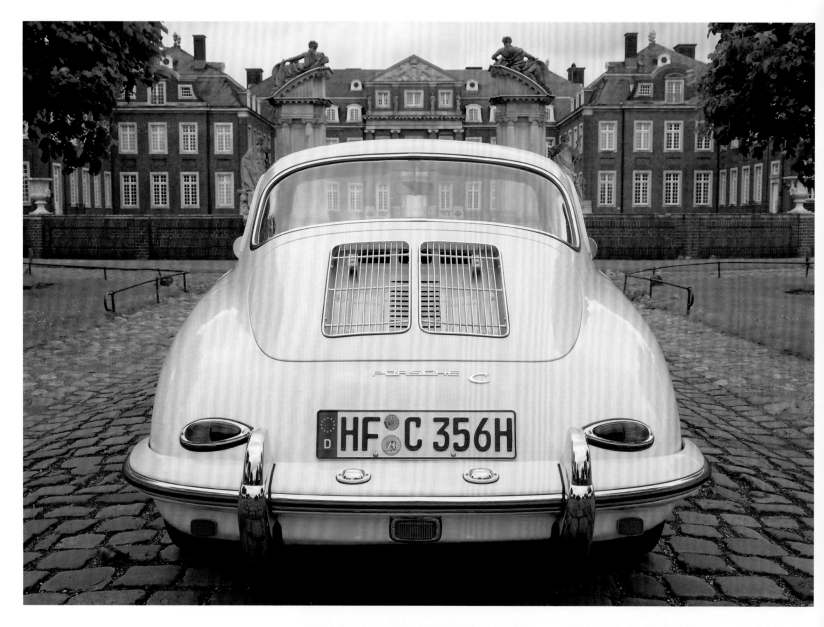

Top C: the only conspicuous change distinguishing the 356 C, apart from the model designation on the rear, is the different wheels and hubcaps made necessary by disk brakes at all four corners.

Hohes C: Auffällig an der letzten Ausbaustufe des 356, abgesehen von der Typenbezeichnung am Heck, sind die geänderten Räder und Radkappen, bedingt durch Scheibenbremsen an allen vier Ecken.

C fini : hormis la désignation du modèle à l'arrière, l'ultime évolution de la 356 se distingue visuellement par les roues et capuchons de roue différents imposés par les freins à disque aux quatre angles.

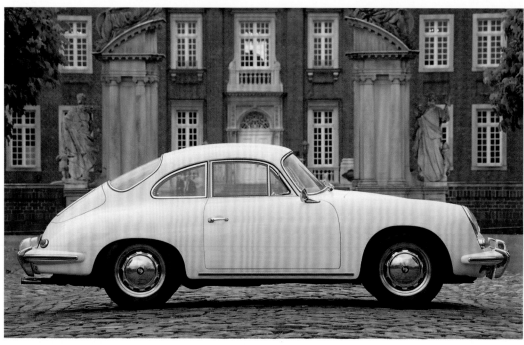

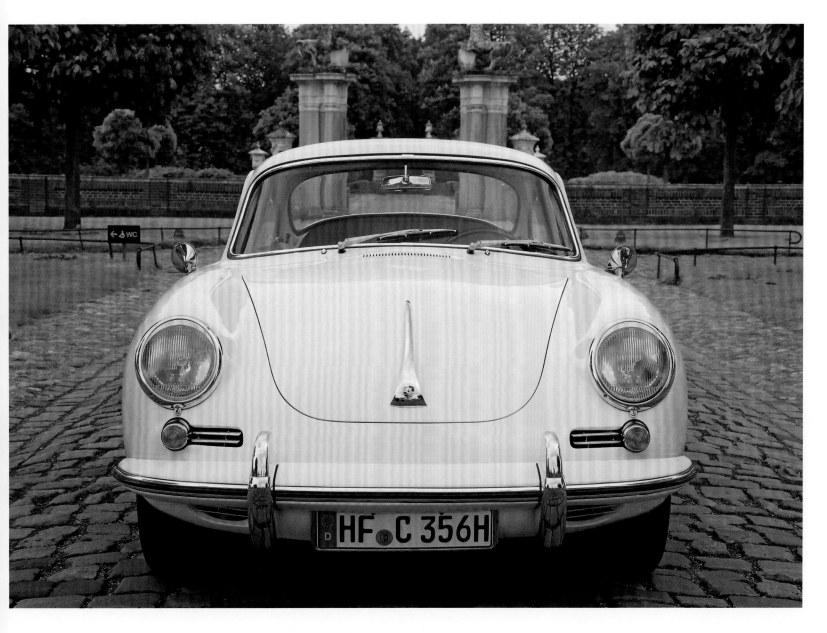

The last 356 in its pushrod varieties is available as a C with 75 bhp and the ultimate SC version delivering a potent 95 bhp. C models always have the "Durant" rearview mirror.

Den letzten 356 in den Stoßstangenversionen gibt es als C mit 75 PS und in der ultimativen Version SC mit 95 PS. Die C-Modelle haben stets den „Durant"-Außenspiegel.

La dernière 356 dans l'exécution à moteur culbuté est disponible en une version C de 75 ch tandis que la version SC, la plus sophistiquée, a 95 ch. Les modèles C possèdent toujours le rétroviseur extérieur « Durant ».

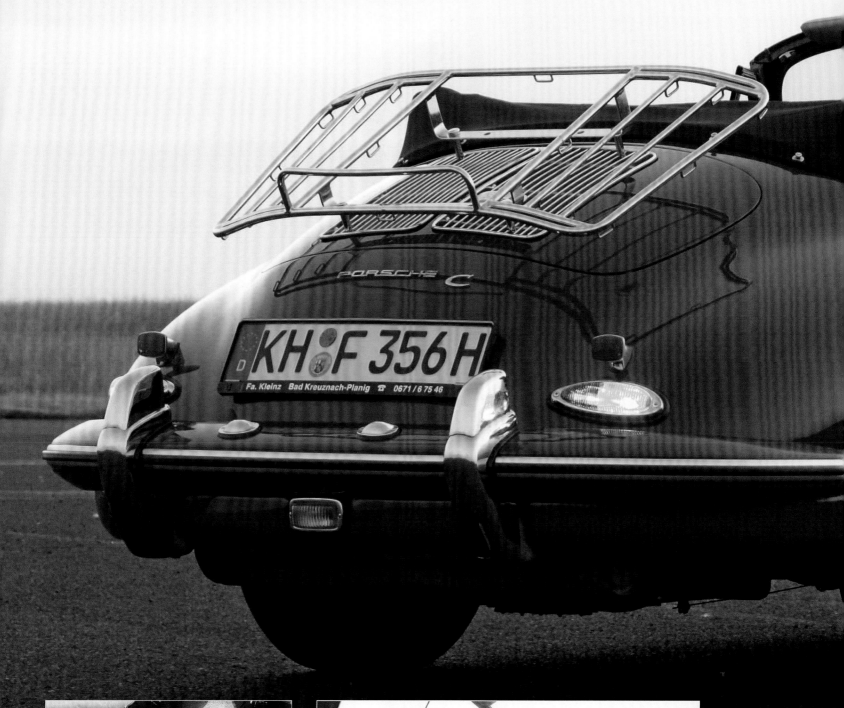

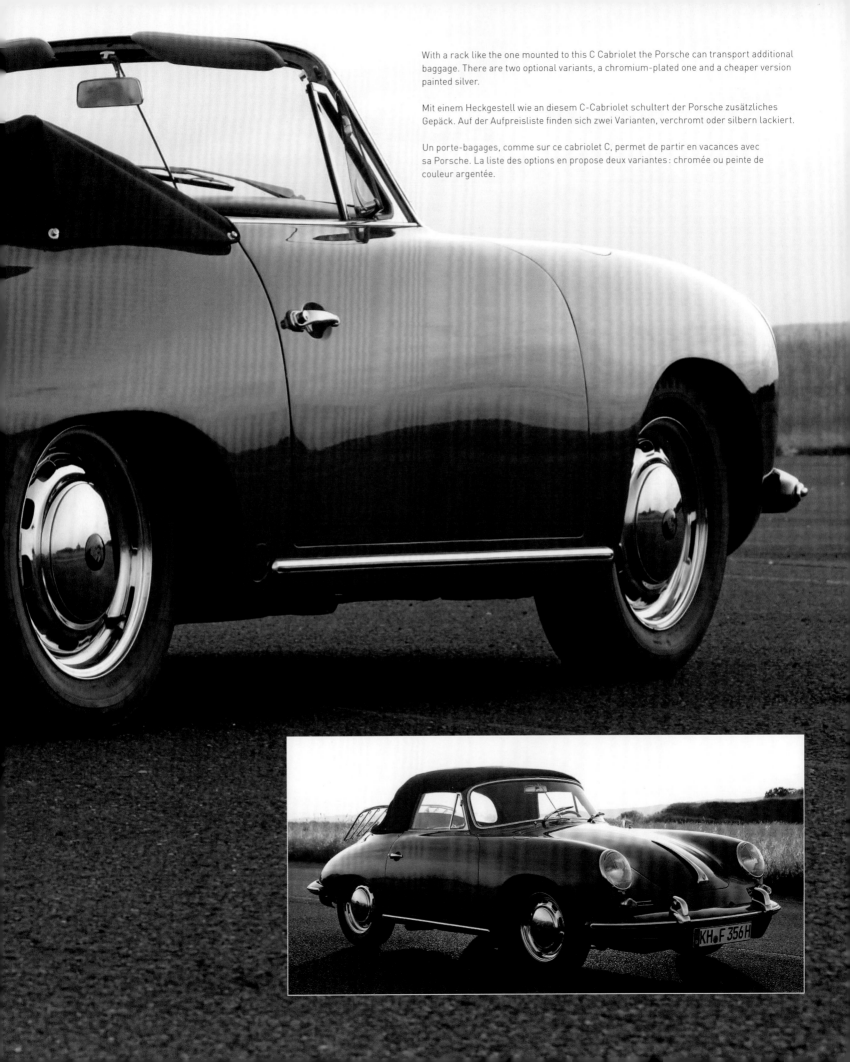

With a rack like the one mounted to this C Cabriolet the Porsche can transport additional baggage. There are two optional variants, a chromium-plated one and a cheaper version painted silver.

Mit einem Heckgestell wie an diesem C-Cabriolet schultert der Porsche zusätzliches Gepäck. Auf der Aufpreisliste finden sich zwei Varianten, verchromt oder silbern lackiert.

Un porte-bagages, comme sur ce cabriolet C, permet de partir en vacances avec sa Porsche. La liste des options en propose deux variantes : chromée ou peinte de couleur argentée.

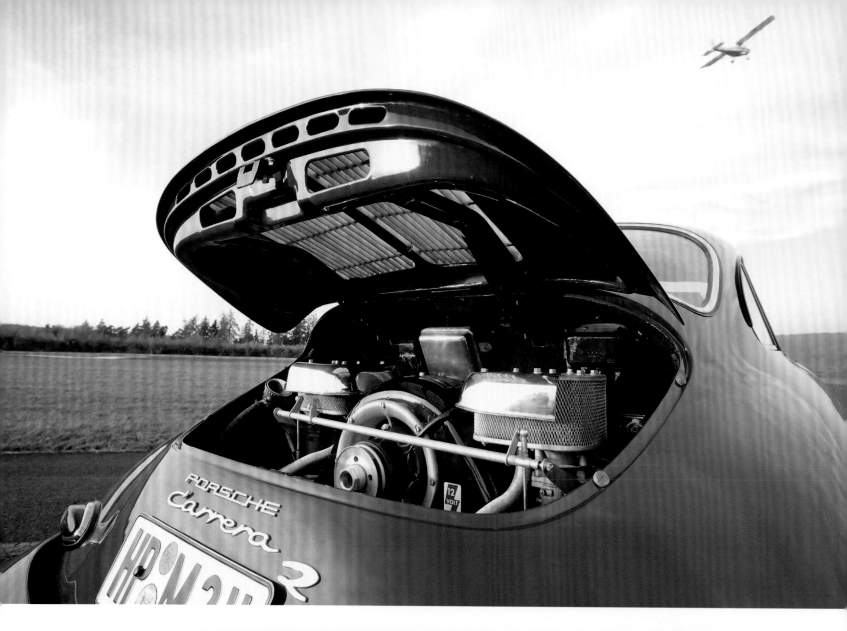

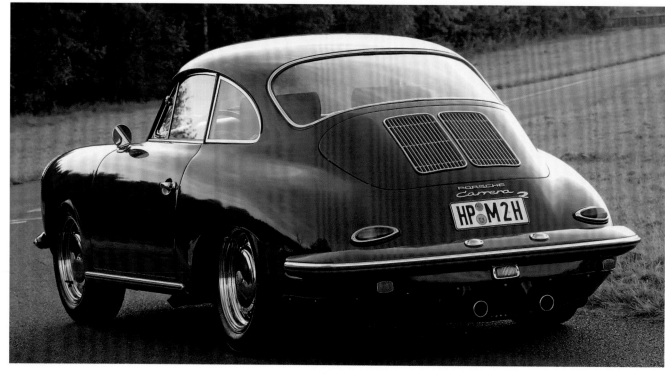

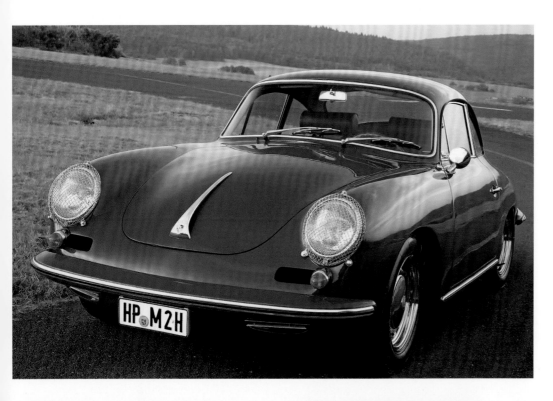

The C model range is crowned by the Carrera 2, perfectly reconciling comfort, luxury and speed with its high-torque and cultivated 130 bhp power plant.

Die C-Modellpalette wird gekrönt vom Carrera 2, der Komfort, Luxus und Leistung auf harmonische Weise in Einklang bringt. Sein drehmomentstarker und kultivierter Motor leistet 130 PS.

La gamme C est couronnée par la Carrera 2, symbiose harmonieuse de confort, de luxe et de puissance. Son moteur cultivé et très coupleux développe 130 ch.

Like Father like Son
Span vom alten Klotz
Tel père, tel fils

In Germany the saying goes that the apple will not fall far from the trunk. When a son takes after his father, the English word it even more drastically: he's a chip off the old block. Without doubt, that saying applied to Ferdinand Porsche jr., universally known as Ferry. Born in Wiener Neustadt on 19 September 1909, he failed to be eclipsed by his illustrious forebear although he inevitably followed in his slipstream for a while, for example as an employee of his Stuttgart engineering office from 1 December 1930 onward, as head of the Volkswagen testing program from 1934, as authorized signatory and member of Dr. Ing. h.c. F. Porsche KG from 1938.

In those years Ferry Porsche was already very much his own man, full of his own ideas. He had been of unchildish seriousness and single-mindedness from an early age. A photo taken in 1920 shows the eleven-year-old at the wheel of the pretty "billy goat car" his father had built for him, in calmly triumphant pose like contemporary racing greats such as Christian Lautenschlager or Max Sailer—a minor professional and even capable

Der Apfel, sagt man, falle nicht weit vom Stamm. Noch drastischer formulieren es die Engländer: A chip off the old block, heißt es, wenn ein Sohn nach dem Vater schlägt, im übertragenen Sinne, versteht sich. Zweifellos war Ferdinand Porsche der Jüngere, genannt Ferry, so ein Span vom alten Klotz. Am 19. September 1909 in Wiener Neustadt geboren, stand er gleichwohl nie im Schatten seines illustren Vaters. Aber naturgemäß schwamm er eine Zeit lang in dessen Windschatten mit, als Mitarbeiter in seinem Stuttgarter Konstruktionsbüro ab 1. Dezember 1930 zum Beispiel, als Leiter der Erprobung für den Volkswagen ab 1934, als Prokurist und Gesellschafter der Dr. Ing. h.c. F. Porsche KG 1938.

Da hatte Ferry Porsche schon längst viel Eigenes im Sinn, war bereits früh von unkindlicher Ernsthaftigkeit gewesen. Ein Foto von 1920 zeigt den Elfjährigen am Lenkrad des hübschen „Ziegenbockwagens", den sein Vater für ihn gebaut hatte, in markiger Pose ganz nach Art der Großen jener Zeit wie Christian Lautenschlager oder Max Sailer – ein kleiner

Tel père, tel fils, dit-on en français. Les Allemands, de façon plus imagée, déclarent que la pomme ne tombe pas loin du tronc. Quant aux Anglais, ils vont encore plus loin : a chip off the old block, disent-ils lorsqu'un fils est taillé dans le même bois que son père, au sens figuré, bien évidemment. Incontestablement, Ferdinand Porsche junior, surnommé Ferry, était taillé dans le même bois que son père. Né le 19 septembre 1909 à Wiener Neustadt, il n'a pourtant jamais vécu dans l'ombre de son illustre père. Mais, naturellement, tel un rémora, il a nagé un certain temps dans son sillage, en tant que collaborateur de son bureau d'études de Stuttgart, dès le 1er décembre 1930, par exemple, où il dirigea les essais pour Volkswagen à partir de 1934 avant de devenir fondé de pouvoir et associé de la société Dr. Ing. h.c. F. Porsche KG en 1938.

Il y a des lustres que Ferry Porsche avait déjà des idées bien arrêtées, ayant très tôt affiché un naturel sérieux qui n'avait rien d'enfantin. Une photo de 1920 représente le gamin de 11 ans au volant du joli chariot à bœufs que son père avait construit pour lui, rayonnant de fierté dans le plus pur style des grands de son époque, tels Christian Lautenschlager ou Max Sailer – un petit pro et, en course automobile, même capable de réaliser d'excellents temps. On ne tarda pas à constater que le vieux professeur avait, avec son rejeton ambitieux, un partenaire génial à ses côtés, ce

Proud moments: Ferry Porsche in 1920 during a gymkhana in a Christmas present from his father, a two-seater featuring a two-cylinder four-stroke engine and two gears, and in 1993 with his son Alexander and 911s from the years 1964 and 1993.

Stolz wie ein Schneekönig: Ferry Porsche 1920 bei einer Gymkhana im Weihnachtsgeschenk seines Vaters, einem Zweisitzer mit einem Zweizylinder-Viertakter und zwei Gängen, und 1993 mit Sohn Alexander und Elfern der Jahrgänge 1964 und 1993.

Tout fier: Ferry Porsche en 1920 – après un gymkhana avec le cadeau de Noël de son père, une petite voiture à deux places, à moteur bicylindre à quatre temps et à deux vitesses – et en 1993, avec son fils Alexander et des 911 de 1964 et 1993.

Visits to the racing front: at the Targa Florio in 1969 between winners Udo Schütz and Gerhard Mitter, and in 1972 with Roger Penske at Watkins Glen.

Der Rennsport ist Vater aller Dinge: 1969 bei der Targa Florio zwischen den Siegern Udo Schütz und Gerhard Mitter, 1972 mit Roger Penske in Watkins Glen.

Occupation favorite, la course : en 1969, à la Targa Florio entre les vainqueurs Udo Schütz et Gerhard Mitter, ainsi qu'en 1972 avec Roger Penske à Watkins Glen.

of some acceptably quick times in local events organized by the Vienna Automobile Club. That Ferry stood by the old Professor as a congenial partner was revealed most impressively by the Type 360, better known as Cisitalia, a grand prix racing car for Italian industrialist Piero Dusio, which took shape in 1947 under his guidance. Not unlike the "P" model adopted by Auto Union in 1933 as their contender for the 750-kg formula, in whose conception Ferry Porsche had been involved from the outset, the plump and compact single-seater was far ahead of its time. Its supercharged 1.5-liter flat twelve with two overhead camshafts per cylinder bank, installed in front of the rear axle like the car's synchronized five-speed gearbox, delivering 350 bhp at 10,500 rpm, bore testimony to that, as did its switch-on four-wheel-drive. Unfortunately, owing to the client's lack of funds, it never made it beyond the test stage. Ferry was also the mastermind behind the 356, which saw the light of day in Carinthian Gmünd in the late forties, destined to be the backbone as well as the apotheosis of Porsche activities from 1950. After his father's death in January 1951, Ferry Porsche became principal of the young sports car manufacturer, keeping that position until the family unanimously decided to withdraw from its actual management on 1 March 1972. Until he was relieved by his first-born son Ferdinand Alexander in March 1990, he looked after the fortunes of Porsche AG as Chairman of the Supervisory Board.

When Vienna's Technical University presented him with an honorary doctorate in 1965, he was on par with his father and role model in academic terms as well. As early as 1959, the then Federal President Theodor Heuss had awarded him the highest Order of Merit of the Federal Republic of Germany. Further honors and decorations were to follow.

Ferdinand Porsche the Second, known as Ferry, died on 27 March 1998. He had dedicated his life to "driving at its most glamorous"— what a great and fascinating objective...

Profi und im Rennsport sogar durchaus zu guten Zeiten fähig. Dass dem alten Professor mit dem strebsamen Sprössling ein kongenialer Partner zur Seite stand, zeigte sich spätestens am Typ 360, besser bekannt als Cisitalia, einem Grand-Prix-Rennwagen für den italienischen Industriellen Piero Dusio, der 1947 unter seiner Leitung entstand. Nicht unähnlich dem 1933 von der Auto Union adoptierten „P"-Modell, in dessen Konzeption Ferry von Anbeginn eingebunden war, wies der gedrungen-rundliche Renner weit über seine Zeit hinaus. Indizien dafür waren sein Boxermotor mit zwölf Zylindern, anderthalb Litern Volumen und zwei oben liegenden Nockenwellen pro Bank und Kompressor, wie das ihm baulich nachgeordnete synchronisierte Fünfganggetriebe vor der Hinterachse angesiedelt und zu 350 PS bei 10 500/min fähig, ebenso wie der zuschaltbare Vierradantrieb. Unter seiner Führung nahm im Kärntner Gmünd auch der 356 Gestalt an, ab 1950 Rückgrat und Krönung der Porsche-Aktivitäten.

Nach dem Tod seines Vaters im Januar 1951 avancierte Ferry Porsche zum Firmenchef und hatte diese Position inne bis zum einvernehmlichen Beschluss der Familienmitglieder, sich am 1. März 1972 aus der Geschäftsführung zurückzuziehen. Anschließend bis zum März 1990, als ihn sein Erstgeborener Ferdinand Alexander ablöste, gestaltete er die Geschicke der Porsche AG als Vorsitzender des Aufsichtsrats mit.

Als ihm 1965 die Technische Hochschule Wien die Ehrendoktorwürde verlieh, zog er gewissermaßen auch akademisch mit seinem Vater und Vorbild gleich. Bereits 1959 hatte ihn der damalige Bundespräsident Theodor Heuss mit dem Großen Verdienstkreuz der Bundesrepublik Deutschland ausgezeichnet, weitere Ehrungen und Auszeichnungen folgten. Ferdinand Porsche der Zweite, genannt Ferry, starb hochbetagt am 27. März 1998. Er hatte sich dem „Fahren in seiner schönsten Form" verschrieben – welch ein attraktiver Lebensinhalt!

que prouva plus tard la 360, mieux connue sous le nom de Cisitalia, une voiture de Grand Prix conçue pour l'industriel italien Piero Dusio, réalisée en 1947 sous la direction de Ferry. Elle n'est pas sans présenter des similitudes avec le modèle « P » adopté en 1933 par Auto Union et à la conception de laquelle Ferry a participé dès le début, petit bolide de course aux lignes râblées très en avance sur son temps. Pour preuves : son moteur boxer à douze cylindres, d'un litre et demi de cylindrée et à deux arbres à cames en tête par banc de cylindres, doté d'un compresseur, moteur placé devant le train arrière, comme la boîte manuelle à cinq vitesses synchronisées qui lui est accolée, et capable de développer une puissance de 350 ch à 10 500 tr/min, sans oublier une transmission intégrale débrayable. C'est aussi sous sa férule qu'a pris forme, à Gmünd, en Carinthie, la 356 qui allait devenir en 1950 l'épine dorsale et participer au couronnement des activités de Porsche.

Après le décès de son père en janvier 1951, Ferry Porsche se voit promu patron de la société, une position qu'il détiendra jusqu'à la décision prise à l'unanimité par les membres de la famille de se retirer de la direction le 1er mars 1972. Ensuite, jusqu'en mars 1990, date à laquelle son propre fils aîné, Ferdinand Alexander, a pris sa succession, il a présidé aux destinées de Porsche AG en tant que président du conseil de surveillance.

Quand l'École supérieure technique de Vienne lui confère le titre de docteur honoris causa en 1965, il s'engage en quelque sorte, sur le plan académique aussi, sur les traces de son géniteur et modèle. En 1959 déjà, le président fédéral de cette époque, Theodor Heuss, l'avait honoré en lui décernant la Grand Croix du Mérite de la République fédérale d'Allemagne, d'autres honneurs et distinctions devant suivre. Ferdinand Porsche II, surnommé Ferry, est décédé à un âge avancé le 27 mars 1998. Il s'était dédié à « la conduite sous sa forme la plus belle » – quelle ambition séduisante pour une vie entière !

The abdication of the old king was still being prepared when the heir apparent imperiously laid claim to the throne. At the 41st Frankfurt IAA from 12 September 1963, however, they stood side by side harmoniously, the 356, definitely in its prime in its C version, and the 901 as a prototype that was not quite ready to go yet.

Its sleek line had been designed by Ferdinand Alexander ("Butzi") Porsche, the eldest son of company boss Ferry. Like many elements of the vehicle it was an amalgam, made up from new components and ingredients of the one-off four-seater Type 754 (Porsche code "T7"), to which Ferry Porsche had denied access to series production as it was not in keeping with the Zuffenhausen firm's profile. The result was convincing, in both visual and technical terms. Its air-cooled boxer engine with force-feed lubrication was a close relative of the vigorously barking eight-cylinder power plant in the 804-Type Formula One car of the marque, with which Dan Gurney had won the French Grand Prix at Rouen in July 1962. But two combustion units had been cut off, and engine man Hans Tomala had insisted that the two camshafts be transplanted from their former position above and below the F1 car's crankshaft to the tops of the cylinder heads.

Much future had also been invested in the 901's suspension, created by the young engineer Helmuth Bott in close cooperation with Peter Falk from Porsche's driving test department: low-installed wishbones and lateral McPherson struts as well as longitudinal torsion bars below the floor at the front, and rear double-joint drive shafts with trailing arms.

13 prototypes had had a hell of a time when, on 14 September 1964, the first 901 rolled off the assembly line. In October the finished product was presented at the Paris show. 82 cars had left the works when it was rechristened the 911 because the French car maker Peugeot owned the right to names comprising a three-digit sequence with an "0" in the middle. Milestones in the model's curriculum vitae in the following decade were these: introduction of the "safety convertible" 911 2.0 Targa with its fixed steel roll bar at the beginning of September 1965, the semi-automatic four-speed transmission Sportomatic as an option from July 1967, and, in the same year, an additional 2.24" to the car's former 87.05" wheelbase to improve its straight-running stability.

The possibilities of the melodiously rasping six-cylinder unit seemed to be almost unlimited, only held in check by the potential owner's preferences and bank account. From the 1991cc of the first generation were evoked 130, 160, 110, 140 and 170 bhp, while the 2195 cc of the first evolutionary stage from September 1969 generated 125, 155 and 185 bhp, and the 2341 cc after the second capacity increase in September 1971 delivered 130, 140, 165 and 190 bhp. When two years later, again in fall, the next upgrade was due, 89,256 specimens in 911, 911 S, 911 T, 911 L, and 911 E guises had spread the Porsche idea of driving in its most beautiful form all over the world.

Noch bereitete man die Abdankung des alten Königs vor, da meldete schon der neue gebieterisch seinen Anspruch auf den Thron an. Auf der 41. Frankfurter IAA ab 12. September 1963 standen sie gleichwohl einträchtig nebeneinander, der 356 in der Ausbaustufe C und somit in der Blüte seiner Manneskraft und der 901 als nicht ganz fahrfertiger Prototyp.

Seine schmissige Linie stammte von Ferdinand Alexander („Butzi") Porsche, dem ältesten Sohn des Firmenchefs Ferry. Wie vieles am Fahrzeug war sie eigentlich ein Amalgam aus Elementen des viersitzigen Einzelgängers Typ 754 (hausintern „T7" geheißen), dem Ferry Porsche aus firmenideologischen Gründen die Aufnahme in die Serie verweigert hatte, und neuen Zutaten, und dennoch stimmte alles. Sein luftgekühlter Boxer mit Druckumlaufschmierung war ein enger Verwandter des kernig bellenden Achtzylinders aus dem Formel-1-Wagen 804, mit dem Dan Gurney im Juli 1962 den Großen Preis von Frankreich in Rouen gewonnen hatte. Zwei Verbrennungseinheiten waren allerdings abgetrennt worden, und auf Betreiben von Motoren-Mann Hans Tomala hatte man die beiden Nockenwellen, vorher über und unter der Kurbelwelle tätig, auf die Zylinderköpfe verpflanzt.

Viel Zukunft war auch in der Aufhängung des 901 angelegt, geschaffen vom jungen Helmuth Bott im engen Zusammenwirken mit Peter Falk vom Fahrversuch: tief angeordnete Querlenker und seitlich aufragende Dämpferbeine sowie längs unter dem Boden liegende Drehstäbe vorn, Doppelgelenk-Antriebswellen und Schräglenker hinten.

13 Prototypen waren durch die Auto-Hölle gehetzt worden, als am 14. September 1964 der erste 901 vom Band lief. Im Oktober präsentierte man das fertige Produkt auf dem Pariser Salon. 82 Fahrzeuge hatten das Werk verlassen, als man ihn zum 911 umwidmete. Der französische Konzern Peugeot hielt dreistellige Ziffernfolgen mit einer Null in der Mitte in Erbpacht und hatte damit bei der Geburt des Elfers Pate gestanden. Einschneidende Ereignisse in der Modell-Vita innerhalb der nächsten zehn Jahre: Anfang September 1965 die Einführung des „Sicherheitscabriolets" Targa mit einem festen stählernen Überrollbügel, ab Juli 1967 die Option des halbautomatischen Vierganggetriebes Sportomatic, im gleichen Jahr ein um 57 auf 2268 mm verlängerter Radstand, um Schwächen beim Geradeauslauf in den Griff zu bekommen.

Schier unerschöpflich waren die Möglichkeiten des wohltönend schnarrenden Sechszylinders, gefächert nach Bedarf und Geldbeutel: Aus den 1991 cm³ der ersten Generation holte man 130, 160, 110, 140 und 170 PS heraus, aus den 2195 cm³ der Evolutionsstufe eins ab September 1969 125, 155 und 180 PS, aus den 2341 cm³ nach der zweiten Hubraumvergrößerung ab September 1971 130, 140, 165 und 190 PS. Als zwei Jahre später wiederum im Herbst erneute Aufrüstung anstand, verbreiteten weltweit 89 256 Exemplare in den Spielarten 911, 911 S, 911 T, 911 L und 911 E die Idee vom Fahren in seiner schönsten Form.

Alors même que le vieux roi se prépare à abdiquer, son successeur prétend d'ores et déjà avec autorité au trône. Lors de la 41e IAA de Francfort, qui ouvre ses portes le 12 septembre 1963, les rivales se côtoient dans une parfaite harmonie sur le stand, la 356 en tant qu'évolution C et, donc, à l'apogée de sa dynastie, et la 901 comme prototype pas encore tout à fait prêt à rouler.

Sa ligne a du chien. Elle est l'œuvre de Ferdinand Alexander (« Butzi ») Porsche, le fils aîné du patron, Ferry. À l'instar de nombreux autres éléments de ce véhicule, ses lignes sont un mélange de nouveautés et de reprises du spécimen unique à quatre places que sera restée la 754 (numéro de code interne « T7 ») : une voiture que Ferry Porsche a refusé de produire en série pour des motifs idéologiques. Et pourtant, le cocktail est cohérent

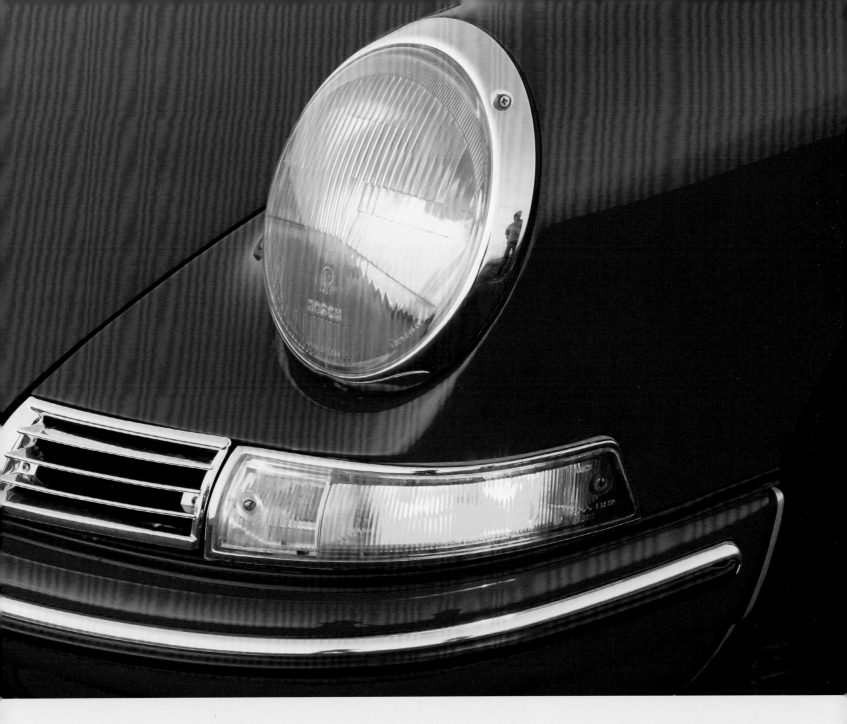

et réussi. Son moteur boxer à refroidissement par air avec lubrification par circulation forcée est un parent très proche du huit-cylindres qui a permis à la monoplace de Formule 1, la 804, de gagner le Grand Prix de France à Rouen en 1962, avec Dan Gurney à son volant. Il a toutefois été amputé de deux cylindres et, sur les injonctions du motoriste Hans Tomala, les deux arbres à cames qui se trouvaient auparavant au-dessus et au-dessous du vilebrequin, ont été transplantés sur les culasses.

Les suspensions de la 901, concoctées par le jeune Helmuth Bott en étroite coopération avec Peter Falk, le patron des essais routiers, renferment un énorme potentiel: elles consistent en des bras transversaux placés très bas et des jambes d'amortisseurs dépassant sur les

côtés ainsi que des barres de torsion avant allongées sous le plancher et des demi-arbres moteurs à double cardan, plus des bras obliques à l'arrière.

Treize prototypes ont été torturés dans l'enfer de l'automobile avant que la première 901 ne sorte des chaînes, le 14 septembre 1964. En octobre, la voiture terminée est présentée au Salon de Paris. Ce sont 82 exemplaires qui ont déjà quitté l'usine lorsque l'on doit la rebaptiser 911. Peugeot avait, en effet, déposé les numéros à trois chiffres avec un zéro au centre, parrainant ainsi, sans le savoir, la naissance de la 911. Quelques événements marquants ponctuent son curriculum vitae au cours des dix années suivantes: début septembre 1965, apparaît le «cabriolet de sécurité» Targa avec un arceau en acier fixe; puis, en juillet 1967, l'option de la boîte

semi-automatique à quatre rapports Sportomatic; et, enfin, la même année, un allongement de l'empattement à 57 mm, soit 2268 mm, pour pallier les défauts affectant la stabilité directionnelle.

Les possibilités du six-cylindres semblent inépuisables: les 1991 cm³ de la première génération autorisent des puissances de respectivement 130, 160, 110, 140 et 170 ch alors que l'évolution 1, qui passe à 2195 cm³ en septembre 1969, se traduit par une puissance de 125, 155 et 180 ch. La deuxième majoration de cylindrée, à 2341 cm³, en septembre 1971, permet d'en extraire 130, 140, 165 et 190 chevaux. Quand la compétition se poursuit de nouveau à l'automne, deux ans plus tard, 89256 exemplaires des différentes variantes – 911, 911 S, 911 T, 911 L et 911 E – incarnent la conduite sous sa plus belle forme.

911 2.0–2.4

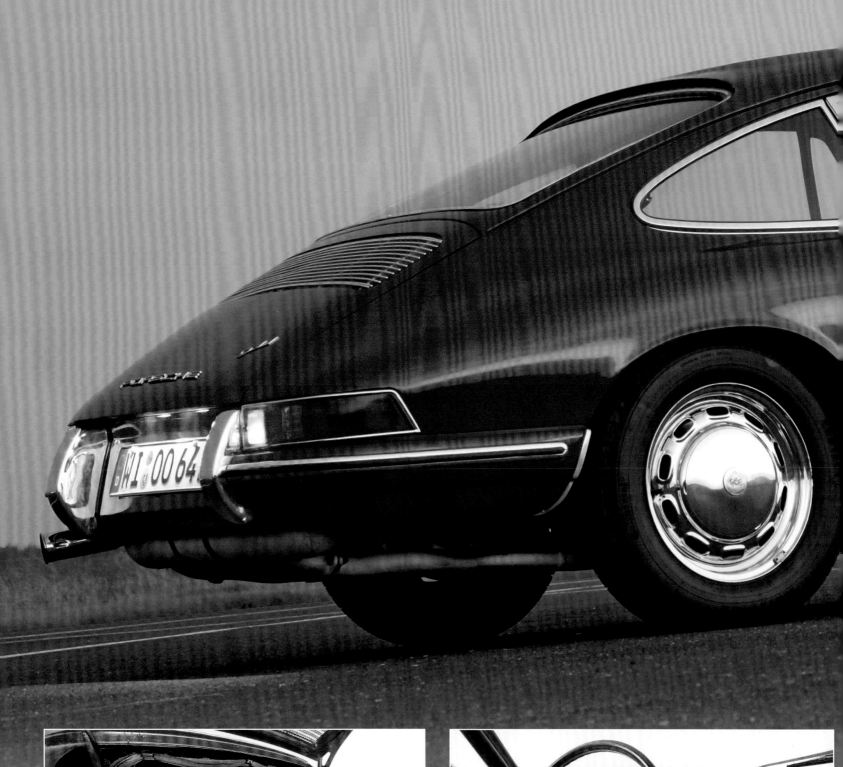

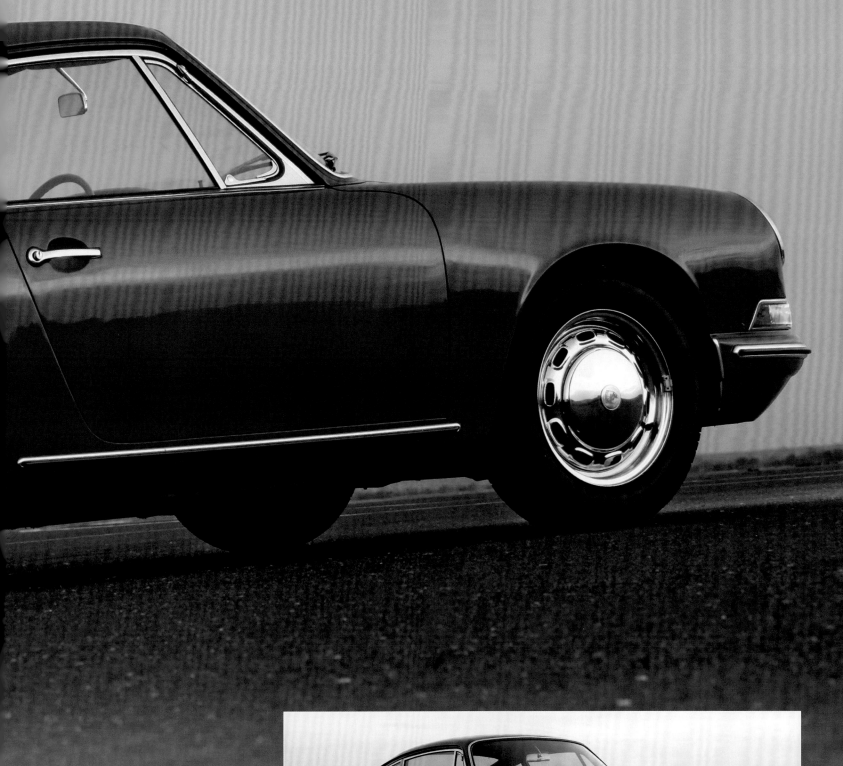

The 356 fundamentalists will need some time to get used to the 911's novel though not dissimilar line. Its five round gages behind the four-spoke steering wheel arch exactly in the driver's field of vision.

Der 356-Purist wird sich noch eine Weile zieren, bevor er sich an die ähnliche und doch so andere Linie des Elfers gewöhnt hat. Die fünf Runduhren hinter dem Vierspeichenlenkrad wölben sich genau im Blickfeld des Piloten.

Le puriste amateur de 356 a besoin d'un peu de temps pour s'habituer à la ligne similaire, et pourtant si différente, de la 911. Les cinq cadrans circulaires derrière le volant à quatre branches étirent leur galbe exactement dans le champ de vision du pilote.

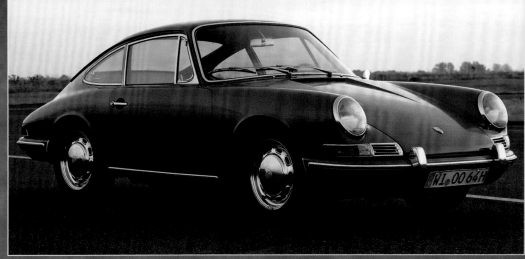

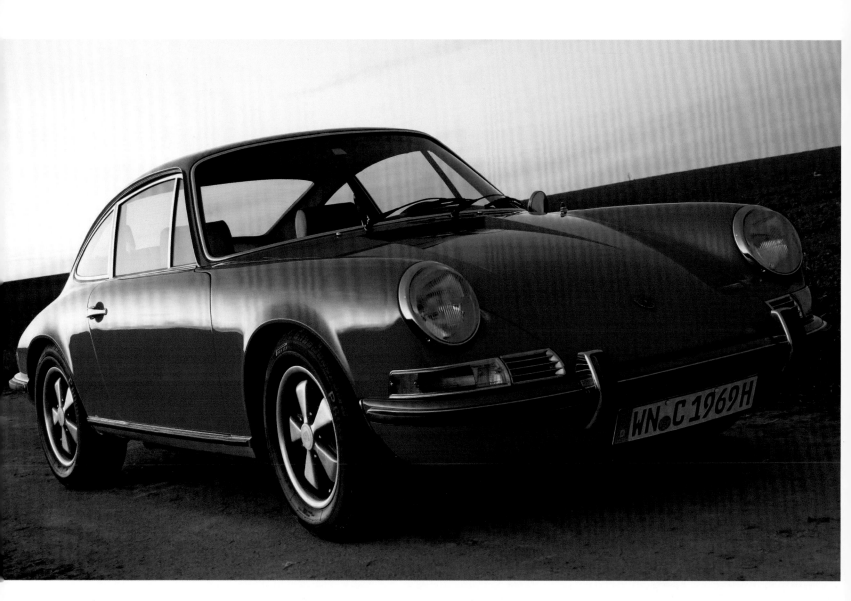

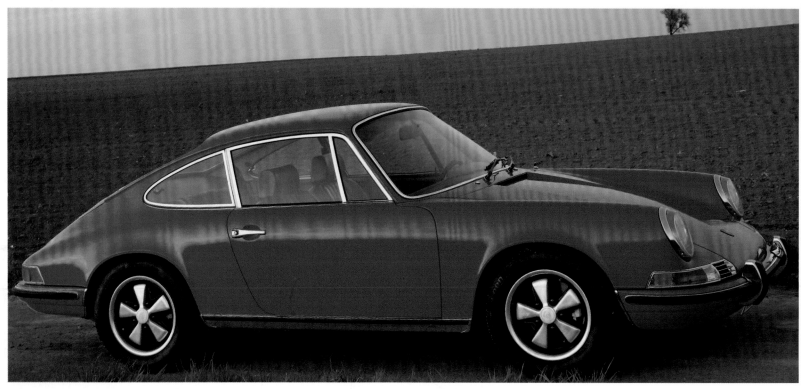

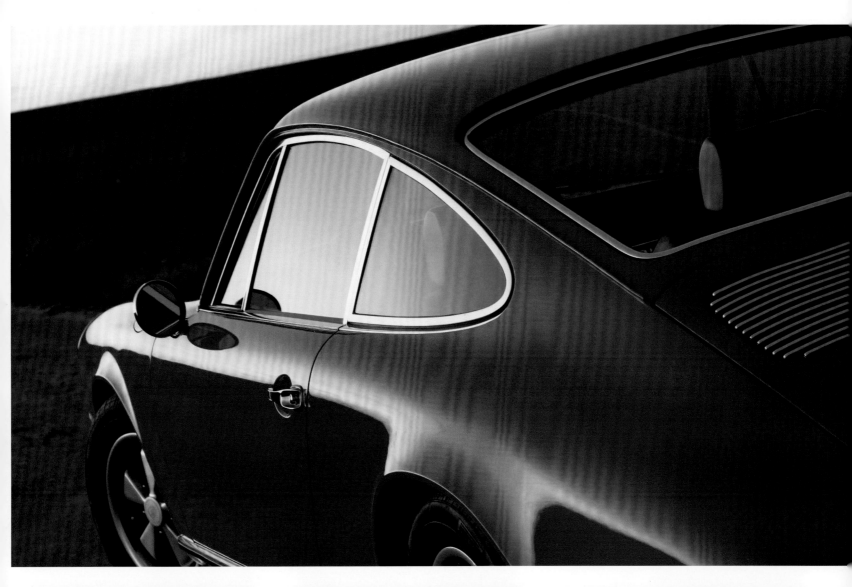

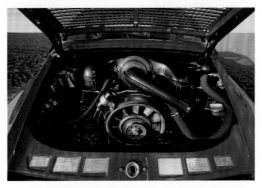

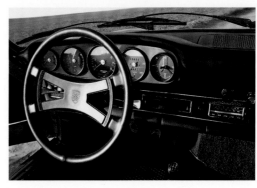

The 911 S, introduced for the model year 1967, is Germany's fastest series-built car of the time. Typical makings are its Fuchs light-alloy rims, more massive rubber inserts on the bumpers and trim moldings below the doors.

Der 911 S, zum Modelljahr 1967 eingeführt, ist damals Deutschlands schnellstes Serienauto. Typisch sind die Leichtmetallfelgen von Fuchs, verstärkte Profilgummis auf den Stoßdämpfern und Zierleisten unter den Türen.

La 911 S, introduite avec le millésime 1967, est à son époque la voiture de série la plus rapide d'Allemagne. Typiques : les jantes Fuchs en alliage léger, les grosses moulures en caoutchouc sur les pare-chocs et les joncs de décoration sous les portières.

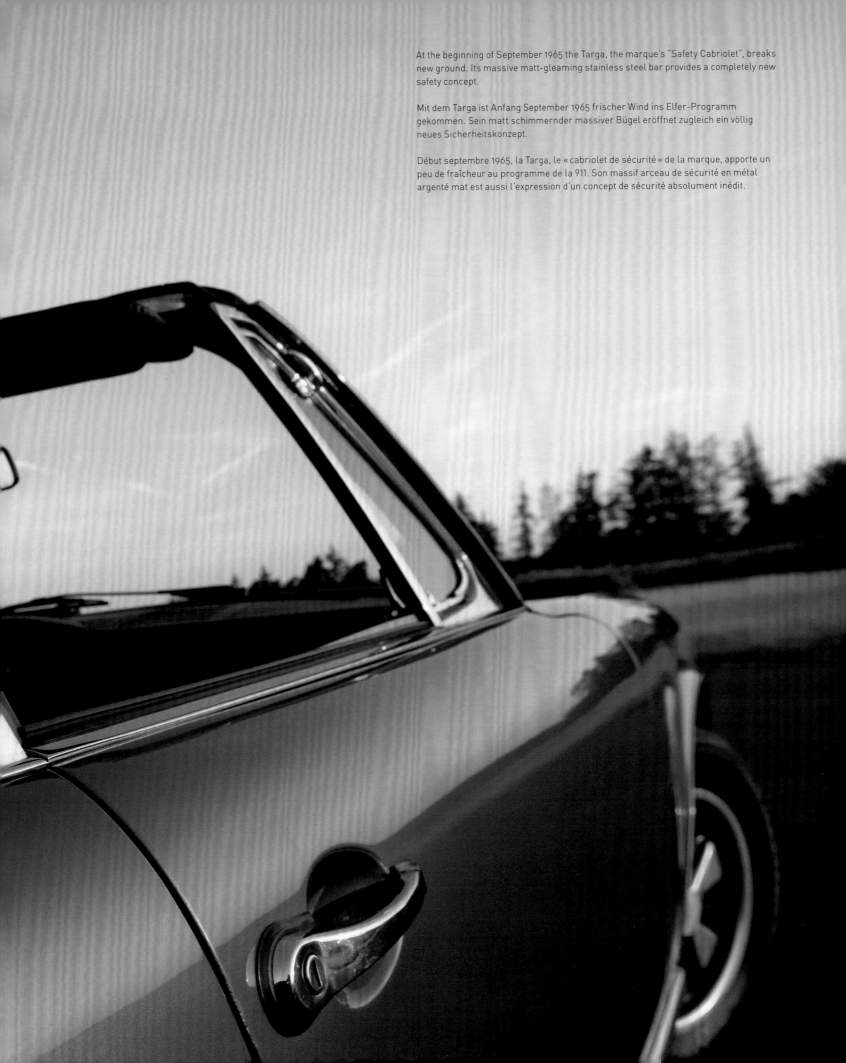

At the beginning of September 1965 the Targa, the marque's "Safety Cabriolet", breaks new ground. Its massive matt-gleaming stainless steel bar provides a completely new safety concept.

Mit dem Targa ist Anfang September 1965 frischer Wind ins Elfer-Programm gekommen. Sein matt schimmernder massiver Bügel eröffnet zugleich ein völlig neues Sicherheitskonzept.

Début septembre 1965, la Targa, le « cabriolet de sécurité » de la marque, apporte un peu de fraîcheur au programme de la 911. Son massif arceau de sécurité en métal argenté mat est aussi l'expression d'un concept de sécurité absolument inédit.

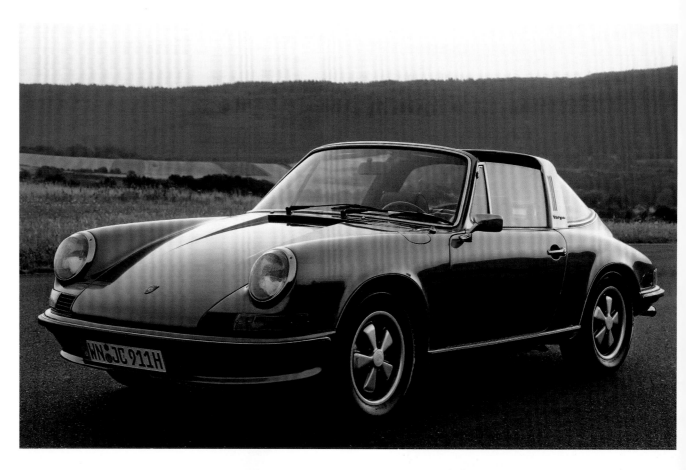

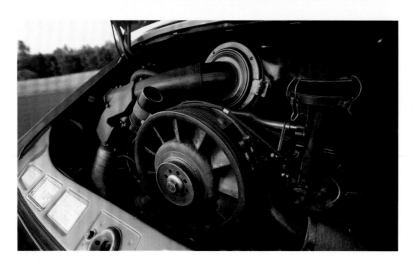

Moreover, the Targa's bar makes for stiffer bodywork than a cabriolet's and also favors an intact hairdo, to the joy of the ladies. But the purists do not like it.

Der Targa-Bügel sorgt überdies für eine höhere Karosseriesteifigkeit als die eines Cabriolets und für unverwirbelte Frisuren. Die Puristen mögen ihn nicht.

L'arceau de la Targa induit en outre une rigidité de carrosserie supérieure à celle d'un cabriolet et ménage la mise en pli des passagères. Mais les puristes l'ont en horreur.

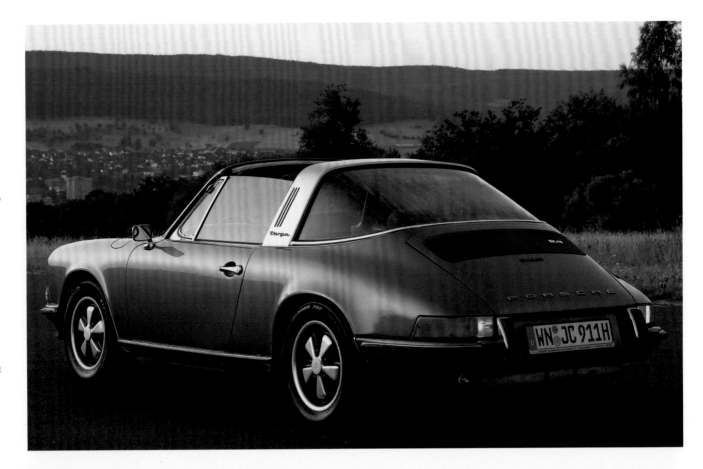

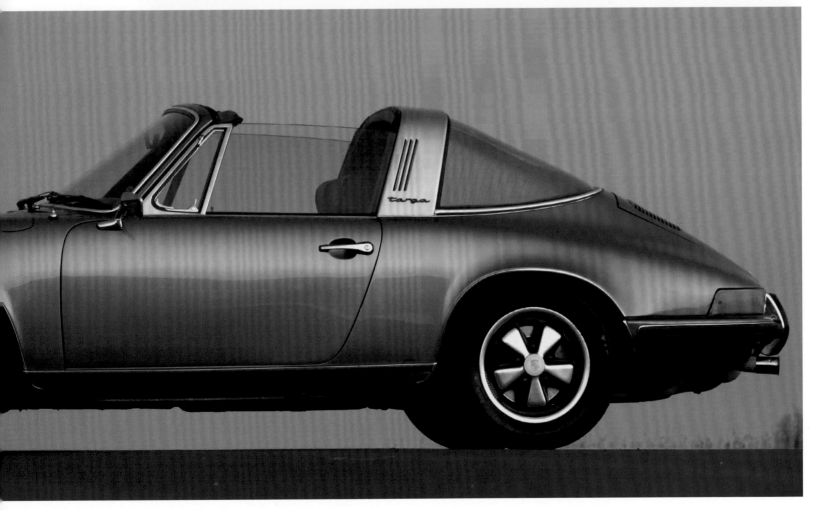

The Porsche 904 GTS, also known as Carrera GTS, was the best example of something really great arising from the straitjacket of a small budget. Following English examples such as diverse Lotus models, for instance, the management's decision to opt for plastic bodywork could be put down to a distinctive lack of funds. The 904's shell, designed by Ferdinand ("Butzi") Porsche jr., weighed two hundredweight and, outsourced to aircraft manufacturer Heinkel at Speyer, was produced from November 1963 onwards in a special procedure. Glass fiber mats soaked in synthetic resin were manually put on to hollow molds which were already covered by gel coat—the future skin of the finished part. That was a great deal cheaper and less labor-intensive than working the customary aluminum sheets.

As the thinly-upholstered spartan seat pans —the one for the passenger serving as an alibi only as stipulated by motor racing's legislative body the FIA, and hardly ever used—protruded from the floor as fixed parts of the bodywork, the driver had to adapt himself to the vehicle via adjustable pedals and the axially movable steering wheel. Getting in and out of the thundering lightweight was easy, however, as the doors had been drawn deeply into the flanks. The idea of a spaceframe had also been renounced. Instead, the responsible team opted for a much cheaper sheet steel structure, incorporating two longerons and box section cross members. The coachwork was inseparably bonded to it with a special adhesive and bolted to the chassis at the corners. Weighing just 100 lbs, the 904's backbone was easy to repair but tended to flex and was not to survive the model. 15-inch perforated disk wheels of 5, 5½, 6 or 7 inch caliber were suspended by double wishbones front and rear where, allied to long pushrods, they achieved exceptional wheel control. Transversal stabilizers were mounted at both ends. The 904 was unusually easy to drive, but once its limits had been overstepped expert hands and lightning-quick reactions were in demand.

Opening the huge rear-hinged engine hood caused surprise because of the enormous distance between the rear panel of the cabin and the power plant. Surrounded by its auxiliaries, the Carrera 2's well-known four-cylinder, four-camshaft unit with 1966 cc was situated there. The surplus space had been left for the six-cylinder of the 901/911, whose installation had initially been envisaged, and prototype versions with eight combustion units. Then, however, the lot had gone to the proven premium boxer engine for cost reasons and because there were spare parts in abundance. The 180 bhp it delivered, allied to the noisy so-called Sebring exhaust, made the 904 an extremely agile motor vehicle anyway. 116 specimens were built, 16 more than had been necessary for homologation as a grand tourisme car. Its brief but happy career culminated in two GT world championships, as well as victory in the 48th edition of the Targa Florio in April 1964 and second place for the Eugen Böhringer/Rolf Wütherich pairing in the 1965 Monte Carlo Rally.

Der Porsche 904 GTS, auch Carrera GTS geheißen, war der beste Beweis dafür, dass sich selbst unter dem kategorischen Zwang zum Sparen etwas Großartiges auf die Beine stellen lässt. Auf ein schmales Budget war beispielsweise, einschlägigen englischen Vorbildern wie etwa diversen Lotus-Fabrikaten folgend, seine Karosserie aus Kunststoff zurückzuführen, 100 kg leicht und ab November 1963 bei dem Flugzeugbauer Heinkel in Speyer im Handauflegeverfahren produziert. Dabei wurden in Kunstharz getränkte Glasfasermatten manuell auf eine Hohlform aufgetragen, die bereits mit einer Lage Feinschichtharz bedeckt war – der künftigen Außenhaut des Fertigteils. Das war billiger als die weitaus aufwändigere Bearbeitung des üblichen Werkstoffs Aluminium.

Da die spartanisch gepolsterten Sitzschalen – die für den Beifahrer diente nur zum Alibi, da von der Rennsport-Legislative FIA vorgeschrieben – als Bestandteile des Aufbaus starr aus dem Boden ragten, musste sich der Pilot über eine verstellbare Pedalerie und das axial bewegliche Lenkrad selber einpassen. Ein- und Ausstieg waren hingegen ein Leichtes, weil die Türen weit hinab in die Flanken gezogen waren. Von einem Gitterrohrrahmen sah man ebenfalls ab und entschied sich für eine preisgünstigere Stahlblechstruktur, gebildet von zwei Längsträgern und kastenförmigen Querverbindungen. Mit ihr war die Karosserie durch einen speziellen Klebstoff untrennbar verbunden und an den Enden verschraubt. Lediglich 45 kg schwer, war das Rückgrat des 904 zwar einfach zu reparieren, verwand sich jedoch freudig und sollte das Modell nicht überleben. 15-Zoll-Lochscheibenräder vom Kaliber 5, 5½, 6 oder 7 Zoll hingen vorn an schräg angestellten doppelten Querlenkern, desgleichen hinten, wo im Bunde mit langen Schubstreben eine exzeptionelle Radführung erzielt wurde. An beiden Enden waren quer liegende Stabilisatoren eingebaut. Der 904 ließ sich kinderleicht fahren. War aber einmal sein weit außen angesiedelter Grenzbereich überschritten, dann bedurfte es kundiger Hände und glänzender Reaktionen.

Öffnete man die hinten angeschlagene riesige Motorhaube, dann fiel der beträchtliche Abstand zwischen der Rückwand der Fahrgastzelle und dem Triebwerk ins Auge. Hier hauste nämlich im Kreise seiner Domestiken der aus dem Carrera 2 bekannte Vierzylinder mit seinen vier Nockenwellen und 1966 cm³. Zwar hatte man Lebensraum freigehalten für den eigentlich vorgesehenen Sechszylinder aus dem 901/911, dann jedoch dem gestandenen Premium-Boxer den Zuschlag gegeben, auch dies aus Kostengründen und wegen der guten Ersatzteillage. Die 180 PS, die er mit dem so genannten Sebring-Auspuff gepaart entwickelte, machten den 904 auch so ungemein munter. 116 Exemplare wurden hergestellt, 16 mehr als für die Homologation als Grand-Tourisme-Fahrzeug nötig. Seine kurze, aber glückliche Karriere gipfelte in zwei GT-Weltmeisterschaften und dem Gesamtsieg bei der 48. Targa Florio im April 1964.

La Porsche 904 GTS, aussi surnommée Carrera GTS, a tiré le meilleur parti de son petit budget. S'inspirant de ses concurrentes britanniques, notamment de Lotus, sa carrosserie a été réalisée en matière plastique. Pesant 100 kg seulement, elle est fabriquée manuellement, à partir de novembre 1963, chez l'avionneur Heinkel, à Spire. Le procédé consiste à déposer à la main, sur un moule creux lui-même déjà recouvert d'une mince couche de résine, des nattes de fibre de verre imbibées de résine synthétique – qui constituent ainsi la face extérieure de la future carrosserie. Ce procédé est beaucoup moins cher et complexe que l'aluminium utilisé d'ordinaire.

Les coquilles de sièges au capitonnage spartiate – celui du passager ne fait que respecter le règlement de la FIA – font partie intégrante de

1963–1964

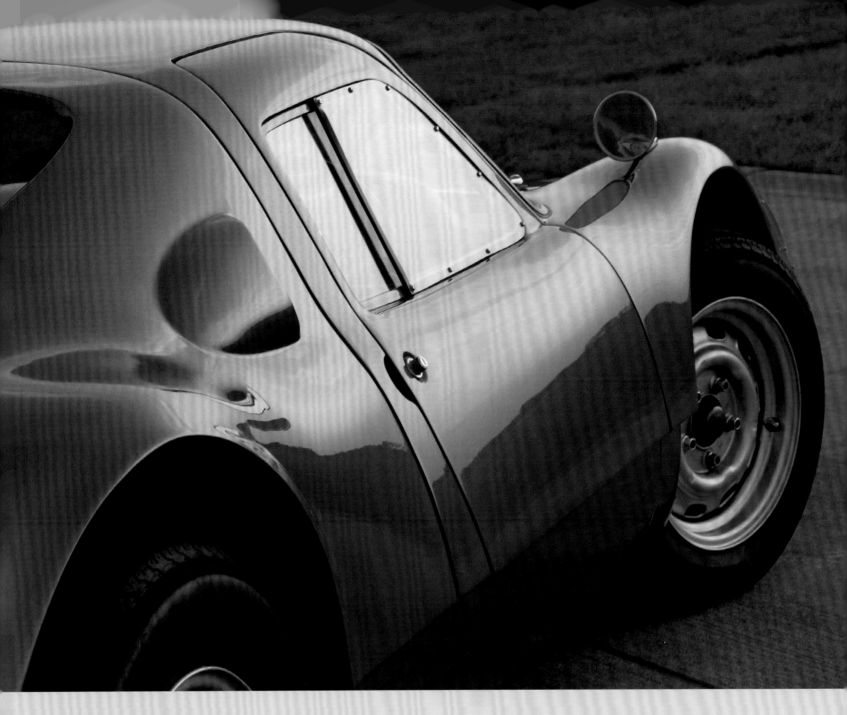

la structure et sont boulonnées au plancher. Le pilote doit donc adapter sa position de conduite à l'aide d'un pédalier réglable et d'un volant qui se déplace en profondeur. Monter à bord de la voiture et en descendre est, en revanche, d'une simplicité enfantine, car les portières mordent largement sur les flancs. C'est en vain que l'on recherchera un châssis tubulaire, Porsche ayant opté pour une solution moins onéreuse, en l'occurrence une structure en tôle d'acier constituée par deux longerons longitudinaux avec des poutres transversales en forme de caissons. La carrosserie est posée une fois pour toutes sur cette structure à l'aide d'une colle spéciale et boulonnée à ses extrémités. Si l'épine dorsale de la 904 ne pèse que 45 kg et s'avère extrêmement simple à réparer, elle se tord en revanche comme une éponge et ne survivra d'ailleurs pas à

ce modèle. Des roues à voile ajouré de 15 pouces pour 5, 5½, 6 ou 7 pouces de large sont accrochées à une double triangulation transversale en diagonale à l'avant et à des épures de suspension identiques à l'arrière où de longues jambes de poussée garantissent un guidage exceptionnel des roues. Conduire une 904 est un jeu d'enfant, grâce à sa barre stabilisatrice transversale à l'avant et à l'arrière. Mais à une condition : ne franchir sous aucun prétexte sa limite d'adhérence – très élevée au demeurant –, car il faut alors compter sur la dextérité du pilote pour en reprendre le contrôle.

Si l'on ouvre l'immense capot moteur qui bascule vers l'arrière, on constate immédiatement la grande distance qui sépare l'auvent de la cellule passagers et le groupe motopropulseur. On découvre, en effet, entouré de ses périphériques, le quatre-cylindres

bien connu de la Carrera 2 avec ses quatre arbres à cames et sa cylindrée de 1966 cm³. Porsche avait prévu d'y implanter à l'origine le six-cylindres de la 901/911, avant d'opter finalement pour l'illustre boxer autant par souci d'économie qu'en raison de la disponibilité des pièces de rechange. De toute façon, les 180 chevaux que le quatre-cylindres développe avec le pot d'échappement Sebring donnent des ailes à la 904. Au final, 116 exemplaires ont été fabriqués, soit 16 de plus qu'exigés pour l'homologation en Grand Tourisme. Très brève, sa carrière honorable culmine avec deux titres de championne du monde en catégorie GT, la victoire au classement général de la 48e Targa Florio en avril 1964, et une deuxième place pour la paire Eugen Böhringer/Rolf Wütherich au Rallye Monte-Carlo en 1965.

904 Carrera GTS

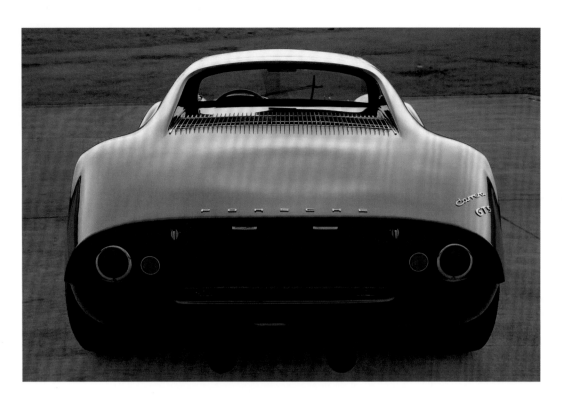

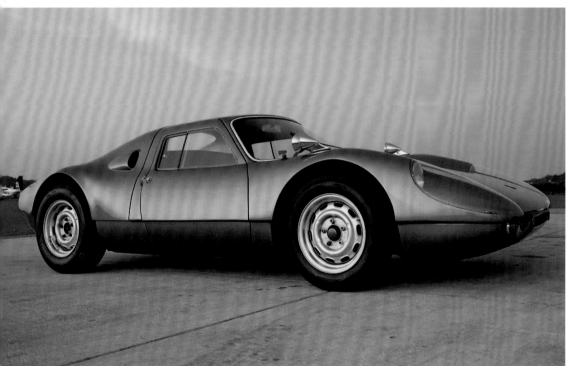

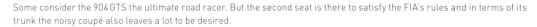

Some consider the 904 GTS the ultimate road racer. But the second seat is there to satisfy the FIA's rules and in terms of its trunk the noisy coupé also leaves a lot to be desired.

Viele sehen den 904 GTS als den ultimativen Sportwagen für die Straße an. Der zweite Sitz genügt aber nur den Bestimmungen der FIA, und auch mit Kofferraum ist es schlecht bestellt.

Nombreux sont ceux qui considèrent la 904 GTS comme la voiture de sport civile par excellence. Le deuxième siège a pour seul but de satisfaire aux stipulations de la FIA. Quant au coffre, mieux vaut ne pas en parler.

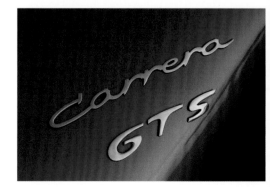

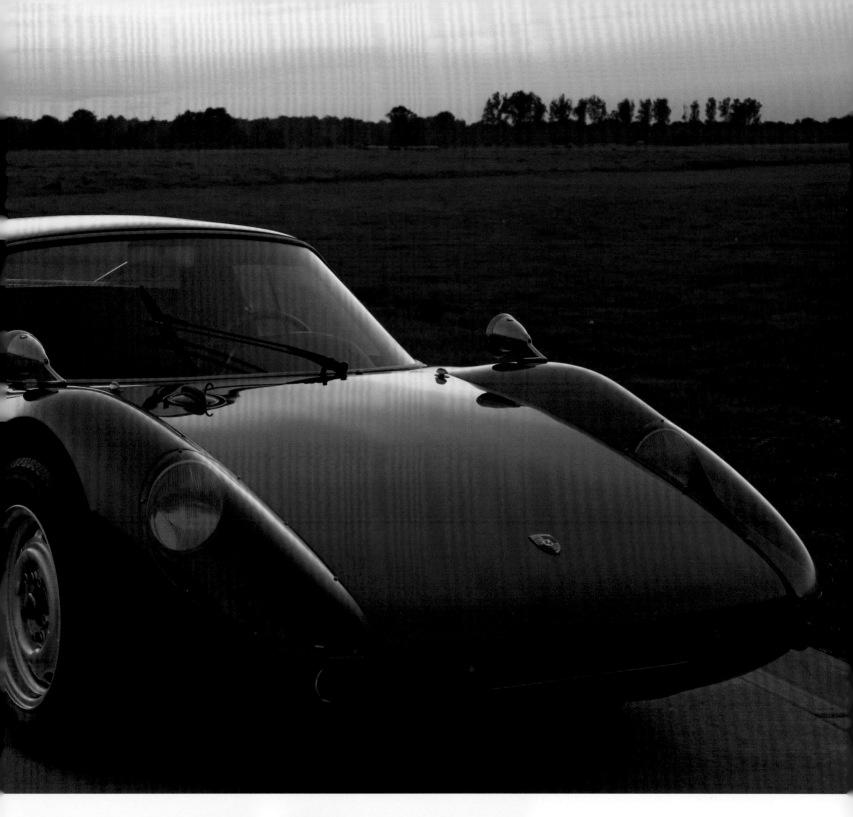

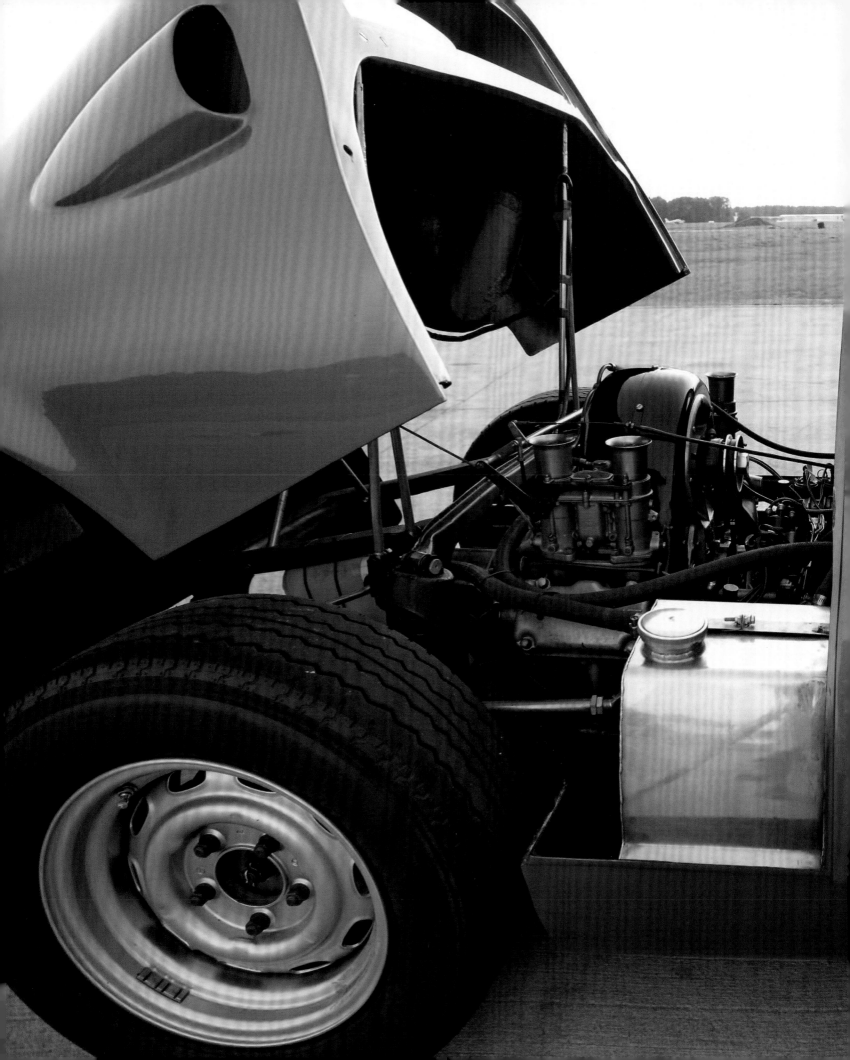

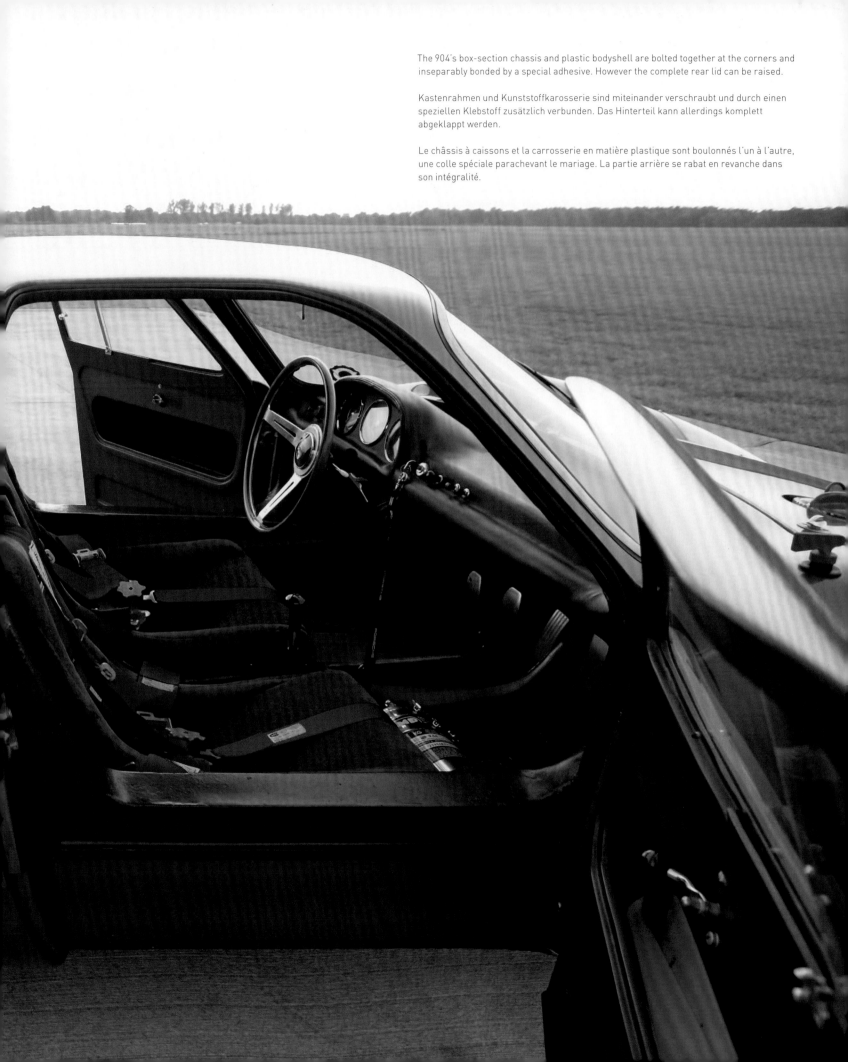

The 904's box-section chassis and plastic bodyshell are bolted together at the corners and inseparably bonded by a special adhesive. However the complete rear lid can be raised.

Kastenrahmen und Kunststoffkarosserie sind miteinander verschraubt und durch einen speziellen Klebstoff zusätzlich verbunden. Das Hinterteil kann allerdings komplett abgeklappt werden.

Le châssis à caissons et la carrosserie en matière plastique sont boulonnés l'un à l'autre, une colle spéciale parachevant le mariage. La partie arrière se rabat en revanche dans son intégralité.

When the six-cylinder made its final bow, purchasing and owning a Porsche became much more expensive. In its last year, 1965, the 1600 SC was 16,450 marks, whereas for the new 911 you had to shell out a hefty 21,900 marks. That was a quarter more. And driving one of the Zuffenhausen cars had long since become an article of faith so that no small part of the clientele had to scrape together their last few dimes to realize their dreams and afford one. These people, decided the Porsche management responding to a call from the sales department, could be helped.

And so the entry-level 912 was unveiled in April 1965, price tag: 16,250 marks. Hardly distinguishable from its big brother in visual terms, it combined time-honored and new components in a fine symbiosis. Its heart was the well-known classic four-cylinder unit in its rear, with 1582 cc, but downrated by five horsepower, not least because of two inlet mufflers which reduced its acoustic emissions to a muffled rumble. This bleeding was also beneficial to its life expectancy. While in a 1600 SC one had to be careful not to exceed the critical 5500 rpm too long, the driver of a 912 with a basically identical power plant could well stay within a range close to 6000 rpm without being sidelined by a massive engine failure. This, the remaining 90 bhp, which were preferably passed on to the rear axle via a five-speed gearbox available at an extra 340 marks, and the 912's top speed of 115 mph were urgently needed to keep at bay upstart sporting sedans such as the Ford 20 M TS or the BMW 1800 TI, which increasingly tended to pester certain ambitious sports car drivers in those years.

In the cabin, too, the 912's proud owner was discreetly reminded that he or she was not sitting at the wheel of the marque's premium model. The dashboard had to make do without such frills as the teak imitation veneer adorning the fascia of the 911. Its instrumentation, too, was reduced to the very essentials. The vital information was provided by three round gages, whereas the oil reserve and pressure indicators had been dispensed with. On the other hand, all running changes made to the 911 were translated to its pushrod sibling at the same time. As was the case with the six-cylinder variant, the Coupé was joined by a Targa version at the 1965 Frankfurt IAA, and as on the 911, the wheelbase was lengthened from 87.05 to 89.29" before the 1967 vacation shutdown, for the benefit of straight-line stability.

The latest Porsche creation had been presented as "European type", to be sold by the dealer network on the Old Continent only. At first naturalization was denied to it by Great Britain and important overseas markets. But after initial abstinence, many of the total of 30,300 Porsche 912s found their way into the United States. In 1968, in-house competition in the shape of the 911 T put paid to its existence. After all, it had six prestigious combustion units and, at 17,550 marks, cost only 2100 marks more than what had once quickly established itself as a best seller.

Mit dem Erscheinen des Sechszylinders wurde das Porschefahren entschieden teurer. In seinem letzten Jahr 1965 kostete der 1600 SC 16 450 Mark, während der neue 911 mit 21 900 Mark zu Buche schlug. Das war gut ein Viertel mehr. Und: Es war längst zum Glaubensartikel geworden. Ein nicht geringer Teil der Klientel musste sich krummlegen, um in diesen manchmal lang ersehnten Genuss zu kommen. Den Leuten, befand das Zuffenhausener Management, konnte geholfen werden.

Und so stellte man Anfang April 1965 den 912 vor, Preis: 16 250 Mark. Optisch von seinem großen Bruder kaum zu unterscheiden, vereinigte er in sich Altes und Neues zu einer gelungenen Symbiose. Herzstück war der sattsam bekannte vierzylindrige Klassiker im Heck, wie gehabt mit 1582 cm³, aber um fünf PS geschwächt schon auf Grund zweier Ansaug-Geräuschdämpfer, die seine akustischen Emissionen auf ein dumpfes Grollen und Poltern reduzierten. Dieser Aderlass war nicht zuletzt seiner Lebenserwartung förderlich. Und wo im 1600 SC Drehzahlen über 5500/min mit Vorsicht zu genießen waren, konnte sich der Pilot des 912 mit einem im Prinzip identischen Triebwerk durchaus über längere Zeit in der Nähe von 6000/min aufhalten, ohne mit einem kapitalen Motorinfarkt an den Rand der Straße rollen zu müssen.

Dies, die verbleibenden 90 PS, am besten vermittelt durch das gegen 340 Mark Aufpreis erhältliche Fünfganggetriebe, und die somit erreichbaren 185 km/h waren dringend nötig. Denn immer häufiger rückten ambitionierten Sportwagenlenkern hurtige Emporkömmlinge aus dem Umfeld der sportlichen Limousinen wie der Ford 20 M TS oder der BMW 1800 TI zu Leibe.

Nach dem Beziehen seines Arbeitsplatzes wurde dem 912-Eigner ebenfalls diskret vor Augen geführt, dass er nicht im Top-Modell der Marke saß. Das Armaturenbrett kam ohne schmückendes Beiwerk wie die im 911 übliche Teakholzimitation aus. Auch in punkto Instrumentierung ließ man es beim Nötigsten bewenden. Die lebenswichtigen Informationen waren auf drei Runduhren verknappt worden, Ölvorratsanzeige und Manometer entfielen. Andererseits enthielt man dem 912 den wohl dosierten Fortschritt nicht vor, der dem 911 zuteil wurde. Wie bei jenem erwuchs dem Coupé auf der IAA 1965 Gesellschaft in Form einer Targa-Variante, und wie bei jenem wurde der Radstand vor den Werksferien 1967 von 2211 auf 2268 mm verlängert, um den Geradeauslauf zu verbessern.

Präsentiert worden war die jüngste Kreation der Stuttgarter als „Europatyp", verteilt ausschließlich durch das europäische Händlernetz. Großbritannien und wichtige Überseemärkte verweigerten ihm zunächst die Einbürgerung. Aber nach anfänglicher Abstinenz fanden viele der insgesamt 30 300 Porsche 912 ihren Weg in die Vereinigten Staaten. 1968 machte ihm ein Konkurrent aus dem eigenen Hause den Garaus: der 911 T. Der hatte sechs prestigeträchtige Zylinder und war mit 17 550 Mark nur 2100 Mark teurer.

Avec l'apparition du six-cylindres, rouler en Porsche devient un luxe. Lors de son ultime année de production, en 1965, la 1600 SC coûtait 16 450 marks alors que la nouvelle 911 était déjà facturée 21 900 marks. Soit une augmentation de près de 25 %! Rouler en Porsche est aussi devenu une véritable profession de foi. Nombreux sont les clients qui ont dû économiser longuement pour s'offrir ce plaisir tant attendu. Mais il faut permettre au plus grand nombre d'accéder à ce rêve, décide la direction de Zuffenhausen.

Et c'est ainsi qu'elle dévoile, début avril 1965, la 912. Son prix : 16 250 marks. Copie pratiquement conforme de sa grande sœur, elle associe l'ancien et le nouveau en un mélange réussi. Son joyau mécanique est le quatre-cylindres classique arrière qu'il n'est plus nécessaire de présenter, toujours avec

1965–1968

une cylindrée de 1582 cm³, mais dégonflé de cinq chevaux, ne serait-ce qu'à cause de la présence de deux silencieux d'aspiration qui réduisent ses émissions acoustiques à de sourds borborygmes que vient parfois interrompre un bruit de scie. Mais cette modeste amputation est bénéfique, surtout pour l'espérance de vie du moteur. Alors que, au volant de la 1600 SC, il est recommandé de savourer avec prudence les régimes supérieurs à 5500 tours, le pilote de la 912 peut flirter longuement avec les 6000 tours, avec une motorisation pratiquement identique, sans craindre de devoir s'arrêter au bord de la route parce que le moteur a rendu l'âme.

Cela dit, les 90 ch survivants qui s'expriment au mieux de concert avec la boîte à cinq vitesses disponible contre un supplément de 340 marks, et les 185 km/h de vitesse de pointe qu'elle autorise sont impérieusement nécessaires. En effet, de plus en plus souvent, des conducteurs de voitures de sport aux dents longues au volant de braves berlines sportives, comme la Ford 20 M TS ou la BMW 1800 TI, viennent marcher sur les brisées des Porsche.

Une fois qu'il a pris place à bord, le propriétaire de la 912 se rend compte, de façon toutefois discrète, qu'il ne pilote pas le modèle le plus prestigieux de la marque. Le tableau de bord doit se passer de l'ornementation en imitation teck de la 911. Pour l'instrumentation, aussi, seul l'indispensable a survécu. Les informations d'importance vitale se circonscrivent à trois cadrans circulaires, la jauge à huile et le manomètre brillant par leur absence. En contrepartie, la 912 a bénéficié des améliorations apportées à la 911. Comme pour celle-ci, la famille s'agrandit, lors de l'IAA de 1965, sous la forme d'une variante Targa et, comme pour la 911 toujours, l'empattement est allongé de 2211 à 2268 mm, avant les grandes vacances de 1967, afin d'améliorer la stabilité directionnelle.

La toute dernière création de Stuttgart, de «type européen», ne devait être distribuée que par le réseau de concessionnaires du Vieux Continent. La Grande-Bretagne et d'importants marchés d'outre-mer refusent tout d'abord de lui ouvrir leurs portes. Mais, après cet accueil glacial, beaucoup des 30 300 Porsche 912 produites au total finissent par se retrouver aux États-Unis. En 1968, une concurrente issue du giron familial, la 911 T, l'oblige à partir à la retraite. Elle possède un autre prestige avec six cylindres et, à 17 550 marks, ne coûte que 2100 marks de plus.

912

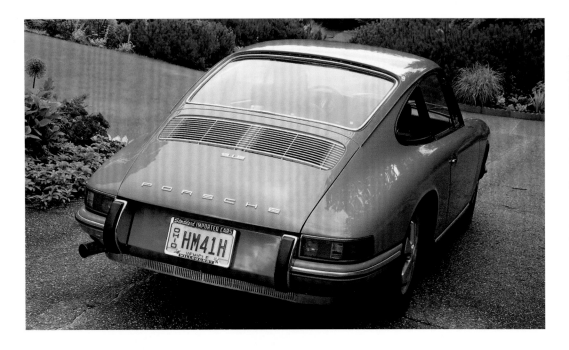

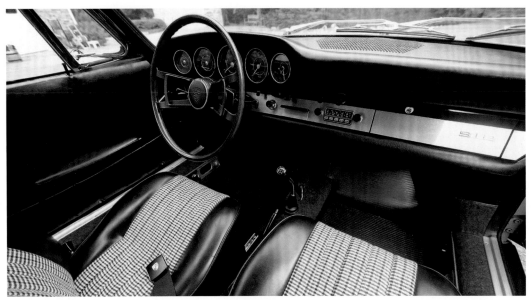

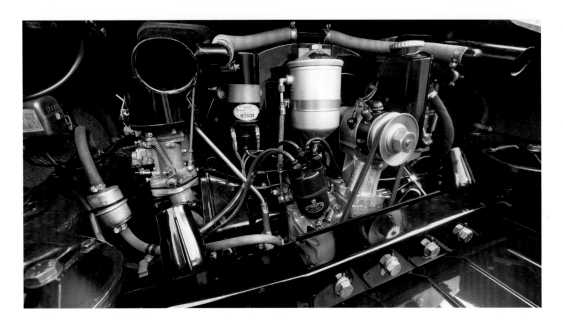

The 912 is a special offer for the less well-heeled enthusiasts of the make. In visual terms it can hardly be discerned from the 911 but features the four-cylinder engine of the 356SC, derated to 90 bhp.

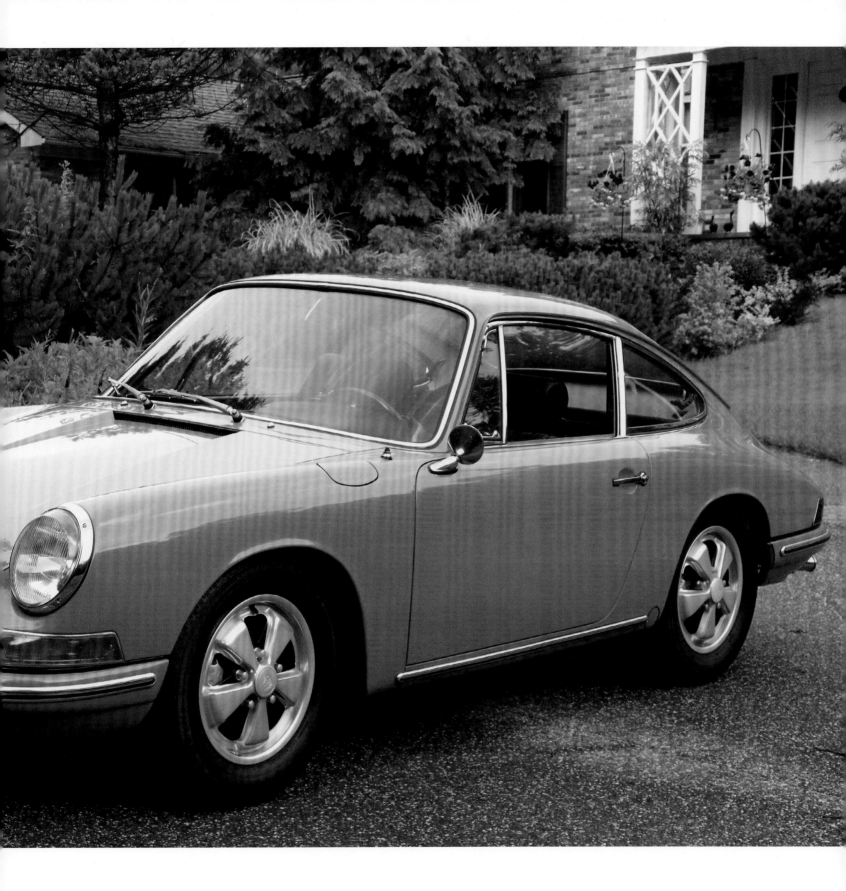

Mit dem 912 wendet man sich an die weniger betuchten Enthusiasten der Marke. Optisch ist er vom Elfer kaum zu unterscheiden, aber im Heck arbeitet der Vierzylinder des 356SC, auf 90 PS gedrosselt.

La 912 interpelle les moins nantis parmi les enthousiastes de la marque. Copie pratiquement conforme de la 911, sa croupe héberge le quatre-cylindres de la 356SC ramené à 90 ch.

Porsche 912

To some the hyphen between the VW and the Porsche names confirmed what had been reality from the outset. To others it was an odd attempt to marry the incongruous. A Porsche for the man in the street?

With a distribution of 96,491 units, the four-cylinder version certainly was to live up to that claim. But when the VW-Porsche 914-4—wide, low, angular, with thin wheels and pop-up headlights that stretched upwards like rabbits' ears in the dark—made its entry at the 1969 Frankfurt IAA, it was not at all in keeping with the clichés of charismatic sportiness. Its architecture followed the then-current mid-engine fashion—almost. In the very center lived, after all, the two passengers, back-to-back with the engine, which was installed just ahead of the rear axle, while the gearbox sat behind it. That accounted for the relatively long wheelbase, 96,45" as compared to the 911's 89.41". The all-steel body was structured by four partitions, and the two trunks at the front and the rear, adding up to a capacity of 13 cu.ft., served as crumple zones, fending off harm from the robust middle tract. Additional protection of the passengers was afforded by a massive welded-on rollover bar, which was the abutment of the 19 lb roof panel made of glass-fiber reinforced plastic as well. When not needed, it was tucked away in the rear luggage space.

Safety had also been a keyword when designing the suspension of the Porsche for the people, with wishbones, McPherson struts and longitudinal torsion bars at the front and rear wheels suspended by semi-trailing links, coil springs and shock absorbers. Beneath a small lid hid the 80 bhp injected engine from the VW 411 E, robust, economical, long-lived and a bit lackluster. In September 1972 the range was extended by the 914 2.0, whose purring power plant produced 100 bhp, while in August of the following year the entry model featured the aggregate of the VW 412 LS, activating 85 bhp from 1795 cc, assisted by a twin-carburetor system.

From 1970, the Porsche Sportomatic and 5½-inch rims with tires of 165 HR 15 caliber were available as options, testifying to continual model improvement. In 1971, the rear apron was shortened and endowed with vertical ventilation slots. At that moment the Porsche management had already rung the knell of the four-cylinder's Cinderella sibling 914-6, which had been wasting away with a poor circulation of only 3351. That was no wonder as it could be distinguished from its more popular brother solely by its five-spoke rims, while it featured ventilated front disks to cope with the 110 bhp and the more sprightly temperament provided by the two-liter six-cylinder engine of the former 911 T. But as it was just 999 marks less than the lowest-ranking member of the Porsche 911 hierarchy, customers preferred the real thing. Because of that obvious lack of attraction, too, only eleven prototypes were made of the up-market 916 with its wide chassis, fixed steel roof and 190 bhp put out by the 2.4-liter engine of the Porsche 911 S.

Für die einen besiegelte die Bindestrichehe VW-Porsche real existierende Verhältnisse, für andere kam sie dem Versuch gleich, die Quadratur des Zirkels zu erzwingen. Ein Porsche fürs Volk?

Gewiss – mit einer Verbreitung von 96 491 Einheiten für den Vierzylinder genügte er diesem Anspruch schon irgendwo. Den gängigen Klischees von charismatischer Sportlichkeit entsprach der VW-Porsche 914-4 jedoch kaum, als er da auf der Frankfurter IAA 1969 seine Aufwartung machte, breit, flach, kantig, mit dünnen Pneus und Klappscheinwerfern, die sich nächtens wie Kaninchenohren in die Höhe reckten. Seine Architektur folgte der aktuellen Mittelmotormode – fast. Denn im Zentrum lagerten die beiden Passagiere, Rücken an Rücken mit dem Motor. Dieser war kurz vor der Hinterachse angesiedelt, das Fünfganggetriebe dahinter. Entsprechend lang war der Radstand, 2450 mm gegenüber den 2271 des Porsche 911. Vier Schotten gliederten die Ganzstahlkarosserie, wobei die Kofferräume an beiden Enden mit einem gemeinsamen Volumen von 370 Litern den stabilen Mitteltrakt als Knautschzonen abschirmten. Dem zusätzlichem Schutz der Insassen diente ein angeschweißter Überrollbügel, zugleich Widerlager für das neun Kilo schwere Dachpaneel aus glasfaserverstärktem Kunststoff. Bei Nichtgebrauch war ihm ein Plätzchen im rückwärtigen Gepäckabteil reserviert.

Sicherheit vermittelte auch das Fahrwerk des Volks-Porsche, mit Querlenkern, Dämpferbeinen und Torsionsstäben vorn und Hinterrädern, die an Schräglenkern und mit Schraubenfedern kombinierten Schwingungsdämpfern aufgehängt waren. Unter einem kleinen Deckel verbarg sich der 80-PS-Einspritzer des VW 411 E, robust, genügsam, langlebig und auch ein wenig langweilig. Im September 1972 wurde der 100 PS leistende 914 2.0 ins Programm aufgenommen, im August des folgenden Jahres dem Einstiegsmodell das Aggregat des VW 412 LS spendiert, das mit Hilfe einer Zweivergaseranlage aus 1795 cm³ 85 PS aktivierte.

Ab 1970 waren die Optionen Porsche-Sportomatic und 5½-Zoll-Felgen mit Reifen des Kalibers 165 HR 15 zu haben. 1971 verkürzte man die Heckschürze und versah sie mit senkrechten Entlüftungsschlitzen. Zu diesem Zeitpunkt erscholl bereits das Halali über dem marktpolitischen Aschenbrödel 914-6, das in einer Auflage von lediglich 3351 dahingesiecht war. Kein Wunder: Äußerlich von seinem Brüderchen lediglich durch fünffach gezackte Felgeneinsätze unterschieden und vorn mittels innenbelüfteter Scheibenbremsen an die Kandare genommen, glänzte er zwar mit dem 110 PS starken Zweiliter-Sechszylinder des früheren 911 T und entsprechenden munteren Fahrleistungen, kostete aber gerade mal knapp 1000 Mark weniger als der unterste Dienstgrad der Porsche-911-Hierarchie. Nur auf elf Prototypen brachte es wegen der unergiebigen Marktlage der 916 mit einem Breitfahrwerk, stählernen Festdach und den 190 PS, die das 2,4-Liter Triebwerk des Porsche 911 S freisetzte.

Si, pour les uns, le mariage de raison entre VW et Porsche scelle l'officialisation d'une liaison, pour d'autres, il équivaut à une mésalliance. Une Porsche pour le peuple?

Produite certes à 96 491 exemplaires dans le cas de la quatre-cylindres, elle aura fait taire les médisants. Mais la VW-Porsche 914-4 ne correspond absolument pas au cliché classique de la sportivité charismatique quand elle fait son apparition à l'IAA de Francfort en 1969: large, toute plate, anguleuse, avec de minces pneumatiques et des phares escamotables qui lui donnent un air de lapin effarouché. Son architecture obéit – enfin presque – à la mode du moteur central, très en vogue à cette époque-là. En effet, ce sont en réalité les deux passagers qui se trouvent au centre, dos à dos avec le moteur. Lequel est lui-même contigu

1969–1976

au train arrière avec, derrière celui-ci, la boîte à cinq vitesses. On peut imaginer la longueur de l'empattement : 2450 mm contre 2271 mm pour la Porsche 911. Quatre panneaux tronquent la structure sous la carrosserie tout en acier, les coffres bannis aux deux extrémités, d'une capacité totale de 370 litres, protégeant la partie centrale comme une espèce de zone de déformation programmée. Un arceau de sécurité soudé offre une protection supplémentaire aux occupants, tout en servant de support pour le hard-top en fibre de verre d'un poids de 9 kg. En cas de non-utilisation, il se loge dans un compartiment qui lui est réservé dans le coffre arrière.

Avec des bras transversaux, des jambes élastiques et des barres de torsion à l'avant ainsi que des roues arrière suspendues à des bras obliques et à des amortisseurs combinés à des ressorts hélicoïdaux, à l'arrière, le châssis de la plus populaire des Porsche joue la carte de la sécurité. Sous un petit capot juste dans le prolongement de la lunette se dissimule le moteur à injection de 80 ch de la VW 411 E, un moteur robuste, sobre, increvable, mais, aussi, un peu ennuyeux. En septembre 1972, celui-ci cède sa place à un deux-litres de 100 ch avant que n'arrive, en août 1973, pour le modèle d'accès à la gamme, le groupe de la VW 412 LS qui, grâce à un double carburateur, développe 85 ch à partir d'une cylindrée de 1795 cm³.

En 1970, pour lui donner de meilleurs arguments, Porsche propose différentes options comme la boîte de vitesses Sportomatic et les jantes de 5½ pouces chaussées de pneus de 165 HR 15. En 1971, le tablier arrière est raccourci et s'enrichit de fentes d'aération verticales. À ce moment-là, le glas a déjà sonné pour la Cendrillon 914-6, condamnée par les aléas du marché et produite à seulement 3351 exemplaires. Ce qui n'a rien d'étonnant : si elle brille avec les 110 ch du six-cylindres de 2 litres de l'ancienne 911 T, et par des performances et un agrément de conduite tout à fait respectables, elle ne se distingue extérieurement de sa sœur que par des jantes à cinq branches et des freins à disque ventilés à l'avant, tout en coûtant à peine 1000 marks de moins que la Porsche la moins gradée de la hiérarchie 911, – les clients ne s'y trompent pas. Quant à la 916 à voies élargies et à toit fixe en acier, propulsée par les 190 ch du moteur de 2,4 litres de la Porsche 911 S, elle ne sera produite qu'à raison de 11 prototypes, n'ayant jamais pu faire sa place sur le marché.

914

The flat four mid-engine of the 914-4
leads a secluded life below a narrow
lid. The actual center of the car is,
however, reserved for the passengers.
Weight distribution is excellent.

Der Vierzylinder-Mittelmotor des
914-4 führt unter einer schmalen
Haube ein ungemein zurückgezogenes
Dasein. Im eigentlichen Zentrum
sitzen allerdings die Passagiere.

Le quatre-cylindres en position centrale
de la 914-4 vit un destin anonyme sous un
étroit capot. Mais ce sont les passagers
qui sont vraiment au centre de toute chose.
La répartition du poids est excellente.

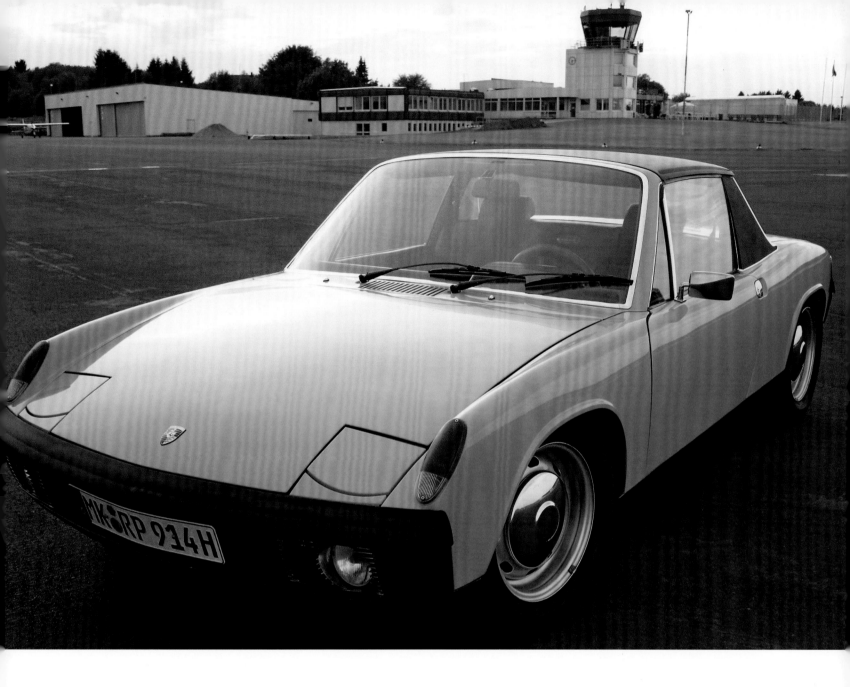

The 914 interior harks back to the 356 Speedster in terms of its austere simplicity. European 914s have the Wolfsburg crest in the steering wheel center, while the models destined for the USA carry the Porsche emblem.

In seiner kargen Simplizität erinnert das Cockpit an den Speedster. Für Europa bestimmte Modelle tragen das Wappen von Wolfsburg in der Mitte des Lenkrads, Exportwagen für die USA das Porsche-Emblem.

Par sa simplicité spartiate, le cockpit n'est pas sans rappeler le Speedster. Certains modèles destinés à l'Europe arborent le blason de Wolfsburg au centre du volant, les versions d'exportation pour les États-Unis, l'emblème Porsche.

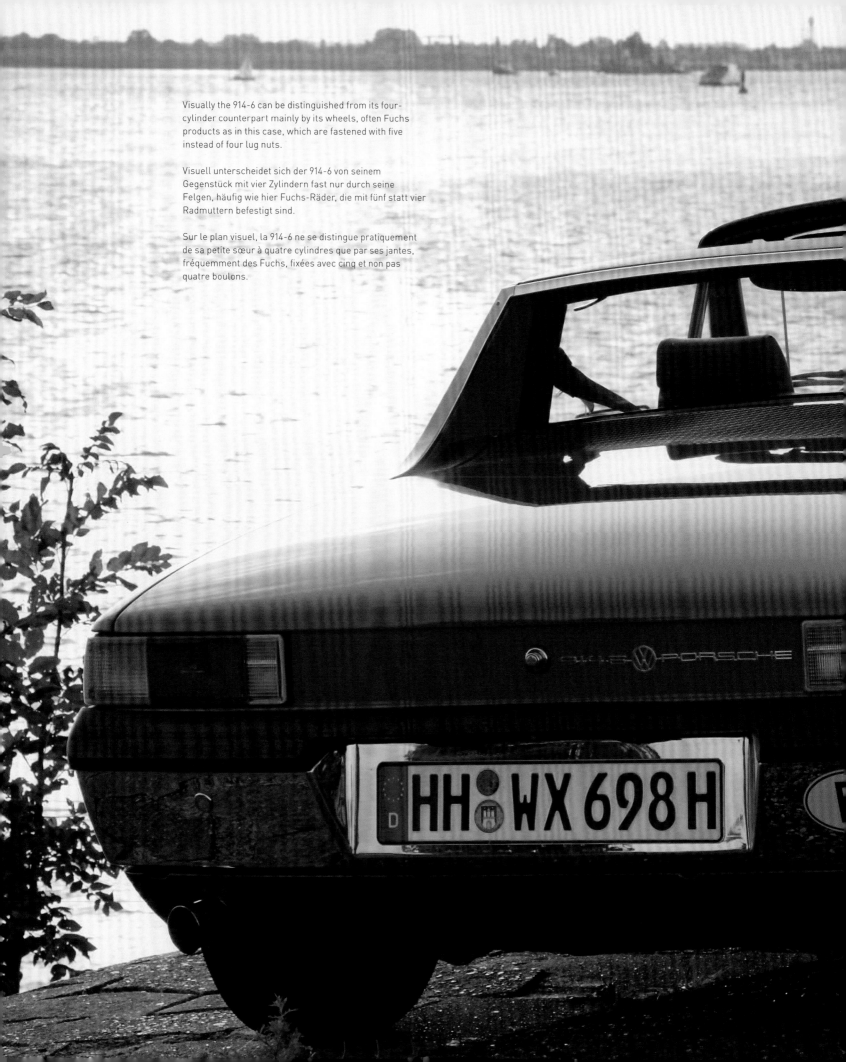

Visually the 914-6 can be distinguished from its four-
cylinder counterpart mainly by its wheels, often Fuchs
products as in this case, which are fastened with five
instead of four lug nuts.

Visuell unterscheidet sich der 914-6 von seinem
Gegenstück mit vier Zylindern fast nur durch seine
Felgen, häufig wie hier Fuchs-Räder, die mit fünf statt vier
Radmuttern befestigt sind.

Sur le plan visuel, la 914-6 ne se distingue pratiquement
de sa petite sœur à quatre cylindres que par ses jantes,
fréquemment des Fuchs, fixées avec cinq et non pas
quatre boulons.

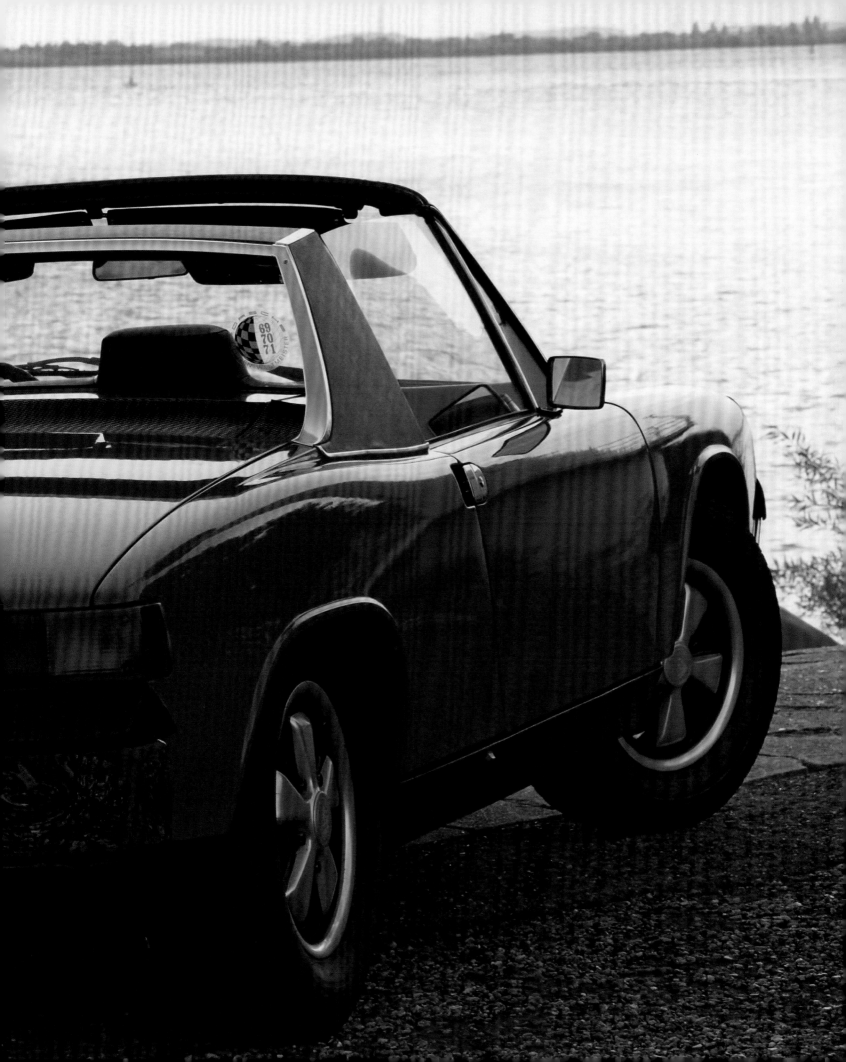

The one-piece glass-fiber roof, fastened between the windshield and the Targa-type roll bar, is quickly removed and then tucked away in the rear baggage compartment.

Das einteilige Fiberglasdach, zwischen dem Rahmen der Windschutzscheibe und dem Targa-Bügel angesiedelt, kann zügig entfernt und dann im hinteren Kofferraum verstaut werden.

Le toit en fibre de verre d'un seul tenant qui s'accroche entre la baie de pare-brise et l'arceau Targa s'enlève instantanément et se range alors dans le coffre arrière.

VW-Porsche 914

It showed the way in more than one respect. On the one hand, it was the precursor of a new 911 generation featuring a capacity of 2687cc by increasing the well-known six cylinder's bore from 84 to 90mm. On the other, it paved the Porsche drivers' way back to rally glory and made the marque's participation in the European GT Championship possible, which required a minimum population of 500. That objective had been achieved in November 1972. Altogether 1525 units were built as the RS2.7 turned out to be a coveted article among a clientele that was hungry for both performance and prestige. Its price was also helpful, the customer having to invest a moderate 33,000 marks, just 1820 more than for the definitely less spectacular 911S, which was, nevertheless, equipped with most of the blessings of modern car civilization.

Thirdly, the RS2.7 revived the cult term Carrera, which had last adorned a 356C model, only to fall into disuse for seven years. Porsche had, after all, secured the right to use it from the organizers of the Carrera Panamericana, traditionally an excellent platform for the Zuffenhausen make. The euphonious word promised freedom and adventure as well as uncompromising sportiness, which the car made no secret of, not least in visual terms. As a rule, the RS2.7 was "grand prix white", as a subtle reminder of the German racing color until 1934, its sides flaunting the Carrera logo in blue, green or red, with the paint of the five-spoke light-alloy rims matching so as to further the model's aggressive impact. If that did not suit the potential owner, the car was also to be had without such loud décor. But the majority would not do without it, just as they were also not prepared to forego the car's trademark glass fiber "ducktail" spoiler on the rear lid made of the same material. Assisted by a corresponding front air dam, massive rear 215/50VR15 and front 185/70VR15 tires and a chassis that had been honed for that purpose by using Bilstein struts and 15-inch stabilizers, the Carrera was virtually nailed to the road, though once its extraordinary limits had been exceeded considerable skill was required to keep it on the tarmac. And all of a sudden, many run-of-the-mill 911s sprouted the threateningly erected racing requisite, a must on the Carrera which could only be exchanged against a normal engine compartment lid at the customer's own risk.

After all, 210 bhp were responsible for the transport of barely 2116 lbs (kerb weight). Compared to the then-current 911S with 2.4 liters, two hundredweight had been pared off. Every non-essential amenity was excluded. There was no sound insulation. The rear seats had been removed as had the clock. The body sheet metal and windshield glass were thinner, the doors were opened by leather straps, with their rubber counterparts locking the plastic rear lid, while the passengers sat in mere Recaro shells with no padding. Paradoxically, however, these ascetic measures could be reversed at an extra 700 marks (Sport package) or in a Touring version (2500 marks).

Er wies den Weg gleich in mehrfacher Hinsicht. Zum einen wurde er Vorreiter einer neuen Generation von Elfern mit 2687 cm³ Hubraum, indem man die Bohrung von 84 auf 90 mm erweiterte. Zum anderen brachte er Porsche-Fahrer im Rallyesport wieder nach vorn und ermöglichte den Einstieg in die Europa-Trophäe für GT-Fahrzeuge, für den es eine Mindestpopulation von 500 Exemplaren nachzuweisen galt. Im November 1972 konnten die Zuffenhausener damit aufwarten. Eine zweite Auflage von 536 Einheiten schloss sich an, da sich der RS2.7 unter einer nach Leistung und Prestige dürstenden Klientel als begehrter Artikel erwies. Hilfreich war dabei eine klug-moderate Preisgestaltung: Seine Anschaffung schlug mit 33000 Mark zu Buche, gerade mal 1820 Mark mehr als der entschieden bürgerlichere, wenn auch mit fast allen Segnungen der Auto-Zivilisation ausgestattete 911S.

Zum Dritten erfüllte er das Kultwort Carrera mit neuem Leben, das zuletzt ein Modell der Baureihe 356C geziert und seit sieben Jahren brachgelegen hatte. Schließlich hatte man sich die Nutzungsrechte einst bei den Veranstaltern der mexikanischen Carrera Panamericana gesichert, traditionell einem guten Porsche-Forum. Die süffig tönende Vokabel verhieß Freiheit, Abenteuer und kompromisslose Sportlichkeit. Schon visuell wurde daraus gar kein Hehl gemacht. In aller Regel war der RS2.7 in „Grand Prix Weiß" gehalten, mithin der einstigen deutschen Rennfarbe, und der Schriftzug Carrera schmückte in Blau, Grün oder Rot seine Flanken. In den gleichen Couleurs verstärkten dann die fünfzackigen Einsätze seiner Aluminiumfelgen seinen militanten Auftritt. Wer wollte, konnte auf diesen aggressiven Dekor verzichten. Aber das tat kaum jemand, ebenso wenig wie auf den frech sich emporreckenden Heckspoiler aus Fiberglas, bald in Analogie zu einem Gegenstück aus dem Reich von Ente und Gans Bürzel genannt. Er nagelte den Carrera RS2.7 im Bunde mit einer tief hängenden Frontlippe, Pneus der Kaliber 215/60VR15 hinten und 185/70VR15 vorn und dem mit Dämpferbeinen von Bilstein und 15-mm-Stabilisatoren aufbereiteten Fahrwerk förmlich an die Straße. Im Gegenteil: Das drohend anmutende Renn-Requisit, am Carrera nur auf eigene Verantwortung des Kunden gegen einen normalen Heckdeckel auszutauschen, dekorierte bald so manchen 911 von der Stange.

Immerhin erklärten sich 210 PS für den Transport von knapp 960 kg (fahrfertig) zuständig. Zwei Zentner gegenüber dem zeitgenössischen 911S mit 2,4 Litern waren abgespeckt worden. Man entfernte die hinteren Notsitze ebenso wie die Zeituhr. Die Bleche waren dünner, die Türen durch Lederriemchen zu öffnen, und leichte Gummizüge arretierten den Kunststoffdeckel über dem Motorraum, während die Passagiere in knallharten wannenförmigen Recaro-Sitzschalen lagerten. Mit einem Sportpaket (700 Mark teuer) und in einer Touring-Version (Aufpreis 2500 Mark) ließen sich diese asketischen Eingriffe in sanfter Paradoxie wieder rückgängig machen.

Elle ouvre la voie sur plusieurs plans. Premièrement, elle annonce toute une nouvelle génération de 911 de 2687 cm³ de cylindrée obtenus par une augmentation de l'alésage de 84 à 90 mm. Deuxièmement, elle permet aux pilotes de Porsche de se battre de nouveau aux avant-postes en rallye et au Trophée d'Europe pour GT, dont l'homologation requiert une production minimum de 500 exemplaires. Le constructeur de Zuffenhausen peut s'en prévaloir en novembre 1972. Une deuxième édition de 536 unités s'en suit, car la RS2.7 est une voiture que s'arrache une clientèle assoiffée de puissance et de prestige – une vogue encouragée par une tarification aussi modérée qu'intelligente. Pour se l'offrir, il « suffit » de 33000 marks, tout juste 1820 marks de plus que pour la 911S, beaucoup plus « bourgeoise »

1972–1973

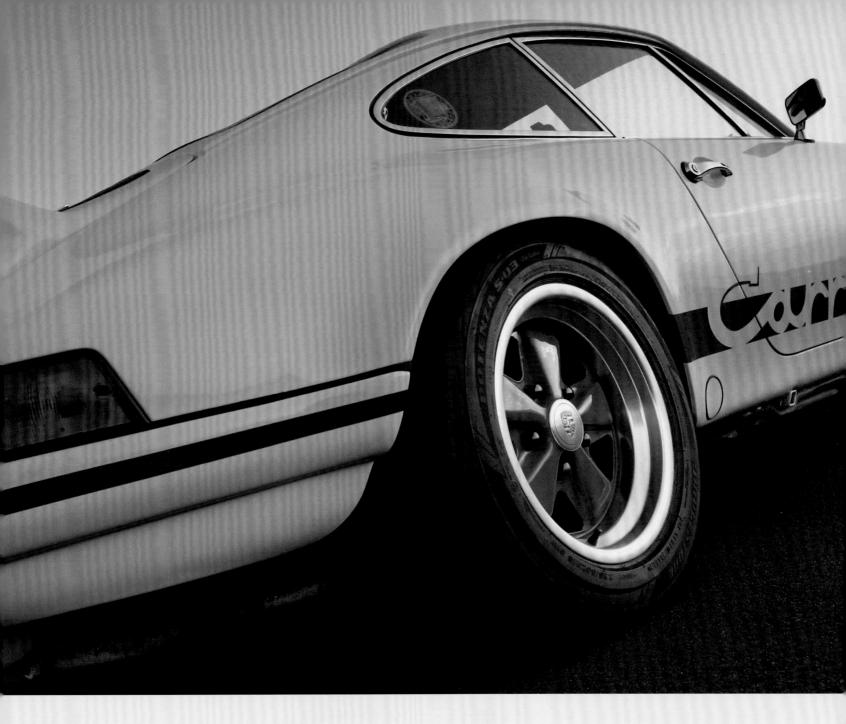

puisqu'elle possède tout ce qui fait le charme d'une voiture moderne.

Troisièmement, elle insuffle de nouveau la vie au vocable culte Carrera qu'arborait tout dernièrement un modèle de la gamme 356C et qui avait brillé par son absence dans les catalogues depuis sept ans. Porsche s'est entre-temps offert les droits d'utilisation de ce nom, racheté aux anciens organisateurs de la Carrera Panamericana mexicaine, où Porsche a glané de nombreux lauriers au fil des ans. Ce patronyme alléchant est synonyme de liberté, d'aventure et de sportivité. Visuellement, déjà, elle ne fait pas mystère de sa nature. En règle générale, la RS 2.7 est commandée en « blanc Grand Prix », ce qui est d'ailleurs l'ancienne livrée des voitures allemandes de Grand Prix alors que le graphisme Carrera orne ses flancs en bleu, vert ou

rouge. Peints dans la même couleur vive, les cinq rayons de ses jantes en aluminium donnent une touche supplémentaire à son allure martiale. Il est toutefois possible de renoncer à ce décor agressif, ce qui ne tente cependant presque aucun acheteur. De même, la majorité des clients commande le becquet arrière en fibre de verre incliné à 45 degrés qui n'est pas sans rappeler une queue de canard. De concert avec un aileron avant qui descend très bas, des pneus du calibre de 215/60 VR 15 à l'arrière et de 185/70 VR 15 à l'avant avec des liaisons au sol consistant en jambes élastiques Bilstein et barres antiroulis de 15 mm, la Carrera RS 2.7 est littéralement collée à la route. Rançon du succès, cet accessoire menaçant issu tout droit des paddocks – et que l'on ne peut échanger contre un becquet arrière normal sur la Carrera que si le client en

assume sciemment la responsabilité – ne tarde pas à venir décorer certaines 911 de gamme inférieure.

Les 210 ch qui figurent sur la fiche d'homologation ont seulement 960 kg (poids prêt à rouler) à mouvoir. Soit 100 kg de moins que sa contemporaine, la 911S à moteur de 2,4 litres. La chasse aux kilos de trop n'a épargné ni les sièges d'appoint arrière ni la montre de bord. Les tôles sont plus légères, les portières s'ouvrent à l'aide d'une petite courroie en cuir et de légers crochets en caoutchouc fixent le capot en matière plastique au-dessus du moteur, tandis que les passagers se recroquevillent dans des baquets Recaro en forme de coquille. Avec le châssis Sport (facturé 700 marks) et une version Touring (supplément de prix : 2500 marks), il est, paradoxalement, possible de faire disparaître tous ces signes d'ascétisme.

911 Carrera RS 2.7

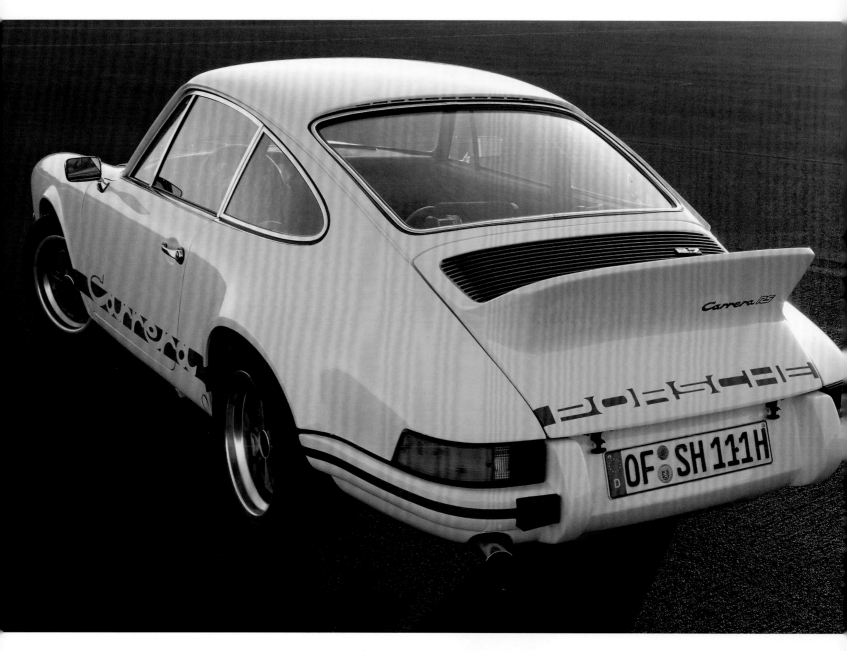

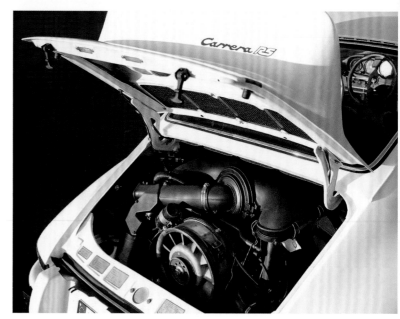

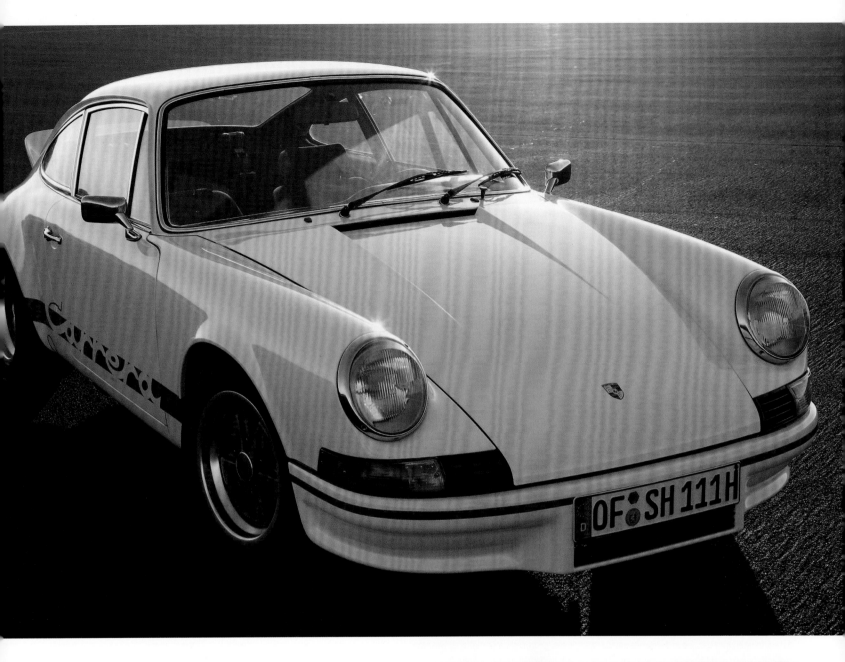

On the 911RS returns the magic Carrera name. It has no sound insulation, thinner sheet metal and glass, and on the rear glass fiber lid sits a small ducktail spoiler that is said to be good for another three miles per hour.

Mit diesem Modell kehrt der Name Carrera zurück. Markantestes Merkmal ist der ständig erigierte Spoiler auf dem Glasfiberheck, im Volksmund bald nur noch Bürzel genannt. Er soll fünf km/h bringen.

Ce modèle marque le retour du nom Carrera. Son signe distinctif le plus marquant est son aileron fixe sur le capot en fibre de verre, que l'on ne tarde pas à surnommer « queue de canard ». Il est crédité de cinq km/h supplémentaires.

Porsche 911 Carrera RS 2.7

Like its long-lived ancestor the 356, the 911 had already proved to be an almost ideal object for a mildly conservative model policy within its first decade. By untiringly ameliorating a basic product with seemingly endless possibilities, the small but noble Stuttgart enterprise spared its friends and an ever-growing following of disciples the frustration of frequent model changes. Instead, they had to live with the slightly uneasy feeling that soon, possibly, they would have to make do with the second best Porsche of all time. But that was a shortcoming that was almost made up for by the legendary and continually increasing longevity and lasting value of Porsche products.

The best one, from September 1973 onwards, was the evolutionary stage code-named G, i.e. the seventh variation of the 911 theme, available with 150 bhp, 175 bhp (911 S) and 210 bhp (Carrera), while the T and E designations had fallen by the wayside in the course of a straightening of the front. On the first two, dependent on the amount of air sucked in, their fossil food (regular gas as in the case of the Carrera, too) was rationed out to the rasping boxer engine in the rear by a K-Jetronic (CIS) from Bosch, while in the top-notch model a mechanical injection remained responsible for that job. As to the outer appearance of the Carrera, which was now also to be had in Targa guise, all the gaudy effects that kept frightening law-abiding citizens on the RS 2.7 had been dispensed with. Porsche-specific understatement was back in fashion, a rear "whale-tail" spoiler which jutted out provokingly having become an option, and in only a couple of cases did a huge lateral logo testify to its identity in case anyone was in doubt. While the former had sported all the spartan cosiness of a monk's cell, its successor had taken part in the general evolution of comfort that had been bestowed upon the series, featuring, for instance, high-backed lightweight seats with inertia-reel belts and electric window lifts.

The exterior of the G model had also been massively retouched. As usual, form followed function far beyond any fashionable frills. Heavy-duty aluminum bumpers, front and rear, had been incorporated into the design, with additional rubber overriders protecting the car's hindquarters. The front lamp units were embedded in the corners of the bumper above the chin spoiler, interrupting a supplementary rubber bulge like the one protecting the 911's sides below the doors.

The most striking feature of that generation —from 1976 onwards the basic 911 remained the only representative of the 2.7-liter breed—consisted in the accordion-pleated rubber boots covering the gap between bumpers and body. They hid collapsible aluminum tubes with a scope of about two inches that crushed under severe impact, Porsche's clever and not at all unattractive answer to American safety legislation asking for both ends of a car being able to resist a five-mph nudge without lasting damage. A hydraulic shock-absorbing attachment that did not have to be replaced after an incident was standard on US cars and optional in other markets.

Wie einst der Dauerbrenner und -renner 356 begann sich der Elfer bereits in seinen ersten zehn Jahren als geradezu ideales Objekt für eine mild-konservative Modellpolitik zu erweisen. Durch die unermüdliche Arbeit an einem Ausgangsprodukt mit offenbar schier unerschöpflichen Möglichkeiten ersparte das kleine, aber feine Stuttgarter Haus seinen Freunden und Jüngern den Verdruss häufiger Typenwechsel. Was blieb, war das sanfte Unbehagen, vielleicht in relativ kurzer Zeit nur den zweitbesten Porsche aller Zeiten zu besitzen – ein Manko, das durch eine geradezu legendäre und immer noch zunehmende Wertbeständigkeit fast wieder austariert wurde.

Der beste – das war ab September 1973 die Ausbaustufe G, die siebente Variation des Motivs 911 also, mit 2,7 Litern Hubraum, erhältlich mit 150 PS, 175 PS (911 S) und 210 PS (Carrera), während die Versionen T und E im Zuge einer Frontbegradigung auf der Strecke geblieben waren. In den ersten beiden wurde dem heisernden Boxer im Heck seine fossile Nahrung (Normalbenzin wie auch im Falle des Carrera) nun abhängig von der angesaugten Luftmenge durch die K-Jetronic von Bosch zugemessen, während im Top-Typ eine mechanische Einspritzung dafür zuständig blieb. Im übrigen enthielt sich der Carrera – jetzt auch als Targa zu beziehen – der knalligen Effekte, mit denen der RS 2.7 friedfertige Bürger vergrämen mochte. Porsche-spezifisches Understatement war angesagt, der provozierend ausladende Heckspoiler zum aufpreispflichtigen Extra verkümmert, und nur in einigen wenigen Fällen schrie ein riesiger Schriftzug auf seinen Flanken seine Identität heraus. Wo jener noch mit der Wohnlichkeit einer mönchischen Strafzelle aufgewartet hatte, nahm sein Nachfolger an der allgemeinen Evolution des Komforts teil, erhielt etwa kommode Fauteuils mit integrierten Kopfstützen sowie serienmäßige Automatikgurte und elektrische Fensterheber.

Kräftig retuschiert hatte man am äußeren Auftritt des G-Modells. Dabei folgte wie gewohnt die Form der Funktion abseits von jeglichem modischem Firlefanz. Die Stoßfänger, am Hinterviertel mit zusätzlichen Hörnern bewehrt, bestanden aus Aluminium. Das Ensemble der Leuchten war vorn in die Ecken des Rammschutzes eingebettet und unterbrach somit einen zusätzlichen schützenden Gummiwulst, wie er auch unterhalb der Türen Unbill von den Flanken des Porsche 911 2.7 abhalten sollte.

Markantestes Merkmal dieser Generation – ab 1976 verblieb der Basis-911 als einziger 2,7-Liter – waren indessen die ziehharmonikaartigen Faltenbälge am Ende der Stoßstangen. Darunter verbargen sich Prallrohre mit ungefähr 50 Millimetern Spielraum, die kluge und keineswegs unattraktive Antwort von Porsche auf die amerikanische Sicherheitsbestimmung, Wagenbug und -heck müssten unbeeindruckt einen Knuff von acht Stundenkilometern wegstecken. Noch besser taten dies die optionalen Pralldämpfer, die Stoßenergie mittels hydraulischer Wirkung auffingen.

À l'instar de l'indestructible 356 en son temps, la 911 se révèle au cours des dix premières années de sa carrière comme une voiture prédestinée pour une politique commerciale conservatrice, mais de bon aloi. Remettant infatigablement sur l'ouvrage un produit modeste offrant des possibilités apparemment inépuisables de modernisation, la petite mais prestigieuse manufacture de Stuttgart épargne à son cercle d'adeptes toujours plus large la frustration d'un changement fréquent de modèles.

À ceux-ci de s'accommoder du léger malaise que l'on ressent à posséder rapidement la deuxième meilleure Porsche de tous les temps – un léger défaut compensé par la longévité légendaire et la valeur exceptionnelle des produits de la firme allemande.

1973–1977

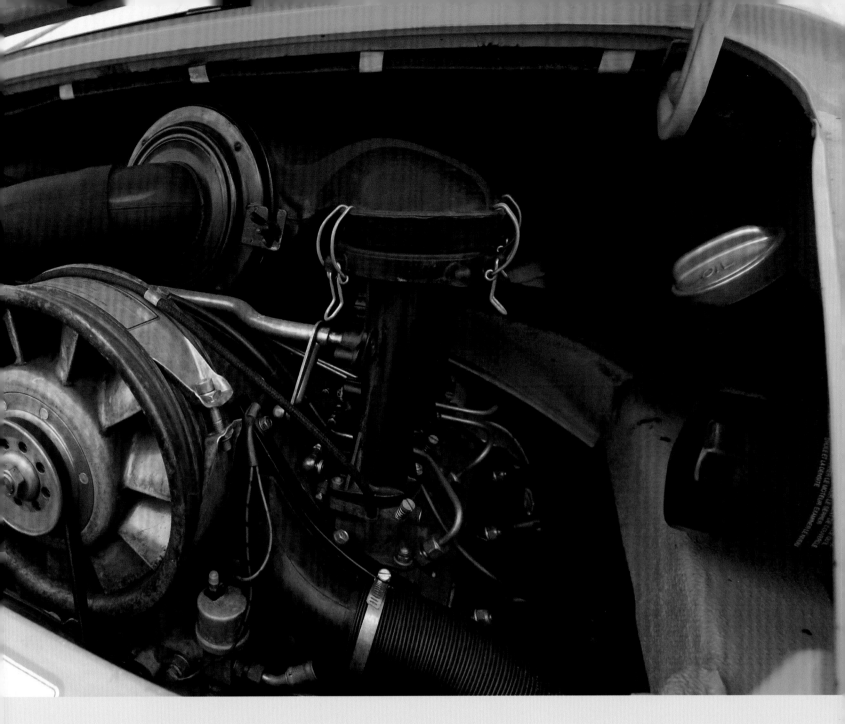

Le meilleur arrive en septembre 1973, avec l'évolution G : septième déclinaison sur le thème de la 911, en l'occurrence avec 2,7 litres de cylindrée disponible dans trois niveaux de puissance – 150 ch, 175 ch pour la 911S et 210 ch pour la Carrera – tandis que les versions T et E ont été supprimées. Les deux premières désaltèrent leur boxer à la voix rauque avec de l'ordinaire (à l'instar de la Carrera), mais en fonction de la quantité d'air aspiré, calculée par une injection Bosch K-Jetronic, alors que la version haut de gamme se contente toujours d'une injection mécanique. Détail qui a son importance, la Carrera – disponible maintenant en version Targa – renonce à ces effets arrogants qui, sur la RS 2.7, constituaient un affront aux yeux des « petits bourgeois bien pensants ». La discrétion est désormais de mise : le becquet arrière

n'est plus qu'une option onéreuse alors que, dans quelques rares cas seulement, le gigantesque graphisme sur ses flancs proclame encore haut et fort son identité. Ceux qui s'attendent à ce que le cockpit soit d'une sobriété monacale constatent que sa remplaçante participe bon gré mal gré de l'évolution générale du confort, par exemple avec de confortables fauteuils à appuie-tête intégré ainsi qu'avec des ceintures automatiques en série et même des lève-vitres électriques.

La présentation extérieure de la version G a aussi fait l'objet de toutes les attentions. Comme de coutume, la forme obéit à la fonction et refuse toute fioriture en vogue. Les pare-chocs sont en aluminium, avec des cornes supplémentaires à l'arrière. À l'avant, les clignotants ont été regroupés aux angles du pare-chocs, interrompant

ainsi le boudin de protection qui la ceinture et dont le prolongement est aussi censé épargner les chocs aux flancs de la Porsche 911 2.7.

La caractéristique la plus marquante de cette génération – à partir de 1976, la 911 de base est la seule à posséder encore un moteur de 2,7 litres – est le soufflet en accordéon entre le pare-chocs et la carrosserie. Ces soufflets dissimulent des tubes télescopiques avec un jeu d'environ 50 mm, réponse intelligente et non disgracieuse de Porsche aux normes de sécurité américaines qui veulent que la proue et la poupe d'une voiture puissent encaisser sans dommage visible un choc jusqu'à la vitesse de 8 km/h. Mais Porsche fait encore mieux avec les amortisseurs optionnels qui annulent l'impact d'un heurt à l'aide d'un dispositif hydraulique.

911 2.7

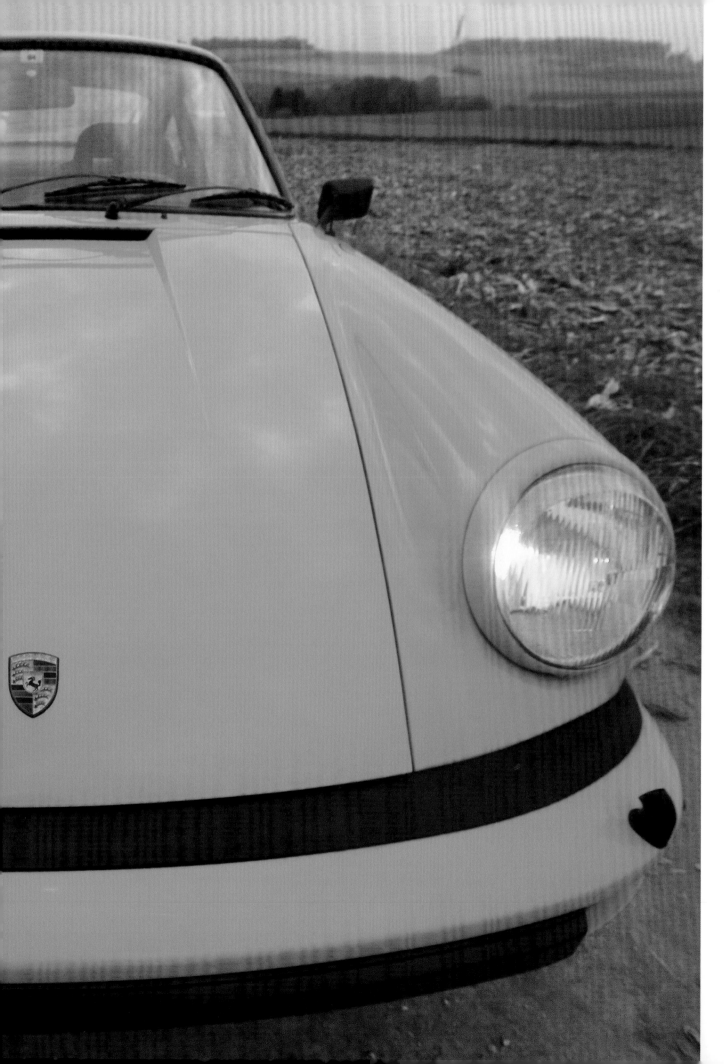

2.7-liter Carrera of 1974 sporting the optional big rear spoiler and gravel protection in front of the rear fenders. This specimen features the RS power plant with 210 bhp, one of 500 left.

2.7-Liter-Carrera von 1974 mit dem als Extra lieferbaren großen Heckspoiler und hinterem Steinschlagschutz. In diesem Exemplar tut das Triebwerk des RS mit 210 PS Dienst, eines von 500 verbliebenen.

Une Carrera 2.7 litres de 1974 arborant le grand aileron arrière optionnel et la protection anti-gravillonnage sur la face avant des ailes arrière. Ce spécimen, l'un des 500 ayant survécu, possède le moteur de la RS de 210 ch.

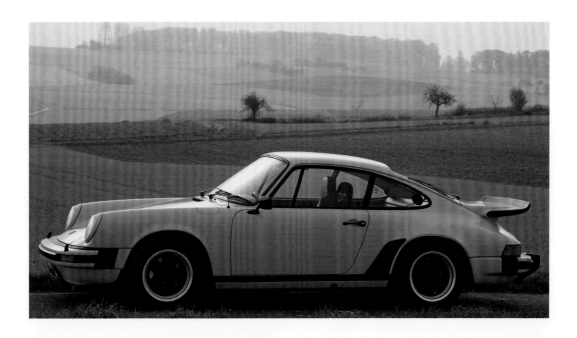

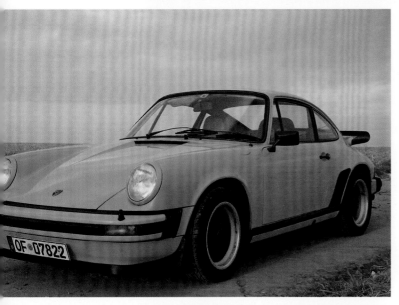

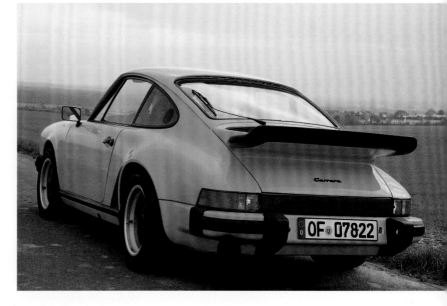

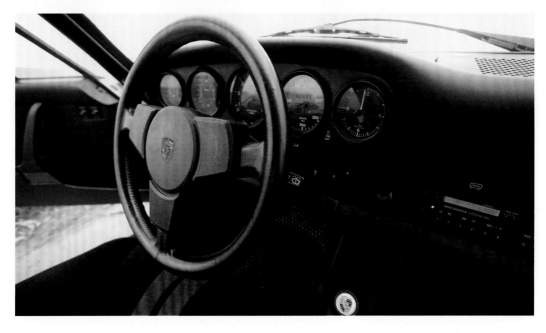

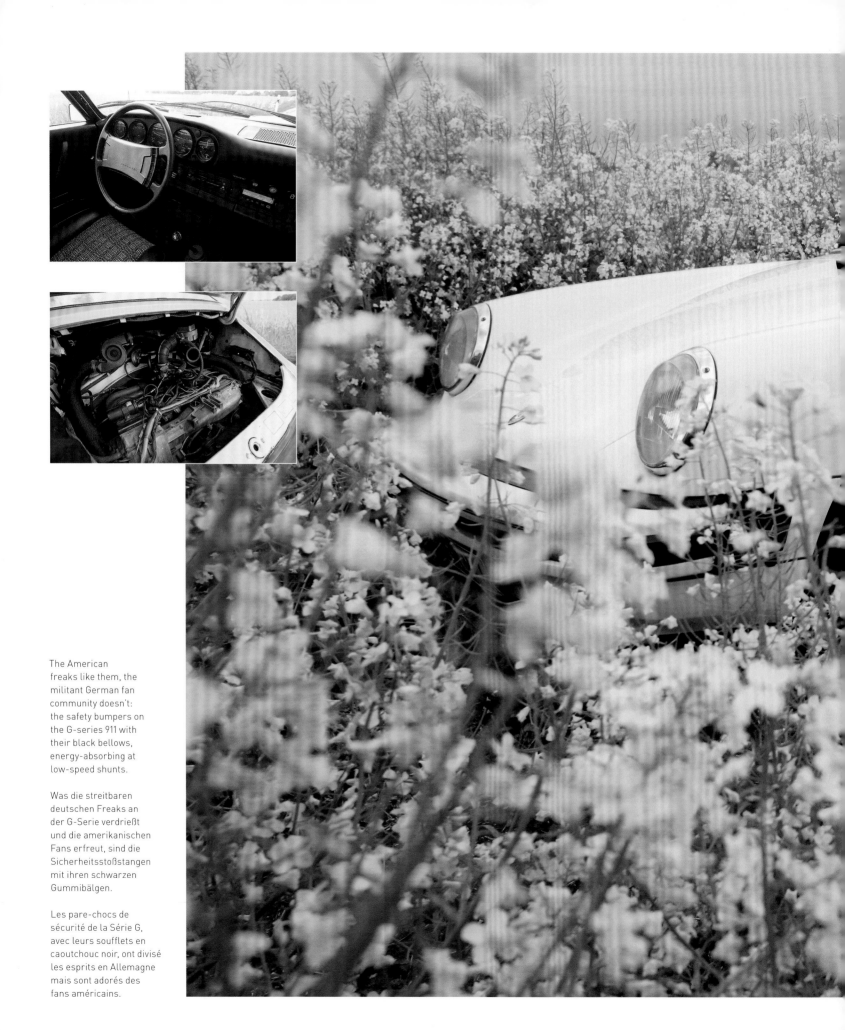

The American
freaks like them, the
militant German fan
community doesn't:
the safety bumpers on
the G-series 911 with
their black bellows,
energy-absorbing at
low-speed shunts.

Was die streitbaren
deutschen Freaks an
der G-Serie verdrießt
und die amerikanischen
Fans erfreut, sind die
Sicherheitsstoßstangen
mit ihren schwarzen
Gummibälgen.

Les pare-chocs de
sécurité de la Série G,
avec leurs soufflets en
caoutchouc noir, ont divisé
les esprits en Allemagne
mais sont adorés des
fans américains.

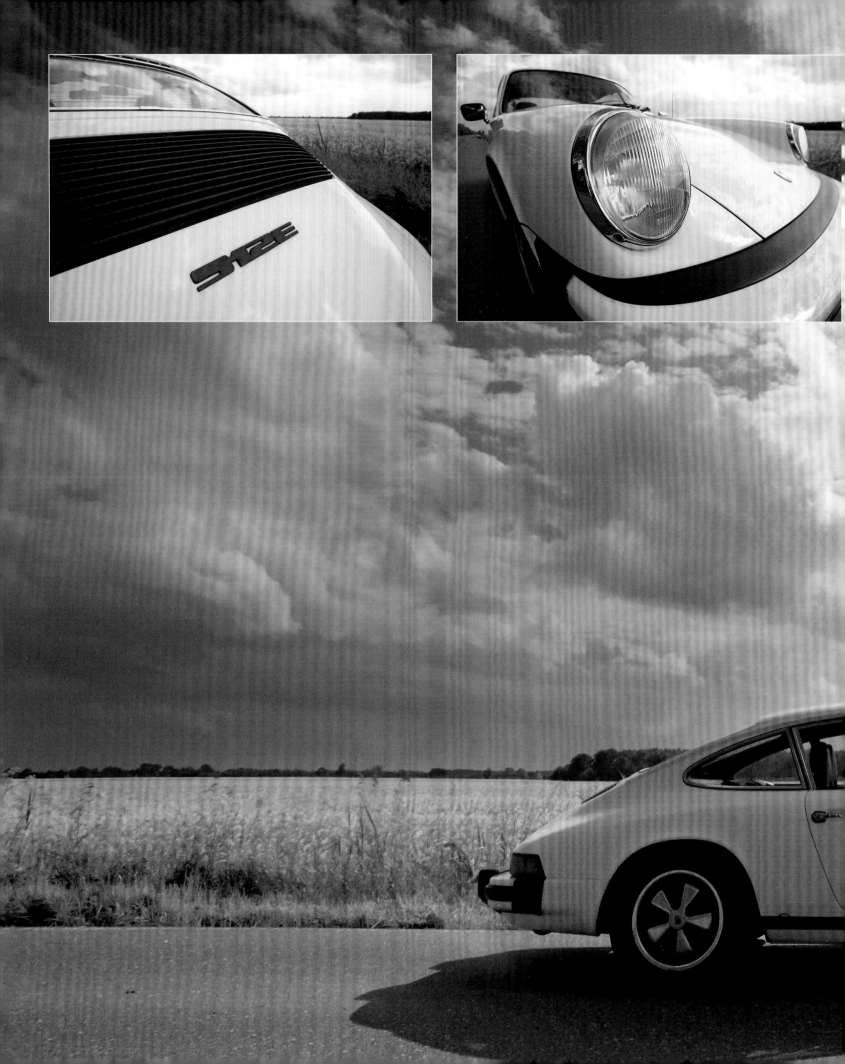

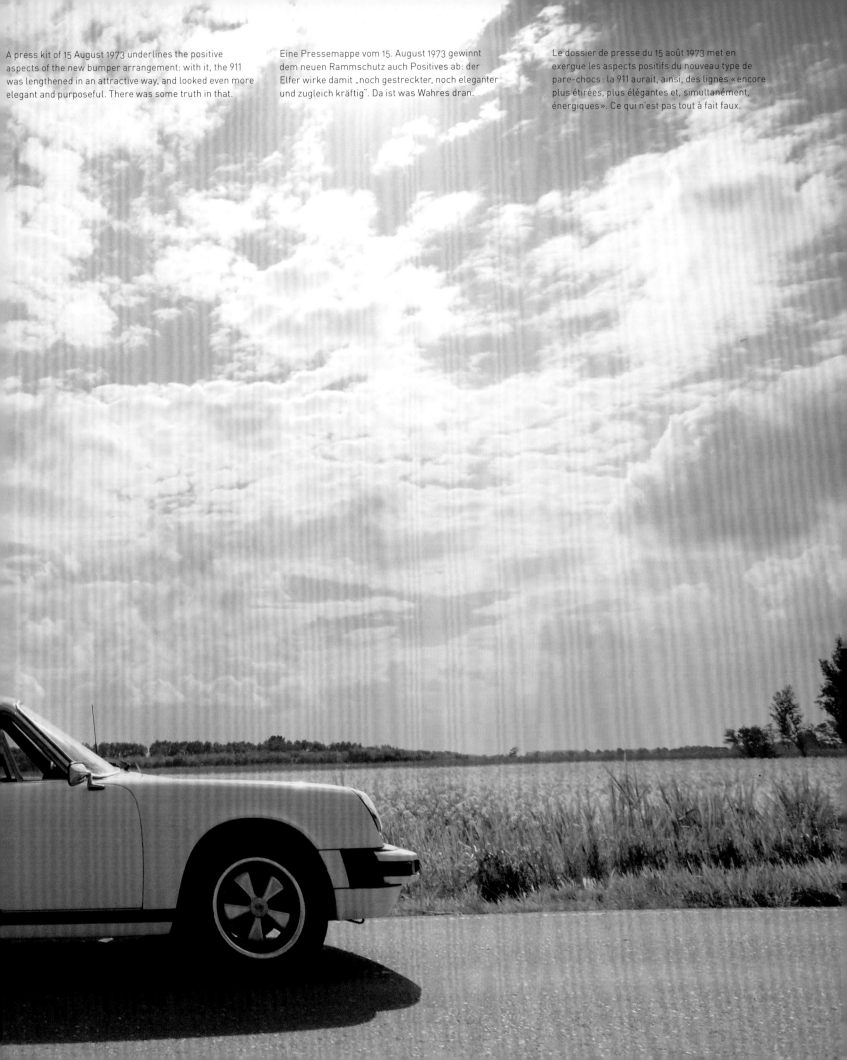

A press kit of 15 August 1973 underlines the positive aspects of the new bumper arrangement: with it, the 911 was lengthened in an attractive way, and looked even more elegant and purposeful. There was some truth in that.

Eine Pressemappe vom 15. August 1973 gewinnt dem neuen Rammschutz auch Positives ab: der Elfer wirke damit „noch gestreckter, noch eleganter und zugleich kräftig". Da ist was Wahres dran.

Le dossier de presse du 15 août 1973 met en exergue les aspects positifs du nouveau type de pare-chocs: la 911 aurait, ainsi, des lignes «encore plus étirées, plus élégantes et, simultanément, énergiques». Ce qui n'est pas tout à fait faux.

The Turbo 3.0, introduced at the Paris motor show in October 1974, proved convincingly that even a genuine sports car can reconcile impressive performance and sumptuous luxury. The new flagship of the Porsche fleet was based on the 911, but obviously sported its own identity, which justified a name of its own—the 930.

Performance: a mighty 260 bhp, generated by the three-liter flat six, put under turbo pressure as on the racing sports cars of the marque. The way that power was unleashed was extremely urbane, the car articulating itself within a gamut that went from a peaceful purr to a restrained growl. The turbocharger in the exhaust system, whose rotor had its muscles swell with 11.6 psi, had the effect of an additional silencer. The dramatic power increase as compared to the naturally aspirated, though not at all feeble, 911 models was transferred to the rear axle via a custom-made four-speed gearbox and was reflected everywhere in the premium Porsche's appearance, in its low-installed front spoiler and its huge rear wing as well as in its sturdily flared wings, the rear ones being guarded against gravel impact by protecting foils. The 930 was a wide car, as seven-inch light-alloy rims for the front wheels (tire size 185/70 VR 15) and eight-inch rims (with 215/60 VR 15 tires) at the rear plus wheel spacers had to be accommodated.

And there was luxury: for instance an automatic heating control system incorporating a rotary knob on the central tunnel between the seats and a temperature sensor between the sun-vizors, tinted glazing, leather interior, electric window-control and deep-pile carpeting resembling the lawn in front of Cambridge colleges. In 1976 the Turbo was equipped with tires of the 205/50 VR 15 and 225/50 VR 15 formats respectively, and a year later followed rims with a 16-inch diameter.

An optimum seemed to have been achieved but again the Porsche technicians were busy improving it. 2876 specimens of the first-generation 930 were spreading the message of the gentle giant from Zuffenhausen worldwide, when in fall 1977 the Turbo 3.3 (3299 cc) toppled the old king. The boxer's bore had been increased from 95 to 97 mm, the stroke from 70.4 to 74.4, while the compression was raised from 6.5 to 7:1. These measures spawned a healthy 300 horsepower. Installed in the even more voluminous rear wing, which had been honed in elaborate tests in the wind tunnel, an intercooler took away up to 180 degrees from the charge air. The Turbo 3.3 had thicker and perforated gray cast iron brake disks as well as aluminum calipers with cooling ribs like the marque's legendary 917 racer, to make sure that the driver returned safely from excursions into the regions beyond 160 mph which the car made possible willingly.

Unstoppable, however, was the further evolution of the Porsche 930. The most important developments were a noise-reducing dual exhaust in 1979, rear wheels of 245/45 VR 16 size featuring nine-inch rims in 1985, Targa and Cabriolet versions in 1987, and a five-speed box in 1988—the last year but one of the 930's life span.

Mit dem Turbo 3.0 erbrachten seine Väter auf dem Pariser Salon im Oktober 1974 den Beweis, dass sich selbst in einem richtigen Sportwagen strotzende Leistung und üppiger Luxus durchaus miteinander vereinbaren lassen. Zwar fußte das neue Flaggschiff der Porsche-Flotte auf dem Elfer, zeichnete sich aber sichtlich durch eine eigene Identität aus, so dass auch ein eigener Name gerechtfertigt war: der 930.

Leistung: mächtige 260 PS, generiert vom Dreiliter-Sechszylinder, unter Turbodruck gesetzt wie in den Rennsportwagen der Marke. Dies geschah überaus mild in der Methode, friedlich schnurrend bis gezügelt grollend. Wie ein zusätzlicher Schalldämpfer wirkte nämlich sein Abgaslader, dessen Turbinenrad ihm mit 0,8 atü die Muskeln schwellte, in der Auspuffanlage. Das dramatische Mehr an Kraft gegenüber den ja schon keineswegs rachitischen Saugern, vermittelt durch ein eigens geschaffenes Vierganggetriebe, bildete sich allenthalben in der Physis des Galions-Porsche ab, in seinem tief hängenden Frontspoiler und weit ausladenden Heckflügel ebenso wie in wuchernden Kotflügelverbreiterungen, hinten durch Schutzfolien vor Steinschlag geschützt. Denn der 930 stand stämmig in der Spur, vorn auf sieben, hinten auf acht Zoll breiten Leichtmetallfelgen (Pneus: 185/70 VR 15 bzw. 215/60 VR 15) zuzüglich Distanzscheiben.

Und Luxus: automatische Heizregulierung über einen Regler auf dem Rahmentunnel zwischen den Sitzen und einen Wärmefühler zwischen den Sonnenblenden zum Beispiel, getöntes Glas, Leder, elektrische Fensterheber und Hochflorteppiche wie englischer Rasen vor den Colleges von Cambridge. 1976 rüstete man auf und um mit Reifen des Kalibers 205/50 VR 15 bzw. 225/50 VR 15, und ein Jahr später folgten Felgen mit 16 Zoll Durchmesser.

Ein Optimum schien erreicht, und wieder schickte man sich an, es zu überbieten. 2880 Exemplare verbreiteten die Botschaft vom sanften Riesen aus Zuffenhausen in aller Herren Länder, da kippte im Herbst 1977 der Turbo 3.3 (3299 cm³) den alten König vom Sockel. Man hatte die Bohrung von 95 auf 97 mm erweitert, den Hub von 70,4 auf 74,4 mm gestreckt und die Verdichtung von 6,5 auf 7:1 aufgestockt. Dabei heraus sprangen 300 ursolide Pferdestärken. Im noch voluminöseren Heckflügel, nach allen Regeln der Kunst im Windkanal ausgeformt, entzog ein Kühler der Ladeluft bis zu 100 Grad. Dickere und nun perforierte Grauguss-Bremsscheiben sowie Aluminium-Festsättel mit Kühlrippen wie im legendären Renn-Typ 917 besorgten, dass der Turbo-Pilot von seinen Ausflügen in Geschwindigkeiten bis zu 260 km/h sicher zurückkehren konnte.

Unaufhaltsam aber nahm die Evolution auch des Porsche 930 ihren Lauf. Die wichtigsten Stationen: ein geräuschmindernder Doppelrohr-Auspuff 1979, Hinterräder vom Format 245/45 VR 16 auf neun Zoll breiten Felgen 1985, Turbo-Targa und Cabriolet 1987, ein Fünfganggetriebe 1988 – dem vorletzten Jahr seiner Verweildauer. Aber weitere würden folgen.

Avec la Turbo 3.0 présentée au Salon de l'Automobile de Paris en octobre 1974, ses créateurs prouvent que puissance débordante et luxe à profusion ne sont pas incompatibles même dans une authentique voiture de sport. Le nouveau navire amiral de la flotte de Porsche est incontestablement une émanation de la 911, mais elle possède tout aussi manifestement sa propre identité et un numéro qui lui est spécifique : 930 – qui semble bel et bien justifié.

Sa puissance est imposante avec 260 ch produit par le six-cylindres de 3 litres suralimenté par un turbo comme dans les voitures de compétition de la marque. La méthode privilégie toutefois la douceur avec une sonorité qui va d'un ronronnement pacifique à des aboiements toujours jugulés. Son turbocompresseur, qui gabe le moteur à une pression de

0,8 bar, joue, en effet, le rôle de silencieux supplé-
mentaire dans la ligne d'échappement. Le gain de
puissance substantiel par rapport aux «atmos-
phériques» qui n'ont pourtant rien de lymphatique
– une puissance encaissée par une boîte à quatre
vitesses conçue spécialement – s'affiche au grand
jour avec la physionomie de figure de proue de
Porsche: un aileron avant descendant très bas et
un becquet arrière interminable. La 930 est, de plus,
bien campée sur ses roues aux jantes en alliage
léger de 7 pouces à l'avant (pneus 185/70 VR 15) et
de 8 pouces à l'arrière (pneus 215/60 VR 15) auxquels
s'ajoutent des disques d'écartement.

Le luxe est en rapport: une régulation automa-
tique du chauffage à l'aide d'une commande sur
le tunnel de transmission à hauteur des sièges et
un capteur de chaleur placé entre les pare-soleil,

par exemple, mais aussi des vitres électriques
teintées, une sellerie cuir et une moquette aussi
épaisse qu'un gazon anglais. En 1976, elle reçoit
des pneus de dimensions majorées à 205/50 VR 15 et
225/50 VR 15 avant de se doter, un an plus tard, de
jantes de 16 pouces de diamètre.

Porsche semble avoir atteint son apogée et,
pourtant, la relève s'annonce déjà. Alors que 2880
exemplaires de la 930 «première génération» ont
déjà trouvé preneur sur les cinq continents, à l'au-
tomne 1977, la Turbo 3.3 (3299 cm³) évince la reine
vieillissante de son trône. L'alésage a été majoré
de 95 à 97 mm tandis que la course a augmenté
de 70,4 à 74,4 mm et le taux de compression, de
6,5 à 7:1. Le haras compte alors 300 chevaux piaf-
fant d'impatience. Dans le becquet arrière encore
plus encombrant et dont la forme a été affinée en

soufflerie, un échangeur prélève jusqu'à 100 degrés
à l'air de suralimentation. Des disques de freins
en fonte plus épais et perforés, ainsi que des
étriers fixes en aluminium avec des nervures de
refroidissement – rappelant ceux de la légen-
daire 917 de course – garantissent que le pilote de
la Turbo 3.3 puisse revenir sur terre en toute sécu-
rité après avoir flirté avec des vitesses proches
de 260 km/h.

Mais la loi de l'évolution n'épargne pas la
Porsche 930. Ses mutations les plus importantes:
un pot d'échappement à double sortie atténuant sa
sonorité en 1979, des roues arrière de 245/45 VR 16
sur des jantes de 9 pouces de large en 1985, de
nouvelles versions Turbo-Targa et Cabriolet en 1987,
une boîte à cinq vitesses en 1988 – l'avant-dernière
année de son règne. Mais d'autres vont suivre.

911 Turbo (930) 3.0 & 3.3

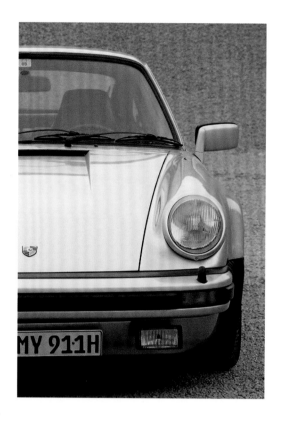

Sign of strength: the Turbo's new flat rear spoiler stems from the 3.0 RS and—as an option, too—from the Carrera. Like the rest of the rear lid it consists of GRP and features an air inlet grill and another intake for the blower.

Zeichen von Stärke: Der neue flache Spoiler des Turbo stammt vom 3.0 RS und – ebenfalls optional – vom Carrera. Er besteht wie die ganze hintere Haube aus GFK und hat ein Lufteinlassgitter und einen Luftkanal zum Gebläse.

Signe de puissance : le nouvel aileron horizontal de la Turbo provient de la 3.0 RS et – mais, là, en option – de la Carrera. Comme tout le capot arrière, il est en fibre de verre et possède une grille de prise d'air ainsi qu'une tubulure alimentant en air le ventilateur.

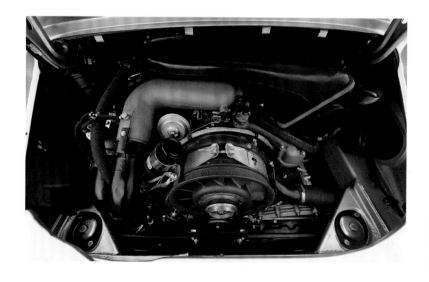

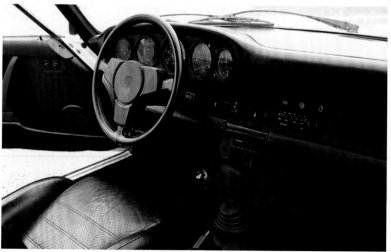

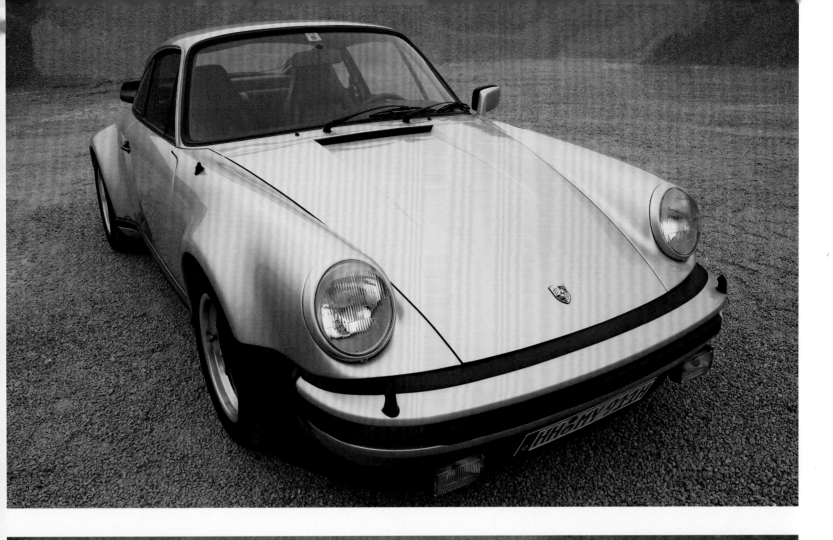
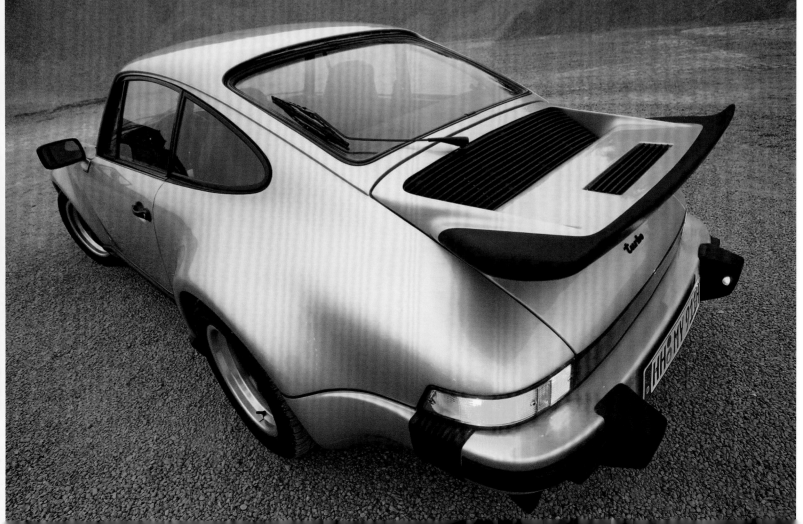

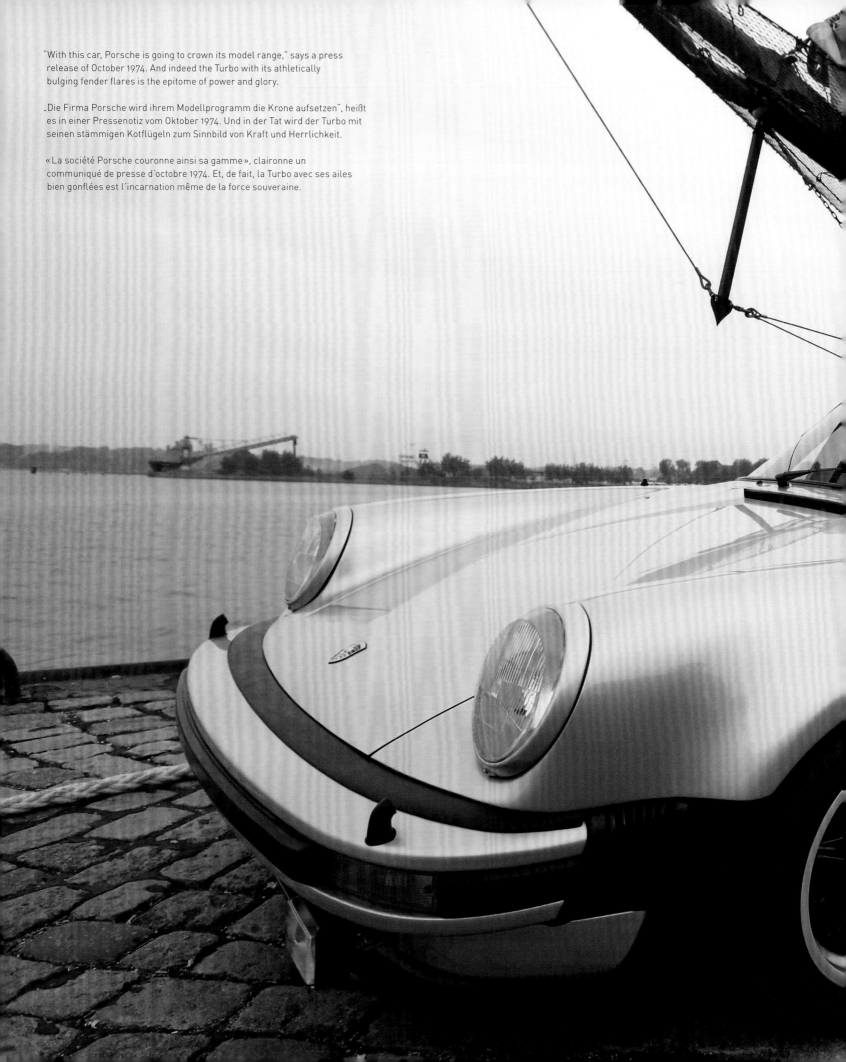

"With this car, Porsche is going to crown its model range," says a press release of October 1974. And indeed the Turbo with its athletically bulging fender flares is the epitome of power and glory.

„Die Firma Porsche wird ihrem Modellprogramm die Krone aufsetzen", heißt es in einer Pressenotiz vom Oktober 1974. Und in der Tat wird der Turbo mit seinen stämmigen Kotflügeln zum Sinnbild von Kraft und Herrlichkeit.

«La société Porsche couronne ainsi sa gamme», claironne un communiqué de presse d'octobre 1974. Et, de fait, la Turbo avec ses ailes bien gonflées est l'incarnation même de la force souveraine.

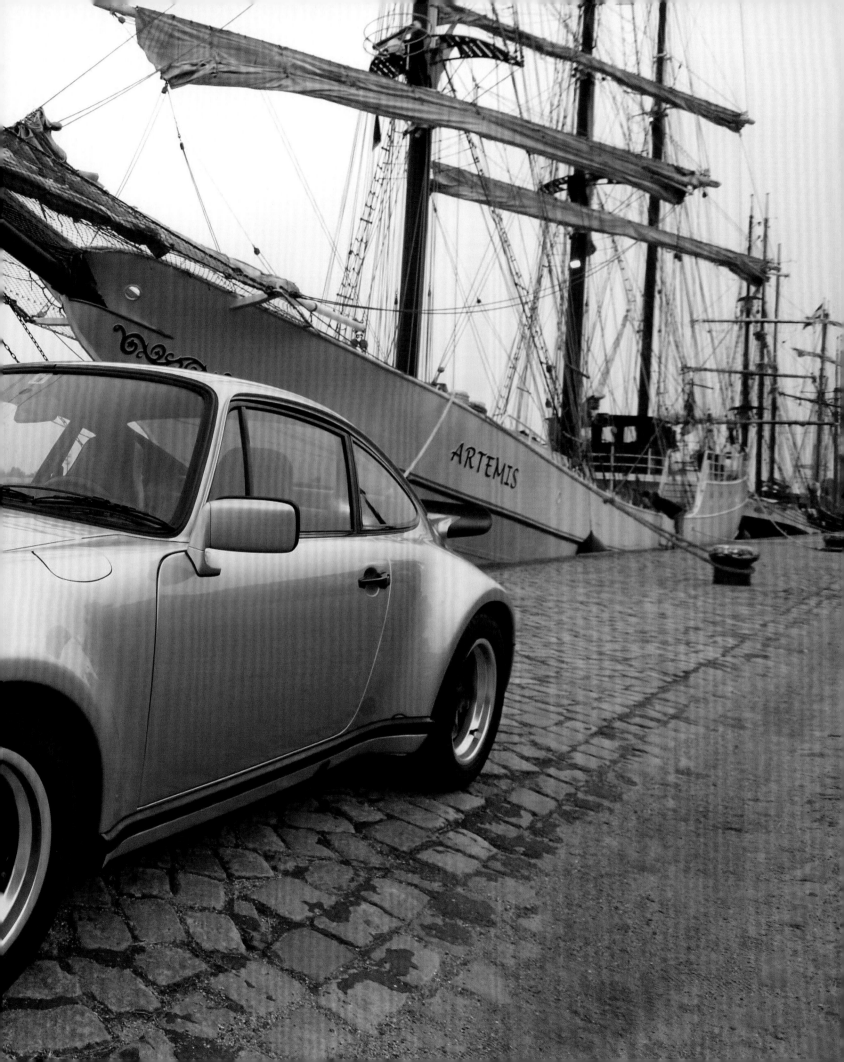

The rear spoiler of the 911 Turbo 3.3 is the result of meticulous work in the wind channel to improve its shape, approach angle and air intake slots. Less lift is produced, while the drag is the same.

Der Heckspoiler des 911 Turbo 3.3 ist das Resultat penibler Versuche im Windkanal zur Verbesserung von Form, Anstellwinkel und Lufteinlassschlitzen. Bei gleichem Luftwiderstand entsteht weniger Auftrieb.

L'aileron arrière de la 911 Turbo 3.3 est le résultat d'interminables heures passées en soufflerie pour améliorer la forme, l'angle d'attaque et les fentes de la prise d'air. À résistance aérodynamique identique, il engendre une moindre portance.

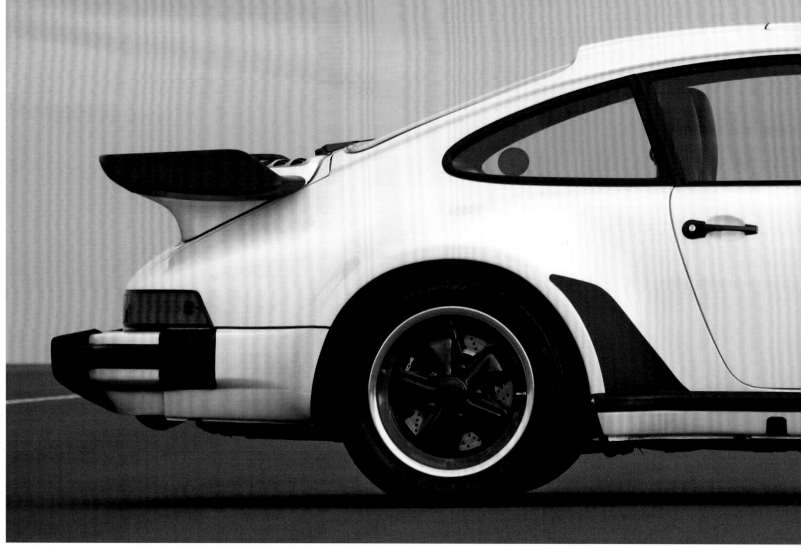

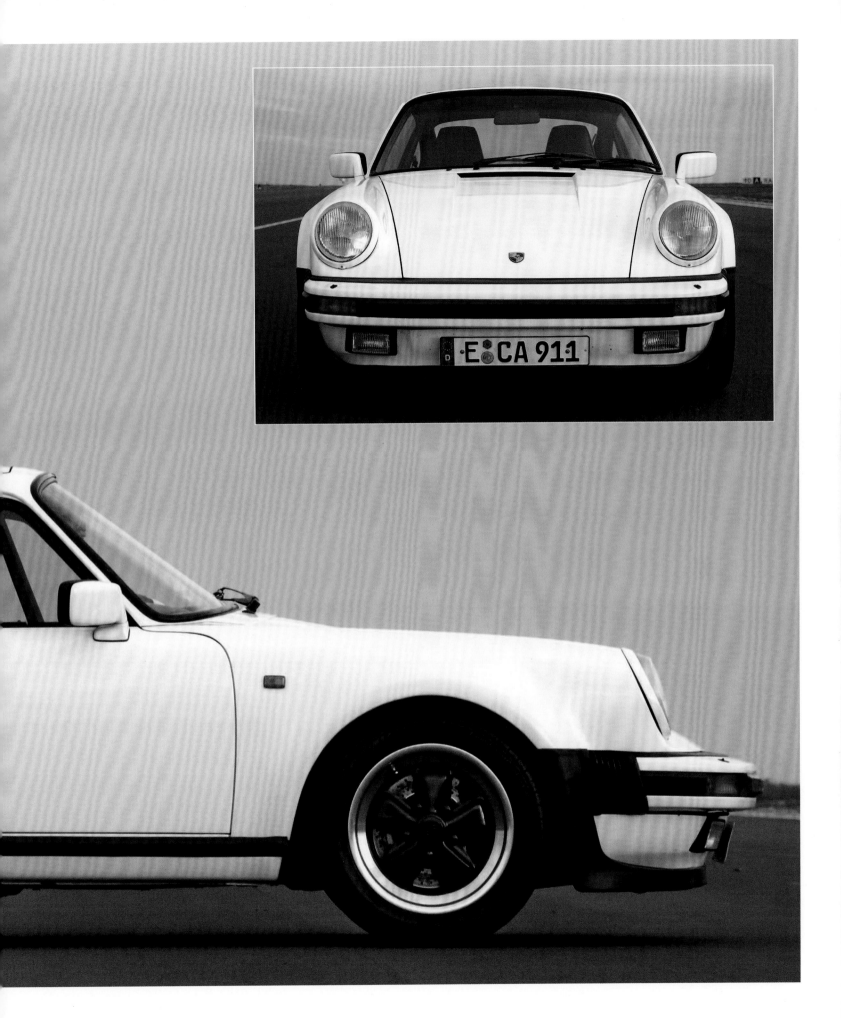

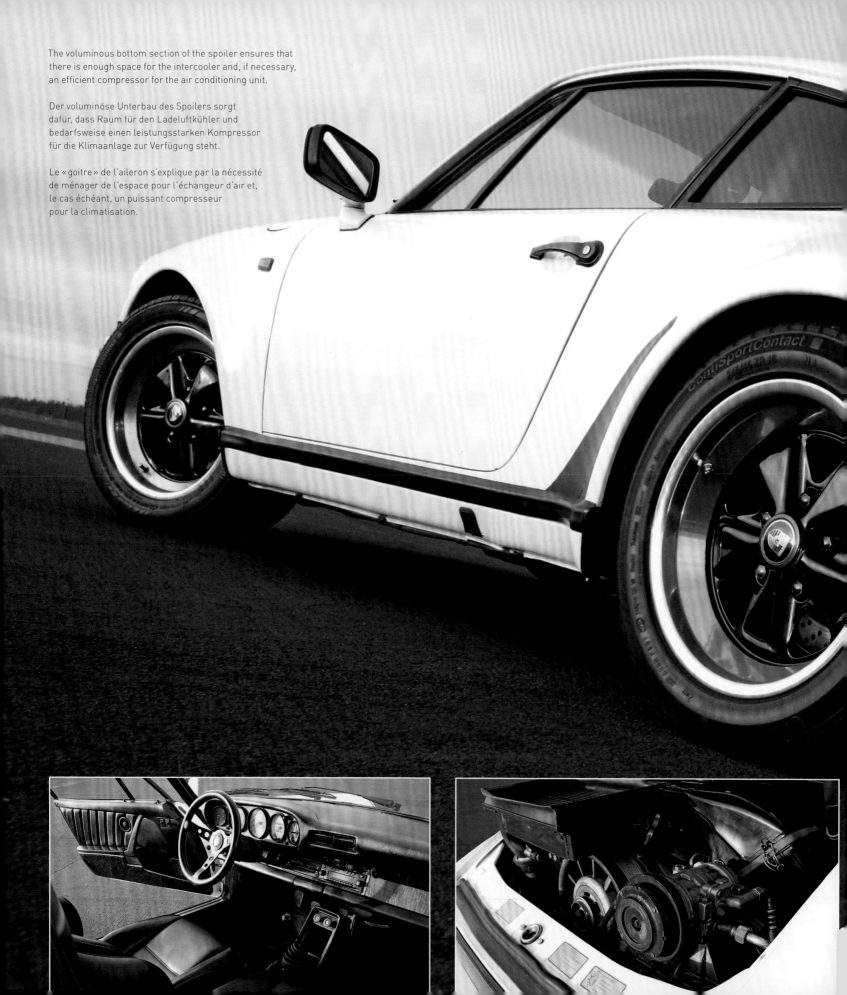

The voluminous bottom section of the spoiler ensures that there is enough space for the intercooler and, if necessary, an efficient compressor for the air conditioning unit.

Der voluminöse Unterbau des Spoilers sorgt dafür, dass Raum für den Ladeluftkühler und bedarfsweise einen leistungsstarken Kompressor für die Klimaanlage zur Verfügung steht.

Le «goitre» de l'aileron s'explique par la nécessité de ménager de l'espace pour l'échangeur d'air et, le cas échéant, un puissant compresseur pour la climatisation.

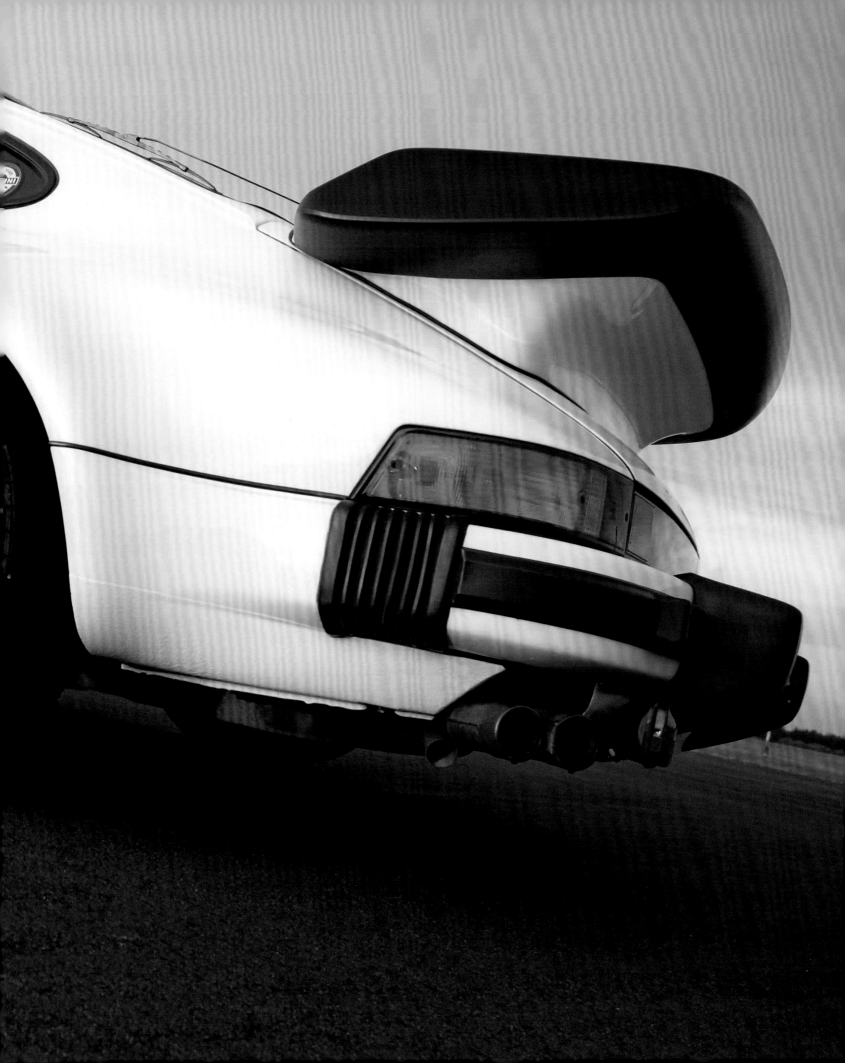

Clean-up before sunrise at the 50th Anniversary in the chocolate city of Hershey. By nine when the commission comes everything must be spick and span.

Morgenputz vor Sonnenaufgang zum 50. in der Schokoladenstadt Hershey. Gegen neun, wenn die Kommission kommt, muss alles blitzsauber sein.

Toilette matinale avant le lever du soleil, lors du 50ᵉ anniversaire, à Hershey, la capitale du chocolat. Vers neuf heures, quand la commission d'examen arrive, tout doit briller comme un sou neuf.

1955–2005

The Porsche Club of America, a bustling association uniting disciples of the marque, celebrated its 50th anniversary in 2005. The Club has grown to cover 139 regions throughout the United States and Canada. The PCA's objective, says a keynote statement, is to celebrate the finer things in life. One desires the comfort of good friends and good conversation, and one praises to a fault the virtues of the world's finest automobile. The members race each other, show their prized (and priceless) possessions, conduct rallies, autocrosses and tours. They know their Porsche inside out. The PCA sponsors driver education, restoration and technical sessions. Almost a creed ...

Der Porsche Club of America, eine rührige Vereinigung von Adepten der Marke, feierte 2005 sein halbes Jahrhundert. Seine Filialen decken 139 Regionen in den USA und Kanada ab. Anliegen des PCA, verkündet eine programmatische Schrift, sei die Pflege der schönen Dinge im Leben. Man sei interessiert am Wohl guter Freunde und dem guten Gespräch, wolle aber vor allem dem besten Automobil von allen huldigen. Man trete gegeneinander an auf der Piste, zeige sich seine kostbaren Schätze, organisiere Rallyes, Autocross-Veranstaltungen und Touren aller Art. Der Club fördere das Fahrkönnen seiner Mitglieder und ihre technischen Kenntnisse. Seinen Porsche kenne man in- und auswendig. Fast schon ein Credo ...

Le Porsche Club of America (PCA), une association de fans, a fêté son 50e anniversaire en 2005. Il compte des relais affiliés dans 139 régions des États-Unis et du Canada. Son objectif consiste à cultiver les bons côtés de la vie. Si ses membres prennent plaisir à côtoyer de bons amis et à mener d'agréables conversations, c'est surtout le culte de la meilleure automobile de tous les temps qui les unit. Ils se mesurent les uns aux autres sur la piste, exhibent leurs précieux trésors, organisent des sorties, disputent des courses d'autocross et participent à des excursions en tout genre. Le club a aussi pour but d'améliorer le coup de volant de ses membres et leurs connaissances techniques. Quant à leur Porsche, ils la connaissent sous toutes ses coutures. C'est déjà presque une profession de foi ...

50 Years of Porsche Club of America

TOP LEFT Phalanx of the participants.
LEFT MIDDLE Maximum points—the winner of the Concours d'Élegance.
ABOVE Members of the Porsche family with special edition 997 model for the US market.
LEFT Presentation of the special edition model, one of 50 identical specimens.

LINKS OBEN Aufmarsch der Teilnehmer.
DARUNTER Mehrfach gepunktet: der Sieger beim Concours d'Élegance.
OBEN Angehörige der Familie Porsche mit Sondermodell des 997 für den US-Markt.
LINKS Enthüllung des Sondermodells, eines von 50 identischen Exemplaren.

EN HAUT À GAUCHE Le défilé des participants.
AU MILIEU À GAUCHE Le gagnant du concours d'élégance.
EN HAUT À DROITE Des membres de la famille Porsche avec la version spéciale de la 997 conçue spécialement pour le marché américain.
CI-CONTRE Le voile se lève sur le modèle spécial, l'un de 50 exemplaires absolument identiques.

Rustic single-seaters: a beautiful collection of Porsche tractors.

Rustikale Einsitzer: eine schöne Kollektion von Porsche-Traktoren.

Des monoplaces bien rustiques – une rutilante collection de tracteurs Porsche.

550 Coupé as driven at the 1953 Carrera by Juhan/Hall.

550 Coupé, bei der Carrera 1953 von Juhan/Hall gefahren.

La 550 Coupé, pilotée lors de la Carrera de 1953 par Juhan/Hall.

Big brother is watching you: the German police are just everywhere.

Big Brother Is Watching You: Die deutsche Polizei ist überall.

Big Brother is watching you – la police allemande est omniprésente.

Encounters: participants of the parade with assorted antiques of the Amish People and the famous Hershey roller coaster.

Begegnungen: Teilnehmer der Parade mit ausgewählten Altertümern der Amish People und der berühmten Achterbahn von Hershey.

Rencontres : des participants à la parade avec quelques carrioles amish et les fameuses montagnes russes de Hershey.

At the beginning of the seventies Porsche had definitely pulled out of the slipstream of other competitors on the racing circuits with the all-conquering 917 and 917/10. In terms of the marque's production cars, this rise could be observed, too, though in less dramatic form, with the advent of the 930 Turbo and the Carrera 3.0 in 1975 in the prestigious realm of the three-liter sports car, hence invading the domain of illustrious Italian rivals such as the Ferrari Dino or the Maserati Merak.

Apart from the rather indefinable exoticism factor, the Carrera 3.0, for example, undoubtedly had all that those had to offer—and more. The increase in capacity had been achieved by adding another five mm to the bore of 90 mm, reducing the Carrera 2.7's output by ten bhp. This and the thriftier alimentation by the Bosch K-Jetronic (CIS) suited the elasticity of the rasping boxer engine without affecting top speed and acceleration of the Carrera.

Zinc coating to each side of the car's Thyssen sheet metal (both chassis and body), allowing the company to issue a six-year no-rust warranty, bore testimony to the time-honored Zuffenhausen philosophy to offer their customers an article of lasting value. This exemplary corrosion prophylaxis was also supported by sundry aluminum parts in the fields of the engine and the suspension, as well as the Targa's stainless steel "T-handle". The Carrera was visually different from its predecessor's generation, for instance in that it had wider wings to accommodate fatter tires (185/70VR15 front, 215/60VR15 rear) on forged light-alloy rims (front: six-inch, rear seven-inch, optionally: one more inch on either end).

It was also comfortable, a genuine gran turismo in every sense of the phrase, with an automatic temperature control unit, electrically adjustable and heated outside rearview mirrors, power windows and a headlamp cleaning system as options. As alternatives to the standard four-speed gearbox the three-gear Sportomatic, as well as a five speed manual, were on offer.

The latter, from 1978 onwards, was at the disposal of the driver at the wheel of the Carrera's successor, the SC (Super Carrera), as part of the basic equipment. The SC incorporated a breakerless ignition system and fixed glassed-in rear side windows to scare off car thieves. Seemingly threatened by the front-engined models of the make, it was the only remaining member of the once so widely ramified 911 family except for the Turbo, and rumor had it that its last hour was near, all the more so as a 20 bhp bleeding seemed to confirm its impending demise. But the classic was alive and kicking, gained another eight bhp in the following year and was declared the world's most economical three-liter in its 1980 edition, though it had to be fed with premium gasoline again. It had sprouted lateral turn indicators in front of the doors, and from 1981 black powder-coated rims played their part in the renunciation of any chrome embellishment whatever. And at the Geneva spring show in March 1982, Porsche played an undeniably irresistible trump card, exhibiting a sleek Convertible based on the 911 SC.

Anfang der siebziger Jahre war Porsche mit dem 917 und dem 917/10 auf den Renn-strecken endgültig aus dem Windschatten anderer ausgeschert. Bei den Produktionswagen zeichnete man diesen Aufstieg in abgemilderter Form nach, war 1975 mit dem 930 Turbo und dem Carrera 3.0 im prestigeschwangeren Segment der Dreiliterwagen angelangt und brach somit bereits in die Domäne illustrer italienischer Rivalen wie des Ferrari Dino oder des Maserati Merak ein.

Abgesehen von dem undefinierbaren Faktor Exotik bot etwa der Carrera 3.0 alles, was diese zu bieten hatten – und mehr. Das Plus an Hubraum hatte man durch die Erweiterung der Bohrung von 90 auf 95 mm erzielt und zugleich die Potenz des Carrera 2.7 um zehn PS zurückgenommen. Dies und die sparsamere Alimentierung durch die K-Jetronic von Bosch waren der Elastizität des raspelnden Boxers durchaus bekömmlich, ohne der Spitzengeschwindigkeit oder der Beschleuni-gung des Carrera etwas anzuhaben.

Vom Bemühen der Zuffenhausener, ihren Kunden einen Wertgegenstand von hoher Bestän-digkeit an die Hand zu geben, zeugten beidseitig feuerverzinkte Thyssen-Stahlbleche für Karos-serie und weitere tragende Elemente, verbunden mit einer sechsjährigen Garantie. Einer vorbild-lichen Korrosions-Prophylaxe dienten darüber hinaus diverse Aluminiumteile im Umfeld von Motor und Aufhängung sowie der Targa-Bügel aus Nirosta. Sichtbar äußerte sich der Unterschied zur Generation der Vorgänger etwa in breiteren Kotflügeln, die fetteren Pneus (185/70VR15 vorn, 215/60VR15 hinten) auf geschmiedeten Felgen aus Leichtmetall (vorn sechs Zoll, hinten sieben Zoll, auf Wunsch jeweils ein Zoll mehr) Unterkunft boten.

Komfortabel war er auch, ein echter Gran Turismo im Sinne des Wortes, mit einer Heizungs-automatik, elektrisch verstell- und beheizbaren Außenspiegeln, elektrischen Fensterhebern und einer Scheinwerfer-Reinigungsanlage als Optionen. Als Alternative zum serienmäßigen Viergang-getriebe wurden ein Dreigang-Automat oder auch fünf manuell geschaltete Fahrstufen angeboten.

Über diese verfügte der Pilot des mit kontakt-loser Zündung und, zur Abwehr von Automardern, fest verglasten Fond-Seitenscheiben ausgestat-teten Nachfolgers 911SC (Super Carrera) ab 1978 als Standard. Nur zum Schein bedroht von den Frontmotor-Typen der Marke, war er der einzige verbliebene Elfer, und Pessimisten stimmten sich bereits zum Halali ein, zumal er um 20 PS geschwächt die Gerüchte über sein baldiges Hinscheiden zu bestätigen schien. Aber der Klas-siker lebte, hatte im Folgejahr schon wieder acht PS zugelegt und geriet in der Ausgabe von 1980 mit 204 PS zum genügsamsten Dreiliter der Welt, wenn auch zu Superbenzin zurückgekehrt. Vor den Türen sprossen seitliche Blinkleuchten, und ab 1981 steuerten pulverbeschichtete Felgen das ihrige zur Abkehr vom Chrom-Zierrat bei. Auf dem Genfer Salon im März 1982 spielte man gar einen schier unwiderstehlichen Trumpf aus: ein Cabriolet auf der Basis des SC.

Au début des années 1970, avec la 917 et la 917/10, sur les circuits, Porsche sort défi-nitivement du sillage de ses rivaux. Cette montée en puissance se ressent également dans le domaine des voitures de production, quoique de façon moins prégnante, avec l'arrivée de la 930 Turbo et la Carrera 3.0. En 1975, elles viennent ainsi marcher sur les brisées de leurs illustres rivales italiennes, comme la Ferrari Dino ou la Maserati Merak, dans le prestigieux segment des voitures de trois litres.

La Carrera 3.0 propose autant, si ce n'est plus, que ces dernières. La majoration de cylindrée a été obtenue au prix d'un agrandissement de l'alé-sage de 90 à 95 mm alors que la puissance de la Carrera 2.7 a été diminuée de 10 chevaux. Cette manipulation et l'alimentation plus économique

1975–1983

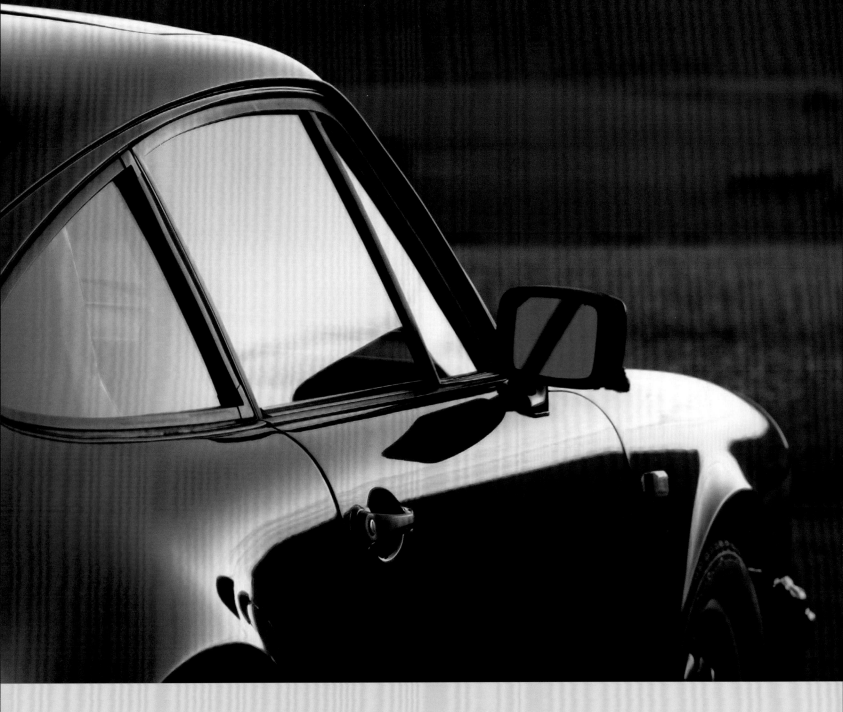

due à la Bosch K-Jetronic ont donné plus d'élasticité au boxer sans que cela n'ait porté préjudice ni à la vitesse de pointe ni aux accélérations de la Carrera.

La présence de tôles d'acier Thyssen et d'autres éléments porteurs galvanisés de chaque côté pour la carrosserie, qui va de pair avec une garantie de six ans, témoigne de la volonté du constructeur de Zuffenhausen d'offrir à ses clients un véhicule dont la valeur ne se déprécie pas. Le choix de divers composants en aluminium dans l'entourage du moteur et des suspensions ainsi que l'arceau Targa en acier inoxydable sont une solution idéale pour une prophylaxie anticorrosion exemplaire. Un détail particulier démarque sans ambiguïté la Carrera de celles qui l'ont précédée : des ailes plus larges qui hébergent de plus

gros pneus (185/70 VR 15 à l'avant et 215/60 VR 15 à l'arrière) chaussant des jantes forgées en alliage d'aluminium (de 6 pouces à l'avant et de 7 à l'arrière, ou de respectivement un pouce de plus en option).

Elle est, aussi, très confortable, véritable Grand Tourisme quand on sait qu'elle comporte au registre des options un chauffage automatique, des rétroviseurs extérieurs électriques dégivrants, des lève-vitres électriques et un lave-phares. En alternative à la boîte à quatre vitesses de série, Porsche propose une transmission automatique à trois rapports ou encore une boîte manuelle à cinq vitesses.

À partir de 1978, le pilote de sa remplaçante, la 911 SC (Super Carrera), en jouit en série avec l'allumage sans contact et, pour repousser les voleurs

éventuels, des vitres latérales arrière collées. Subissant l'apparente menace des modèles à moteur avant de la marque, elle est la seule 911 survivante et la diminution de sa puissance de 20 chevaux semble alimenter les rumeurs de sa disparition prochaine. Mais la grande classique survit et, l'année suivante, elle regagne même dix chevaux avant de devenir, pour le millésime 1980, la trois-litres la plus sobre du monde avec ses 204 chevaux, même si elle se met de nouveau à consommer du super. Des clignotants latéraux ont poussé devant les portières et, à partir de 1981, des jantes à enduction de poudre contribuent à la disparition du chrome. Au Salon de Genève de mars 1982, Porsche abat même un atout qui fait taire ses adversaires : un cabriolet sur la base de la SC.

911 Carrera 3.0 & SC 3.0

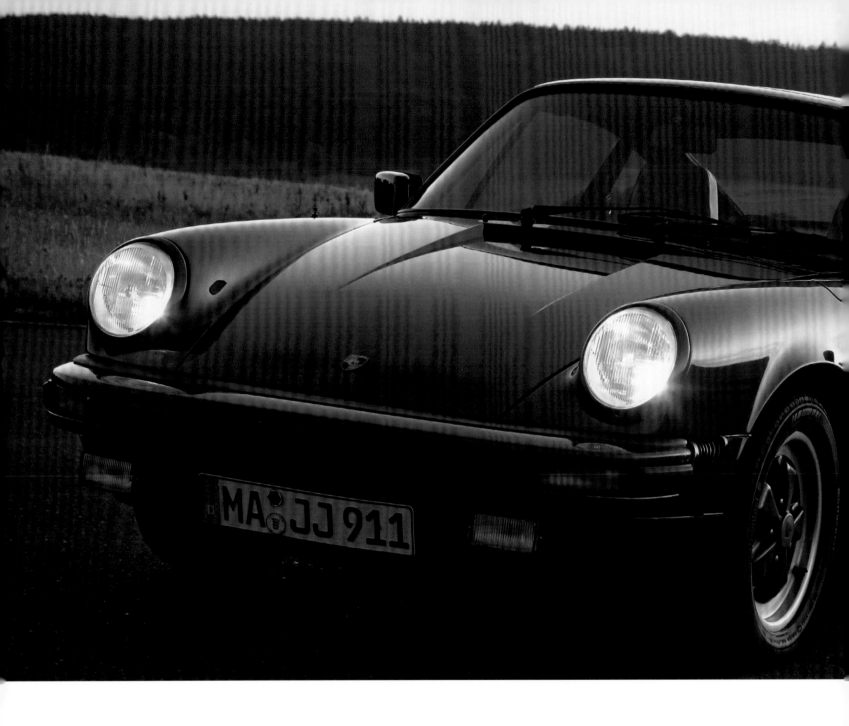

Those who seem written off live longer. The obituaries already lying in the drawers, the SC appears to be the last of the classic 911s, with wider fenders and lots of matt black instead of chrome as was already seen for the Carrera 3.0 preceding it. But the mourners are mistaken.

Totgesagte leben länger: Die Nachrufe liegen bereits in den Schubladen, der SC scheint der letzte Elfer zu sein, mit breiteren Kotflügeln und viel Mattschwarz anstelle von Chrom wie schon der Carrera 3.0 vor ihm. Aber weit gefehlt!

Ceux qu'on donne pour morts sont éternels : sa nécrologie est déjà rédigée, tout porte à croire que la SC sera la dernière des 911, avec ses ailes élargies et des applications noires mates à la place du chrome, comme sur la Carrera 3.0 avant elle déjà. Quelle erreur monumentale !

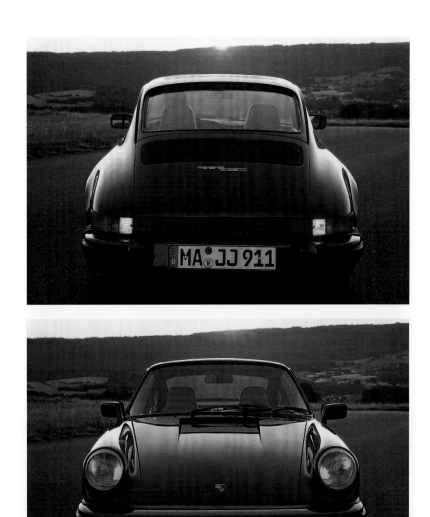

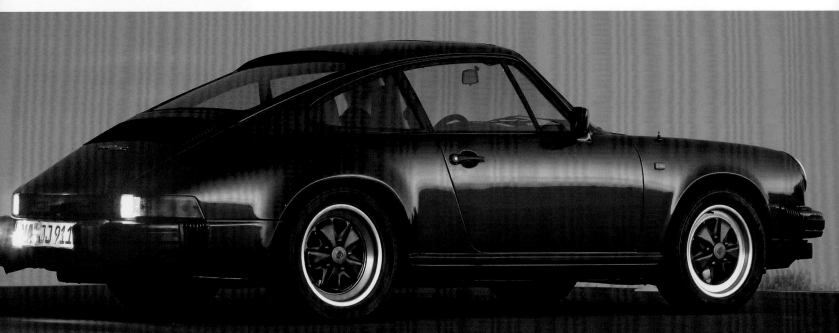

The lateral hinged windows are fixed now, a measure which is meant to put off car thieves. From the 1980 model year, the 911 is equipped with a smaller three-spoke leather steering wheel.

Dass die seitlichen Ausstellfenster nun fest sind, verleidet Automardern das trübe Handwerk. Ab Modelljahr 1980 ist der 911SC mit einem etwas kleineren Dreispeichen-Lederlenkrad ausgestattet.

Au grand dam de nombreux voleurs à la tire, les déflecteurs latéraux sont maintenant fixes. À partir du millésime 1980, la 911SC comporte un volant gainé de cuir à trois branches d'un diamètre légèrement plus petit.

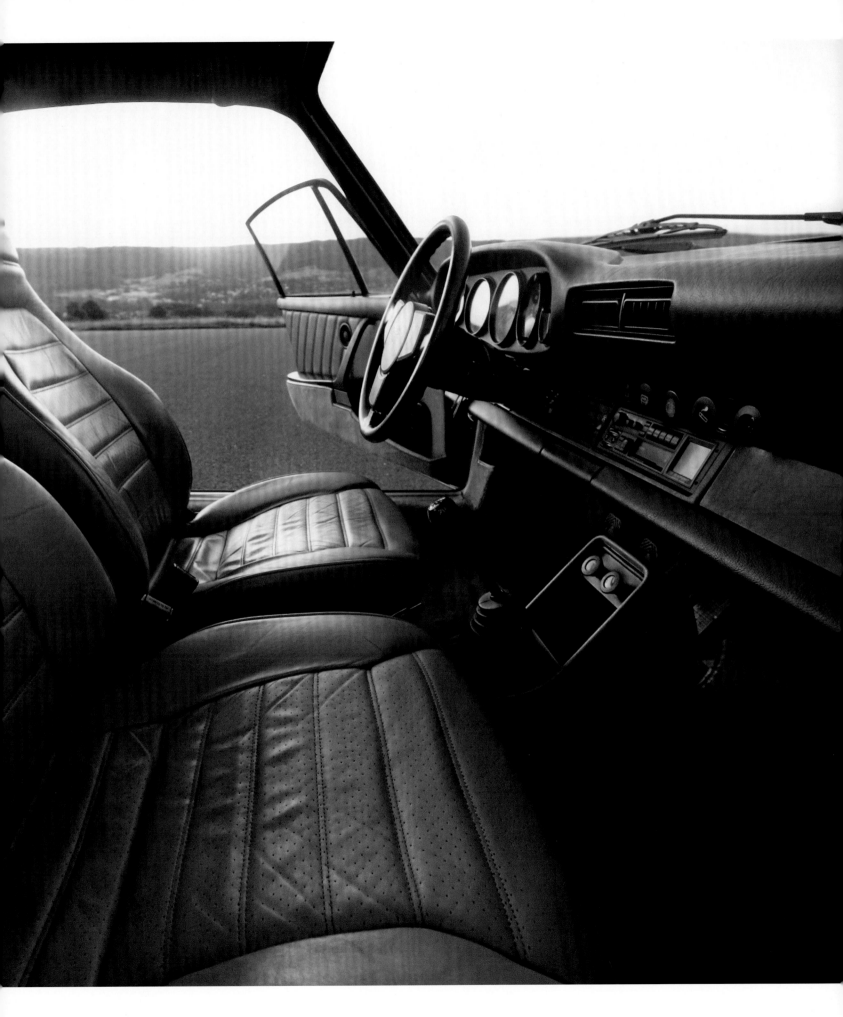

Introduced in November 1975, the latest bearer of the Porsche name concealed below its smooth hood an in-line four-cylinder unit, whose elixir vitae air was channeled through an inlet discreetly integrated in the front spoiler lip. Apart from that, it was water-cooled, in unit with the clutch and linked to the four-speed gearbox near the rear axle by means of a 4/5"-diameter driveshaft that revolved inside a rigid steel torque tube, according to the transaxle principle.

Those were blatant infringements of the hallowed Porsche maxim that in the best sports car of them all the air-cooled engine belonged in the rear. But the time seemed to be ripe for something new, and the aim above all else was to keep and to tap a clientele below the 911's and the 928's, the soon-to-be flagship of the Zuffenhausen line-up, with a successor to the 914, obviously not destined to be a lasting favorite. And like the 914, the new model was to incorporate as many parts from the shelves of the VW concern as possible. Those considerations proved right, endorsed by 150,689 specimens within the next ten years.

The 924 was outsourced to the Audi/NSU plants at Neckarsulm, where it was also provided with the slightly modified two-liter engine of the Audi 100, installed at an angle of 40 degrees from the vertical to the right, and its final drive/transmission assembly. A weight distribution of 48 to 52 per cent and a foolproof suspension with disk brakes at the front and drum brakes at the rear made the 2+2 seater hatchback coupé a joy to drive, and it was economical to boot. In 1978 an optional five-speed Porsche gearbox was offered, while an Audi one became standard a year later, when the frames of the side windows flaunted a fashionable black. In the model year 1986, the 924 came up with more power, as well as the addition S to its designation. Its 150 bhp, compared to the original 125 bhp, was delivered by the 2479 cc basic engine of big brother 944 in its US version. In 1988 another ten bhp was added.

The 170 bhp power plant of the up-market 924 Turbo had been working just as reliably since 1978. The normally aspirated 924's sister car could be identified by a NACA intake duct on the hood blowing the airstream directly against the turbocharger and a bypass valve, and four oblong apertures above the front bumper for the ventilation of the power unit. The original one had been reduced to a torso, crowned by a new head with recessed combustion chambers and flat pistons, instead of the Heron-type solution so far implemented. There were ventilated disks all round, 15-inch wheels and an uprated suspension. In 1980, the output was raised by seven bhp but the Turbo expired in mid-1982 after a run of 12,356 units. This was also the fate of some special scions of the 924 family: the two editions celebrating Porsche's two world championships in 1976 and the model's Le Mans debut in 1980, as well as the 1979 210 bhp Carrera GT and its two competition variants GTS (245 bhp) and GTR (375 bhp), of which altogether 76 units had been built between December 1980 and March 1981.

Der jüngste Träger des Namens Porsche, im November 1975 vorgestellt, verbarg unter seiner glatten vorderen Haube einen Reihenvierzylinder, dem das Lebenselixir Luft durch einen im Frontspoiler diskret integrierten Einlass zugeführt wurde. Ansonsten war er jedoch an gefährdeten Stellen von Wasser umspült, verblockt mit der Kupplung und gemäß dem Transaxle-Prinzip mit dem Vierganggetriebe nahe der Hinterachse verbunden durch eine 20 mm dünne Welle, die von einem starren Rohr ummantelt wurde.

Das waren eklatante Verstöße gegen den Artikel 1 im Porsche-Grundgesetz, im besten aller Sportwagen gehöre ein luftgekühlter Motor ins Heck. Aber die Zeit war reif für etwas Neues, und vor allem wollte man sich unterhalb des Elfers und des künftigen Dickschiffs 928 Käufer bewahren und gewinnen in der Nachfolge des 914. Und: Wie dieser sollte der Neue möglichst viele Elemente aus den Regalen des VW-Konzerns in sich vereinigen. Wie 150 689 Exemplare innerhalb der nächsten zehn Jahre bewiesen, ging das Kalkül auf.

Gebaut wurde der 924 zu Neckarsulm im Audi/NSU-Werk, wo man ihm zugleich den um 40 Grad nach rechts geneigten sanft modifizierten Zweiliter des Audi 100 und dessen Achsantrieb-Getriebe-Einheit verpasste. Die Gewichtsverteilung von 48 zu 52 Prozent und ein narrensicheres Fahrwerk mit vorderen Scheiben- und hinteren Trommelbremsen führten zu problemlosem Fahrspaß mit dem Hatchback-Coupé, und auch an den Zapfsäulen zeigte es sich genügsam. 1978 gab es ein Fünfganggetriebe von Porsche auf Wunsch, 1979 – die Einfassungen der Seitenscheiben waren nun modisch schwarz – eines von Audi als Standard. Mehr Kraft (150 statt der 125 PS bisher) wuchs ihm, wie auch ein S in der Typenbezeichnung, im Modelljahr 1986 durch den 2479-cm³-Basismotor aus der USA-Ausführung des größeren Bruders 944 zu. 1988 kamen noch einmal zehn dazu.

Ebenso zuverlässig arbeitete seit 1978 das 170 PS starke Triebwerk des 924 Turbo, erkennbar an einer NACA-Öffnung, die Fahrtwind unmittelbar auf den Lader und ein Bypass-Ventil pustete, und vier längliche Durchbrüche oberhalb des vorderen Stoßfängers zur Beatmung der Maschine. Von der ursprünglichen war nur noch der Rumpf geblieben, gekrönt von einem neuen Kopf, der im Gegensatz zur Saugversion Teile der Brennräume aufgenommen hatte. Innen belüftete Bremsscheiben ringsum sorgten für angemessene Verzögerung, und auch das Umfeld der 15-Zoll-Räder war auf das Mehr an Kraft eingerichtet worden. 1980 wuchs seine Leistung um sieben PS. Gleichwohl verblich der Turbo Mitte 1982 nach 12 356 Exemplaren.

Geschichte waren zu diesem Zeitpunkt bereits ein paar spektakuläre Sonderlinge der 924-Familie, die beiden Editionen anlässlich der Porsche-Championate 1976 und des Le-Mans-Einstands des Modells anno 1980 ebenso wie der Carrera GT von 1979 mit seinen 210 PS und dessen Wettbewerbs-Varianten GTS (245 PS) und GTR (375 PS) in zusammen 76 Einheiten zwischen Dezember 1980 und März 1981.

Le plus jeune modèle porteur du nom Porsche, présenté en novembre 1975, héberge sous son capot avant tout en rondeurs un quatre-cylindres en ligne aéré par une ouverture discrètement intégrée à l'aileron avant. Ce moteur, dont toutes les autres parties sensibles sont refroidies par eau, fait bloc avec l'embrayage et, reprenant une architecture Transaxle, est relié à la boîte à quatre vitesses greffée sur le train arrière par un mince arbre de transmission de 20 mm de diamètre qui tourne dans un tube rigide.

Il s'agit donc d'une véritable entorse à l'article 1 du credo de Porsche, qui veut que la meilleure de toutes les voitures de sport soit propulsée par un moteur refroidi par air et en position arrière. Mais l'époque est sensible à la nouveauté et, surtout, en dessous de la 911 et de la future grosse 928, Porsche

veut ménager sa clientèle et continuer à gagner de l'argent avec la remplaçante de la 914. D'ailleurs, à l'instar de cette dernière, la nouvelle se procurera le plus grand nombre d'éléments vitaux possible auprès de la banque d'organes du groupe VW. Le calcul n'est pas si mauvais comme le prouveront les 150 689 exemplaires qui seront construits au cours des dix années suivantes.

La 924 est donc construite à Neckarsulm, à l'usine Audi/NSU, où on lui greffe simultanément le deux-litres de l'Audi 100 légèrement modifié, incliné de 40 degrés vers la droite et doté du bloc demi-arbres/boîte de vitesses de celle-ci. La répartition du poids, de 48 pour 52%, et un châssis offrant une sécurité absolue avec freins à disque à l'avant et à tambour à l'arrière permettent de s'éclater sans inquiétude au volant de ce coupé hatchback. En 1978, il reçoit

une boîte Porsche à cinq vitesses en option et, en 1979 – les vitres latérales possèdent un encadrement noir très en vogue à cette époque – une transmission Audi en série. Sa puissance augmente (avec 150 ch au lieu de 125 ch auparavant) et son patronyme s'enrichit d'un S, le millésime 1986 voyant l'arrivée du moteur de base de 2479 cm³ de la version américaine de sa grande sœur, la 944. En 1988, dix chevaux supplémentaires viennent s'ajouter à ce haras.

Une fiabilité tout aussi exemplaire caractérise à partir de 1978 le moteur de 170 ch de la 924 Turbo qui se distingue par une prise d'air NACA, dirigeant l'air directement vers le turbocompresseur et la soupape de décharge, ainsi que par quatre ouïes d'aspiration transversales juste au-dessus du pare-chocs avant pour ventiler le moteur. De ce moteur originel, on n'a conservé que le bloc-cylindres, coiffé d'une nouvelle

culasse qui, contrairement à celle de la version atmosphérique, intègre une partie des chambres de combustion. Quatre freins à disque ventilés lui confèrent une décélération digne de son rang et les liaisons au sol avec jantes de 15 pouces tiennent compte de ce surcroît de puissance. En 1980, cette puissance augmente de 7 ch. Le glas sonne finalement pour la Turbo, à la mi-1982, après 12 356 exemplaires construits. À cette époque, quelques extrapolations spectaculaires de la famille 924 sont déjà entrées dans l'histoire, par exemple les éditions produites à l'occasion des Championnats Porsche de 1976 et de l'engagement de ce modèle aux 24 Heures du Mans en 1980, sans oublier la Carrera GT de 1979 avec ses 210 ch ni ses variantes Compétition, la GTS (245 ch) et la GTR (375 ch), produites au total à 76 exemplaires entre décembre 1980 et mars 1981.

924

The 210 bhp 924 GT is basically identical to the Turbo. At first sight the most striking difference consists in the air scoop sitting on its light-alloy engine hood. It provides the intercooler with its elixir vitae.

Bei grundsätzlicher Identität unterscheidet sich der 210 PS starke 924 GT vom Turbo beim ersten Hinsehen vor allem durch den Lufteinlass auf der Leichtmetall-Motorhaube. Er dient der Beatmung des Ladeluftkühlers.

Pratiquement identique sur le plan visuel, la 924 GT de 210 ch se distingue au premier coup d'œil de la Turbo, surtout par la prise d'air qui orne son capot moteur en alliage léger. Elle permet d'alimenter l'échangeur d'air.

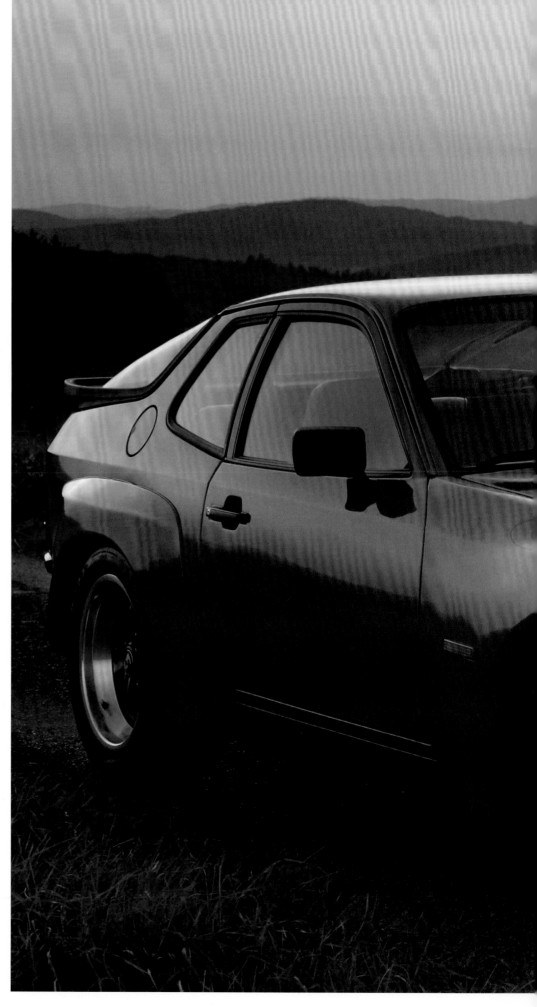

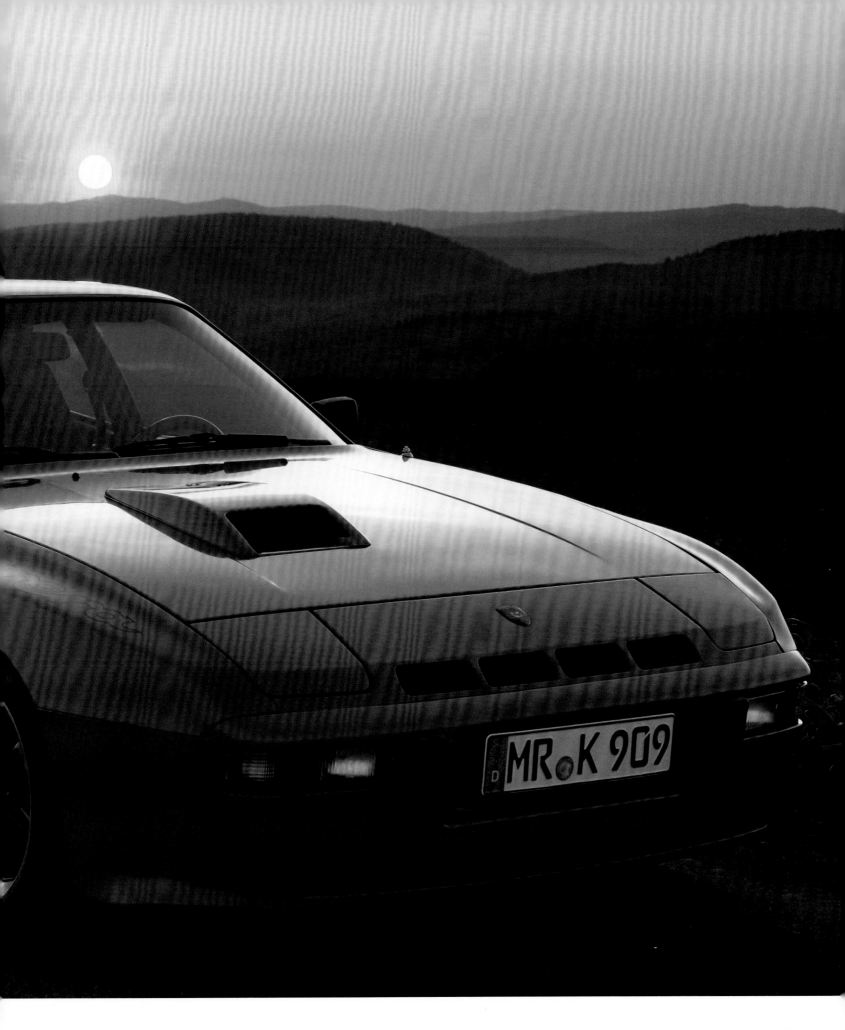

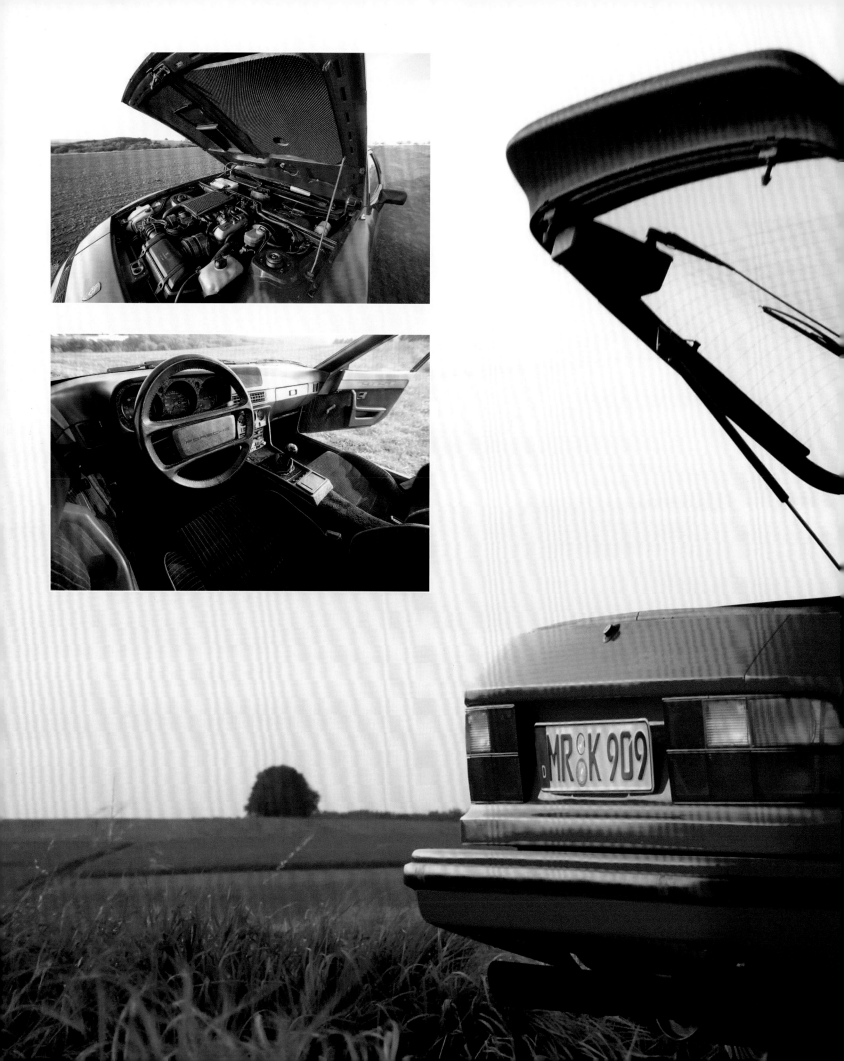

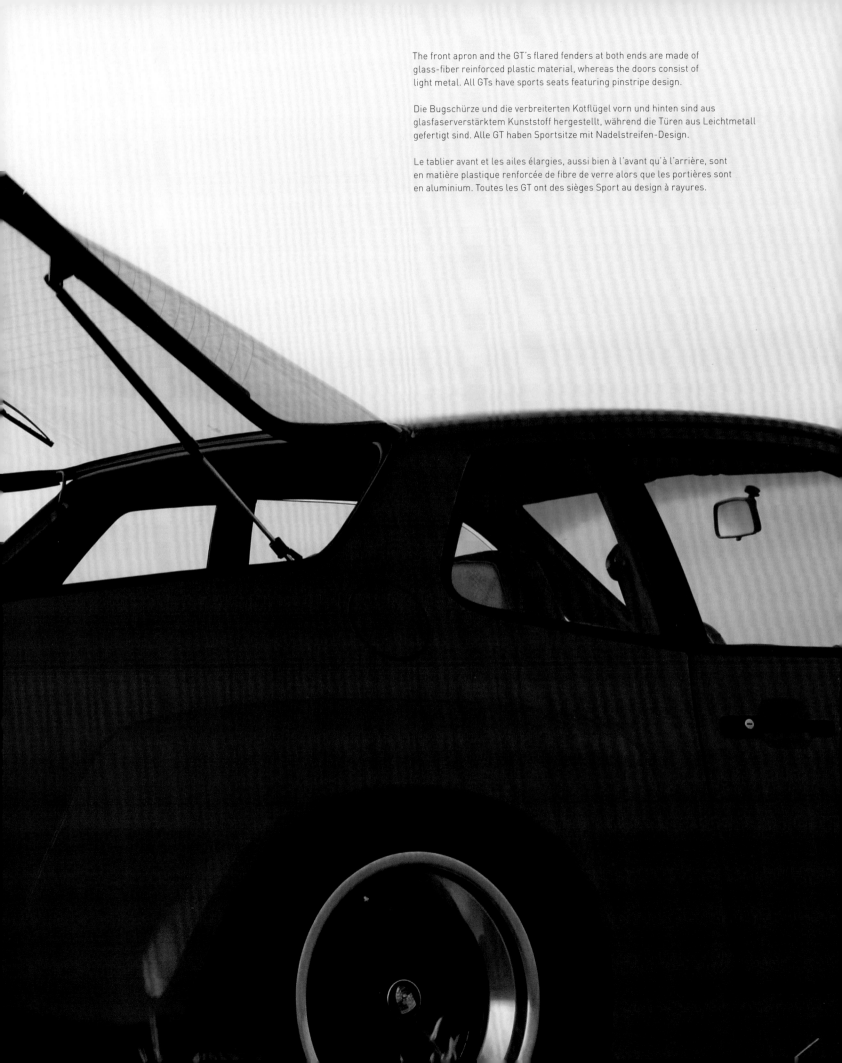

The front apron and the GT's flared fenders at both ends are made of glass-fiber reinforced plastic material, whereas the doors consist of light metal. All GTs have sports seats featuring pinstripe design.

Die Bugschürze und die verbreiterten Kotflügel vorn und hinten sind aus glasfaserverstärktem Kunststoff hergestellt, während die Türen aus Leichtmetall gefertigt sind. Alle GT haben Sportsitze mit Nadelstreifen-Design.

Le tablier avant et les ailes élargies, aussi bien à l'avant qu'à l'arrière, sont en matière plastique renforcée de fibre de verre alors que les portières sont en aluminium. Toutes les GT ont des sièges Sport au design à rayures.

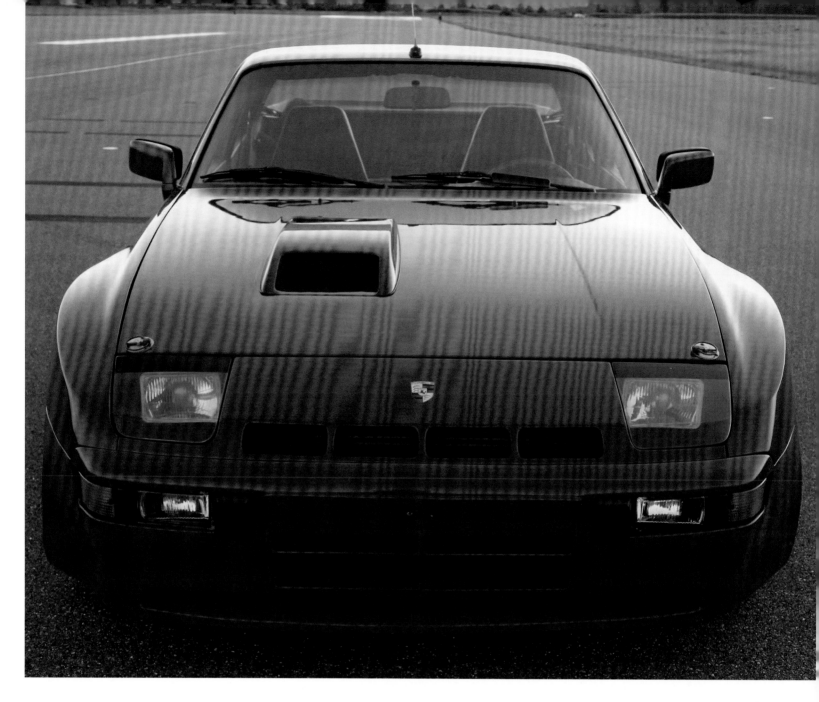

This is a 924 GTS. You can hardly tell it apart from its less potent GT sibling in visual terms. But the resemblance to the future Porsche 944 high-volume model is unmistakable.

Hier ein 924 GTS, vom schwächeren Bruder GT äußerlich so gut wie nicht zu unterscheiden. Aber die Ähnlichkeit zum künftigen Volumenmodell 944 ist nicht zu verkennen.

Ici une 924 GTS, pratiquement impossible à distinguer extérieurement de sa soeur la GT moins musclée. Mais la similitude avec le futur modèle plus démocratique, la 944, est incontestable.

The very heart of the 924 GTS: its 245 bhp straight four based on the 924's gray cast iron cylinder block. The crankgear stems from the 924 Turbo. The extra performance is, above all, provided by a voluminous intercooler.

Das Herzstück des 924 GTS: sein 245 PS starker Reihenvierzylinder mit dem Graugussblock des 924. Der Kurbeltrieb stammt vom 924 Turbo. Die stattliche Mehrleistung wird vor allem über einen großvolumigen Ladeluftkühler erreicht.

Le joyau mécanique de la 924 GTS : son quatre-cylindres en ligne de 245 ch avec le bloc en fonte grise de la 924. L'embiellage provient de la 924 Turbo. Le substantiel surcroît de puissance est surtout obtenu grâce à un échangeur d'air à gros débit.

In the history of the transaxle Porsche 924 the GT and GTS versions
are just footnotes since they are in a definite minority. But they
do a lot for the image of both the model and the marque.

In der Geschichte des Transaxle-Typs Porsche 924 bilden
die Versionen GT und GTS lediglich eine Fußnote. Aber sie
leisten eine Menge für das Image von Modell und Marke.

Dans l'histoire de la Porsche 924 à transmission Transaxle, les versions
GT et GTS ne resteront qu'une anecdote. Mais leur contribution à
l'image du modèle de la marque est bel et bien considérable.

There was something odd about the genesis of the Porsche 928: nine years elapsed between first considerations and its eventual introduction at the 1977 Geneva spring show, whereas it was actually present in the market for 18 years. The idea behind it was to create a car that was thoroughly different from the 911, as an up-market addition to or even future replacement for the Zuffenhausen classic. A water-cooled V8 below the front hood was to communicate with the rear axle complying with the transaxle principle, so as to achieve an almost perfect weight distribution. But then the project was delayed by topsy-turvydom, the oil crisis, managers who did not see eye to eye, until things got going in the shape of a truly remarkable test program, with a Mercedes 350 SL, an Opel Admiral, three Audi 100 Coupés and a Jeep-like vehicle as harmless and inconspicuous guises in which elements of the new model were tested out. From 1974, a fleet of 13 prototypes set out for a trip through automotive hell, on the Porsche-owned test track at Weissach as well as in the scorching heat of Algeria and the extreme cold of the Arctic Circle. They were also submitted to brutal crash tests from every possible angle.

Its shape was greeted with applause, but also sharp disapproval. Chief designer Anatole Lapine, however, rejected all criticism. His inspiration, he said, had been guided by the aspect of timelessness rather than a much-too-fleeting notion of what was beautiful. The plump appearance of his creation also bore out the existence of deformable structures adjoining the rigid passenger cell. The raw bodywork contributed only 18 per cent (911: 23 per cent) of the overall weight, as the unit body of galvanized welded sheet steel construction was complemented by doors, front fenders and engine hood made of special aluminum alloy. Meticulous detail work had gone into the suspension, double wishbones and McPherson struts at the front while the rear had the so-called Weissach axle, with semi-trailing arms, lower wishbones, coil springs and coaxial tubular shock absorbers. The 4474 cc V8 was flat (bank angle 90 degrees), light (520 lbs) and compact (34"×30"×28"). Its 240 bhp were conveyed to the rear wheels via dual-joint shafts with length adjustment.

In 1978, the top-notch Porsche took the coveted "Car of the Year" award. After its compression ratio had been raised from 8.5 to 10:1 in 1979, it had to be fed with premium gas. The same year saw the debut of the 928 S, which was to take its place entirely by the end of the 1982 model year. Its displacement of 4664 cc and better breathing helped to engender 300 bhp, topped up by another ten bhp in 1983, mainly due to Bosch's latest LH-Jetronic. In 1986, the 928 S4 with a 4957 cc 32-valve version of the rumbling eight-cylinder carried that escalation of strength on, followed by the 330 bhp 928 GT in 1989. In 1991, the model range culminated in the 928 GTS (5397 cc, 350 bhp), only to expire in the course of 1995, when a total of 61,056 had been built, also terminating the era of the front-engined Porsches. Somehow, the revolution had not worked.

Ein Kuriosum: Von der Idee bis zur Realisation des Porsche opus 928 mit seinem faktischen Erstauftritt beim Genfer Frühjahrssalon 1977 verstrichen neun, seine Präsenz auf dem Markt belief sich auf 18 Jahre.

Die Idee: ein ganz anderes Auto als den Elfer in die Welt zu setzen, als hierarchisch höher angesiedelte Ergänzung oder sogar als künftige Alternative zu diesem. Ein wasserumspülter V8 im Bug sollte mit der Hinterachse gemäß dem Transaxle-Prinzip kommunizieren, um die Gewichtsverhältnisse bestens auszuwuchten. Irrungen und Wirrungen stellten sich dazwischen, die Ölkrise, Meinungsverschiedenheiten der Bosse, ehe die Sache in einem Testprogramm sondergleichen in die Gänge kam, mit einem Mercedes 350 SL, einem Opel Admiral, drei Audi 100 Coupés sowie einem Jeep-ähnlichen Gefährt als harmlos-unverdächtigen Versuchsträgern für Teilbereiche des Neuen. Ab 1974 lief eine Flotte von 13 Prototypen aus, die auf der hauseigenen Prüfstrecke Weissach, in der Gluthitze Algeriens und der Eiseskälte des Polarkreises nach Herzenslust geschunden und brutalen Crashtests unterzogen wurden.

Seine Form löste Zustimmung, aber auch Naserümpfen aus: Er habe sich, wehrte sich Chef-Designer Anatole Lapine, eher dem Aspekt der Zeitlosigkeit als einer allzu flüchtigen modischen Schönheit verpflichtet gefühlt. Im massig-rundlichen Auftritt seiner Kreation bildeten sich allerdings auch die Deformationszonen ab, welche im Falle eines Falles den rigiden Wohntrakt abfederten. Nur mit 18 Prozent (911: 23 Prozent) des Gesamtgewichts schlug die Rohkarosserie zu Buche, da man in die beidseits feuerverzinkte Stahlblechschale Türen, Kotflügel und eine Motorhaube aus Aluminium eingelagert hatte. Pedantische Kleinarbeit floss in das Fahrwerk ein, doppelte Querlenker und Federbeine vorn und die so genannte Weissach-Achse hinten, mit Längsschubstreben und unteren Querlenkern, Schraubenfedern und koaxialen Teleskopdämpfern. Die 240 PS des flachen (Gabelwinkel 90 Grad), kompakten (860×750×710 mm) und leichten (236 kg) V8 von 4474 cm³ wurden durch Doppelgelenkwellen mit Längenausgleich an die Hinterräder weitergereicht.

1978 holte der Top-Porsche das begehrte Attribut „Auto des Jahres" nach Zuffenhausen. Nachdem seine Kompression 1979 von 8,5 auf 10:1 erhöht worden war, mochte er nur noch Superbenzin speisen. Im gleichen Jahr wurde ihm der 928 S zur Seite gestellt, der ihn mit dem Ende des Modelljahrs 1982 gänzlich ablöste. Sein Hubraum von 4664 cm³ und geglättete Ansaug- und Auspufftrakte ermöglichten 300 PS, die 1983 noch einmal vor allem dank der LH-Jetronic von Bosch um zehn weitere PS überboten wurden. Mit 320 PS setzte der auf 4957 cm³ vergrößerte Vierventiler des 928 S4 von 1986 diese Eskalation der Stärke fort, mit 330 PS der 928 GT anno 1989. Die Baureihe kulminierte 1991 mit dem GTS (5397 cm³, 350 PS) und verblich 1995 nach 61056 Exemplaren in Schönheit, mit ihr das Intermezzo der Frontmotor-Porsche. Die Revolution hatte nicht so richtig geklappt.

Fait rare : neuf ans s'écoulent entre l'idée et la réalisation de la Porsche 928, finalement présentée en première mondiale au Salon de l'Automobile de Genève en 1977. Quant à sa présence sur le marché, elle durera dix-huit ans.

L'idée consistait à créer une voiture diamétralement opposée à la 911 et positionnée plus haut dans la hiérarchie maison, voire destinée à en prendre la succession si celle-ci venait à disparaître un jour. Un V8 à refroidissement liquide placé à l'avant et combiné à une boîte faisant bloc avec le train arrière selon le principe Transaxle est censé garantir une parfaite répartition du poids. Mais les aléas de l'économie – le premier choc pétrolier – et de la politique – des divergences d'opinions au sein de la direction – viennent contrecarrer ce projet. Il prendra finalement la forme d'un programme

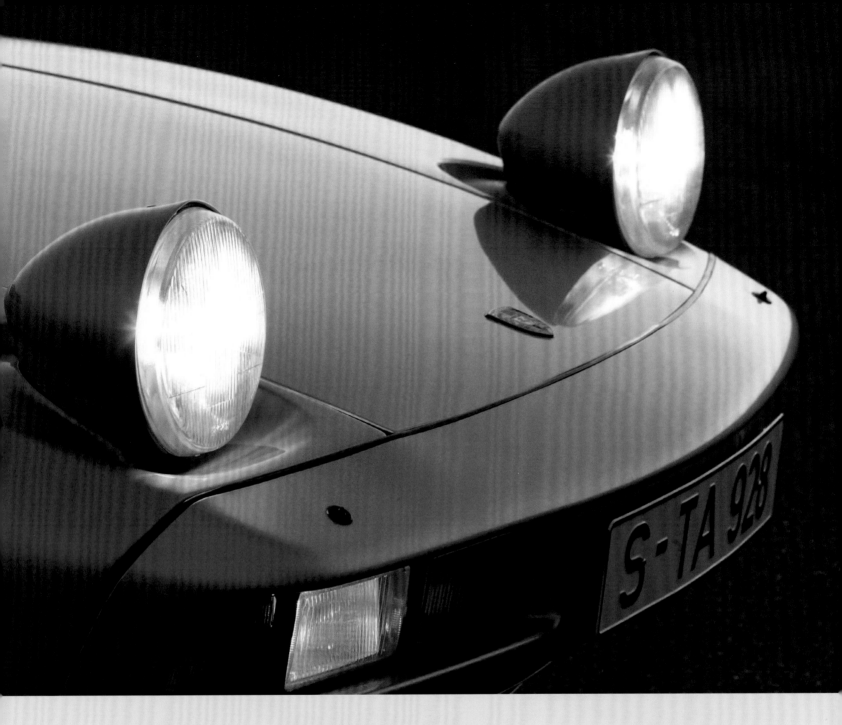

d'essais sans précédent (une Mercedes 350 SL, une Opel Admiral, trois coupés Audi 100 et un engin ressemblant à une Jeep), les véhicules-laboratoires permettant de tester les différents organes de la nouvelle recrue. À partir de 1974, 13 prototypes subit un traitement d'une dureté sans précédent : sur le circuit d'essais Porsche de Weissach, sous la chaleur torride du désert d'Algérie et dans le froid impitoyable du cercle polaire. Les véhicules sont également soumis à des tests de collisions sous tous les angles.

Si les formes de la 928 sont plébiscitées, elles n'en ont pas moins des détracteurs. Mais le chef-styliste Anatole Lapine leur rétorque qu'elle se veut plutôt intemporelle qu'assujettie aux canons d'une beauté convenue parfois trop éphémère. Sous les rondeurs inhabituelles de sa création, dit-il, se

dissimulent accessoirement aussi des zones de déformation programmée qui protègent les passagers de son cockpit. La carrosserie blanche ne représente que 18 % du poids total (pour la 911 : 23 %), car sa coquille en tôles d'acier galvanisées des deux côtés est habillée de portières, d'ailes et d'un capot moteur en aluminium. Les liaisons au sol sont le fruit d'études d'une minutie inimaginable avec leurs doubles bras transversaux et des jambes élastiques à l'avant ainsi que le fameux essieu Weissach à l'arrière avec barres de poussée longitudinales et bras transversaux inférieurs, ressorts hélicoïdaux et amortisseurs coaxiaux. Les 240 ch du V8 très plat (calé à 90 degrés), compact (860×750×710 mm) et léger (236 kg) de 4474 cm³ de cylindrée sont transmis aux roues arrière par des arbres à double cardan avec compensation de la longueur.

En 1978, le porte-drapeau de Porsche remporte le prix de la «Voiture de l'année». Après une majoration de son taux de compression de 8,5 à 10:1 en 1979, son moteur exige d'être gavé de super. La même année, le coupé est rejoint par une 928 S qui le supplante à la fin du millésime 1982. Sa cylindrée passe à 4664 cm³ et ses collecteurs d'aspiration et d'échappement lissés se traduisent par une puissance de 300 ch qui s'enrichit de 10 chevaux en 1983, notamment grâce à l'injection LH-Jetronic de Bosch. Avec 320 ch, le quatre-soupapes à la cylindrée majorée à 4957 cm³ de la 928 S4 augmente sa puissance en 1986, imité en cela par la 928 GT de 330 ch en 1989. La gamme atteint son apogée en 1991 avec la 928 GTS (5397 cm³, 350 ch) avant d'expirer en 1995. Avec 61 056 exemplaires produits, l'épisode des moteurs avant n'aura pas le succès attendu.

928

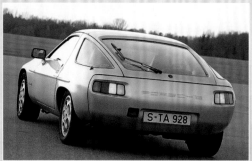

While the 928 is in the making, the Porsche engineers pay great attention to its aerodynamics. Later the drag coefficient turns out to be no better than with some family sedans, let alone the in-house 924 Turbos.

Mit besonderer Sorgfalt nehmen sich die Porsche-Techniker in der Entstehungsphase des 928 seiner Aerodynamik an. Wie sich später herausstellt, ist der Luftwiderstandsbeiwert indessen nicht besser als bei mancher Limousine.

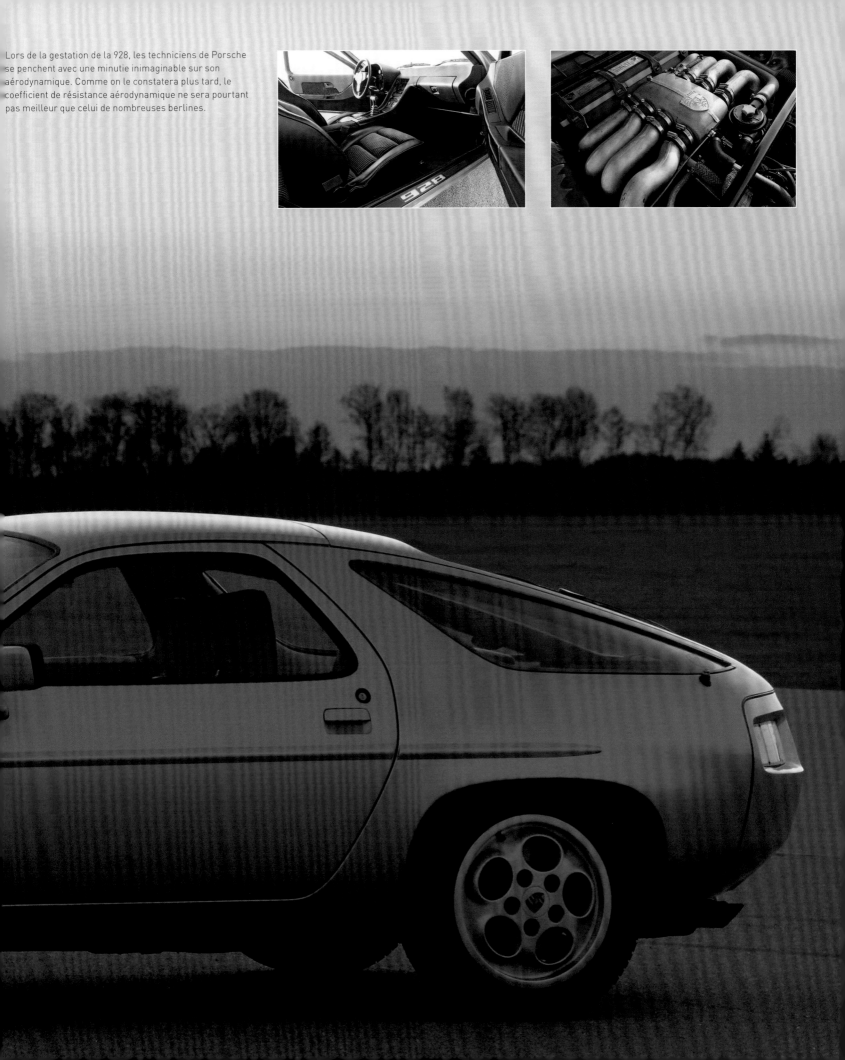

Lors de la gestation de la 928, les techniciens de Porsche se penchent avec une minutie inimaginable sur son aérodynamique. Comme on le constatera plus tard, le coefficient de résistance aérodynamique ne sera pourtant pas meilleur que celui de nombreuses berlines.

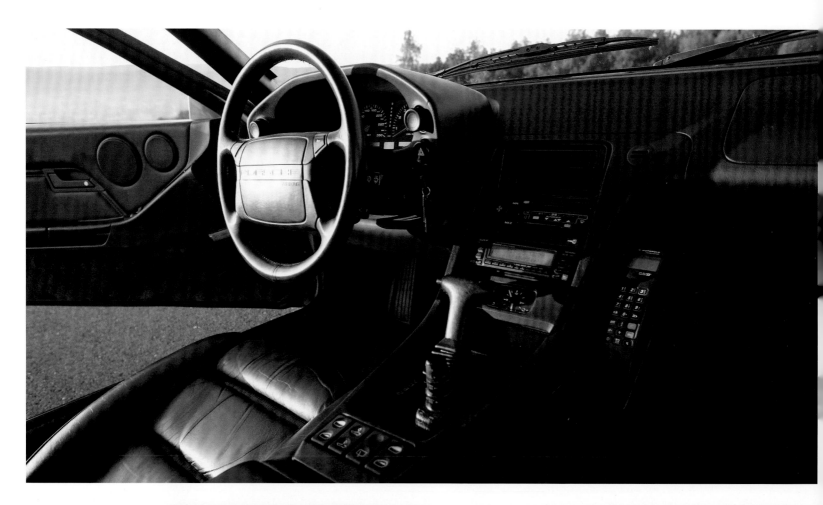

Last of the 928 Mohicans: the GTS. Equipped with a 5.4-liter version of the V8 and 350 hefty horsepower, the final 928 can be distinguished from its immediate forerunner by its unobtrusive fender extensions and 17-inch-wheels.

Letztes Wort in Sachen 928: der GTS. Jetzt mit 5,4 Litern Hubraum und 350 stämmigen PS ausgestattet, grenzt sich der finale 928 gegen seinen Vorgänger durch dezente Kotflügelverbreiterungen und 17-Zoll-Räder ab.

Dernier avatar de la déclinaison sur le thème de la 928 : la GTS. Propulsée maintenant par un V8 de 5,4 litres de cylindrée et 350 chevaux bien en chair, la 928 dernière édition se distingue de sa devancière par de discrets élargisseurs d'aile et des roues de 17 pouces.

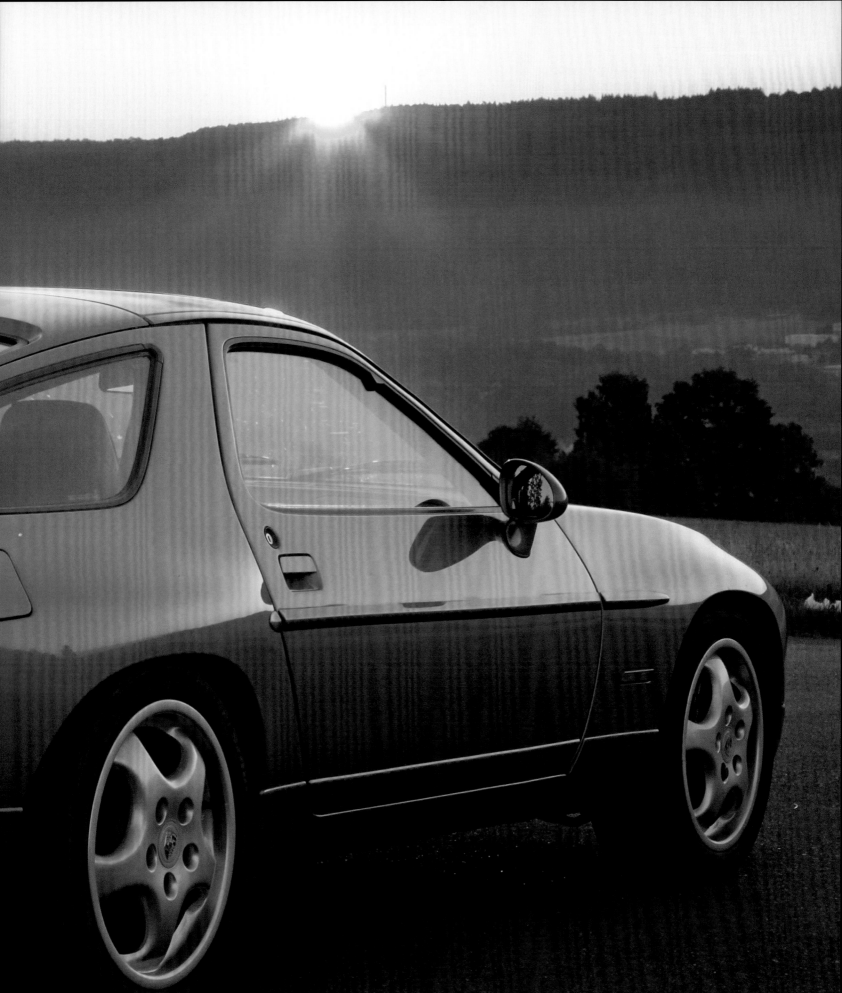

The common denominator with the 911: the 944, introduced in July 1981, was a Porsche, fast, safe, eminently suitable for everyday use, whose value was as stable a jewel's. As much as 17½cu.ft. of baggage could be taken on a trip, a lot for two, albeit displayed stark naked below a huge glass hatchback to notoriously curious fellow men.

But it belonged to that markedly no-nonsense species of transaxle cars, with a front water-cooled four-cylinder engine and gearbox as well as final drive close to the rear axle, linked by a rigid tube with a "fast shaft" rotating in it. That could be the reason for a certain lack of prestige and charisma, like its smaller brother the 924. The entry-level Porsche had contributed its floor assembly and suspension, by means of wishbones and McPherson struts at the front, semi-trailing arms and transverse torsion bars at the rear and stabilizers at both ends. Key impulses in terms of the styling had come from the 924GTS. The 944's light-alloy engine with initially 2479cc and 150bhp had also not arisen from a clean sheet of paper. The Porsche sorcerers at Weissach had basically carved a bank out of the 928's V8 and meticulously fine-honed it with two belt-driven balance shafts that resulted in impeccable manners. Its big combustion chambers were ideally suited for detoxification, demanded, for instance, by the strict emission laws of the important export country the USA. The aggregate was built in Zuffenhausen and then transported to nearby Neckarsulm, where the 944 took shape in the Audi plants.

In 1985 an addition to the family came in the shape of the 944 Turbo which, with a turbocharger and charge-air cooler, developed a healthy 220bhp, in spite of its standard catalytic converter. It was recognizable by its new front and rear spoilers, developed in the wind tunnel for a specific purpose on a much faster vehicle. As of August 1986, the metabolism of the 944S (180bhp, 142mph) was taken care of by a four-valve cylinder head with two overhead camshafts. In the same year the 944 Turbo got its own racing series in the ADAC Supercup, from 1987 with a 250bhp power plant that, from that year's November onwards, was also available with a limited edition of 1000 series-built Turbos and was adopted for good in 1988. At the same time, displacement and output of the normally-aspirated 944 were raised to 2681cc and 165bhp respectively, whereas the production of the evolutionary stage S2 with 2990cc and 211bhp was delayed until the final months of the year. The same went for an attractive convertible variant of the S2, not available before January 1990.

At that moment the death knell had already been rung on the basic 944, and the writing was on the wall for the model as a whole because the contract with Audi expired in 1991. The last 429 of altogether 162,302 Porsche 944s rolled off the assembly line in Zuffenhausen, while a final run of 500 special-edition convertibles was built at ASC (American Sunroof Corporation) at Heilbronn, all with turbo engines, electrical roof operation and air conditioning.

Der gemeinsame Nenner mit dem 911: Der 944, im Juli 1981 eingeführt, war ein Porsche, schnell, sicher, unbedingt alltagstauglich, haltbar und wertbeständig wie ein Juwel. Sogar bis zu 500 Litern Gepäck ließen sich mit auf die Reise nehmen, reichlich für zwei, wenn auch unter dem riesigen gläsernen Heckdeckel nackt vor einer notorisch neugierigen Umwelt ausgebreitet.

Aber er zählte zu dem so überaus vernünftigen Transaxle-Genre, mit einem wassergekühlten Vierzylinder vorn und Getriebe und Radantrieb bei der Hinterachse, verbunden durch ein starres Rohr mit einer „schnellen Welle" darinnen. Daher gingen ihm ein wenig das Charisma und das Prestige ab wie schon dem kleineren Bruder 924. Von diesem hatte man Bodengruppe und Aufhängung übernommen, mit Querlenkern und McPherson-Federbeinen vorn, Schräglenkern und quer liegenden Drehstäben hinten und Stabilisatoren an beiden Enden. Energische Impulse für seine Linie kamen vom 924GT. Auch sein Leichtmetalltriebwerk mit zunächst 2479 cm³ und 150 PS wurde keineswegs auf einem weißen Blatt Papier geboren. Es handelte sich praktisch um den halbierten V8 aus dem 928, dem die PS-Zauberer zu Weissach mit zwei per Zahnriemen angetriebenen Ausgleichswellen gepflegte Manieren beigebogen hatten. Seine großen Brennräume waren im Übrigen wie geschaffen für Entgiftungsmaßnahmen, wie sie etwa die Gesetze des wichtigen Exportlandes USA einforderten. Gebaut wurde es in Stuttgart und dann nach Neckarsulm spediert, wo der 944 in den Audi-Werkshallen Gestalt annahm.

1985 stellte sich Familienzuwachs ein in Gestalt des 944 Turbo, der mit Abgaslader, Ladeluftkühlung und trotz Katalysator 220 solide PS leistete, erkennbar etwa durch im Windkanal optimierte Front- und Heckspoiler. Der Stoffwechsel des 944S (190 PS, 228 km/h) ab August 1986 vollzog sich über einen Vierventilkopf mit zwei oben liegenden Nockenwellen. Ebenfalls 1986 bekam der 944 Turbo im Rahmen des ADAC Supercups eine eigene Rennserie, ab 1987 mit einem 250-PS-Aggregat, das im November jenes Jahres auch dem Serientyp in einer Auflage von 1000 zugänglich gemacht und 1988 endgültig übernommen wurde. Zur gleichen Zeit wurden Hubraum und Leistung des Saugmotor-944 auf 2681 cm³ und 165 PS angehoben, während sich die Produktion der Entwicklungsstufe S2 mit 2990 cm³ und 211 PS bis auf die letzten Monate des Jahres verzögerte. Das Gleiche galt für eine schöne Cabrio-Version der Spielart S2, die erst im Januar 1990 verfügbar wurde.

Da hatte bereits das Sterbeglöcklein für den Einstiegs-944 gebimmelt, und insgesamt waren die Tage der Modellreihe gezählt. Denn der Vertrag mit Audi erlosch 1991, und die letzten 429 von 163302 Porsche 944 verließen in Zuffenhausen das Band, während in einer Edition von 500 ein finales Sonder-Cabriolet bei ASC (American Sunroof Corporation) in Heilbronn das Licht dieser Welt erblickte, mit Turbo-Triebwerken, elektrisch betätigtem Verdeck und Klimaanlage.

La 944 présentée en 1981 a plusieurs points communs avec la 911: c'est une Porsche rapide, sûre, parfaitement utilisable au quotidien, endurante et à la valeur aussi pérenne que celle d'un bijou. Et elle peut même embarquer jusqu'à 500 litres de bagages, soit largement assez pour un week-end en amoureux. Assez également pour susciter la convoitise des curieux, à les voir exposés sous l'immense coupole vitrée du coffre.

Elle reprend l'architecture Transaxle, expression-même de la raison, avec un quatre-cylindres refroidi par eau à l'avant et une boîte de vitesses faisant bloc avec l'essieu arrière moteur, les deux organes étant reliés l'un à l'autre par un tube rigide qui héberge l'arbre de transmission en rotation. Mais cette Porsche dégage tout aussi peu de charisme et de prestige que sa petite sœur,

1981–1991

la 924. Laquelle lui a d'ailleurs légué sa plate-forme et ses suspensions, ses bras transversaux et jambes élastiques McPherson à l'avant ainsi que ses bras obliques et barres de torsion transversales horizontales à l'arrière, complétées par des barres antiroulis pour les deux essieux. Quant à ses lignes, elles s'inspirent étroitement de celles de la 924 GT. De même, son moteur en alliage léger d'une cylindrée initiale de 2479 cm³ et 150 ch ne lui est pas spécifique. En effet, il s'agit pratiquement du demi-V8 de la 928, auquel les magiciens motoristes de Weissach ont inculqué un comportement civilisé avec deux arbres antivibrations entraînés par une courroie crantée. Ses généreuses chambres de combustion répondent aux sévères normes environnementales en vigueur sur son principal marché d'exportation, les États-Unis.

Elle est construite à Zuffenhausen avant d'être envoyée à Neckarsulm, où la 944 prend son allure définitive dans les ateliers d'Audi.

En 1985, la famille s'agrandit avec la 944 Turbo, développant 220 chevaux fringants grâce à un turbo-compresseur et un échangeur d'air, et ce malgré la présence des catalyseurs. Ce modèle est reconnaissable à ses tabliers avant et arrière optimisés en soufflerie. L'alimentation de la 944 S (190 ch, 228 km/h), apparue en août 1986, s'effectue à l'aide d'une culasse à quatre soupapes avec deux arbres à cames en tête. Cette année-là aussi, la 944 Turbo bénéficie de son propre trophée dans le cadre de l'ADAC Supercup avec, à partir de 1987, un moteur de 250 ch dont hérite aussi, en novembre 1987, la version de série dans une édition tirée à 1000 exemplaires et qui devient définitive en 1988. En même

temps, la cylindrée et la puissance de la 944 à moteur atmosphérique augmentent, passant respectivement à 2681 cm³ et 165 ch, tandis que la production de l'évolution S2 avec 2990 cm³ et 211 ch est repoussée jusqu'à la fin de l'année. La règle est la même pour une jolie version cabriolet de la variante S2, qui n'est disponible qu'en janvier 1990.

Mais les vautours planent déjà au-dessus de la 944, modèle d'accès à la gamme, dont, *a priori*, les jours sont comptés. En effet, le contrat conclu avec Audi arrive à expiration en 1991. Les 429 dernières Porsche 944 (sur 163 302 au total) sortent des chaînes de Zuffenhausen, pendant que 500 cabriolets d'une série limitée sont produits chez ASC (American Sunroof Corporation), à Heilbronn, avec un moteur turbo, une capote à commande électrique et une climatisation.

944

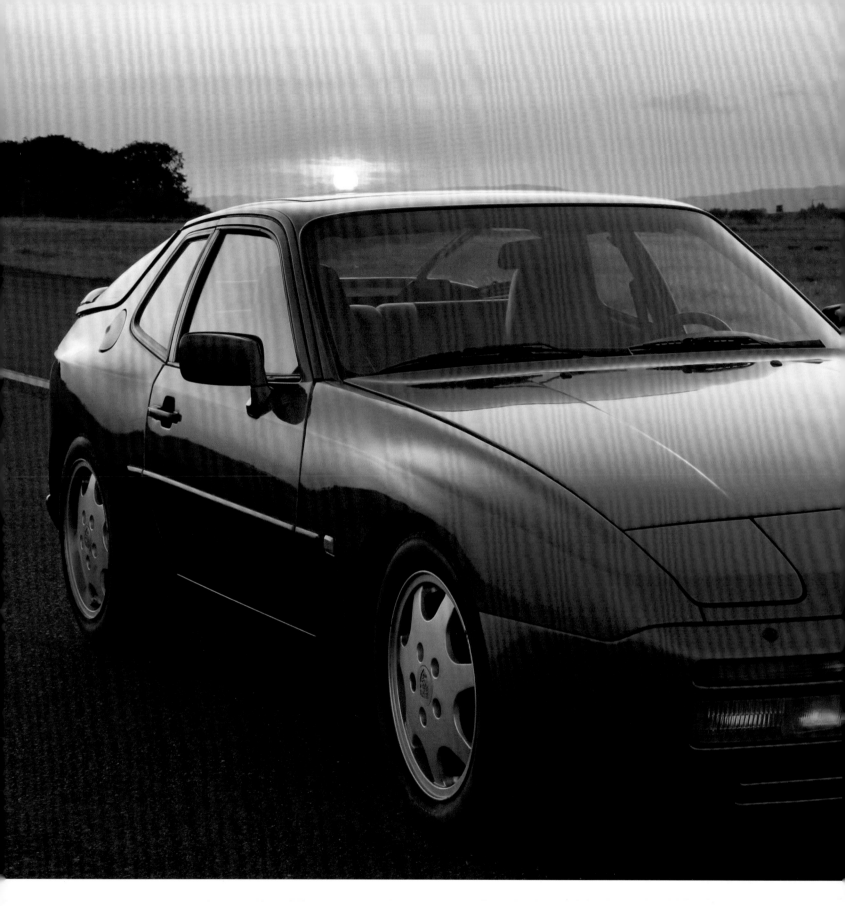

The 944 Turbo can be distinguished from the normally aspirated version by an aerodynamically improved front end and an angled addition to the rear apron. For the 1990 model year, both versions share a new rear spoiler made of plastic, fastened to the hatchback frame.

Von der Saugversion unterscheiden den 944 Turbo ein aerodynamisch verbesserter Bugbereich und ein gewinkelter Zusatz unter der Heckschürze. Mit ihr teilt er zum Modelljahr 1990 einen neuen Spoiler aus Kunststoff, am Rahmen der Heckklappe befestigt.

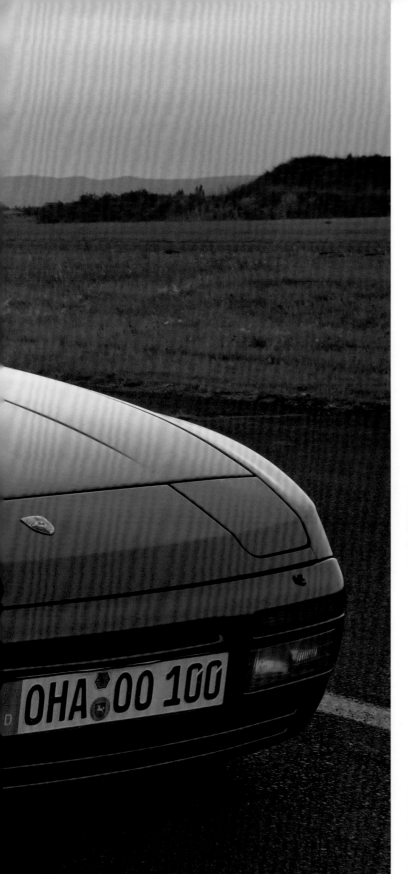

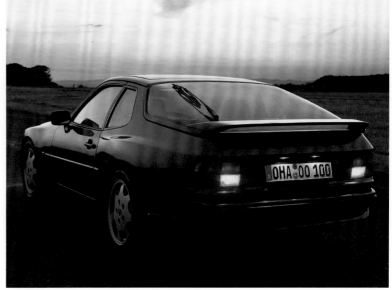

La 944 Turbo se distingue de la version atmosphérique par une proue affinée sur le plan aérodynamique et une nervure supplémentaire sous le tablier arrière. Pour le millésime 1990, elle partage avec celle-ci un nouvel aileron arrière en matière plastique fixé directement sur le hayon.

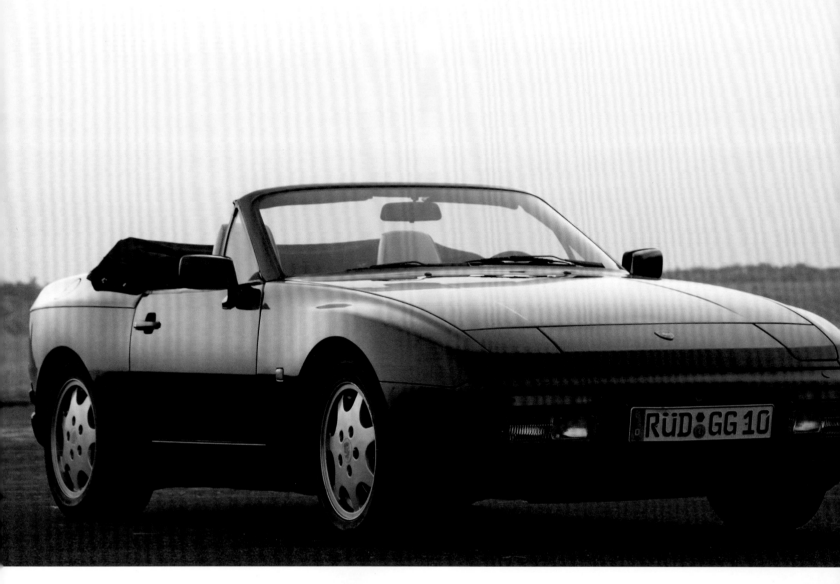

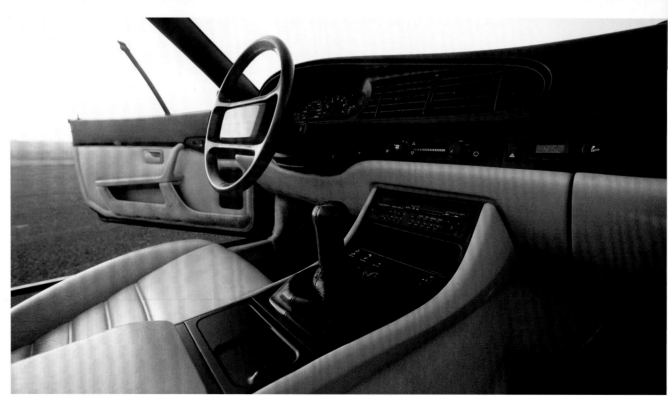

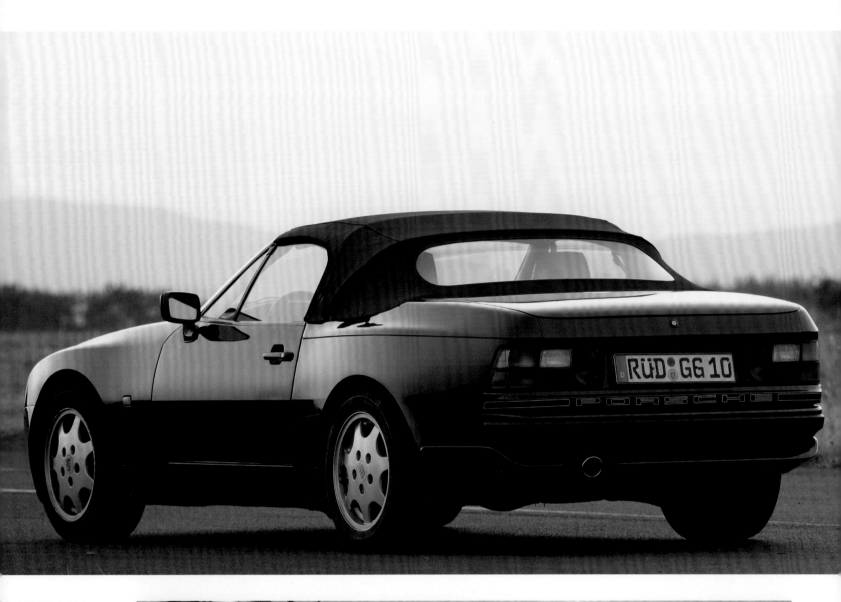

The 944 S2 Cabriolet—
in this case with the
optional lush leather
interior—is available
from January 1989. The
changes necessary for
the open version are
performed by the German
Weinsberg ASC branch.

Das 944 S2 Cabriolet –
hier mit der optionalen
opulenten Leder-
ausstattung – ist ab
Januar 1989 zu haben.
Die für die offene Version
erforderlichen Eingriffe
nimmt die Firma ASC
in Weinsberg vor.

La 944 S2 Cabriolet –
photographiée ici avec
l'opulente sellerie
cuir optionnelle – est
commercialisée en janvier
1989. C'est la société
ASC, à Weinsberg, qui se
charge d'en extrapoler
une version décapotable.

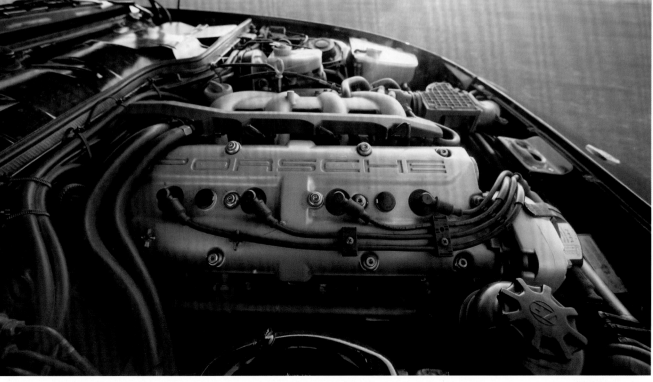

The latest exhibit on the Porsche stand at the 1983 Frankfurt IAA was unmistakably a 911, endorsed by the fact that the model range as a whole bore the time-honored Carrera name again. But in many respects it was a completely different motor vehicle. The changes began with its power plant. It owed its larger capacity of 3164 cc, made possible, above all, by the use of aluminum for the cylinders instead of cast iron as in the early years, to an increase of the stroke by four millimeters, generating 231 bhp. There were, however, other factors that also made their contribution, such as a novel Bosch Motronic that monitored smooth engine operation in all conditions with electronically stored mapping, an optimal compression ratio of 10.3:1, a resonance-type intake as well as an exhaust system with relatively low back pressure. Porsche was progressively, albeit at steep additional charges, improving its catalyst technology, though this did not prove particularly popular with a clientele traditionally craving more power, accounting as it did for the loss of initially 24 and later 14 bhp. The five-speed gearbox had been stepped in a new way, painstakingly adjusting to the altered engine profile. The new package also contained bigger rear brake pistons, disks that were 0.14" wider and the brake-power modulator from the 911's rumbling sibling the 928 S.

The latest 911 generation could be recognized by a differently-styled front apron, from which peeped out rectangular fog lamps, cast light-alloy wheels in "telephone design" featuring five holes and the Carrera logo on the engine bay lid. Optionally, the Coupé was offered in the wide Turbo look, including the 930's chassis and its voluminous "whale tail" wing. Its example was followed in 1985 by the Targa and the Convertible, which had quickly become a best seller accounting for half of the Carrera 3.2's production (74,026 altogether).

A year later, by request and at an extra 4000 marks, the driver could open or close the open variant's soft top fully automatically in just 20 seconds, and in the 1987 model year the rear light strip comprised two fog lamps rather than the one that had lived to the left below the bumper until then. Front tires were of 195/65 (previously 185/70) VR 15 format, and in 1989, the year of the model's demise, 205/55 (6J×16), as opposed to 225/50 (8J×16) at the rear.

In 1987, the Porsche 911's first quarter of a century was celebrated with a special edition in diamond blue metallic for all three body shapes. In the same year, triggered by urgent requests mainly from the United States as of yore, the red prototype of a Speedster made the mouths of the purists water. However, it was only to become available two years later, after some massive retouches to the original concept, derived from the standard Carrera, but in the majority of cases in the chubby-cheeked Turbo look and on the 930's chassis. The fundamentalists had also been provided for in the forms of the lightweight 911 scions CS/RS (2994 cc, 255 bhp in a road-going version in 1984) or the Carrera Clubsport (1987), which was certainly no less ascetic.

Das neueste Exponat auf dem Porsche-Stand bei der IAA 1983 war sichtlich ein Elfer und trug wie zur Bekräftigung den vollen Traditionsnamen Carrera. Und doch handelte es sich in vieler Hinsicht um ein anderes Auto. Das begann mit dem Triebwerk: Seinen 3164 cm³ Hubraum, vor allem möglich gemacht durch die Verwendung von Aluminium für die Zylinder statt dem Grauguss der Gründerjahre, lag ein um vier Millimeter erweiterter Hub zugrunde. Es setzte nun 231 PS frei. Dazu trugen allerdings auch weitere Faktoren bei, etwa die Bosch-Motronic, die mit einem elektronisch gespeicherten Kennfeld einen gleichbleibend runden Motorlauf überwachte, die optimale Verdichtung von 10,3:1, das Resonanz-Ansaugsystem sowie eine Abgasanlage mit relativ geringem Gegendruck. Der schrittweise zur Reife entwickelten, aber deftig aufpreispflichtigen Katalysatortechnik begegnete die leistungshungrige 911-Klientel mit zähem Desinteresse, da sie anfänglich 24 und später immer noch 14 PS erdrosselte. Das Fünfganggetriebe war geschmeidig auf das neue Motorprofil abgestimmt worden, und mit ins Paket geschnürt hatte man um 3,5 mm breitere Bremsscheiben, größere Bremskolben hinten sowie den Bremskraftregler aus dem 928 S.

Erkennen konnte man die jüngste Carrera-Generation am neuen Bugspoiler, aus dem liegend rechteckige Nebellampen hervorschauten, den Leichtmetall-Gussfelgen mit fünf Löchern im „Telefondesign" und dem Schriftzug Carrera auf dem hinteren Deckel. Wahlweise gab es das Coupé im breiten Turbo-Look, inbegriffen das Fahrwerk des 930 und sein voluminöser Heckflügel. Die Targaversion und das Cabriolet, das sich inzwischen als Renner entpuppt hatte und für die Hälfte der Produktion von insgesamt 74 026 aufkam, zogen 1985 nach.

Ein Jahr später vollzog sich das Öffnen und Schließen des Verdecks am Cabrio auf Wunsch und gegen 4000 Mark Mehrpreis in 30 Sekunden vollautomatisch, und im Modelljahr 1987 hatte das hintere Leuchtenband zwei Nebellampen statt der einzelnen bislang unter dem Stoßfänger aufgenommen. Vorne rollte der Carrera auf Reifen des Kalibers 195/65 (vorher 185/70) VR 15, 1989, im Jahr seines Abschieds, sattelte man noch einmal drauf mit ZR-Reifen des Formats 205/55 (6J×16) und hinten 225/50 (8J×16).

1987 feierte man das erste Vierteljahrhundert des Elfers mit einer Jubiläums-Edition in Diamantblau-Metallic. Im gleichen Jahr ließ auf der IAA, wie einst vor allem auf dringliche Anfragen aus den USA hin, der in Rot gehaltene Prototyp eines Speedsters den Puristen den Mund wässern. Zu haben war er allerdings erst zwei Jahre später nach ein paar kräftigen Retuschen in 2102 Exemplaren, abgeleitet vom Standard-Carrera, zumeist aber im stämmigen Turbo-Look und auf dem 930-Chassis. Auch der Anhänger der reinen Lehre hatte man inzwischen gedacht mit asketischen Elfer-Seitenlinien wie dem 911SC/RS von 1984 (2994 cm³, 255 PS in der Straßenversion) oder dem Carrera Clubsport (1987) in seiner nicht weniger dürren Unwirtlichkeit.

La dernière nouveauté exposée sur le stand de Porsche à l'IAA de 1983 est une 911, ce dont elle ne fait pas mystère puisqu'elle affiche fièrement en toutes lettres son « Carrera », comme les autres modèles de la gamme. Mais les apparences sont trompeuses. Cela commence avec le moteur : sa cylindrée de 3164 cm³ s'explique par une majoration de la course de 4 mm, rendue possible, notamment, par l'utilisation d'aluminium pour les cylindres et non de fonte. Il délivre maintenant 231 ch. Mais ce n'est pas la seule explication : une injection Bosch Motronic surveille le bon fonctionnement du moteur avec une cartographie archivée dans une mémoire électronique ; un taux de compression optimal de 10,3:1, un système d'aspiration à résonance, et une ligne d'échappement avec une contre-pression relativement

1983–1989

réduite complètent le nouveau dispositif. En revanche, l'option du pot catalytique, dont la technique a été graduellement mise au point, laisse de marbre la clientèle de la 911 éprise de puissance : non seulement elle coûte cher, mais surtout elle est très « énergivore ». Après avoir « mangé » 24 ch à l'origine, elle en dévore tout de même encore 14 par la suite. La boîte à cinq vitesses adaptée aux nouvelles caractéristiques du moteur se distingue par sa souplesse et va de pair avec des disques de frein majorés de 3,5 mm, des pistons de frein de plus grand diamètre à l'arrière ainsi que le régulateur de la force de freinage de la 928 S.

La 911 Carrera 3.2 se remarque aussi à son nouvel aileron avant avec ses phares antibrouillard rectangulaires à l'horizontale, aux jantes en alliage léger à cinq trous rappelant un cadran téléphonique

et au monogramme Carrera sur le capot arrière. Pour les amateurs, le coupé est également proposé au look Turbo élargi, avec les trains roulants de la 930 et son immense becquet arrière. Une option qui sera reprise en 1985 par la version Targa et le cabriolet, et que les clients plébiscitent immédiatement : elle représente la moitié de la production de Carrera 3.2 (sur un total de 74 026 exemplaires).

Un an plus tard, une capote ultra performante (ouverture-fermeture automatique en 30 secondes) est proposée en option – pour 4000 marks. Pour le millésime 1987, enfin, le seul et unique feu de brouillard sous le pare-chocs disparaît au profit de deux optiques intégrées au bandeau lumineux arrière. À l'avant, la Carrera est chaussée de pneus de 195/65 (contre 185/70 auparavant) en VR 15, puis passe à la pointure supérieure en 1989, l'année de

ses adieux, avec des pneus ZR de 205/55 (6J×16) à l'avant et de 225/50 (8J×16) à l'arrière.

En 1987, Porsche célèbre les 25 ans de la 911 avec une série limitée de couleur bleu diamant métallisé. La même année, à l'IAA – comme jadis le fruit des demandes insistantes des États-Unis –, le prototype de couleur rouge d'un Speedster fait saliver les puristes. Il ne sera toutefois disponible que deux ans plus tard, après quelques modifications importantes, et vendu à 2102 exemplaires extrapolés de la Carrera standard, mais la plupart du temps au look macho de la Turbo et sur le châssis de la 930. Quant aux purs et durs, Porsche les satisfait entre-temps avec des extrapolations comme la 911 SC/RS de 1984 (2994 cm³, 255 ch en version routière) ou la Carrera Clubsport (1987) au caractère tout aussi spartiate.

911 Carrera 3.2

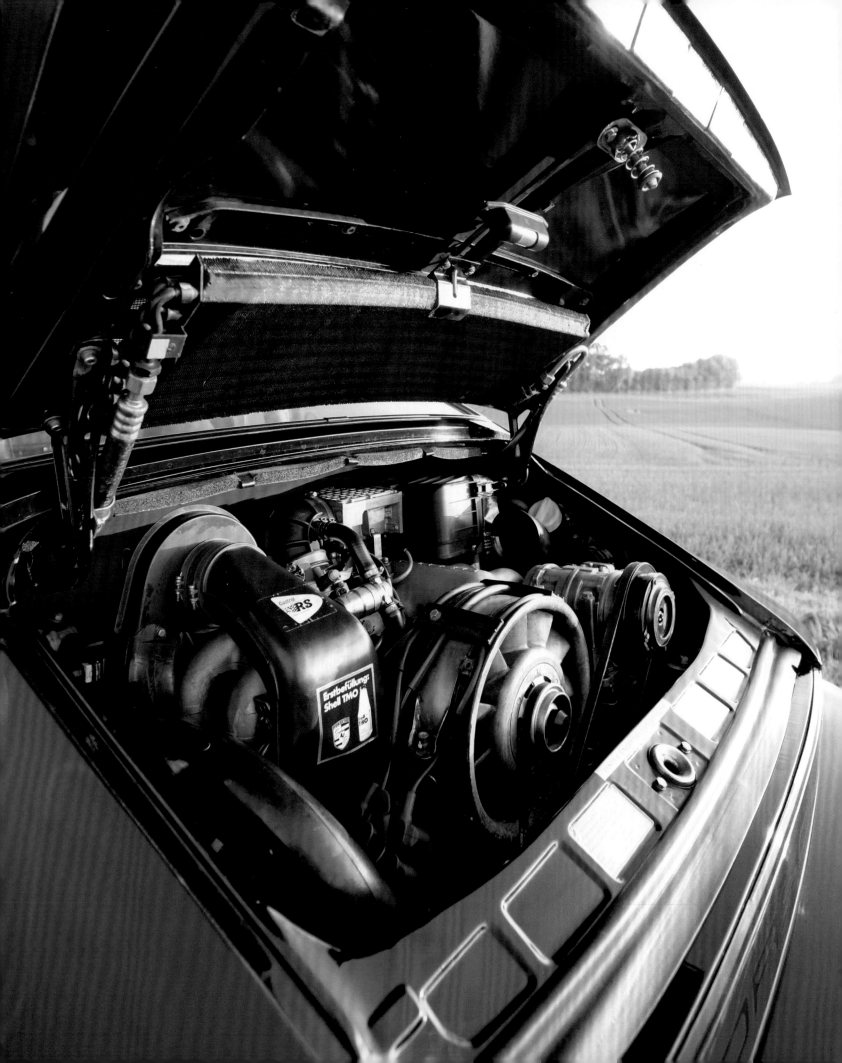

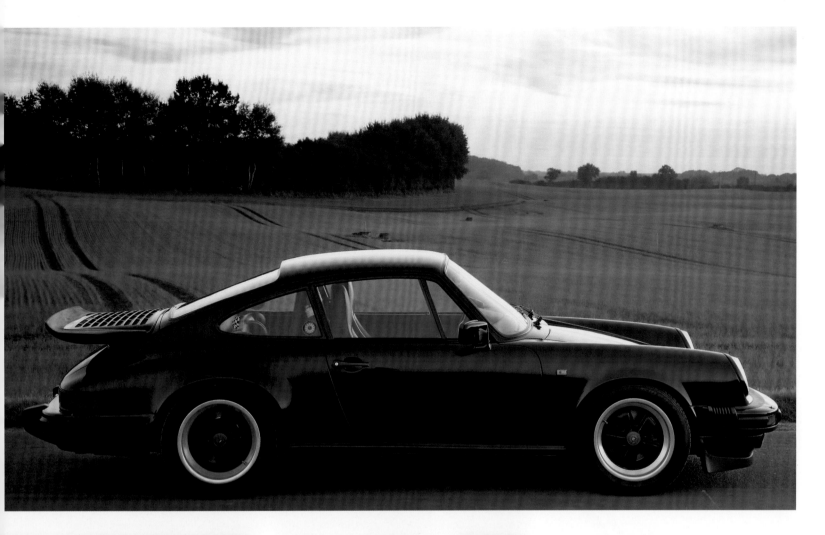

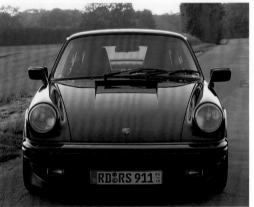

The Carrera 3.2 ushers in the renaissance of a great name. Allied to a new front spoiler, a huge rear wing—albeit as an extra—looks after improved straightline stability.

Der Carrera 3.2 läutet ab 1983 die Renaissance eines großen Namens ein. In Verbindung mit dem neuen Bugspoiler sorgt, allerdings als Zubehör, ein großer Heckflügel für eine bessere Fahrstabilität.

En 1983, la Carrera 3.2 marque la renaissance d'un nom mythique. En combinaison avec le nouvel aileron avant, en option, un grand becquet arrière lui confère une meilleure stabilité directionnelle.

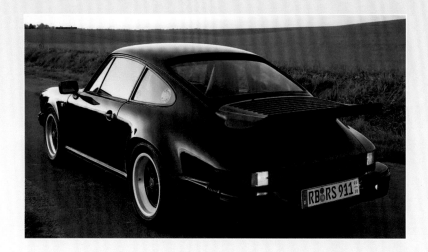

The latest metamorphosis of the 911 is externally recognizable by fog lights embedded in the front apron, its striking cast aluminum rims as well as the Carrera logo displayed at the rear.

Die jüngste Metamorphose des Elfers ist nach außen hin durch in die Bugschürze eingelassene Nebelleuchten, markante Felgen aus Leichtmetallguss sowie den Schriftzug Carrera am Heck zu erkennen.

La toute dernière métamorphose de la 911 se distingue extérieurement par des phares antibrouillard intégrés au tablier avant, des jantes au dessin particulier en alliage léger ainsi que par le monogramme Carrera sur la poupe.

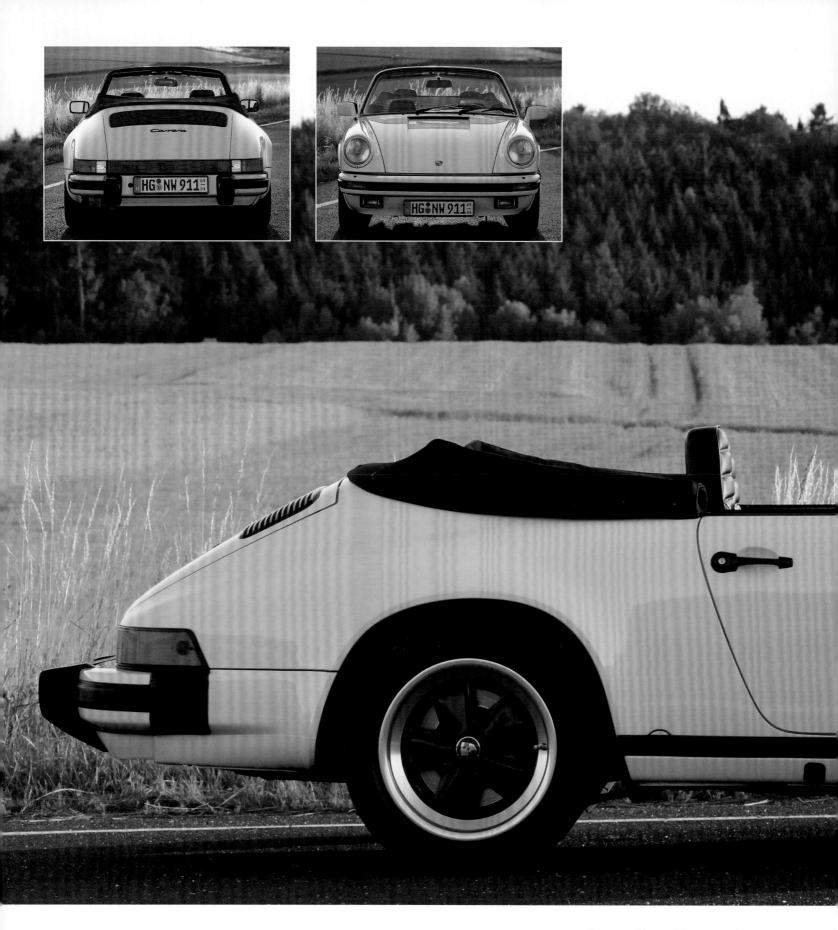

The convertible top of the open version represents
an optimum in terms of form, function and operation.
Sophisticated three-bow technology with a solid element
accounting for 50 per cent when closed makes it
extraordinarily stable.

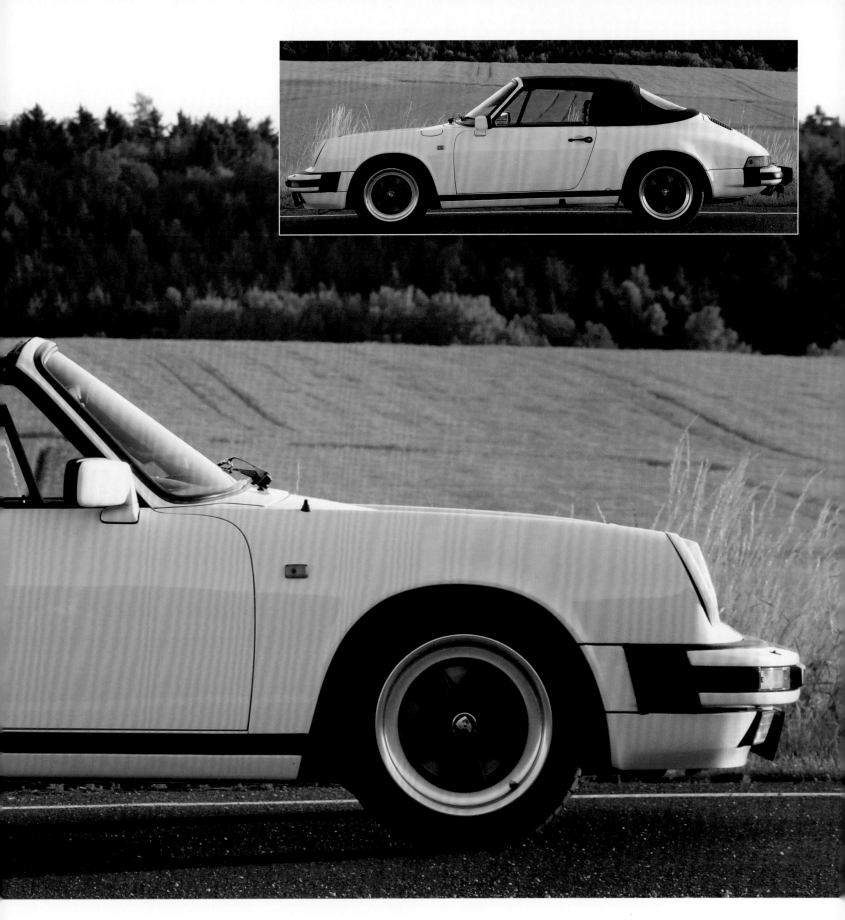

Das Cabrioverdeck der offenen Version stellt nach Form, Funktion und Bedienung ein Optimum dar. Eine raffinierte Dreispriegeltechnik mit 50 Prozent Festdach in geschlossenem Zustand macht es ungewöhnlich stabil.

La capote de la version décapotable incarne ce qui se fait de mieux sur le plan de la forme, de la fonction et de la manipulation. Une technique raffinée à trois arceaux avec 50 % de toit rigide quand elle est fermée lui confère une stabilité exceptionnelle.

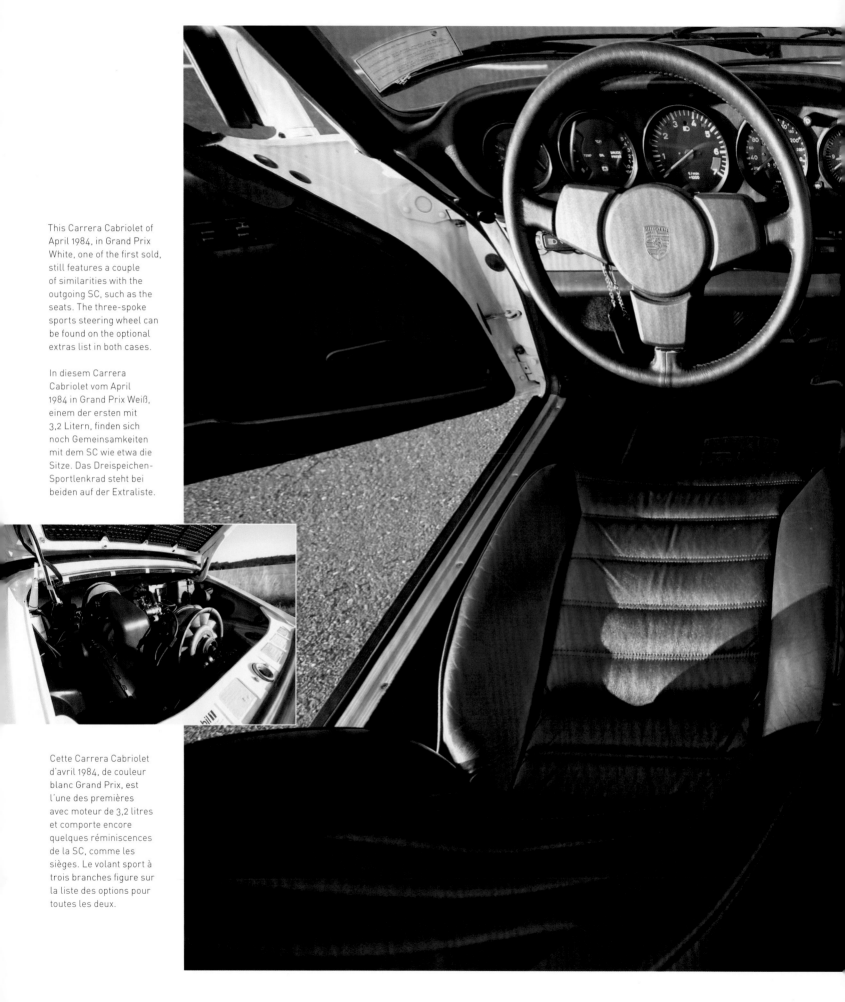

This Carrera Cabriolet of April 1984, in Grand Prix White, one of the first sold, still features a couple of similarities with the outgoing SC, such as the seats. The three-spoke sports steering wheel can be found on the optional extras list in both cases.

In diesem Carrera Cabriolet vom April 1984 in Grand Prix Weiß, einem der ersten mit 3,2 Litern, finden sich noch Gemeinsamkeiten mit dem SC wie etwa die Sitze. Das Dreispeichen-Sportlenkrad steht bei beiden auf der Extraliste.

Cette Carrera Cabriolet d'avril 1984, de couleur blanc Grand Prix, est l'une des premières avec moteur de 3,2 litres et comporte encore quelques réminiscences de la SC, comme les sièges. Le volant sport à trois branches figure sur la liste des options pour toutes les deux.

The Targa has become a true classic and can stand its ground even against strong in-house competition from the bar-free Cabriolet. From 1988 onwards, both of them roll on wider forged rims with tires to match.

Der Targa ist inzwischen zum Klassiker geworden und kann sich selbst gegen die Konkurrenz des bügelfrei offenen Cabriolets behaupten. Beide rollen ab Baujahr 1988 auf breiteren geschmiedeten Felgen mit entsprechenden Pneus.

La Targa s'est entre temps imposée, même face à la concurrence interne du cabriolet sans arceau. Les deux se pavanent, à partir du millésime 1988, sur des jantes forgées plus larges avec pneus assortis.

Porsche 911 Carrera 3.2

Originally there was a rear PVC window behind the targa bar, held in place by a zip fastener. Later the customer had the choice of that arrangement or a fixed rear window made of safety glass. It was eventually to replace the PVC solution altogether.

Hinter dem Targa-Bügel gab es ursprünglich ein Heckfenster aus PVC mit umlaufendem Reißverschluss. Später hatte der Kunde die Wahl zwischen diesem und der fest eingebauten Heckscheibe aus Sicherheitsglas, die schließlich die PVC-Lösung ganz ersetzte.

À l'origine, l'arceau Targa se prolongeait par une lunette arrière en matière plastique zippée. Plus tard, le client a eu le choix entre celle-ci et une lunette fixe en verre de sécurité qui l'a finalement emporté.

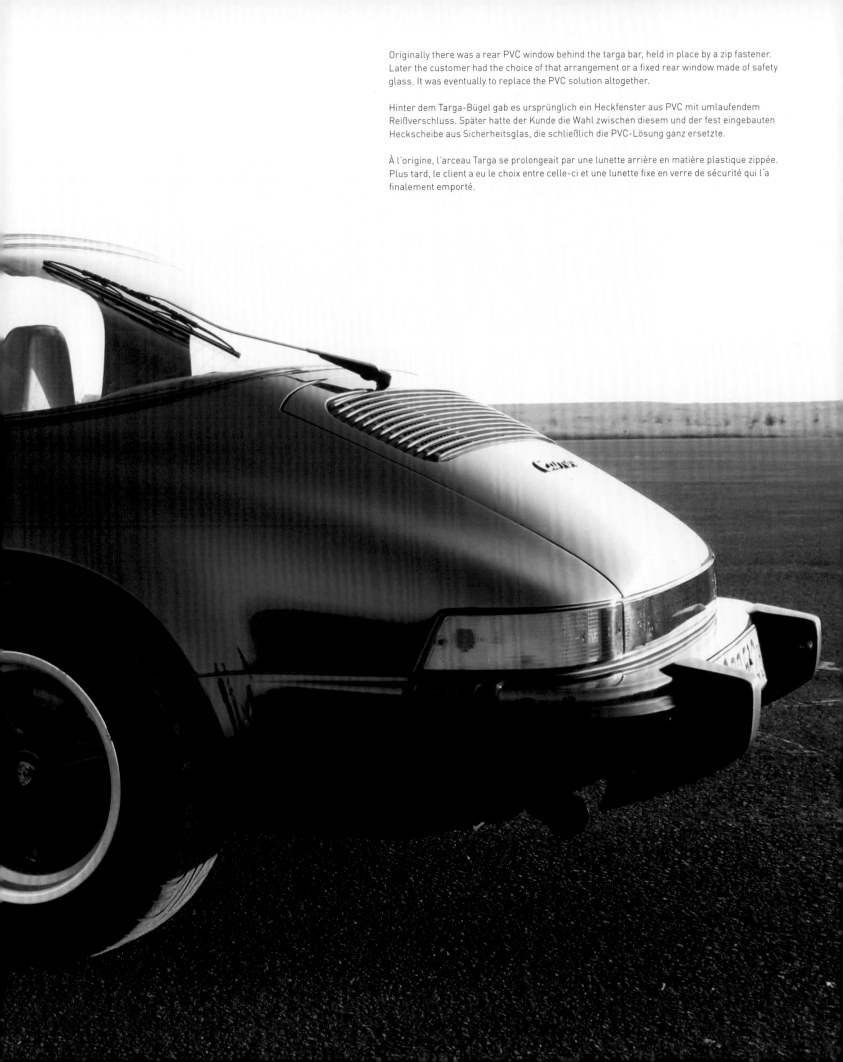

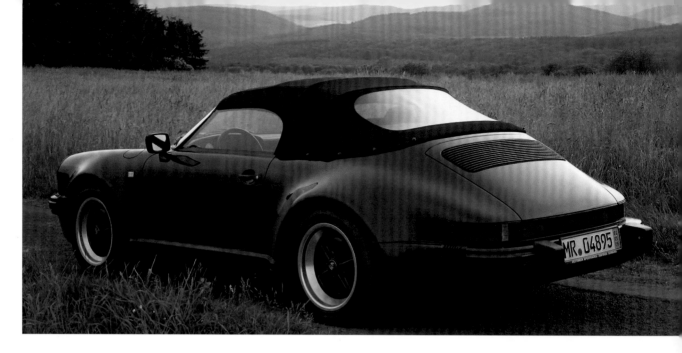

Driving the 911 in its most beautiful form: the top of the Speedster—here a specimen in Turbo look—has no fabric headlining. That is why it consumes less space when folded and disappears from sight below a hinged cover.

Elfer-Fahren in seiner schönsten Form: Das Verdeck des Speedsters – hier ein Exemplar im Turbo-Look – hat keinen Stoffhimmel und nimmt daher in gefaltetem Zustand nicht so viel Platz ein. So verschwindet es unter einer klappbaren Kunststoffabdeckung von der Bildfläche.

Piloter la 911 sous sa forme la plus belle : la capote du Speedster – ici un exemplaire au look Turbo – n'est pas capitonnée et, repliée, n'est donc pas aussi encombrante. Ainsi disparaît-elle au regard sous un couvercle en matière plastique.

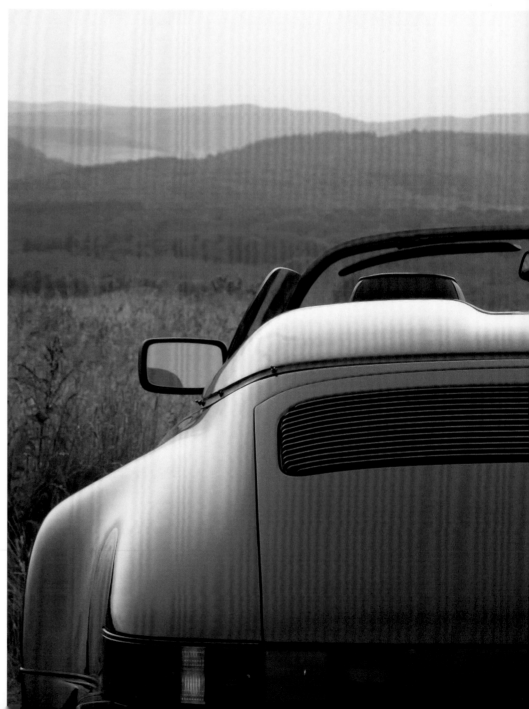

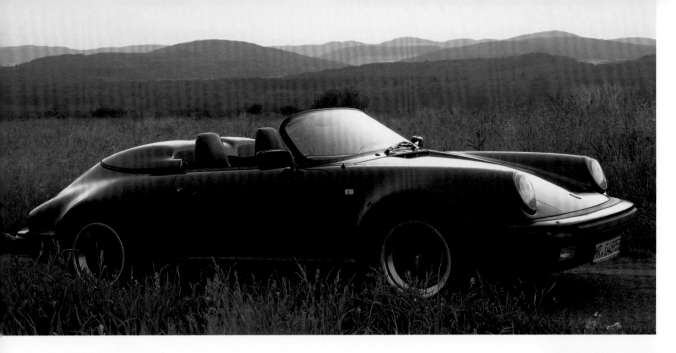

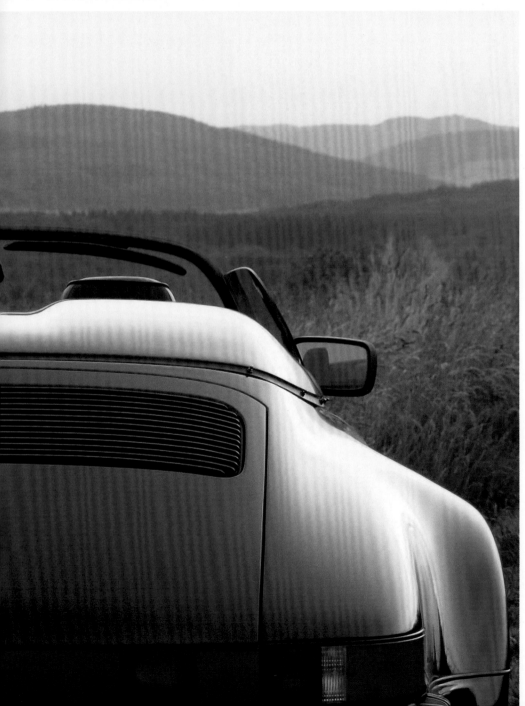

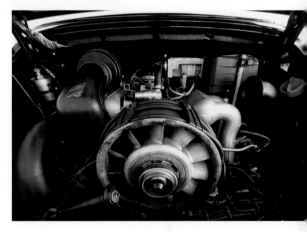

Pleasurable listening in the Speedster is less impeded than in all other 911 versions because there are next to no barriers to overcome for the adrenaline-raising and addictive sound of the flat six.

Da sich dem vollendeten Hörgenuss im Speedster weniger Stoffliches entgegenstellt als in allen anderen Elfern, teilt sich den Insassen die Melodik des Sechszylinders noch intensiver mit.

Dans le Speedster, la mélodie du six-cylindres se fait entendre de façon encore plus intense que dans les autres 911, en raison de la finesse de la capote.

It was a manifest of the feasible and of what had already been achieved, a signpost showing the way into the automobile future. Money played no role in its genesis, and in spite of its enormous basic price of 398,000 marks it brought in no profit for its sires, only fame. But as soon as the 283 specimens had left the so-called "Rössle" building of the Zuffenhausen factory they were worth up to twice as much. The market had run wild as demand by far exceeded supply.

As early as autumn 1983, a "Group B study" at the Frankfurt IAA contained what was to distinguish the finished product. The silhouette of the 911 was kept in principle, though thoroughly reworked in terms of aerodynamics and weight. In order to prevent lift, the elite team responsible sculpted the rounded nose, made from polyurethane foam, as well as the rear section with an integrated wing, in the wind tunnel in many hours of intensive work. The windshield was bonded flush onto the bodywork. The quartet of voluptuously bulging fenders was linked at the bottom by wide door sills and the undertray was completely flat. The drag coefficient was 0.32.

Steel accounted for less than half of the car's 3200 lbs. The hot-dip zinc-coated central structure consisted of it, while doors and front lid were made from aluminum, and the skin consisted of aramid and glass-fiber reinforced epoxy resin. The 450 bhp 2850 cc flat six was derived from the racing 911 935/76's and a close relative of the 959 and 962 Group C cars', the four-valve heads being water-cooled, with the cylinders cooled by air. Unlike the competition cars, the 959s had chain drive.

But the most striking feature of its biturbo engine was the sequential arrangement of its two turbochargers for the sake of responsiveness. Below 4000 rpm, all the exhaust gas was fed to a single and relatively small turbo. This made it operate earlier than in conventional solutions. Between 4000 and 4200 rpm, the second turbo had "prespin", prepared for engaging very quickly and preventing any lag. Above 4200 rpm, the two operated simultaneously to provide full boost of up to 13 psi. The elemental force of that power plant was conveyed to the road by means of all-wheel drive, in league with a specially developed six-speed gearbox. Torque distribution between front and rear wheels could be varied manually and automatically, adapting to the prevailing conditions in no time. A speed-dependent level control system brought into accordance ride height and flow conditions, lowering the 959 at high velocity. At low speeds the driver could pump it upward again, for instance when he or she wanted to clear a speed bump. The 959 had twin wishbones at both ends, not least to guarantee passable spring travel on a car of that price group. Apart from that, the Porsche engineers had emptied a veritable cornucopia of gadgetry over their favorite child—with every conceivable luxury, though the Porsche 959 was certainly a full-blooded sports car.

Er war das Dream Car schlechthin, ein Ausbund hoher Technologie, in dem sich Bewährtes aus der Vergangenheit und Erstrebenswertes für die Zukunft zusammenfanden, alles vom Feinsten. Denn diesmal hatten sich die Ingenieure, sonst eingeklemmt von Sachzwängen, dem Rotstift des Kalkulators und der Notwendigkeit, in einem Preisgefüge eine bestimmte Position zu behaupten, auf der Spielwiese ihrer Träume tummeln und ein Füllhorn von Ideen über dem Modell mit dem schlichten Namen 959 ausschütten dürfen.

Er sollte gewissermaßen zum König des Elfer-Volks gesalbt werden, teilte mit der Basis indessen nur noch die ungefähren Konturen und ein paar Parameter.

Im Hinblick auf Geschwindigkeiten jenseits der 300 km/h und die Optimierung des Abtriebs war die vertraute Form einer stationären Behandlung im Windkanal unterzogen worden, die den Luftwiderstandsbeiwert auf 0,32 (frühe 911: 0,40) absenkte. Eine tempoabhängige Niveauregulierung mit einem elektronisch geregelten Hydrauliksystem stimmte den Abstand zur Fahrbahn auf die obwaltenden Strömungsverhältnisse ab, sorgte aber auch dafür, dass der 959 etwa beim Überfahren eines „schlafenden Polizisten" keinen Schaden nahm.

Überall hatte man Gewicht gespart, mit einer tragenden Struktur aus Stahl, Türen und vorderer Haube aus Aluminium, der rundlich geglätteten Frontpartie aus Polyurethanschaum, dem Rest aus Epoxydharz, mit Glasfaser verstärkt.

Und allenthalben holte Renn-Technologie das Beste aus der reichhaltigen Erfahrung des Hauses auf der Piste in den ansonsten luxuriösen Premium-Porsche für die Straße herüber. Dazu zählten die Aufhängung vorn und hinten mit Doppelquerlenkern sowie je einem Federbein und einem parallelen Dämpferbein pro Rad. Für 450 PS machte sich der 2,85-Liter-Boxer des 959 stark. Wasser umspülte die von je zwei Nockenwellen gekrönten Vierventilköpfe mit hydraulischem Ausgleich für das Ventilspiel, während die Zylinder das gewohnte Axialgebläse kühlte. Sein breites Drehzahlband verdankte der geflügelte Straßen-Sportler einer Register-Turboaufladung: Im unteren Bereich blieb der eine Lader in Lauerstellung, beim energischen Tritt aufs Gaspedal beschickten alle beide die sechs Verbrennungseinheiten. Kaum weniger subtil wirkte der elektronisch gesteuerte variable Vierradantrieb des 959, dessen Ur-Kraft den mit Denloc-Sicherheitsreifen von Dunlop beschuhten Magnesiumrädern nicht einfach zu gleichen Teilen, sondern individuell den Fahrbedingungen gemäß zugemessen wurde.

Zur Diskussion stellte Porsche das Mega-Mobil 959 bei der IAA im Oktober 1983 als Studie „911 Gruppe B". Da noch viel zu tun war, lief die Auslieferung des fertigen Produkts – es blieb bei 283 Exemplaren – erst im März 1987 an. Ein gefundenes Fressen für Boulevardpresse und Stammtisch – neben seiner Klientel, die sich hauptsächlich aus den so genannten Reichen und Schönen rekrutierte – war vor allem sein Preis von 398 000 Mark. Er deckte nicht einmal die Kosten.

Voiture de rêve par excellence, elle est un concentré de haute technologie où se combinent, tout frisant la perfection, des ingrédients éprouvés et des techniques avant gardistes. En effet, une fois n'est pas coutume, les ingénieurs – débarassés des contraintes comptables – ont pu laisser libre cours à leurs rêves et matérialiser librement leurs idées dans l'élaboration de ce modèle qui arbore le sobre patronyme 959.

Destinée à incarner le *summum* dans la dynastie des 911, elle ne partage pourtant avec le modèle d'entrée de gamme, plus « populaire » – et encore de très loin – que ses contours et quelques rares paramètres.

Compte tenu des vitesses supérieures à 300 km/h où elle va pouvoir s'ébattre et de l'optimisation de l'appui, les lignes qui nous sont familières

1987–1988

ont subi en soufflerie une longue et minutieuse thérapie qui a permis de ramener le C_x à 0,32 par rapport au 0,40 des premières 911. Un système de correction de l'assiette asservi à la vitesse avec un circuit hydraulique à commande électronique gère la garde au sol en fonction des conditions d'écoulement de l'air rencontrées et garantit aussi que la 959 ne se blesse pas sur un passage surélevé.

Dans tous les domaines, la chasse aux kilos superflus a prévalu avec une structure porteuse en acier, les portières et le capot avant en aluminium, une proue lissée et arrondie en mousse de polyuréthane, le reste se composant de résine d'époxy renforcée de fibre de verre.

Sous le capot de la 959, le flat-six de 2,85 litres, inspiré de la 911 935/76 de course, développe 450 chevaux. Les culasses à quatre soupapes avec rattrapage hydraulique du jeu des soupapes et couronnées par respectivement deux arbres à cames en tête sont à refroidissement liquide tandis que les cylindres sont refroidis, comme de coutume, par la bonne vieille turbine axiale. Véritable voiture de course camouflée pour la route, elle doit sa large plage de régime utile à une suralimentation à registre : à bas régime, l'un des deux turbos reste en veille mais les deux gavent les six-cylindres dès que le conducteur donne des éperons. La transmission intégrale à répartition variable du couple et commande électronique sait faire preuve d'autant de subtilité : en effet, elle ne transmet pas le couple démoniaque aux roues en magnésium chaussées de pneus de sécurité Denloc de Dunlop à parts égales, mais en fonction des conditions d'adhérence de chaque roue.

Porsche enflamme les conversations avec sa 959 extraterrestre à l'IAA d'octobre 1983 où elle est qualifiée d'étude «911 Groupe B». Mais la tâche est plus ardue que prévu et la commercialisation des premiers exemplaires – il n'y en aura d'ailleurs que 283 – ne va débuter qu'en mars 1987. Son prix faramineux de 398 000 marks – qui ne couvre même pas ses coûts de fabrication – constitue une source de discussions intarissable pour les tabloïds et les débats au café du commerce. Sauf pour sa clientèle qui se recrute essentiellement parmi les *people* et les nantis.

959

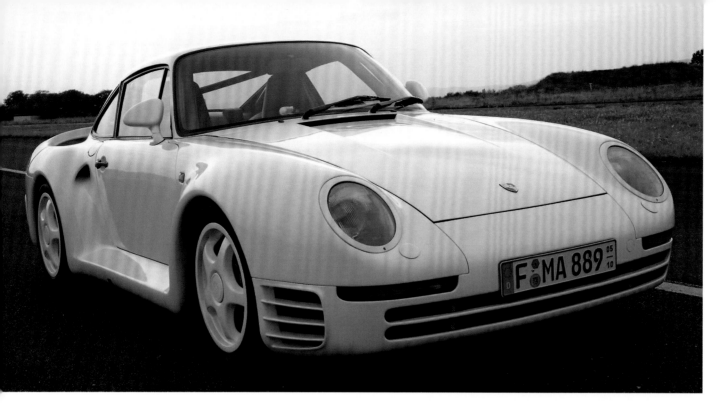

Mega Porsche 959: behind smooth and flowing lines and
in the treacherous guise of purring gentleness hides an
automobile extremist, the ultimate interpretation of the
911 theme.

Mega-Porsche 959: Hinter gleitenden und fließenden
Linien und im trügerischen Gewand schnurrender
Sanftmut verbirgt sich ein automobiler Extremist, die
ultimative Ausformung des Themas 911.

Mega-Porsche 959: derrière ses lignes harmonieuses
et fluides et sous sa robe trompeuse d'une douceur
ronronnante se dissimule en réalité une extrémiste à
quatre roues, la déclinaison la plus sophistiquée du thème
de la 911.

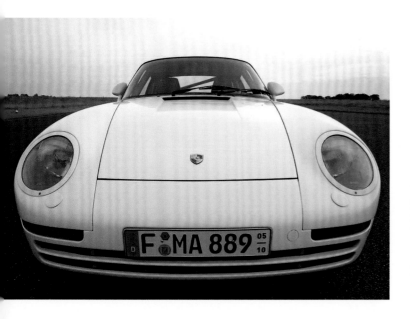

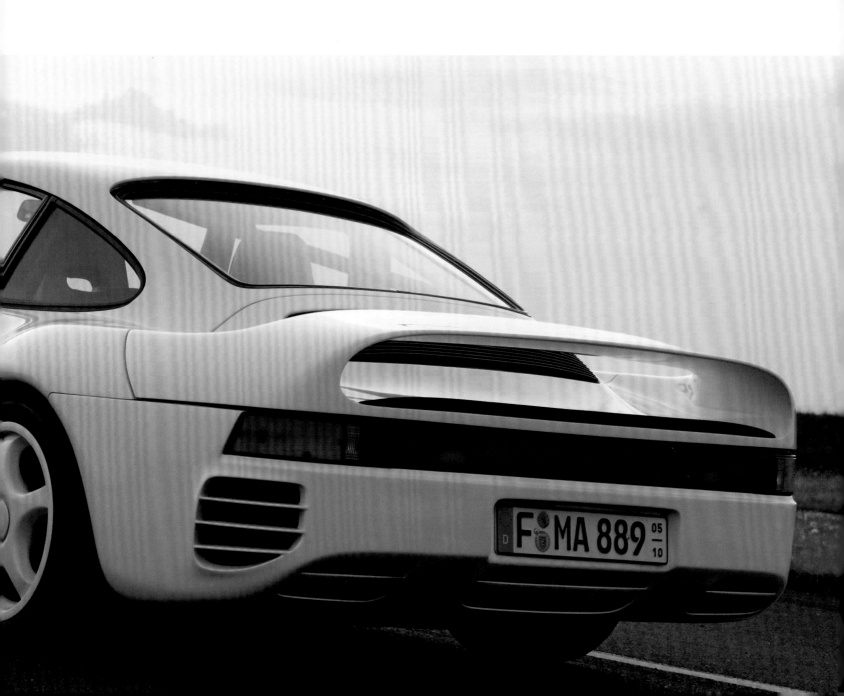

The 959 represents the epitome of the then-current turbo technology. Forced induction is effectuated by two turbochargers with electronic boost control and intercoolers. The flat six owes its reliability not least to its water-cooled four-valve heads and its air-cooled engine block.

Im 959 wird die aktuelle Turbotechnik auf die Spitze getrieben. Zwei Turbolader mit elektronischer Ladedruckregelung und Ladeluftkühlern besorgen seine Zwangsbeatmung. Seine Zuverlässigkeit verdankt der Sechszylinder nicht zuletzt seinen wassergekühlten Vierventilköpfen und dem luftgekühlten Motorblock.

La 959 pousse au paroxysme la technique de la suralimentation de son époque. Deux turbocompresseurs à régulation électronique de la pression de suralimentation et à échangeurs d'air assurent une ventilation sans défaut. Le six-cylindres doit sa fiabilité aussi et surtout à ses culasses à quatre soupapes à refroidissement liquide et à son bloc moteur refroidi par air.

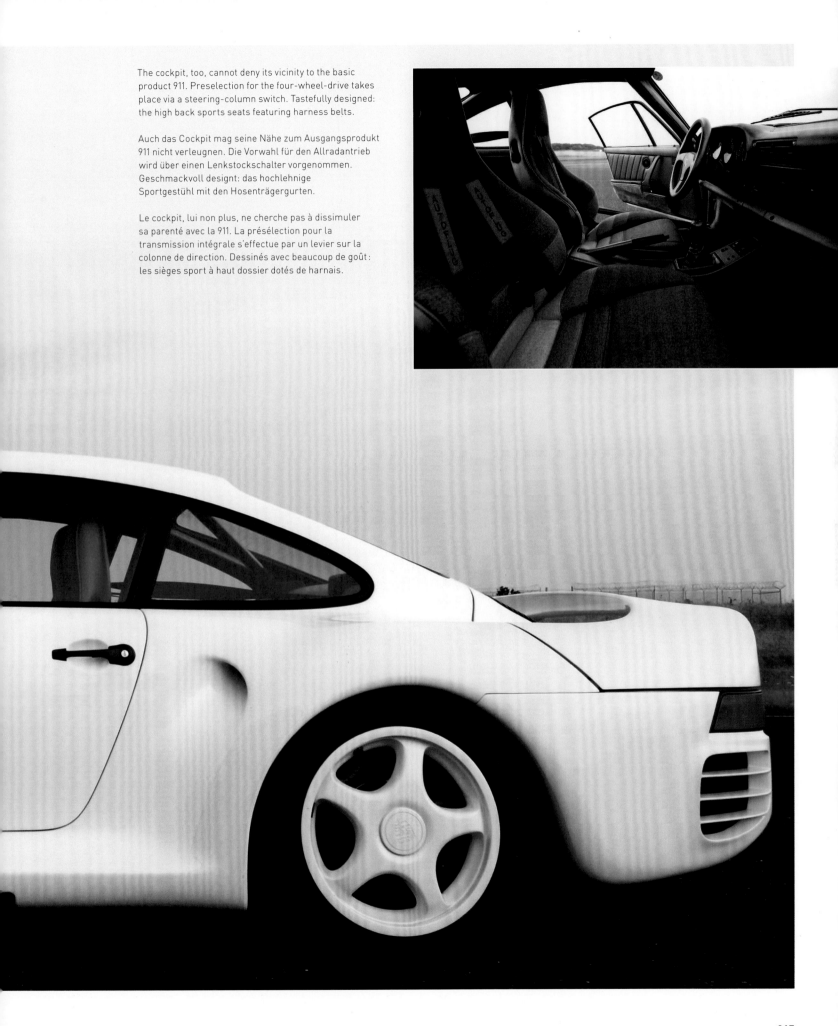

The cockpit, too, cannot deny its vicinity to the basic product 911. Preselection for the four-wheel-drive takes place via a steering-column switch. Tastefully designed: the high back sports seats featuring harness belts.

Auch das Cockpit mag seine Nähe zum Ausgangsprodukt 911 nicht verleugnen. Die Vorwahl für den Allradantrieb wird über einen Lenkstockschalter vorgenommen. Geschmackvoll designt: das hochlehnige Sportgestühl mit den Hosenträgergurten.

Le cockpit, lui non plus, ne cherche pas à dissimuler sa parenté avec la 911. La présélection pour la transmission intégrale s'effectue par un levier sur la colonne de direction. Dessinés avec beaucoup de goût : les sièges sport à haut dossier dotés de harnais.

Somehow the evolutionary principle behind the model was mirrored by the mere figures: even the 964, planned as early as 1984, but first produced as late as the dying months of the year 1988, was a 911, though it had absorbed 25 years of progress. It was separated by a quantum leap from its predecessor, just 15 per cent of whose ingredients had been taken over. The essential innovation, however, was betrayed by the addition of "4" to the traditional Carrera designation. It stood for its permanent four-wheel drive, derived from the system that had come through its baptism of fire in the heat of the 1984 Paris–Dakar Rally. A central differential allocated the potent flat six's power to two further ones at the front and the rear axle in a 31 to 69 per cent ratio. Two electronically and hydraulically controlled multi-disk clutches transferred surplus torque to the other wheels as soon as one of the four ABS wheel sensors became aware of slip. A massive transaxle tube, located as low as possible, connected the outlet of the gearbox and the front differential.

That revolution in the basement necessitated a couple of other changes as well. The torsion bars, for example, were superseded by coil springs. The trunk capacity had dwindled by 0.3 to 2.7 cu.ft. The engine had been slightly slanted until then and was now installed vertically so that the transaxle shaft was spared the necessity of a joint. Seen in that light, it seemed to be of minor importance that its displacement had been increased yet again to exactly 3600 cc, with 100 mm bore and 76.4 mm stroke, and that double ignition brought about better combustion. As it had reached 250 bhp, ever higher speeds asked for ever more downforce. So as not to spoil the beautiful simplicity of the cult car the 911, the technicians opted for a mobile wing behind the rear window which, activated electronically, rose into the air stream at 50 mph, demurely returning into its exile at six mph. In autumn 1989, the four-wheel-drive version was complemented by the Carrera 2 (as Coupé, Convertible and Targa). With it came, as an extra, the Tiptronic, which endowed the driver with these options: automatic transmission in familiar form, triggering the gear-shift process with the gas pedal, or lightning-quick gear change by tapping a small lever.

63,762 units of the 964 until 1994 bore out that even the seemingly special can become something quite normal. To cope with that, Porsche, as usual, offered ample choice. Introduced in October 1990 in Birmingham, there were also the Carrera RS, 1.57" deeper, ten bhp stronger, 400 lbs lighter, and the 1992 RS 3.8, which, from 3746 cc, churned out 300 roaring bhp at 6500 rpm. There was the Turbo flagship, presented in 1990 in its 964 guise in Geneva, where two years later the Turbo 2 made its debut: 400 lbs lighter and, at 380 bhp, also 60 bhp stronger. Unveiled in Paris in autumn 1992, the standard version, with the 3600 cc of the normally aspirated Carrera, had only 20 bhp less. From the October of that year, there was a new run of Speedsters, mostly in Turbo look like their immediate forebears and, in a distribution of 930, certainly a rarity.

Irgendwie bildete sich das evolutionäre Prinzip hinter dem Modell in der Paradoxie der nackten Zahlen ab: Auch der 964, bereits 1984 im Planungsstadium, aber erst Ende 1988 in der Produktion, war ein 911, nur dass 25 Jahre Fortschritt in ihn eingepflegt worden waren. Vom Vorgänger trennte ihn ein Quantensprung. Nur 15 Prozent von dessen Bausubstanz blieben erhalten. Der eigentliche Innovationsschub jedoch schlug sich in der Ziffer 4 hinter dem Traditionsnamen Carrera nieder. Sie stand für seinen permanenten Allradantrieb, wie er sich bei der schwierigen Rallye Paris–Dakar 1984 bewährt hatte. Ein mittleres Differential maß zwei weiteren an den beiden Achsen die Kraft des Boxers im Verhältnis 31 zu 69 zu. Stellte einer der vier ABS-Radsensoren Schlupf fest, vermittelten zwei elektronisch-hydraulisch gesteuerte Lamellenkupplungen das überschüssige Drehmoment an die anderen Rädern weiter. Die Verbindung zwischen dem Ausgang des Getriebes und dem vorderen Differential wurde durch eine Welle in einem tief angesiedelten massiven Rohr hergestellt.

Die Revolution im Souterrain zeitigte diverse zum Teil gravierende Umbauarbeiten. Die Drehstäbe wichen Schraubenfedern. Der Gepäckraum schrumpfte um acht auf 76 Liter. Der Motor, bislang leicht geneigt, war nun senkrecht installiert, um der Transaxle-Welle ein Gelenk zu ersparen. Da geriet es fast zur Nebensache, dass sein Volumen bei 100 mm Bohrung und 76,4 mm Hub auf genau 3600 cm³ vergrößert worden war und er durch Doppelzündung befeuert wurde. Seine Leistung war bei 250 PS angelangt und verlangte somit nach mehr Abtrieb am Heck. Um die schöne Elfer-Linie nicht zu verschandeln, entschied man sich für einen beweglichen Spoiler hinter der Heckscheibe, der sich bei Tempo 80 in den Fahrtwind reckte und bei zehn km/h demütig in den Ruhestand zurückkehrte. Im Herbst 1989 stellte man dem Vierradler den Carrera 2 (als Coupé, Cabriolet und Targa) zur Seite. Mit ihm kam wahlweise die Tiptronic, die dem 964-Piloten mit den Optionen automatische Kraftübertragung in der gewohnten Form, Steuern des Schaltvorgangs mit dem Gaspedal oder blitzschnelles manuelles Schalten durch Antippen eines Wählhebels an die Hand ging.

63 762 Elfer der Baureihe 964 bis 1994 bewiesen, dass selbst das Besondere zur Norm werden kann. Wer sich dieser entziehen wollte – und konnte –, war wie immer gut bedient. Da waren der Carrera RS, im Oktober 1990 in Birmingham vorgestellt, 40 mm tiefer, zehn PS stärker, 180 kg leichter, sowie 1992 der RS 3.8, der bei 6500/min 300 donnernde PS aus 3746 cm³ gebar. Da waren der Top-Typ Turbo, in der Variante 964 anno 1990 in Genf eingeführt, wo zwei Jahre später für die Nimmersatte auch der Turbo S debütierte, 180 kg leichter und mit 380 PS um 60 PS stärker. Nur 20 PS weniger bot, im Herbst 1992 in Paris enthüllt, die Standard-Version auf, nunmehr auch mit 3600 cm³. Da war schließlich, ab Oktober jenes Jahres gebaut, die Neuauflage des Speedsters, wie der vorige meist im Turbo-Look. Die schwache Verbreitung von 930 sicherte ihm nachhaltig die gebotene Exklusivität.

Le principe de l'évolution qui a présidé à ce modèle est contredit par les chiffres : la 964, planifiée dès 1984, entrée en production seulement fin 1988, est bien une 911, à ceci près qu'elle incarne 25 ans de progrès. Des années-lumières la séparent de sa devancière. Elle ne reprend, en effet, que 15 % de sa substance. Le chiffre 4, ajouté à son patronyme traditionnel Carrera, révèle la poussée d'innovation. Il symbolise sa transmission intégrale permanente, rodée lors de la difficile édition du Paris–Dakar de 1984. Un différentiel central répartit la puissance du moteur boxer, à l'aide de deux autres différentiels placés chacun sur un essieu, selon un rapport de 31 pour 69. Quand l'un des quatre capteurs de roue d'ABS enregistre un patinage, les deux embrayages à lamelles à commande électrohydraulique retransmettent le couple excédentaire

1988–1994

aux autres roues. Un arbre placé dans un tube massif agencé très bas assure la liaison entre la prise de force de la boîte de vitesses et le différentiel avant.

La révolution qui a sévi sous la plate-forme a imposé des modifications parfois profondes. Les barres de torsion ont cédé la place à des ressorts hélicoïdaux. La capacité du coffre a régressé de 8 litres, à 76 litres. Le moteur, jusqu'ici légèrement incliné, est maintenant en position verticale afin d'épargner une articulation à cardan à l'arbre Transaxle. Face à tous ces changements, sa majoration de cylindrée, passée à exactement 3600 cm³ grâce à un alésage de 100 mm pour une course de 76,4 mm et l'arrivée d'un double allumage ne sont plus que détails. Sa puissance culmine à 250 ch et exige donc plus d'appui à hauteur du train arrière. Pour ne pas déflorer les lignes incomparables de

la 911, Porsche opte pour un aileron mobile, placé au pied de la lunette arrière, qui s'érige dès que la voiture atteint 80 km/h et reprend sa position initiale invisible à 10 km/h. À l'automne 1989, la 911 à quatre roues motrices est rejointe par la Carrera 2 (en versions coupé, cabriolet et Targa). Ce modèle innove avec la boîte Tiptronic qui permet au pilote de 964, avec l'option transmission automatique, de changer de vitesse traditionnellement en actionnant le pommeau et en débrayant ou bien, à la vitesse de l'éclair, à la main, uniquement en donnant une impulsion au sélecteur.

Les 63 762 exemplaires de la 911 de la gamme 964 produite jusqu'en 1994 prouvent que même ce qui est exceptionnel peut devenir commun. Mais celui qui en a les moyens saura rester rare. En octobre 1990, à Birmingham, Porsche dévoile en effet la Carrera RS

– plus basse de 40 mm, avec 10 ch supplémentaires et allégée de 180 kg – puis, en 1992, la RS 3.8 qui développe 300 ch à partir de 3746 cm³ à 6500 tr/min. Mais il y a encore mieux : le porte-drapeau de la marque, la Turbo, est présentée avec la variante 964 en 1990 à Genève, où débute également la Turbo S, allégée de 180 kg et musclée de 60 ch supplémentaires (soit 380 ch au total). Dévoilée à l'automne 1992, à Paris, la version standard ne revendique que 20 ch de moins, pour une cylindrée désormais portée à 3600 cm³. Cerise sur le gâteau : le constructeur de Zuffenhausen développe une série confidentielle du Speedster construite à partir d'octobre 1992 et que les clients commandent, comme sa devancière, le plus souvent au look Turbo. Sa diffusion à 930 exemplaires lui assurera durablement une exclusivité digne de son rang.

911 (964)

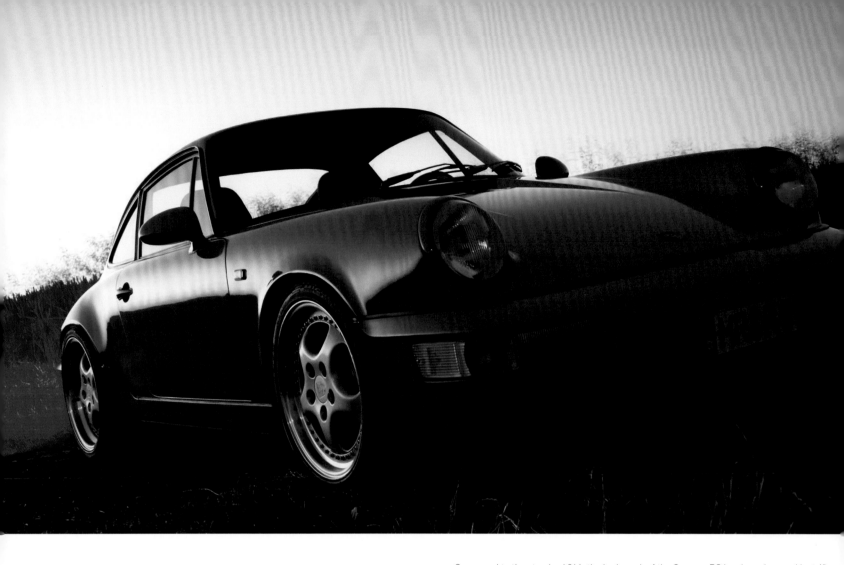

Compared to the standard 964, the bodywork of the Carrera RS has been lowered by 1.6". The car rolls on 17-inch Cup wheels made of magnesium. Its racing suspension has a definite predilection for smooth surfaces.

Der Aufbau des Carrera RS ist gegenüber dem normalen 964 um 40 mm abgesenkt. Er rollt auf 17 Zoll großen Cup-Rädern aus Magnesium. Sein Rennfahrwerk verträgt sich am besten mit topfebenen Fahrbahnen.

Par rapport à la 964 normale, la carrosserie de la Carrera RS a été abaissée de 40 mm. Elle possède les grosses roues en magnésium de la version Cup en 17 pouces. Son châssis compétition affiche une prédilection évidente pour les routes bien surfacées.

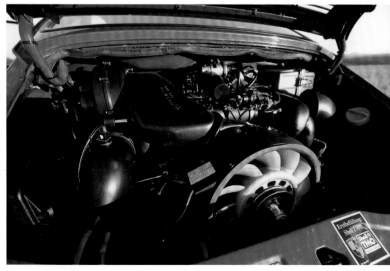

If only for the sake of weight reduction the RS's interior is markedly sporting. Among other features its tight-fitting bucket seats as well as the small four-spoke steering wheel (diameter 14") bear testimony to that.

Schon aus Gewichtsgründen gibt sich sein Interieur ungemein sportlich. Davon zeugen bereits die knapp anliegenden Schalensitze sowie das kleine Vierspeichenlenkrad mit 360 mm Durchmesser.

Pour des raisons de poids, déjà, son habitacle se veut résolument sportif : ce dont témoignent à eux seuls les sièges baquet à la coupe très étroite ainsi que le petit volant à quatre branches de 360 mm de diamètre.

This RS has been prepared for Group N-GT racing by means of optional safety equipment, comprising a roll cage, six-point belts, a fire extinguishing system and a battery emergency switch.

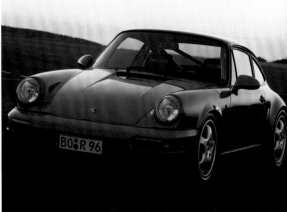

Dieser RS ist mit einer auf Wunsch gelieferten Sicherheitsausstattung für den Einsatz in der Gruppe N-GT präpariert: Überrollkäfig, Sechspunktgurte, Feuerlöschsystem sowie Batterie-Notschalter.

Cette RS est préparée avec un équipement de sécurité disponible en option en vue d'une utilisation dans le groupe N-GT: arceau-cage, harnais à six points, système d'extincteur ainsi que coupe-batterie.

The 964 Targa also deploys the rear spoiler typical of this evolutionary stage of the 911. Apart from that, there prevails, as usual, far-reaching similarity with the Coupé, albeit the half-open version is not quite as rigid as the closed one.

Auch der 964 Targa fährt den Heckbürzel aus, der diese Elfer-Evolutionsstufe kennzeichnet. Ansonsten besteht, wie üblich, ebenfalls weit gehende Identität mit dem Coupé, nur dass diese Karosserievariante nicht ganz so verwindungssteif ist.

La 964 Targa, elle aussi, arbore le becquet arrière qui caractérise cette évolution de la 911. Pour le reste, comme d'habitude, la similitude avec le coupé est presque totale à ceci près que cette variante de carrosserie n'est, évidemment, pas aussi rigide à la torsion.

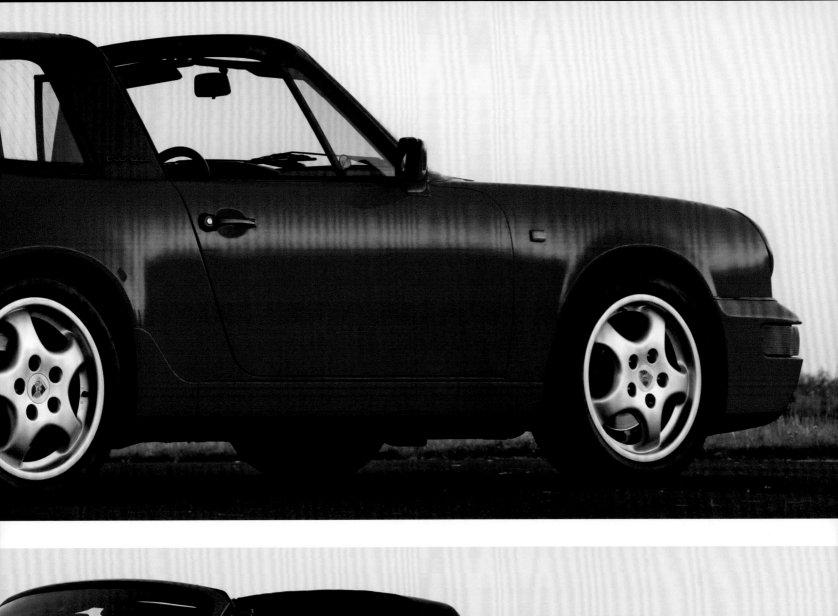
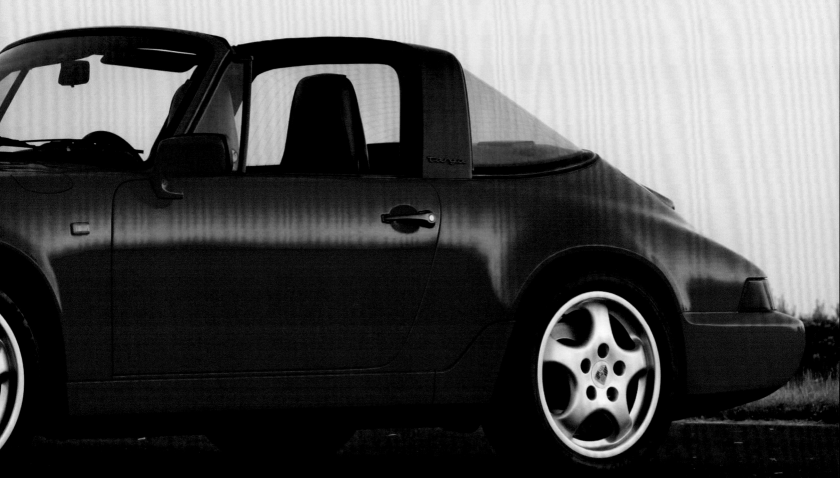

Invitation for a ride: the Targa practically offers the advantages of open-top driving without the wind blast whishing into the passengers' faces. Compared to the Cabriolet, it also features more safety—if everyone has fastened their seatbelts.

Einladung zum Einsteigen: Der Targa bietet praktisch die Vorzüge des Offenfahrens, ohne dass seinen Insassen der Fahrtwind um die Ohren pfeift. Dem Cabriolet hat er überdies ein Mehr an Sicherheit voraus, vorausgesetzt, man schnallt sich an.

Invitation à monter à bord : la Targa préserve presque intégralement les avantages de la conduite cabriolet sans exposer ses occupants aux courants d'air. Par rapport à celui-ci, elle offre aussi un peu plus de sécurité, mais encore faut-il boucler la ceinture.

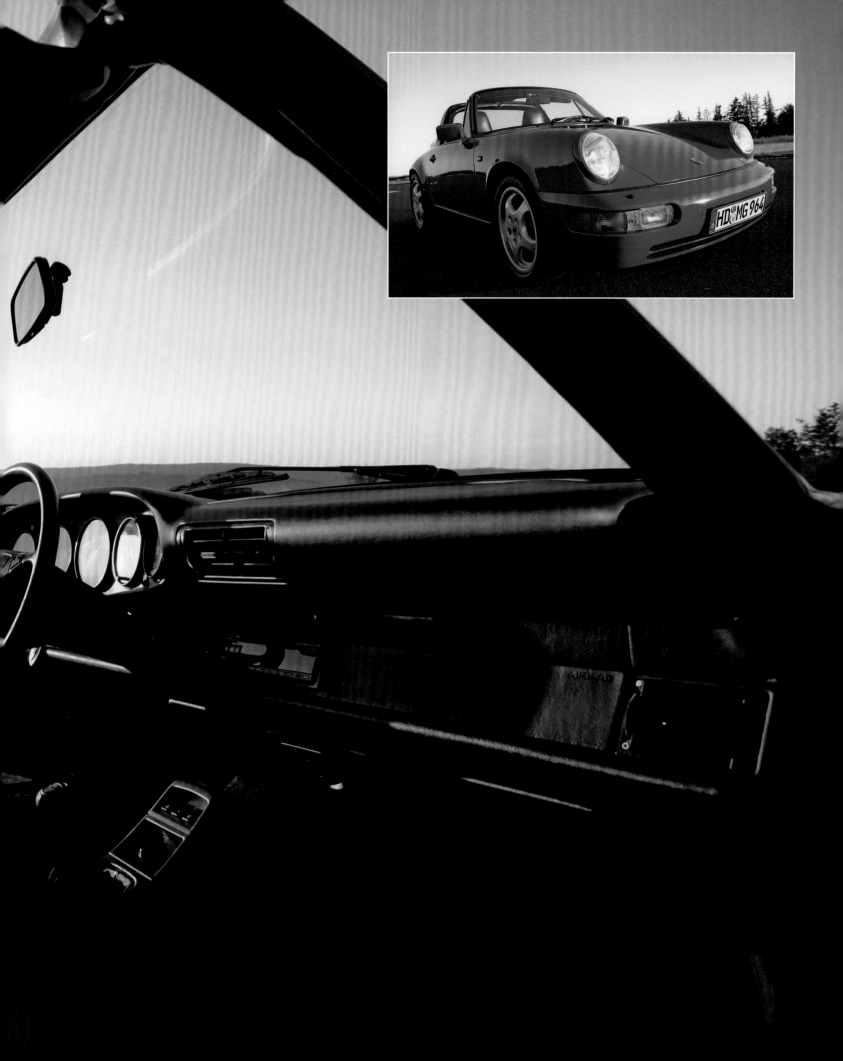

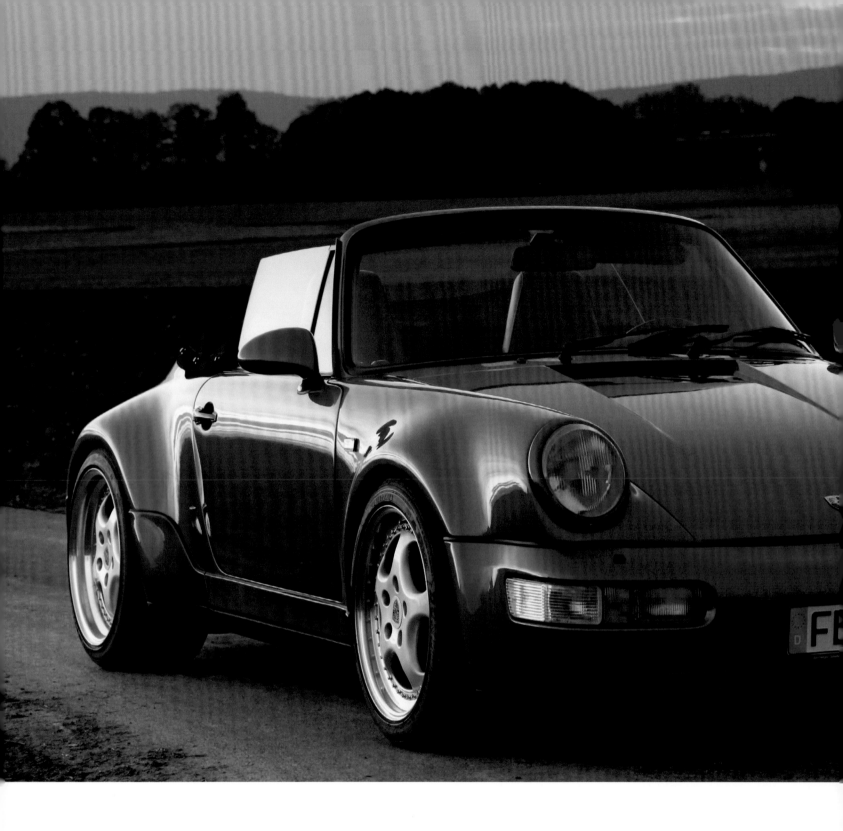

Undoubtedly, this 964 Works Turbo Look Cabriolet exudes lots of chubby-cheeked virility. But 911 purists are not necessarily in favor of an appearance that, in their view, places too much emphasis on visual aspects.

Allzeit breit: Visuell stark, in pausbäckiger Virilität, kommt dieses 964 Cabriolet im Werks-Turbolook daher. Den Anhängern der reinen Elfer-Lehre geht dieser Auftritt allerdings gegen den Strich.

Rouler des mécaniques, une preuve de virilité pour ce Cabriolet 964 au look Turbo d'usine? Les puristes de la 911 n'apprécient pas vraiment ces effets de manche qui privilégient les apparences.

Bodywork and chassis stem from the 911 Turbo, while below the rear lid is housed the compact and reliable normally-aspirated 3.6-liter engine. With its 250 bhp, it is a paragon of strength anyway by the standards of the time.

Karosserie und Fahrwerk stammen vom 911 Turbo, unter der hinteren Haube haust kompakt und verlässlich der 3,6-Liter-Saugmotor, der sich mit seinen 250 PS ja auch schon nicht gerade lumpen lässt.

La carrosserie et le châssis proviennent de la 911 Turbo avec, sous le capot arrière, compact et fiable, le moteur atmosphérique de 3,6 litres qui ne déçoit pas avec ses 250 chevaux.

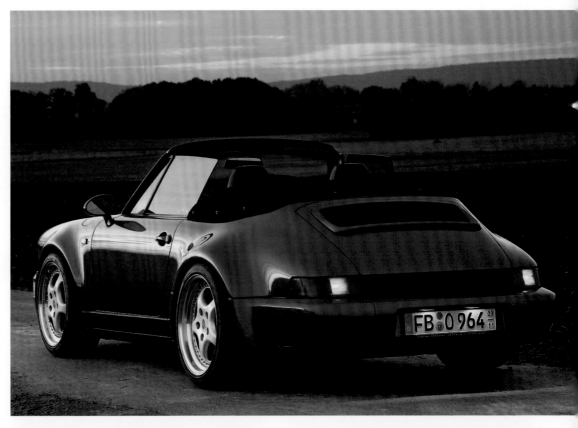

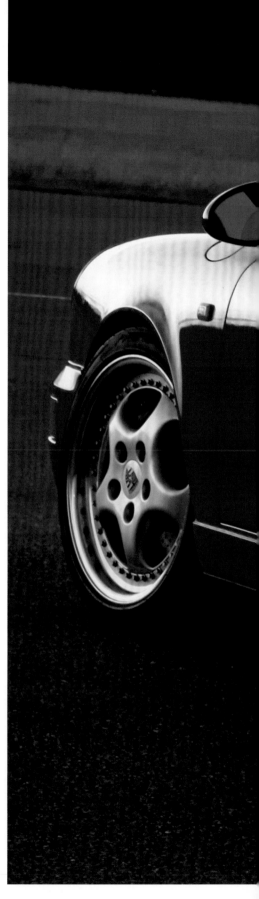

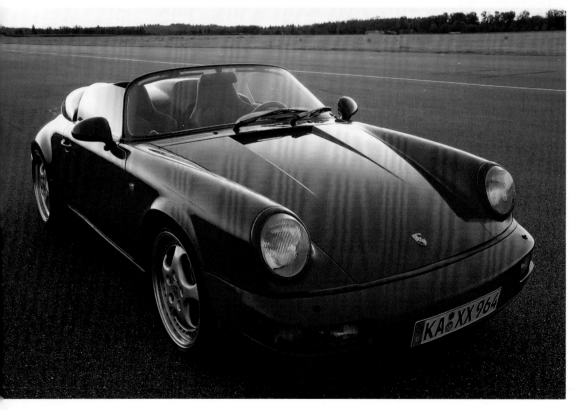

During the 1993 model year a second series of Speedsters in the normal width of 65" is produced. It is based on the Carrera 2 Targa, whose bar is not much of a structural element. Thus the Speedster is almost as torsion-proof.

Während des Modelljahres 1993 wird eine zweite Serie von Speedstern in der normalen Breite von 1652 mm hergestellt. Basis ist der Carrera 2 Targa. Da dessen Bügel relativ wenig tragende Funktion zufällt, ist der Speedster fast ebenso rigide.

Pendant l'année-modèle 1993, Porsche lance une
deuxième série du Speedster à la largeur normale de
1652 mm. La base en est la Carrera 2 Targa. Étant donné
que l'arceau de celle-ci est plutôt décoratif, le Speedster
est presque aussi rigide qu'elle.

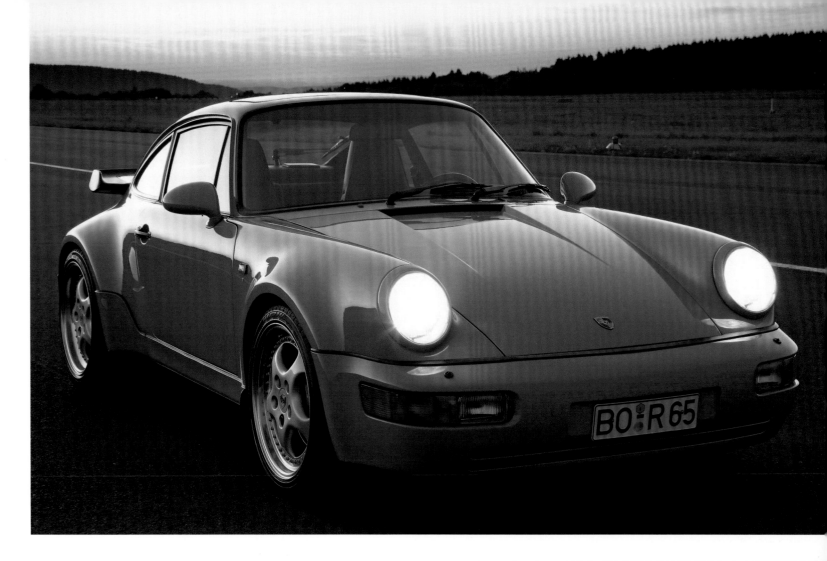

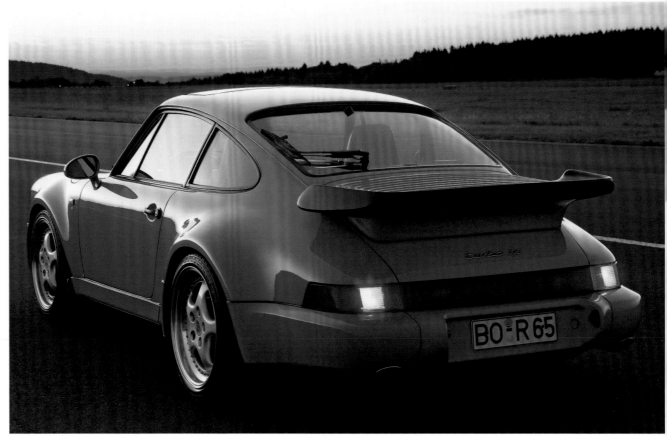

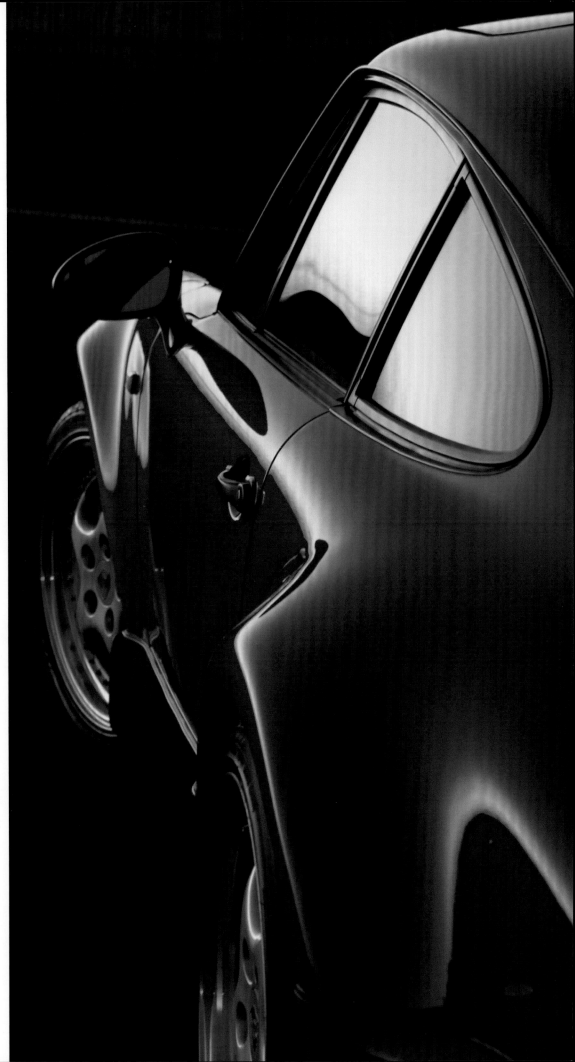

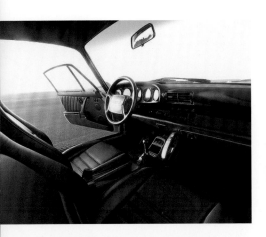

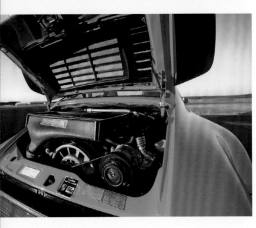

Introduced at the Paris Salon in fall 1992, the 911 Turbo 3.6 raises the benchmark yet again. Its power plant is based on the 3.6-liter unit of the Carrera 2, puts out 360 bhp and provides 332 lb-ft between 2400 and 5500 rpm.

Auf dem Pariser Salon im Herbst 1992 vorgestellt, setzt der 911 Turbo 3.6 neue Maßstäbe. Sein Antrieb basiert auf dem 3.6-Liter-Triebwerk des Carrera 2, leistet 360 PS und hält zwischen 2400 und 5500/min 450 Nm bereit.

Présentée au Salon de Paris à l'automne 1992, la 911 Turbo 3.6 pose de nouveaux jalons. Sa chaîne cinématique reprend le moteur de 3,6 litres de la Carrera 2, qui développe 360 ch pour un couple de 450 Nm entre 2400 et 5500 tr/min.

Porsche 911 (964)

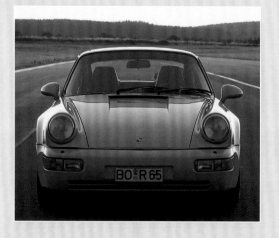

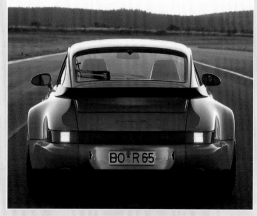

Visually the Turbo 3.6 remains unchanged from its predecessor with 3.3 liters, except for new 18-inch wheels. Athletically flared fenders as well as the huge rear wing express strength and competence.

Visuell bleibt der Turbo 3.6 gegenüber seinem Vorgänger mit 3.3 Litern unverändert bis auf neue 18-Zoll-Räder. Muskulöse Kotflügelverbreiterungen und der große Heckflügel signalisieren Stärke und Kompetenz.

Visuellement, la Turbo 3.6 est pratiquement le clone de sa devancière de 3,3 litres hormis les nouvelles jantes de 18 pouces. Des élargisseurs d'aile très prononcés et le grand becquet arrière expriment sa puissance et sa compétence.

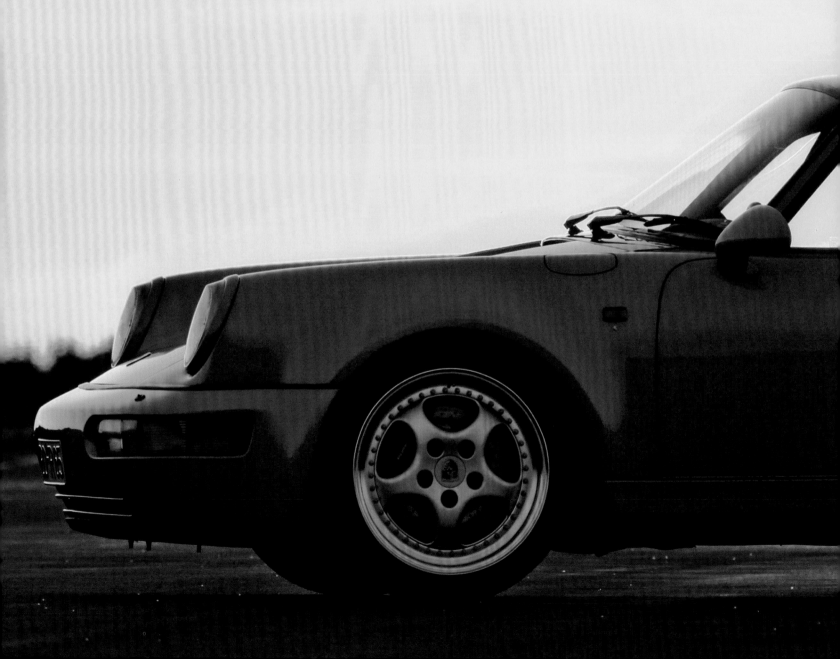

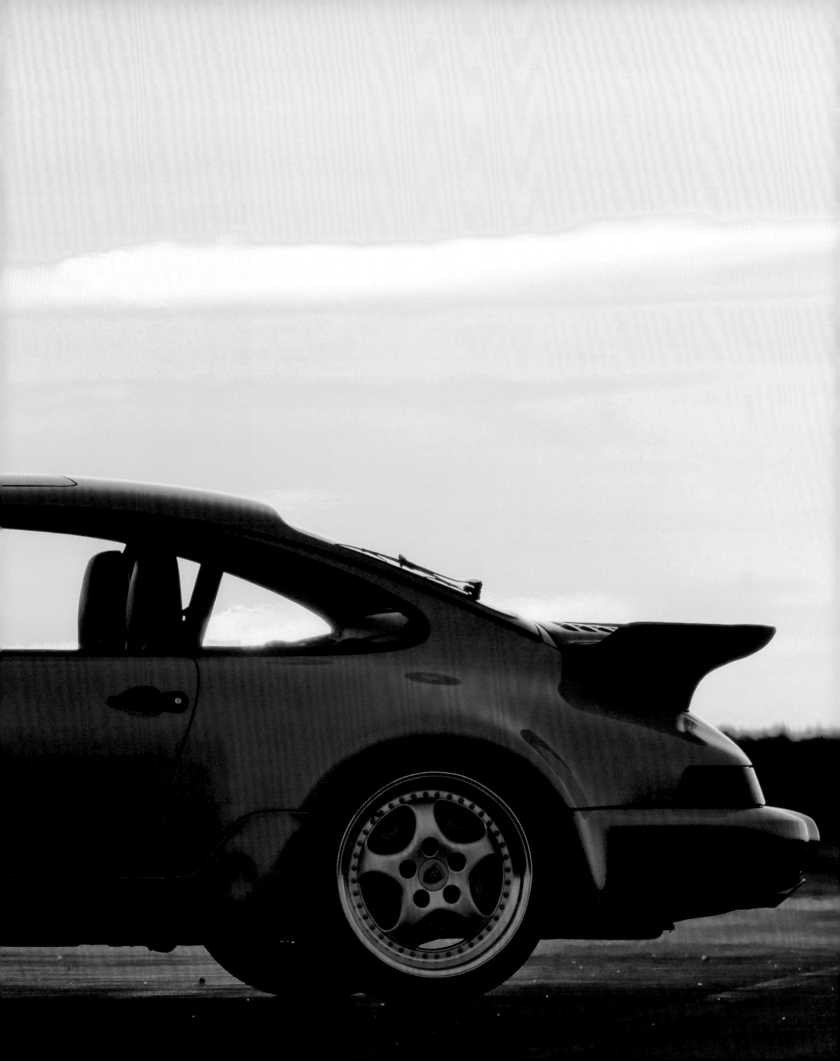

Available in Coupé and in Convertible guise since late summer 1991, it resembled the 944 to a T, at least at first sight. The 968, though, had absorbed the insight of ten years. Apart from that, the customer was to be sold markedly more Porsche identity for his money. The car went down well with the clientele, borne out by a circulation of 11,245 units until 1995—during a time of flagging interest in the marque's front-engined models.

The platform of the predecessor had been carried over almost unchanged. The layout of the running gear, with McPherson struts and lower wishbones at the front and rear semi-trailing links with transversely installed torsion bars, was both sporting and comfort-orientated and made possible amazingly problem-free driving, the 968 clinging to the ground like a leech. The silkily smooth four-valve engine with a displacement of three liters was also an old acquaintance, though morphed into state-of-the-art perfection by the Porsche-specific VarioCam variable timing system for the intake cams. It produced an astoundingly serene 240 bhp, to the tune of an equally impressive torque raised from 207 to 225 lb-ft, which was transferred to the rear wheels via transaxle incorporating either a conventional six-speed gearbox or the optional four-speed Tiptronic that had been specially honed for use in the 968. In manual mode, the latter could be operated in either direction in a flash, just by tapping a small lever.

Not least because of its beneficial bearing on the 968 Coupé's gas consumption, its low drag coefficient of 0.34 was exemplary. The entry-level Porsche's front fenders were rounded more distinctly, with headlamps that were visible, staring into the sky even when they were at rest. The bumpers were integrated into their surroundings in visual and in factual terms, the bow consisting of polyurethane, coated with impact-resistant and enormously resilient special paintwork. On the glass tailgate, as on the 944 Turbo's, squatted an unobtrusive spoiler, and the electric roof of the Convertible required manual assistance only for the locking and unlocking part of the process.

Confronted with frequent requests for diversification, Porsche responded with two very different 968 derivatives for the 1993 model year. There was the 968 CS (Clubsport), lightened by a hundredweight by ditching, for instance, the servo motors for seat adjustment and the power windows, deep-pile carpets, airbag system and even the radio, and installing light plastic Recaro bucket seats. As the rudimentary rear seats had also been dispensed with in favor of a glass-fiber board, travelers in the 968 CS enjoyed a useful additional storage space—more for fewer people. It was 18,121 marks cheaper than the much more opulently equipped standard Coupé, whereas, at 175,000 marks, the 968 Turbo S Coupé, with a KKK turbocharger, two valves per cylinder and 305 bhp, was almost twice as expensive. Only ten were registered for road traffic, as there was strong in-house competition—the Carrera RS 3.8. In its last two years, the 968 remained basically unchanged.

Seit dem Spätsommer 1991 als Coupé wie auch als Cabriolet auf dem Markt, war er dem 944 wie aus dem Gesicht geschnitten. Und dennoch steckte im 968 die geballte Erkenntnis von zehn weiteren Jahren. Im Übrigen sollte dem Kunden spürbar mehr Porsche-Identität fürs Geld geboten werden. Das Kalkül ging auf, bewiesen durch eine Verbreitung von 11245 bis 1995 – mitten hinein in eine Zeit abschwingender Konjunktur für die Frontmotor-Modelle der Marke.

Fast unverändert wurde die Plattform des Vorgängers übernommen. Das sportlich-kommod ausgelegte Fahrwerk, McPherson-Einzelradaufhängung und untere Dreiecklenker vorn, hinten Schräglenker mit quer liegenden Drehfederstäben, verhieß und erbrachte ein erstaunlich problemfreies Fahren. Der 968 klebte förmlich am Boden.

Um einen alten Bekannten handelte es sich auch bei dem seidig laufruhigen Vierventiler mit drei Litern Volumen, mit dem Porsche-spezifischen System VarioCam zur Verstellung der Steuerzeiten für die Einlassnocken auf den letzten Stand der Dinge gebracht. Auf 240 PS belief sich nun seine mit unaufgeregter Selbstverständlichkeit bereitgestellte Leistung, bei einem von 280 auf 305 Nm gesteigerten Drehmoment. Via Transaxle an die Hinterräder vermittelt wurde das alles durch ein Sechsganggetriebe oder die speziell auf den 968 hin entwickelte Tiptronic, mit der sich im manuellen Modus die Fahrstufen durch Antippen eines Wählhebelchens im Bruchteil einer Sekunde einlegen ließen.

Beispielhaft nicht zuletzt wegen seiner segensreichen Auswirkungen für den Verbrauch war der geringe Luftwiderstandsbeiwert von 0,34 (Coupé). Aus stärker gerundeten vorderen Kotflügeln starrten große, runde Hauptscheinwerfer auch im Ruhestand sichtbar in den Himmel. Das Paar der Stoßfänger war optisch wie faktisch in den Aufbau eingebunden, die Bugpartie aus stoßfestem Polyurethan, mit elastischem Speziallack überzogen, und auf der gläsernen Heckklappe hockte hinten ein dezentes Flügelchen. Am Cabriolet mussten nur noch das Ent- und Verriegeln des elektrischen Verdecks per Hand erledigt werden.

Im Modelljahr 1993 kam man den sich mehrenden Kundenwünschen nach mehr Vielfalt durch zwei 968-Seitenstränge entgegen. Da war zum einen, etwa durch das Fehlen von Servomotoren für Fensterheber und Sitzverstellung, schwerer Dämmmatten und des Airbag-Systems sowie die Unterbringung der Passagiere in Schalensitzen aus Kunststoff um einen Zentner erleichtert, der 968 CS (Clubsport). Da auch das rudimentäre hintere Gestühl ausgebeint worden war, verfügten die im CS Reisenden über ein willkommenes Mehr an Ladekapazität. Sein Minderpreis im Vergleich zum vergleichsweise üppig ausgestatteten Normal-Coupé reichte schon für einen netten kleinen Zweitwagen. Und da war das mit 175000 Mark doppelt so teure 968 Turbo S Coupé, ein Zweiventiler mit 305 PS. Für den öffentlichen Straßenverkehr wurden nur zehn zugelassen.

Commercialisée depuis la fin de l'été 1991 en deux versions, coupé et cabriolet, c'est un véritable clone de la 944. Et pourtant, la 968 a dix ans d'expérience de plus à son actif. En outre, les clients de Porsche en ont pour leur argent. Le calcul s'avère juste puisqu'elle sera produite à 11245 exemplaires jusqu'en 1995 – alors même que les modèles à moteur avant de la marque perdent leur popularité.

La plate-forme de sa devancière a été reprise et quasiment inchangée. Un châssis à la fois sportif et confortable, avec des suspensions à roues indépendantes McPherson et triangles inférieurs à l'avant ainsi que des bras obliques avec suspensions à barres de torsion transversales à l'arrière. Ce qui garantit un comportement sécurisant: en effet, la 968 colle littéralement à la route.

1991–1995

Quant au moteur dont elle est équipée, il s'agit d'une vieille connaissance : un trois-litres à quatre soupapes assez docile auquel a été greffé le système VarioCam, spécifique à Porsche, de décalage de la distribution pour l'arbre à cames d'admission, qui est un véritable chef d'œuvre. Il délivre sans effort une puissance de 240 chevaux, pour un couple majoré de 280 à 305 Nm. La puissance est transmise aux roues arrière selon le système Transaxle, en l'occurrence par une boîte manuelle à six vitesses ou bien par la Tiptronic automatique conçue spécialement pour la 968 qui permet au conducteur de changer de rapport à sa guise en une fraction de seconde par simple impulsion.

Son faible coefficient de résistance aérodynamique, de 0,34 (pour le coupé), est exemplaire, ce qui favorise une consommation très réduite. Les ailes avant aux contours plus arrondis hébergent deux grands phares tournés vers le ciel en position marche comme à l'arrêt. Tant sur le plan visuel que mécanique, les pare-chocs sont intégrés à la carrosserie, la proue est constituée d'un bloc de polyuréthane résistant aux chocs et revêtu d'une peinture spéciale élastique, tandis qu'un discret becquet souligne l'extrémité de la lunette arrière. Sur le cabriolet, la capote à commande électrique se verrouille et se déverrouille à la main.

Pour le millésime 1993, Porsche répond aux désirs de changement de ses clients en leur proposant deux variantes de la 968. L'une se distingue notamment par l'absence de servomoteurs pour les lève-vitres et les réglages des sièges, de lourds tapis insonorisants et du système d'airbags ainsi que par la présence de sièges baquet en matière plastique. Les 50 kilos ainsi économisés justifient le nom de 968 CS (Clubsport). Du fait de la disparition des sièges d'appoint à l'arrière, les passagers de la CS bénéficient d'un coffre de plus grande capacité. Son prix attractif face au coupé standard peut tenter certains de céder au plaisir d'acquérir une jolie petite voiture secondaire. Mais il existe aussi la 968 Turbo S Coupé, deux fois plus onéreuse puisqu'elle coûte 175 000 marks, avec un moteur à deux soupapes de 305 ch. Seuls dix exemplaires seront homologués pour la circulation routière.

968

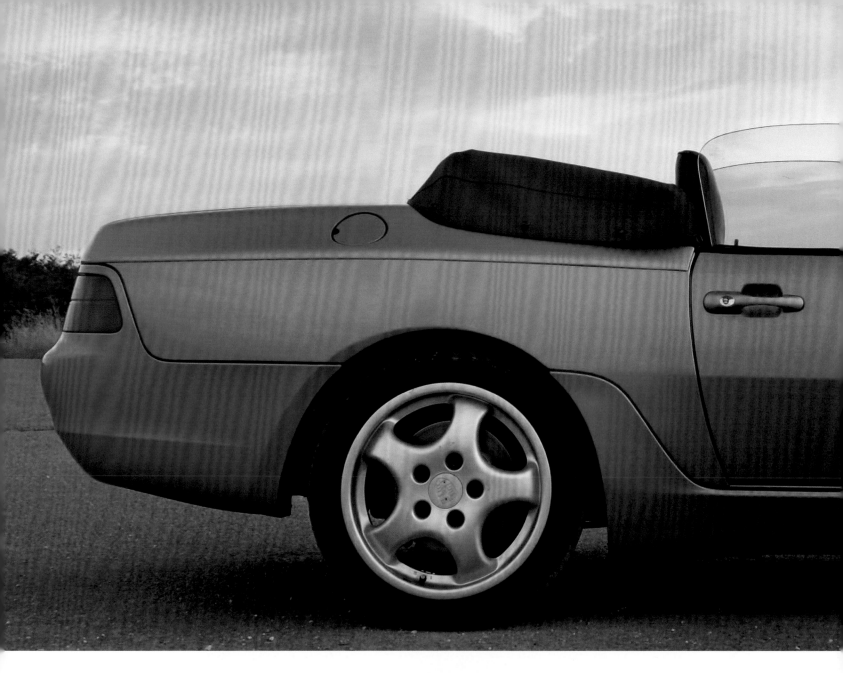

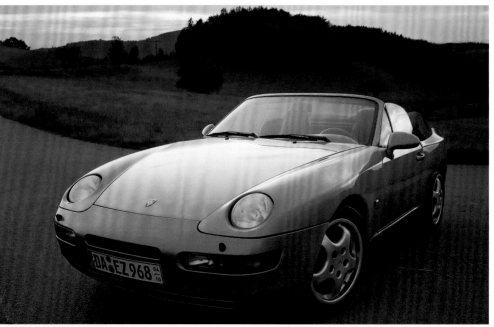

The 968 is immediately available as Coupé and, with stiffened bodywork, as Cabriolet. Only when being locked and unlocked does the latter's high-quality soft top require manual action.

Der 968 ist sofort als Coupé und, mit versteifter Karosserie, als Cabriolet verfügbar. Das hochwertige elektrische Verdeck der offenen Version bedarf nur noch beim Ver- und Entriegeln der Handarbeit.

La 968 est en vente d'emblée en deux versions : Coupé et, avec une carrosserie rigidifiée, Cabriolet. La capote électrique sophistiquée de la version décapotable ne requiert une intervention manuelle que pour le verrouillage et le déverrouillage.

Porsche 968

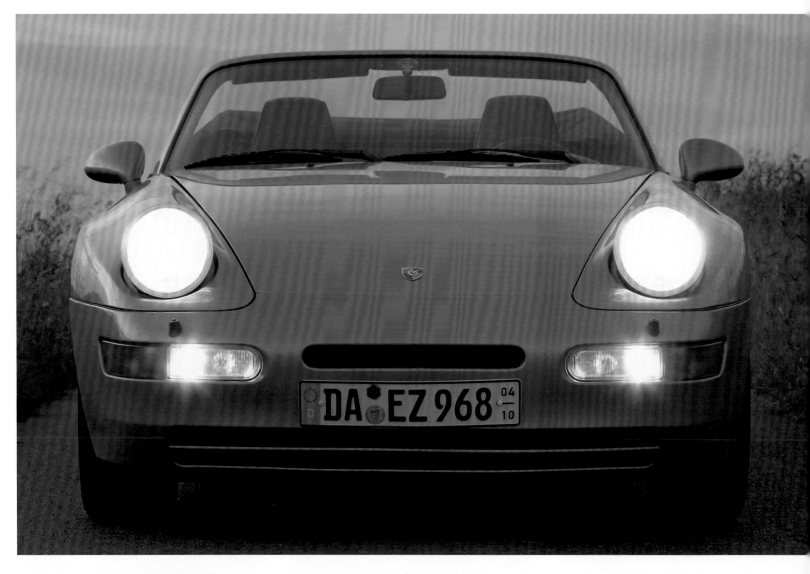

As in the 928, the round pop-up headlights of the 968 vanish from the scene in off position. To improve light efficiency, Porsche has installed reflectors with variable focus.

Wie beim 928 verschwinden die runden Scheinwerfer des 968 im Ruhestand von der Bildfläche. In ihnen werden Reflektoren mit variablem Brennpunkt verwendet, um die Lichtausbeute zu verbessern.

Comme avec la 928, les phares en forme de bulle disparaissent sous le capot en cas de non utilisation. Ils comportent un réflecteur à portée variable pour améliorer le rendement lumineux.

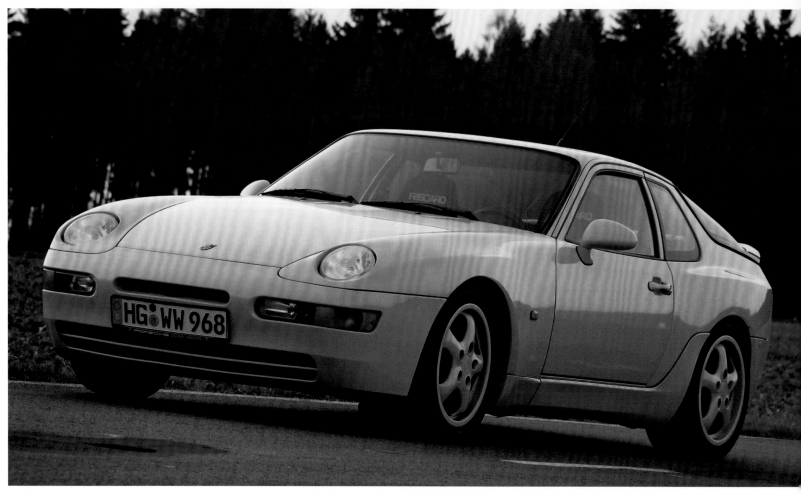

From 1992, the 968CS carries on the tradition of lightweight Zuffenhausen sports versions. As the weight-saving measures go hand in hand with a massive reduction of comfort, it is also a lot cheaper.

Der 968CS steht ab 1992 in der Tradition der abgemagerten Zuffenhausener Sportversionen. Da die Reduktion an Gewicht mit dem Verzicht auf Komfort Hand in Hand geht, ist er auch preisgünstiger.

En 1992, la 968CS fait revivre la tradition des versions Sport allégées de Zuffenhausen. La chasse aux kilos superflus allant de pair avec le renoncement à tout confort, elle a l'avantage de coûter moins cher.

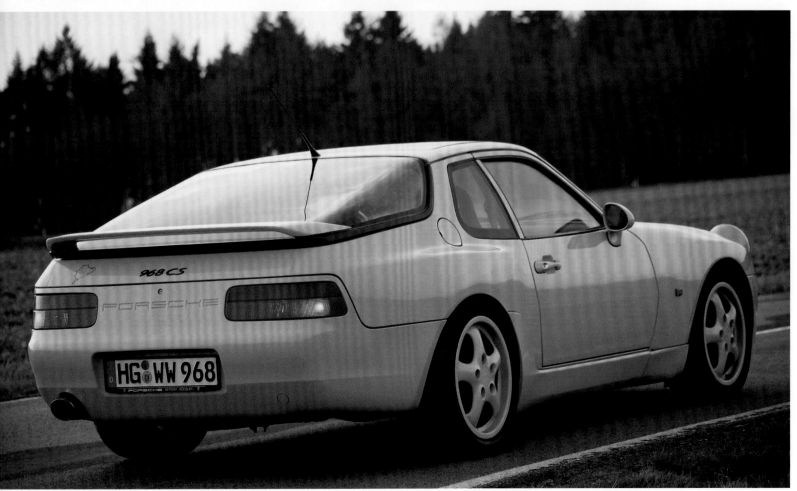

17-inch wheels in Cup design are fitted as standard, garishly matched to the five body colors available. Light Recaro bucket seats enhance the weight-saving theme, offering excellent lateral support.

Zur Serienausstattung des CS zählen 17-Zoll-Räder im Cup-Design. Sie sind stets in Wagenfarbe lackiert. Im Inneren wird das Bild beherrscht von Schalensitzen, die bei geringem Gewicht festen Halt gewähren.

La CS offre en série des jantes de 17 pouces au design Cup. Elles sont toujours peintes dans la couleur de la carrosserie. Dans le cockpit, les sièges baquet, d'une grande légèreté, offrent un excellent maintien latéral.

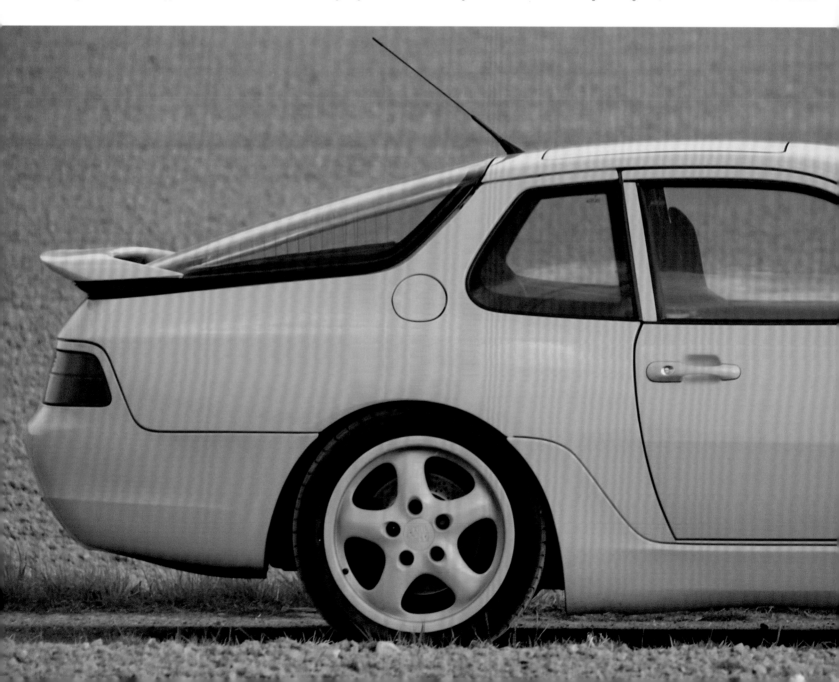

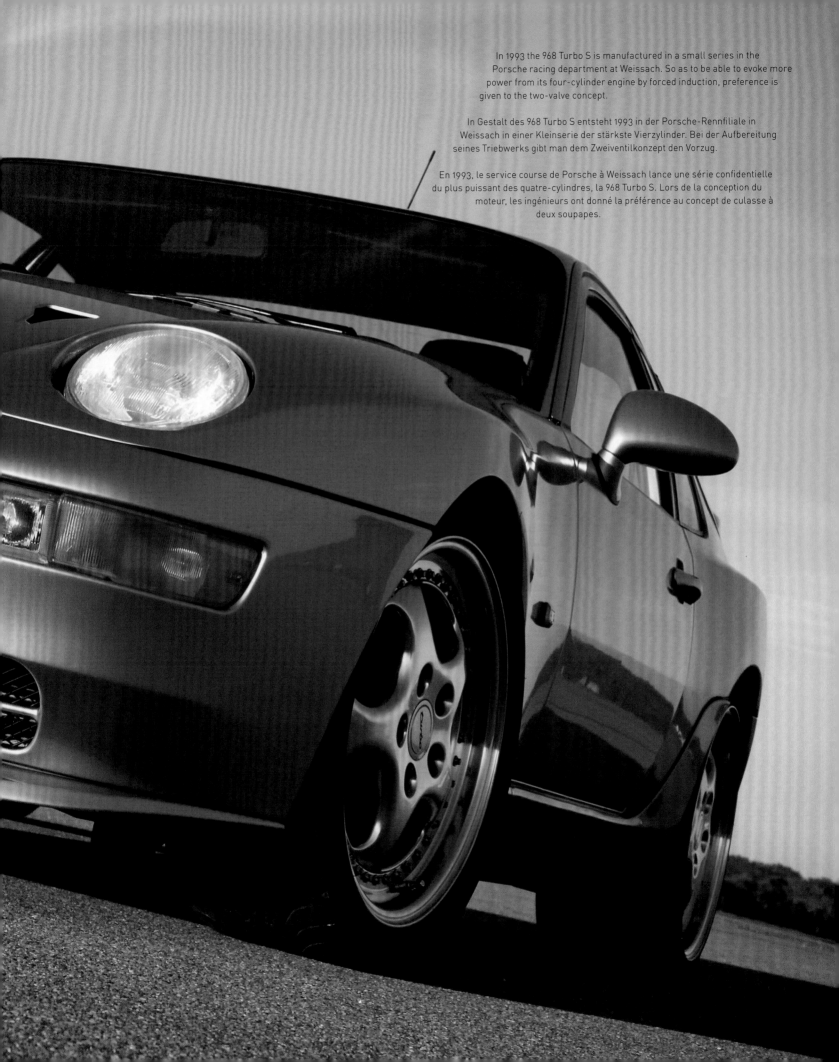

In 1993 the 968 Turbo S is manufactured in a small series in the Porsche racing department at Weissach. So as to be able to evoke more power from its four-cylinder engine by forced induction, preference is given to the two-valve concept.

In Gestalt des 968 Turbo S entsteht 1993 in der Porsche-Rennfiliale in Weissach in einer Kleinserie der stärkste Vierzylinder. Bei der Aufbereitung seines Triebwerks gibt man dem Zweiventilkonzept den Vorzug.

En 1993, le service course de Porsche à Weissach lance une série confidentielle du plus puissant des quatre-cylindres, la 968 Turbo S. Lors de la conception du moteur, les ingénieurs ont donné la préférence au concept de culasse à deux soupapes.

248

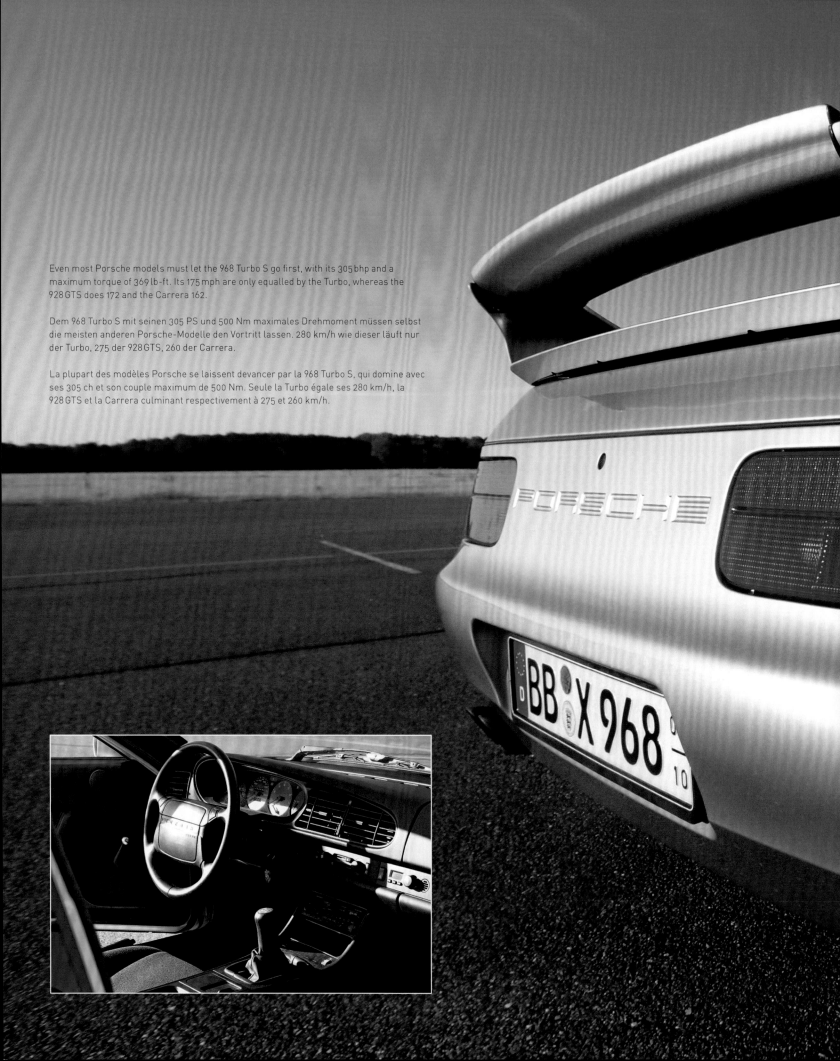

Even most Porsche models must let the 968 Turbo S go first, with its 305 bhp and a maximum torque of 369 lb-ft. Its 175 mph are only equalled by the Turbo, whereas the 928 GTS does 172 and the Carrera 162.

Dem 968 Turbo S mit seinen 305 PS und 500 Nm maximales Drehmoment müssen selbst die meisten anderen Porsche-Modelle den Vortritt lassen. 280 km/h wie dieser läuft nur der Turbo, 275 der 928 GTS, 260 der Carrera.

La plupart des modèles Porsche se laissent devancer par la 968 Turbo S, qui domine avec ses 305 ch et son couple maximum de 500 Nm. Seule la Turbo égale ses 280 km/h, la 928 GTS et la Carrera culminant respectivement à 275 et 260 km/h.

Four years of preparatory work and an investment of 400 million marks had been put into it. The 993, introduced at the Frankfurt IAA in fall 1993, was the latest on the 911 theme, and as usual the new car (the first of 65,695) would not deny its own identity, with a flatter and more aerodynamic profile of its front fenders, headlights that were raked more steeply and integrated flush into their surroundings like the side windows, bumpers that blended into the bodywork seamlessly, a wider backside and light-alloy five-spoke wheels.

Outer innovation just mirrored inward progress in the shape of, for instance, a multilink rear axle with twin wishbones, which had finally converted the once notoriously tail-happy 911 into a good-humored companion. The air-cooled flat six, again featuring 3600 cc, had emerged from a comprehensive update with a strengthened crankshaft, hydraulic valve adjustment and a twin exhaust system, delivering a healthy 272 bhp, to which another 13 was added in 1995.

In 1994 followed the Convertible, whose electric hood increased the passengers' headroom infinitely in a mere 13 seconds, and the Carrera 4 was resuscitated as well. The central differential had been replaced by a relatively simple visco clutch that assigned the engine's torque according to the prevailing circumstances, but as a rule almost 100 per cent to the rear axle. There were other obvious advantages, too: fifty per cent of the power loss in the drivetrain had been dispensed with, 100 pounds of extra weight pared off, and the additional charge for the four-wheel-drive variety had been cut by 5000 marks. The same solution was used for the alpha animal among the Porsche pack, first presented at the Geneva show in March 1995, to cope with its enormous power. The fourth-generation Turbo had two small-dimensioned KKK chargers that raised the benchmark for the performance of the 3.6-liter boxer to 408 bhp at a modest 5750 rpm, with 398 lb-ft at 4500 rpm as maximum torque. At the same year's Amsterdam exhibition the gap between the Turbo and the Carrera 2 was filled with the austere Carrera RS, whose VarioCam power unit had been bored out to 3746 cc, giving 300 bhp. By the usual steps, such as resorting to ascetic Recaro bucket seats and an aluminum front lid, 220 lbs had been saved.

The same path, though in visual rather than functional terms, was taken in 1995 with the Carrera 4S, an all-wheel-drive variant with the normally-aspirated engine and the 18-inch running gear of the Turbo and its flared wings to match, but without the voluminous rear end of the top Porsche, and the conventionally driven Carrera S of 1996. The Turbo's characteristic features were carried to extremes by the 1995 GT2, as a basis for racing, incorporating an even bigger wing, wider wheels and more pronounced fender flares. Initially it produced 430 bhp, later 450 bhp. That year's Frankfurt IAA saw the rebirth of the Targa, whose innovative glass sunroof slid back electrically behind the rear window at the touch of a button.

Vier Jahre Vorbereitung und eine Investition von 400 Millionen Mark waren in ihn eingespeist worden, wie er da im Herbst 1993 auf der Frankfurter IAA Lust auf Porsche machte. 993 – das war das letzte Wort in Sachen 911, und wie immer mochte der Neue seine eigene Identität schon visuell nicht verleugnen, mit einem flacheren Profil der vorderen Kotflügel, steileren und wie die Seitenscheiben bündig in ihre Umrahmung eingelassenen Scheinwerfern, Stoßfängern, die sich glatt und übergangslos in den Aufbau schmiegten, einem breiteren Hintern und Leichtmetallrädern im Fünfspeichendesign.

Die äußere Innovation spiegelte die innere wider, etwa in Gestalt der Multilink-Hinterachse mit Fahrschemel, die den einst so cholerischen Übersteuerer 911 endgültig zu einem gutmütigen Gesellen läuterte, oder des letztmalig luftgekühlt heisernden Boxers mit nach wie vor 3600 cm³, aber aus einer umfassenden Verjüngungskur beispielsweise mit einem automatischen Ausgleich des Ventilspiels mit 272 kerngesunden PS hervorgegangen. Im Modelljahr 1996 kamen 13 weitere dazu.

Ein Jahr ließ das Cabriolet auf sich warten, dessen elektrisches Verdeck in lediglich 13 Sekunden den Zugang zum Universum eröffnete, und auch der Carrera 4 lebte auf. Eine vergleichsweise simple Visco-Kupplung hatte die Stelle des zentralen Differentials eingenommen und erkannte das Drehmoment des Sechszylinders den Umständen gemäß zu, in der Regel jedoch zu fast 100 Prozent den Hinterrädern. Angenehme Begleiterscheinungen: die Verschlankung um einen Zentner, 50 Prozent weniger Reibungsverlust bei der Kraftübermittlung, 5000 Mark Minderkosten gegenüber dem Vorgänger. Mit dieser Lösung bekam auch das Alpha-Tier im Porsche-Rudel, erstmalig gezeigt beim Genfer Salon im März 1995, seine unbändige Kraft in den Griff – der Turbo der vierten Generation. Zwei kleine KKK-Lader hatten ihn auf 408 PS bei moderaten 5750/min erstarken lassen, mit einem maximalen Drehmoment von 540 Nm bei 4500/min. Im selben Jahr platzierte man auf der Show in Amsterdam in die Lücke zwischen dem Macho-Modell und dem Carrera 2 den kargen Carrera RS, mit einem auf 3746 cm³ aufgebohrten VarioCam-Triebwerk von 300 PS und durch geeignete Maßnahmen um 100 kg erleichtert.

Ein ähnlicher Weg wurde 1995 mit dem Carrera 4S beschritten. Er betraf indessen vor allem dessen Erscheinungsbild, da dem Vierradler mit dem Saugmotor des Standard-Carrera das 18-Zoll-Fahrwerk und weitgehend auch der Aufbau des Turbo, allerdings ohne dessen Heckleitwerk, anverwandelt wurden. Einer ähnlichen Kur wurde der hinterradgetriebene Carrera S von 1996 unterzogen. Keinerlei Kompromisse gab es indessen mit dem GT2 von 1995, Basis für den Sport, mit einem noch größeren Flügel, noch breiteren Rädern, noch geräumigeren Kotflügeln und anfänglich 420 und später 450 PS. Im gleichen Jahr, wieder in Frankfurt, rundete ein neuer Targa mit einem gläsernen Dachpavillon die Palette ab, dessen Topteil bei Bedarf elektrisch unter die Heckscheibe geschoben wurde.

Le modèle exposé à l'IAA de Francfort à l'automne 1993, et qui fait toujours rêver représente quatre ans de travail et un investissement de 400 millions de marks. Il est ce qui se fait de mieux en termes de 911 et, comme toujours, la nouvelle Stuttgartoise affiche son caractère : un profil plus plat pour les ailes avant des phares plus verticaux et, comme les vitres latérales, affleurant dans leur encadrement, des pare-chocs qui épousent à la perfection les lignes de la carrosserie, une croupe plus large hébergeant des jantes en alliage léger au design à cinq branches.

Et ce qu'elle cache à l'intérieur n'est pas en reste en matière d'innovation. Par exemple, le train arrière Multilink avec berceau auxiliaire transforme la 911 au survirage légendaire en auto

1993–1998

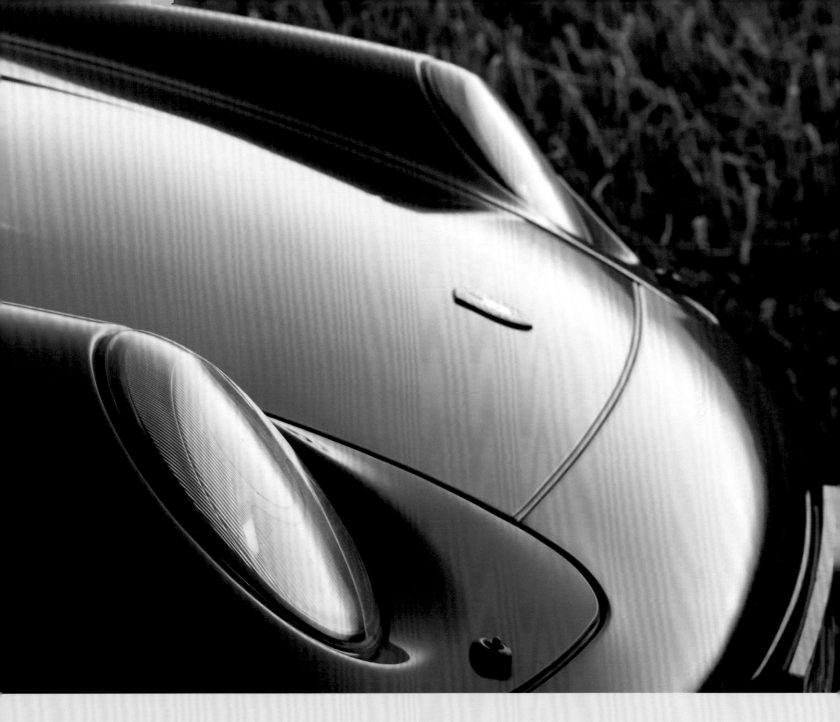

mobile d'une docilité exemplaire, où officie ce qui sera le dernier représentant de la lignée des *flat-six* à refroidissement par air, toujours d'une cylindrée de 3600 cm³, mais profondément revu sur le plan mécanique, notamment avec un rattrapage automatique du jeu des soupapes et 272 ch d'une fiabilité à toute épreuve. Treize chevaux de plus s'y ajouteront pour le millésime 1996.

Il faut attendre un an l'arrivée du cabriolet, dont la capote électrique s'ouvre en treize secondes seulement, et de la Carrera 4 qui fait, elle aussi, sa réapparition. Un simple viscocoupleur a pris la place du différentiel central et transmet le couple délivré par le six-cylindres en fonction des circonstances, mais presque toujours à 100 %, aux roues arrière. Détails non négligeables : elle a maigri en cours de route d'une cinquantaine de

kilos, les pertes de frictions de la transmission ont diminué de 50 % et elle coûte 5000 marks de moins que sa devancière. Avec cette configuration mécanique, le chef de file de la meute des Porsche, dévoilé au Salon de Genève en mars 1995 – la Turbo de la quatrième génération – maîtrise sans difficulté toute cette puissance. Deux petits turbocompresseurs KKK font grimper sa puissance à 408 ch au régime modéré de 5750 tr/min pour un couple maximum de 540 Nm à 4500 tours. La même année, au Salon de l'Auto d'Amsterdam, Porsche présente un modèle qui vient s'intercaler entre la virile 911 et la Carrera 2 : la sobre Carrera RS, dont le moteur à distribution VarioCam avec une cylindrée majorée à 3746 cm³ développe 300 ch et à laquelle une cure d'allègement a fait perdre 100 kg. Une méthode apparemment efficace, puisqu'elle

est aussi appliquée, en 1995, à la Carrera 4S. Mais cela concerne surtout son aspect extérieur, car la quatre-roues motrices à moteur atmosphérique de la Carrera standard reprend les liaisons au sol de 18 pouces et, aussi, presque entièrement la carrosserie de la Turbo, à l'exception de son becquet arrière proéminent. La Carrera S à propulsion de 1996 subit le même régime. Le refus de tout compromis s'applique, en revanche, pour la GT2 de 1995 qui sert de base pour la compétition, avec un aileron encore plus grand, des roues plus larges, des ailes plus spacieuses et, au début, 420 ch puis, plus tard, 450 ch. La même année, à Francfort, le programme est complété par une nouvelle Targa à pavillon entièrement vitré, dont la partie supérieure se glisse électriquement sous la lunette arrière d'une simple pression sur un bouton.

911 (993)

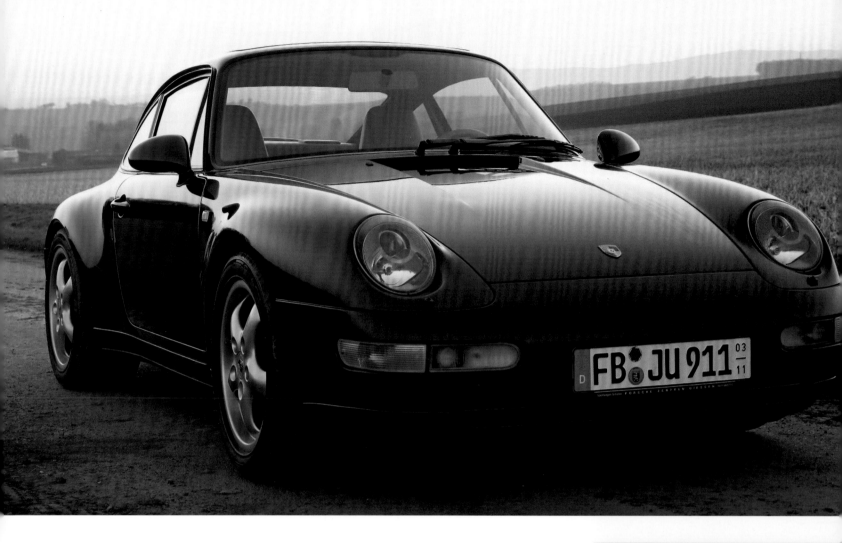

The familiar silhouette of the 911 has been thoroughly reworked for the first time, the front end being smoother and flatter, with a more pronounced, round tail end. A cross bar above the engine lid incorporates a third brake light, compulsory in some export countries and optional in Germany.

Die vertraute Elfer-Silhouette wurde umfassend überarbeitet. Flacher und glatter gibt sich die Front des 993, stämmiger das Hinterteil. Die Dachblende nimmt das in einigen Ländern vorgeschriebene und in Deutschland optionale Bremslicht auf und verkürzt visuell die Heckscheibe.

La si familière silhouette de la 911 a été revue en profondeur. La proue de la 993 s'est lissée et a été abaissée alors que la croupe est plus rebondie. L'arête supérieure du toit héberge le troisième feu de frein, obligatoire dans certains pays et optionnel en Allemagne, raccourcissant ainsi visuellement la lunette arrière.

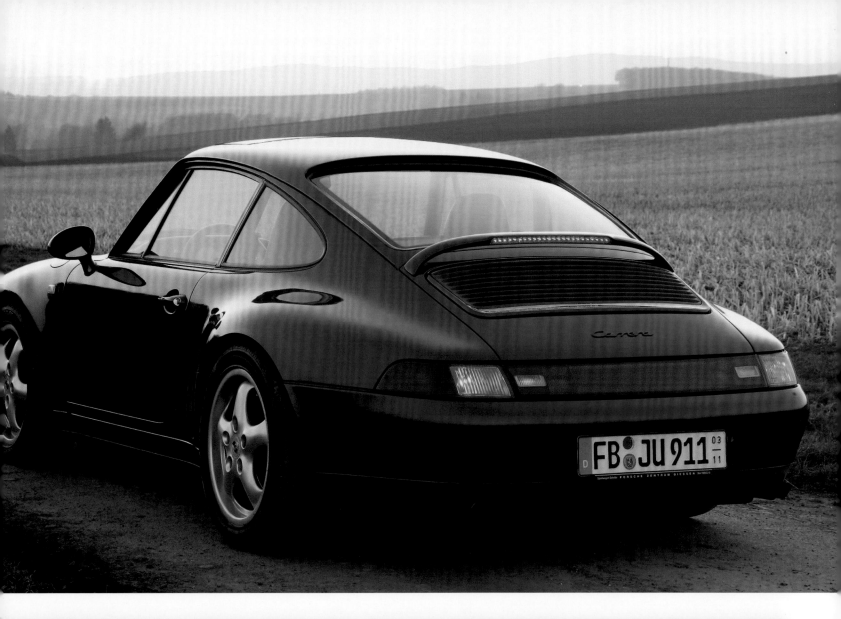

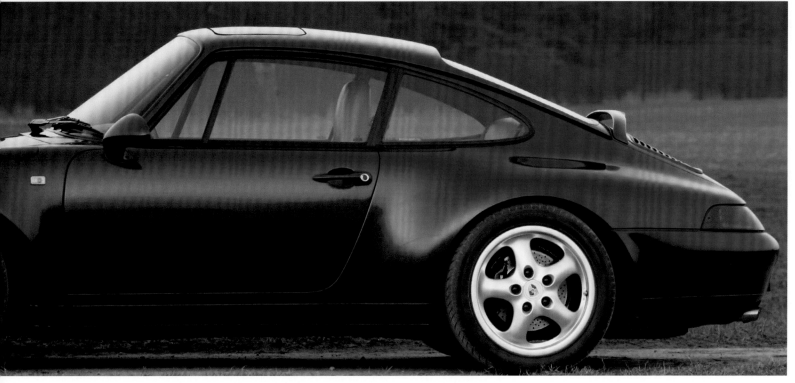

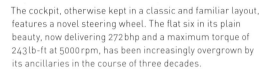

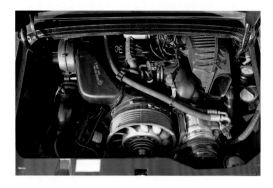

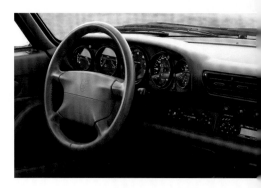

The cockpit, otherwise kept in a classic and familiar layout, features a novel steering wheel. The flat six in its plain beauty, now delivering 272 bhp and a maximum torque of 243 lb-ft at 5000 rpm, has been increasingly overgrown by its ancillaries in the course of three decades.

Dem klassisch-vertraut eingerichteten Cockpit hat man ein neues Lenkrad spendiert. Die Boxermaschine in ihrer schlichten Schönheit, nun bei 272 PS und einem maximalen Drehmoment von 330 Nm bei 5000/min angelangt, wurde im Lauf der Jahrzehnte immer mehr verhüllt.

Le cockpit si familier par son agencement classique a reçu un nouveau volant. Le moteur boxer aussi sobre que beau développe maintenant 272 ch pour un couple maximum de 330 Nm à 5000 tr/min et se dissimule de plu en plus aux regards au fil des décennies.

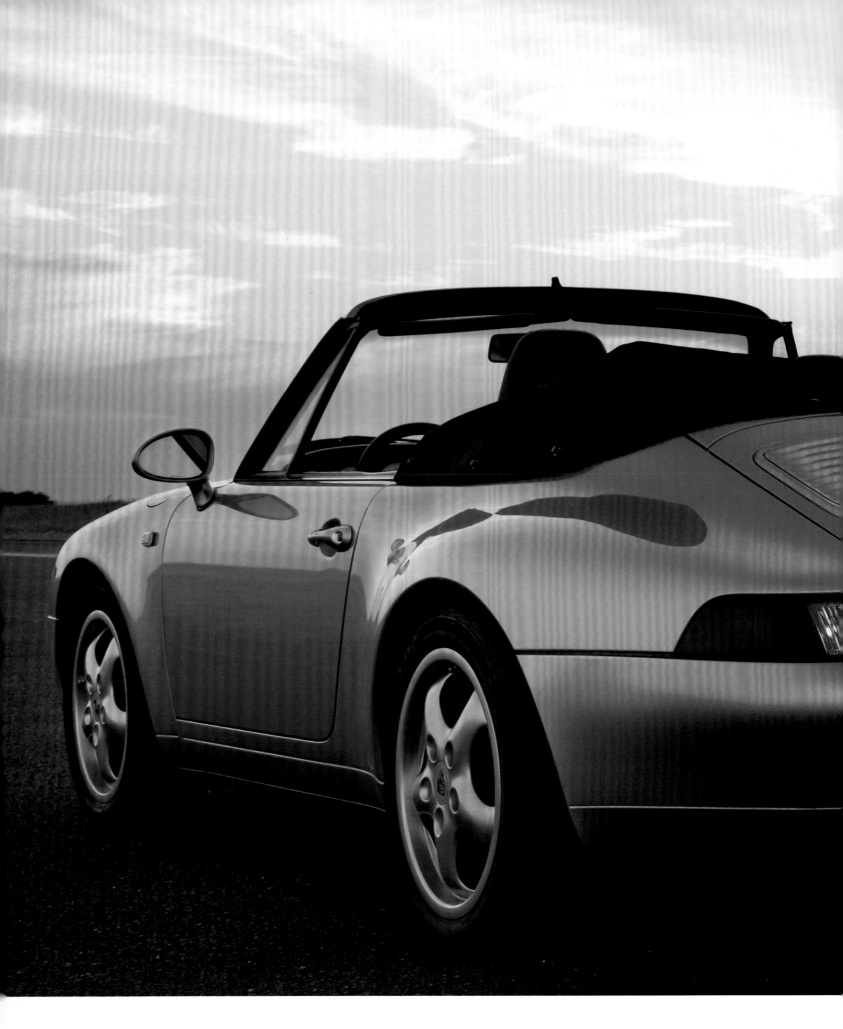

The components of the Carrera S have been taken from the Porsche shelves yet again. It features the chassis and the wider bodyshell of the Turbo, but also the rear pop-up spoiler of the standard 911. Its typical bipartite cooling-air grate is kept in body color.

Aus dem Baukasten komponiert ist der Carrera S, mit dem Fahrwerk und der breiteren Karosserie des Turbo, aber dem beweglichen Spoiler des Normal-Elfers. Das in Wagenfarbe gehaltene Kühlluftgitter ist zweigeteilt.

La Carrera S profite du système modulaire en vigueur à Zuffenhausen avec le châssis et la carrosserie plus large de la Turbo, mais l'aileron mobile de la 911 normale. La grille d'aération scindée en deux éléments reprend la couleur de la voiture.

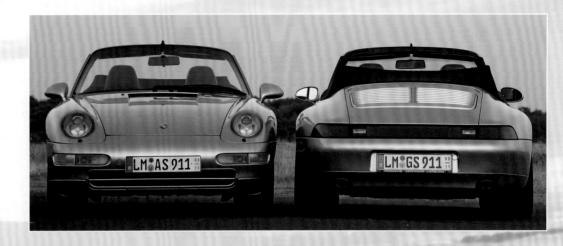

The model rolls on 17-inch light-alloy wheels in Cup design whose heat emission has been improved. More rounded and smoother than before, they fall into line with the overall appearance of the 993.

Das Modell rollt auf 17-Zoll-Leichtmetall-rädern im Cup-Design, deren Wärmeabgabe verbessert worden ist. Optisch wirken sie – wie die Gesamterscheinung des 993 – weicher und gerundeter.

Ce modèle est chaussé de jantes en alliage léger de 17 pouces, dont l'évacuation de la chaleur a été améliorée. Avec leur design Cup, elles sont plus douces et plus arrondies, à l'image de l'ensemble de la 993.

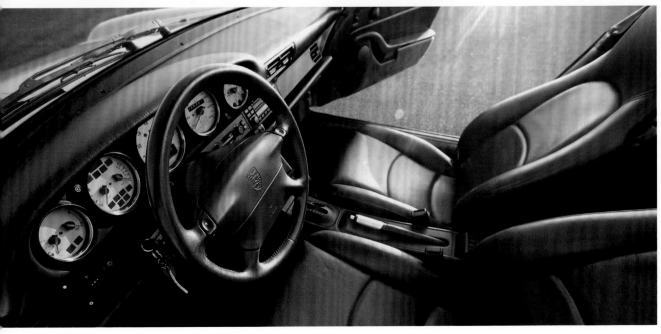

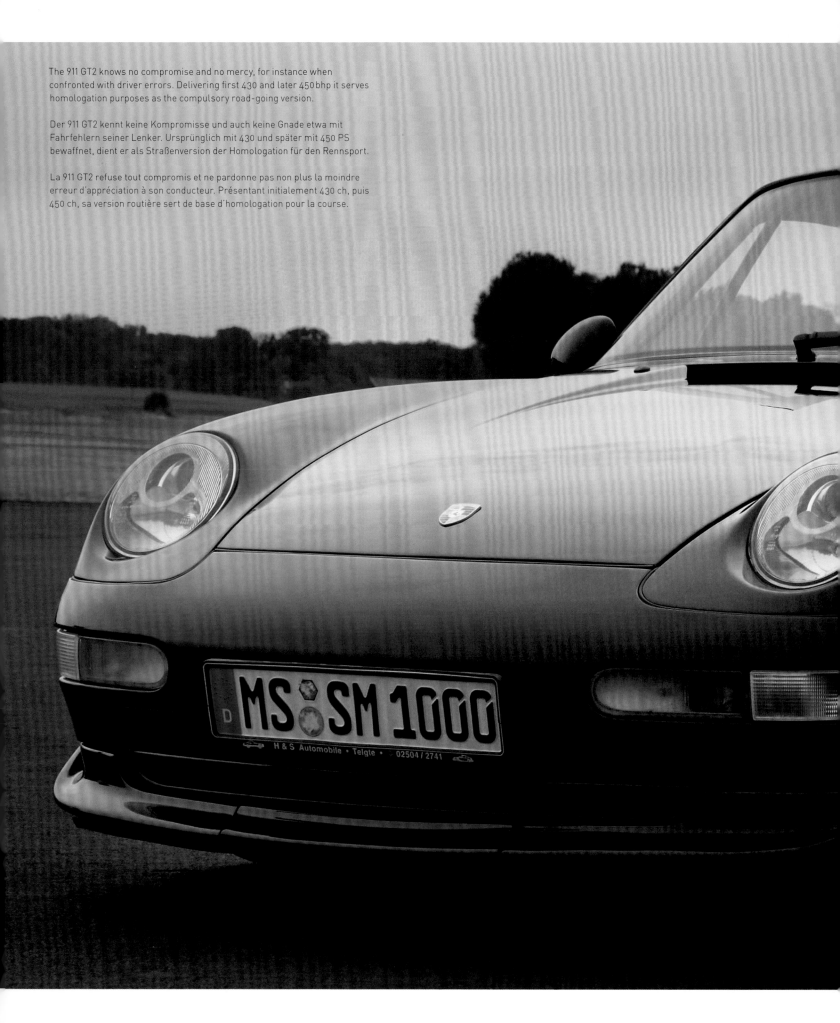

The 911 GT2 knows no compromise and no mercy, for instance when confronted with driver errors. Delivering first 430 and later 450 bhp it serves homologation purposes as the compulsory road-going version.

Der 911 GT2 kennt keine Kompromisse und auch keine Gnade etwa mit Fahrfehlern seiner Lenker. Ursprünglich mit 430 und später mit 450 PS bewaffnet, dient er als Straßenversion der Homologation für den Rennsport.

La 911 GT2 refuse tout compromis et ne pardonne pas non plus la moindre erreur d'appréciation à son conducteur. Présentant initialement 430 ch, puis 450 ch, sa version routière sert de base d'homologation pour la course.

The fenders of the Turbo
have been cut and
replaced with bolt-on
plastic elements to
accommodate the GT2's
large racing wheels. The
inclination of the fixed
rear spoiler is adjustable.

Breiten-Sport:
Aufgeschraubte
Kotflügelverbreiterungen
aus Kunststoff schaffen
den nötigen Mehr-Raum
für die dickeren Räder des
GT2. Die Flügelneigung
des festen Heckspoilers
lässt sich einstellen.

In the interior of the GT2 prevails unadulterated and naked sportiness. Below the huge intercooler, however, peeps out almost bashfully what does not need to hide at all—its potent six-cylinder boxer engine.

Nackt zu Tage tretende Sportlichkeit herrscht auch im Inneren des GT2. Unter dem riesigen Ladeluftkühler lugt indessen verschämt hervor, was sich absolut nicht zu verstecken braucht – der potente Sechszylinder.

À la sportivité de l'extérieur répond celle du cockpit de la GT2. Sous l'immense échangeur d'air dépasse timidement ce qui n'a pourtant absolument pas besoin de se cacher – le puissant six-cylindres.

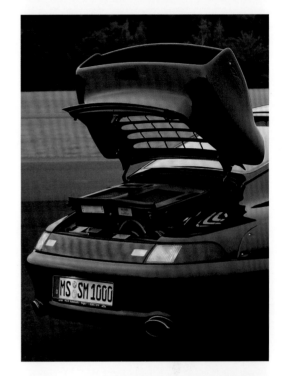

Des élargisseurs d'aile vissés en matière plastique hébergent les larges roues compétition de la GT2. L'inclinaison de l'aileron arrière fixe est réglable.

Strictly speaking, it was a thoroughbred sports racer, drifting off the wild freedom of Le Mans or Laguna Seca straight into the strictly regulated chaos of public traffic. Its alibi was that at least one road-going specimen with the blessing of the authorities had to be built for it and its kind to gain access to the FIA GT Championship. And as things invariably get expensive beyond the cost-cutting effects of the assembly line, the GT1 was a steep 1.5 million marks, which alone narrowed down its potential clientele to a lucky few: 21, to be precise.

On 24 July 1995, the board of directors gave the go-ahead for the project. On 14 March 1996, Jürgen Barth had the ready product go through its paces for the first time at the Porsche test track at Weissach. On 16 July of that year, second and third places after the Le Mans 24 Hours seemed to spell a happy future, though the GT1 actually failed to live up to its promise, despite winning the Sarthe classic in 1998. The parameters given, for instance, to the designer Anthony R. Hatter by project managers Norbert Singer and Horst Reitter asked for the model to show an affinity to the ongoing 993 production car. Indeed there was a remote resemblance, and a piece of Carrera, reinforced by a sturdy roll cage, was also found in the front end of the GT1. But behind the bulkhead immediately following the passenger cell there was a tubular framework which housed its mid engine, rear axle and six-speed gearbox. The wheels were suspended by twin wishbones with Bilstein spring/damper units and pushrods at the rear. The structural parts of the grotesquely rugged bodywork were made of sheet-steel, whereas its outward components such as the ultralight doors consisted of a blend of kevlar, carbon fiber and epoxy resin. An enormous adjustable wing loomed up on top of the rear, in league with a corresponding treatment of the undertray. The 544bhp 3.2-liter flat six, whose cylinder banks and heads were combined into units of three, anticipated elements of oncoming production 911s, but also dispensed with sacred and time-honored traditions: its sires had opted for water cooling, both to cope with thermal aspects of the filigree turbo technology featuring two overhead camshafts respectively and four valves per combustion unit, and to dampen the noise emissions of the engine.

Over the winter, the experiences made with the first-generation GT1 were distilled into the 911 GT1/97, for example in the shape of a new front axle and wider track, while the vicinity to the standard 911 was endorsed by incorporating the shape of the 996's headlights ("lachrymal sacs"). Similar lamps were sported by the 911 GT/98, which otherwise had been dramatically uprated. Two hundredweight had been pared off, mainly by installing a carbon-fiber monocoque as backbone, which put paid to all trace elements of the series-built siblings in the front half of the car. As in Formula 1, the safety tank had been transplanted from there to a new position between cockpit and power plant, with the wheelbase being increased from 98.4" to 105.9" in the process.

Eigentlich war er ein reinrassiges Renngerät, gleichsam aus der wilden Freiheit von Le Mans und Laguna Seca direkt in das straff geregelte Chaos des Verkehrs auf öffentlichen Straßen abgedriftet. Sein Alibi: Mindestens ein ziviles Exemplar mit dem Segen der zuständigen Behörden musste vorgelegt werden, damit ihm und seinesgleichen Zutritt zum internationalen GT-Championat gewährt wurde. Da es abseits der Bänder richtig teuer wird, kostete der GT1 satte 1,5 Millionen Mark. Schon das dampfte seine Klientel auf einige wenige Glückliche ein, 21 an der Zahl.

Am 24. Juli 1995 winkte der Vorstand das Projekt durch. Am 14. März 1996 gab Jürgen Barth dem fertigen Produkt auf dem Porsche-Versuchskurs Weissach zum erstenmal die Sporen. Am 16. Juni jenes Jahres schienen Rang zwei und drei in Le Mans eine glückliche Zukunft zu verheißen, ein Versprechen, das der GT1 nur bedingt einlöste, trotz des Sieges 1998 bei dem Sarthe-Klassiker. Die Vorgaben, die Projektleiter Norbert Singer und Horst Reitter etwa dem Designer Anthony R. Hatter mit auf den Weg gegeben hatten, verlangten nach einer Ähnlichkeit zum aktuellen 993. Von diesem ließen sich in der Tat vage Konturen ausmachen, und ein Stück Carrera, verstärkt durch einen robusten Überrollkäfig, fand sich auch mit dem Vorderwagen. Hinter einem Querschott im Anschluss an den Passagierraum folgte jedoch ein Röhrengebälk, das Mittelmotor, Hinterachse und Sechsganggetriebe aufnahm. Die Räder wurden an doppelten Querlenkern mit Feder-/Dämpfereinheiten von Bilstein und Pushrods hinten geführt.

Die tragenden Teile der grotesk zerklüfteten Karosserie waren aus Stahlblech gefertigt, ihre äußeren Elemente wie die federleichten Türen aus einer Kunststoff-Melange von Kevlar, Kohlefaser und Epoxidharz. Über dem Heck wucherte ein einstellbarer Riesenflügel. Der 3,2-Liter-Boxer mit 544 PS, dessen Zylinderbänke und -köpfe jeweils in Dreierpacks zusammengegeben waren, nahm Motive der künftigen Serie vorweg und ermordete auch gleich ein paar heilige Kühe. Denn um die Thermik seiner filigranen Turbo-Technologie mit je zwei oben liegenden Nockenwellen und vier Ventilen pro Verbrennungseinheit in den Griff zu bekommen und, nicht zuletzt, um seine Geräuschemissionen zu mäßigen, gab man Wasserkühlung den Vorzug.

Über den Winter 1996/97 brachte man die Erfahrungen mit dem Extrem-Elfer der ersten Generation in den 911 GT1/97 ein, zum Beispiel mit neuer Vorderachse und breiterer Spur, während mit der Scheinwerferform des 996 („Tränensäcke") die Nähe zur Basis unterstrichen wurde. Ähnliche Leuchten fanden sich auch am 911 GT1/98, der ansonsten umfassend überarbeitet worden war. Zwei Zentner wurden abgespeckt, vor allem durch ein Kohlefaser-Monocoque als Rückgrat, das endgültig alle Spurenelemente der Serie aus dem vorderen Teil tilgte. Wie in der Formel 1 waren der Tank von dort in ein sichereres Plätzchen zwischen Cockpit und Maschine transplantiert und zugleich der Radstand von 2500 auf 2690 mm erweitert worden.

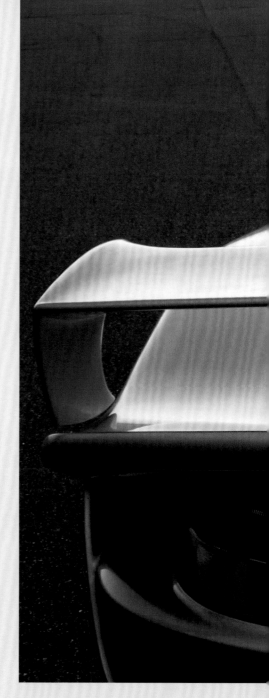

Cette authentique voiture de course semble tout droit sortie des circuits du Mans ou de Laguna Seca pour se retrouver instantanément lâchée dans la circulation bien orchestrée sur routes ouvertes. Mais il existe une raison à cela : au moins un exemplaire civil doit pouvoir être présenté avec l'homologation des autorités compétentes pour qu'elle puisse, elle et ses semblables, disputer le Championnat international GT. Cependant, une voiture qui n'est pas fabriquée à la chaîne coûte cher, ce que confirme la GT1 avec son prix mirobolant de 1,5 million de marks ! Cela réduit sérieusement sa clientèle potentielle à quelques rares nantis : 21 en l'occurrence.

Le 24 juin 1995, le directoire de la firme donne son feu vert au projet. Le 14 mars 1996, Jürgen Barth est le premier à la tester sur le circuit d'essais

1996–1998

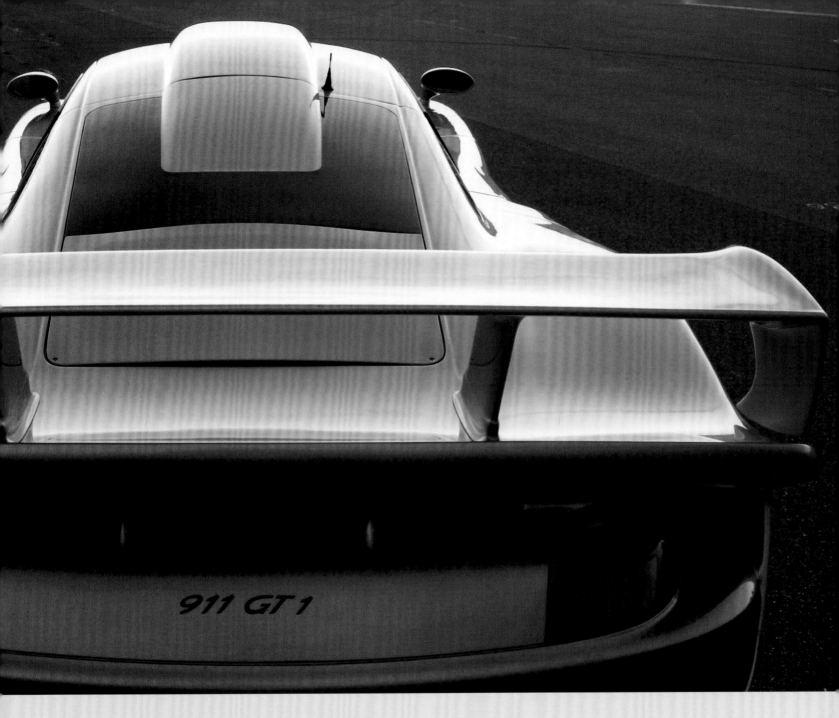

privé de Porsche à Weissach. Et, le 16 juin 1996, la deuxième et la troisième place remportées au Mans semblent lui promettre un bel avenir, une promesse que la GT1 ne tient qu'avec des réserves, malgré sa victoire en 1998 dans la classique sarthoise. Les instructions données par les chefs de projet Norbert Singer et Horst Reitter au designer Anthony R. Hatter exigeaient une similitude avec la 993 actuelle. C'est pourquoi on peut discerner les contours de celle-ci et un fragment de Carrera renforcé par un solide arceau-cage s'y retrouve aussi avec la partie avant de la voiture. Derrière l'auvent fermant l'habitacle, se trouve cette fois un châssis tubulaire qui reçoit le moteur central, le train arrière et la boîte à six vitesses. Les roues sont guidées par des doubles bras transversaux avec unité ressort/amortisseur Bilstein et poussoirs à l'arrière.

Les éléments porteurs de la carrosserie aux formes torturées sont en tôle d'acier alors que ses composants extérieurs, par exemple les portières d'une légèreté incroyable, sont un cocktail de Kevlar, de fibre de carbone et de résine d'époxy. La poupe est dominée par un immense becquet réglable, auquel répond un soubassement massif. Le boxer de 3,2 litres et 544 ch, dont les bancs de cylindres et les culasses sont regroupés par trois, laisse déjà augurer de la future série et anéantit au passage quelques principes sacrés. En effet, pour maîtriser les aspects thermiques de sa filigrane technologie suralimentée avec respectivement deux arbres à cames en tête et quatre soupapes par cylindre et, surtout, pour tempérer un tant soit peu ses émissions acoustiques, Porsche a adopté un refroidissement... liquide.

Au cours de l'hiver 1996–1997, les expériences faites avec la 911 de la première génération sont transposées dans la 911 GT1/97, par exemple avec un nouveau train avant et des voies plus larges, alors que la forme des phares est reprise de la 996 (les fameux «yeux larmoyants»). Ces phares, si peu appréciés, se retrouvent aussi sur la 911 GT1/98, qui, pour le reste, a été profondément revue et corrigée. Allégée de 100 kg, notamment grâce à une monocoque en fibre de carbone qui lui sert d'épine dorsale, elle bannit définitivement tous les éléments proches du modèle de série de la partie avant de la voiture. Comme en Formule 1, le réservoir a déménagé de cette partie du véhicule pour un emplacement plus sûr entre le cockpit et le moteur et, simultanément, l'empattement s'est allongé de 2500 à 2690 mm.

The men who conceived the GT1 envisaged a
mid-engined vehicle as a derivative of the 993. Purpose-
built for the racing track it still had to resemble
the basic product. Take a closer look, though...

Die Väter des GT1 sehen ein Fahrzeug mit Mittelmotor
auf der Grundlage des 993 vor, das bei perfekter
Ausrichtung auf seinen Zweck noch immer als Elfer zu
erkennen ist. Aber man muss schon genau hinschauen...

Les pères de la GT1 imaginent une voiture à moteur
central dérivée de la 993. Construite pour la
course, elle se devait néanmoins de ressembler à
l'original. Il faut tout de même y regarder de près...

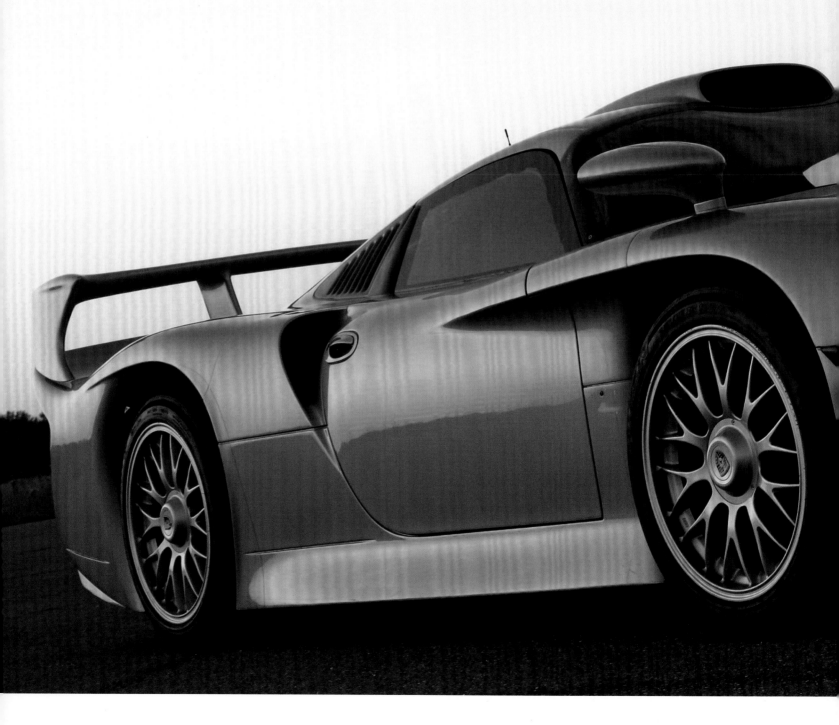

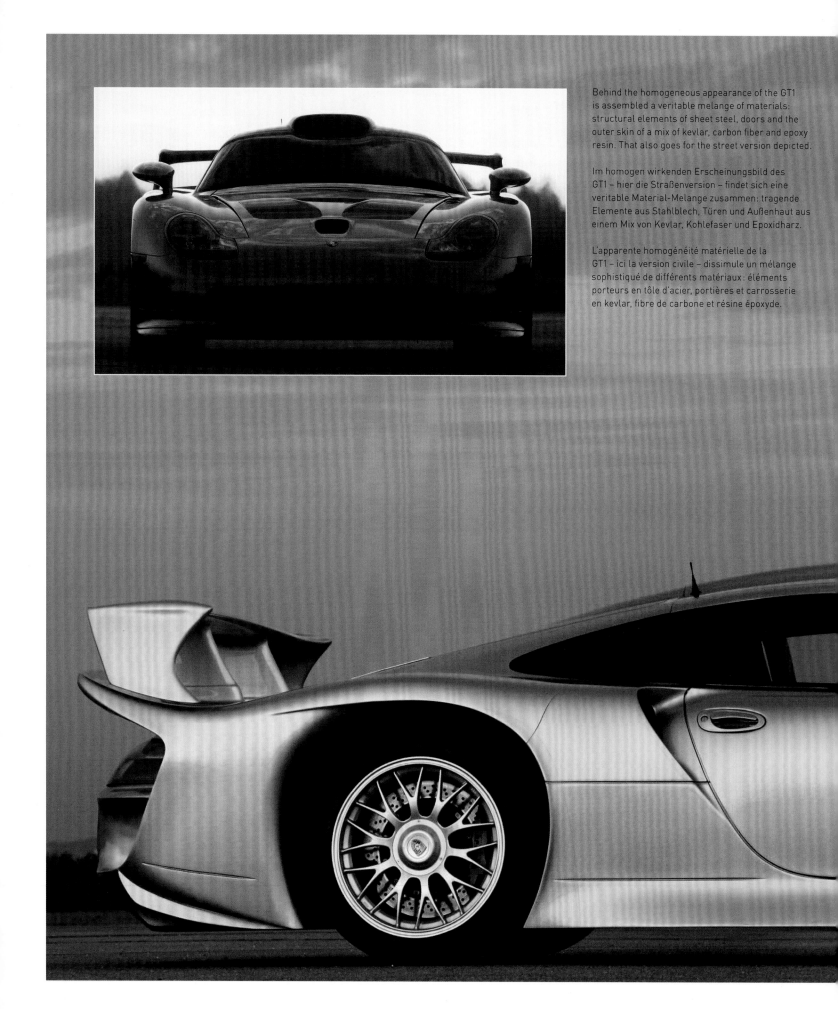

Behind the homogeneous appearance of the GT1
is assembled a veritable melange of materials:
structural elements of sheet steel, doors and the
outer skin of a mix of kevlar, carbon fiber and epoxy
resin. That also goes for the street version depicted.

Im homogen wirkenden Erscheinungsbild des
GT1 – hier die Straßenversion – findet sich eine
veritable Material-Melange zusammen: tragende
Elemente aus Stahlblech, Türen und Außenhaut aus
einem Mix von Kevlar, Kohlefaser und Epoxidharz.

L'apparente homogénéité matérielle de la
GT1 – ici la version civile – dissimule un mélange
sophistiqué de différents matériaux: éléments
porteurs en tôle d'acier, portières et carrosserie
en kevlar, fibre de carbone et résine époxyde.

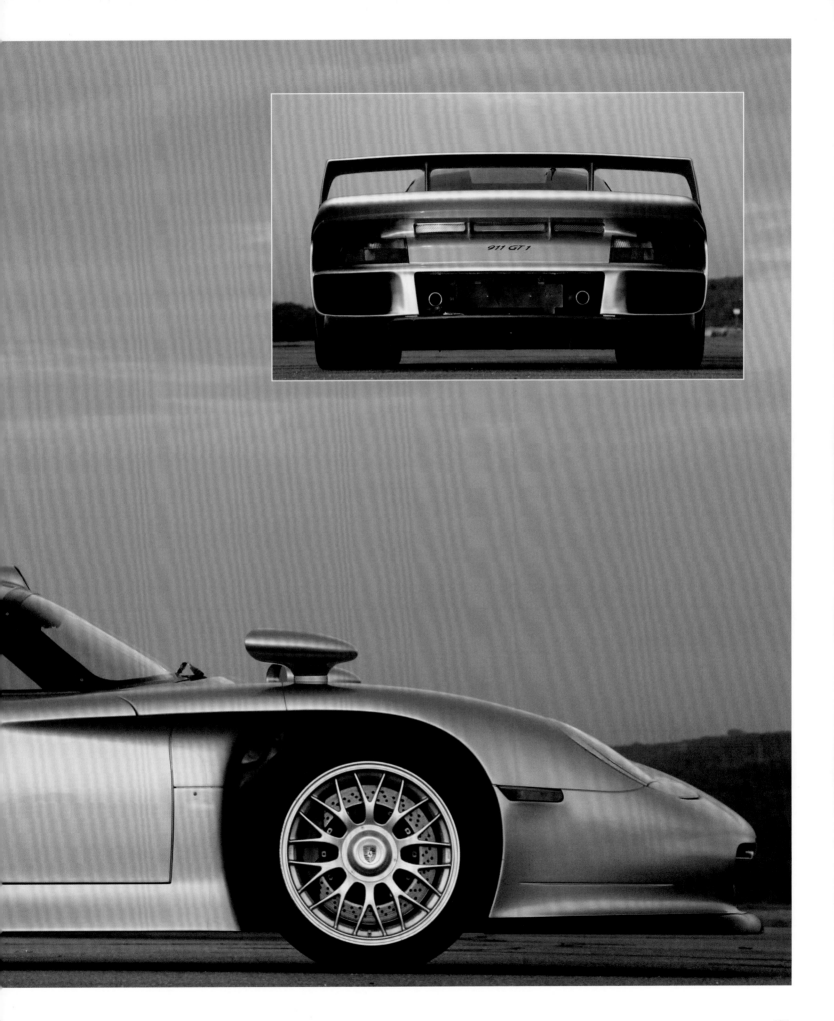

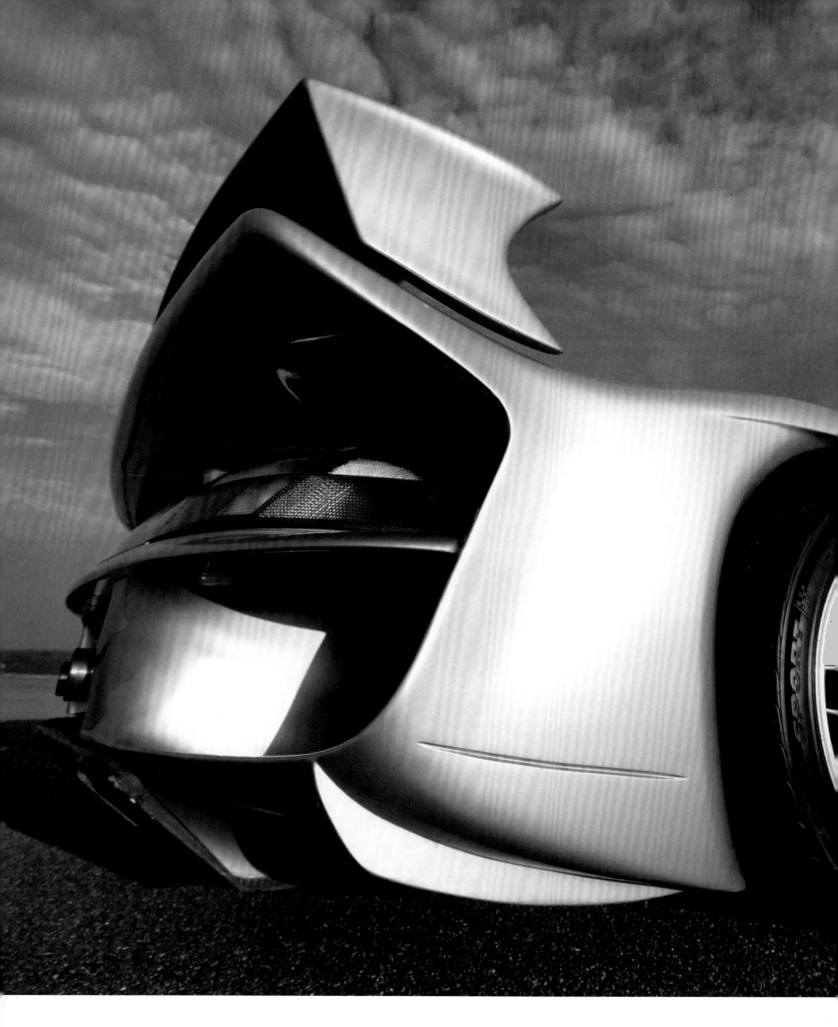

As is usually the case with racing vehicles, the space below the tight-fitting bodywork is crowded. As to the instrument panel and the position of the ignition key to the left of the steering wheel, the driver finds himself in familiar surroundings.

Unter dem knappen Trikot geht es, wie stets in Rennfahrzeugen, eng zu. Was die Armaturentafel und die Anordnung des Zündschlüssels (natürlich links) anbelangt, findet der GT1-Pilot Vertrautes vor.

Comme il se doit pour une voiture de course, l'espace sous la carrosserie étriquée est restreint. En présence du tableau de bord avec la clé naturellement placée à gauche, le pilote se retrouve dans un environnement familier.

Presented as a concept car at the 1993 Detroit Show and wowing customers as a dealership demo car three years later, by the time it launched, the Boxster had already caused quite a stir. 10,000 advance orders were received, and Zuffenhausen had to outsource part of the production to Finland due to insufficient capacity. By 2004, 109,213 Boxsters had been brought into the world. The Boxster—a name that blended both roadster and boxer—was designed as a callback to the 550 Spyder, a sports car icon. Its mid-engine left space for two trunks (albeit modest ones), while the water-cooled flat six gave the car (code 986) an initial output of 204 bhp—still a respectful distance from the flagship 911. As the car evolved over the years, this figure would rise to 260 bhp. The crowning jewel in this show of strength was the Boxster S "550 Spyder 50th Anniversary Edition", which boasted 266 bhp. In keeping with the theme, 1953 units were produced for this edition, and these were painted predominantly in GT Silver Metallic, just like their forebear. The new code (987) signaled a whole host of innovations, including an extra burst of power and aesthetic embellishments that gave the Boxster more beef. The 2007 production models were given even more power, with the output now rising to 245 bhp for the starter model.

Two years earlier, at the Frankfurt IAA 2005, the Cayman (code 987c) had been launched, filling the gap between the Boxster and the 911 in the cleverly constructed Porsche pecking order. Its rigid design revealed an interplay between concave and convex elements, and it also stood out on account of its wide, yawning front air inlets, its pronounced flanks, the bold curves of its fenders and its generous hatchback. With a total of 14.5 cu.ft of trunk space across the two compartments, storage was anything but tight. And there weren't any issues in terms of power, either: just like the Boxster S, which would appear on the market a few years later, the Cayman S put out a solid 295 bhp and a maximum torque of 250 lb-ft using its 3387 cc displacement—enough to reach 170 mph. The Porsche VarioCam Plus gave the car plenty of torque at lower speeds and a high output at the top end. A six-speed transmission and the optional five-step Tiptronic S fitted perfectly with this profile, while the chassis took the forces to which it was subjected calmly in its stride thanks to its longitudinal and transverse control arms, McPherson suspension, and front and rear stabilizers. The large, perforated disk brakes with interior ventilation and four-piston aluminum calipers were painted red—after all, what's the point in being outstanding if you don't stand out?

The Cayman and the Boxster kicked off the production year 2009 with a new engine—2893 cc displacement, 265 bhp. The Cayman S and its sporty, stripped-down "R" variant had a displacement of 3436 cc, allowing them to reach 330 bhp. Its Porsche dual clutch allowed it to sprint from 0 to 60 mph in under five seconds, and the "R" wasn't far off either, with a top speed of 175 mph. Further tribute was paid to the 550 Spyder in 2011 with the lightweight Boxster Spyder, which ran to 1667 units.

Als Concept Car 1993 in Detroit präsentiert und 1996 als Vorführwagen bei den Händlern zu bestaunen, hatte der Boxster bereits Furore gemacht: 10 000 Blindbestellungen. Mangels Kapazitäten in Zuffenhausen musste ein Teil der Produktion nach Finnland ausgelagert werden, wo bis 2004 109 213 Exemplare das Licht der Welt erblickten. Der Boxster – ein Verschnitt aus Roadster und Boxer – sollte sich an die Sportwagen-Ikone 550 Spyder anlehnen. Dank des Mittelmotors bietet er gleich zwei, wenn auch nicht sehr voluminöse Gepäckabteile. Der mit einem wassergekühlten Sechszylinder-Boxermotor bestückte Wagen (Code 986) wahrte zunächst mit 204 PS den Respektabstand zum Marken-Primus 911. In Evolutionsstufen stieg die Leistung auf 260 PS. Krönung dieser Politik der Stärke: die Sonderedition des Boxster S „50 Jahre 550 Spyder" mit 266 PS, sinnigerweise in 1953 Einheiten produziert und wie ihr Ahn vornehmlich in GT-Silbermetallic lackiert. Eine Fülle von Innovationen – weiterer Power-Schub und optische Retuschen, durch die der Boxster bulliger wirkte – schlugen sich in einem neuen Code (987) nieder. Das Modelljahr 2007 begleitete eine weitere Leistungsanhebung, nunmehr auf 245 PS für das Einstiegsmodell.

Zwei Jahre zuvor bei der Frankfurter IAA 2005 schloss sich mit dem Cayman (Code 987c) in der klug ausgeheckten Porsche-Hackordnung die Lücke zwischen Boxster und Elfer. In seinem rigiden Aufbau spielen konvexe und konkave Elemente ineinander. Weitere Kennzeichen: klaffend gähnende Lufteinlässe vorn, ausgeprägte Taille, kühner Kotflügelschwung und eine voluminöse Heckklappe. Mit insgesamt 410 Litern Kofferraum, verteilt auf die zwei Abteile, herrscht kein Platzmangel. Aber auch hinsichtlich der Kraftentfaltung gab es keine Mangelerscheinungen, denn – wie ein wenig später auch der Boxster S – schöpfte der Cayman S stämmige 295 PS und ein maximales Drehmoment von 340 Nm aus 3387 cm³ Hubraum, gut für 275 Stundenkilometer. Porsches VarioCam Plus sorgte dabei für viel Drehmoment im unteren Bereich und hohe Leistung oben heraus. Diesem Profil schmiegsam angepasst waren ein Sechsgang-Schaltgetriebe und die optionale Tiptronic S mit ihren fünf Fahrstufen, während das Fahrwerk den Kräften, die da munter walten, mit gelassener Reserve begegnete: Längs- und Querlenker, McPherson-Federbeine sowie Stabilisatoren vorn und hinten. Großdimensionierte, gelochte, innenbelüftete Bremsscheiben mit Vierkolbensätteln aus Aluminium, rot lackiert: Schließlich sollte alles, was gut war, auch schön aussehen.

Mit neuem Motor – 2893 cm³ Hubraum, 265 PS – starteten Cayman und Boxster in das Modelljahr 2009. Der Cayman S und seine sportlich abgespeckte Variante „R" verfügten über 3436 cm³ Hubraum, aus dem 330 PS quollen. Dank PDK erzielte er einen Sprintwert unter fünf Sekunden, und auch mit seinen 282 km/h rückte der „R" dem Elfer bedrohlich nahe. Erneute Reminiszenz an den 550 Spyder: ein Leichtgewicht namens Boxster Spyder, bis 2011 in 1667 Exemplaren gebaut.

Comme *concept car* présenté à Detroit en 1993, et comme véhicule de démonstration qui a fait des merveilles chez les concessionnaires en 1996, le Boxster avait déjà fait sensation 10 000 commandes en aveugle. Par manque de capacité à Zuffenhausen, une partie de la production avait dû être externalisée en Finlande, où 109 213 exemplaires ont vu le jour jusqu'en 2004. Le Boxster – mélange de roadster et de boxer devait s'inspirer de la sportive emblématique 550 Spyder. Grâce à son moteur central, il offre deux coffres, bien qu'ils ne soient pas très volumineux. Cette voiture (type 986) équipée d'un moteur boxer six cylindres refroidi par eau avait d'abord maintenu, avec 204 ch, un écart respectable par rapport à la 911, star de la marque. La puissance est passée à 260 ch en plusieurs étapes d'évolution

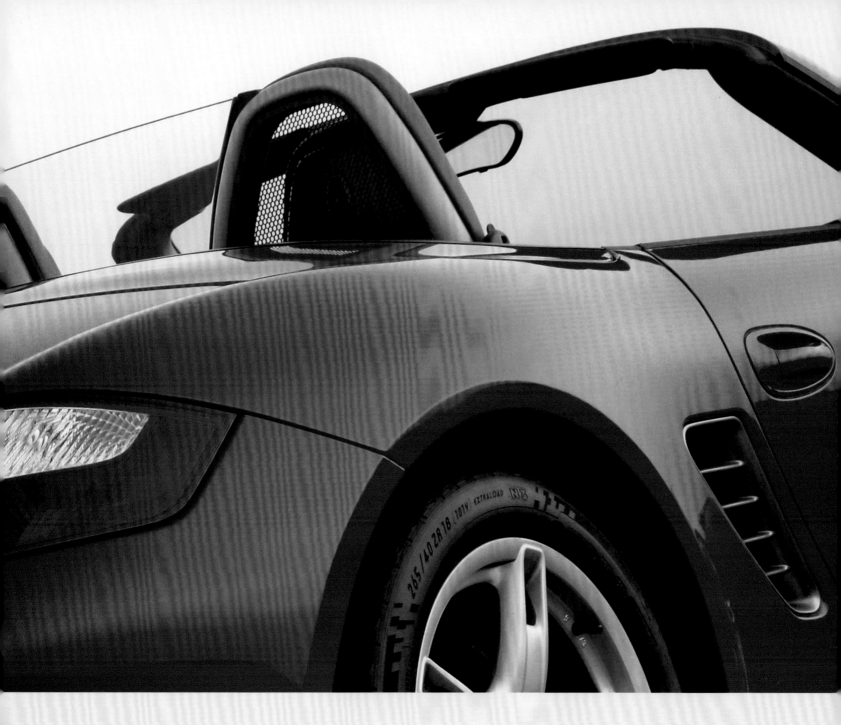

Couronnement de cette politique de la force : l'édition spéciale du Boxster S «50 ans du 550 Spyder» avec 266 ch, dont les 1953 unités produites, chiffre symbolique, sont de préférence peintes en argent métallisé GT comme leur ancêtre. Une multitude d'innovations – une puissance encore plus poussée et des retouches esthétiques qui rendent le Boxster encore plus imposant – se manifestent dans le nouveau type 987. L'année modèle 2007 s'est accompagnée d'une autre augmentation de puissance, de désormais 245 ch pour le modèle de base.

Deux ans plus tôt, sur l'IAA de Francfort en 2005, le Cayman (type 987c) avait comblé le fossé entre le Boxster et la 911 dans la savante hiérarchie de Porsche. Sa structure rigide crée un jeu entre éléments convexes et concaves. Autres éléments distinctifs : prises d'air béantes à l'avant, taille marquée, courbe audacieuse des ailes, et grand hayon. Avec un volume total de 410 litres réparti entre les deux coffres, la place ne manque pas.

Mais le déploiement de puissance ne laissait lui non plus rien à désirer, car – tout comme, un peu plus tard, le Boxster S – le Cayman S puisait 295 ch et un couple maximal de 340 Nm dans une cylindrée de 3387 cm³, ce qui l'emmenait à 275 km/h. Le système VarioCam Plus de Porsche optimisait le couple dans les régimes inférieurs et la puissance dans les régimes supérieurs. La transmission à six rapports et le Tiptronic S à cinq rapports en option étaient parfaitement adaptés à ce profil, tandis que le châssis accompagnait avec sérénité les forces allègrement déployées : bras transversal et longitudinal, suspension McPherson et stabilisateurs à l'avant et à l'arrière. Grands disques de frein perforés et ventilés de l'intérieur avec étriers à quatre pistons en aluminium, laqués rouge : car enfin, ce qui est bon doit aussi être beau.

Le Cayman et le Boxster ont commencé l'année modèle 2009 avec un nouveau moteur – cylindrée de 2893 cm³, 265 ch. Le Cayman S et sa variante sportive «R» allégée disposaient d'une cylindrée de 3436 cm³ dont jaillissaient 330 ch. Grâce à la boîte PDK il atteignait les 100 km/h en moins de cinq secondes, et avec ses 282 km/h il s'approchait dangereusement de la 911. Autre souvenir du 550 Spyder : le poids plume du Boxster Spyder, acheté à 1667 exemplaires jusqu'à 2011.

Boxster & Cayman (986, 987)

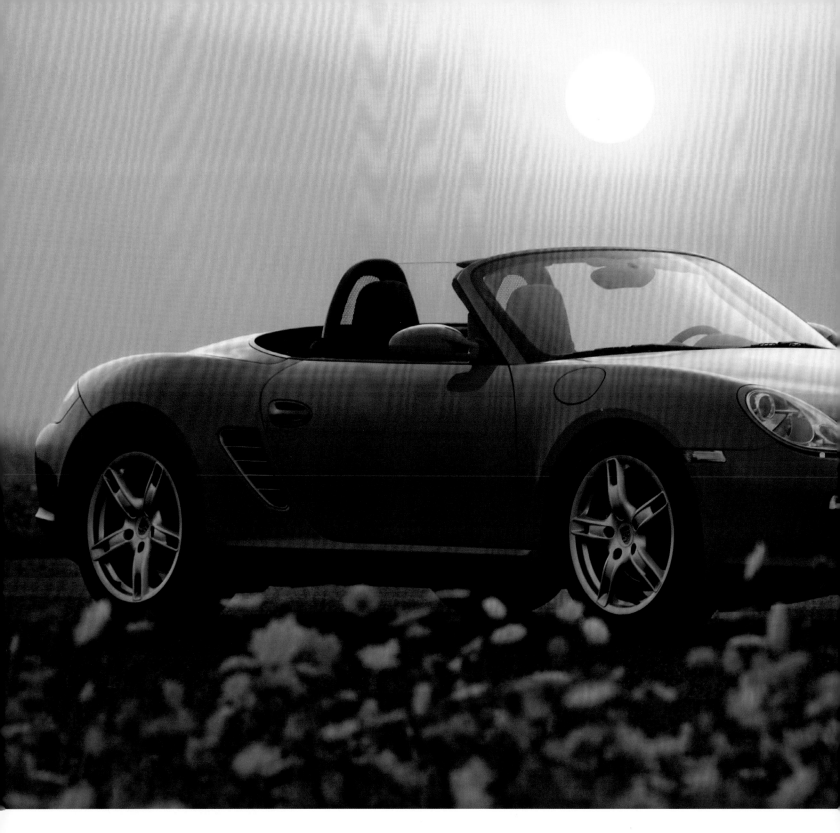

The face of the second-generation Boxster approaches that of the ongoing 911 once again, with oval headlights, separate fog lamps and larger air-intake vents, as well as a front lid that has also been given new contours.

Das Antlitz des Boxsters der zweiten Generation nähert sich wieder dem aktuellen Elfer an, mit anders geformten Scheinwerfern, separaten Bugleuchten, vergrößerten Lufteinlässen und einer neu konturierten Fronthaube.

Le style du Boxster de la deuxième génération se rapproche légèrement de celui de l'actuelle 911, mais avec des phares de forme différente, des optiques arrière séparées, des prises d'air de plus grandes dimensions et un capot avant redessiné.

In just twelve seconds, the electric soft top of the Boxster grants access to sun and wind or efficiently blocks them out. When open, it vanishes from view completely behind the two sturdy rollover bars.

In lediglich zwölf Sekunden gewährt das elektrische Faltverdeck des Boxsters Zugang für Sonne und Wind oder sperrt diese nachhaltig aus. In geöffnetem Zustand verschwindet es rückstandsfrei hinter den Sturzbügeln.

Douze secondes seulement suffisent pour replier la capote du Boxster ou protéger ses occupants du soleil ou du vent. Repliée, elle disparaît sans bossage disgracieux derrière les arceaux de sécurité.

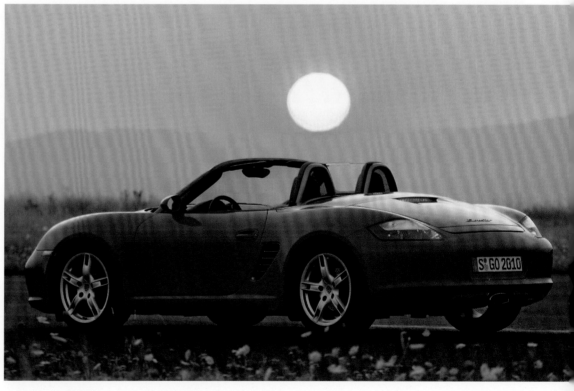

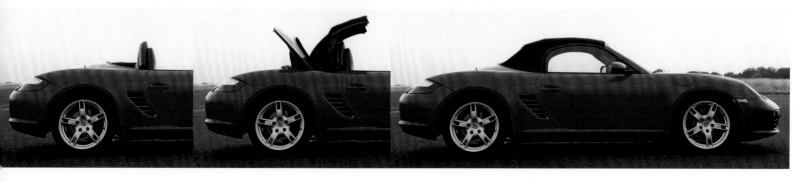

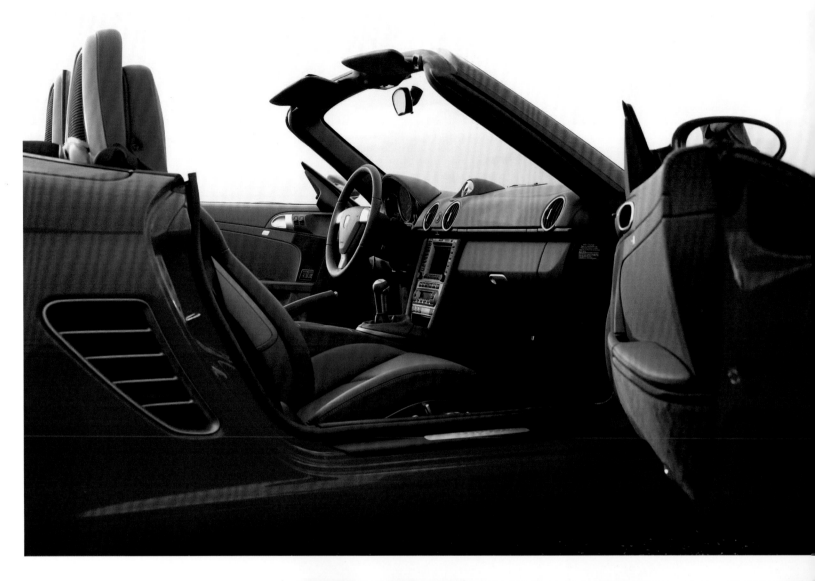

The resemblance of the 2005 version to its 997 sibling is also visible in the cockpit. Behind the height-adjustable steering wheel, three round instruments, slightly slotted into each other, provide the maximum information in the limited space.

Auch hinsichtlich seines Cockpits lehnt sich die Evolutionsstufe von 2005 an den 997 an. Hinter dem höhenverstellbaren Lenkrad halten drei leicht verschachtelte Rundinstrumente gedrängte Information bereit.

Par son cockpit aussi, l'évolution de 2005 se rapproche de la 997. Derrière le volant réglable en hauteur, trois instruments circulaires mordant légèrement l'un sur l'autre diffusent le maximum d'information sur un espace limité.

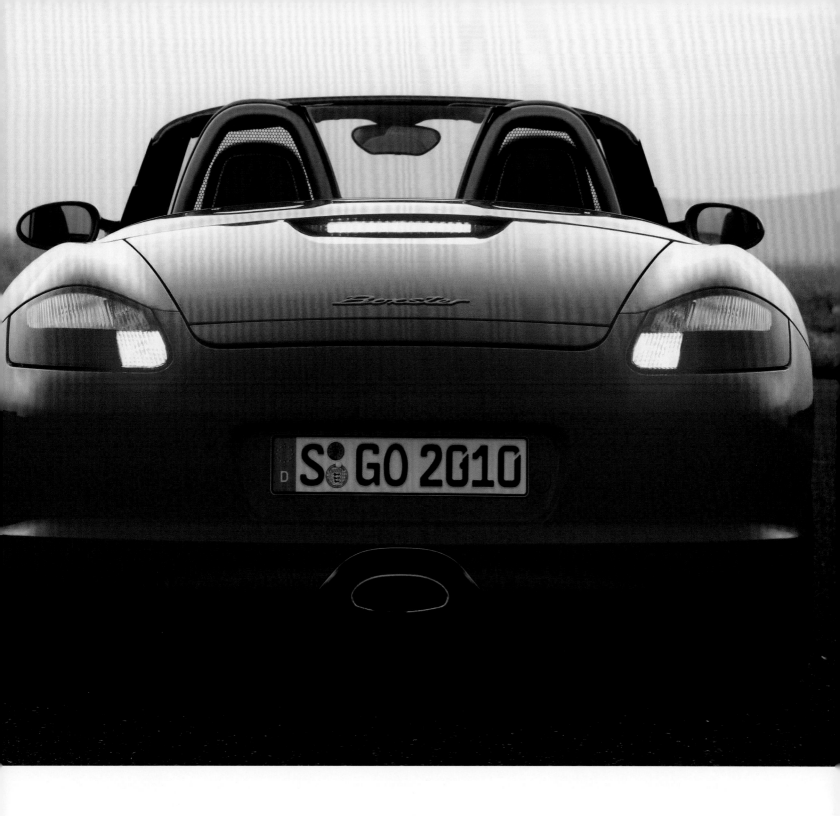

With regard to the Boxster's rear quarters there have been no essential changes, though the tail of the new car (code-named 987) offers a somewhat more muscular physique due to oblique interstices.

Wesentliche Einschnitte hat es bei der Gestaltung des Hinterviertels nicht gegeben. Allerdings wirkt das Heck des neuen Boxsters (Code 987) durch schräg nach oben geführte Trennfugen kraftvoller.

Rien d'essentiel n'a changé dans le dessin de la poupe. La croupe du nouveau Boxster (code 987), elle, séduit en revanche par son physique plus musclé grâce aux fentes obliques.

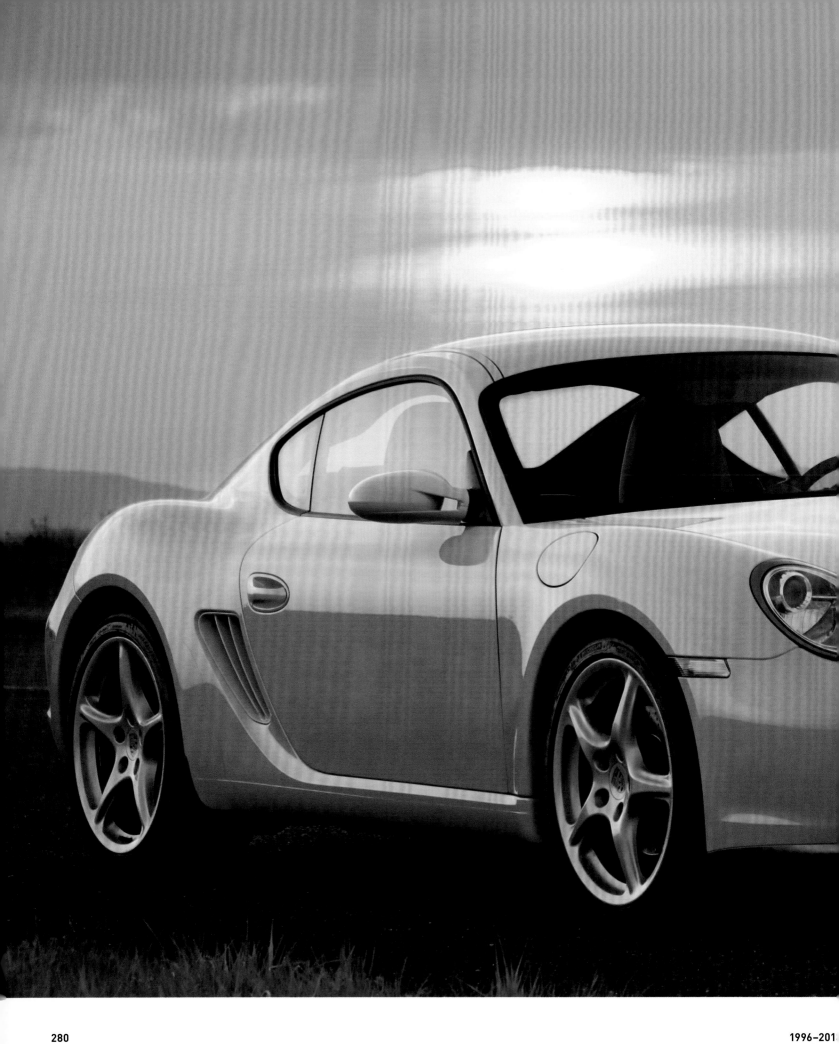

The line of the Cayman is without doubt a lucky strike, both similar to the 911 and different from the big brother, with a lot of attractive details. It certainly possesses all of the bite of the reptile that provided its name.

Die Linienführung des Cayman ist zweifellos ein großer Wurf, ähnlich dem Elfer und doch ziemlich anders, mit vielen schönen Details. Und: Sie verheißt den ganzen grimmigen Biss der Panzerechse, die dem Modell den Namen spendete.

Le dessin du Cayman est incontestablement une grande réussite ; bien que proche de la 911, il est malgré tout totalement différent et regorge de jolis petits détails. Et, surtout, il possède l'aspect hargneux du reptile qui lui a donné son nom.

With a capacity of
5.3 cu.ft. the front
baggage compartment
corresponds to the
Boxster's format. The
rear trunk holds up to
6.5 cu.ft. below the lower
edge of the window or
9.2 cu.ft. when stowed
away up to the roof, so
the passengers need
not economize.

Der vordere Kofferraum
entspricht mit 150 Litern
Volumen dem Format
des Boxsters. Der hintere
fasst 185 Liter bis zur
Scheibenunterkante oder
260 Liter bis unters Dach.
Die beiden Insassen
sind somit gut bedient.

Avec 150 litres, le coffre
avant a une capacité
identique à celui du
Boxster. La malle
arrière offre un volume
de 185 litres, jusqu'aux
vitres, ou de 260 litres,
jusqu'au toit. Les deux
passagers n'ont donc
pas de soucis à se faire.

From June 1997, the employees of Dr. Ing. h.c. F. Porsche AG could be reached at the telephone number 911-0, not least an expression of the marque's commitment to its mainstay, the 911. That year's Frankfurt IAA saw its latest sibling code-named 996. This time, three sacred cows had been slaughtered and dispensed with clandestinely. On the one hand the youthful classic shared 38 per cent of its parts with the new entry-level Porsche Boxster, such as the complete nose section including boot, the basically identical cluster of headlamps and turn indicators—bad-mouthed by die-hard purists as the "lachrymal sac" or "fried-egg" look—as well as the doors. On the other, chief stylist Harm Lagaay had smoothed everything out, incorporating a flattened windshield and the pleasant rotundity of the roof that resulted from it, along with slightly curved side windows. Gone were the drip moldings, a fossil from days of yore. The 996 had become 7¼" longer and 1¼" wider, its wheelbase extended from the former 89½" to 92½", for the good of both the passengers and their baggage.

Thirdly, the flat six was cooled by water, now with four valves per combustion unit, 3387 cc and 4.6" distance between its cylinders, leaving enough space for future displacement increases. With 300 bhp, it mobilized 15 more than its 3.6-liter predecessor 993, with a torque of 258 lb-ft at 4600 rpm rather than 251 lb-ft at 5250 rpm. More low-end power and a free respiratory tract at higher revs were provided not only by the switch-over intake system but also by the variable control of the two intake camshafts. To the boundless joy of the strictly conservative 911 camarilla, the wonderfully potent sawing *bel canto* typical of the model had hardly been affected at all, with a little help from 50-odd sound engineers in the service of the make. That it scaled a hundredweight less also helped to further the latest Carrera's agility.

At the 1998 Geneva salon the Convertible was unveiled, upgraded yet again by two preloaded roll bars shooting up as soon as a rollover threatened, and a two-shell aluminum hardtop included in the basic price of 154,000 marks. At the Paris show in fall a titanium-colored "4" at the rear betrayed the presence of four-wheel drive. The visco clutch necessary to split torque depending on conditions was now situated at the front differential rather than the gearbox in the rear, which allowed installing the Tiptronic option. Again at Geneva, the GT3 made its entry in 1999, propelled by a derivative of the GT1's engine, though without forced induction, with five millimeters more bore and two millimeters more stroke, new camshafts, VarioCam, an 11.7:1 compression ratio and 360 bhp.

The Turbo appeared at that year's Frankfurt IAA, its 420 bhp biturbo power plant also derived from that of 1998's Le Mans winner, with 3598 cc like the GT3's aggregate, but otherwise based on the Carrera 4. The program's spearhead, presented at Detroit in January 2001, was the 911 GT2, with 462 bhp and 457 lb-ft, featuring the chassis of the GT3 and the engine of the Turbo, put under more pressure by bigger chargers.

Schon in der Sammelnummer für die Mitarbeiter der Dr. Ing. h.c. F. Porsche AG ab Juni 1997 schlug sich das unverbrüchliche Bekenntnis zum Elfer nieder: 911-0. Der Elfer – das war ab der Frankfurter IAA jenes Jahres der Typ 996, und gleich drei mit der Patina der Tradition überzogene Grundsätze hatte man zum Sperrmüll der Geschichte gestellt. Zum Ersten teilte der jugendfrische Klassiker kostensparend 38 Prozent seiner Bauteile mit dem neuen Einstiegs-Porsche Boxster, etwa den kompletten Vorderwagen inklusive Kofferraum und das mäkelnd-kontrovers aufgenommene Leuchtenensemble („Spiegelei-Look") sowie die Türen. Zum Zweiten hatte ihn Chef-Stylist Harm Lagaay überall geglättet, die Windschutzscheibe flacher angeordnet, das Dach hübsch gerundet, die Seitenscheiben sanft gekrümmt und die Regenrinnen heraustranchiert. Der 996 war 185 mm länger und 30 mm breiter geworden, sein Radstand von den traditionellen 2272 auf 2350 mm gewachsen, alles Maßnahmen zum Wohle der Passagiere und der Dinge, die sie so mit sich führten.

Zum Dritten kühlte Wasser den Sechszylinder-Boxer, nun ein Vierventiler von 3387 cm³ und 118 mm Abstand zwischen den Zylindern, genügend Substanz für noch mehr Volumen in der Zukunft. Mit 300 PS mobilisierte er 15 PS mehr als sein Vorfahr mit 3,6 Litern im 993 (Drehmoment 350 Nm bei 4600/min statt 340 Nm bei 5250/min). Schaltsaugrohr und variable Steuerung für die beiden Nockenwellen der Einlassventile sorgten für energischen Durchzug und freie Atemwege bei hohen Drehzahlen. Zu ihrem Ergötzen wurden die Elfer-Fundamentalisten mit dem gewohnten heiseren Sägen beschallt, sensibel komponiert von über 50 Ingenieuren, die von Berufs wegen für den guten Ton zuständig waren. Munterer wurde der jüngste Carrera überdies durch einen Zentner Mindergewicht.

Wie gewohnt setzte hurtig die Ausweitung der Palette ein. Auf dem Genfer Salon 1998 folgte das Cabriolet, erneut aufgewertet durch zwei vorgespannte stählerne Überrollbügel und ein im Basispreis von 154 000 Mark einbegriffenes Hardtop aus Aluminium. Auf der Pariser Show im Herbst kündete eine titanfarbene 4 auf dem Heck vom Allradantrieb. Die Visco-Kupplung zur situationsgerechten Zuteilung der Kraft war indessen nicht länger dem Getriebe, sondern dem vorderen Differential zugeordnet, was etwa die Option Tiptronic zuließ. Wiederum in Genf debütierte 1999 der GT3, im Heck einen Ableger des GT1-Triebwerks, allerdings ohne Auflladung, mit fünf Millimetern mehr Bohrung und zwei Millimetern mehr Hub, neuen Nockenwellen, VarioCam, auf 11,7:1 erhöhter Verdichtung und 360 PS stark.

Bis zur Frankfurter IAA ließ der geladene 996 bitten, auch sein mit 420 PS auftrumpfender Biturbo ein enger Verwandter des Le-Mans-Siegers von 1998 mit 3598 cm³ wie der GT3, ansonsten im Carrera 4 wurzelnd. Speerspitze war gleichwohl, im Januar 2001 in Detroit erstmalig gezeigt, der 911 GT2 mit 462 PS und 620 Nm, mit dem Fahrwerk des GT3 und der durch größere Lader unter Druck gesetzten Maschine des Turbo.

Dès juin 1997, le numéro de dossier qui circule dans les couloirs de la société Porsche est le 911-0. Derrière lui se cache un monument de l'automobile. Et l'IAA de Francfort de 1997 marque un tournant : avec le type 996 de la 911, la firme de Zuffenhausen a jeté par-dessus bord trois principes fondamentaux. Tout d'abord, pour réduire les coûts, cette classique déjà expérimentée partage 38 % de ses composants avec la nouvelle Porsche d'entrée de gamme, la Boxster. En l'occurrence, toute la partie avant, coffre compris, les optiques (surnommés « œufs sur le plat »), ainsi que les portières.

Ensuite, le chef styliste, Harm Lagaay, a lissé toutes ses lignes, fait incliner encore plus le pare-brise, joliment arrondi le toit, conféré un galbe modéré aux vitres latérales et tranché les gouttières

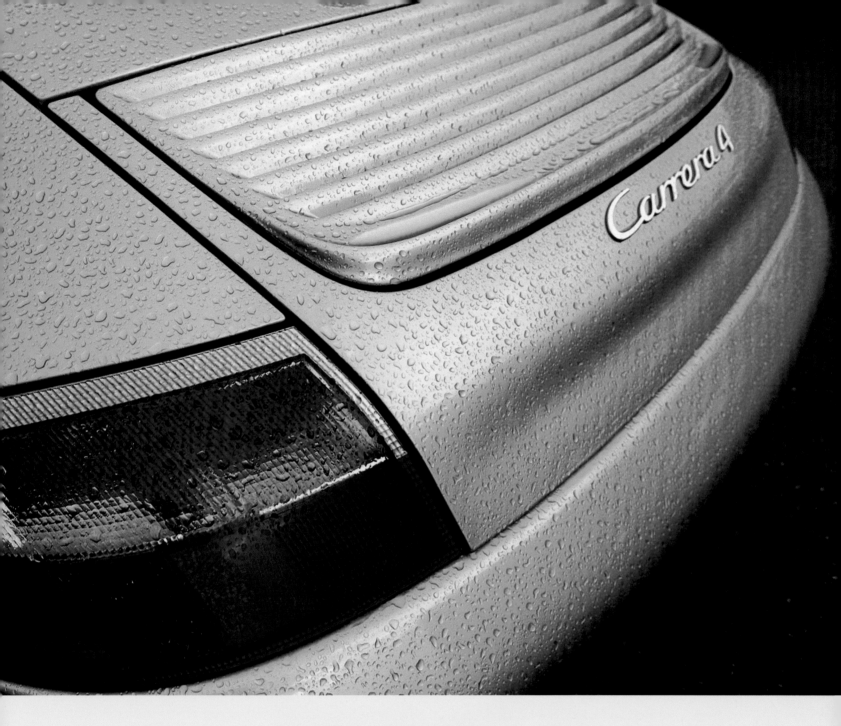

au scalpel. La 996 s'est allongée de 185 mm et élargie de 30 mm, alors que son empattement a abandonné la cote traditionnelle de 2272 mm pour passer à 2350 mm, un étirement dont les passagers et leurs bagages peuvent profiter.

Troisième grand changement, c'est de l'eau qui refroidit désormais le *flat-six*, le boxer étant maintenant un quatre-soupapes de 3387 cm³ avec un entraxe de 118 mm, ce qui laisse suffisamment de marge pour augmenter la cylindrée à l'avenir. Avec 300 ch, il mobilise 15 ch de plus que son prédécesseur de 3,6 litres équipant la 993 (son couple est de 350 Nm à 4600 tr/min au lieu de 340 Nm à 5250 tours). Un collecteur d'aspiration à résonance et une distribution variable pour les deux arbres à cames entraînant les soupapes d'admission garantissent des reprises énergiques et une

bonne respiration à haut régime. Les mordus de la 911 retrouvent leur ronronnement favori, légèrement retravaillé par une cinquantaine d'ingénieurs. La toute dernière Carrera a, en outre, gagné en agilité grâce à un allégement d'une cinquantaine de kilos.

Comme de coutume, la gamme s'est rapidement enrichie. Le Salon de Genève de 1998 voit l'arrivée du cabriolet, plus attrayant grâce à deux arceaux de sécurité en acier prétendus et un hard-top en aluminium compris dans le prix de base de 154 000 marks. Pour le Salon de Paris, à l'automne, un 4 de couleur titane sur le capot arrière témoigne de la présence de la transmission intégrale. Le viscocoupleur, qui assure la répartition du couple en fonction de la situation, n'est, en revanche, plus accolé à la boîte de vitesses, mais au différentiel avant, ce qui rend ainsi possible l'option Tiptronic. C'est de nouveau

à Genève, en 1999, que la GT3 fait ses premiers pas, avec un moteur extrapolé de celui de la GT1, mais sans suralimentation, avec 5 mm de plus pour l'alésage et 2 mm de plus pour la course, de nouveaux arbres à cames, la Variocam, un taux de compression majoré à 11,7:1 et une puissance de 360 ch.

Il faut attendre l'IAA de Francfort pour découvrir la 996 suralimentée, dont le biturbo de 420 ch est proche du moteur victorieux au Mans en 1998 avec une cylindrée de 3598 cm³ comme pour la GT3, et, pour le reste, dérivée de la Carrera 4. Mais le fer de lance de Porsche est, en réalité, la 911 GT2 de 462 ch et 620 Nm, dévoilée en janvier 2001 à Detroit, qui reprend le châssis de la GT3 et le moteur de la Turbo gavé par des turbocompresseurs de plus grandes dimensions.

911 (996)

In the 996, the outer appearance of the 911 has basically been adjusted in an elegant and flowing fashion to the chassis, which has become a lot wider in the course of time. The transition of the windshield into the roof is also more fluent.

Im Grunde genommen wird mit dem 996 das äußere Erscheinungsbild des Elfers auf elegante und flüssige Weise auf das breiter gewordene Fahrwerk abgestimmt. Fließender geht auch die Windschutzscheibe in das Dach über.

Le châssis élargi de la 996 s'adapte avec élégance et fluidité à l'allure générale de la 911. La transition entre le pare-brise et le toit est également plus douce.

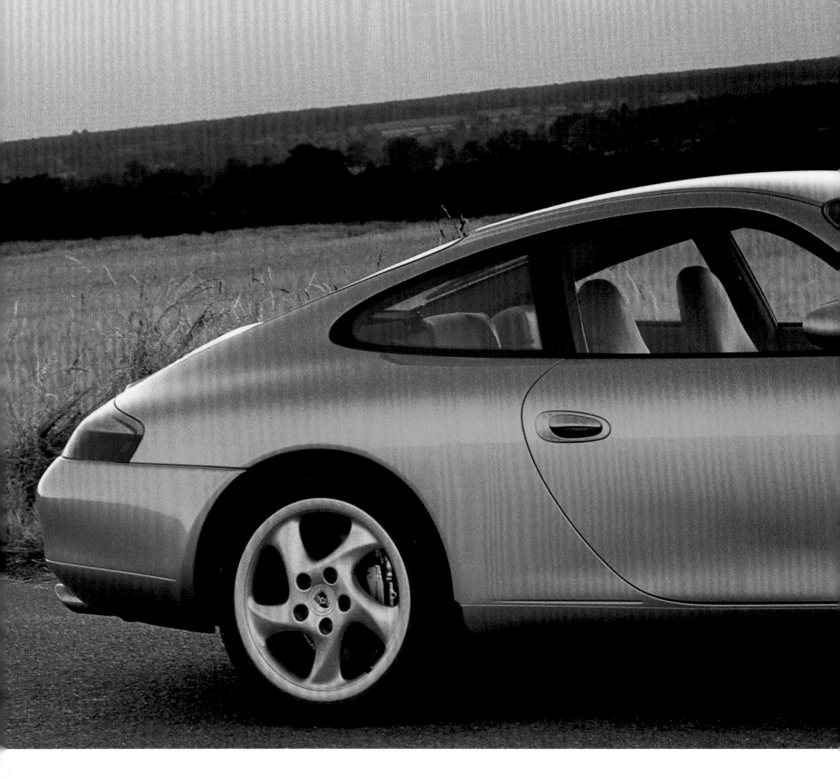

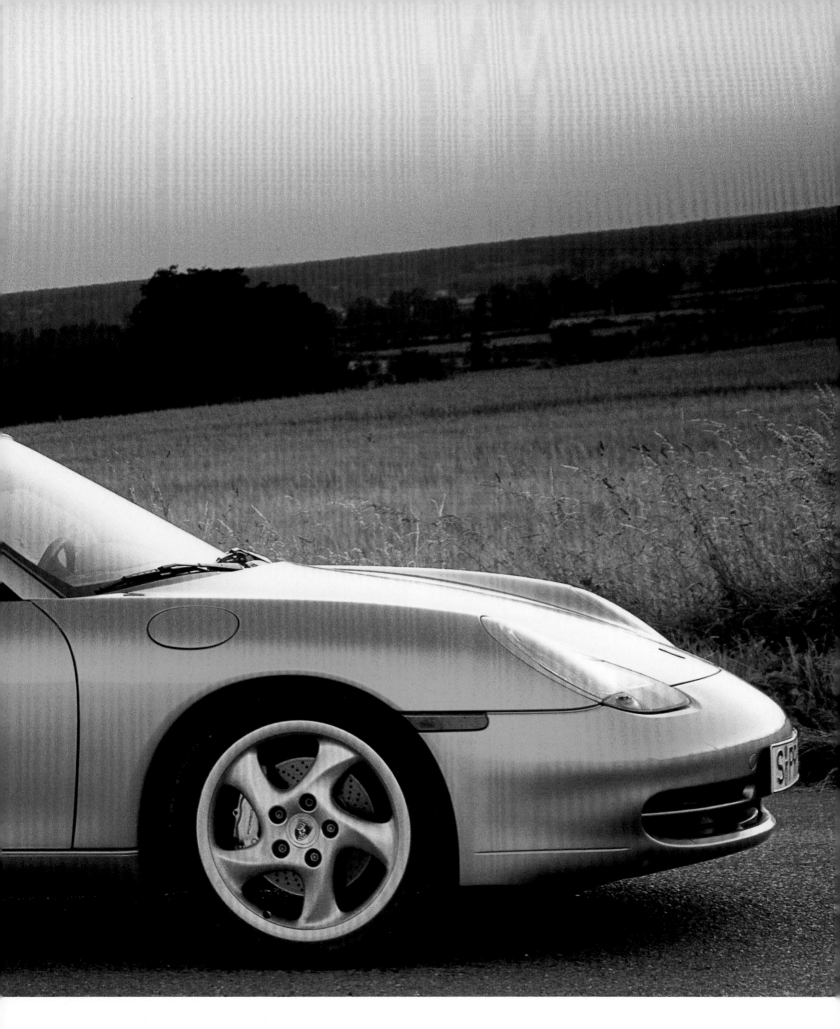

The enormously torsion-resistant Cabriolet has been developed in step with the Coupé. Its soft top can be opened and closed in a mere 20 seconds. It can be actuated by means of a switch in the central console as well as by remote control triggered by the ignition key or by further pressing it in the door lock .

Das ungemein verwindungsresistente Cabriolet ist parallel zum Coupé entwickelt worden. Sein Verdeck öffnet und schließt sich in jeweils 20 Sekunden, was mit einem Schalter in der Mittelkonsole, per Funk über den Zündschlüssel oder durch weiteren Druck auf diesen im Türschloss ausgelöst werden kann.

Le cabriolet d'une rigidité à la torsion exceptionnelle a été conçu en même temps que le coupé. Sa capote s'ouvre et se ferme en 20 secondes en appuyant sur le bouton de la console médiane, la liaison radio de la clé de contact ou en exerçant sur elle une nouvelle pression après l'avoir glissée dans la serrure de la portière.

Again the rear pop-up wing can be activated by hand. Below it a radical breach with the 911 tradition has taken place as the flat six with its four camshafts and 24 valves goes about its business water-cooled.

Wieder kann der Heckflügel auch manuell aktiviert werden. Darunter ist es zu einem radikalen Bruch mit der Elfer-Tradition gekommen: Der Sechszylinder-Boxer mit vier Nockenwellen und 24 Ventilen verrichtet nun seine Arbeit von Wasser umspült.

Il est de nouveau possible d'actionner à la main le becquet arrière. Mais la rupture avec la tradition de la 911 est brutale sous celui-ci : le *flat-six* à quatre arbres à cames et vingt-quatre soupapes est désormais refroidi par eau.

The passengers' tract
of the 997 can hardly
be improved, also in
visual and haptic terms.
Typically and inevitably,
accommodation in
the second row is
cramped. A conspicuous
detail in this car is
the selector lever of
the Tiptronic S with its
five drive positions.

Am Wohntrakt des 997
gibt es, auch optisch und
haptisch, kaum noch
etwas zu optimieren. Die
Sitzverhältnisse hinten
sind artenspezifisch
beengt. Auffälliges
Detail: der Wählhebel
für die Tiptronic S mit
ihren fünf Fahrstufen.

Que pourrait-on encore
optimiser, sur le plan
de l'esthétique et du
toucher, dans l'habitacle
de la 997 ? Par nature,
l'habitabilité à l'arrière
est symbolique. Détail
frappant : le pommeau de
vitesse de la Tiptronic S
avec ses cinq rapports.

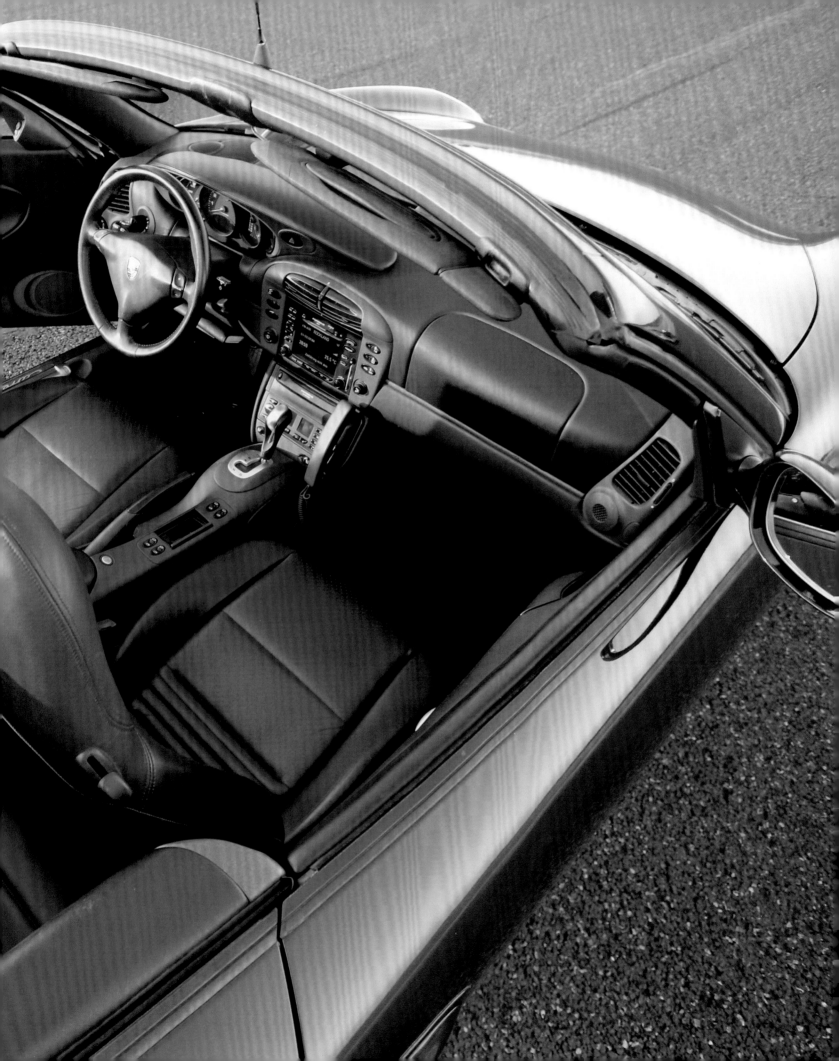

The premium 996 version, the GT3, hardly stands out against the base model, with a differently shaped bow, rather inconspicuous side sills, its own 18-inch wheels, brake calipers in aggressive red and fixed rear wing.

Nur wenig hebt sich das 996-Spitzenprodukt GT3 vom Ausgangsmodell ab, durch eine andere Bugpartie, eher unauffällige Seitenschweller, eigene 18-Zoll-Räder, Bremssättel in aggressivem Rot, einen starren Heckflügel.

La GT3, la version la plus sophistiquée de la gamme 996, se distingue très peu du modèle d'origine, si ce n'est pas une proue légèrement différente, des seuils de portière très discrets, des roues de 18 pouces spécifiques, des étriers de freins d'un rouge vif et un becquet arrière fixe.

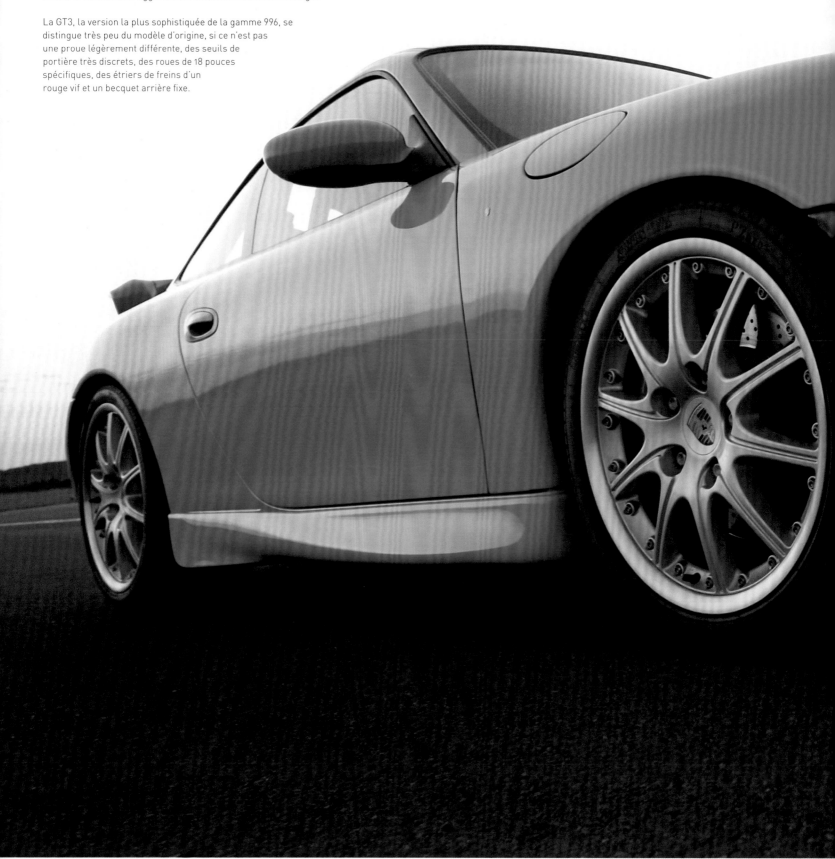

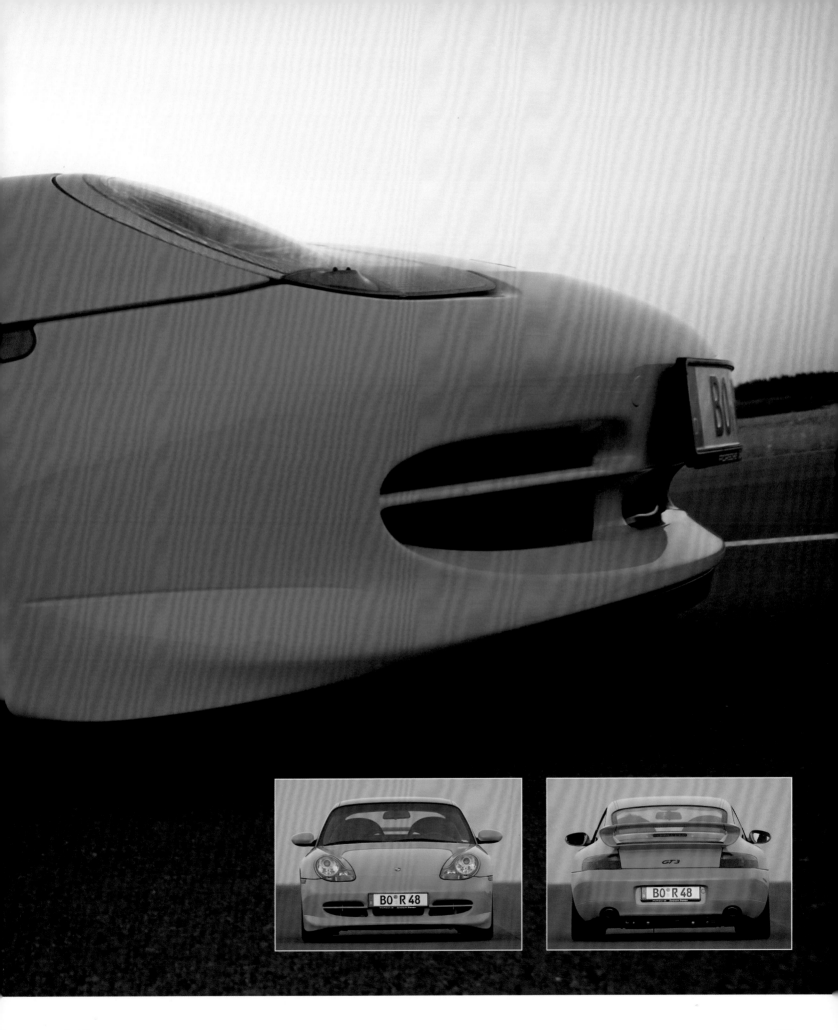

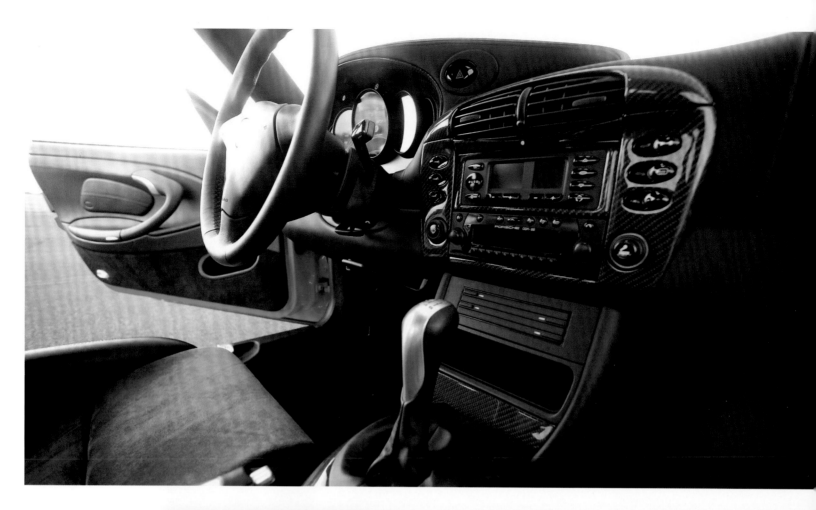

Power plant: the 3.6-liter
flat six of the GT3 harks
back on the water-cooled
unit of the Le Mans winner
GT1. With its 360 bhp
behind him, Walter Röhrl
laps the Nürburgring in
less than eight minutes.

Der 3,6-Liter-Boxermotor
des GT3 leitet sich her
vom wassergekühlten
Triebwerk des Le-Mans-
Siegers GT1. Mit seinen
360 PS im Nacken
umrundet Walter Röhrl
den Nürburgring in unter
acht Minuten.

Le moteur boxer de
3,6 litres de la GT3 est
extrapolé du groupe
refroidi par eau de la GT1
victorieuse au Mans. Avec
ses 360 ch dans le dos,
Walter Röhrl couvre un
tour du Nürburgring en
moins de huit minutes.

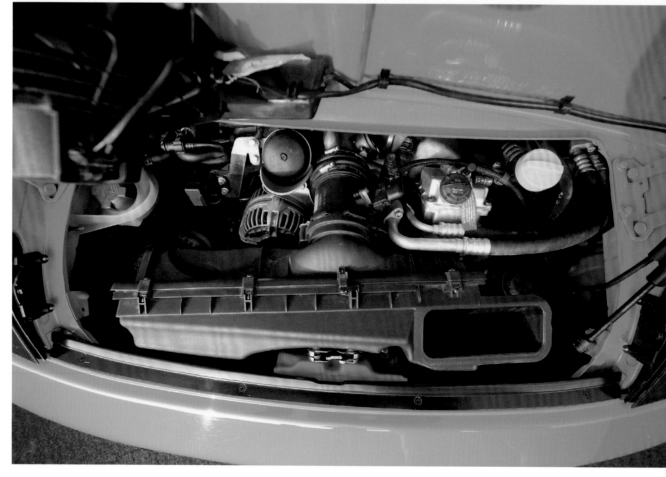

In league with a new front apron, the firmly installed claw-shaped rear wing of the GT3 does not only reduce lift but even generates slight downforce, 13 lbs at 124 mph, 30 at 186 mph.

Im Bunde mit der neuen Frontschürze verringert der fest installierte krallenförmige Heckflügel des GT3 nicht nur den Auftrieb, sondern erzeugt sogar leichten Abtrieb, sechs Kilogramm bei Tempo 200, 13,5 bei 300 km/h.

De concert avec le nouveau tablier avant, le becquet arrière fixe en forme de griffe de la GT3 ne diminue pas seulement la portance, mais produit même un léger appui, 6 kg à 200 km/h et 13,5 kg à 300 km/h.

About 80,000 of the total of 148,501 specimens of the Porsche 996 had already been built and bought, but eventually the persistent protest of the 911 community against the conspicuous partial identity with the Boxster was acted upon. At the 2001 Frankfurt IAA a thoroughly uprated version was unveiled. A new standard feature is an illuminated, lockable glove compartment beneath the airbag in front of the passenger's seat. It holds 300 cubic inches.

Rund 80000 von 148501 Einheiten des Porsche 996 insgesamt waren ihren Besitzern zugeführt worden, da trug man dem anhaltenden Protest der Elfer-Gemeinde wegen der allzu deutlich sichtbaren Teil-Identität mit dem Boxster Rechnung und präsentierte 2001 auf der Frankfurter IAA eine liebevoll überarbeitete Version. Vor dem Beifahrersitz unterhalb des Airbags findet sich nun ein abschließbares fünf Liter fassendes Ablagefach.

Environ 80000 des 148501 exemplaires de la Porsche 996 ont déjà trouvé preneur lorsque l'usine décide d'accéder aux doléances toujours plus pressantes des mordus de la 911 en raison de la trop grande parenté visuelle avec la Boxster. En 2001, à l'IAA de Francfort, est donc présentée une version modifiée sur de menus points de détail. Sous l'airbag côté passager se trouve maintenant une boîte à gants de cinq litres fermant à clé.

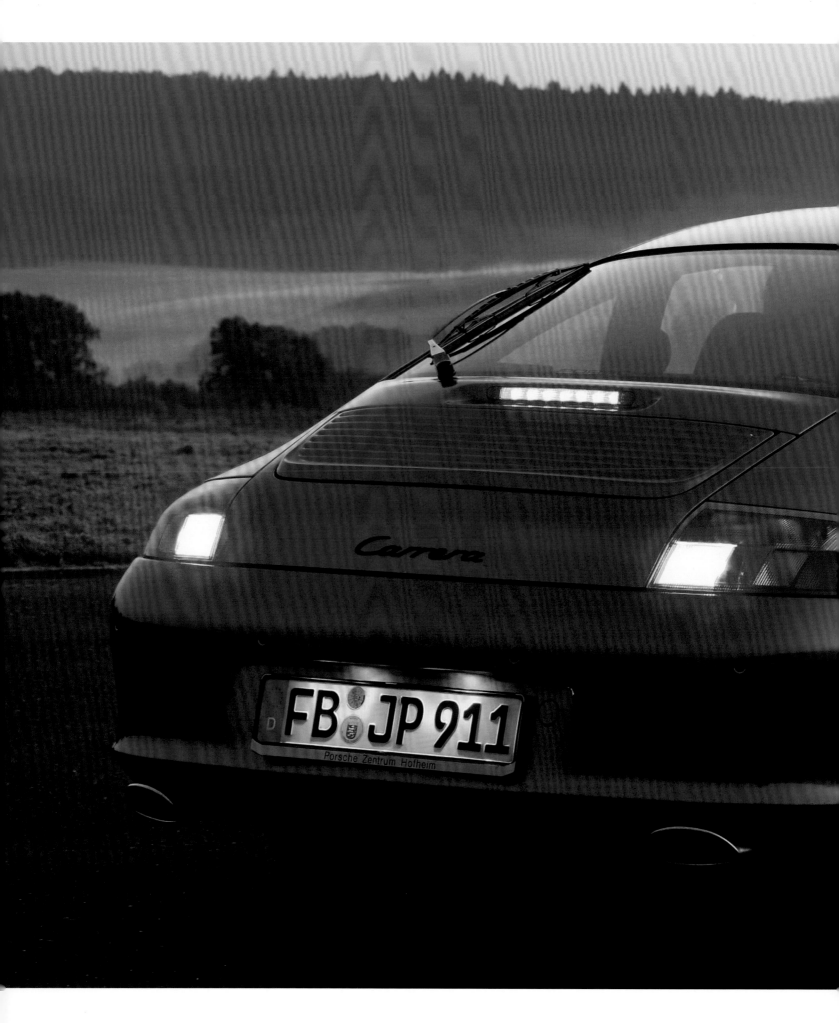

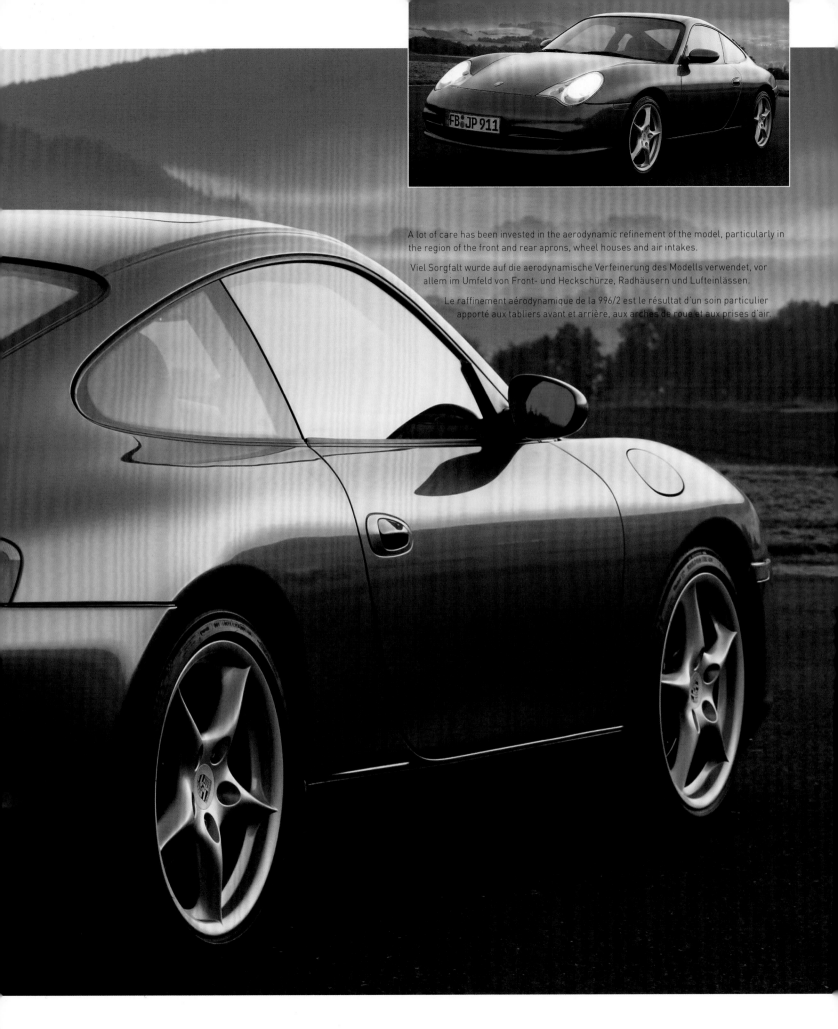

A lot of care has been invested in the aerodynamic refinement of the model, particularly in the region of the front and rear aprons, wheel houses and air intakes.

Viel Sorgfalt wurde auf die aerodynamische Verfeinerung des Modells verwendet, vor allem im Umfeld von Front- und Heckschürze, Radhäusern und Lufteinlässen.

Le raffinement aérodynamique de la 996/2 est le résultat d'un soin particulier apporté aux tabliers avant et arrière, aux arches de roue et aux prises d'air.

From the 2002 model year onwards, the Cabriolet's rear window, originally made from flexible vinyl, has been replaced by a heated backlite consisting of safety glass, which, among other things, has enhanced its winter suitability. One thing is certain though: it gives most pleasure when tucked away behind the passengers.

Ab Jahrgang 2002 wird das Heckfenster des Cabriolets aus biegsamem Vinyl durch eine heizbare Scheibe aus Sicherheitsglas ersetzt, was unter anderem seine Wintertauglichkeit aufwertet. Am meisten Freude bereitet es allerdings, wenn es gar nicht erst sichtbar wird.

Avec le millésime 2002, la lunette arrière du cabriolet en vinyle souple disparaît au profit d'une lunette dégivrante fixe en verre de sécurité, ce qui lui permet d'affronter désormais les rigueurs de l'hiver. Or c'est justement quand elle était enlevée que l'on avait le plus de plaisir.

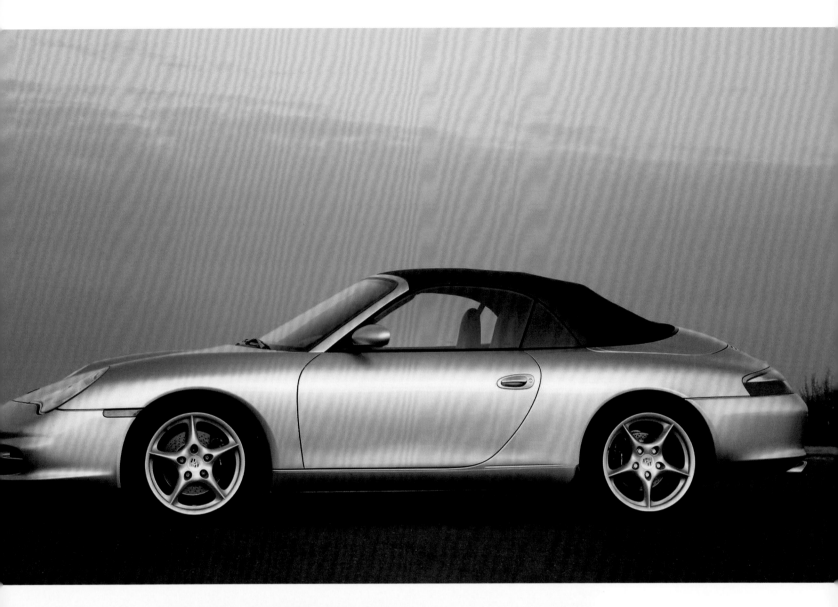

The second-generation 996 Cabriolet has become even more torsion-proof, by eleven per cent. Compared to the Coupé, it weighs 180 pounds more. But that hardly affects its sprightly temperament.

Das Cabrio der zweiten 996-Generation ist noch einmal torsionssteifer geworden, um elf Prozent. Verglichen mit dem Coupé wiegt es 80 Kilogramm mehr. Seinem Temperament aber tut das kaum Abbruch.

La version Cabriolet de la deuxième génération de la 996 a encore gagné en rigidité à la torsion, de 11%. Elle pèse 80 kg de plus que le Coupé. Cela ne porte en aucun cas préjudice à son tempérament.

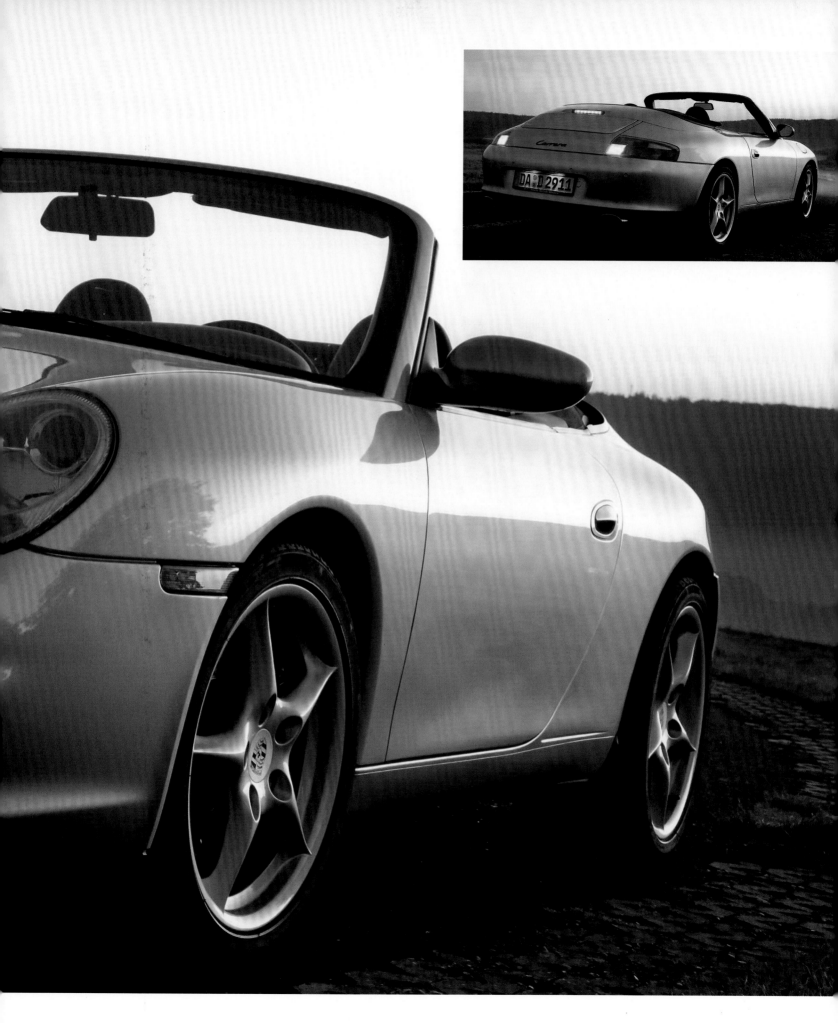

Progress has found its way into the classic cockpit, featuring a modified fascia and central console as well as a three-spoke steering wheel, for instance in the shape of a sophisticated in-board computer and navigation system. The lower third of the rev counter houses a large display able to present various messages at the same time.

In das klassisch-unantastbare Cockpit mit modifizierter Instrumententafel und Konsole sowie Dreispeichenlenkrad ist der Fortschritt eingezogen, etwa in Gestalt eines Navigationsgeräts. Die digitale Geschwindigkeitsanzeige ist jetzt im analogen Tacho enthalten.

Le classique cockpit a évolué : des instruments et une console transformés, un volant à trois branches et un ordinateur de bord avec système de navigation intégré. L'affichage numérique de la vitesse est maintenant intégré au tachymètre analogique.

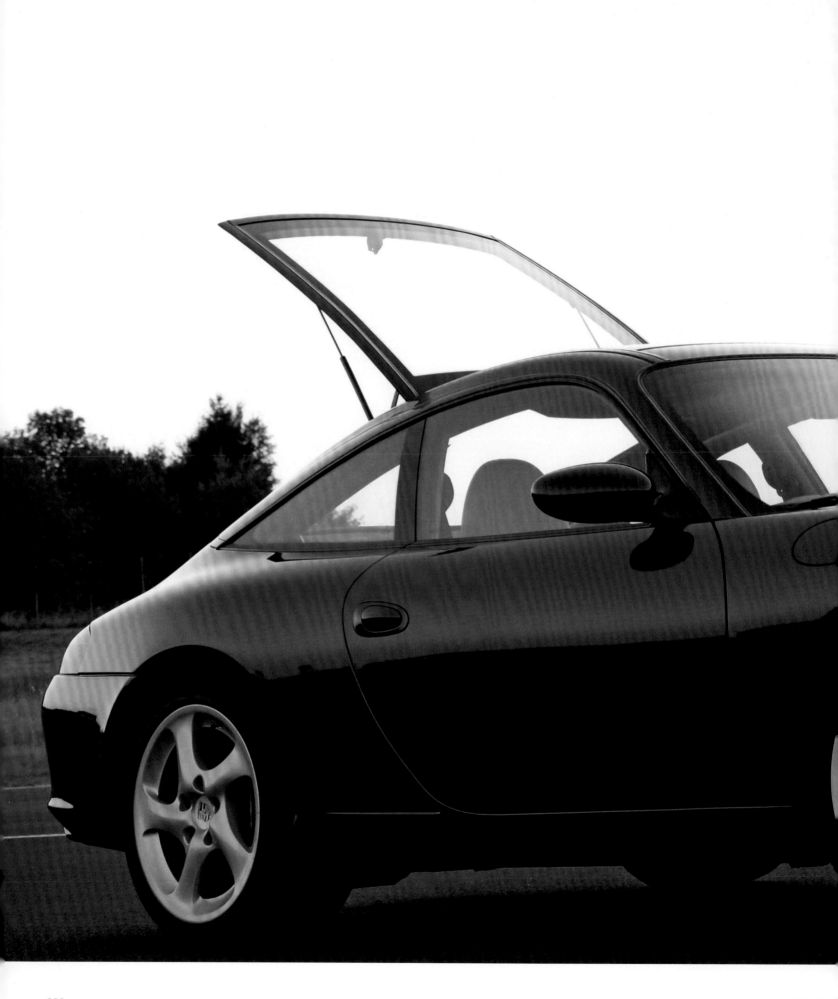

After a four-year break in which the shortcomings of the first version were eliminated, the new-type Targa is part of the model range again. Not much is left of the original Targa concept, which featured a massive roll bar.

Große Klappe, viel dahinter: Nach vier Jahren Denkpause, in der die Mängel der ersten Ausführung ausgemerzt wurden, ist der Targa neuer Art wieder mit von der Partie. Vom ursprünglichen Konzept ist nicht mehr viel übrig geblieben.

Après quatre ans d'interruption consacrée à éliminer les tares de la première mouture, la Targa nouvelle génération revient au programme. Il reste toutefois bien peu de choses du concept originel.

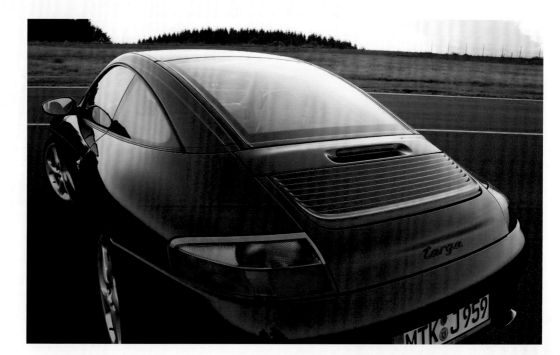

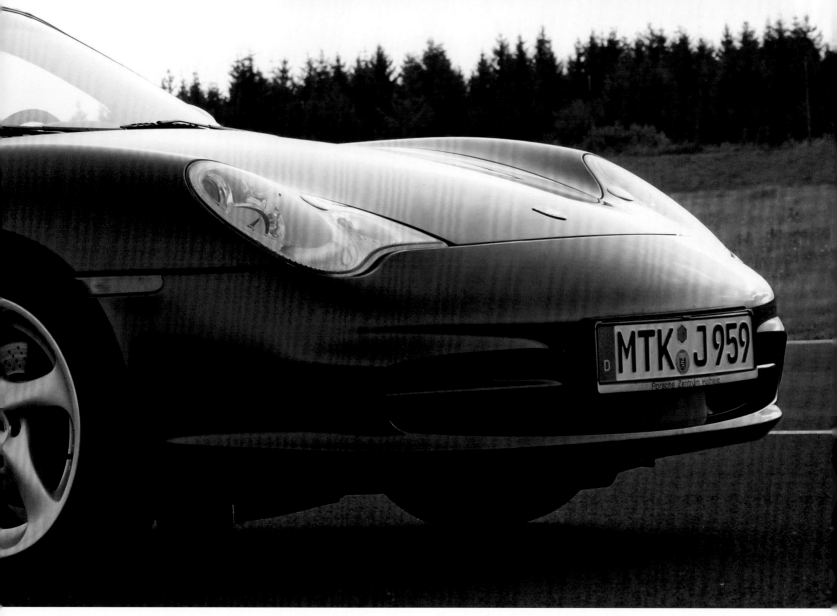

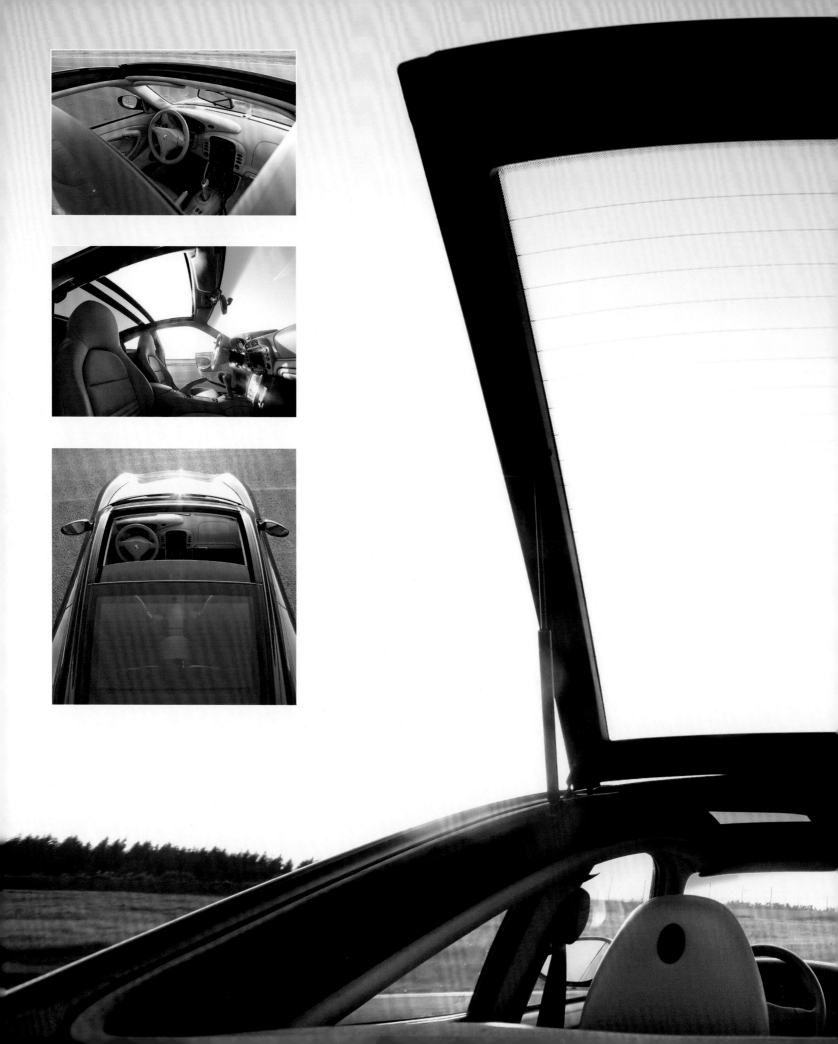

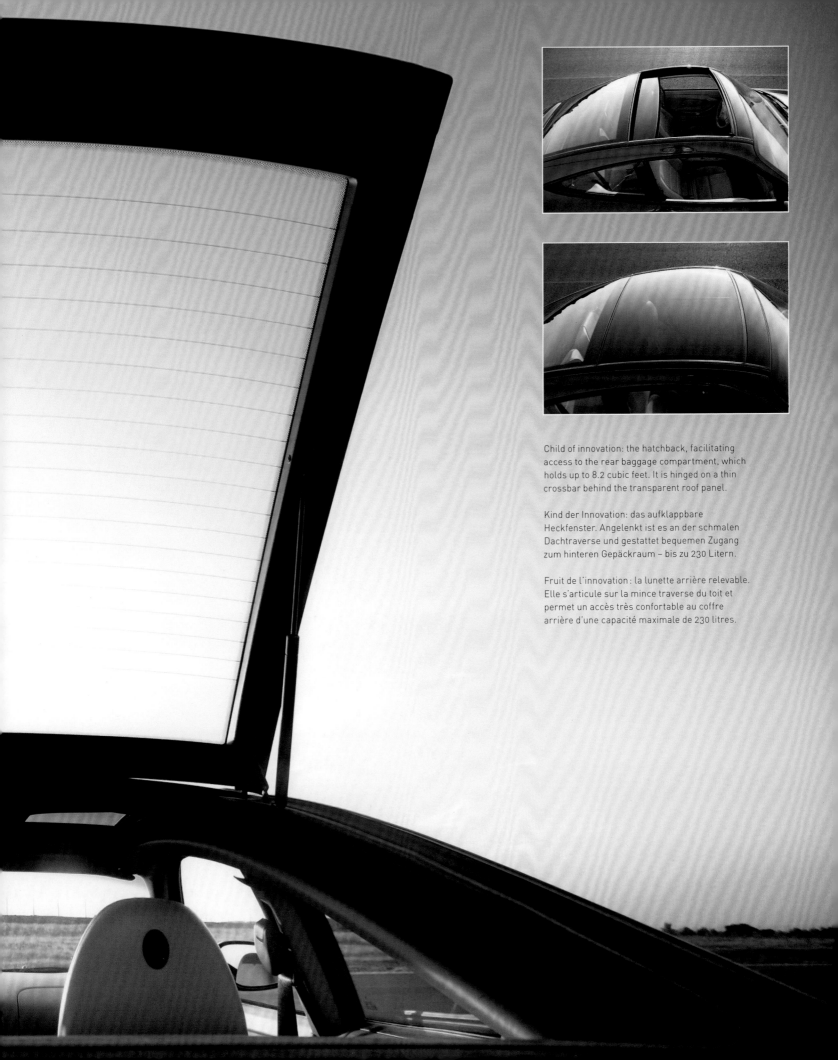

Child of innovation: the hatchback, facilitating access to the rear baggage compartment, which holds up to 8.2 cubic feet. It is hinged on a thin crossbar behind the transparent roof panel.

Kind der Innovation: das aufklappbare Heckfenster. Angelenkt ist es an der schmalen Dachtraverse und gestattet bequemen Zugang zum hinteren Gepäckraum – bis zu 230 Litern.

Fruit de l'innovation : la lunette arrière relevable. Elle s'articule sur la mince traverse du toit et permet un accès très confortable au coffre arrière d'une capacité maximale de 230 litres.

Power and glory: the chassis of the 911 Turbo (996) has been lowered by 0.4", while the rear cowling features outlet openings for the charge-air. The rear fenders have been widened by 2.6" to accommodate the model's fat 18-inch wheels comfortably.

Kraft und Herrlichkeit: Das Fahrwerk des 911 Turbo (996) wurde um zehn Millimeter abgesenkt, die Heckverkleidung durch die Austrittsöffnungen für die Ladeluft aufgebrochen. Die hinteren Kotflügel sind um 65 mm verbreitert, damit sie die fetten 18-Zoll-Räder kommod beherbergen können.

Puissance et opulence : le châssis de la 911 Turbo (996) a été abaissé de 10 mm et des sorties d'air pour l'échangeur ont été ménagées sur les côtés de la poupe. Les ailes arrière se sont élargies de 65 mm de façon à pouvoir héberger aisément les grosses roues de 18 pouces.

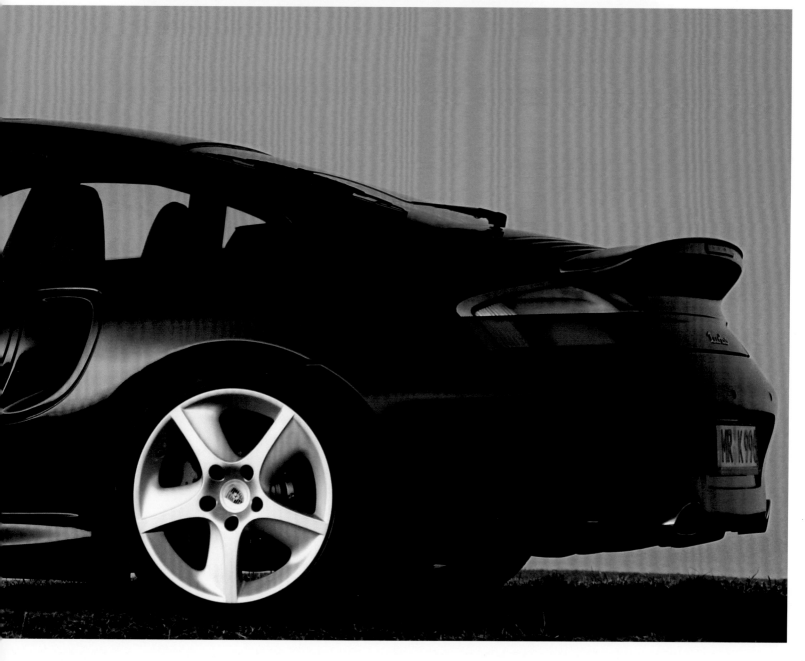

Porsche 911 (996)

313

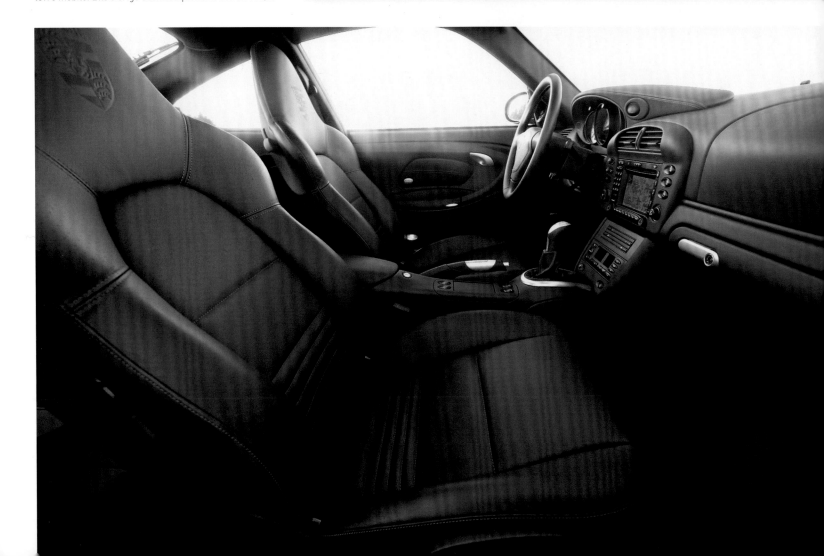

Instead of the pop-up rear wing of the naturally aspirated 911 Carrera there is a fixed spoiler with an all-new retracting element on top of it that automatically rears up into the air stream at 75 mph.

An die Stelle des ausfahrbaren Heckflügels am Saugmotor-Elfer ist ein fester Spoiler mit einem beweglichen Luftleitwerk getreten. Es reckt sich bei Tempo 120 automatisch in den Fahrtwind.

Le becquet arrière amovible de la 911 à moteur atmosphérique a fait place à un aileron fixe doté d'une lèvre mobile. Elle s'érige automatiquement dès 120 km/h.

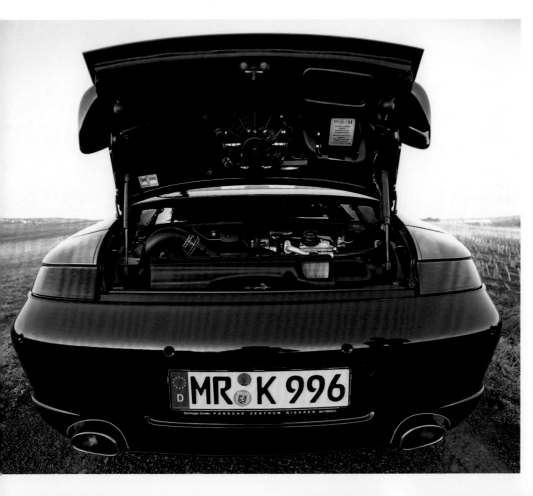

The Turbo's engine: a purring powerhouse with six combustion units, 24 valves, two turbochargers with intercooler and an angry 420 bhp. It has to put up with cramped conditions, though.

Das Triebwerk des Turbo: ein schnurrendes Power-Paket mit sechs Verbrennungseinheiten, 24 Ventilen, zwei Abgas-Turboladern mit Ladeluftkühler und zornigen 420 PS. Es muss sich gleichwohl mit beengten Raumverhältnissen begnügen.

Le groupe motopropulseur de la Turbo : une belle bête à six cylindres, 24 soupapes, deux turbocompresseurs avec échangeur d'air et 420 chevaux agressifs. Étonnant que tout cela puisse prendre place dans un compartiment aussi exigu.

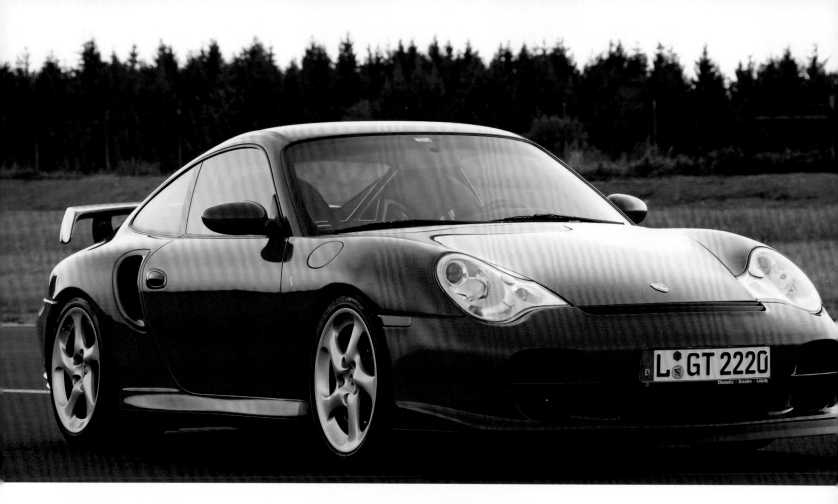

s 462 bhp make the
11 GT2 (996) the strongest
oad-going Porsche of
s era. Compared to the
urbo, its lightweight
hassis has been
owered by another 0.8".

eine 462 PS machen
en 911 GT2 (996)
um stärksten zeit-
enössischen Porsche
ür die Straße. Im
ergleich mit dem Turbo
auert er auf seinem
eichtbau-Chassis noch
inmal 20 mm tiefer
ber der Fahrbahn.

es 462 ch font de la
11 GT2 (996) la Porsche
e route la plus puissante
e son époque. Par
apport à la Turbo, son
hâssis de construction
llégée s'est encore
approché de la route de
0 mm supplémentaires.

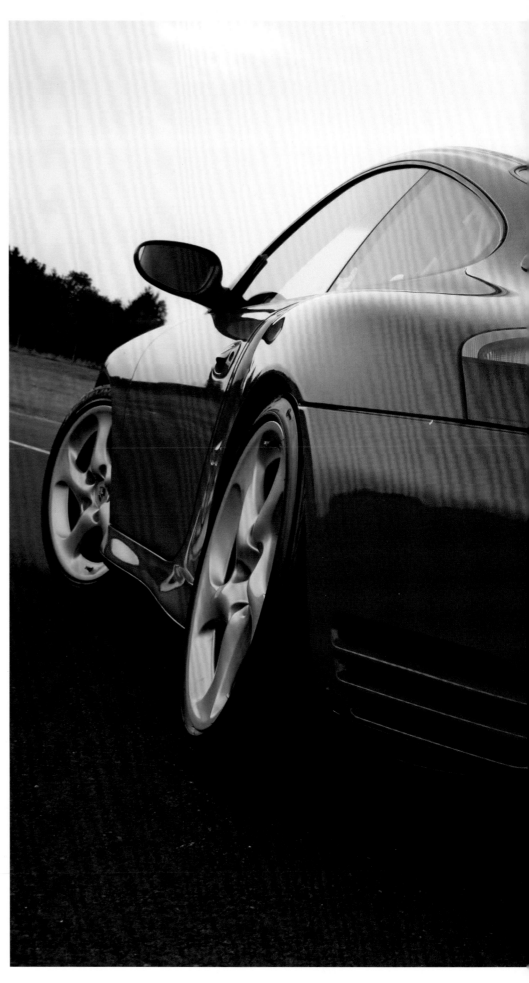

The rear tires of the GT2 are even wider than on the Turbo.
Its large fixed rear wing can be adjusted in five positions.
On the Clubsport variant a roll cage bolted onto the
bodywork looks after more safety for the passengers.

Die hinteren Reifen des GT2 sind noch breiter als am Turbo.
Der große, feste Heckflügel gestattet fünf Einstellungen.
Bei der Clubsport-Variante sorgt ein mit der Karosserie
verschraubter Überrollbügel für innere Sicherheit.

Les pneus arrière de la GT2 sont encore plus
larges que ceux de la Turbo. Le gros becquet
arrière fixe permet cinq réglages. Sur la version
Clubsport, la sécurité des occupants est assurée
par un arceau boulonné à la carrosserie.

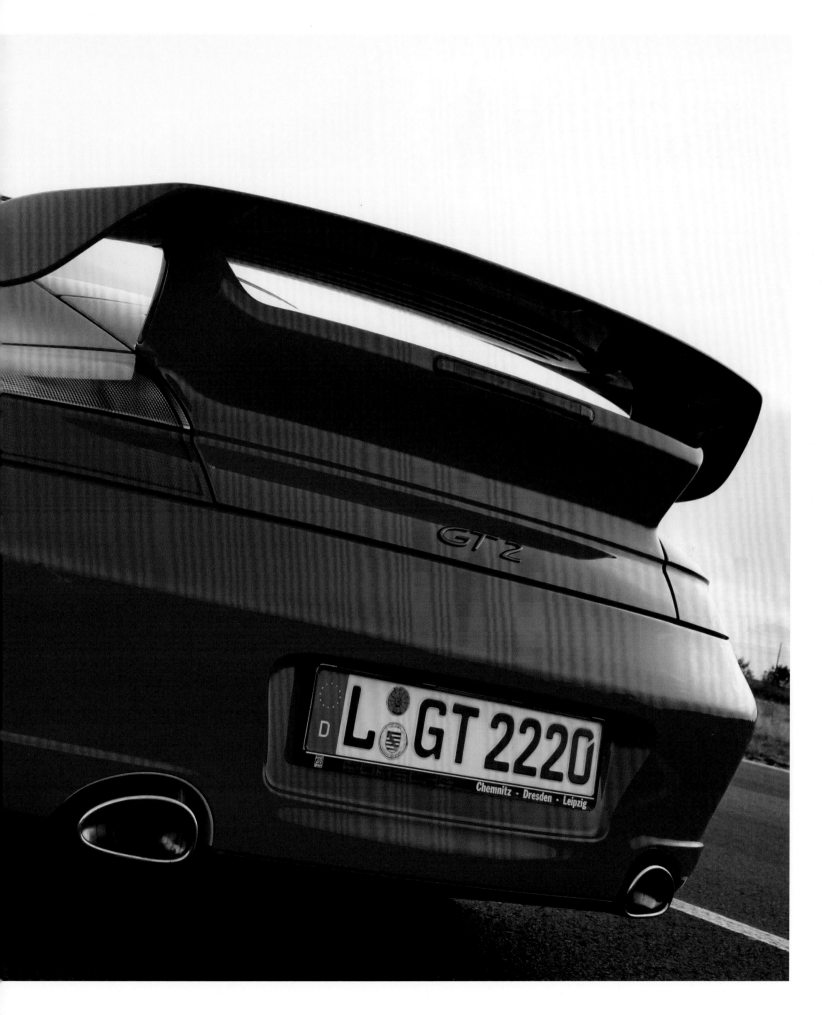

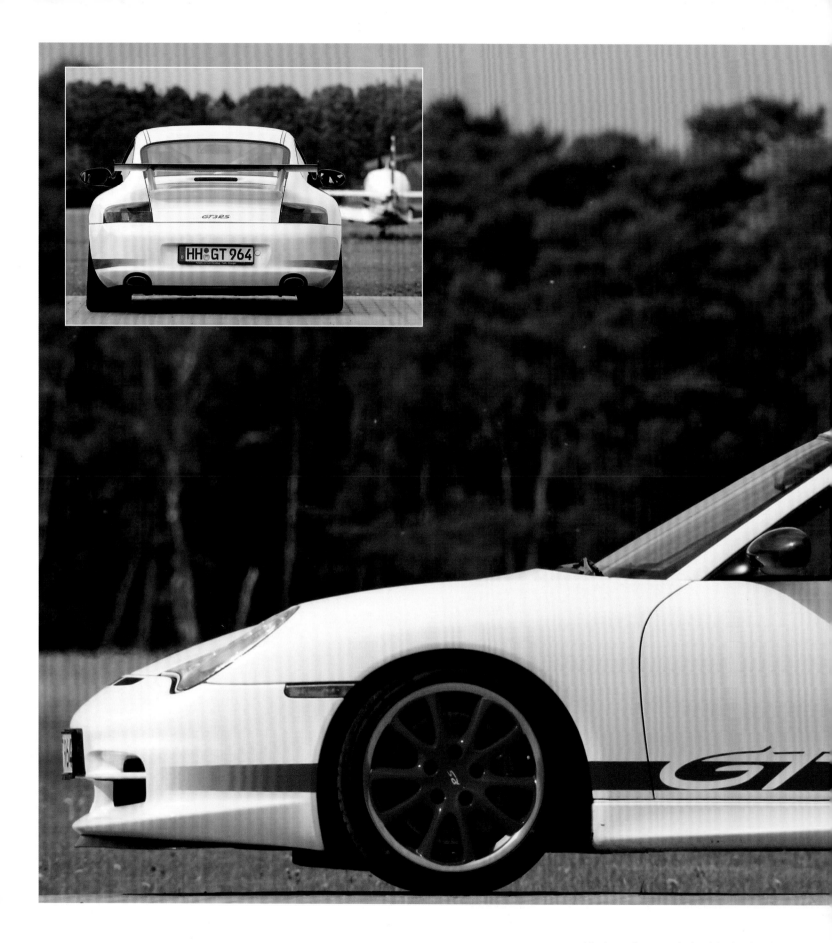

Like its predecessor—both spiritual and on the roads—the Carrera 2.7 RS cult car of 1972, the GT3 RS makes no secret of its existence and of its character in general. It is always painted in innocent white.

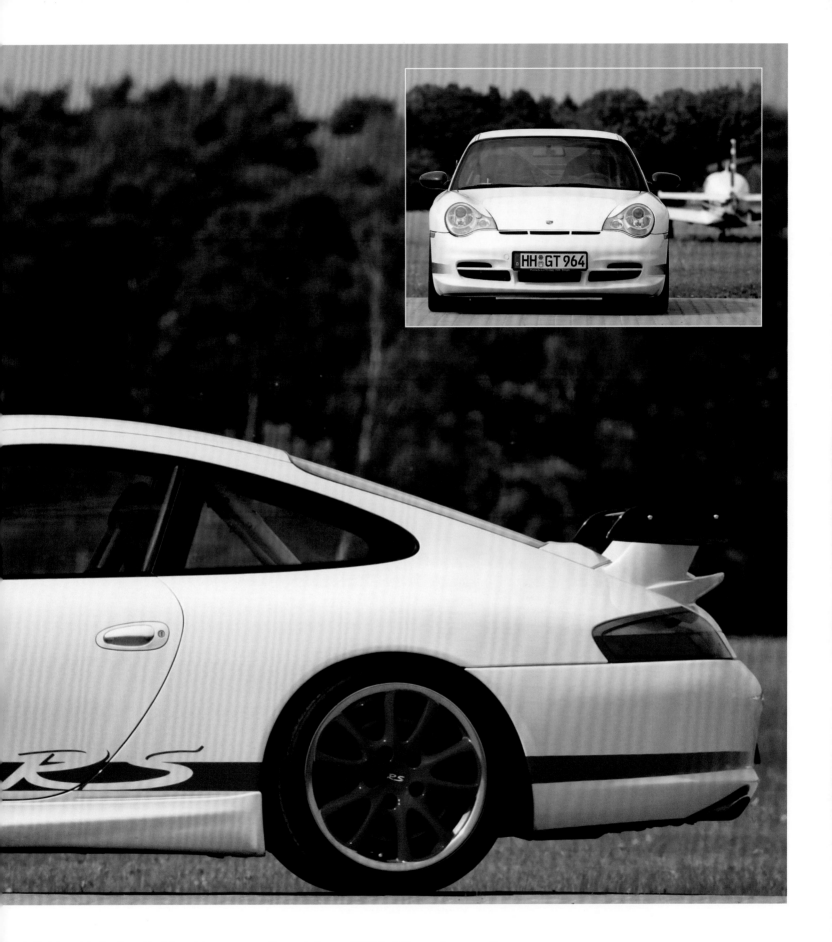

Wie sein Vorfahr auf der Straße und im Geiste, das Kultmobil Carrera 2.7 RS von 1972, mag der GT3 RS aus seiner Existenz und aus seiner Gesinnung keinen Hehl machen. Stets ist er in unschuldigem Weiß lackiert.

Comme la Carrera 2.7 RS de 1972, son précurseur culte, la GT3 RS sait imposer sa philosophie. Elle est toujours peinte d'un blanc immaculé.

Indisputable identification: even the lids of the wheel hubs sport the RS logo. Like its equivalents on the flanks and on the rear of the car, it can be had either in red or in blue.

Eindeutige Identifizierung: Selbst die Deckel der Radnaben tragen den RS-Schriftzug, wie auch seine Pendants auf Heck und Flanken wahlweise in Rot oder in Blau gehalten.

Identification sans ambiguïté : même l'enjoliveur des moyeux de roue arbore le monogramme RS que l'on retrouve aussi, au choix en rouge ou en bleu, à l'arrière et sur les flancs.

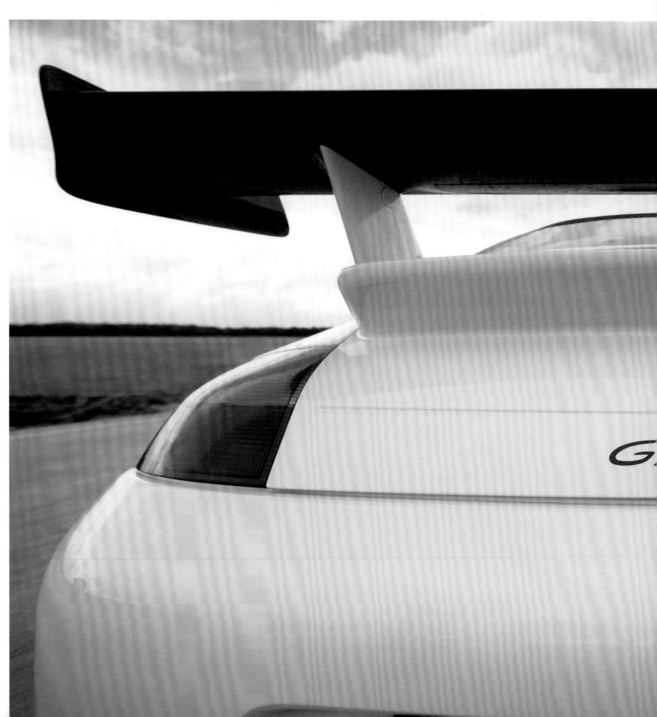

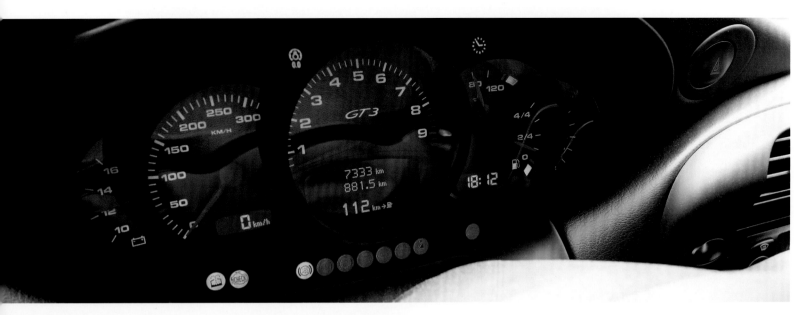

The huge rear wing of the GT3RS made of carbon fiber resembles the solution found for the GT3 Cup sister model and can be set in two positions for racing purposes. Like the vehicle as a whole, the lamp cluster below the round instruments indicates "ready to go".

Der mächtige Heckflügel des GT3RS aus Kohlefaser ähnelt dem des Schwestermodells GT3 Cup und lässt sich für den Rennbetrieb in zwei Positionen fixieren. Das Lämpchen-Ensemble unter den Rundinstrumenten signalisiert wie das ganze Fahrzeug „ready to go".

L'imposant aileron arrière en fibre de carbone de la GT3RS s'inspire de celui de sa cousine, la GT3 Cup. Il est réglable selon deux angles d'attaque pour la course. La ribambelle de petits voyants sous les cadrans circulaires signale, comme toute la voiture elle-même, « ready to go ».

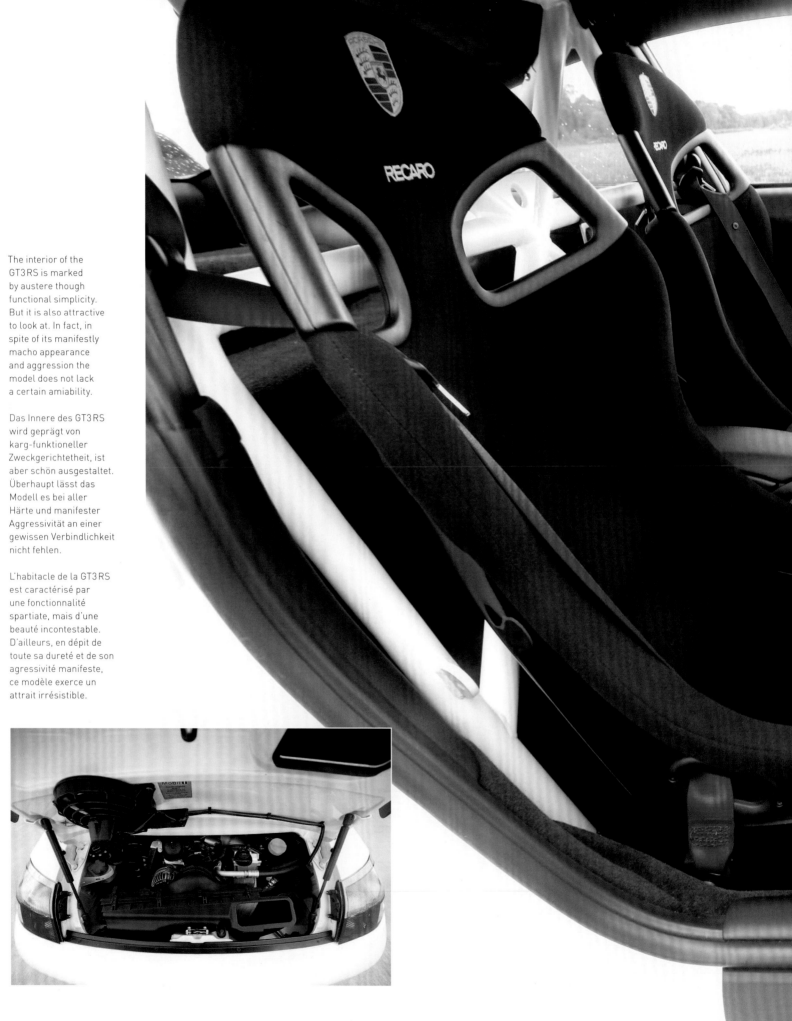

The interior of the
GT3RS is marked
by austere though
functional simplicity.
But it is also attractive
to look at. In fact, in
spite of its manifestly
macho appearance
and aggression the
model does not lack
a certain amiability.

Das Innere des GT3RS
wird geprägt von
karg-funktioneller
Zweckgerichtetheit, ist
aber schön ausgestaltet.
Überhaupt lässt das
Modell es bei aller
Härte und manifester
Aggressivität an einer
gewissen Verbindlichkeit
nicht fehlen.

L'habitacle de la GT3RS
est caractérisé par
une fonctionnalité
spartiate, mais d'une
beauté incontestable.
D'ailleurs, en dépit de
toute sa dureté et de son
agressivité manifeste,
ce modèle exerce un
attrait irrésistible.

Four years elapsed between saying and doing: on 3 June 1998 Porsche announced that the 911 and Boxster model ranges would be complemented with an off-road multipurpose vehicle in the near future. During the official opening ceremony for Porsche Leipzig GmbH on 20 August 2002, the ready product made a surprise appearance while the actual premiere of the Cayenne took place at that year's Paris Mondial de l'Automobile.

That it was built by Porsche sharpened the paradox inherent in the mere term "sport utility vehicle" anyway. In that particular case it had to be even sportier and an even more versatile utility vehicle, though thoroughly in keeping with the unique philosophy of the marque. The venture was to bear fruit—the agile and ultra-quick giant was to become a top seller. In terms of its exterior, Porsche ambience was conveyed by signals like the aggressive V shape of front, rear and engine hood, the obvious muscle of the wide wheel arches, strikingly threatening exhaust pipes and the positioning of the ignition key to the left of the steering wheel. As far as its equipment was concerned, the monumental Porsche anticipated its buyer's every wish, not to mention a whole gamut of extras that made it even more desirable. It was also a paragon of safety, featuring, for instance, brakes that had gone through the chicanes of the Porsche Fading Test, 25 deceleration processes from 90 per cent of its top speed (up to 168 mph) to 62 mph with a constant 0.8 g. Its suspension, exiled into subframes, was also state of the art: double wishbones separated by considerable distances at the front, a rear multilink axle that was able to cope with enormous traction forces and additional loads, McPherson struts with long travel installed at an angle, air suspension on the Turbo variants. Its bodywork, produced in the Bratislava VW plant like that of its cousin VW Touareg which had been developed parallel to its Porsche sibling, incorporated the latest in the make-specific lightweight steel design, using triple-skin structures with robust three-box sections and a three-tier deformation zone that shielded the passenger cell. The Porsche Traction Management assigned the engine's torque to the rear and front axle using a standard split of 62:38. If necessary, a multi-disk clutch mediated up to 100 per cent to the front or the back or triggered a complete longitudinal lock of the right or left wheels. A six-gear manual or the Tiptronic S (also with six speeds) could be ordered.

At the beginning, there were the S and Turbo variants, both relying on the latest light-alloy 4.5-liter V8 with four valves per cylinder, continuously adjustable inlet camshafts as well as integrated dry-sump lubrication. Between 2500 and 5500 rpm it produced a torque of 310 lb-ft. In the S it delivered 340 bhp, in the Turbo 450 bhp, assisted by two turbochargers connected in parallel. From December 2004, there was an optional 500 bhp; in the Turbo S presented at the 2006 Detroit Auto Show even a standard 521 bhp. The entry-level Cayenne, launched in 2003, had a brand-new 3289-cc V6, at 250 bhp a veritable high-tech work of art.

Zwischen Gesagt und Getan lagen vier Jahre: Am 3. Juni 1998 gab Porsche bekannt, die Baureihen 911 und Boxster würden künftig durch ein geländegängiges Mehrzweckmodell ergänzt. Bei der Einweihung der Filiale Porsche Leipzig GmbH am 20. August 2002 wurde überraschend das fertige Produkt vorgestellt, auf dem Pariser Salon jenes Jahres war der Cayenne erstmalig für jedermann zur Besichtigung freigegeben.

Dass Porsche ihn baute, verschärfte die Paradoxie, die ohnehin bereits in dem bloßen Begriff Sport Utility Vehicle angelegt ist. So hatte er noch sportlicher zu sein, ein noch vielseitigeres Nutzfahrzeug, und sich dennoch in die sehr eigene Philosophie des Hauses zu fügen. Das Wagnis gelang – das behände Trumm geriet zum Renner, in beiden Sinnen des Wortes.

Bereits rein äußerlich wurde Porsche-Ambiente durch Signale wie die aggressive V-Form von Front, Heck und Motorhaube, die muskulös ausgewölbten Radkästen, markant drohende Endrohre oder den links vom Lenkrad angesiedelten Zündschlüssel vermittelt. Die Ausstattung ließ nur wenige und dann per Aufpreis vollzählig erfüllbare Wünsche übrig, und vorbildlich war der rasende Monumental-Porsche auch in punkto Sicherheit, mit Bremsen etwa, die im Vorfeld der Serie dem unerbittlichen Porsche Fading Test unterworfen worden waren, 25 Verzögerungsvorgängen aus 90 Prozent der Höchstgeschwindigkeit von bis zu 270 km/h auf Tempo 100 mit konstant 0,8 g. Kongenial die Aufhängung, in Fahrschemel ausgelagert: doppelte Querlenker mit großen Abständen vorn, eine hintere Mehrlenkerachse, die erhebliche Traktionskräfte und Zuladungen gleichermaßen auffangen musste, schräg gestellte Federbeine mit langen Wegen, Luftfederung bei den Turbo-Varianten. Für den Aufbau, in Bratislava gefertigt wie der des parallel entwickelten Vetters VW Touareg, hatte man den markenspezifischen Stahl-Leichtbau weiter optimiert, eine Drei-Schalen-Konstruktion mit Drei-Kammer-Profil und von enormer Festigkeit. Das Porsche Traction Management des Cayenne teilte das Drehmoment der Hinter- und der Vorderachse im Grundmodus 62:38 Prozent zu. Wenn nötig, vermittelte eine Lamellenkupplung bis zu 100 Prozent nach vorn oder nach hinten oder verhängte eine Längssperre links oder rechts. Dem Piloten des hurtigen Kletterers ging ein Sechsgang-Schaltgetriebe zur Hand oder die Tiptronic S.

Am Anfang standen die Versionen S und Turbo, mit einem neuen 4,5-Liter-V8 aus Leichtmetall mit vier Ventilen je Zylinder, kontinuierlich verstellbarer Einlass-Nockenwelle und integrierter Trockensumpfschmierung. Zwischen 2500 und 5500/min lag ein Drehmoment von 420 Nm an. Seinen 340 PS im Typ S hatte der Turbo 450 PS entgegenzusetzen, unter Mithilfe zweier parallel geschalteter Abgaslader. Ab Dezember 2004 standen wahlweise 500 PS zur Verfügung, im Turbo S, 2006 bei der Detroit Auto Show präsentiert, sogar 521 PS. Der Einstiegs-Cayenne war 2003 nachgeliefert worden, mit einem brandneuen V6 von 3289 cm³ – auch er schon 250 PS stark und ein veritables High-Tech-Kunstwerk.

Sitôt dit, sitôt fait, enfin presque : quatre an après. Le 3 juin 1998, Porsche annonce so intention de compléter les gammes 911 e Boxster par un 4×4 de loisirs. Lors de l'inauguratio de la filiale Porsche Leipzig GmbH, le 20 août 2002 la surprise est totale avec la présentation de ladit voiture, que le grand public a pour la première foi l'occasion d'admirer au Salon de Paris sous le nor de Cayenne.

Que Porsche construise un tel engin souligr le côté paradoxal du terme *Sport Utility Vehicle*. L Cayenne se devait donc d'être encore plus sportif e plus polyvalent, tout en s'insérant dans la philoso phie de la maison Porsche. Le pari est réussi : ce imposant 4×4 fait un tabac.

Sur le plan extérieur, la patte de Porsche s manifeste avec l'agressive forme en V de la prou

de la poupe et du capot-moteur, avec les arches de roue au renflement musclé, les imposantes sorties d'échappement ou la clé de contact positionnée, comme toujours, à gauche du volant. L'équipement, complet, ne laisse place qu'à de très rares options, que l'on peut s'offrir dans leur intégralité. Comme toujours chez Porsche, le Cayenne-«TGV» est exemplaire, lui aussi, en termes de sécurité. Par exemple, les freins, sur les modèles de présérie, ont subi l'impitoyable test de *fading* de Porsche : à savoir, 25 décélérations successives à partir de 90 % de la vitesse maximale, soit 270 km/h, jusqu'à une vitesse de 100 km/h à 0,8 g constant. Les suspensions sont tout simplement extraordinaires avec leurs berceaux auxiliaires : doubles bras transversaux séparés par une grande distance à l'avant, un essieu multibras à l'arrière capable d'encaisser des forces de traction

considérables ainsi que les charges additionnelles, des jambes élastiques obliques à long débattement, et une suspension pneumatique pour les versions Turbo. Pour la carrosserie blanche, fabriquée à Bratislava sur les mêmes lignes de montage que celles du VW Touareg mis au point simultanément, Porsche a encore optimisé la construction allégée en acier spécifique à la marque avec une réalisation à trois coquilles à profilés à trois chambres d'une rigidité exceptionnelle. Le Porsche Traction Management du Cayenne répartit le couple entre les trains arrière et avant selon le mode de base de 62:38. Si nécessaire, un embrayage à lamelles peut toutefois envoyer jusqu'à 100 % du couple soit vers l'avant soit vers l'arrière ou faire intervenir un blocage longitudinal à gauche ou à droite. Le pilote de cet engin capable de grimper aux murs

dispose d'une boîte manuelle à six vitesses ou de la Tiptronic S.

Au début, les versions S et Turbo sont propulsées par un tout nouveau V8 de 4,5 litres en aluminium à quatre soupapes par cylindre, arbres à cames à décalage en continu côté admission et lubrification par carter sec intégrée. Le couple est de 420 Nm entre 2500 et 5500 tr/min. La version Turbo oppose ses 450 ch aux 340 ch du «petit» modèle S grâce à deux turbocompresseurs parallèles. À partir de décembre 2004, la puissance est, au choix, de 500 ch et passe même à 521 ch avec la Turbo S présentée en 2006 au Detroit Auto Show. Le Cayenne d'entrée de gamme, apparu en 2003, possède un tout nouveau V6 de 3289 cm³ – une puissance relativement confortable avec 250 ch et un véritable concentré de haute technologie.

Cayenne (9PA)

With its 521 bhp the
Cayenne Turbo S is
second only to the GT
in the Porsche power
hierarchy. Externally
just the front air intake
grilles bear testimony
to that identity.

Mit seinen 521 PS ist der
Cayenne Turbo S der
zweitstärkste Porsche
im Programm nach
dem GT. Nur die in
Wagenfarbe lackierten
Lufteinlassgitter vorn
zeugen äußerlich von
dieser Identität.

Avec ses 521 chevaux, le
Cayenne Turbo S est, par
la puissance, la deuxième
Porsche du programme
après la GT. Seules les
grilles de prise d'air
peintes dans la couleur de
la carrosserie, à l'avant,
trahissent extérieurement
son identité réelle.

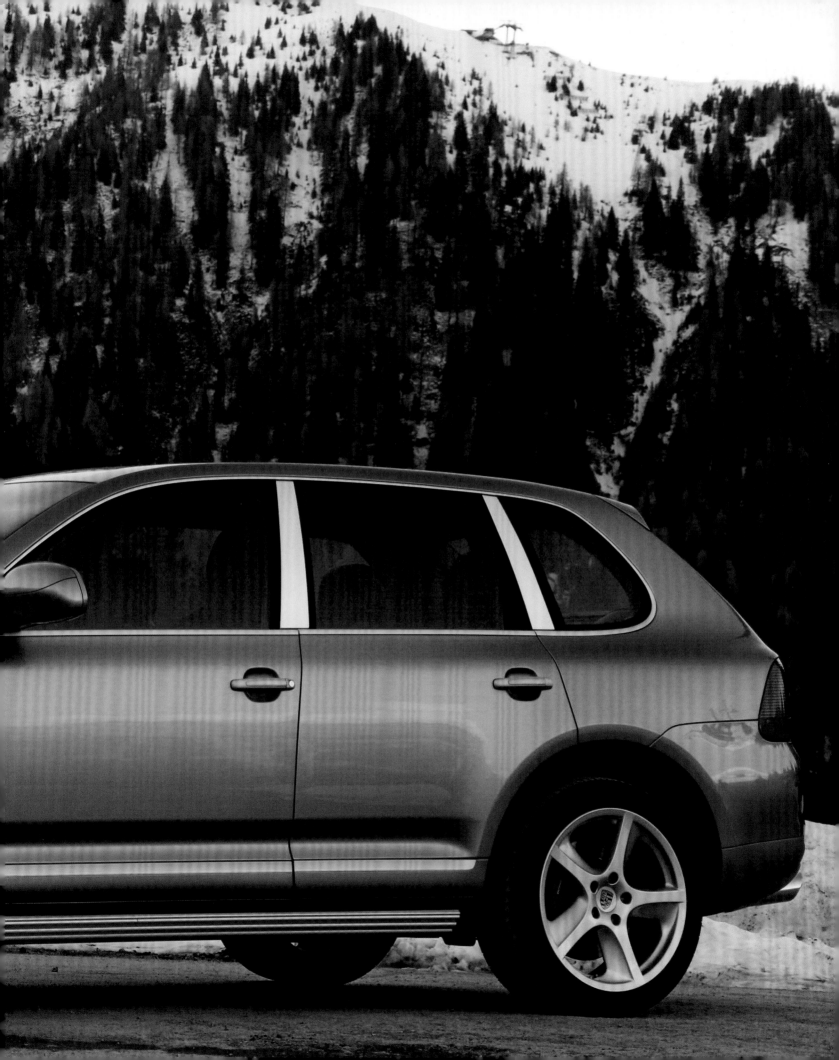

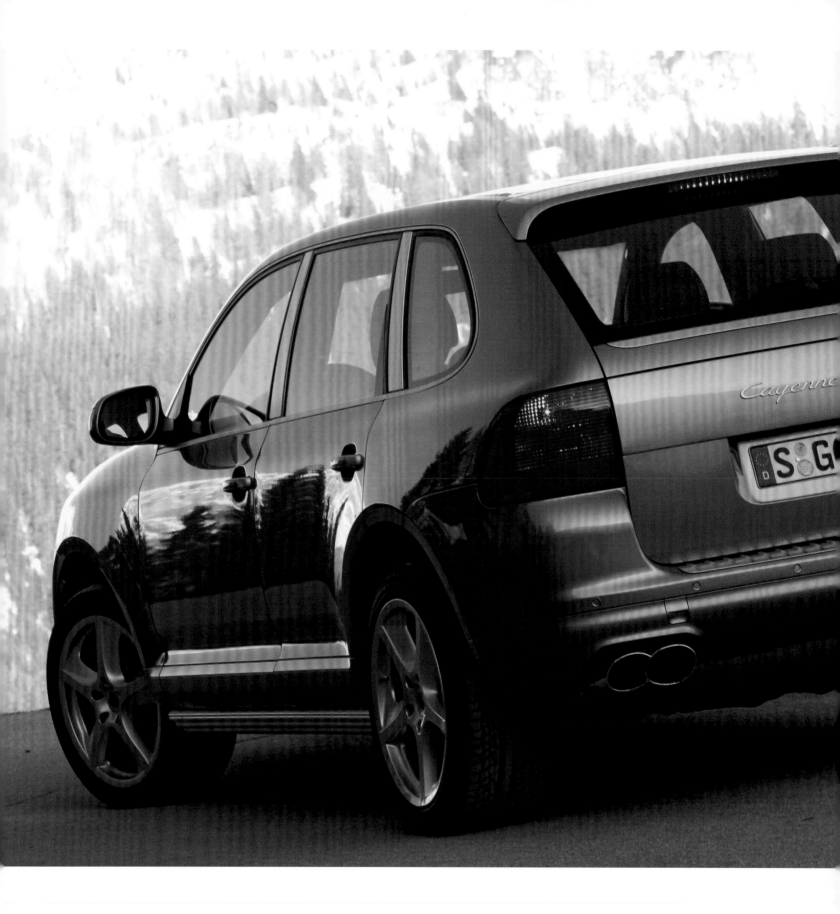

At full acceleration two pairs of twin tailpipes made of stainless steel voice a martial roar of approval. In the passengers' compartment a logo beneath the air-conditioning unit indicates that this is the top-of-the-range Cayenne.

Bei voller Beschleunigung entweicht martialisches Kampfgebrüll aus jeweils zwei Sportendrohren aus Edelstahl. Ein Schriftzug unter der Klimaanlage weist innen auf den stärksten Cayenne hin.

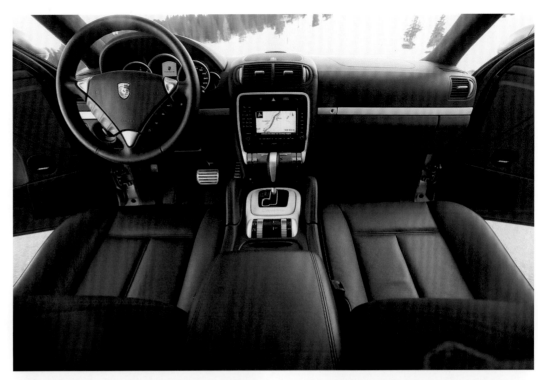

ccélérateur collé au plancher, les deux pots
'échappement sport en acier inoxydable éructent des
urlements martiaux. Dans l'habitacle, le logo sous la
limatisation signale que l'on est à bord du Cayenne le
lus puissant.

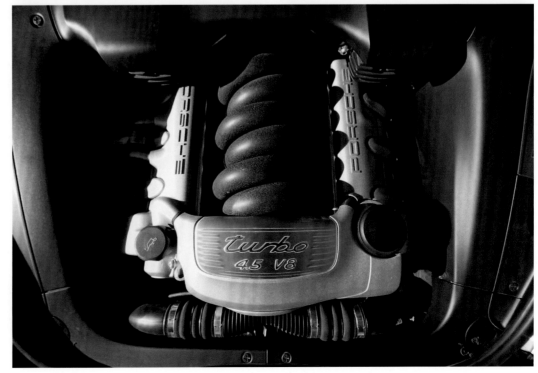

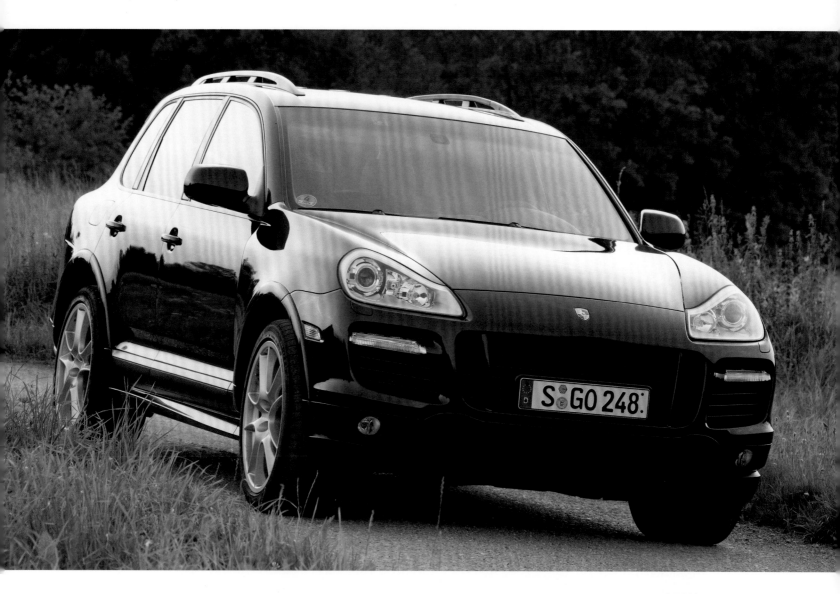

A large front grille, bi-xenon headlamps with static and dynamic cornering light and reworked tail lights mark the 2008 facelift.

Große Frontgitter, Bi-Xenon-Scheinwerfer mit statischem und dynamischem Kurvenlicht und überarbeitete Heckleuchten kennzeichnen das Facelift von 2008.

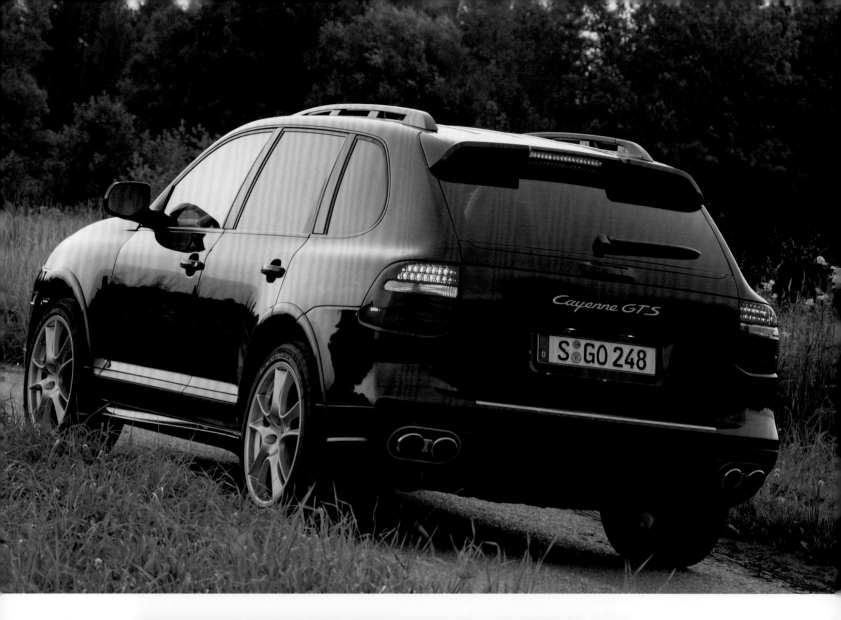

e lifting de 2008 s'est
oldé par une grande
rille de radiateur, des
hares au bixénon avec
clairage statique et
ynamique de virage
t des feux arrière
etravaillés.

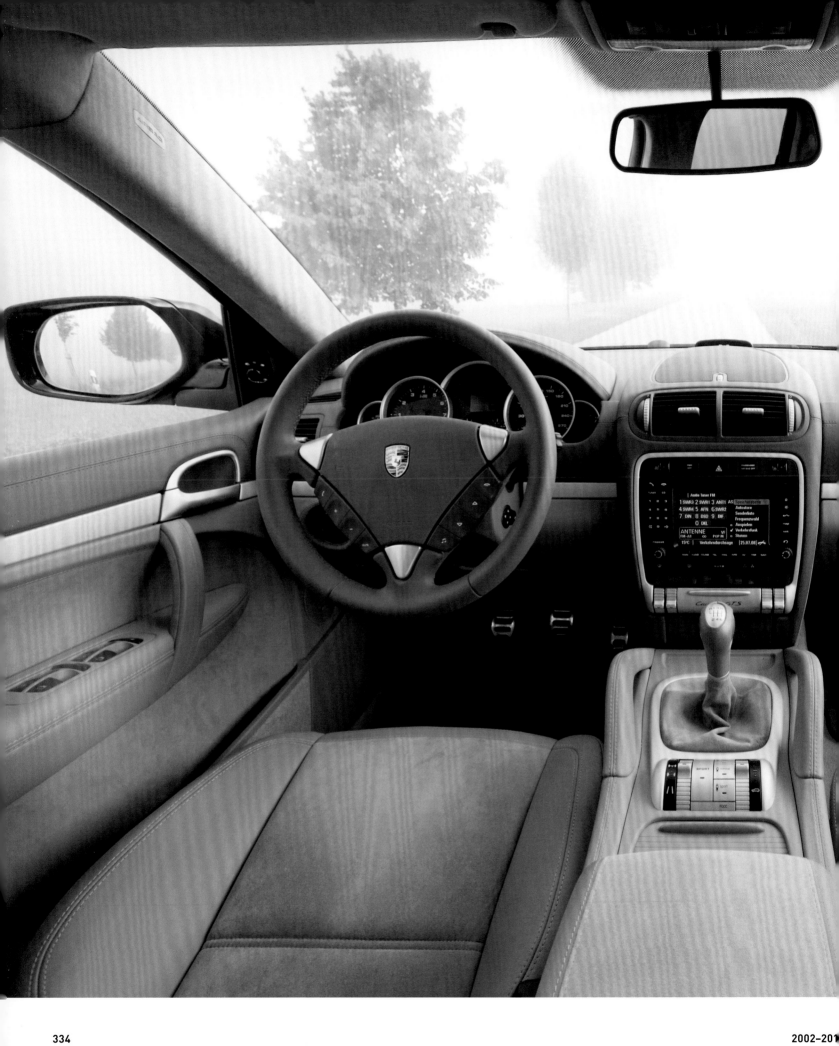

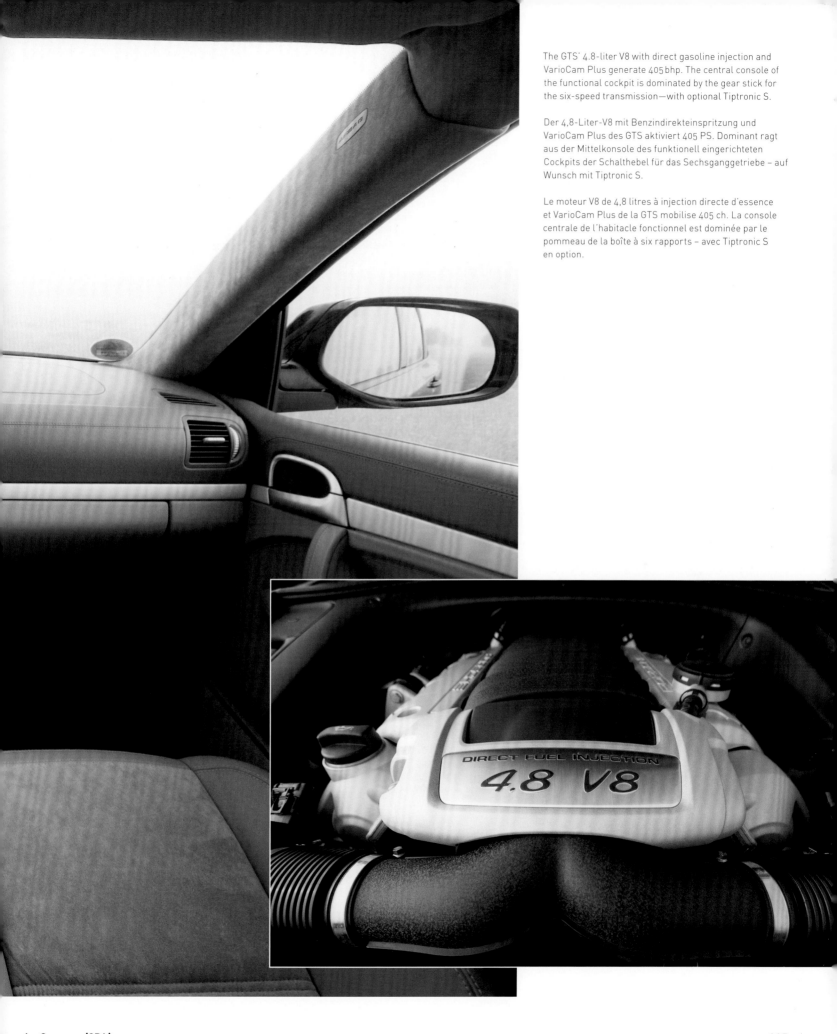

The GTS' 4.8-liter V8 with direct gasoline injection and VarioCam Plus generate 405 bhp. The central console of the functional cockpit is dominated by the gear stick for the six-speed transmission—with optional Tiptronic S.

Der 4,8-Liter-V8 mit Benzindirekteinspritzung und VarioCam Plus des GTS aktiviert 405 PS. Dominant ragt aus der Mittelkonsole des funktionell eingerichteten Cockpits der Schalthebel für das Sechsganggetriebe – auf Wunsch mit Tiptronic S.

Le moteur V8 de 4,8 litres à injection directe d'essence et VarioCam Plus de la GTS mobilise 405 ch. La console centrale de l'habitacle fonctionnel est dominée par le pommeau de la boîte à six rapports – avec Tiptronic S en option.

It was made of the same stuff as the mega Porsches the 550 Spyder, 959 or GT1. Unlike its spiritual ancestors, however, it did not strive for a racing car career but put its foot down as a demonstration of rampant strength: look here—this is the epitome of what we are able to achieve.

For all that, the Porsche Carrera GT endowed the 1270 lucky ones who were capable of affording one—for the princely sum of 452,690 euros—with the safety of a competition car and the fire of the race track until the end of its production in May 2006. But it also gave them the perilous freedom already inherent in only approaching its limits, which bordered on the unlikely, such as its top speed of 205 mph. The idea behind it was triggered by the GT1's victory at Le Mans in June 1998. At the Paris salon in 2000, Porsche presented a study sculpted by chief stylist Harm Lagaay with bold strokes. As became evident three years later in Geneva, hardly anything was changed. In autumn 2003, the Carrera GT, built in the new Porsche plant at Leipzig, was eventually put on the market.

A superlative itself, it was composed of superlatives and incorporated a plethora of innovation. In terms of the GT, more than 70 patents were filed by the marque's Weissach think tank. Its 5733 cc V10, installed amidships longitudinally, delivered 612 bhp at 8000 rpm. Quite in keeping with Porsche heritage, its thunder was sparked off by an ignition key to the left of the steering wheel. It harked back to the 3.5-liter V12 the Arrows-Footwork Formula 1 racing team had been provided with in 1991, beautiful to behold and a delight to listen to, but, alas, too heavy. At 472 lbs, its late derivative, on show below two tapering rounded sieve panels, accounted for about a seventh of the curb weight. 295 lb-ft torque was available as early as 2000 rpm, a maximum of 435 lb-ft at 5750 rpm. As the crankshaft rotated just 3.9" above the car's bottom, it did its bit to keep the GT's centre of gravity low, as did its 68-degree cylinder banks, the ceramic clutch only 6.7" in diameter and the longitudinally and low-installed six-speed gearbox.

Acceleration values such as 3.8 s to 60 and 10.9 s to 124 mph took the unsuspecting passenger's breath away, and breathtaking in the literal sense of the word also described the retardation made possible by the Porsche's ceramic brakes, ventilated, with a diameter of 15" and relentlessly clasped by six-piston aluminum calipers. Another indication that the GT was actually a child of the race track was its suspension, twin wishbones with pushrod coupling activating horizontal spring/damper units. The Zuffenhausen thunderbolt was built from exquisite ingredients, bodywork as well as chassis and rear subframes consisting of carbon-fiber reinforced high-quality plastic, as did the bipartite and easy-to-fit CRP roof, with premium materials like aluminum, titanium, magnesium and carbon in other places to boot. From the point of view of the penny-pinching family man the Carrera GT was an absurdity—but what a wonderful one.

Er stand ganz in der Tradition der Mega-Porsche vom Schlage des 550 Spyder, des 959 oder des 911 GT1. Aber im Unterschied zu seinen Vorfahren im Geiste strebte er keine Rennwagenkarriere an, sondern trumpfte auf als Demonstration strotzender Stärke: Schaut her, so etwas vermögen wir auf die Räder zu stellen.

Und dennoch beschenkte der Porsche Carrera GT die 1270 Glücklichen, die sich bis zum Auslaufen seiner Produktion im Mai 2006 zum fürstlichen Preis von 452690 Euro einen gönnen konnten, mit der Sicherheit des Wettbewerbsfahrzeugs und dem Feuer der Rennbahn. Aber er gab ihnen auch die gefährliche Freiheit, sich seinen im Graubereich des Unwirklichen gesteckten Grenzen auch nur anzunähern, den 330 km/h zum Beispiel, zu denen er fähig war. Die Idee zu ihm wurde Mitte Juni 1998 durch den Le-Mans-Sieg des GT1 angestoßen. Eine von Chefdesigner Harm Lagaay kühn gezeichnete Studie tat auf dem Pariser Salon 2000 wie erwartet ihre Pflicht als Lockvogel und wurde vor seiner Premiere in Genf 2003 kaum verändert. Im Herbst verließen die ersten Exemplare das neue Werk Leipzig.

Selbst ein Superlativ, war der GT eine Collage aus lauter Superlativen und geballter Innovation – über 70 Details meldete die Porsche-Denkfabrik zu Weissach zum Patent an. Sein V10 Mitte längs mit 5733 cm³ und 612 PS bei 8000/min, nach Art des Hauses durch einen Zündschlüssel links vom Lenkrad zu donnerndem Schaffen angeregt, wurzelte in jenem 3,5-Liter-V12, mit dem die Zuffenhausener 1991 den Rennstall Arrows-Footwork in der Formel 1 ausgestattet hatten, schön anzusehen, von betörendem Wohlklang, aber zu schwer. Unter zwei Hutzen aus gelochtem Edelstahl auch optisch präsent, machte sein spätes Derivat mit 214 kg rund ein Siebtel des Leergewichts aus. Schon bei 2000/min lagen 400 Nm Drehmoment an, bei 5750/min das Maximum von 590 Nm. Die Kurbelwelle rotierte lediglich 100 mm über dem Wagenboden und steuerte somit ebenso zum niedrigen Schwerpunkt des GT bei wie seine im Winkel von 68 Grad gespreizten Zylinderbänke, die Keramikkupplung mit ganzen 169 mm Durchmesser sowie das tief und quer liegende Sechsganggetriebe.

Angesichts von Beschleunigungswerten wie 3,8 s auf 100 und 10,9 s auf 200 km/h blieben dem arglosen Passagier Luft und Spucke weg, und atemberaubend im Wortsinn war auch die Verzögerung, welche seine Keramikbremsen ermöglichte, innenbelüftet mit 380 mm Durchmesser und umklammert von Sechskolben-Aluminiumzangen. Als entsprungenen Sohn der Piste wies den GT überdies seine Aufhängung aus, doppelte Querlenker mit Pushrod-Anlenkung der liegenden Federstäbe. Vom Feinsten schließlich die Werkstoffe, aus denen er gefertigt war, Karosserie mitsamt Chassis und Aggregateträger im Heck aus kohlefaserverstärkten Nobelkunststoffen wie auch das zweigeteilte und im Handumdrehen zu montierende Dach, weiteres Edelmaterial wie Aluminium, Titan, Magnesium und Karbon. Da die Sinnfrage zu stellen – wie kleinlich.

Elle s'inscrit dans le droit fil de la tradition de Porsche les plus extravagantes, de l'ac bit des 550 Spyder, 959 ou 911 GT1. Mais ell n'aspire pas à faire carrière sur les circuits et s contente d'administrer la preuve d'une force bou lonnante : « regardez-moi, devinez de quoi je su capable ».

Et pourtant, la Porsche Carrera GT offre l sûreté d'une voiture de course et le feu sacré d la piste à ses 1270 heureux propriétaires (pour l prix astronomique de 452690 euros), jusqu'à la fi de sa production en mai 2006. Mais elle leur donn aussi la liberté dangereuse de ne pouvoir que fl ter avec ses limites insondables, par exemple le 330 km/h qu'elle est tout à fait capable d'atteindr L'idée de cette voiture est née vers la mi-juin 199 après la victoire au Mans de la GT1. Une étude au

gnes hardies, œuvre du chef styliste Harm Lagaay, comme escompté, joué le rôle d'appât au Salon e Paris de l'an 2000 et n'a, par la suite, pratique- ent subi aucune modification avant son premier ain de foule à Genève en 2003. Les premiers exem- laires sont sortis de la nouvelle usine de Leipzig à automne.

Alliance de superlatifs et débauche d'inno- ations font de la GT un nouveau *summum* auto- obile. L'usine à cerveaux de Porsche à Weissach a éposé 70 brevets pour ce modèle. Son V10 en posi- on longitudinale de 5733 cm³ de cylindrée déve- ppe 612 ch à 8000 tr/min. Comme de coutume chez orsche, il s'éveille à la vie dans un grondement e tonnerre grâce à une clé de contact placée à auche du volant; ses origines remontent au V12 de 5 litres livré par Zuffenhausen en 1991 à l'écurie

de Formule 1 Arrows-Footwork – un moteur magni- fique, à la sonorité tout aussi envoûtante, mais trop lourd. Bien visible lui aussi sous deux bossages en acier inoxydable perforé, son tardif descendant représente un $\frac{1}{7}^e$ du poids à vide avec 214 kg. Son couple est déjà de 400 Nm à 2000 tr/min et culmine à 590 Nm à 5750 tr/min. Le vilebrequin ne tourne qu'à 100 mm au-dessus du fond de la voiture et contribue donc au faible centre de gravité de la GT au même titre que ses bancs de cylindres calés à 68 degrés, que l'embrayage en céramique de seule- ment 169 mm de diamètre ou encore la boîte à six vitesses placée très bas en position transversale.

Avec des chiffres d'accélération comme les 3,8 s pour le 0 à 100 km/h ou les 10,9 s pour le 0 à 200 km/h départ arrêté, le passager qui ne s'y attend pas a le souffle coupé. Tout comme la décé-

lération que permettent ses freins en céramique avec des disques ventilés et perforés de 380 mm de diamètre attaqués par des étriers en alumi- nium à six pistons lui fait manquer d'air. Issue en droite ligne des circuits, la GT se distingue en outre par une suspension à doubles bras transversaux avec articulation à poussoirs pour les ressorts à barre de torsion horizontaux. Un extrême raffine- ment caractérise enfin ses matériaux, par exemple la carrosserie avec le châssis et le berceau auxi- liaire arrière en matériaux composites sophisti- qués, renforcés de fibre de carbone, à l'instar du toit à deux panneaux qui se mettent en place quasi instantanément, ou d'autres matériaux de grande noblesse comme l'aluminium, le titane, le magné- sium et le carbone. N'en demandez pas la justifica- tion, ce serait une insulte…

Carrera GT

Main thing: basically, all other components of the car are related to it or actually cooperate with it one way or another: the water-cooled 5.7-liter V10 with a bank angle of 68 degrees, four valves per cylinder and four camshafts, VarioCam, 612 bhp at 8000 rpm and 435 lb-ft at 5750 rpm.

Haupt-Sache: Im Grunde genommen ist alles auf ihn bezogen oder arbeitet ihm zu: dem wassergekühlten 5,7-Liter-V10 mit einem Bankwinkel von 68 Grad, vier Ventilen pro Zylinder und vier Nockenwellen, VarioCam, 612 PS bei 8000/min, 590 Nm bei 5750/min.

Il n'y en a que pour lui – tout se réfère à lui ou est à son service : le V10 de 5,7 litres refroidi par eau, avec un angle de cylindres de 68 degrés, quatre soupapes par cylindre et quatre arbres à cames, VarioCam, 612 ch à 8000 tr/min et 590 Nm à 5750 tr/min.

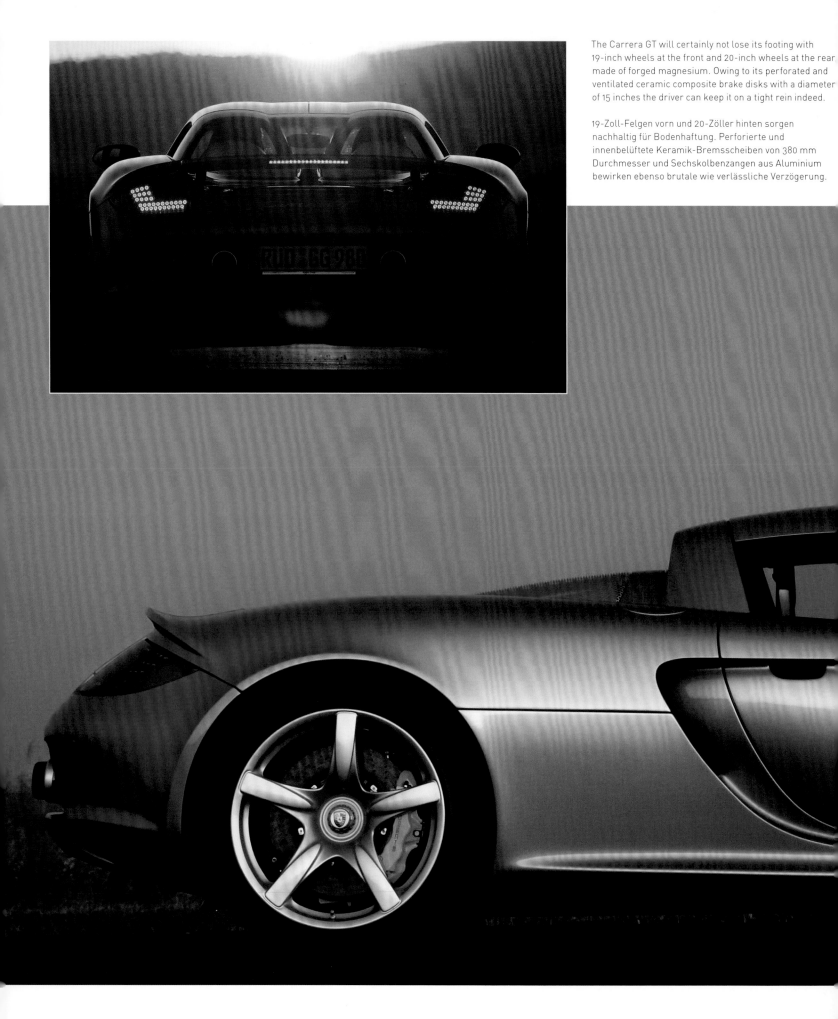

The Carrera GT will certainly not lose its footing with 19-inch wheels at the front and 20-inch wheels at the rear made of forged magnesium. Owing to its perforated and ventilated ceramic composite brake disks with a diameter of 15 inches the driver can keep it on a tight rein indeed.

19-Zoll-Felgen vorn und 20-Zöller hinten sorgen nachhaltig für Bodenhaftung. Perforierte und innenbelüftete Keramik-Bremsscheiben von 380 mm Durchmesser und Sechskolbenzangen aus Aluminium bewirken ebenso brutale wie verlässliche Verzögerung.

Avec ses jantes en magnésium forgé de 19 pouces à l'avant et 20 à l'arrière, la Carrera GT colle littéralement à la route. Avec ses freins à disques en céramique ventilés et perforés de 380 mm de diamètre attaqués par des étriers à six pistons en aluminium, elle décélère avec une docilité déconcertante.

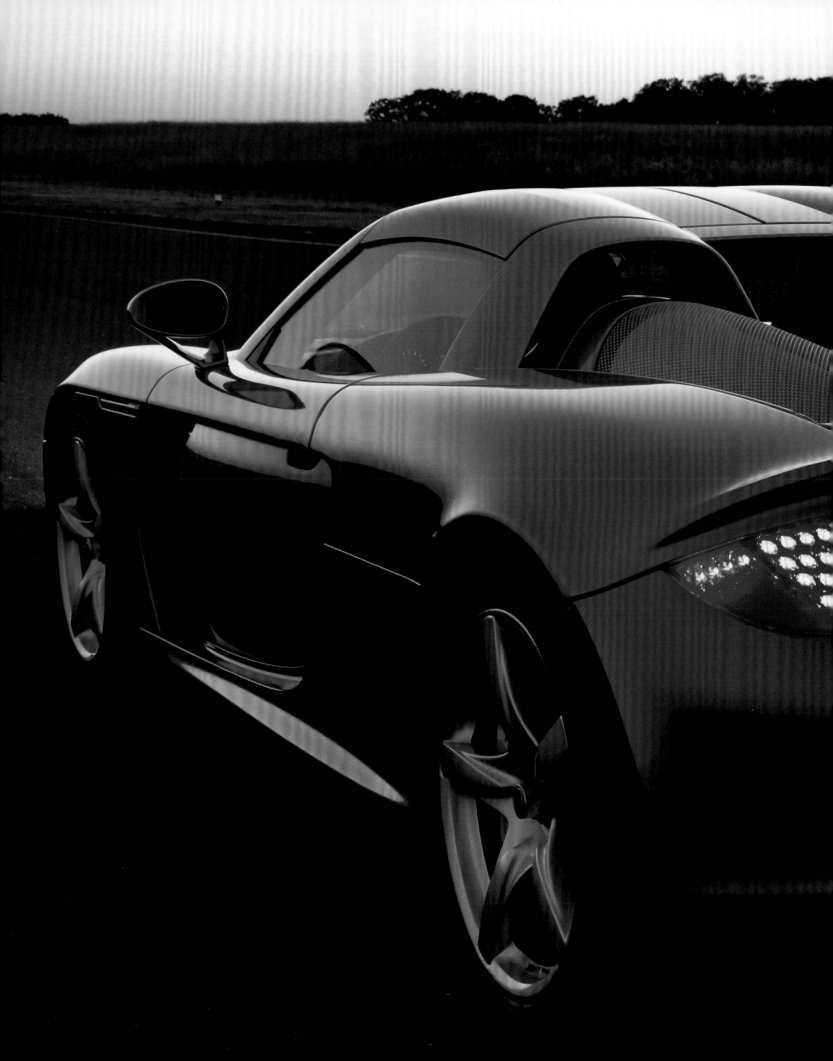

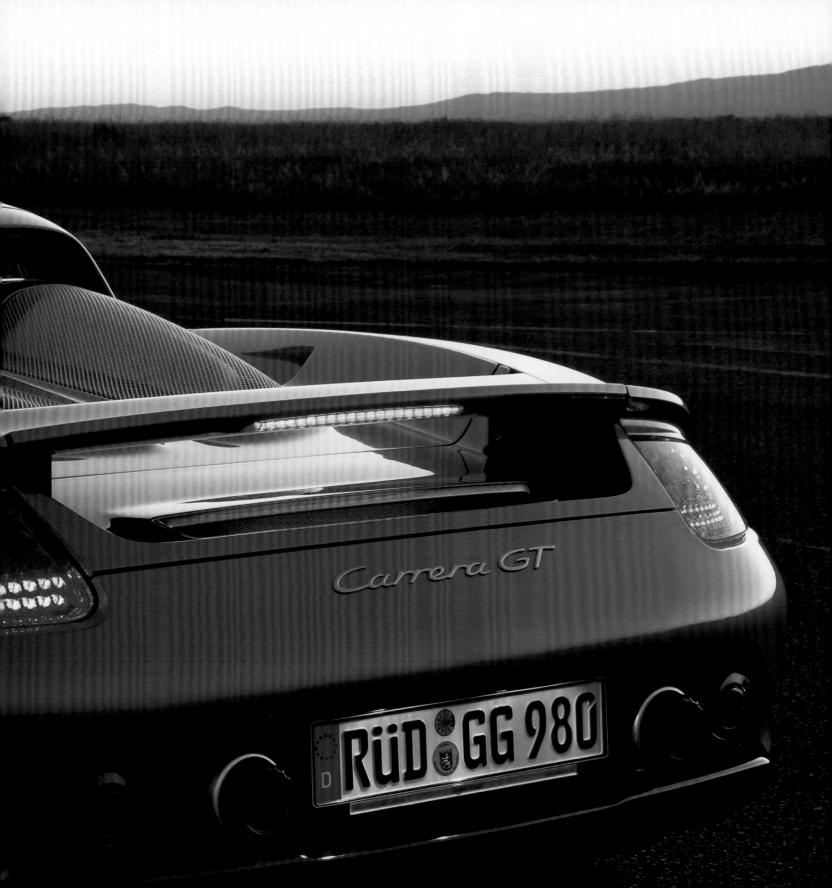

Birth of the 911

Von der Geburt des Elfers

La naissance de la 911

1 Crankshaft assembly **2** Induction system ready for instalment **3** Gearbox assembly **4** Assembly of valve gear **5** Assembly of exhaust system **6** Engine transport with driverless system **7** Fitting of rear spoiler **8** Engine transport for running gear assembly **9** Last steps before joining bodywork and aggregates ("marriage") **10** Exact positioning of bodywork and engine **11** Joining bodywork and aggregates ("marriage") **12** Coupling lines on the underbody

This photo series was taken when Rainer W. Schlegelmilch picked up his second Porsche at the factory in 1971. Skilled handiwork prevailed in every department. The first robot put into operation at Porsche was a welding robot for the 911 rear axle transverse tube. 1988 marked a milestone in bodyshell assembly when a newly constructed plant was opened with 15 robots. While automation continued its progress everywhere, work in the upholstery section, for instance, is characterized by its craftsmanship to this day.

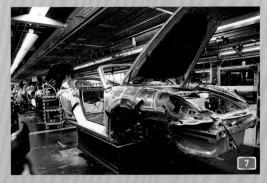

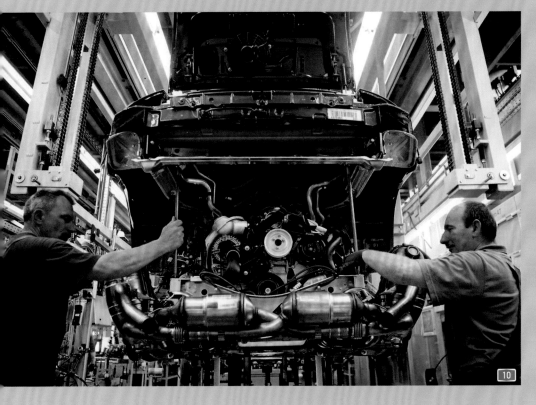

Kurbelwellenmontage **2** Bereitstellung der Sauganlagen **3** Getriebemontage **4** Montage Ventiltrieb Montage Abgasanlagen **6** Motorentransport mit fahrerlosem System **7** Montage Heckspoiler **8** Motortransport beim Fahrwerkaufbau **9** letzte Schritte vor der Zusammenführung Karosserie und Aggregate („Hochzeit") **10** Führung für die exakte Positionierung von Karosserie und Motor **11** Zusammenführung von Karosserie und Aggregaten („Hochzeit") **12** Anschluss von Leitungen am Unterboden

1 Montage du vilebrequin **2** Mise à disposition des collecteurs d'aspiration **3** Montage de la boîte de vitesses **4** Montage des soupapes **5** Montage des collecteurs d'échappement **6** Transport des moteurs avec un système robotisé **7** Montage des becquets arrière **8** Transport de moteurs lors de l'assemblage du châssis **9** Les dernières étapes avant l'assemblage de la carrosserie et du moteur (le « mariage ») **10** Guidage pour le positionnement exact de la carrosserie du moteur **11** L'assemblage de la carrosserie et du moteur (le « mariage ») **12** Branchement des conduites sur le soubassement

13 Fitting wheel-house
liners 14 Wheel mounting
15 Preparations for
fixing gravel protection
film 16 Final assembly
inspection chassis
17 Fitting of cowl
panel 18 Fixing gravel
protection film 19 Fixing
protective film for
rear lid 20 Installation
of center console

13 Montage
Radhausschale
14 Rädermontage
15 Vorbereitung
zum Anbringen der
Steinschlagfolie
16 Endabnahme
Fahrwerkmontage
17 Montage
Windlaufblende
18 Anbringen der
Steinschlagfolie
19 Anbringen der
Schutzfolie für den
Heckdeckel 20 Einbau
Mittelkonsole

Diese Fotostrecke wurde aufgenommen, als Rainer W. Schlegelmilch
1971 seinen zweiten Porsche im Werk abholte. In allen Abteilungen
überwog Handarbeit durch Spezialisten. Der erste Roboter bei
Porsche war ein Schweißroboter für das Hinterachsrohr des 911. Zum
Meilenstein bei der Herstellung der Karosserie wurde das Jahr 1988, als
ein neues Werk eröffnet wurde, in dem 15 Roboter tätig waren. Während
sich die Automatisierung überall Bahn brach, fußt die Arbeit in der
Polsterabteilung noch weitgehend auf handwerklichem Können.

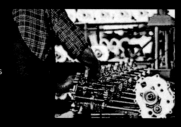

3 Montage de la coquille d'arche de roue 14 Montage des roues 15 Préparation pour le montage du film antigravillonnage 16 La réception finale du montage du châssis 17 Montage d'un panneau d'auvent 18 Montage du film antigravillonage 19 Montage du film de protection sur le capot arrière 20 Montage de la console médiane

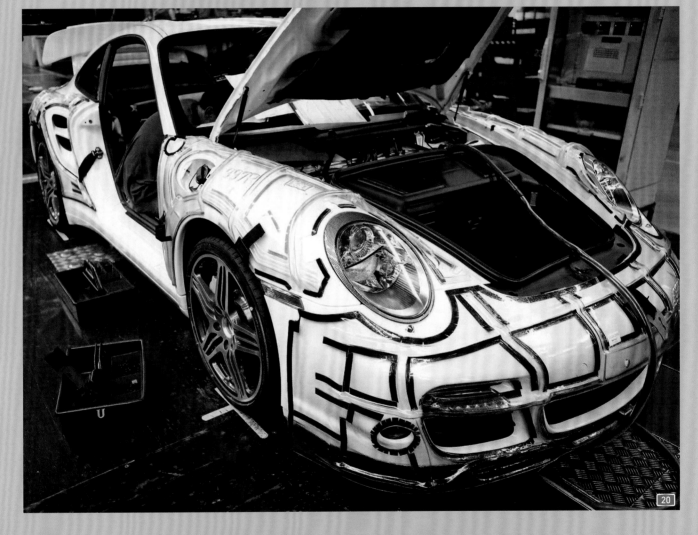

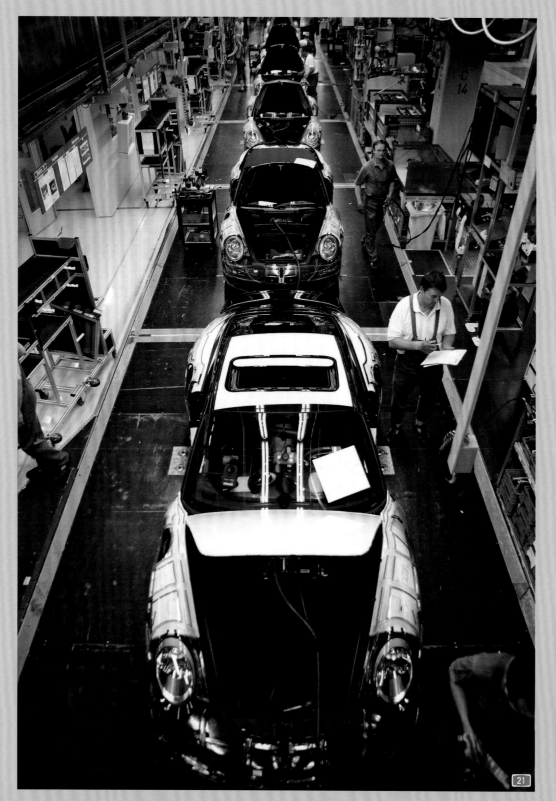

21 Diagnosis/final inspection interior fittings
22 Function check rollover bar **23** Work places at
the interior trim assembly line **24** Plastics welding
for rear compartment side trim **25** Test field
finish line **26/27** Paint control in light tunnel

21 Diagnose/Montageendprüfung Innenausstattung
22 Funktionsprüfung Überrollbügel **23** Arbeitsplätze am
Band für die Innenausstattung **24** Kunststoffschweißen
für die Fondseitenverkleidung **25** Finishband im
Prüffeld **25/26** Lackkontrolle im Lichttunnel

21 Diagnostic/contrôle final du montage de l'habitacle
22 Contrôle du bon fonctionnement des arceaux
de sécurité **23** Postes de travail sur la chaîne de
l'aménagement intérieur **24** Soudage de matière
plastique pour le capitonnage des panneaux latéraux
arrière **25** Ligne de finition dans le champ de contrôle
26/27 Contrôle de la peinture dans le tunnel lumineux

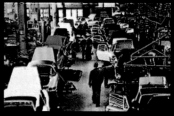

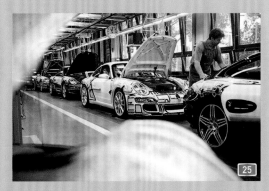

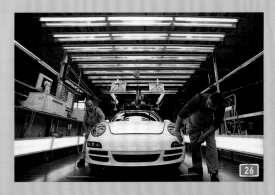

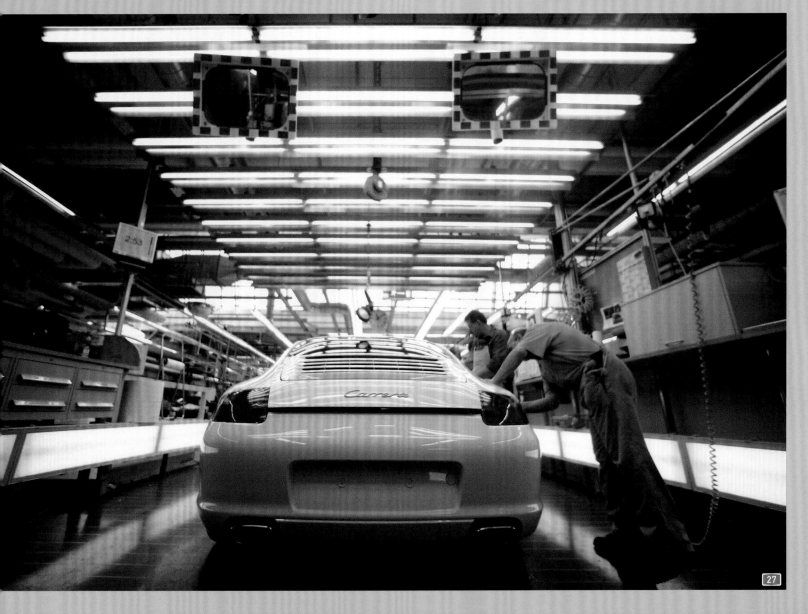

Cette série de photographies a été prise lorsque Rainer W. Schlegelmilch est venu prendre possession de sa deuxième Porsche à l'usine, en 1971. Ce n'est qu'en 1998, lors de l'inauguration d'une nouvelle usine, que quinze robots ont été mis en service pour la fabrication des carrosseries. Le premier robot mis en service chez Porsche était un robot de soudage pour le tube de train arrière de la 911. L'année 1988 est devenue une date à marquer d'une pierre blanche pour la fabrication des carrosseries avec l'inauguration d'une nouvelle usine où quinze robots étaient en service. Alors que l'automatisation s'est propagée partout, le travail au département de la sellerie continue, jusqu'à aujourd'hui, à faire presque totalement appel au savoir-faire artisanal et au travail manuel.

Unveiled as a sort of appetizer simultaneously at 85 German Porsche Centers, the 911 (997) set out for a happy future on 16 July 2004. At first sight, progress seemed to be nothing more than harking back to the past, as it resembled the 993 rather than the 996. Gone were the fried-egg look-alike headlights, products of the cell division from which the front lamps of the entry-level Porsche Boxster had also emerged, to the exhilaration of the die-hard 911 *aficionados*. Instead, the time-honored circular assemblies peeped out of the tips of more rounded fenders. A great deal of care had been invested into a strong visual appearance anyway. The 997 had a more pronounced waist again, carved out of an extra 1½" width. The rear ventilation louvers stood steeper, the wheels were bigger, 19-inch rims allied to 235/35 front and 295/30 rear rubber on the Carrera S variant, while the basic version Carrera had 18-inch rims with 235/40 and 265/40 tires respectively. Typically, those were not just attempts to impress: its proven 3.6-liter flat six, adorned with elegant decoration in the narrow confines of the Porsche's engine bay, now put out 325 bhp and a maximum torque of 273 lb-ft. A so-called Helmholtz resonator produced exactly the thrillingly vicious sound wished for by the clientele. In the Carrera S a newly developed 3824 cc unit gave a mighty 355 bhp and 295 lb-ft. With a top speed of 179 mph, 4.7 s for the spurt to 60 and 16.7 s for reaching 124 mph, the S was among the fastest exponents of the sports car world.

It took a good two years until the 997 flotilla was complete. Early in 2005 in Detroit the Convertible varieties of Carrera and Carrera S were added, with conventional soft tops that were integrated harmoniously into the overall silhouette of the car. In summer followed the four-wheel-driven Carrera 4 and 4S. At the Geneva show from 28 February 2006 the GT3 (3.6 liters) was premiered, as the usual basis for racing, which, at 415 bhp, 299 lb-ft, a rev limit of 8400 rpm and maximum speed of 193 mph, rightfully claimed to be top boy in its class among street-legal sports cars. Just as quick, but with a completely different background, was the sixth-generation Turbo presented at the same event. Supported by turbochargers with variable turbine geometry, used on a spark-ignition engine for the first time, its 3600 cc power plant produced the elemental force of 480 bhp and 457 lb-ft with perilously purring alacrity. But it had also been endowed with all the blessings of the ongoing automobile civilization, quite in contrast to the strictly ascetic GT3. That fundamentally different profile was sharpened further by the latter's even more austere and 44 lbs lighter version the RS, available as of October 2006. Its rear had been widened by 1.7" as was the case with the 911 Targa and Targa S twins launched in November 2006. Only available with four-wheel drive, they, like their immediate ancestors, featured a big glass cupola whose rearmost section doubled as a lifting hatch to give access to the rear luggage compartment.

Gewissermaßen als Amuse-Gueule zunächst einmal an 85 deutsche Porsche-Zentren überstellt, trat der 911 (997) seine Fahrt in eine glückliche Modellzukunft am 16. Juli 2004 an. Vordergründig gesehen bestand der Fortschritt im Rückgriff. Vor allem ließ aus jüngerer Vergangenheit der 993 grüßen. Verschwunden waren die zart verquasten und von ihren Verächtern lautstark geschmähten vorderen Leuchteneinheiten, mithin die Gesichtsähnlichkeit zum Einstiegs-Porsche Boxster. An ihrer statt äugten klassisch-runde Scheinwerfer aus energischer ausgeformten Kotflügeln. Auch sonst hatte man an seinem visuellen Auftritt gefeilt: Der 997 war wieder mehr auf Taille gearbeitet, herausgeschnitten aus der Substanz von 38 mm zusätzlicher Breite, die hinteren Lüftungsgitter standen steiler, die Räder waren größer, 19-Zöller besohlt im Format 235/35 vorn und 295/30 hinten am Carrera S, 18-Zoll-Felgen mit Pneus vom Kaliber 235/40 beziehungsweise 265/40 an der Basis-Spielart Carrera. Nach Art des Hauses handelte es sich dabei keineswegs um bloßes Imponiergehabe. 325 PS und ein maximales Drehmoment von 370 Nm setzte nun dessen bekannter 3,6-Liter-Boxer frei, neuerdings appetitlich aufbereitet in seinem engen Kämmerlein, untermalt von einem süffig komponierten Soundtrack. 355 PS und 400 Nm waren es im Carrera S, in dessen Heck dessen neueste Ausbaustufe mit 3824 cm³ mächtig zur Sache ging: Mit 288 km/h, 4,7 s auf Tempo 100 und 16,6 s auf 200 km/h zählte der S zu den Schnellsten im ganzen Lande.

Reichlich zwei Jahre Zeit nahm man sich, bis die Elfer-Flottille vollzählig aufgestellt war – wie üblich. Anfang 2005 wurden in Detroit die Cabriolets von Carrera und Carrera S nachgelegt, schöne Windsbräute mit konventionellen Stoffdächern, die sich harmonisch in die klare Silhouette eingliederten, im Sommer die Vierradler Carrera 4 und 4S. Auf dem Genfer Salon ab 28. Februar 2006 folgte als Basis für den Sport der GT3 (3,6 Liter), der sich mit 415 PS, 405 Nm, einer Drehzahlgrenze von 8400/min und 310 km/h Spitze zum Klassenprimus bei den für die Straße zugelassenen Serien-sportwagen aufschwang. Ebenso hurtig, wenn auch vor einem gänzlich anderen Hintergrund, war die sechste Generation des Turbo, die bei der gleichen Gelegenheit vorgestellt wurde. In gefährlich schnurrender Bereitwilligkeit stellte sein Triebwerk von exakt 3600 cm³, unterstützt von beim Ottomotor erstmalig eingesetzten Abgasturboladern mit variabler Turbinengeometrie, die Urkraft von 480 PS und 620 Nm zur Verfügung. Dazu gesellten sich alle Segnungen der aktuellen Auto-Zivilisation, ganz im Gegensatz zum strengen Asketen-Elfer GT3, ein Charakterunterschied, der durch dessen noch kargere und 20 kg leichtere Sublimationsform RS, ab Oktober 2006 erhältlich, noch stärker konturiert wurde. Wie dessen Hinterviertel um 44 mm verbreitert war das Heck der Zwillinge 911 Targa 4 und 4S, im November 2006 herausgebracht und stets mit Allradantrieb ausgerüstet. Markante Merkmale waren das große Glasdach und die klappbare Heckscheibe – wie gehabt.

Réservée tout d'abord à 85 centres Porsch[e] allemands, la 911 (997) roule confiante ve[rs] l'avenir le 16 juillet 2004. Un avenir q[ui] commence par un flash-back sur la 993. Adie[u] les phares disgracieux, que leurs détracteurs n'o[nt] jamais cessé de critiquer d'autant plus ouve[r]tement qu'ils rappelaient la Porsche d'accès [à] la gamme, la Boxster. Ils ont cédé la place à de[s] phares classiques ronds dans l'écrin d'une aile au[x] formes aguichantes. Ses lignes aussi ont été af[fi]nées : la 997 affiche une taille de guêpe qui m[et] en évidence ses hanches élargies de 38 mm av[ec] des grilles d'aération arrière plus verticales, de[s] roues de plus grand diamètre chaussées de pne[us] de 19 pouces de 235/35 à l'avant et de 295/30 [à] l'arrière pour la Carrera S, contre des jantes d[e] 18 pouces avec des pneus de respectivement 235/4[0]

265/40 pour la Carrera de base. Il n'est pas dans la philosophie de la maison de jeter de la poudre aux yeux. Et les 325 ch et un couple maximum de 370 Nm produits par l'inusable boxer de 3,6 litres ne sont pas un vain mot. En plus du plaisir des yeux qu'il procure, logé dans son étroit compartiment, il charme l'oreille par sa mélodie. Montant en gamme, la Carrera S, dont la poupe héberge la toute nouvelle évolution de 3824 cm³, développe 355 ch et 400 Nm qui font mouche : avec 288 km/h, 4,7 s pour le 0 à 100 km/h et 16,6 s pour le 200 km/h départ arrêté, la S est l'un des engins à quatre roues les plus rapides.

Il aura fallu deux ans pour que la flottille de la 911 soit au grand complet – comme de coutume. Début 2005, à Detroit, viennent s'y ajouter les versions cabriolet de la Carrera et de la Carrera S,

magnifiques reines de la vitesse à la capote conventionnelle en tissu qui s'intègre avec harmonie sur cette silhouette sans fioritures. Ces dernières sont rejointes, au cours de l'été 2005, par les Carrera 4 et 4S à quatre roues motrices. Au Salon de Genève, le 28 février 2006, tourne sur le stand, comme base pour la compétition, la GT3 (3,6 litres) qui décroche le titre de meilleur élève de la classe pour les voitures de sport de série homologuées pour la route avec 415 ch, 405 Nm, une zone rouge qui débute à 8400 tr/min et une vitesse de pointe de 310 km/h. Dans la même veine, mais taillée dans un tout autre bois, se présente la sixième génération de la Turbo, dévoilée à la même occasion. Son moteur aux ronronnements dociles, qui peuvent néanmoins vite devenir hargneux, possède une cylindrée d'exactement 3600 cm³, dopée par

les turbocompresseurs utilisés pour la première fois sur le moteur à essence, avec des ailettes à géométrie variable, qui développent l'énorme puissance de 480 ch pour un couple de 620 Nm. À cela s'ajoutent tous les progrès de la technique automobile actuelle, aux antipodes de la GT3, la plus sobre des 911. La RS, encore plus spartiate, est allégée de 20 kg supplémentaires et disponible en octobre 2006. Reprenant sa croupe élargie de 44 mm, les deux jumelles 911 Targa 4 et 4S, commercialisées en novembre 2006, hébergent une transmission intégrale de série. Avec deux caractéristiques traditionnelles qui leur sont communes : un vaste toit en verre et une lunette arrière relevable.

911 (997)

In the eyes of many, the
latest 911 metamorphosis
it is the most beautiful
ever. In a lot of essential
points it harks back
to everybody's darling
the 993. Gone are the
strangely-shaped
headlights of the 996,
and its appearance
has generally become
more masculine.

Der Schein trügt
nicht: Die jüngste
Metamorphose des 911
ist für viele auch die
schönste bislang. In
wesentlichen Punkten
knüpft er formal an den
allseits geschätzten
993 an, die missliebigen
Leuchten am 996
sind verschwunden,
sein Auftritt ist
maskuliner geworden.

L'habit fait bel et bien le
moine : la plus récente
métamorphose de
la 911 est aussi, pour
beaucoup, la plus réussie
à ce jour. Sur des points
essentiels, elle s'inspire
esthétiquement de la
993 plébiscitée par les
amateurs tandis que
les disgracieux phares
de la 996 ont disparu
et que son style est
devenu plus masculin.

The tail end has been revised in a subtle but attractive fashion. New rearview mirrors flatter the eye as well as the aerodynamics of the car. The rear spoiler pops up automatically at 75 mph, and the instruments are arranged more clearly.

Das Heck wurde subtil, aber wirkungsvoll modifiziert, die Rückspiegel schmeicheln dem Auge wie dem Fahrtwind. Der Heckspoiler fährt ab Tempo 120 automatisch aus. Die Instrumente bieten sich weniger verschachtelt dar.

La poupe a été modifiée avec subtilité mais efficacité. Les rétroviseurs et l'aérodynamique séduisent l'œil. Le becquet arrière s'érige automatiquement à partir de 120 km/h. L'agencement des cadrans est plus clair.

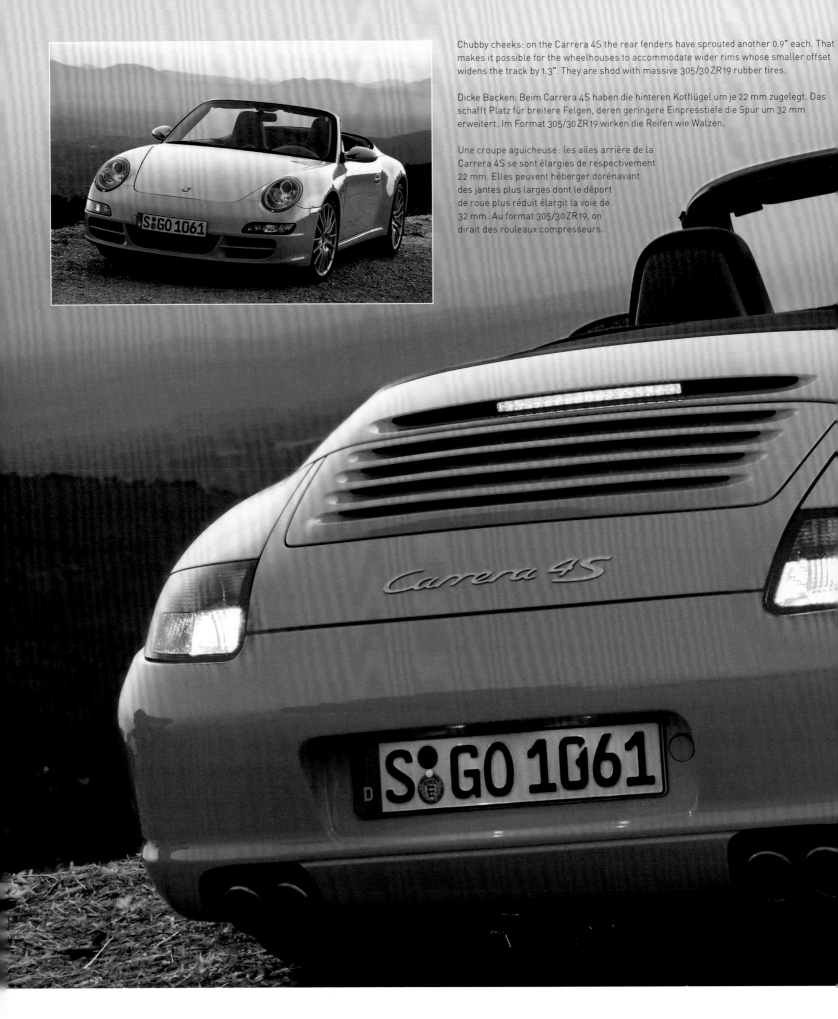

Chubby cheeks: on the Carrera 4S the rear fenders have sprouted another 0.9" each. That makes it possible for the wheelhouses to accommodate wider rims whose smaller offset widens the track by 1.3". They are shod with massive 305/30 ZR19 rubber tires.

Dicke Backen: Beim Carrera 4S haben die hinteren Kotflügel um je 22 mm zugelegt. Das schafft Platz für breitere Felgen, deren geringere Einpresstiefe die Spur um 32 mm erweitert. Im Format 305/30 ZR19 wirken die Reifen wie Walzen.

Une croupe aguicheuse : les ailes arrière de la Carrera 4S se sont élargies de respectivement 22 mm. Elles peuvent héberger dorénavant des jantes plus larges dont le déport de roue plus réduit élargit la voie de 32 mm. Au format 305/30 ZR19, on dirait des rouleaux compresseurs.

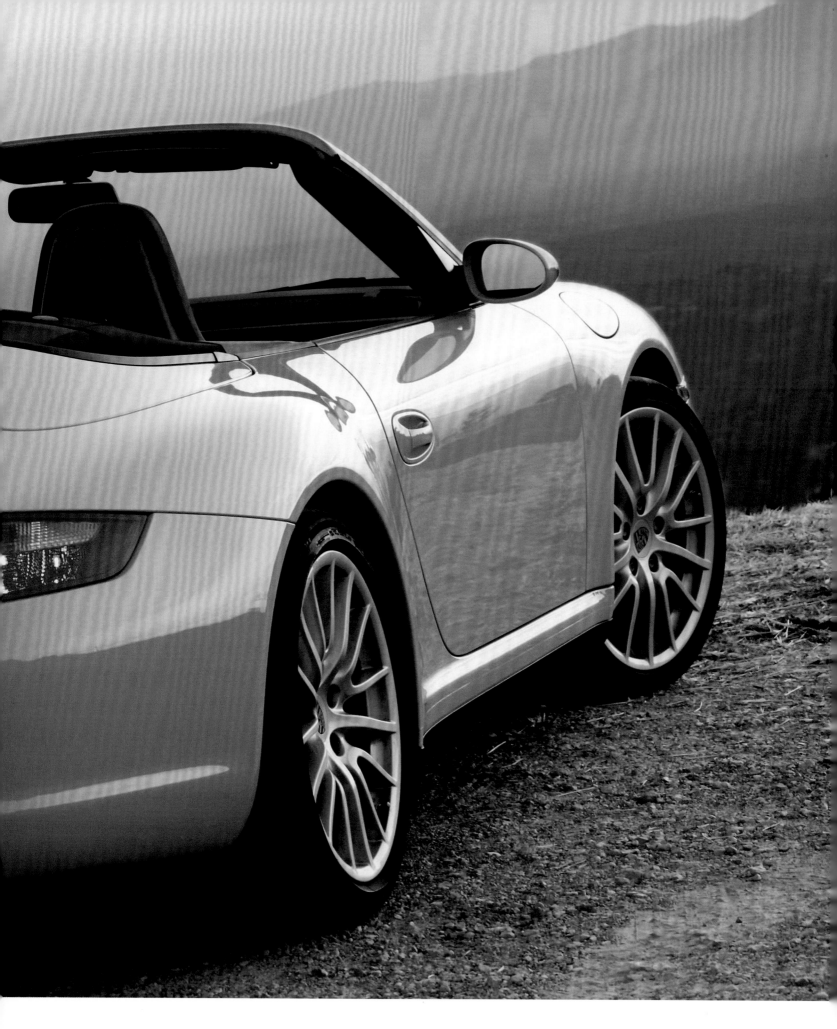

Lined in white, the figures on the instruments of the 4S
bode dynamism, even dynamite. That promise is easily
honored by the 355 bhp of its six-cylinder power plant.
After unfolding in a complicated process, a bottle holder
prevents liquid from being spilled.

Hell unterlegte Zahlen auf den Instrumenten des 4S
verheißen Dynamik, ein Versprechen, das die 355 PS
seines Sechszylinders locker einlösen. Ein sich scheinbar
kompliziert entfaltender Dosenhalter sorgt derweil dafür,
dass nichts verschüttet wird.

Les chiffres noirs sur fond blanc des cadrans de la 4S sont
synonymes de dynamisme, une promesse qu'elle tient
aisément avec les 355 ch de son six-cylindres. Un porte-
gobelets qui se déplie avec sophistication garantit que l'on
ne renverse rien.

By meticulous aerodynamic honing the Cabriolet's drag coefficient has been reduced to a mere 0.29. Opening and closing its top is achieved in 20 seconds. The driver need not necessarily stop as the hood can be raised or lowered at speeds up to 31 mph.

Aerodynamischer Feinschliff erzeugt auch beim Cabrio einen Luftwiderstandsbeiwert von nur 0,29. In 20 Sekunden wechselt es seinen Aggregatszustand. Zur Eröffnung muss man nicht unbedingt anhalten – sie kann selbst noch bei Tempo 50 stattfinden.

Les raffinements aérodynamiques du Cabriolet, aussi, se traduisent par un c_x de 0,29 seulement. Vingt secondes lui suffisent pour changer de nature et retrouver un toit, procédure pour laquelle il n'est même pas nécessaire de s'arrêter – elle reste possible jusqu'à 50 km/h.

In visual terms alone already the GT3 holds out the promise of 911 driving in its purest form, with a new front apron and an abundance of large, greedy air intakes that seem to be ready to devour loads of road.

Schon optisch verheißt der GT3 Elfer-Fahren in seiner reinsten Form, mit neuer Bugschürze und etlichen großen, gierigen Lufeinlässen, die bereit sind, die Straße förmlich zu verschlingen.

Esthétiquement, déjà, la GT3 promet le plaisir de rouler en 911 à l'apogée de sa forme avec un nouveau tablier avant et une ribambelle de grosses prises d'air qui semblent vouloir littéralement engloutir le macadam.

The voluminous 19-inch wheels seem to bulge out even of the generous accommodation attributed to them. The GT3 exudes and epitomizes power that is fully under control, generously provided by a 3,6-liter flat six derived from the Le Mans winning GT1's unit. Alcantara equipment is standard.

Fast sprengen die üppigen 19-Zoll-Räder ihren breiten Rahmen. Der GT3 kann vor Kraft sehr gut laufen. Für diese sorgt reichlich der 3,6-Liter-Boxermotor, wie er einst den Le-Mans-Renner GT1 befeuerte. Ein serienmäßiges Alcantara-Interieur lockt zu frohen Taten.

Les énormes jantes de 19 pouces ont l'air de vouloir sortir des arches de roue. Malgré sa puissance, la GT3 reste très maniable. Elle le doit à son flat-six de 3,6 litres qui a propulsé, en premier lieu, la GT1 ayant couru au Mans. Un cockpit en Alcantara de série incite à passer gaiement à l'action.

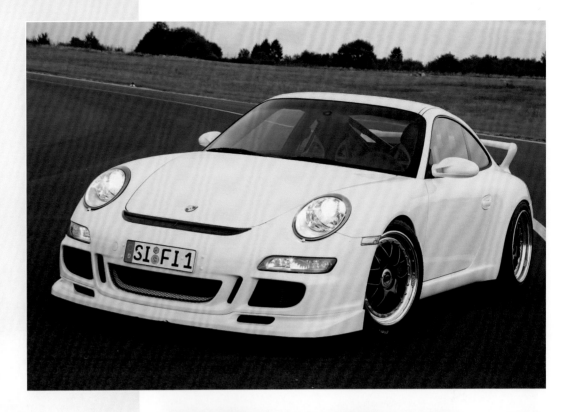

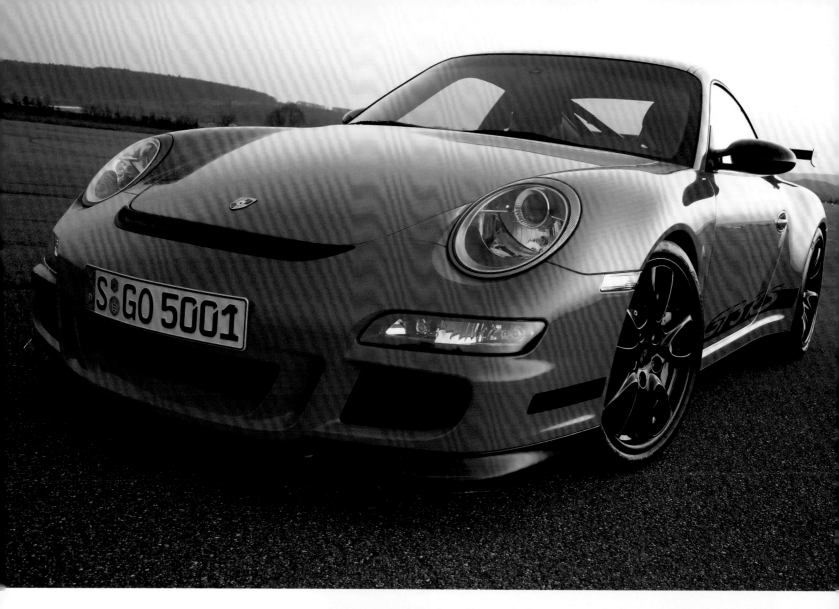

A middle mark on the steering wheel advises the driver of the GT3RS as to where he should go and which direction should rather be avoided. If he nevertheless goes astray, a massive roll cage will protect him.

Eine Mittelmarkierung auf dem Lenkrad berät den Piloten des GT3RS darüber, wohin er steuern oder welche Richtung er besser vermeiden sollte. Ist er dennoch einmal auf Abwege geraten, schützt das Gebälk eines geschraubten Rohrkäfigs.

Une bague de couleur contrastée sur le volant indique toujours au pilote de la GT3RS dans quelle direction il se rend ou quelle direction il ferait mieux d'éviter. S'il se retrouve malgré tout dans la verdure, il peut compter sur la protection d'un arceau-cage boulonné.

e GT3 RS inevitably attracts attention not least because of its garish color scheme and
e threatening lateral logos proclaiming its warlike identity. Compared to the GT3 base
odel it has gained another 1.3" rear axle track. The carbon-fiber rear wing is adjustable.

chrill gibt sich der GT3 RS nicht zuletzt hinsichtlich seiner Farbgebung und der
ohenden seitlichen Signatur. Gegenüber dem Basismodell GT3 hat er noch einmal
mm Hinterachsspur zugelegt. Der Heckflügel aus Kohlefaser ist einstellbar.

GT3 RS attire immanquablement le regard, en particulier à cause de son choix de
uleurs peu discret et de la signature menaçante sur ses flancs. Par rapport au modèle
base, la GT3, ses voies arrière se sont encore élargies de 34 mm et son becquet en fibre
carbone est réglable.

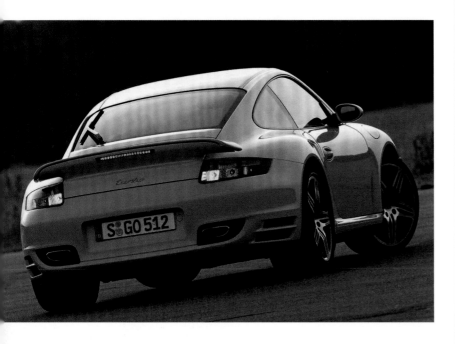

The Turbo generates much more power in a much gentler way than the members of the rude GT3 family. With a rather inconspicuous appearance, the sixth generation of the forced-induction 911 with variable turbo geometry and electronically controlled four-wheel drive is faster but also more urbane than ever before.

Auf viel sanftere Weise als die schrecklich nette GT3-Familie erzeugt der Turbo viel mehr Leistung. Von eher unaufdringlichem Erscheinungsbild gibt er sich in der sechsten Generation mit variabler Ladergeometrie und fahraktivem Allradantrieb schneller, aber auch verbindlicher als je zuvor.

La Turbo génère beaucoup plus de puissance et de façon bien plus civile que les véhicules de la brutale famille GT3. D'allure discrète, la sixième génération de la 911 avec turbo à géométrie variable et transmission intégrale active est néanmoins plus rapide.

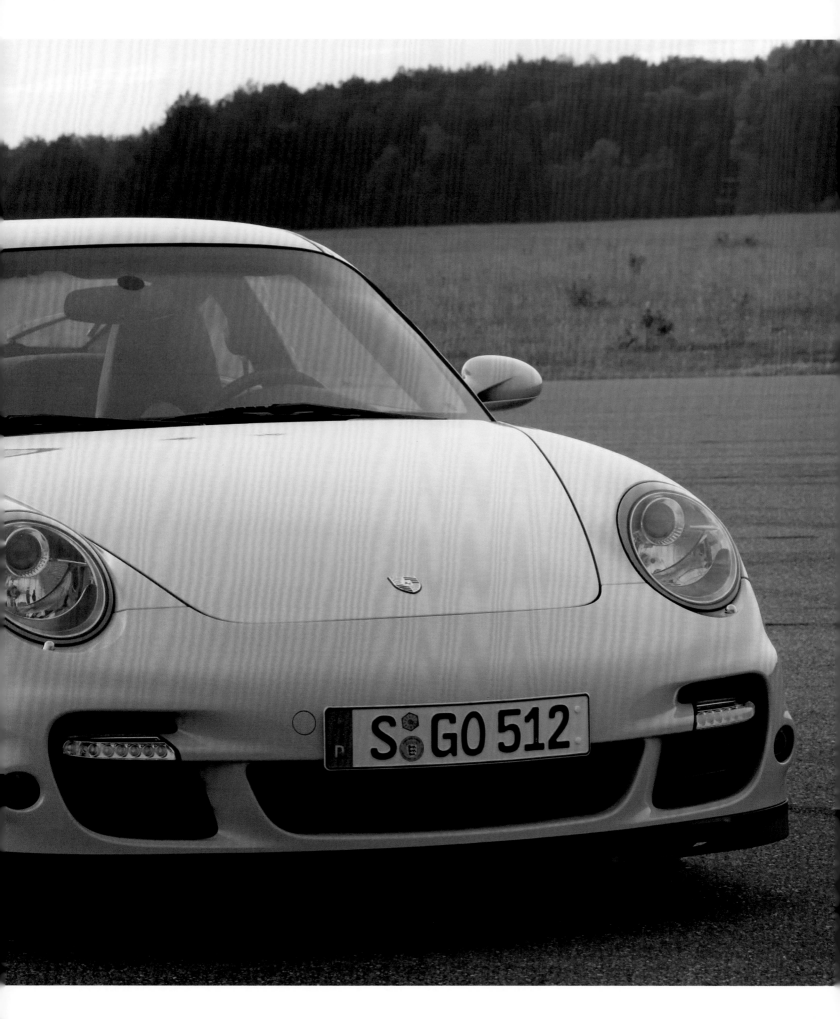

The upper part of the rear wing, which is diminutive compared to former generations, is pushed into the airstream at 75 mph. The red line looms at 6500 rpm, as, after all, the biturbo aggregate's forte is the massive torque it provides. They are attained swiftly indeed.

Zierlicher als an vergangenen Generationen stülpt sich bei Tempo 120 der obere Teil des Heckflügels in den Fahrtwind. Der rote Bereich warnt bereits bei 6500/min, da das Biturbo-Triebwerk vom Drehmoment lebt. Sie sind hurtig erreicht.

The 3.6-liter boxer engine generates a mighty 480 bhp, receiving the air it breathes and burns through the rear lid. 19-inch-wheels in this shape can only be found on the flagship of the 911 fleet.

Der 3,6-Liter-Boxer wartet mit mächtigen 480 PS auf un bezieht seine Verbrennungsluft durch die Heckklappe. D 19-Zoll-Felgen finden sich in dieser Form nur am Elfer-Flaggschiff Turbo.

Plus gracile que sur les modèles précédents, la partie supérieure du becquet arrière brave le vent à partir de 120 km/h. La plage rouge du compte-tours commence déjà à 6500 tr/min, mais le moteur biturbo vit de son couple. Et il n'en manque pas.

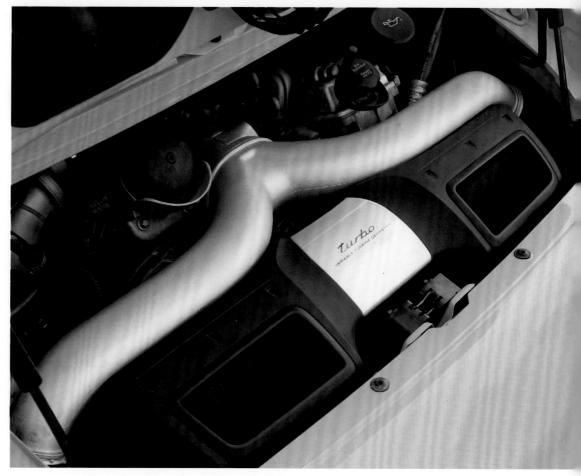

Le boxer de 3,6 litres offre une puissance imposante de 480 chevaux et respire goulûment à travers le capot arrière. Sous cette forme, seul le navire-amiral, la 911 Turbo, possède de telles jantes de 19 pouces.

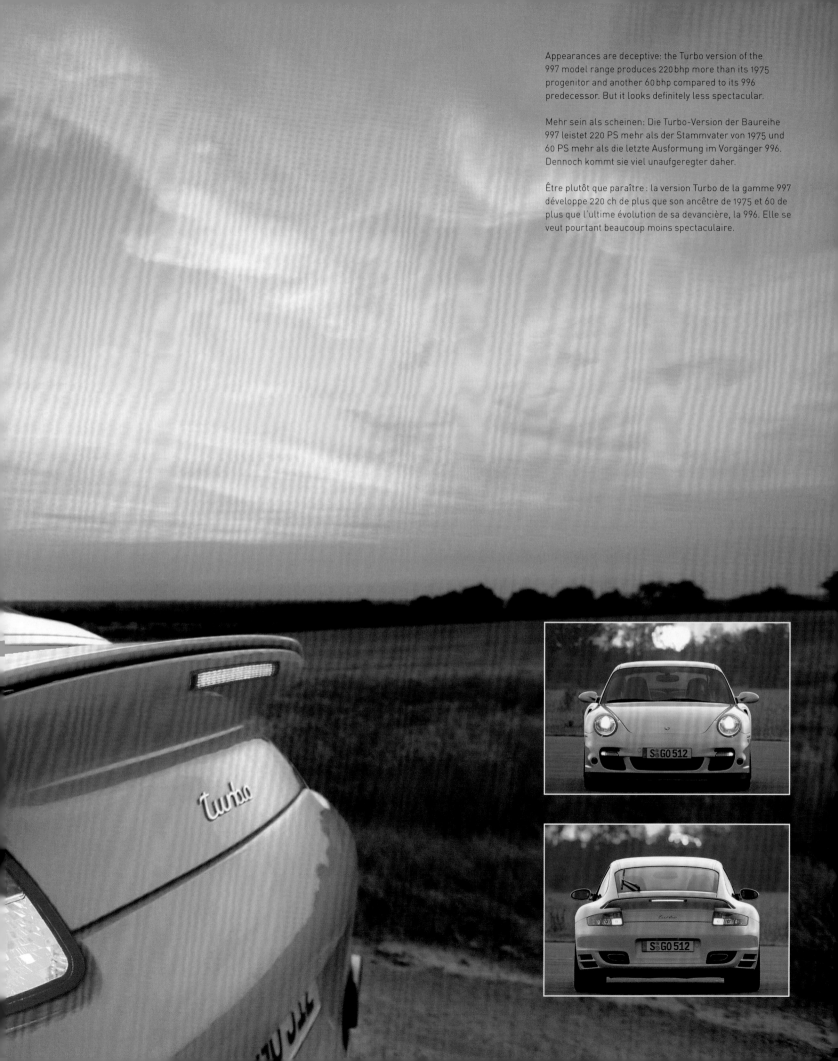

Appearances are deceptive: the Turbo version of the
997 model range produces 220 bhp more than its 1975
progenitor and another 60 bhp compared to its 996
predecessor. But it looks definitely less spectacular.

Mehr sein als scheinen: Die Turbo-Version der Baureihe
997 leistet 220 PS mehr als der Stammvater von 1975 und
60 PS mehr als die letzte Ausformung im Vorgänger 996.
Dennoch kommt sie viel unaufgeregter daher.

Être plutôt que paraître : la version Turbo de la gamme 997
développe 220 ch de plus que son ancêtre de 1975 et 60 de
plus que l'ultime évolution de sa devancière, la 996. Elle se
veut pourtant beaucoup moins spectaculaire.

Like the model preceding it, the 997 Targa is based on the Carrera Coupé so that the silhouette is quite similar. It is produced exclusively with four-wheel drive and presents the viewer a rear that has been widened by 1.7", on the 4 as well as on the 4S varieties.

Wie beim Vorgänger-modell basiert der Targa auf dem Carrera Coupé, so dass die Silhouette sehr ähnlich ist. Er wird ausschließlich mit Allradantrieb ausgeliefert und bietet dem Betrachter ein um 44 mm verbreitertes fülligeres Hinterviertel dar, gleich ob als 4- oder 4S-Variante

Comme pour la version précédente, la Targa dérive de la Carrera Coupé et leurs silhouette sont donc très similaires. Elle est commercialisée exclusivement avec la transmission intégrale et offre aux regards une croupe élargie de 44 mm identique, donc, à celle de la 4 ou de la 4S.

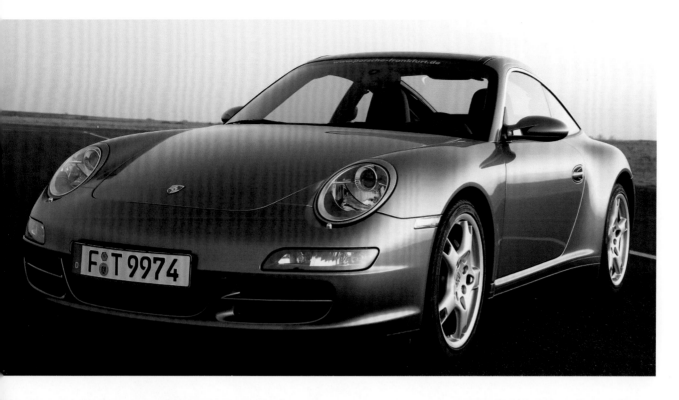

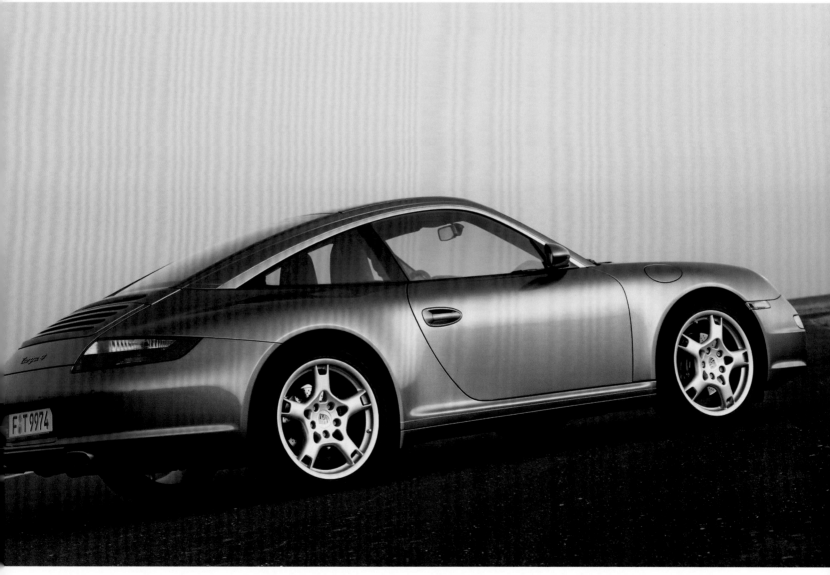

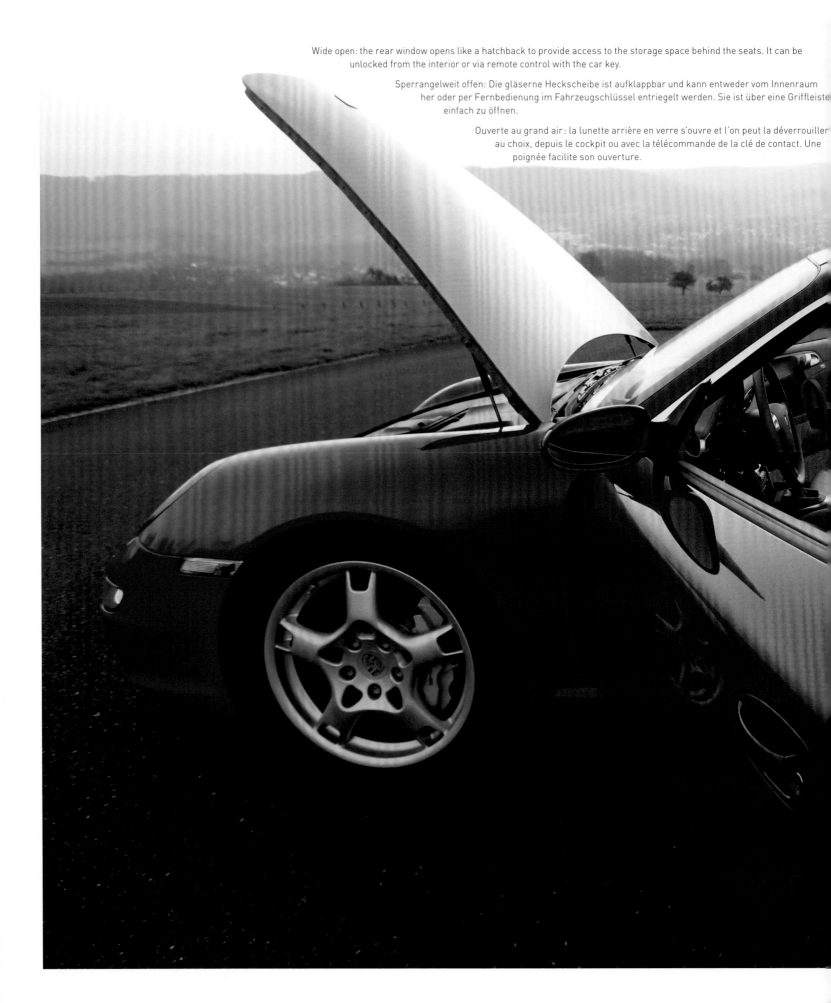

Wide open: the rear window opens like a hatchback to provide access to the storage space behind the seats. It can be unlocked from the interior or via remote control with the car key.

Sperrangelweit offen: Die gläserne Heckscheibe ist aufklappbar und kann entweder vom Innenraum her oder per Fernbedienung im Fahrzeugschlüssel entriegelt werden. Sie ist über eine Griffleiste einfach zu öffnen.

Ouverte au grand air : la lunette arrière en verre s'ouvre et l'on peut la déverrouiller au choix, depuis le cockpit ou avec la télécommande de la clé de contact. Une poignée facilite son ouverture.

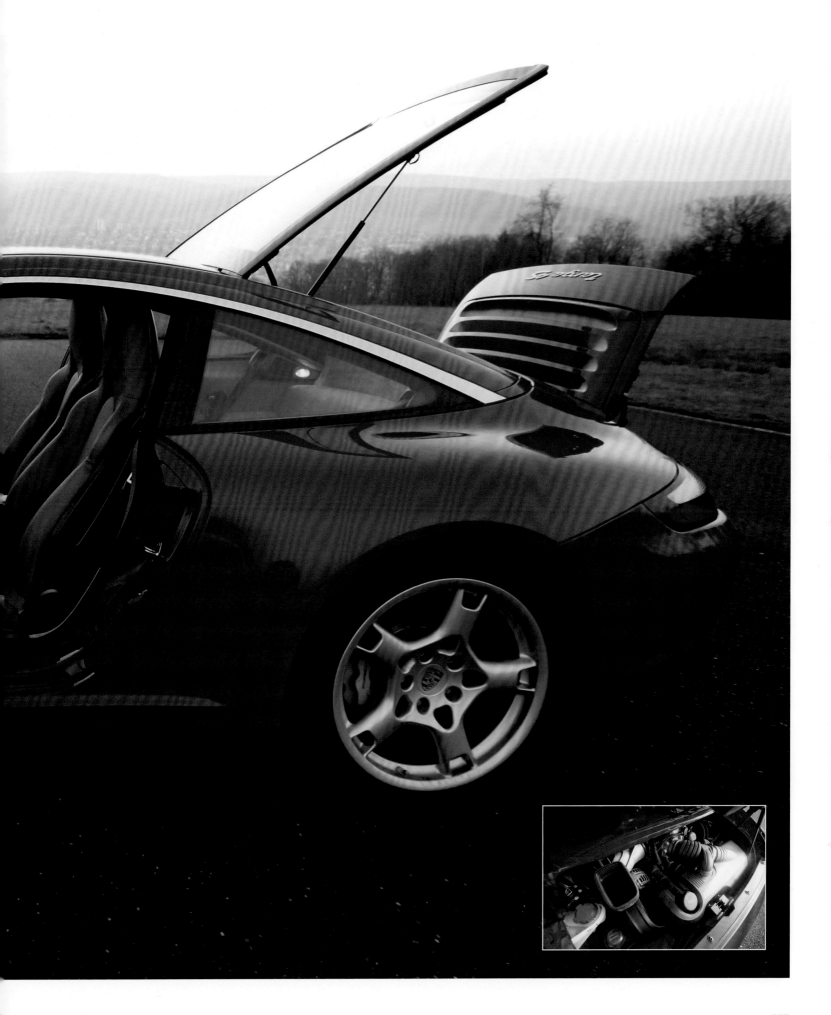

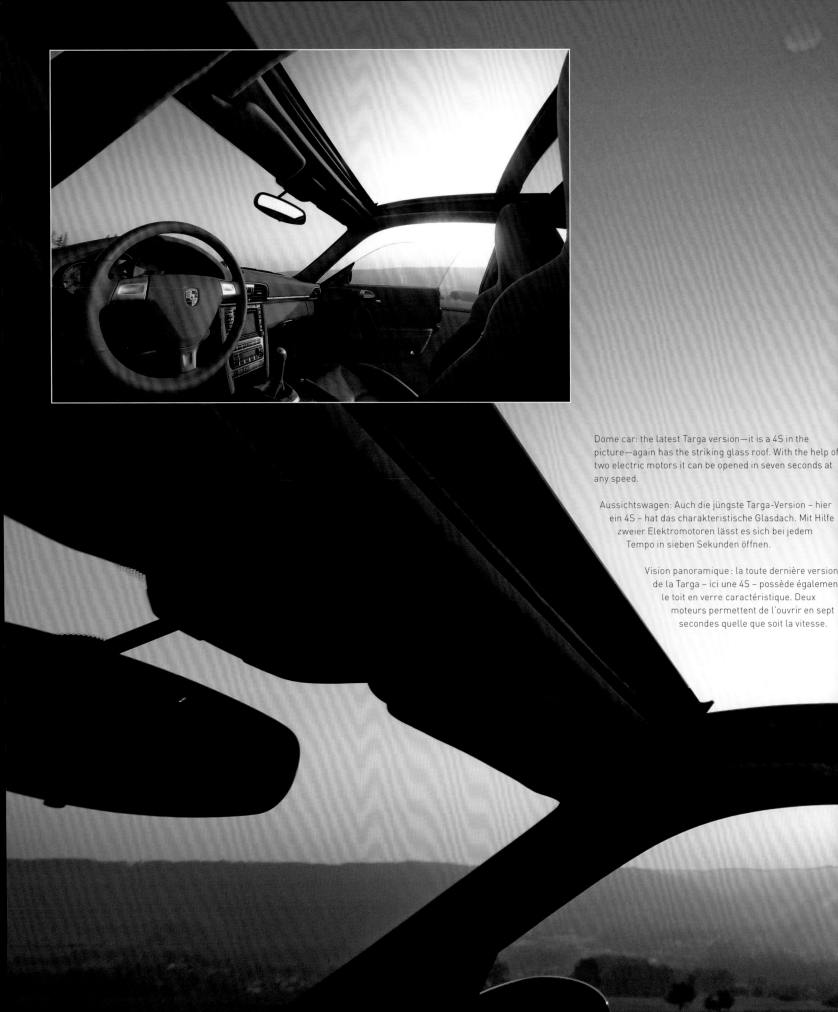

Dome car: the latest Targa version—it is a 4S in the picture—again has the striking glass roof. With the help of two electric motors it can be opened in seven seconds at any speed.

Aussichtswagen: Auch die jüngste Targa-Version – hier ein 4S – hat das charakteristische Glasdach. Mit Hilfe zweier Elektromotoren lässt es sich bei jedem Tempo in sieben Sekunden öffnen.

Vision panoramique : la toute dernière version de la Targa – ici une 4S – possède également le toit en verre caractéristique. Deux moteurs permettent de l'ouvrir en sept secondes quelle que soit la vitesse.

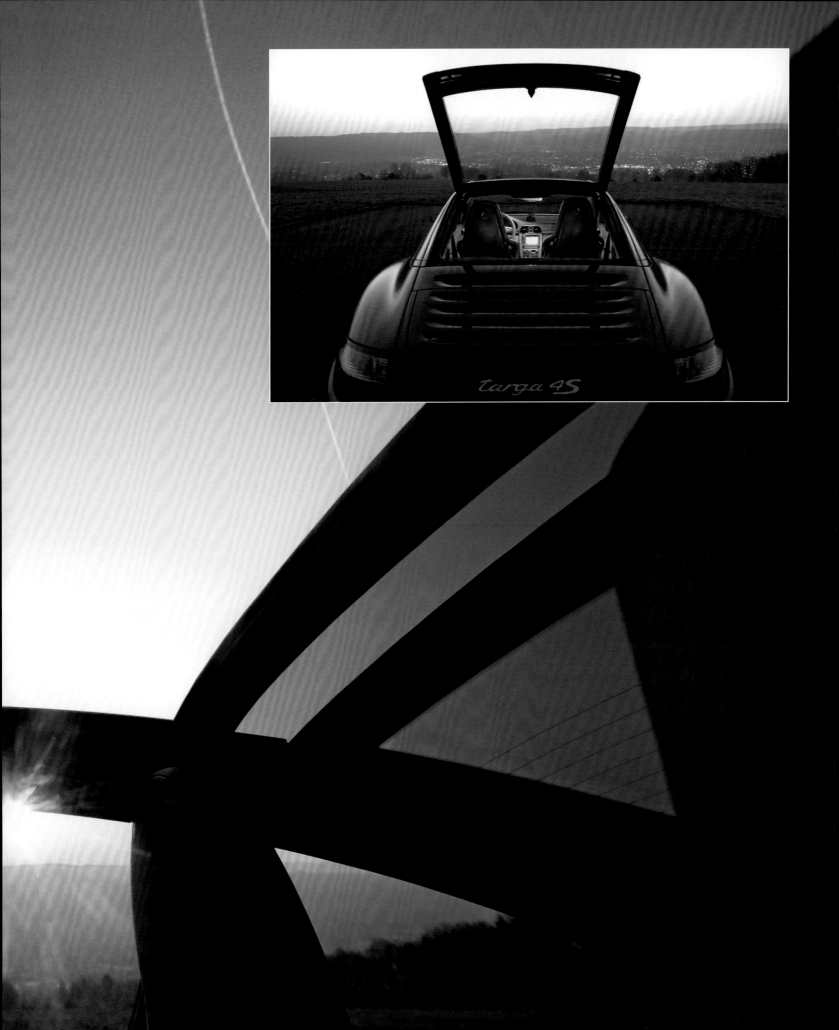

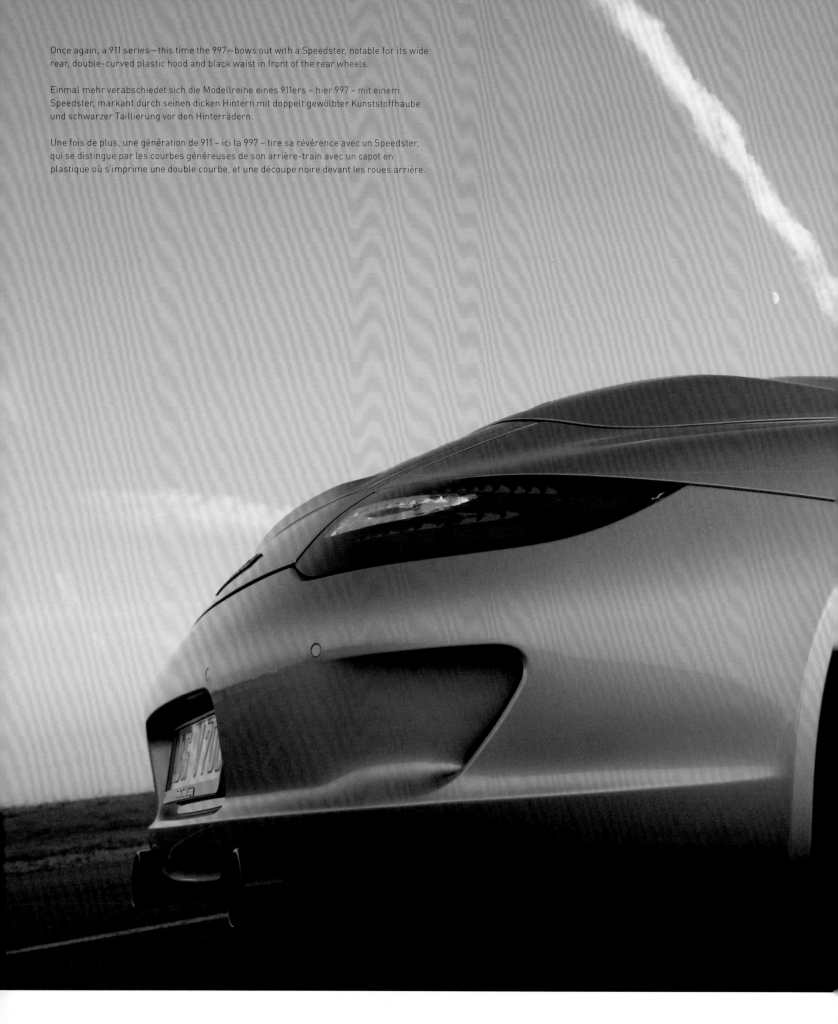

Once again, a 911 series—this time the 997—bows out with a Speedster, notable for its wide rear, double-curved plastic hood and black waist in front of the rear wheels.

Einmal mehr verabschiedet sich die Modellreihe eines 911ers – hier 997 – mit einem Speedster, markant durch seinen dicken Hintern mit doppelt gewölbter Kunststoffhaube und schwarzer Taillierung vor den Hinterrädern.

Une fois de plus, une génération de 911 – ici la 997 – tire sa révérence avec un Speedster, qui se distingue par les courbes généreuses de son arrière-train avec un capot en plastique où s'imprime une double courbe, et une découpe noire devant les roues arrière.

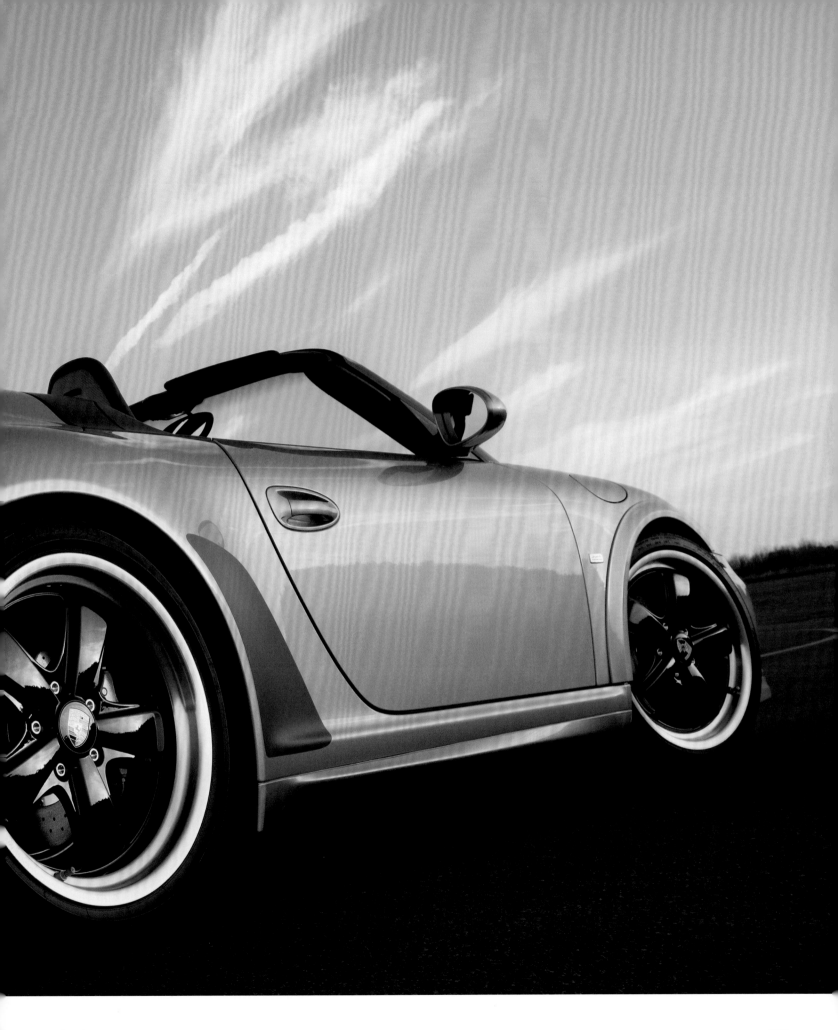

Electric hood opening mechanism, but semi-manual soft top: the Speedster's folding mechanism has its quirks—but that didn't stop this convertible with the flat windshield from selling out within one month.

Elektrische Haubenentriegelung, aber teilweise manuell zu betätigendes Stoffverdeck: Der Faltmechanismus des Speedsters hat seine Tücken. Dennoch war dieses Cabrio mit flacher Frontscheibe innerhalb eines Monats ausverkauft.

Ouverture électrique du capot, mais capote semi-manuelle : le mécanisme de pliage du Speedster est assez particulier. Mais cela n'a pas empêché ce cabriolet à pare-brise plat de se vendre comme des petits pains. Toutes les unités sont parties en un mois.

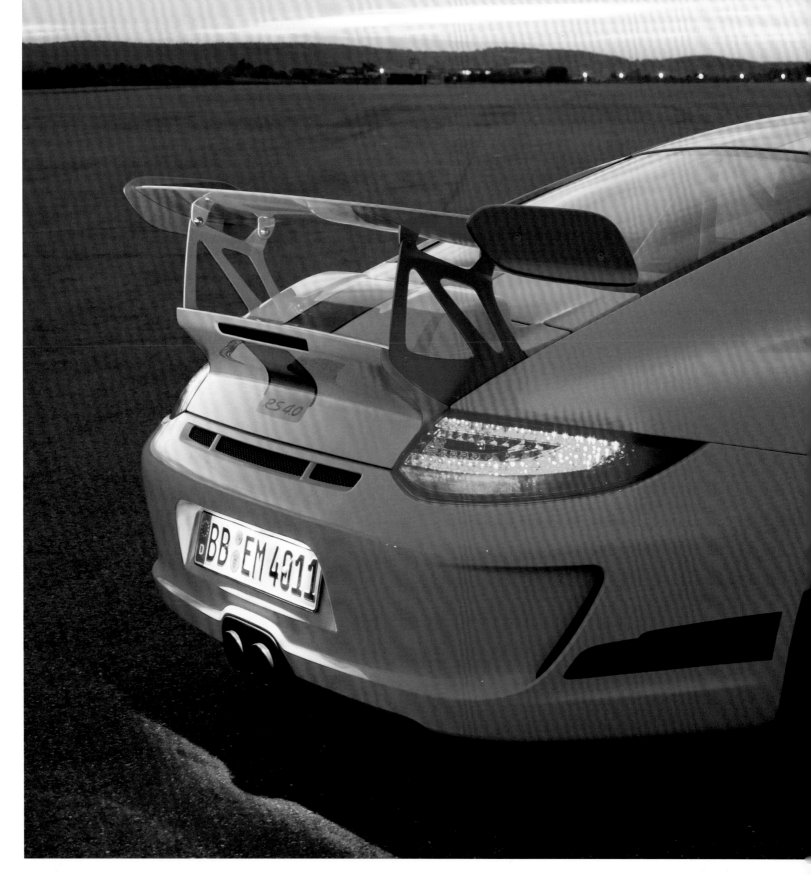

Where its road stops, its race track begins: the GT3 RS 4.0, third and final stage in the evolution of the GT3 RS, based on the 911 (997). Thanks to its 500 bhp with an empty weight of just 2800 pounds, this RS catapults to 60 mph in 3.9 seconds.

Wo hört bei ihm die Straße auf, fängt die Rennstrecke an: der GT3 RS 4.0, dritte und letzte Evolutionsstufe des GT3 RS auf Basis des 911 (997). Dank seiner 500 PS bei einem Leergewicht von nur 1270 Kilo katapultiert sich dieser RS in 3,9 Sekunden auf 100 km/h.

Lorsque la route se termine, la piste de course commence : la GT3 RS 4.0, troisième et dernière étape de l'évolution de la GT3 RS sur la base de la 911 (997). Grâce à ses 500 ch et à un poids à vide de seulement 1270 kilos, cette RS se catapulte à 100 km/h en 3,9 secondes.

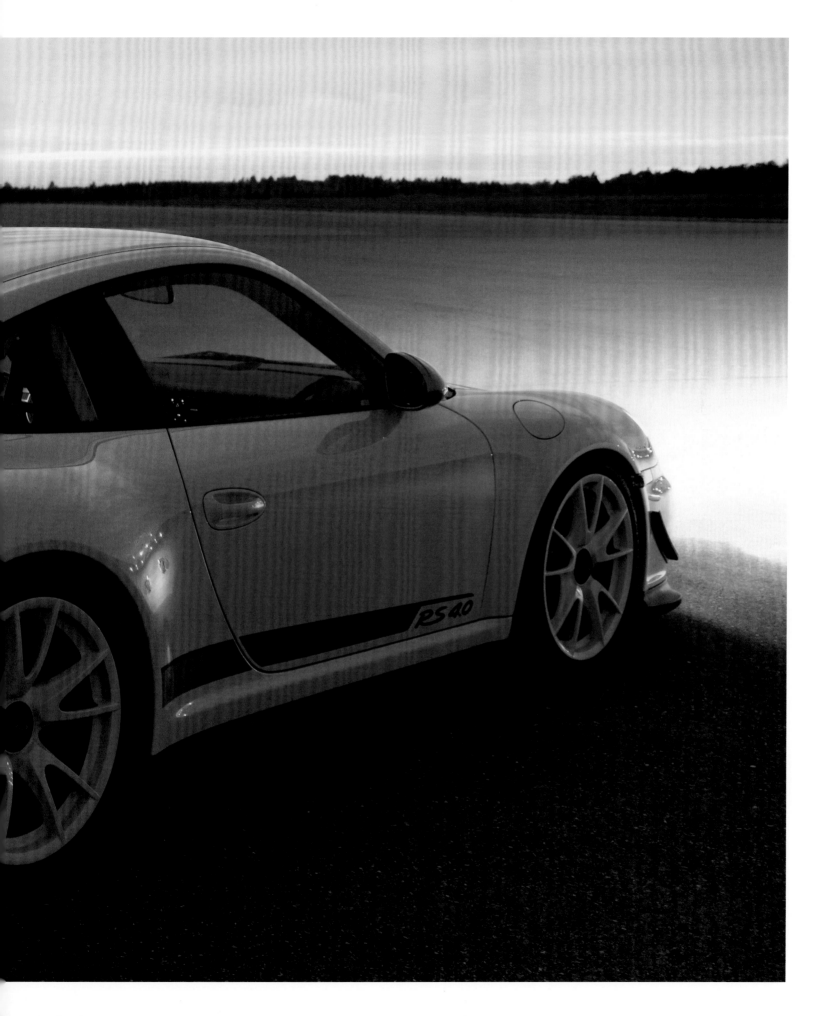

Clever slipstream
channeling, spoiler and
a powerful rear wing:
the GT3 RS 4.0 certainly
isn't lacking in efficient
aerodynamic features.

Geschickte Fahrtwind-
kanalisierung, Spoiler
und ein gewaltiger
Heckflügel: An effizienten
aerodynamischen
Hilfsmitteln fehlt es dem
GT3 RS 4.0 wirklich nicht.

Canalisation ingénieuse
de l'air, spoiler et aileron
arrière : la GT3 RS 4.0
ne manque vraiment
pas de ressources
aérodynamiques
efficaces.

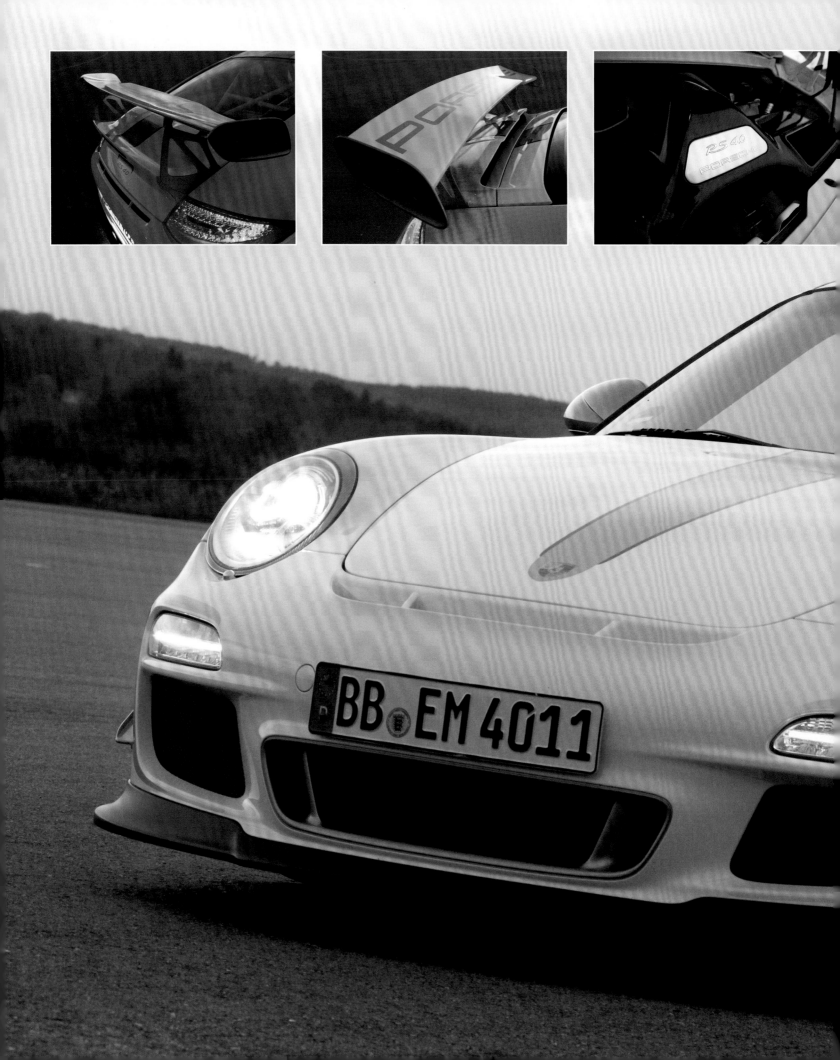

The engine is characterized by the larger four-liter displacement, racing crankshaft, titanium connecting rods and a special VarioCam control system. There are only 600 copies of this white racer.

Auf vier Liter vergrößerter Hubraum, Rennkurbelwelle, Titanpleuel und eine spezielle VarioCam-Steuerung zeichnen das Triebwerk aus. Von diesem nur in Weiß lackierten Renner gibt es nur 600 Exemplare.

Le moteur se distingue par une cylindrée augmentée de quatre litres, un vilebrequin de course, les bielles en titane et le VarioCam à commande spéciale. Cette sportive disponible uniquement en blanc n'existe qu'en 600 exemplaires.

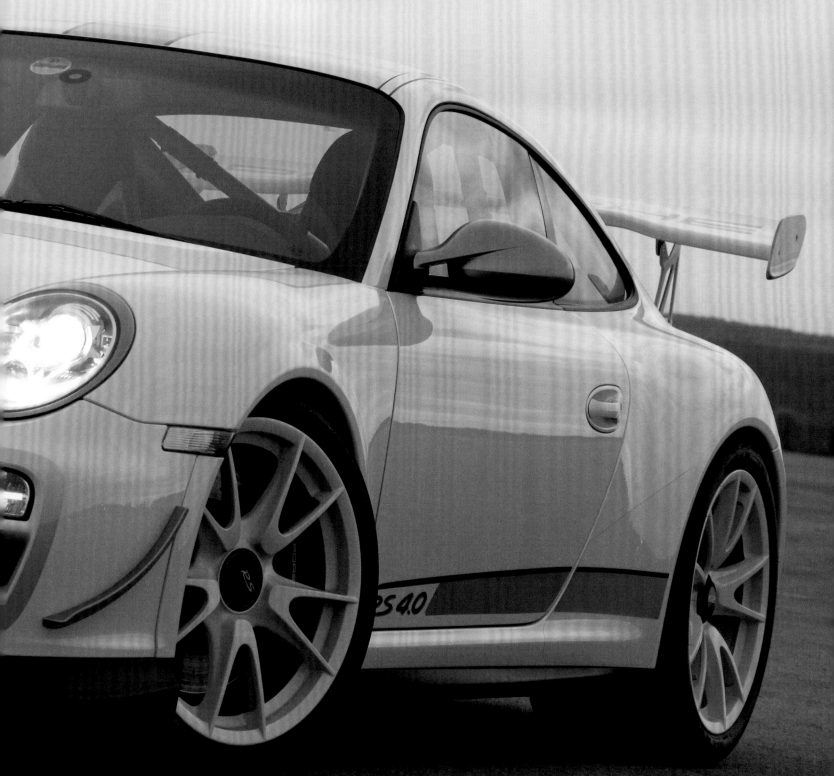

The Panamera, introduced in April 2009 at the 13th Shanghai Car Show in the sprawling, gigantic, wildly ambitious Chinese metropolis, was the answer to an anxious question that had haunted generations of passionate Porsche drivers: what will happen to us when we have children? But it was more than that—the creators of the new car had excelled themselves and fitted a second row of seats on which even someone more than six foot tall could travel with head erect, in the same level of comfort as those in front, likewise separated by a high, densely populated center console, surrounded by wood and leather.

This feature plus the front mid-engine design—and the *idée fixe* that the four-door model must, in the typical Porsche way, be low, with an unmistakable family resemblance and looking like a real sports car—dictated its enormous proportions: 16 feet long, 6'4" wide, and only 4'8" high. It was part of the dual nature of the new Porsche, half sedan and half sports coupé, that it could be transformed into a small "van" by folding down the rear backrests. An ample load volume of 15 cubic feet had previously been available: now it had increased to 53 cubic feet.

In addition, it was nailed to the ground by a movable spoiler that automatically deployed at 56 mph and lowered back down again at 37 mph, and was added to by lateral extensions in the turbo version. The superior dynamics for four came mainly through its powerful engines, familiar from its companion the Cayenne. Their power could all be measured in round hundreds of bhp: the 4.8-liter V8 had a whopping 400 bhp in the types S and 4S, and 500 bhp in the fastest variant, the Turbo. In the 4S, at 175 mph the slowest in the Panamera fleet before the release of the diesel (250 bhp, 150 mph), this horsepower was distributed via a multi-plate clutch to meet the traction needs of all four wheels.

More economic, and chiming in with the spirit of the new age, a 300 bhp, 3.6-liter V6 conjured up in the laboratories of VW in 2010—but downright stingy was the 350 bhp hybrid variant that came out in 2011. Between the six cylinders and the engine throbs a 34-kilowatt electric motor. In a dungeon beneath the trunk dwells a nickel-metal hydride battery with a capacity of 17 kilowatt hours. A lithium-ion battery was slow in coming—these batteries were new entries in the sportscar driver's dictionary, as was the start-stop system with brake energy recuperation. A low rev level is ensured not least by a dual-clutch transmission developed by ZF, with seven gears imperceptibly merging into one another.

Porsche presented a natural progression of the Panamera with an extended rear section and larger air intakes in 2013 in Shanghai, as well as an Executive version with a longer wheelbase. The V8 with 400 bhp gave way for a V6 biturbo with 420 bhp. The 2014 assortment featured a new 300 bhp diesel.

Der Panamera, vorgestellt im April 2009 auf der 13. Auto Shanghai in der wuchernd-ambitionierten chinesischen Riesenmetropole, war die Antwort auf eine bange Frage, die Generationen von passionierten Porsche-Fahrern umgetrieben hatte: Was wird aus uns, wenn wir Nachwuchs bekommen? Mehr noch – die Väter des Neuen hatten Nägel mit Köpfen gemacht und eine zweite Sitzreihe eingerichtet, in der man selbst mit fast zwei Metern aufrechten Hauptes zu reisen vermochte, auf demselben kommoden Gestühl wie im ersten Glied zumal und wie dort getrennt durch eine hohe, dicht besiedelte Mittelkonsole und eingebettet in Holz und Leder.

Dies, die Front-Mittelmotor-Auslegung und das Mantra, der Viertürer müsse nach Porsche-Art flach, mit einer unverkennbaren Familien-Anmutung und wie ein richtiger Sportwagen daherkommen, bedingte seine enormen Proportionen: 4870 mm lang, 1931 mm breit, nur 1418 mm hoch. In die Zwienatur des großen Zuffenhauseners zwischen Limousine und Sportcoupé fügte sich, dass er sich durch Umlegen der Fondsitzlehnen in einen kleinen Transporter verwandeln ließ. Reichliche 430 Liter Ladevolumen standen schon vorher zur Verfügung, nun waren es 1500 Liter.

Zusätzlich an den Boden genagelt wurde er durch einen beweglichen Bürzel, der bei 90 km/h automatisch aus- und bei 60 km/h wieder einfuhr, in der Turbo-Version erweitert durch seitlich sich herausstülpende Protuberanzen. Überlegene Dynamik für vier: Dafür zeichneten in erster Linie seine potenten Triebwerke verantwortlich, bekannt aus dem geländigen Bruder Cayenne. Alle mobilisierten sie Pferdestärken in runden Hundertschaften, der 4,8-Liter-V8 satte 400 PS in den Typen S und 4S, 500 PS in der schnellsten Variante Turbo. Diese wurden im 4S, mit 282 km/h vor Auftritt des Diesel (250 PS, 242 km/h) der langsamste in der Panamera-Flotte, bedarfsgerecht durch eine Lamellenkupplung an die vier Räder weitergereicht.

Sparsamer und im Einklang mit dem Geist der neuen Zeit sollte ab 2010 ein 300 PS starker 3,6-Liter-V6 aus den Hexenküchen von VW agieren, vergleichsweise geradezu knauserig dessen 2011 erschienene Hybrid-Spielart mit 350 PS. Zwischen dem Sechszylinder und dem Getriebe rotierte ein 34-Kilowatt-Elektromotor. In einem Verlies unterhalb des Kofferraums hauste eine Nickel-Metallhydrid-Batterie mit einer Kapazität von 17 Kilowattstunden. Ein Lithium-Ionen-Akku ließ noch auf sich warten – allesamt Neologismen im Wörterbuch für den Sportwagenfahrer wie auch etwa das Start-Stopp-System mit Bremsenergie-Rekuperation. Für ein niedriges Drehzahlniveau sorgte nicht zuletzt ein von ZF entwickeltes Doppelkupplungsgetriebe mit sieben unspürbar ineinander gleitenden Fahrstufen.

Einen konsequent weiterentwickelten Panamera mit gestrecktem Heck und größeren Lufteinlässen präsentierte Porsche 2013 in Shanghai, ebenso wie die Executive-Version mit längerem Radstand. Der V8 mit 400 PS wich einem V6 Biturbo mit 420 PS. 2014 im Programm: ein neuer 300-PS-Diesel.

La Panamera présentée en avril 2009 lor du 13ᵉ salon de l'automobile de Shangh dans la gigantesque métropole chinoise l'ambitieuse expansion, fut la réponse à une que tion angoissante qui obsédait les conducteur passionnés de Porsche : qu'adviendra-t-il de nou lorsque nous aurons des enfants ? Les conce teurs de la petite nouvelle n'ont pas fait les chose à moitié : la deuxième rangée de sièges, similaire à ceux des places avant, permet de voyager tête droite même lorsqu'on mesure presque deu mètres. Là aussi, une console centrale montan bien équipée recouverte de bois et de cuir sépar les sièges.

Ses immenses proportions, 4870 mm de lon 1931 mm de large et seulement 1418 mm de hau sont dues à cette deuxième rangée de sièg

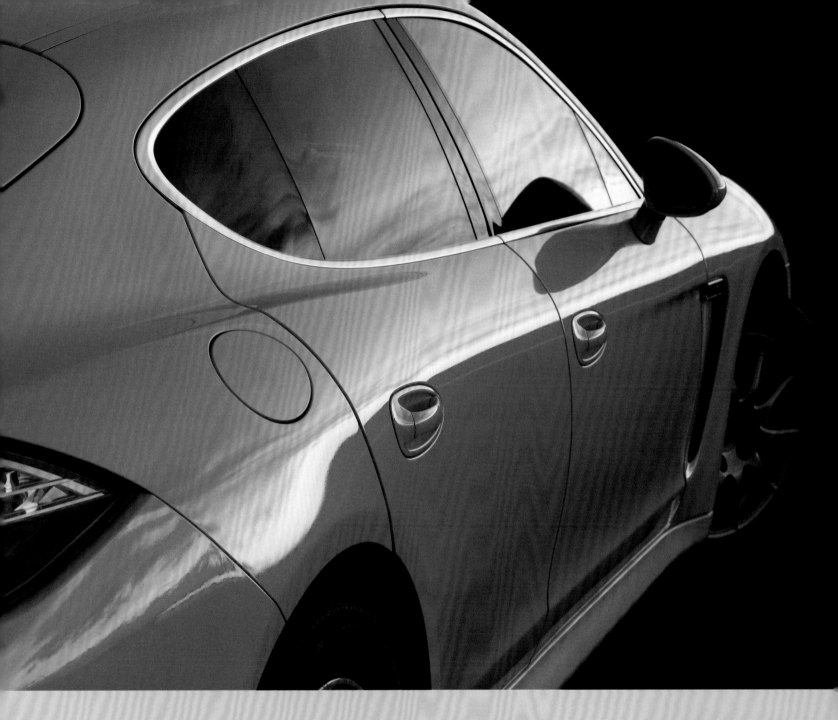

nais également au moteur avant central et au
hantra selon lequel la quatre portes doit être
asse, avoir un air de famille évident et ressem-
ler à une véritable voiture de sport. La dualité de
a nature de la grande Porsche, qui se situe entre
a berline et le coupé sport, lui permet également
e se transformer en petit fourgon lorsqu'on rabat
es dossiers des sièges arrière. Les généreux
30 litres de volume de chargement déjà dispo-
ibles se transforment alors en 1500 litres.

Elle est également clouée au sol par un aileron
rrière mobile qui se déploie automatiquement
 partir de 90 km/h et se rétracte à nouveau à
0 km/h. Dans la version turbo il se départage et
éploie des extensions à droite et à gauche. Cette
ersion est caractérisée par ses puissantes moto-
sations déjà célèbres grâce au Cayenne, son

frère tout-terrain. Elles mobilisent les chevaux
par centaines : le V8 de 4,8 litres est doté de 400 ch
pour les modèles S et 4S, et 500 ch équipent la
version la plus rapide, le Turbo. Dans leur version
4S, avant l'arrivée du diesel (250 ch, 242 km/h) la
moins rapide de la flotte Panamera, avec 282 km/h,
elles devinrent parfaitement transmis aux quatre
roues par un embrayage multidisques.

Plus économique et dans l'esprit actuel, un
V6 de 3,6 litres offrant 300 ch issu du chaudron
magique de Volkswagen opère depuis 2010, mais
sa variante hybride de 350 ch sortie en 2011 se
contente d'encore moins. Entre le six cylindres et
la boîte de vitesses il y a un moteur électrique de
34 kilowatts. Une batterie nickel-hydrure métal-
lique (NiMh) d'une capacité de 17 kWh se loge dans
une cachette située sous le coffre. Un accumula-

teur lithium-ion (Li-ion) se fait encore attendre.
Tous ces termes sont sans exception des néolo-
gismes dans le dictionnaire des conducteurs
de voitures de sport, tout comme par exemple
le système stop-start avec récupération de
l'énergie de freinage. La boîte de vitesses à double
embrayage mise au point par ZF permet un niveau
de régime plus faible ; elle comprend sept vitesses
qui passent les unes après les autres sans qu'on
s'en aperçoive.

En 2013, à Shanghai, Porsche présente une
évolution naturelle de la Panamera, avec un
arrière-train allongé et des prises d'air plus
grandes, ainsi qu'une version Executive à empatte-
ment long. Le V8 et ses 400 ch. laissent la place à
un V6 biturbo avec 420 ch. Dès 2014, il y a même un
nouveau diesel de 300 ch.

Panamera (970)

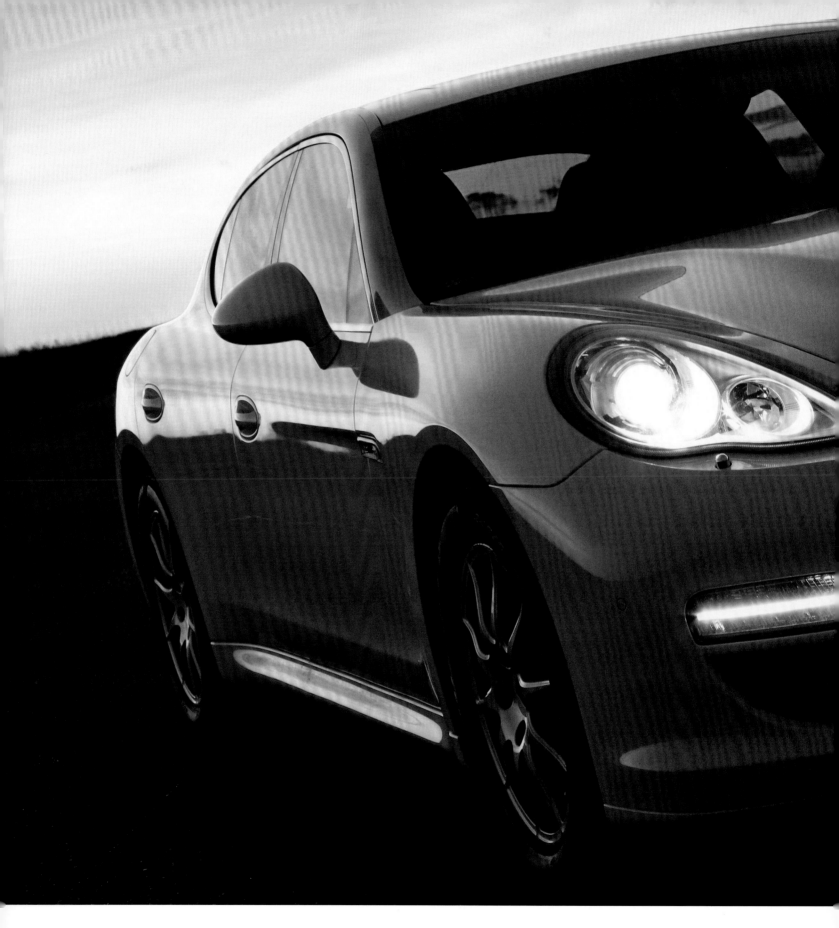

Actually, in spite of its clear echoes of the classic 911, the Panamera is a hatchback sedan with a large tailgate, only much flatter than usual. This design combines sportiness with space, user-friendliness and adaptability.

Eigentlich handelt es sich beim Panamera trotz deutliche Anklänge an den Klassiker 911 um eine Schrägheck-Limousine mit großer Heckklappe, nur viel flacher als üblich. In dieser Auslegung verbindet sich Sportivität mit Volumen, Nutzwert und Variabilität.

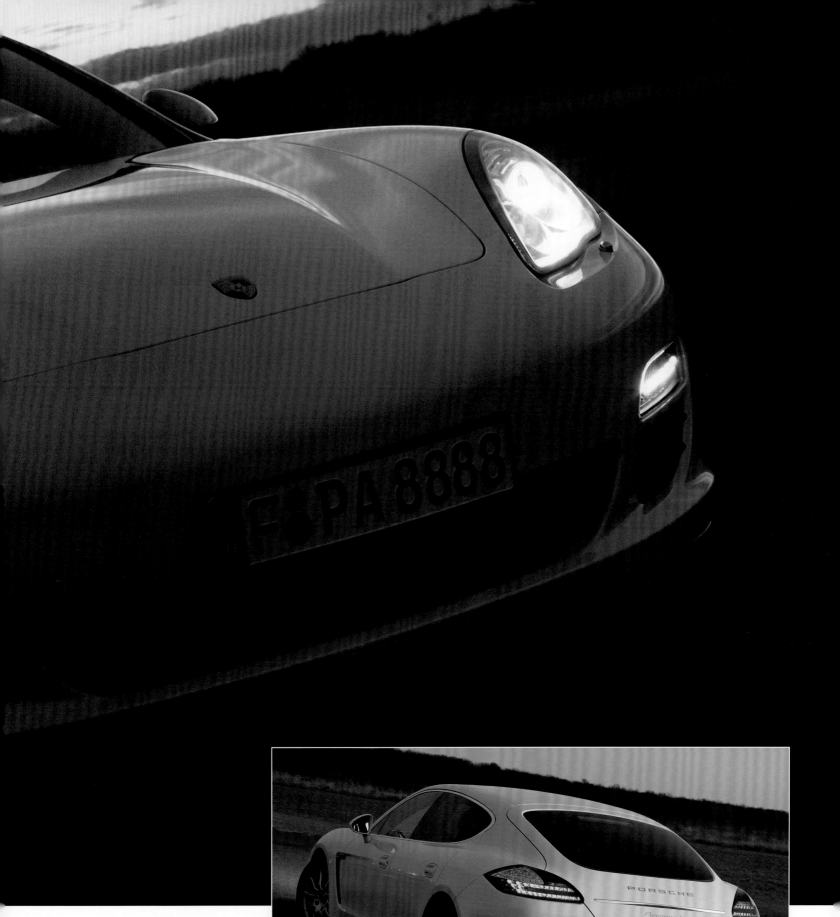

algré une nette réminiscence de la classique 911, la
anamera est une berline à l'arrière incliné dotée
un grand hayon, légèrement plus plat qu'il ne l'est
abituellement. Cette version associe sportivité et
olumes, utilité et adaptabilité.

orsche Panamera (970)

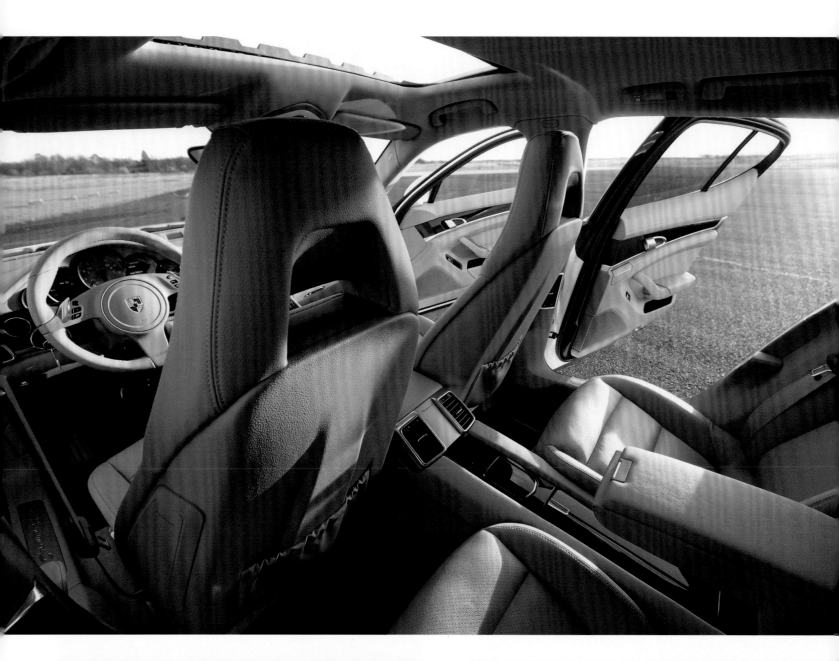

The allure of the big Porsche resides especially in its comfy
seating arrangements. The rear seats are identical to those
in the front row—right down to the missing height setting.
The cockpit has a classical, top-notch elegance—sweet-
smelling leather above and below, with wood and nicely
rounded instruments in the middle. Under the hood, the
V8 relies on its mere strength of presence, and avoids any
unnecessary decoration.

Der große Porsche besticht durch eine kommode Sitzposi-
tion. Die Fondsessel sind mit ihren Pendants in der ersten
Reihe identisch – bis auf die fehlende Höheneinstellung.
Das Cockpit mutet klassisch schön und hochwertig an –
duftendes Leder oben und unten, dazwischen Holz und
runde Instrumente. Der V8 unter der Fronthaube baut auf
seine bloße Präsenz und verzichtet auf Zierrat.

La grande Porsche séduit par sa position assise confor-
table. Les sièges arrière sont identiques à ceux de l'avant,
jusqu'au réglage de la hauteur. Le poste de pilotage de
qualité est d'une beauté classique : le cuir en haut et en bas
répand sa bonne odeur, au cœur du bois et des instruments
ronds. On peut compter sur l'efficacité du V8 présent sous le
capot et on se passe de fioritures.

The Cayenne family was popular with pragmatists, SUV fans and power freaks alike, and meanwhile made up more than 50 percent of Porsche's total sales. 74,763 were shipped in 2012, around 19,000 of which were Cayenne S, GTS and Turbo: impressive! Porsche's clever juggling of variants and derivatives ranged from the basic six-cylinder model (300 bhp) with much lower consumption and emission values, through the diesel, the eight-cylinder Cayenne S—also available as a diesel and hybrid—to the GTS and Turbo, and its S edition. Porsche presented this in 2013 in Detroit as a super SUV with 550 bhp, good for 176 mph. The latest GTS generation also enjoyed an increased output of 420 bhp. Even without the primal power boost of a Cayenne Turbo S, it was incredibly quick off the mark thanks to its relatively closely-stepped, eight-speed Tiptronic, accelerating its weight to 60 mph in 5.7 seconds and hitting 162 mph before it started to push the boundaries of physics.

However, it wasn't just the power of its engine—which can be channeled into the cockpit from the engine compartment by "sound symposers"—that emphasized the sportiness of the GTS. Other racy features included the one-inch-lower chassis with "Porsche Active Suspension Management" (PASM) and the 21-inch wheels with 295 tires. Of course, its breeding demanded the right look to match, with a powerful roof spoiler with a double-winged profile, and a front air intake whose grille could be mistaken for that of a Ferrari. In spite of their sportiness the GTS and the Turbos provided great comfort with standard leather seats. With the gritty sound emitted through the flaps of the sports exhaust and out of the tail pipes, and the V8's unmissable inhalation in their ears, drivers at the wheel of a GTS or Turbo felt like professional racers, in spite of the higher seating position. The Cayenne's comfortable interior was completely redone and improved. Right between two air vents: the 7-inch touchscreen of the information and communication system. A range of interior packages were available to cater to individual needs.

The Cayenne Diesel's biturbo engine demonstrated its efficiency with an average mileage of 32.5 mpg, while the optional 26-gallon tank increased its range to match. The Cayenne S Diesel and the S Hybrid, whose aggregates together generated 380 bhp, also proved efficient. At low speeds, such as in residential areas, the two-tonner could tip-toe around powered solely by its 47 bhp electric motor. Unlike the other gasoline Cayennes, it went at least 26 miles per gallon, even within city limits. And if you were to end up in the country with a Cayenne: its approach angles were just under 25 degrees, and the fording depth was about one and a half feet. As a result, its towing capacity, sportiness and comfort were complimented by a respectable off-road capability.

Bei Pragmatikern, SUV-Verliebten und Kraftprotzen gleichermaßen hoch im Kurs stand die Cayenne-Familie, die inzwischen mehr als 50 Prozent des gesamten Porsche-Absatzes ausmachte. 74 763 Auslieferungen 2012, davon rund 19 000 Cayenne S, GTS und Turbo: beeindruckend! Porsches geschickte Jonglage zwischen Varianten und Derivaten reichte vom Sechszylinder-Basismodell (300 PS) mit deutlich gesenkten Verbrauchs- und Emissionswerten über den Diesel, den Achtzylinder Cayenne S – auch als Diesel und Hybrid – bis zu GTS und Turbo samt dessen S-Ausführung. Diese präsentierte Porsche 2013 in Detroit als Super-SUV mit 550 PS, gut für 283 km/h. Die jüngste GTS-Generation durfte sich ebenfalls über eine Leistungssteigerung auf nunmehr 420 PS freuen. Auch ohne die Urgewalt eines Cayenne Turbo S beschleunigte dieser Sauger ungemein forsch, dank seiner relativ kurz abgestuften Achtgang-Tiptronic. So schaffte er seine Tonnage in 5,7 Sekunden auf Tempo 100 und stieß erst bei 261 km/h an die Grenzen der Physik.

Doch nicht nur die Kraft seiner Maschine – über sogenannte Sound-Symposer aus dem Motorraum ins Cockpit übertragbar –, sondern auch das um 24 Millimeter tiefer gelegte Fahrgestell mit dem „Porsche Active Suspension Management" (PASM) sowie die 21-Zoll-Räder mit 295er Walzen betonten die Sportlichkeit des GTS. Dessen Gene verlangten natürlich nach der entsprechenden Optik wie einem gewaltigen Dachspoiler mit Doppelflügelprofil oder einem frontalen Lufteinlass, dessen Gitter von einem Ferrari hätten stammen können. GTS und die Turbos boten bei aller Sportlichkeit viel Komfort mit serienmäßigen Ledersitzen. Mit dem kernigem Sound, der durch die Klappen der Sportauspuffanlage aus den Endrohren drang, und dem unüberhörbaren Luftholen des V8 im Ohr kam man sich am Volant eines GTS oder der Turbos wie ein Sportwagen-Lenker vor – trotz der höheren Sitzposition. Komplett überarbeitet und noch komfortabler gestaltet wurde der Innenraum des Cayenne. Mittig zwischen zwei Belüftungsschächten: der Sieben-Zoll-Touchscreen des Informations- und Kommunikationssystems. Individuelle Sonderwünsche befriedigten diverse Interieur-Pakete.

Sparsamkeit zeigte der Biturbo-Motor des Cayenne Diesel mit einem Durchschnittsverbrauch von 7,2 Litern. Mit dem optionalen 100-Liter-Tank lag seine Reichweite entsprechend hoch. Effizienz demonstrierten auch der Cayenne S Diesel und der S Hybrid, dessen Aggregate zusammen 380 PS aktivierten. Sein 47 PS starker Elektromotor bewegte den Zweitonner bei niedriger Geschwindigkeit, etwa in einem Wohngebiet, auf leisen Sohlen ganz allein. Im Gegensatz zu den anderen Cayenne-Benzinern begnügte er sich selbst innerorts mit weniger als neun Litern. Und falls man sich mit einem Cayenne einmal ins Gelände verirrt haben sollte: Seine Böschungswinkel lagen knapp unter 25 Grad, und die Wattiefe betrug fast einen halben Meter. Zu seinen Charakteristika wie Zugkraft, Sportlichkeit und Reisekomfort gesellte sich also auch eine ordentliche Portion Geländetauglichkeit.

La famille des Cayenne est populaire auprè des pragmatiques, des amateurs de SUV e des toqués de la puissance, et en est venu représenter plus de 50 % des ventes de Porsch 74 763 unités ont été vendues en 2012, dont enviro 19 000 Cayenne S, GTS et Turbo : impressonnant Porsche jongle adroitement avec les variantes e les dérivés et présente un éventail qui va du modèl de base six cylindres (300 ch) avec des chiffres d consommation et d'émissions considérablemer réduits jusqu'au diesel, la Cayenne S huit cylindre – disponible aussi en diesel et hybride – et le modèles GTS et Turbo, avec son édition S. Porsch l'a présenté en 2013 à Detroit en tant que super SU avec 550 ch qui monte à 283 km/h. La jeune géné ration de GTS a également bénéficié d'une augmer tation de puissance et développe désormais 420 ch

Même sans la force boostée d'une Cayenne Turbo S, elle accélère avec une énergie singulière, grâce à la boîte de vitesses Tiptronic à huit rapports avec une gradation relativement courte. C'est ainsi qu'elle arrive à lancer son poids jusqu'à 100 km/h en 5,7 secondes, et qu'elle ne se cogne aux lois de la physique qu'à 261 km/h.

Ce n'est pourtant pas seulement la puissance de son moteur – dont le son peut être dérivé dans l'habitacle grâce aux «sound symposers» – qui souligne le caractère sportif du modèle GTS, mais aussi le châssis rabaissé de 24 millimètres avec le «Porsche Active Suspension Management» (PASM) ainsi que les jantes 21 pouces avec des pneus de 295. Évidemment, ces gènes exigeaient une esthétique à l'avenant, par exemple un imposant spoiler de toit avec double renflement ou une prise d'air centrale

dont la grille pourrait descendre de celle d'une Ferrari. Les modèles GTS et Turbo ont beau être sportifs, leurs sièges en cuir de série offrent tout le confort que l'on peut désirer. Avec dans les oreilles le son vrombissant émis par les sorties d'échappement sport et la prise d'air tonitruante du V8, assis au volant d'une GTS ou d'une Turbo, on se sent immanquablement comme un pilote de course professionnel, malgré la position plus élevée du siège. L'intérieur de la Cayenne a été complètement revu, et est maintenant encore plus confortable. L'écran tactile de 7 pouces du système d'information et de communication est placé au milieu, entre deux bouches d'aération, et plusieurs packs intérieurs satisfont les envies d'individualisation.

Le moteur biturbo de la Cayenne Diesel fait preuve d'économie, avec une consommation

moyenne de 7,2 litres. Le réservoir de 100 litres, en option, augmente considérablement son autonomie. La Cayenne S Diesel et la S Hybrid, dont les agrégats produisent 380 ch, sont aussi des machines très efficientes. À basse vitesse, par exemple dans les zones résidentielles, les deux tonnes de la Cayenne S Hybrid peuvent très bien se déplacer en toute discrétion grâce à la seule puissance de son moteur électrique de 47 ch. Contrairement aux autres Cayenne à essence, elle ne dépasse pas les neuf litres, même en cycle urbain. Et si un jour on finit par s'égarer à la campagne dans une Cayenne, son angle de pente de presque 25 degrés et sa hauteur guéable de presque 50 cm ajoutent à ses qualités de traction, sportivité et confort une bonne ration de capacités tout-terrain.

Cayenne (92A)

The Cayenne's look is defined by well-proportioned, unembellished curves, while its extended roof spoiler aids the aerodynamics.

Wohlproportionierte Rundungen ohne jegliche Schnörkel bestimmen die Optik des Cayenne, dessen langgestreckter Dachspoiler der Aerodynamik zugute kommt.

Le look de la Cayenne est défini par des courbes parfaites sans aucune fioriture, et son spoiler de toit allongé profite à son aérodynamique.

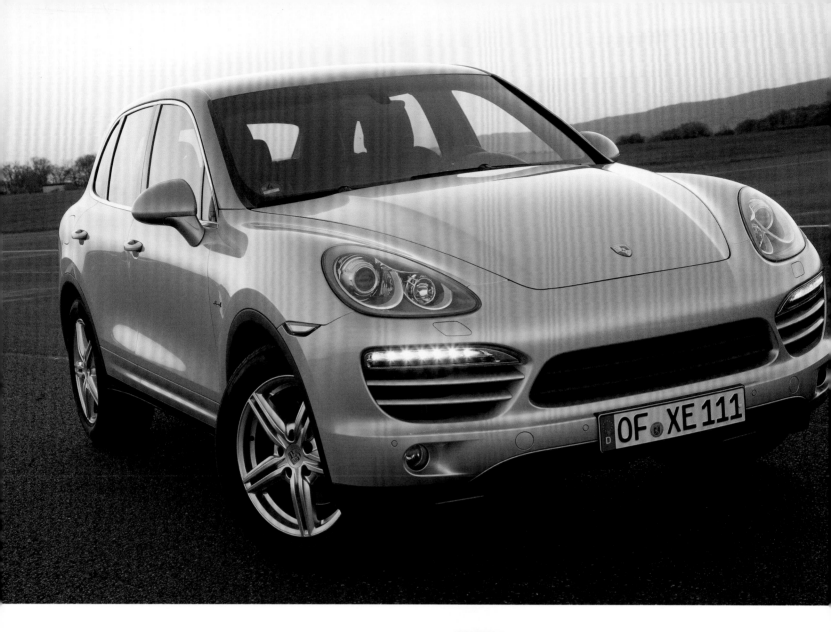

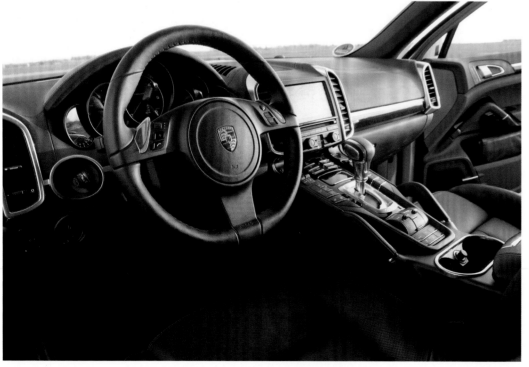

The elegant, downward-curving front section with its flat air intakes and the headlight configuration emphasize the sporty image of this SUV, which also boasts a typical Porsche cockpit.

Die elegant nach unten gezogene Frontpartie mit flacher Lufteinlässen sowie die Scheinwerferkonfiguration unterstreichen das sportliche Image dieses SUV, der auc im Cockpit Porsche-Typisches offeriert.

La proue plongeante élégante avec des prises d'air plate et la configuration des phares soulignent le caractère sportif de ce SUV, dont l'habitacle est aussi typique de Porsche.

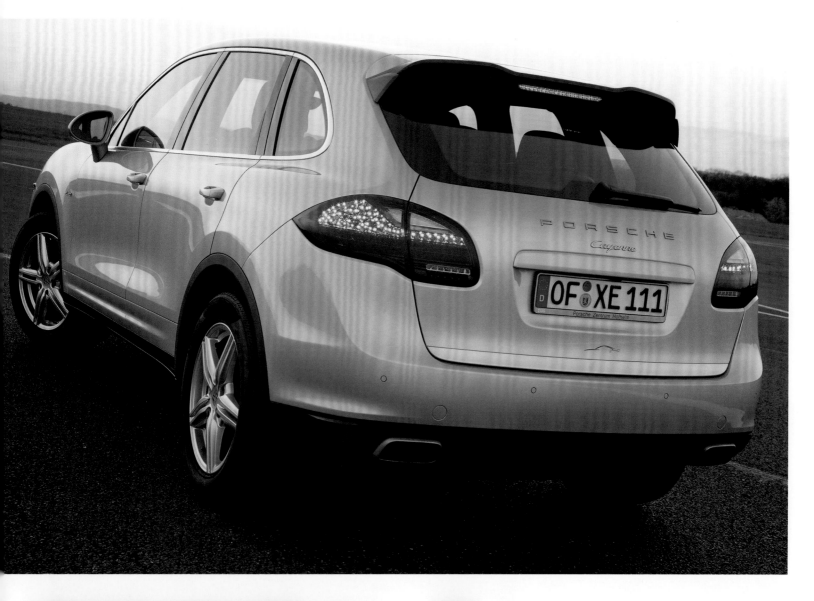

The imposing tail lights and square exhaust pipes of the Cayenne Diesel accentuate the main features, as does the interior design.

Gewaltige Rückleuchten und die viereckigen Endrohre des Cayenne Diesel setzen besondere Akzente, die auch das Interieurdesign für sich in Anspruch nehmen kann.

Les imposants feux arrière et les sorties d'échappement rectangulaires sont des accents pleins de personnalité, que l'on retrouve aussi dans l'aménagement intérieur.

On "open door" the Cayenne demonstrates plenty of space not only for its passengers, but also for luggage. Well-packed: the V6 turbo diesel.

Beim „Tag der offenen Tür" zeigt der Cayenne nicht nur viel Platz für seine Passagiere sondern auch für das Gepäck. Gut verpackt: der V6-Turbodiesel.

Toutes portes ouvertes, on peut voir que la Cayenne dispose d'un espace généreux, non seulement pour ses passagers, mais aussi pour les bagages. Bien emballé : le turbodiesel V6.

The seventh generation of the 991, which was presented at the 2011 Frankfurt IAA, continued the Porsche mainstay's incredible success story. Despite the facelift it was given in 2015, it was still recognizably derived from "Butzi" Porsche's basic design, as the utmost attention has always been given to preservation when making changes.

The wheelbase of the 991 was four inches longer than that of the 997 in order to give the driver and front passenger more legroom, while the entire length was only increased by just about two inches. The fenders were given a more sumptuous upward curve before flowing into a slightly higher rear end cutoff, where the narrower LED tail lights peek out. The aerodynamic aid for generating great downforce extended automatically at 75 mph. The front air intakes were given greater throughput, and an end-to-end spoiler lip channeled the airflow in fine quantities under the well-formed undercarriage of the new Carrera, which now had a more lightweight body.

A special gray-and-black model with a retro interior was produced for Porsche's 50th anniversary. In fall 2013, Turbo S and its 560 bhp put the fear of God into the GT3, and 2014 heralded the launch celebrations for a new Targa fitted with the traditional Targa arch and a fully automatic roof system—just in time for the open air season. A GTS, which was positioned between the Carrera S and the GT3, rounded off the year 2014 for Porsche.

While the Carrera S engine's displacement remained at 3.8 liters, 178 cubic centimeters were shaved off the basic Carrera engine, though the output was also increased from 345 to 350 bhp. If this was Porsche demonstrating its skill for optimization, it was followed up at the 2015 IAA by an expression of the company's revolutionary streak—the facelift saw the aspirators replaced with turbo engines and the manual transmission superseded by a new, faster, automatic system. With the GT3 RS (fifth generation) and the 911 R with six-speed manual transmission (production run: 991 units), Porsche had produced two exceptional aspirators. But the acoustic pleasures ended there, as the 420 bhp bi-turbo in the Carrera S was unable to replicate them. The actual Porsche Turbo had also undergone a facelift, though its changes were mainly under the hood: the new 580 bhp output really stood out, allowing the model to accelerate from 0 to 60 mph in 2.9 seconds. Its top speed? 205 mph!

March 2017 saw the presentation of the GTS in Geneva, with a newly developed turbocharger that raised the three-liter boxer's output to 450 bhp—30 bhp more than its aspirated predecessor. It also boasted an almost unbelievable seven-speed manual transmission. But this wasn't the only debutant at Geneva 2017, as the GTS was joined by a GT3 with a 500 bhp, four-liter boxer engine. Like the 911 R, this was also available with a six-speed manual transmission. Its sporty chassis with rear-wheel steering carried the genes of the cup version, taking the series back to its roots.

Mit seiner siebenten Modell-Generation, als 991 auf der Frankfurter IAA 2011 vorgestellt, setzte der 911er von Porsche seine unglaubliche Erfolgsstory fort. Trotz eines Facelifts 2015 bleibt das Grunddesign von „Butzi" Porsche noch immer erkennbar, da alle Änderungen stets sehr behutsam vorgenommen wurden.

Gegenüber dem 997 war der Radstand des 991 um zehn Zentimeter gewachsen, zugunsten des Fußraums von Fahrer und Beifahrer, während die Gesamtlänge nur knapp sechs Zentimeter zugelegt hatte. Die sich üppiger nach oben wölbenden hinteren Kotflügel mündeten nun in einer geringfügig höher angelegten Abrisskante, unter der schmalere LED-Rückleuchten hervorschauten. Das aerodynamische Hilfsmittel zur Erzeugung von mehr Anpressdruck fuhr bei 120 km/h automatisch aus. Den Lufteinlässen der Frontpartie hatte Porsche mehr Durchsatz gewährt, und eine durchgehende Spoilerlippe lenkte den Luftstrom fein dosiert unter den wohlgeformten Unterboden des neuen Carrera, dessen Karosserie leichter geworden war.

Zum 50. Jubiläum von Porsche wurde ein Sondermodell nur in Grau und Schwarz mit Retro-Interieur aufgelegt. Im Herbst 2013 lehrte der Turbo S mit 560 PS den GT3 das Fürchten, und rechtzeitig zur Open-Air-Saison feierte 2014 ein neuer Targa, mit klassischem Targa-Bügel und vollautomatischem Dachsystem ausgestattet, seine Premiere. Ein GTS, zwischen Carrera S und GT3 positioniert, beschloss das Porsche-Jahr 2014.

Während der Hubraum des Carrera-S-Triebwerks bei 3,8 Litern geblieben war, wurden beim Basis-Carrera-Motor 178 Kubikzentimeter abgeschöpft, zugleich aber die Leistung von 345 PS auf 350 PS angehoben. Hatte Porsche hier noch seine Optimierungskunst demonstriert, folgte auf der IAA 2015 die Palastrevolution, denn mit dem Facelift lösten Turbotriebwerke die Sauger ab, und das Handschaltgetriebe musste einer Automatik weichen, die wesentlich schneller funktioniert. Zuvor hatte Porsche mit dem GT3 RS (fünfte Generation) und dem 911 R mit Sechsgang-Handschaltgetriebe (Auflage 991 Exemplare) für zwei Sauger-Höhepunkte gesorgt. Das war's mit den akustischen Genüssen, die der Biturbo mit 420 PS im Carrera S nicht bieten kann. Der eigentliche Porsche Turbo hatte ebenfalls ein Facelift über sich ergehen lassen, vornehmlich unter der Motorhaube: 580 PS, die sich in einer Beschleunigung von 0 auf 100 km/h in 2,9 Sekunden bemerkbar machten. Spitze: 330 km/h!

Im März 2017 präsentierte sich in Genf der GTS, dessen neu entwickelter Turbolader die Leistung des Dreiliterboxers auf 450 PS steigert, also 30 PS mehr als der GTS-Vorgänger mit Saugmotor und – man sollte es kaum glauben – mit manuellem Siebenganggetriebe. Debüt ebenfalls in Genf 2017: ein GT3 mit einem 500-PS-Vierliterboxer, wie der 911 R auch mit einer Sechsgang-Handschaltung erhältlich. Das sportliche Fahrwerk mit Hinterachslenkung trägt die Gene der Cup-Version. Back to the roots!

Présentée sous le code 991 avec sa septièm[e] génération de modèle sur l'IAA de Francfo[rt] en 2011, la 911 de Porsche poursuivait s[on] incroyable success story. Malgré un lifting en 201[5] le design initial de «Butzi» Porsche est toujou[rs] reconnaissable, car les changements apportés a[u] fil des ans ont toujours été accompagnés d'u[ne] grande volonté de respect.

L'empattement de la 991 est plus long que cel[ui] de la 997 de dix centimètres afin de donner plus d[e] place aux jambes du conducteur et du passag[er] avant, tandis que la longueur totale n'a augmen[té] que de six centimètres. La courbe de l'aile arriè[re] est maintenant plus prononcée et débouche s[ur] une arête de rupture légèrement plus hau[te] sous laquelle viennent se nicher les feux arriè[re] LED plus minces. L'aileron aérodynamique s[o]

automatiquement à 120 km/h pour augmenter la éportance. Les prises d'air avant ont maintenant ne plus grande capacité, et une lèvre de spoiler ontinue guide l'air avec précision sous le châssis albé de la nouvelle Carrera, qui a maintenant une arrosserie plus légère.

Pour le 50ᵉ anniversaire de Porsche, un modèle pécial avait été édité, uniquement en gris et oir avec un intérieur rétro. À l'automne 2013 le urbo S 560 ch fit trembler le GT3, et juste à temps our la belle saison 2014 un nouveau Targa vit le our avec l'arceau Targa classique et un toit entiè- ement automatique pour la première fois. Un TS, entre Carrera S et GT3, termina l'année 2014 our Porsche.

Tandis que la cylindrée du moteur de la arrera S est restée à 3,8 litres, 178 centimètres

cube ont été rognés sur le moteur de la Carrera de base, bien que la puissance ait été portée de 345 à 350 ch. Porsche avait ici démontré encore une fois son sens de l'optimisation, et sur l'IAA 2015 c'est une révolution de palais qui suivit, car avec ce lifting les moteurs turbo ont pris la relève de l'aspiration naturelle, et la boîte manuelle a dû céder la place à une boîte automatique, bien plus rapide. Porsche avait déjà sorti deux moteurs à aspiration naturelle marquants avec le GT3 RS (cinquième génération) et la 911 R à boîte manuelle six vitesses (produite à 991 unités). Ils assuraient le plaisir acoustique que le biturbo à 420 ch de la Carrera S ne pouvait pas offrir. La Porsche Turbo avait aussi subi un lifting, surtout sous le capot : 580 ch, qui brillaient avec une accélération de 0 à 100 km/h en 2,9 secondes. Vitesse de pointe : 330 km/h !

En mars 2017, le GTS présenté à Genève avait un nouveau turbocompresseur qui augmente la puis- sance du boxer trois litres à 450 ch, soit 30 ch de plus que son prédécesseur à aspiration naturelle et, on y croit à peine, avec une boîte manuelle à sept vitesses. Également présenté à Genève en 2017 : un GT3 avec boxer quatre litres de 500 ch, également disponible avec une boîte manuelle à six vitesses, comme la 911 R. Le châssis sportif avec direction à l'essieu arrière porte les gènes de la version Cup. Retour aux racines !

911 (991)

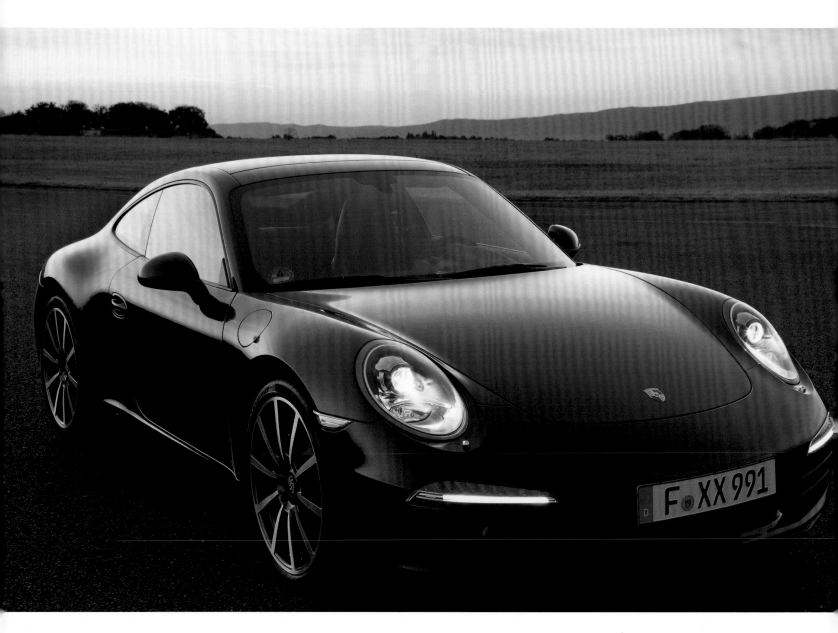

With well-proportioned curves and a wide rear, the seventh-generation 911—the 991—marked the fiftieth birthday of Porsche's 911 series.

Mit wohlproportionierten Rundungen und breiten Hinterbacken präsentiert sich die siebte Generation des 911ers, Baureihe 991. Mit ihr feiert Porsche 2013 das 50jährige Jubiläum des Typs 911.

Avec ses courbes bien proportionnées et son large arrière-train, la 911 septième génération, la 991, marque cinquantième anniversaire de la série Porsche 911.

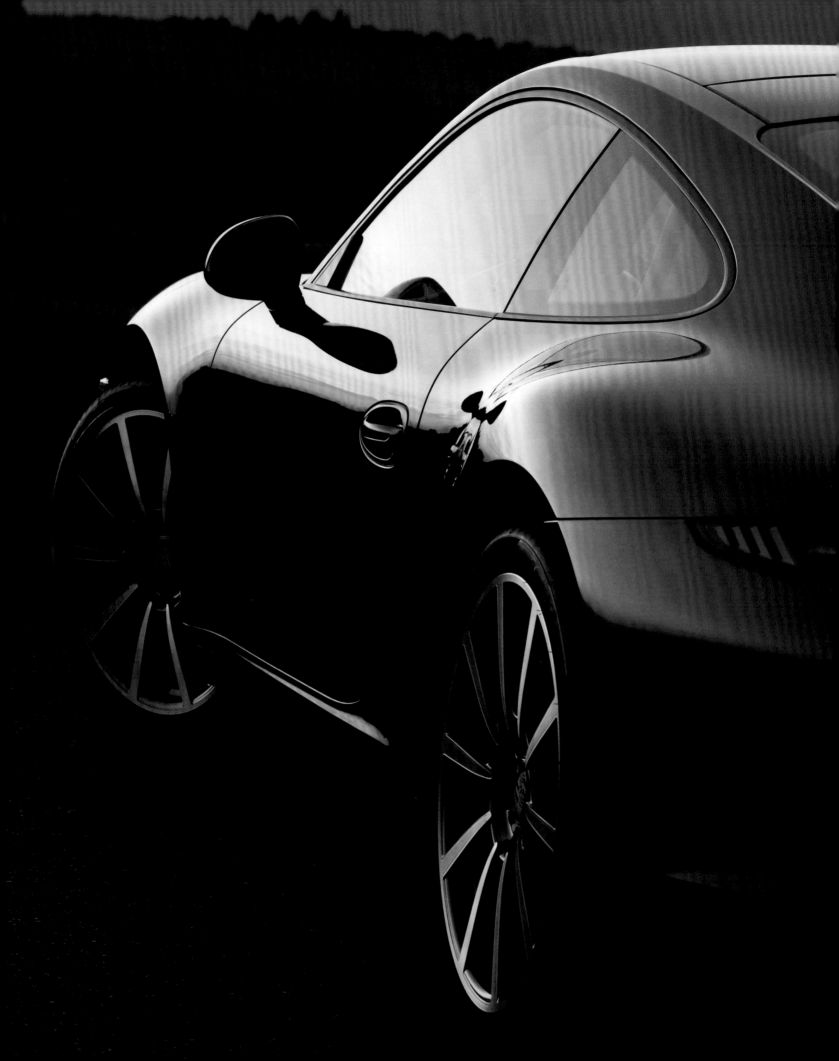

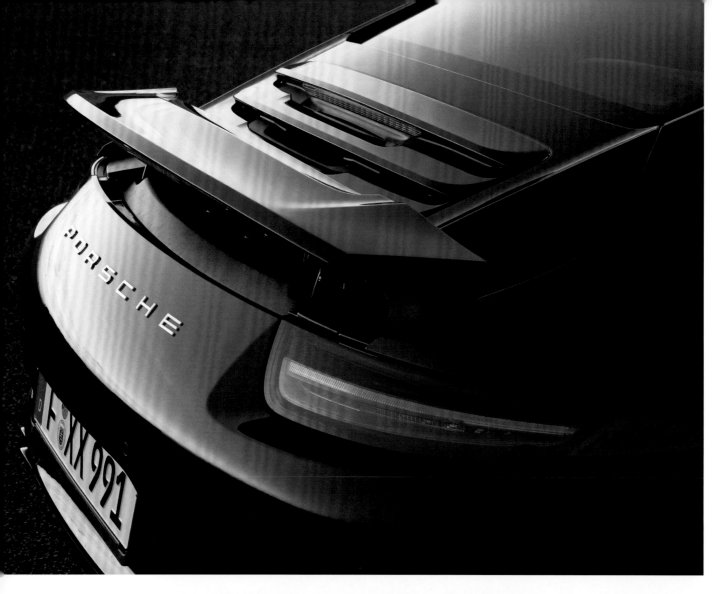

The 991 was characterized by an extendable rear spoiler, slotted tail lights and dynamic headlights, as well as the engine, which was fully clad up to the filling nozzles. Typical the overlapping gauges.

Ausfahrbarer Heckflügel, schlitzförmige Rücklichte und dynamische Frontleuchten charakterisieren den 991 ebenso wie der bis auf die Einfüllstutzen verkleidete Motor. Typisch: die ineinandergreifenden Rundinstrumente.

La 991 se caractérise par son aileron arrière télescopique, ses feux arrière allongés en forme de fente et ses phares dynamiques, ainsi que par son moteur couvert jusqu'aux tubes de remplissage. Typiques : les cadrans qui mordent l'un sur l'autre.

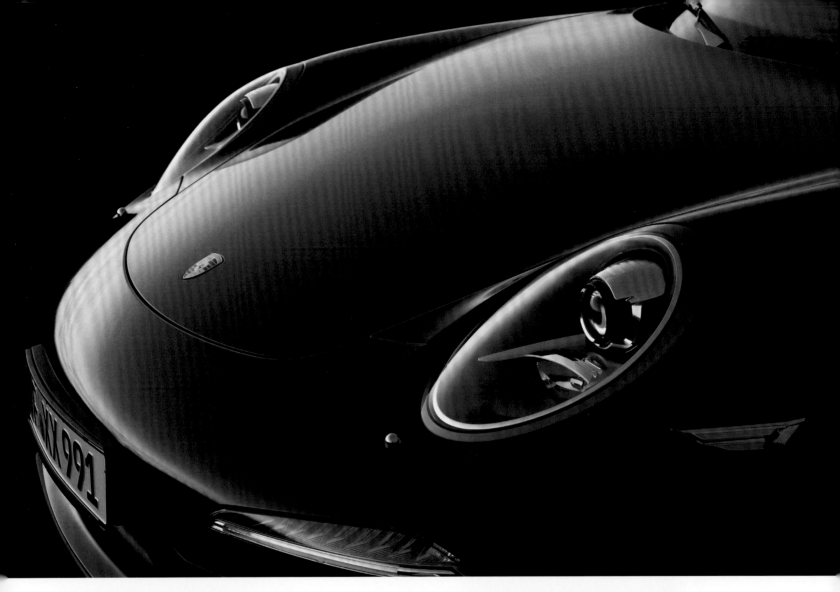

The profile demonstrates how, after seven generations, more attractive details could still be added to the basic design of the Porsche 911.

Dass dem klaren Grunddesign des Porsche 911 auch in der siebten Generation weitere schöne Details abgewonnen werden können, zeigt sich im Profil.

La vue de profil montre bien qu'il était possible d'ajouter au design de base de la Porsche des détails supplémentaires qui la rendent encore plus belle, même à la septième génération.

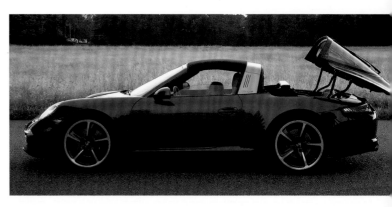

Reminiscent of the 1965 Porsche Targa: the classic arch that connects the fully automatic lowering roof insert with the windscreen frame. When the roof is lowered, the all-round rear window is briefly lifted, pushed back and then moved back to its original position. Fresh air at the push of a button!

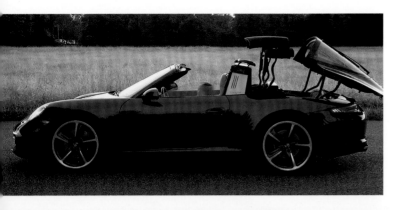
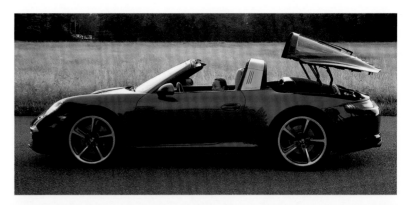

Reminiszenz an den Porsche Targa von 1965: der klassische Bügel, der den vollautomatisch versenkbaren Dacheinsatz mit dem Windschutzscheibenrahmen verbindet. Dabei wird die umlaufende Heckscheibe kurz angehoben, nach hinten geklappt und wieder zurück positioniert. Freiluftvergnügen per Knopfdruck!

Souvenir de la Porsche Targa de 1965 : l'arceau classique, qui fait le lien entre le toit escamotable (tout automatique) et le cadre du pare-brise. La lunette arrière englobante se soulève, se rabat vers l'arrière puis reprend sa position d'origine. Il suffit d'appuyer sur un bouton pour prendre l'air !

The Targa roof, a refined soft-top comprising a magnesium shell and fabric cover, fits in seamlessly with the lines of this 911, which is actually even more visually striking thanks to the arch, which seems to extend the door stop. The cockpit—shown here with the standard seats—is designed to cater to the driver's every need.

Das Targa-Dach, ein raffiniert konstruiertes Softtop aus Magnesiumschale und Stoffverdeck, fügt sich harmonisch in die Linienführung dieses 911er ein, der durch den Bügel als optische Verlängerung des Türanschlags sogar gewinnt. Das Cockpit – hier mit den serienmäßigen Sitzen ausgestattet – lässt keine Wünsche offen.

Le toit Targa, un système raffiné de plaques de magnésium revêtues de tissu, s'intègre harmonieusement à la ligne de cette 911, qui est même mise en valeur par l'arceau qui allonge visuellement la butée de porte. L'habitacle – ici équipé des sièges de série – ne laisse absolument rien à désirer.

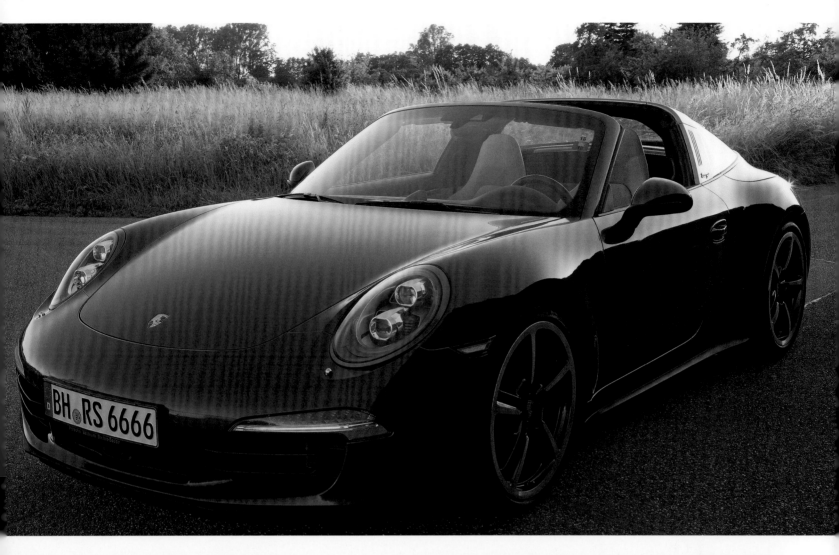

Imposing and dynamic: Even the look of the GT3 RS reflects its full-blooded nature, blowing away even the Carrera GT. 3220 lbs with a full tank, it accelerates from 0-60 mph in just 3.3 seconds and can easily keep pace with a McLaren MP4-12C on the Nürburgring Nordschleife.

Imposant und dynamisch: Der GT3 RS demonstriert auch optisch, dass in ihm ein Vollblut steckt, das sogar den legendären Carrera GT verblassen lässt. Seine 1461 Kilo, vollgetankt, beschleunigt er in nur 3,3 Sekunden auf Tempo 100, und auf der Nordschleife des Nürburgrings hält er locker mit einem McLaren MP4-12C mit.

Imposant et dynamique : la GT3 RS démontre aussi par son aspect qu'elle a un cœur de pur-sang, qui pourrait même faire de l'ombre à la légendaire Carrera GT. Elle emmène ses 1461 kilos, réservoir plein, de 0 à 100 km/h en 3,3 secondes, et tient confortablement sur la boucle nord du Nürburgring face à une McLaren MP4-12C.

20-inch wheels at the front, ventilatic
grilles for the wheelhouses in the
fenders, large air intakes in the rear
section for the aspirated 500 bhp
engine, and the protruding rear spoil
reflect the car's sports genes.

20-Zoll-Räder vorn, Luftschlitze in
den Kotflügeln zur Radhausentlüftun
ein Heck mit großen Lufteinlässen fü
den Saugmotor, der 500 PS entfaltet,
und der herausragende Heckflügel
dokumentieren die sportlichen Gene

Les roues de 20 pouces à l'avant, les
grilles de ventilation sur les ailes po
le passage de la roue, les grandes
prises d'air à l'arrière pour le moteu
à aspiration naturelle qui déploie
500 ch et l'aileron formidable atteste
de ses gènes sportifs.

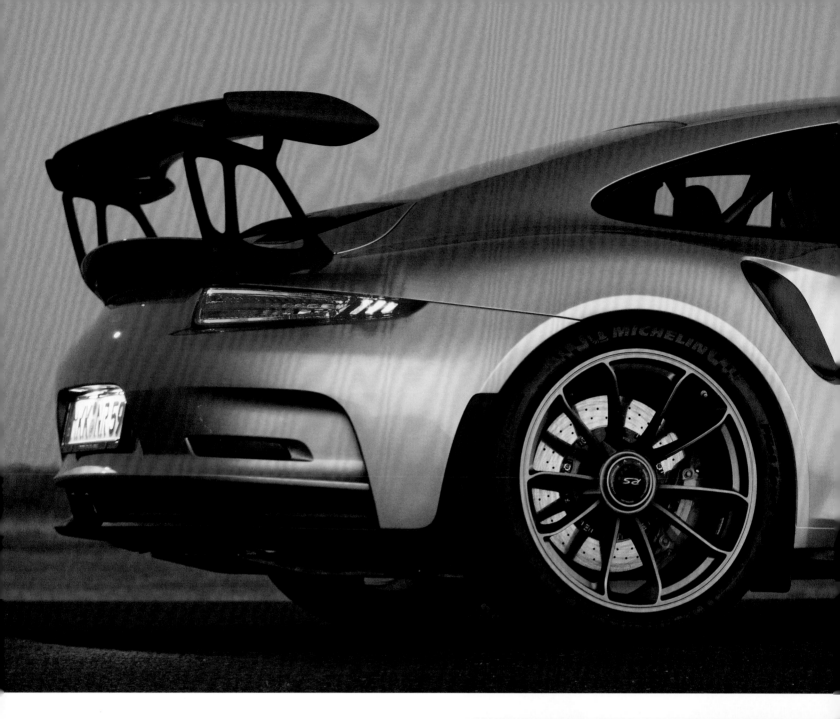

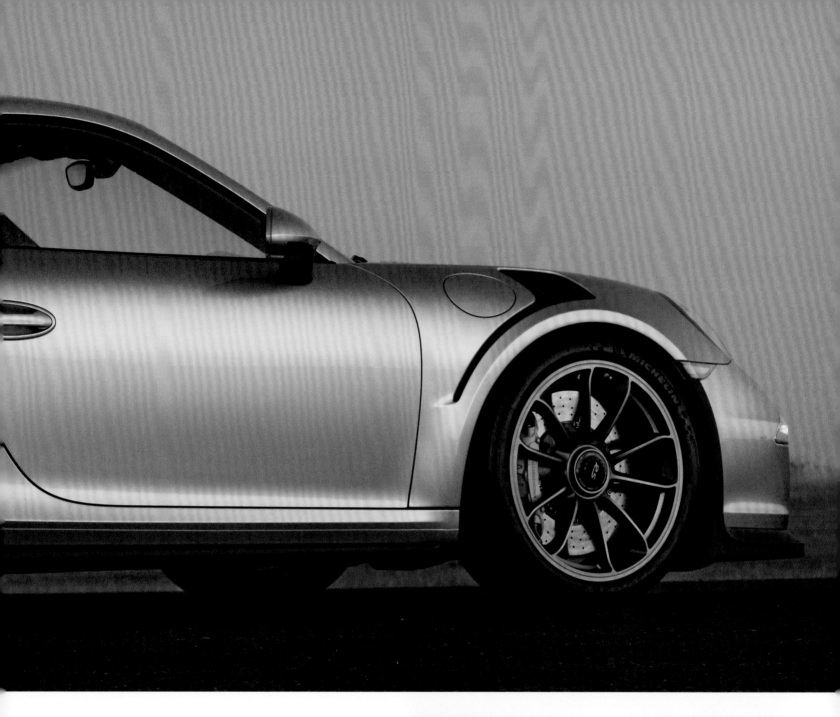

arbon bucket seats with harnesses, a roll cage with diagonal struts, a leather steering
heel with top center marking and a mighty rear spoiler that contributes to a downforce of
0 lbs: unmistakable signs of a racer!

arbon-Sitzschalten mit Hosenträgergurten, dahinter eine diagonal verstrebte
berrollkäfigkonstruktion, Lederlenkrad mit Geradeauslaufmarkierung und ein gewaltiger
eckflügel, der zu einem Abtrieb von 345 Kilo beiträgt: Merkmale eines Renners!

èges en carbone avec harnais, avec derrière une cage de sécurité à structure en
agonale, volant cuir avec marque à 12 heures, et énorme aileron arrière qui génère une
rtance de 345 kilos : les qualités d'une coureuse !

The "interim phase" from 2012 to 2016, during which the third generations of both the Boxster (code 981) and the Cayman (code 981c) were produced with the same platform, brought with it a shocking revelation for die-hard 911 drivers: Their S versions were quite close to the Carrera S.

As an "S" model, the water-cooled flat six engine still produced 315 bhp, pushing it to a top speed of 173 miles per hour. Without the "S", the Boxster relied on the output of a 2.7-liter engine, whose 265 bhp offered enough power for almost the same top speed.

This was followed by the fourth generations of the Boxster and the Cayman—now labeled 718—which were both visually and acoustically more striking than their predecessors. Both cars used the same basic engine: a new turbocharged flat four that had been tested thoroughly in the Canadian winter and could reach 300 bhp. The relatively high torque of the two-liter engine alone made for an fun drive, but when this was combined with the extra 50 bhp offered by the S model's 2.5-liter engine—which, of course, came with a turbocharger with variable turbine geometry—the results were even better: improved drive in every rpm range, a sprint time of 4.2 seconds (which was possible because the engine only needed to accelerate 3000 lbs), and a top speed of 177 mph.

The overhauled chassis visibly improved the handling of the 718, with more rigid suspension and stabilizers, re-tuned shock absorbers and a more direct steering system all leading to greater cornering stability. Drivers only needed to be careful when pushing the car to its limits, as it would start to protest a little. With this in mind, Porsche placed no limits on the car's driving dynamics as long as the customer had enough money: 20-inch wheels, low-riding suspension, the Sport Chrono package with program switches on the steering wheel and a reinforced brake system—with disk diameters of 13" at the front and 11¾"at the rear—were all available for the right price. At its front axle, the "S" borrowed the tried-and-tested four-piston calipers from the 911 Carrera, but with thicker brake disks.

A sense of 718 harmony was generated by the new side sections and the front and rear, which included rear lights that were connected by a high-gloss black strip. The larger cooling air intakes gave the 718 a beefier look, and there were improvements to the aerodynamics as well.

Porsche's interior designers also came up with new aesthetic touches, especially in the upper section of the instrument panel, which housed the four hot and cold-air nozzles. The new sport steering wheel gave the car a 918 Spyder feel, and a couple of improvements were also made to the stick for the 7-speed dual clutch transmission. In keeping with the *Zeitgeist*, the 718 came with all kinds of networking options and the Porsche Communication Management system as standard, as well as a 150-watt sound package.

Die „Interimsphase" mit der jeweils dritten Generation vom Boxster (Code 981) und vom Cayman (Code 981c) mit gleicher Plattform von 2012 bis 2016 brachte eine für den eingeschworenen Elfer-Fahrer erschreckende Erkenntnis: Ihre S-Versionen kommen dem Carrera S ziemlich nahe.

Als „S" produzierte der wassergekühlte Sechszylinderboxer immerhin 315 PS, die ihn auf eine Spitze von 279 Stundenkilometern trieben. Ohne das Kürzel „S" vertraute der Boxster auf die Leistung eines 2,7-Liter-Aggregats, das mit 265 PS genügend Vortrieb für fast ebenso viele Stundenkilometer lieferte.

Optisch und akustisch etwas markanter als die Vorgänger, präsentierte sich sodann die nun 718 genannte vierte Generation von Boxster und Cayman. Beide Wagen verfügen über die gleiche Basismotorisierung: einen ausgiebig im kanadischen Winter getesteten neuen Vierzylinder-Boxermotor, der es mit Turboaufladung auf 300 PS bringt. Das relativ hohe Drehmoment des Zweilitertriebwerks beschert einen Fahrspaß, der natürlich durch den 50 PS stärkeren 2,5-Liter-Motor des S-Modells, der über einen Turbolader mit variabler Turbinengeometrie verfügt, noch steigerungsfähig ist: besserer Durchzug in allen Drehzahlbereichen, ein Sprintwert von 4,2 Sekunden, da weniger als 1400 Kilo beschleunigt werden müssen, und eine Spitze von 285 km/h.

Das überarbeitete Fahrwerk mit steiferen Federn und Stabilisatoren, anders abgestimmten Stoßdämpfern und einer direkteren Lenkung haben das Fahrverhalten des 718 durch bessere Kurvenstabilität sichtlich erhöht. Nur im Grenzbereich ist Vorsicht angesagt, hier begehrt er auf. Deswegen setzt Porsche der Fahrdynamik keine Grenzen, wenn es der Geldbeutel des Kunden erlaubt: ganz gleich, ob 20-Zoll-Räder, Tieferlegung, Sport-Chrono-Paket mit Programmschalter am Lenkrad oder eine verstärkte Bremsanlage mit Scheibendurchmessern von 330 Millimetern vorn und 299 hinten. Der „S" entlehnt an der Vorderachse die bewährten Vierkolbensättel vom 911 Carrera mit dickeren Bremsscheiben.

718er-Eintracht dokumentieren die neuen Seitenteile sowie Front- und Heckpartie, deren Rückleuchten durch eine schwarze Hochglanzleiste verbunden werden. Größere Kühllufteinlässe lassen den 718 bulliger wirken. Gewonnen hat auch die Aerodynamik.

Die Interieur-Designer des Hauses Porsche warten ebenfalls mit neuen Akzenten auf, besonders im oberen Bereich des Armaturenbretts mit den vier Warm- und Kaltluftdüsen. 918-Spyder-Feeling vermittelt das neue Sportlenkrad, und auch der Hebel für das Siebengang-Doppelkupplungsgetriebe ließ sich ein paar Korrekturen gefallen. Mit dem Zeitgeist gehend, bietet der 718 allerlei Vernetzungsmöglichkeiten und serienmäßig das Porsche Communication Management sowie ein 150 Watt starkes Sound-Package.

La « phase d'intérim » avec les troisièmes gén[é]rations du Boxster (type 981) et du Cayma[n] (type 981c) avec la même plateforme de 20[12] à 2016 a amené le conducteur de 911 invétéré [à] une conclusion terrifiante : leurs versions S s[e] rapprochent drôlement de la Carrera S.

Sur le modèle « S », le moteur boxer six cylindre[s] refroidi par eau produit toujours 315 ch et pouss[e] le Boxster à une vitesse de pointe de 279 km/[h]. Sans le « S », le Boxster compte sur un moteur d[e] 2,7 litres, qui avec 265 ch fournit assez de pui[s]sance pour atteindre presque la même vitess[e] de pointe. La quatrième génération du Boxster [et] du Cayman, maintenant appelée 718, est un pe[u] plus marquante sur les plans visuel et acoustiqu[e] que la précédente. Les deux voitures ont la mêm[e] motorisation de base : un boxer quatre cylindre[s]

vec turbocompression amplement testé dans e paysage hivernal canadien, qui arrive à 300 ch. Le couple relativement élevé du moteur de deux tres assure un plaisir de conduite qui peut être ncore intensifié par le moteur de 2,5 litres avec 0 ch supplémentaires du modèle S, équipé d'un urbocompresseur à géométrie variable : meilleure raction à tous les régimes, une accélération de à 100 km/h en 4,2 secondes, puisqu'il y a moins e 1400 kilos à emmener, et une vitesse de pointe e 285 km/h.

Le châssis revu avec ressorts et stabilisateurs lus rigides, le nouveau réglage des amortisseurs t la transmission directe ont considérablement mélioré le comportement de la 718 grâce à une meilleure stabilité dans les courbes. La prudence st de rigueur dans la zone limite, car là il y a des turbulences. Porsche n'impose pour autant pas de limite à la dynamique de conduite, si le portefeuille du client est assez profond : roues de 20 pouces, abaissement, pack Sport Chrono avec sélecteur de programme au volant ou système de freinage renforcé avec des disques de 330 millimètres à l'avant et 299 à l'arrière. La « S » emprunte à l'axe avant les étriers à quatre pistons de la 911 Carrera avec des disques de frein plus épais.

L'harmonie de la 718 se manifeste dans les nouveaux flancs ainsi que l'avant et l'arrière, dont les feux sont reliés par une arête noire haute brillance. Les prises d'air plus grandes donnent à la 718 un air plus imposant. L'aérodynamique a aussi gagné.

Les designers d'intérieur de la maison Porsche ont aussi apporté leur touche de nouveauté, particulièrement dans la partie supérieure du tableau de bord, avec les quatre bouches d'air chaud et froid. Le nouveau volant sport évoque la 918 Spyder, et le levier de la boîte à double embrayage à sept vitesses a aussi subi quelques corrections. En accord avec son temps, la 718 offre toutes sortes de possibilités de mise en réseau et est équipée en série du système Porsche Communication Management ainsi que d'un pack audio de 150 watts.

Boxster & Cayman / 718 (981, 982)

The perfect figure of a model athlete : the Boxster S is more than just a mid-engine Roadster—its sports car qualities push it into the range of its big brother, the 911.

Formschön wie ein Modellathlet: Der Boxster S ist mehr als nur ein Mittelmotor-Roadster – seine Sportwagenqualitäten rücken ihn schon in die Nähe des großen Bruders 911.

Une silhouette d'athlète parfaite : le Boxster S est bien plus qu'un simple roadster à moteur central – ses qualités sportives le rapprochent sérieusement de sa grande sœur la 911.

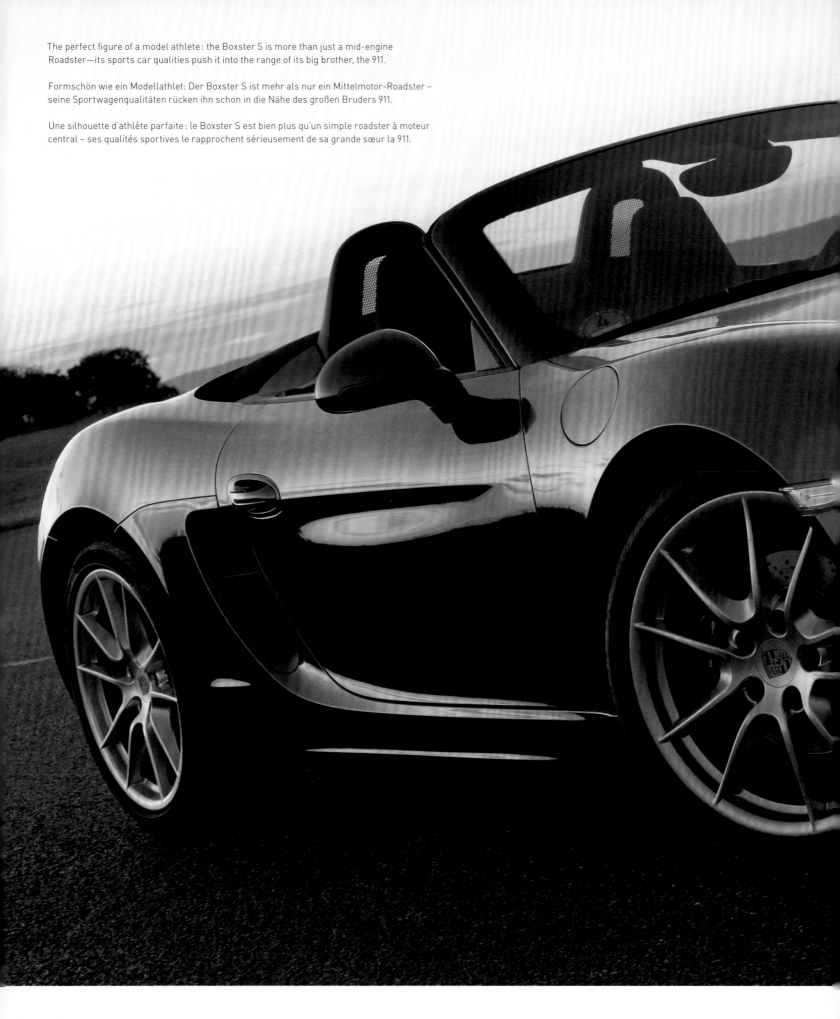

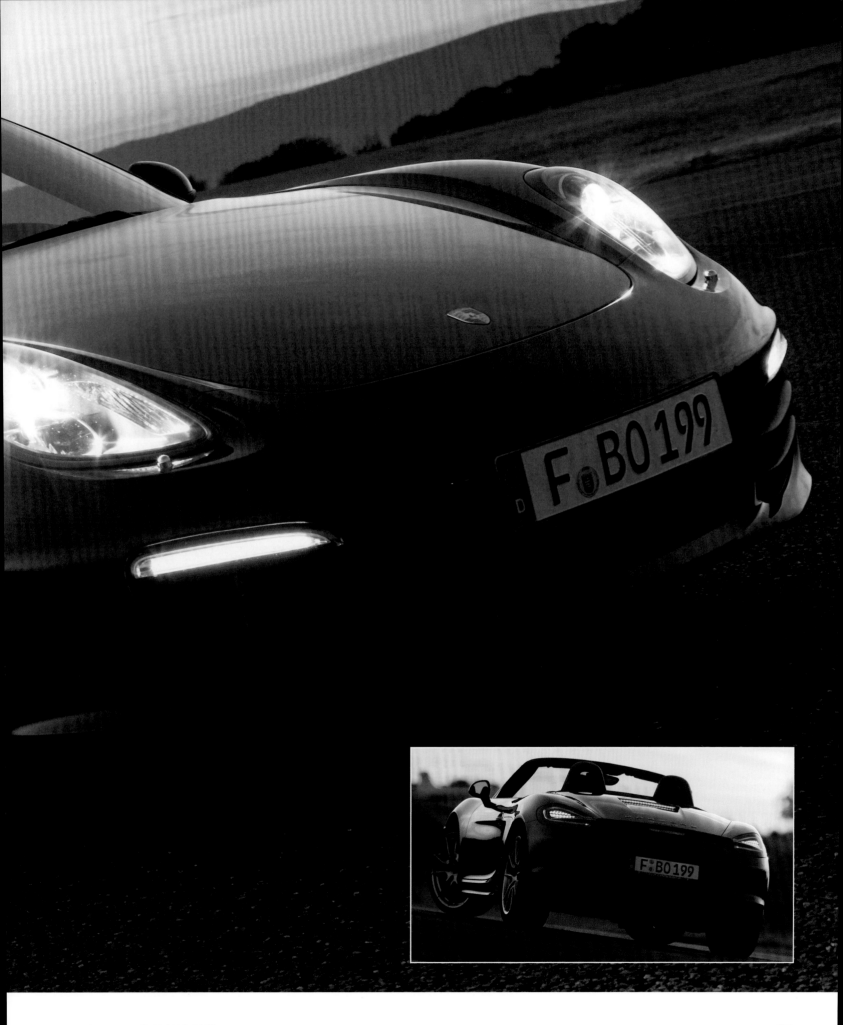

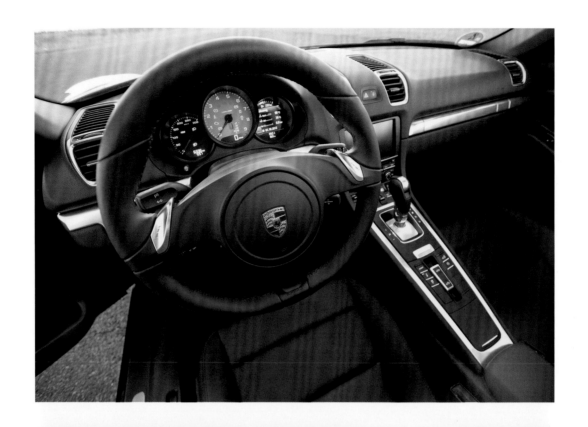

A clear view: the triple gauges. Open or closed, the Boxster's swung-down air intakes dominat the side view.

Übersichtlich: das Instrumententrio. Ob offen oder geschlossen: Die heruntergezogenen Luftschächte des Boxster dominieren die Seitenansicht.

Des informations claires et nettes avec les trois cadrans. Ouvertes ou fermées, les aérations tournées vers le bas du Boxster dominent sa vue de profil.

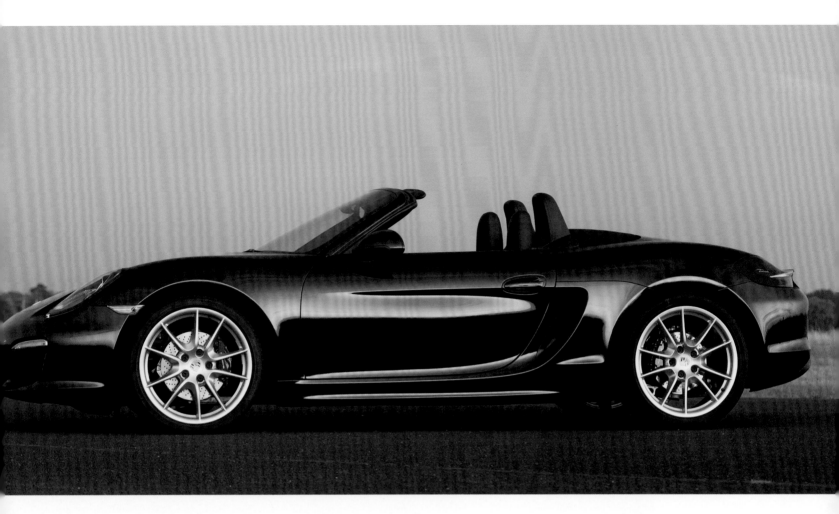

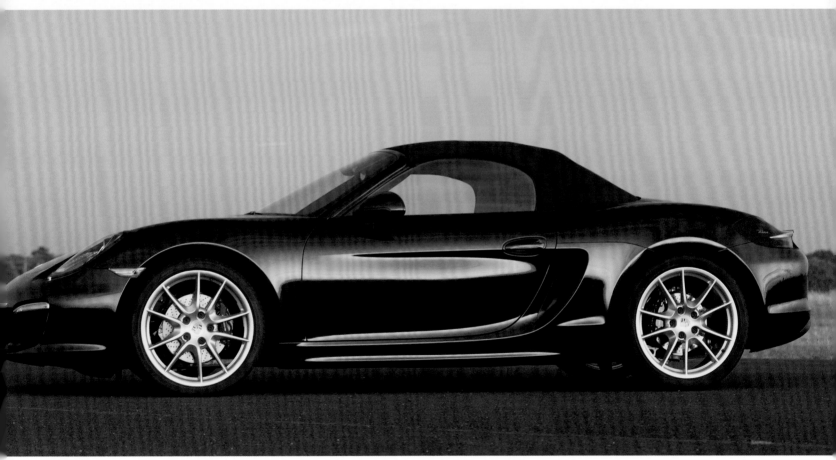

Muscular (the aspirator generates 385 bhp), aerodynamic and equipped with all the attributes required to provide sufficient downforce, the Porsche Cayman GT4 joins the ranks of the 911s, with enough potential to make the hair of any Carrera S owner turn white.

Muskulös – der Sauger generiert 385 PS – und aerodynamisch mit allen Attributen für genügend Abtrieb versehen, schiebt sich der Porsche Cayman GT4 in die 911er-Phalanx mit einem Potenzial, das die Haare von Carrera-S-Besitzern sicherlich ergrauen lässt.

Musclée – le moteur à aspiration naturelle génère 385 ch – et dotée de tous les attributs pour une portance adéquate, la Porsche Cayman GT4 se place au même rang que la 911 avec un potentiel qui donne sûrement des cheveux blancs aux propriétaires de Carrera S.

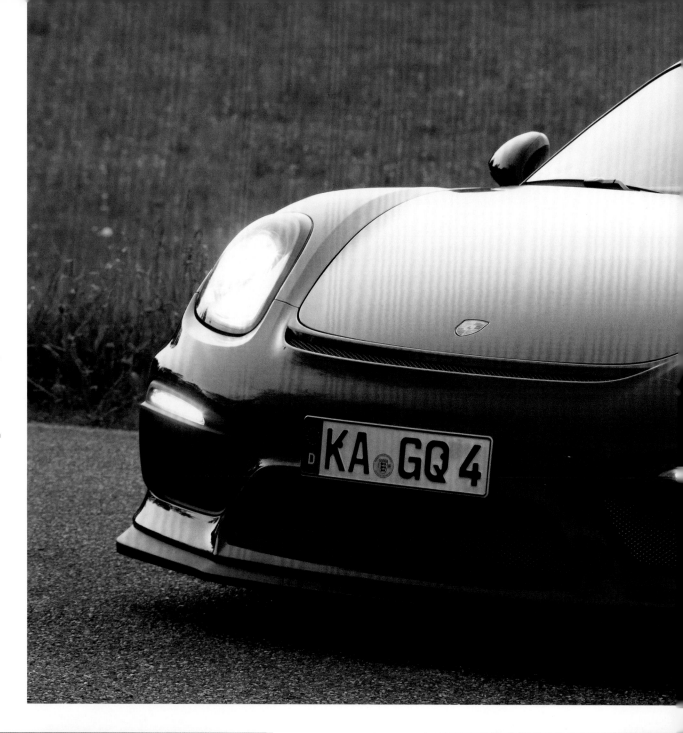

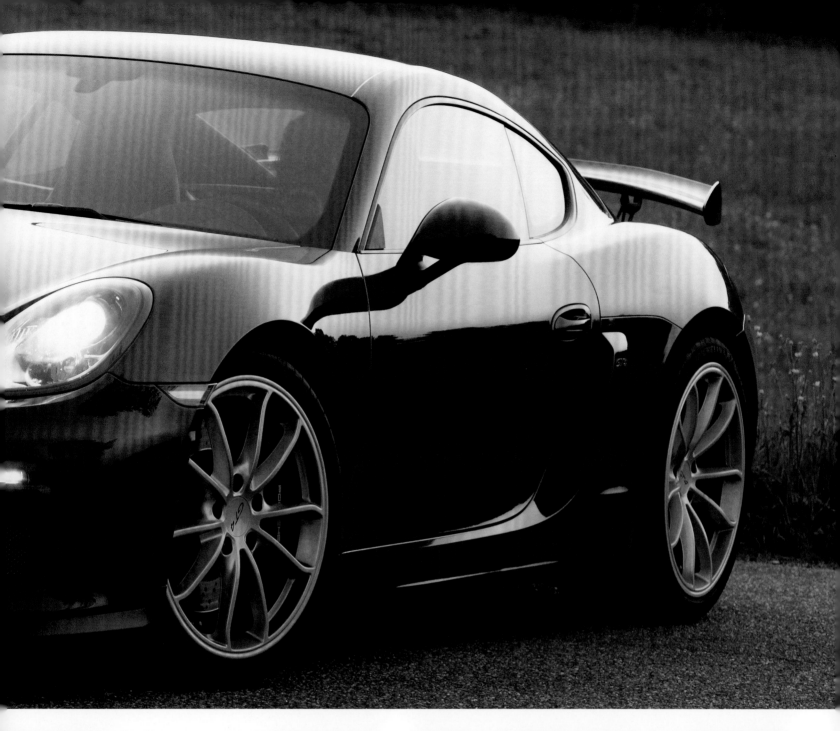

Pop the hood and take a look inside the GT4: the manual shift in the center console isn't just for decoration, as this model doesn't have the optional dual-clutch transmission. The concealed mid-engine leaves space for a trunk.

Hauben auf zu einem Blick in das Interieur des GT4, dessen Mittelkonsole ein Handschalter nicht nur ziert, da hier auf ein optionales Doppelkupplungsgetriebe verzichtet wird. Der verdeckte Mittelmotor lässt noch für ein Gepäckfach Platz.

Le capot s'ouvre pour révéler l'intérieur du GT4, où le levier ne sert pas uniquement à décorer la console centrale, car ici on renoncé à la boîte à double embrayage en option. Le moteur central couvert laisse encore de la place pour un compartiment bagages.

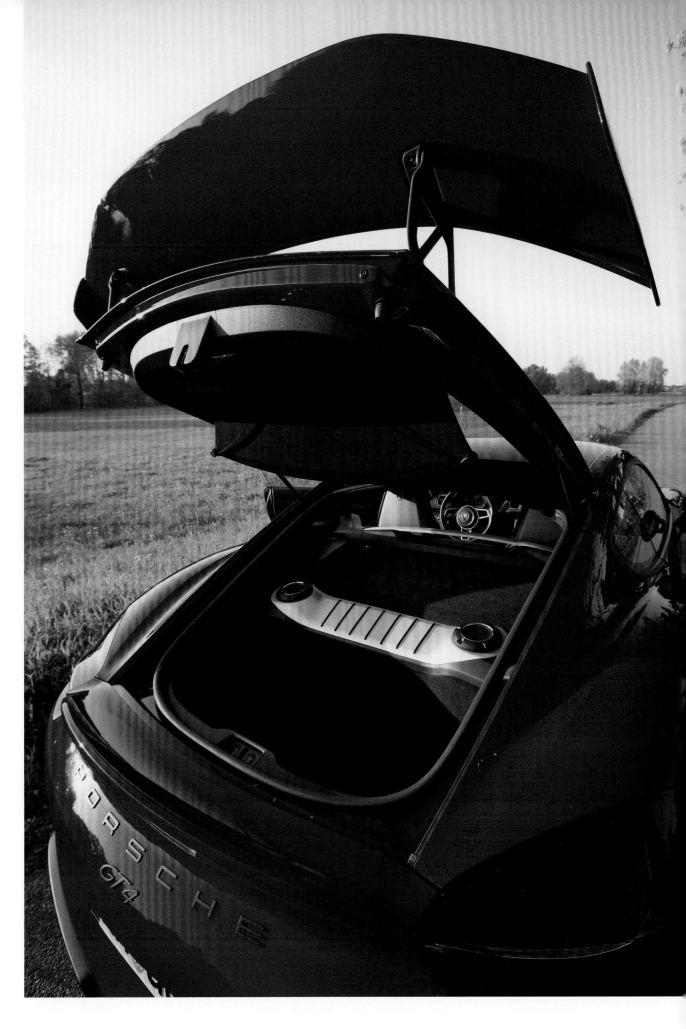

link and you'll miss it: Porsche's hybrid super sports car, the 918 Spyder—which was limited to 918 units—sold out in just one year. With 297 units and a basic price of 769,026 euros, US Porsche fans were delighted—only 100 each were reserved for Germany and China.

Direct comparisons with other ecologically friendly beefcakes, such as the LaFerrari and the McLaren P1, clearly showed that this successor to the Porsche Carrera GT was the first among equals. Although its system output of 887 bhp—a good 285 bhp of which was generated by the electric motors at the front and rear axles—lagged significantly behind that of the Ferrari and the McLaren, the Porsche demonstrated hitherto unseen qualities in terms of handling. In spite of its weight handicap, which made it a good 400 pounds heavier than its competitors, it was able to beat them both in the sprint, going from 0–60 mph in just 2.6 seconds. The P1's 2.8 couldn't match it—and the LaFerrari was even further behind, at just under the three-second mark. On the Nürburgring, the 918 Spyder completed the Nordschleife in 6.57 minutes, demonstrating the hybrid genes of a 911 GT3 R combined with the power of an RS Spyder, and causing uproar in the LMP2 motorsports class. Its top speed of "only" 214 mph—its competitors from Maranello and Woking could both do three miles per hour more—did the economical German model no harm. When it came to mileage, the 918 was extremely frugal, even if the 78 miles per gallon of premium gasoline specified by the factory were only a theoretical value—in practice, some 55 miles or so were apparently cut.

The 918 Spyder with its thoroughly optimized aerodynamics may have seemed a little tame compared to the LaFerrari and the P1, each of which cost 300,000 euros more, but the "Weissach Package" was on hand for those looking for a really sporty look. The following options were available for the "ultimate sports car of the decade" (Porsche slogan): the Martini Racing design, which harks back to the Le Mans victory in 1971; and the red-and-white Porsche Salzburg design, reminiscent of this racing classic's first great success one year earlier. Alternatively, a matte black variant was also available. The Weissach Package, which trimmed an extra 90 pounds off the car's weight, cost 71,400 euros, 40,000 of which was accounted for by the ultra-light magnesium wheels alone.

When the 918's 4.6-liter V8 reaches its top power at 8700 rpm, a throaty roar accompanies the thermal system of the top-mounted tailpipes. In electric mode—the 230 kW lithium-ion battery under the tanks is guaranteed to last for seven years or up to 60,000 miles—the Spyder can run silently for 18 miles. While the electric motor works in harmony with the V8 at the steered rear axle, the front motor is disengaged when it reaches 16,000 rpm (around 165 mph). Blink and you'll miss it!

isch und weg: Innerhalb von nur einem Jahr zwar Porsches Hybrid-Supersportwagen 918 Spyder – auf 918 Einheiten limitiert – ausverkauft. 297 Exemplare, Grundpreis 769 026 Euro, erfreuten US-amerikanische Porsche-Freaks, während der deutschen und chinesischen Kundschaft lediglich je 100 zugestanden wurden.

Dieser Nachfolger des Porsche Carrera GT geht bei den Öko-Muskelprotzen im direkten Vergleich mit LaFerrari und McLaren P1 als Primus inter Pares hervor. Obwohl seine Systemleistung von 887 PS, davon entfallen satte 285 auf die Elektromotoren an Vorder- und Hinterachse, dem Ferrari und dem McLaren deutlich hinterher hinkt, zeigt der Porsche ungeahnte Qualitäten im Fahrbetrieb. Trotz seines Gewichtshandicaps – gut 200 Kilo schwerer als seine Konkurrenten – schlägt er diese im Sprint auf Tempo 100. Seinen dafür benötigten 2,6 Sekunden kann der P1 lediglich 2,8 entgegen setzen. Der LaFerrari liegt knapp unter der Drei-Sekunden-Marke. Mit 6.57 Minuten auf der Nordschleife des Nürburgrings entfaltet der 918 Spyder die in ihm steckenden Hybrid-Gene eines 911 GT3 R, verbandelt mit der Kraft eines RS Spyder, der in der LMP2-Klasse des Motorsports für Furore gesorgt hatte. Dass es bei der Höchstgeschwindigkeit „nur" zu 345 km/h reicht – die Konkurrenten aus Maranello und Woking schaffen fünf Stundenkilometer mehr – tut dem sparsamen Schwaben kein Abbruch. Im Verbrauch ist der 918 äußerst genügsam, wenngleich die vom Werk angegebenen drei Liter Super Plus auf hundert Kilometer nur theoretisch zu betrachten sind. In der Gasfuß-Praxis müssen wohl noch acht Liter addiert werden.

Der im Windkanal rundum optimierte 918 Spyder mag gegenüber LaFerrari und P1, für die jeweils 300 000 Euro mehr hinzublättern sind, etwas bieder wirken, doch wer sich eine besonders sportliche Optik für seinen Spyder wünscht, bekommt sie mit dem „Weissach-Paket" serviert. Für den „ultimativen Sportwagen seiner Dekade" (Porsche-Slogan) stehen zur Auswahl: das Martini-Racing-Design, das nicht zuletzt an den Le-Mans-Sieg 1971 erinnern soll, und das rotweiße Porsche-Salzburg-Design, Reminiszenz an den ersten großen Erfolg bei diesem Rennklassiker im Jahr zuvor. Alternativ drängt sich eine mattschwarze Variante auf. Aufpreis für das um 40,8 Kilo abgespeckte Weissach-Paket: 71 400 Euro. Davon entfallen allein 40 000 auf die ultraleichten Magnesiumräder.

Wenn der 4,6-Liter-V8 des 918 bei 8700 Touren seine maximale Kraft entwickelt, begleitet die Thermik der oben liegenden Auspuffrohre ein gewaltiger Sound. Im Elektro-Modus – die unter dem Tank geschützt liegende Lithium-Ion-Batterie mit 230 kW besitzt eine Haltbarkeitsgarantie von sieben Jahren oder bis zu 100 000 Kilometern – bewegt sich der Spyder 30 Kilometer auf leisen Sohlen dahin. Während der E-Motor an der Mitlenkerhinterachse im Verbund mit dem V8 operiert, schaltet sich der vordere bei einer Drehzahl von 16 000/min, also etwa bei 265 km/h ab. Zisch und weg!

peine arrivée, elle est déjà partie : supercar hybride de Porsche, la 918 Spyde – limitée à 918 unités – s'est vendue e moins d'un an. Les fanas américains de Porsch ont pu se régaler avec 297 exemplaires à u prix de base de 769 026 euros, tandis que l'Alle magne et la Chine ont dû se contenter de 10 unités chacune.

L'héritière de la Porsche Carrera GT occupe place de *primus inter pares* dans la catégorie de hypercars en comparaison directe avec LaFerrari la McLaren P1. Alors que sa puissance de 887 c dont 285 viennent des moteurs électriques sur l'a avant et arrière, reste à la traîne derrière la Ferra et la McLaren, la Porsche offre un comporteme de conduite aux qualités insoupçonnées. Malgré s handicap de poids – quelque 200 kilos de plus qu

es rivales – elle les bat à la course de 0 à 100 km/h. ne lui faut que 2,6 secondes pour atteindre cette tesse, contre 2,8 pour la P1. LaFerrari est quant elle juste sous la barre des trois secondes. Avec 57 minutes sur la boucle nord du Nürburgring, la 18 Spyder exprime ses gènes hybrides hérités de la 1 GT3 R, associés à la puissance d'une RS Spyder, ui avait fait fureur dans la catégorie LMP2 des orts automobiles. Et même si sa vitesse de pointe tteint «seulement» 345 km/h – ses rivales de aranello et Woking font 5 km/h de mieux – cela enlève rien à la Souabe économe. Au chapitre e la consommation, la 918 est extrêmement peu igeante, même si le chiffre de trois litres de super us aux cent kilomètres n'est que théorique. Avec pied sur l'accélérateur, il faut bien ajouter huit res de plus.

La 918 Spyder entièrement optimisée en soufflerie veut présenter un visage plus sage que LaFerrari et la P1, pour lesquelles il faut débourser 300 000 euros de plus, mais ceux qui veulent un total look sportif pour leur Spyder peuvent opter pour le «pack Weissach». Pour la «voiture de sport la plus aboutie de sa décennie» (slogan Porsche), on peut choisir l'extérieur Martini Racing, qui évoque la victoire du Mans en 1971, et l'extérieur Porsche Salzburg, souvenir du premier grand succès de cette classique des circuits l'année précédente. Une variante noir mat s'impose également. Supplément à payer pour le pack Weissach allégé de 40,8 kilos: 71 400 euros. Sur cette somme, 40 000 euros sont consacrés aux roues ultralégères en magnésium.

Quand le V8 4,6 litres de la 918 déploie sa puissance maximale à 8700 tours, un son colossal accompagne la thermique des sorties d'échappement hautes. En mode électrique – la batterie lithium-ion de 230 kW cachée sous le réservoir est garantie sept ans ou jusqu'à 100 000 kilomètres – la Spyder se déplace en mode furtif sur 30 kilomètres. Lorsque le moteur électrique de l'axe arrière à direction assistée fonctionne avec le V8, le moteur avant se coupe à 16 000 tours/min, c'est-à-dire aux environs de 265 km/h. À peine arrivée, elle est déjà partie!

918 Spyder

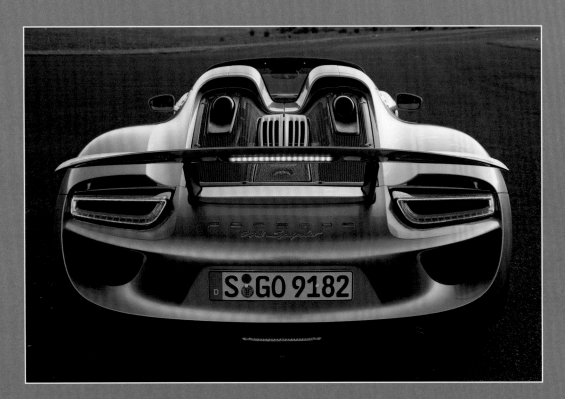

Motorsports and the latest hybrid technology are the driving forces behind the 918 Spyder, whose mid-engine works in harmony with two electric motors to deliver a system output of 887 bhp to the four wheels. The result: 0–60 mph in 2.6 seconds and a top speed of 214 mph.

er Motorsport und modernste Hybrid-Technologie
anden Pate beim 918 Spyder, dessen Mittelmotor im
rbund mit zwei Elektromotoren eine Systemleistung von
7 PS auf die vier Räder bringt. Resultat: 2,6 Sekunden
f Tempo 100, Spitze: 345 km/h.

sport automobile et la technologie hybride la plus
ancée sont les piliers de la 918 Spyder, dont le moteur
ntral allié à deux moteurs électriques délivre 887 ch sur
s quatre roues. Résultat : 0 à 100 km/h en 2,6 secondes,
esse de pointe : 345 km/h.

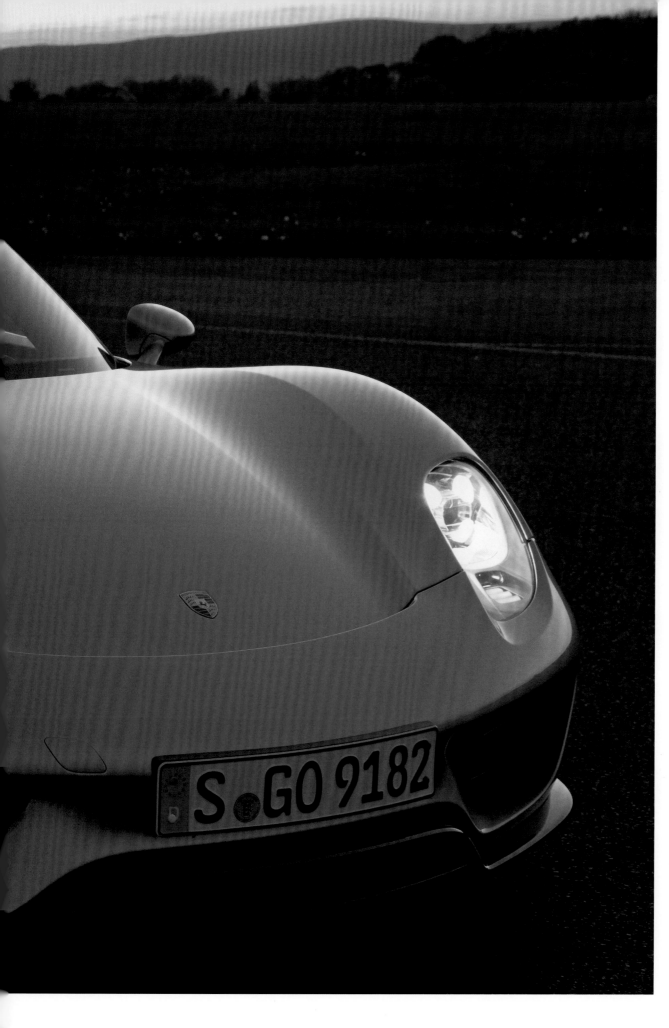

The front nostrils are modest, with LED lamps peeking over the top of them. The air shaft for the engine reaches almost to the removable roof halves, which can be stored in the front trunk.

Eher brav wirkt die Front mit den Nüstern, über denen das LED-Leuchten-Geviert hervorblinzelt. Der Luftschacht für das Triebwerk reicht fast bis zu den abnehmbaren Dachhälften, die vorn im Gepäckraum verstaut werden können.

L'avant, avec ses naseaux ponctués d'un carré de LED, a un air plutôt sage. Les bouches d'aération pour le moteur se prolongent presque jusqu'aux moitiés de toit amovibles, qui se rangent dans le coffre avant.

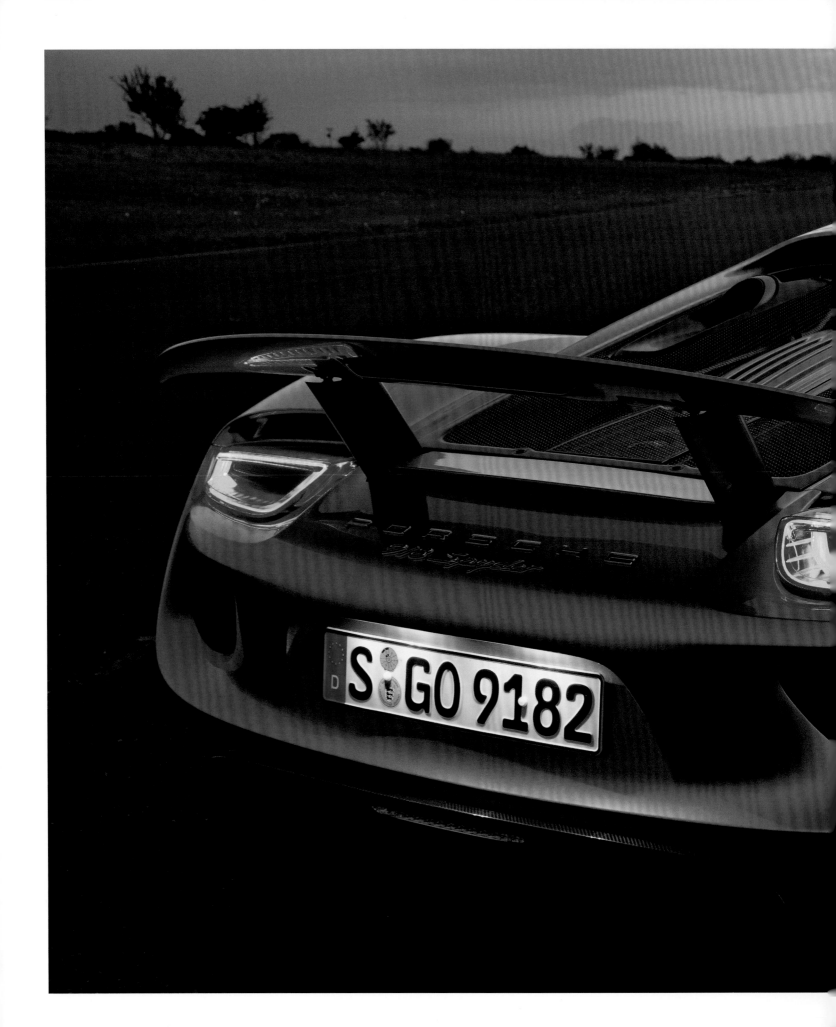

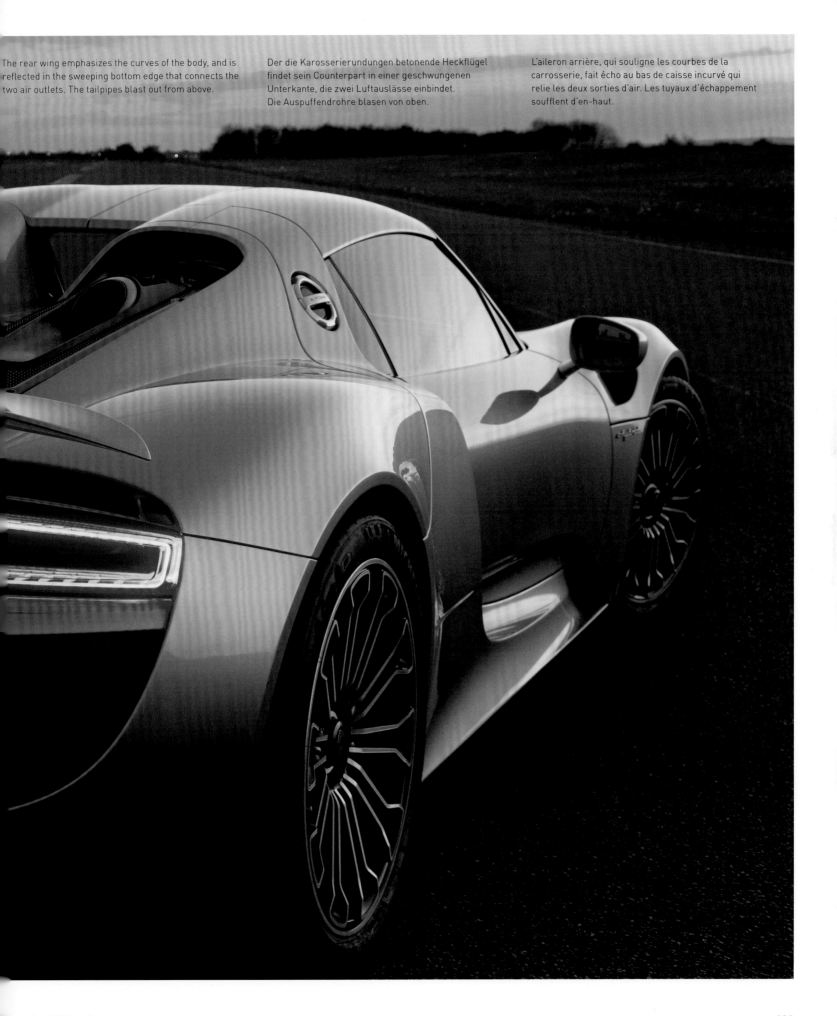

The rear wing emphasizes the curves of the body, and is reflected in the sweeping bottom edge that connects the two air outlets. The tailpipes blast out from above.

Der die Karosserierundungen betonende Heckflügel findet sein Counterpart in einer geschwungenen Unterkante, die zwei Luftauslässe einbindet. Die Auspuffendrohre blasen von oben.

L'aileron arrière, qui souligne les courbes de la carrosserie, fait écho au bas de caisse incurvé qui relie les deux sorties d'air. Les tuyaux d'échappement soufflent d'en-haut.

If you find yourself caught in these headlamps, you'd better get out of the way! The V8 combustion engine is completely concealed but for the oil fill nozzle, which is hidden beneath a flap.

Wer von dieser Lichtbatterie angestrahlt wird, sollte schleunigst Platz machen. Vom V8-Verbrennungsmotor ist nichts zu sehen, nur der Öleinfüllstutzen unter einer Klappe.

Si vous êtes éclairé par ce feu, faites place ! Le moteur thermique V8 reste invisible, sauf pour le bouchon de remplissage d'huile sous un couvercle.

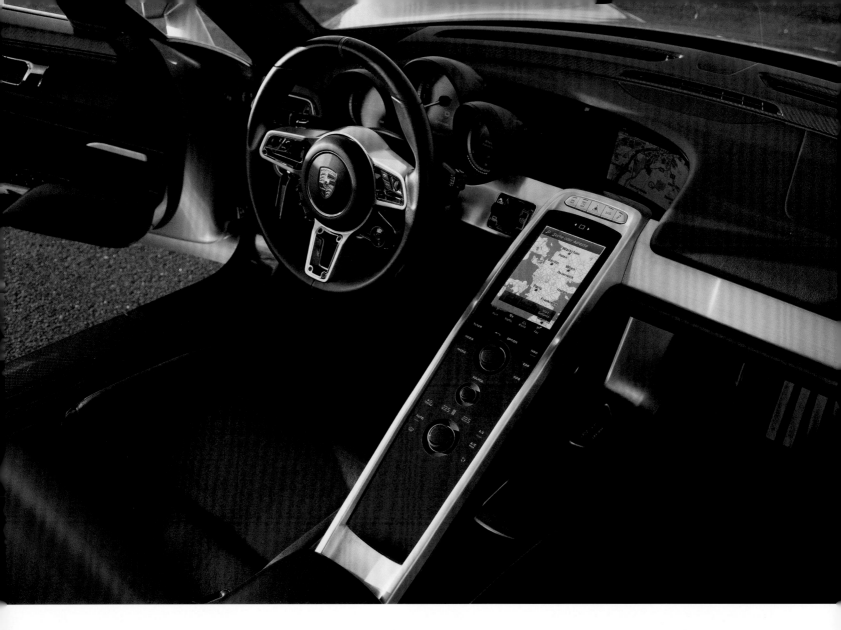

s in the Carrera GT, the center console is curved. The operating mode switch is built into the multifunctional steering wheel. When in the up position, the wing provides 70 pounds of downforce.

Wie beim Carrera GT ist die Mittelkonsole gewölbt. In das Multifunktionslenkrad ist der Betriebsmodischalter integriert. Steil gestellt bringt der Flügel 440 Kilo Abtrieb.

Comme pour la Carrera GT, la console centrale est curviligne. Le commutateur de mode est intégré au volant multifonction. En position verticale, l'aileron assure une déportance de 440 kilos.

The little brother of the Cayenne was launched on 20 November 2013, and catapulted to the top in just its first year of production. Based on the Audi Q5, the SUV—Porsche's fifth series—sold 45,000 units right from the word "go", in the company's customary number of variants.

However, the actual basic Macan, featuring a two-liter, direct-injection straight-four engine from the VW shelves, trailed behind a little, not hitting the market until June 2016. The S, S Diesel, GTS and Turbo all enjoyed success in this time. They were followed in September 2016 by a Turbo with a performance package, whose 3.6-liter bi-turbo V6 generates 440 bhp. This top-of-the-range model goes from 0–60 mph in 4.4 seconds, and only starts to tire at 169 mph. It is not a car designed for the country life: its active low-riding sport suspension, the Sport Chrono package, 21-inch wheels with the 911 Turbo design and high-gloss black paint on the spoke sides, classy leather interior and Alcantara covers wouldn't be the best choice for going off the beaten track. But if the driver does get into an offroad situation—either deliberately or otherwise—a button on the center console can be used to activate all the necessary systems for a traction-oriented offroad setup and automatically raise the optional air suspension to a suitable level. In the Macan, which comes with a seven-speed, dual-clutch transmission as standard, the drive power can be distributed variably between the front and rear wheels. And when it gets up into true mountaineering territory, the "Porsche Hill Control" makes sure the car doesn't come down again too soon. As the Macan's advertising said: "Those who prefer to blaze a trail of their own don't need to follow the lead of others".

Even the basic model boasts 252 bhp and a top speed of 142 mph, and the Macan S Diesel's three-liter engine comes with a similar power level. All Macan models are free from electronic top speed limiters, and even the 340 bhp Macan S can break the 155 mph barrier. The GTS, almost two tons in weight in accordance with EC directives, is even sportier—no wonder, thanks to the extra 20 bhp provided by its V6 engine.

The Macan catches the eye with a beefy front end, accentuated by the Ferrari-esque radiator grille and a hood that extends down to the wheelhouses, with integrated headlamps. Its sporty nature is reflected in the swooping rear contour of the roof, dubbed the "flyline" by Porsche head designer Michael Mauer. The brake calipers add a splash of color: black on the Macan, silver on the S variants, and red to signal GTS and Turbo. Everything is Turbo: even the model name of the standard 19-inch rims.

Am 20. November 2013 feierte der kleine Bruder des Cayenne seine Premiere, und bereits im ersten Serienproduktionsjahr katapultierte sich der auf dem Audi Q5 basierende SUV an die Spitze: Diese fünfte Modellreihe bescherte Porsche auf Anhieb 45 000 verkaufte Einheiten, ganz nach Art des Hauses in verschiedenen Varianten.

Der eigentliche Basis-Macan mit einem Zwei-liter-Vierzylinder-Direkteinspritzer aus dem Volks-wagen-Regal kam jedoch als Nachzügler erst im Juni 2016 auf den Markt. Zuvor hatten S, S Diesel, GTS und Turbo reüssiert. Im September 2016 folgte ein Turbo mit Performance-Paket, dessen 3,6-Liter-V6 mit Biturbo-Aufladung 440 PS ausspuckt. Dieses Spitzenmodell spurtet in 4,4 Sekunden auf hundert Stundenkilometer und wird erst bei 272 km/h müde. Mit diesem Wagen sollte man sich nicht unbedingt ins Gelände wagen: Geregeltes Sportfahrwerk mit Tieferlegung, Sport-Chrono-Paket, 21-Zoll-Räder im Turbo-Design des 911 mit seitlich schwarz hochglanzlackierten Speichen sowie die edle Lederausstattung und Alcantara-Bezüge im Interieur passen eigentlich nicht zu einem Ausflug in die Botanik. Für eine unvermeidliche oder gewollte Offroad-Funktion des Macan ist auf der Mittelkonsole eine Taste positioniert, die alle relevanten Systeme in einem traktionsorientierten Geländeprogramm aktiviert. Die optionale Luftfederung geht dabei automatisch auf ein entsprechendes Niveau. Der serienmäßig mit Siebengang-Doppelkupplungsgetriebe bestückte Macan bietet die Möglichkeit, die Antriebskraft völlig variabel auf die Hinter- oder Vorderräder zu verteilen. Im Bergziegenterrain assistiert die „Porsche Hill Control", damit es nicht zu schnell bergab geht. „Wer lieber eigene Spuren hinterlässt, braucht nicht denen anderer zu folgen", heißt es in der Macan-Werbung.

Selbst der Basis-Macan verfügt über 252 PS, die ihn auf eine Spitze von 229 km/h beschleunigen. Etwa die gleiche Leistung bringt der Macan S Diesel mit seinem Dreilitertriebwerk auf die Räder. Dem Zwang einer elektronischen Begrenzung der Höchstgeschwindigkeit müssen sich die anderen Macan-Lenker nicht unterwerfen, denn schon der Macan S mit 340 PS durchbricht die 250-km/h-Barriere. Der GTS, nach EG-Richtlinie fast ein Zweitonner, gebärdet sich noch sportlicher – kein Wunder, denn sein V6 aktiviert weitere 20 PS.

Die Optik des Macan besticht durch seine bullige Front, akzentuiert durch ein Ferrari-ähnliches Kühlergitter und eine bis zu den Radkästen reichende Motorhaube mit integrierten Scheinwerfern. Seinen sportlichen Habitus unterstreicht die nach hinten abfallende Dachkontur, von Porsche-Chefdesigner Michael Mauer als „Flyline" kreiert. Farbe ins Spiel bringen die Bremssättel: schwarz beim Macan, silber bei den S-Varianten und rot als Signalwirkung für GTS und Turbo. Alles Turbo: auch die Bezeichnung der serienmäßigen 19-Zoll-Räder

Le petit frère du Cayenne a été présenté a monde le 20 novembre 2013. Dès la premièr année de production en série, ce SUV bas sur l'Audi Q5 s'est catapulté au sommet : 45 00 unités de cette cinquième gamme se sont vendue d'emblée, en plusieurs variantes comme il est c coutume pour Porsche.

Le véritable Macan de base, avec un moteur c deux litres à injection directe emprunté à VW et ur pression d'admission de jusqu'à deux bars, n'e cependant arrivé sur le marché qu'en juin 2016. avait été précédé des modèles S, S Diesel, GTS Turbo. En septembre 2016, il a été suivi par un Turk avec pack Performance, dont le V6 de 3,6 litres biturbocompresseur dégage 440 ch. Ce modèle pointe sprinte à 100 km/h en 4,4 secondes et mon jusqu'à 272 km/h. Cette voiture n'est pas forcéme

2014→

aite pour l'aventure : le châssis sport abaissé, le
ack Sport Chrono, les jantes de 21 pouces dans
e design Turbo de la 911 avec branches laquées de
oir brillant sur les côtés ainsi que l'intérieur cuir
t les revêtements en alcantara ne sont pas vrai-
nent pensés pour les escapades dans la verdure.
our une excursion off-road inévitable ou volon-
aire, un bouton situé sur la console centrale du
lacan fait basculer tous les systèmes concernés
n programme tout-terrain, qui favorise la traction.
a suspension pneumatique en option se met auto-
natiquement au niveau correspondant. Le Macan
quipé en série d'une boîte à double embrayage
 sept rapports offre la possibilité de répartir la
rce motrice à volonté entre les roues arrière
t avant. Sur les terrains à chèvres de montagne,
e système Porsche Hill Control aide à réguler

la vitesse en descente. « Pour laisser sa propre
empreinte, il ne faut surtout pas suivre celles des
autres », conseille la publicité du Macan.

Même le Macan de base dispose de 252 ch, qui
l'emmènent à une vitesse de pointe de 229 km/h.
Le Macan S Diesel assure une performance simi-
laire avec son moteur trois litres. Les autres
conducteurs de Macan ne doivent pas se soumettre
à la contrainte d'une limitation électronique de la
vitesse maximale, car même le Macan S avec ses
340 ch passe la barrière des 250 km/h. Le GTS, qui
fait presque deux tonnes selon la directive CE, a un
comportement encore plus sportif – rien d'éton-
nant à cela, car son V6 développe 20 ch de plus.

Visuellement, le Macan en impose avec son
avant massif, accentué par une calandre qui évoque
une Ferrari et un capot avec phares intégrés qui

va jusqu'aux passages de roue. La ligne de toit qui
plonge vers l'arrière souligne son esprit sportif.
C'est Michael Mauer, designer en chef de Porsche,
qui a créé cette « flyline ». Les étriers de frein
jouent sur la couleur : noirs pour le Macan, argent
pour les variantes S et rouges pour signaler le GTS
et le Turbo. Tout Turbo : c'est aussi la désignation
des jantes 19 pouces en série.

Macan

Large alloy wheels, red brake calipers: the Macan Turbo variant is unmistakable from any perspective, as demonstrated by a glanc under the hood.

Große Leichtmetallräder rote Bremssättel: Auch aus dieser Perspektive ist die Turbo-Variante des Macan unverkennba bestätigt von einem Blic unter die Motorhaube.

Grandes jantes en alliag léger, étriers de frein rouges : sous cet angle aussi, la variante Turbo Macan est toujours auss reconnaissable, et il suff d'un coup d'œil sous le capot pour confirmer.

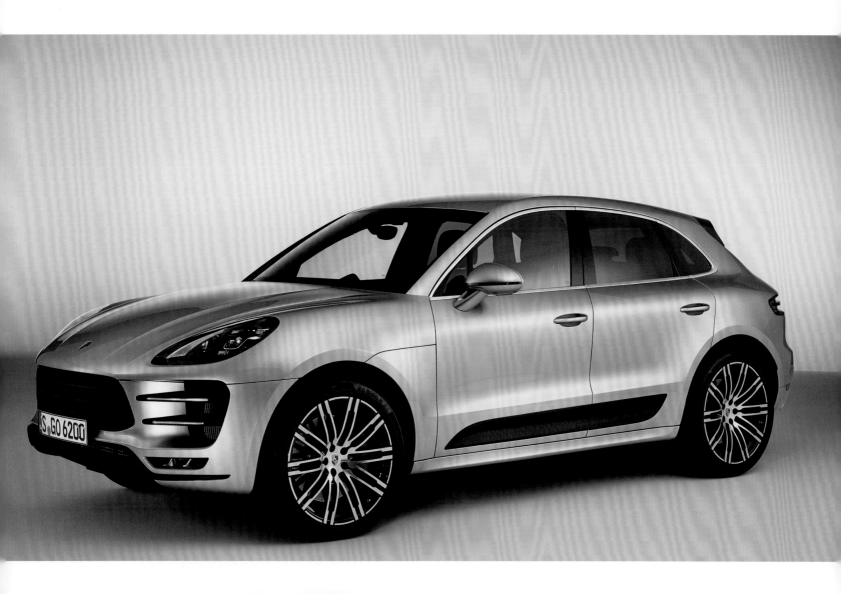

The beefy yet sporty SUV,
which is based on the
Audi Q5, boasts 400 bhp.
The spacious cockpit is
dominated by the center
console, which is adorned
with various control
buttons.

Der bullig aber dennoch
sportlich wirkende
SUV auf Basis des Audi
Q5 aktiviert 400 PS.
Die Mittelkonsole mit
unzähligen Tasten
dominiert das geräumige
Cockpit.

Le SUV massif mais à
l'esprit sportif basé sur
l'Audi Q5 dégage 400 ch.
La console centrale
pourvue d'innombrables
boutons domine
l'habitacle spacieux.

Step by step, Porsche has expanded the range of models in the second Panamera generation, which was launched in summer 2016. One new addition was the Panamera E-Hybrid, which debuted in Paris and was described by Porsche boss Oliver Blume as "a luxurious four-door coupé with the identity of the 911 and the genes of the 918 Spyder."

The plump rear of the first Panamera was replaced with an elegantly elongated roof and slim tail lights, connected by an LED bar. Thanks to the innovative mechanical and thermal joining techniques used in the ultra-modern coachbuilding department at the Leipzig factory, 475 robots and 200 highly-qualified humans per shift are able to make each new Panamera to measure. 220 yards of adhesive seams connect the roll-hemmed aluminum sheets with high-strength steel.

Rear-wheel or all-wheel drive; S, GTS or Turbo; Executive or Exclusive design—the price range of 83,000 to more than a quarter million euros offers luxurious variety, with a sporty touch reinforced by the lower overall weight and a new, more efficient, more dynamic generation of engines. The power play starts with the 3-liter V6, a turbo gas engine with 330 bhp that drives the digital speedometer up to 164 mph (only the rev counter is still analog). Powered by a new, 4-liter V8 with twin-scroll chargers, VarioCam Plus and adaptive cylinder control, the Panamera Turbo's performance takes it into sports car territory: 550 bhp, 0–60 mph in 3.6 seconds and a top speed of 190 mph. And the Panamera 4 E-Hybrid, with its system output of 462 bhp—the 136 bhp electric motor kicks in to support the 330 bhp V6 when the gas pedal is tapped—is no slouch, either, completing the sprint in 4.6 seconds and hitting a top speed of 173 mph. Like this all-wheel drive model, which boasts very low consumption, all the Panameras come with the new, eight-speed, dual-clutch transmission. Improved lithium-ion batteries with greater capacity have extended the electric range to 30 miles.

In China, the most popular vehicles have a lot of space in the back. Porsche's Executive version caters to this business need, with a 6" longer wheelbase and exclusive features in its larger interior. Designed as a chauffeur limousine, the electronically controlled damper system and adaptive air suspension of this long Panamera ensure maximum comfort while driving. A panorama roof and an array of features to make passengers more comfortable are fitted as standard. Only the Executive versions of the Panamera S and the Turbo are more impressive, with their four-zone climate control, rear-wheel steering and "soft-close" doors.

Launched at Geneva 2017, the Sport Turismo adds a station wagon with a striking roof spoiler to the Panamera range. With the back seats down, it boasts a luggage capacity of up to 54.5 cu.ft.

Schlag auf Schlag vergrößerte Porsche die Modellpalette der im Sommer 2016 vorgestellten zweiten Panamera-Generation. Diese bekam weiteren Zuwachs durch den Panamera E-Hybrid, der in Paris debütierte, laut Porsche-Chef Oliver Blume „ein luxuriöses viertüriges Coupé mit der Identität des 911 und den Genen des 918 Spyder".

Anstelle des pummeligen Hecks des ersten Panamera überzeugt sein Nachfolger mit einem elegant gestreckten Dach mit schmalen, durch eine LED-Leiste verbundenen Rückleuchten. Dank innovativer mechanischer und thermischer Fügetechniken im ultramodernen Karosseriebau des Leipziger Werkes fertigen 475 Roboter und 200 hochqualifizierte Mitarbeiter pro Schicht die neue Panamera-Generation auf Maß. 200 Meter Klebenaht verbinden bei den rollgefalzten Blechen Aluminium mit hochfestem Stahl.

Ob Heckantrieb oder Allrad, S, GTS oder Turbo, Executive- oder Exclusive-Ausführung, zwischen 83000 und mehr als einer Viertelmillion Euro bietet die Preisskala luxuriöses Allerlei, kombiniert mit sportlichem Touch, verstärkt durch Reduzierung des Gesamtgewichts und eine neue Motorengeneration mit mehr Dynamik und Effizienz. Das Powerplay beginnt beim 3-Liter-V6, einem Turbo-Benziner mit 330 PS, der den digitalen Tacho (nur der Drehzahlmesser funktioniert noch analog) auf 264 km/h treibt. Von einem neuen 4-Liter-V8 mit Twin-Scroll-Ladern, VarioCam Plus und adaptiver Zylindersteuerung befeuert, rückt der Panamera Turbo leistungsmäßig in Sportwagenregionen: 550 PS, 3,6 Sekunden auf 100 km/h und eine Spitze von 306 km/h. Aber auch der Panamera 4 E-Hybrid mit einer Systemleistung von 462 PS – der 330-PS-V6 wird beim Antippen des Gaspedals direkt vom 136-PS-Elektromotor unterstützt – bewegt sich munter: 4,6 Sekunden für den Sprint und 278 km/h oben heraus. Wie dieses im Benzinverbrauch sehr genügsame Allradmodell verfügen alle Panamera über das neu entwickelte Achtgang-Doppelkupplungsgetriebe. Verbesserte Lithium-Ionen-Zellen mit höherer Kapazität erhöhen die elektrische Reichweite auf 50 Kilometer.

Beliebt sind in China vornehmlich Fahrzeuge mit viel Platz im Fond. Diesem Business-Bedürfnis kommt Porsche mit der Executive-Ausführung entgegen: um 15 Zentimeter verlängerter Radstand und exklusive Ausstattung des vergrößerten Innenraums. Konzipiert als eine Chauffeurslimousine, wartet dieser Lang-Panamera mit einem elektronisch geregelten Dämpfungssystem und adaptiver Luftfederung für höchsten Fahrkomfort auf. Panoramadach und diverse Bequemlichkeiten für die Passagiere gehören zum Standard. Der wird nur noch vom Panamera S und dem Turbo in der Executive-Version – mit Vierzonen-Klimaautomatik, Hinterachslenkung und „Soft-Close"-Türen – übertroffen. Mit dem Sport Turismo ist der Panamera seit Genf 2017 auch als Kombi mit einem markanten beweglichen Dachkantenspoiler erhältlich. Ladevolumen bei umgelegten Rücksitzen: bis zu 1550 Liter!

Porsche avait agrandi coup sur coup la palett de modèles de la deuxième génération d Panamera présentée à l'été 2016. Elle grand encore avec la Panamera E-Hybrid, qui a fait se débuts à Paris. D'après le P.-D.G. de Porsch Oliver Blume, c'est «un luxueux coupé quatr portes avec l'identité de la 911 et les gènes d la 918 Spyder».

L'arrière potelé de la première Panamera fa place à un toit qui s'allonge élégamment avec de feux arrière minces reliés par une barrette d LED. Grâce aux techniques d'assemblage méc niques et thermiques innovatrices ultramoderne de l'usine de Leipzig, 475 robots et 200 collabor teurs hautement qualifiés par équipe fabriquer la nouvelle génération de Panamera sur mesur Une ligne de collage de 200 mètres joint aluminiu

t acier haute résistance pour les feuilles serties
u rouleau.

Transmission arrière ou intégrale, S, GTS ou
urbo, version Executive ou Exclusive, une four-
hette de prix d'entre 83 000 et plus d'un quart
e million d'euros offre un luxe de possibilités,
ombiné à un esprit sportif, renforcé par la réduc-
on du poids global, et complété par un moteur
ouvelle génération plus dynamique et plus effi-
ent. Le coup de force commence avec le V6 trois
tres, un moteur essence turbo de 330 ch, pour
quel le compteur numérique (seul le compte-
urs est encore analogique) monte à 264 km/h.
imentée par un V8 quatre litres avec compres-
eur Twin-Scroll, VarioCam Plus et commande
daptative des cylindres, la Panamera Turbo entre
ans le domaine des performances sportives :

550 ch, de 0 à 100 km/h en 3,6 secondes et une
vitesse de pointe de 306 km/h. Mais la Panamera 4
E-Hybrid, avec une puissance de 462 ch – il suffit
d'effleurer l'accélérateur pour que le V6 330 ch
soit directement assisté par le moteur électrique
de 136 ch – ne traîne pas non plus : de 0 à 100 km/h
en 4,6 secondes et jusqu'à 278 km/h. Comme ce
modèle à quatre roues motrices très peu gour-
mand en essence, toutes les Panamera sont
dotées de la nouvelle boîte à double embrayage
à huit rapports. Les cellules lithium-ion à capa-
cité améliorée portent l'autonomie électrique à
50 kilomètres.

Le marché chinois apprécie les véhicules
qui offrent un espace généreux à l'arrière.
Porsche satisfait cet impératif commercial avec
la version Executive : l'empattement y est allongé

de 15 centimètres, et l'ample espace intérieur est
richement aménagé. Conçue comme une limou-
sine de chauffeur, cette longue Panamera offre un
confort de conduite extrême grâce à son système
d'amortissement à régulation électronique et à
sa suspension pneumatique adaptative. Le toit
panoramique et diverses commodités pour les
passagers sont la norme. Ce confort n'est dépassé
que par le modèle S et le Turbo en version Execu-
tive – avec air conditionné automatique à quatre
zones, direction à l'essieu arrière et portes
« soft close ».

Avec le modèle Sport Turismo, la Panamera
est aussi disponible en break avec un remarquable
aileron de toit mobile depuis Genève 2017. Volume
de chargement avec les sièges arrière rabattus :
jusqu'à 1550 litres !

Panamera (971)

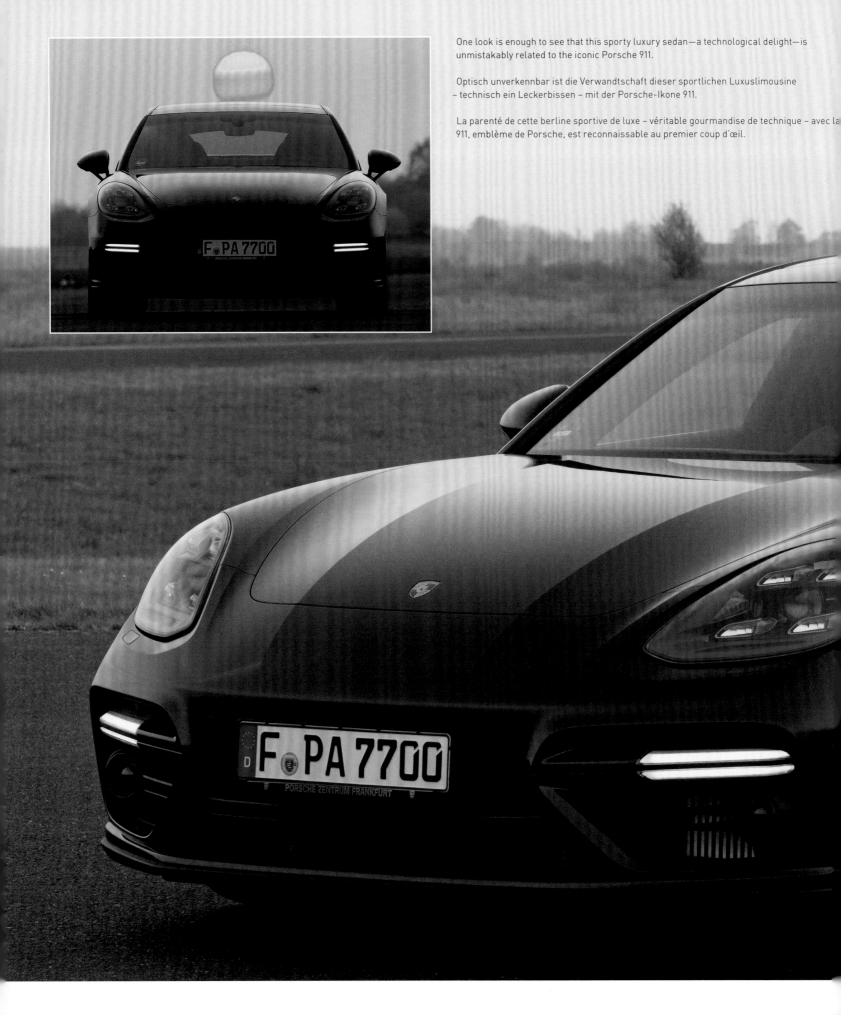

One look is enough to see that this sporty luxury sedan—a technological delight—is unmistakably related to the iconic Porsche 911.

Optisch unverkennbar ist die Verwandtschaft dieser sportlichen Luxuslimousine – technisch ein Leckerbissen – mit der Porsche-Ikone 911.

La parenté de cette berline sportive de luxe – véritable gourmandise de technique – avec la 911, emblème de Porsche, est reconnaissable au premier coup d'œil.

The once-plump rear of the first Panamera generation has given way to elegant, sporty lines. But the Panamera Turbo is more than just a looker: it also comes with a retractable rear spoiler—helpful in view of a top speed of 193 mph—, alloy wheels with a wide footprint, and strong brakes with red calipers—classic Porsche.

Das einst doch sehr pummelige Heck der ersten Panamera-Generation ist einer sportlich gestreckten Linienführung gewichen. Der Panamera Turbo besticht nicht nur durch seine Gesamtoptik sondern auch durch Details wie einen ausfahrbaren Heckspoiler – bei einer Spitze von 310 km/h durchaus hilfreich –, die Leichtmetallräder mit breiten Puschen und starke Bremsen mit roten Bremssätteln, ganz nach Art des Hauses.

L'arrière très dodu de la première génération de Panamera a fait place à une ligne allongée et sportive. Ce n'est pas seulement par son aspect général que la Panamera Turbo brille, mais aussi avec des détails tels que son aileron arrière extensible – fort utile avec une vitesse de pointe de 310 km/h –, ses jantes en alliage léger, ses pneus larges et ses freins puissants à étriers rouges, bien dans l'esprit de la maison.

This compact legroom in the rear is six inches larger in the Executive version, which was designed primarily for the Chinese market. As in many modern vehicles, the twin-turbo V8 engine is more or less hidden, just peeking out slightly from under the covers.

Dieser knappe Beinraum für das menschliche Fahrgestell im Fond wird in der Executive-Ausführung – vornehmlich für den China-Export konzipiert – erweitert durch einen 15 Zentimeter längeren Radstand. Wie bei modernen Fahrzeugen üblich, lässt sich der V8-Motor mit seinen zwei Turbos unter den Abdeckelementen nur erahnen.

L'espace exigu laissé aux jambes à l'arrière est plus ample dans la version Executive – conçue surtout pour le marché chinois – grâce à un empattement plus long de 15 centimètres. Comme il est courant de le voir dans les voitures modernes, le moteur V8 et ses deux turbos se laissent seulement deviner sous leur couvercle.

The cockpit includes all the usual amenities of the automotive upper class, accessible via a so-called "Direct Touch Control" in the center console. Apart from the analog rev counter in the center of the instrument cluster, the controls and gauges are entirely electronic, and include a 12-inch touch screen and automatic climate control.

Im Fahrerabteil finden sich sämtliche Annehmlichkeiten der automobilen Oberschicht, abrufbar durch eine sogenannte „Direct Touch Control" in der aufsteigenden Mittelkonsole. Abgesehen von einem analogen Drehzahlmesser in der Mitte des Kombiinstruments regiert die Elektronik, so auch der 12-Zoll-Touchscreen und die Klimaautomatik.

L'avant est équipé de toutes les commodités que l'on peut attendre dans les meilleures automobiles, disponibles à travers le système Direct Touch Control de la console centrale. Exception faite du compte-tours analogique, les instruments de bord sont dominés par l'électronique, avec un écran tactile de 12 pouces et l'air conditionné automatique.

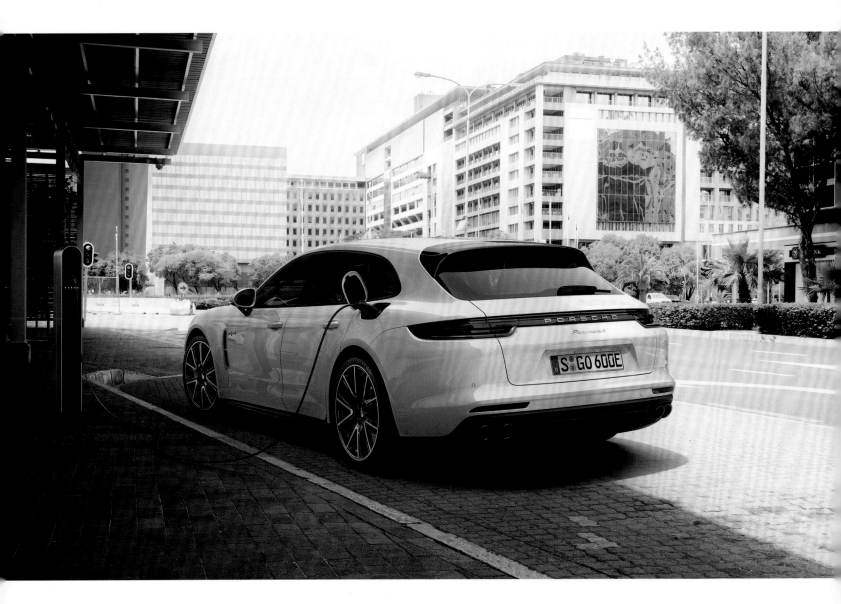

The Panamera Sport Turismo—a "sports station wagon"—was premiered at the 2017 Geneva show. The Turbo S E-Hybrid boasts a system output of 680 bhp, while the 100 kW (136 bhp) electric motor provides a range of around 30 miles. Of course, a little patience is required when charging. The rear section is almost tailor-made for Shanghai, with plenty of storage space for business equipment.

Premiere feierte auf dem Genfer Salon 2017 der Panamera Sport Turismo, sozusagen ein Sportkombi. Als Turbo S E-Hybrid bringt er es auf eine Systemleistung von 680 PS, wobei der 100-kW-Elektromotor mit seinen umgerechnet 136 PS eine Reichweite von rund 50 Kilometer ermöglicht. Freilich muss man sich beim Ladevorgang etwas gedulden. Wie geschaffen für Shanghai ist das Heck, das genügend Stauraum für Geschäftsutensilien bietet.

La Panamera Sport Turismo, que l'on peut définir comme un break sportif, a été présentée au salon de Genève 2017. Dans la variante Turbo S E-Hybrid, elle délivre une puissance totale de 680 ch, et le moteur électrique de 100 kW (136 ch) a une autonomie d'environ 50 kilomètre. Bien sûr, il faut faire preuve d'un peu de patience pendant le chargement. L'arrière très spacieux est idéal pour y ranger de l'équipement professionnel.

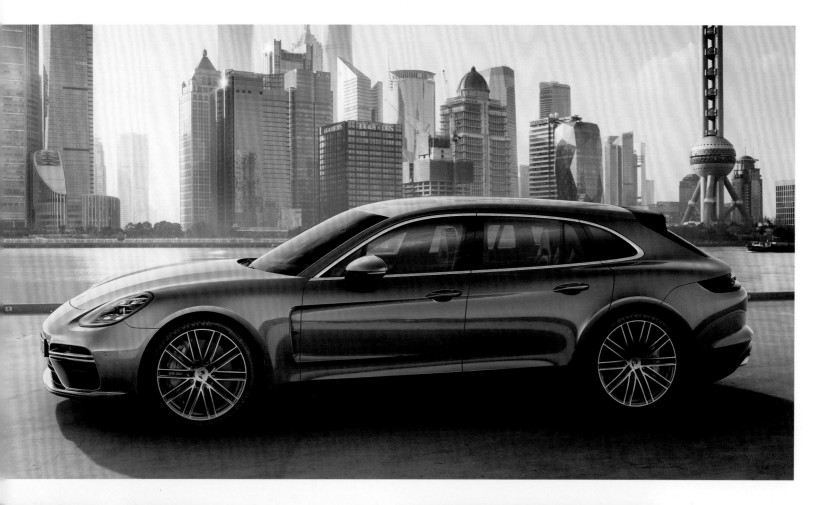

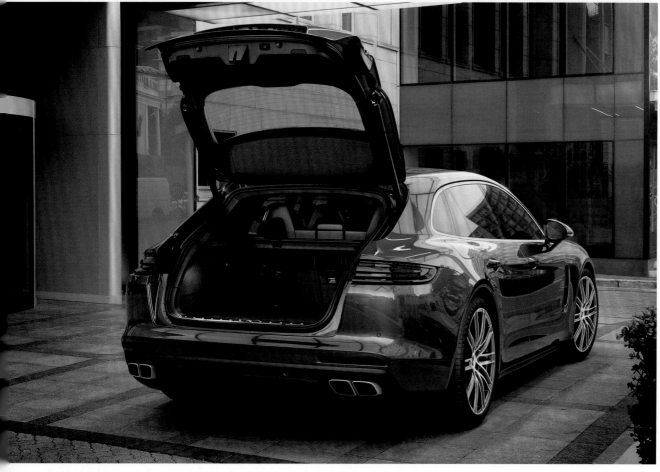

Baureihe	Porsche 356 Alu Coupé (Fahrgestell 009)	Porsche 356
Baujahre	1948–1951	1950–1955
Modell	356 Alu (Fahrgestell 009)	1500 1954
Motor Konfiguration	4-Zylinder-Boxer	4-Zylinder-Boxer
Hubraum	1131 cm³	1488 cm³
Bohrung × Hub	75×64 mm	80×74 mm
Kraftstoffversorgung	2 Fallstromvergaser Solex 26 VFI	2 Fallstromvergaser Solex 32 PBI
Leistung	40 PS bei 4000/min	55 PS bei 4400/min
Getriebe	4-Gang	4-Gang
Chassis Rahmen	Stahlblech-Kastenrahmen	Stahlblech-Kastenrahmen
Aufhängung vorn	Längslenker, gebündelte Querdrehstabfedern	Längslenker, gebündelte Querdrehstabfedern
Aufhängung hinten	Längslenker, Drehstabfedern	Längslenker, Drehstabfedern
Maße Radstand	2100 mm	2100 mm
Länge × Breite × Höhe	3880×1660×1300 mm	3950×1660×1300 mm
Gewicht	630 kg	830 kg
Höchstgeschwindigkeit	140 km/h	155 km/h

Baureihe	Porsche 356 B	Porsche 356 C
Baujahre	1959–1963	1963–1965
Modell	1600 Super Roadster 1960	2000 CS Carrera 2 1964
Motor Konfiguration	4-Zylinder-Boxer	4-Zylinder-Boxer, 2×DOHC, 2 Königswellen
Hubraum	1582 cm³	1966 cm³
Bohrung × Hub	82,5×74 mm	92×74 mm
Kraftstoffversorgung	2 Doppelfallstromvergaser Zenith 32 NDIX	2 Doppelfallstromvergaser Solex 40 PJJ-4
Leistung	75 PS bei 5000/min	130 PS bei 6200/min
Getriebe	4-Gang	4-Gang
Chassis Rahmen	Stahlblech-Kastenrahmen	Stahlblech-Kastenrahmen
Aufhängung vorn	Längslenker, gebündelte Querdrehstabfedern	Längslenker, gebündelte Querdrehstabfedern
Aufhängung hinten	Längslenker, Drehstabfedern	Längslenker, Drehstabfedern
Maße Radstand	2100 mm	2100 mm
Länge × Breite × Höhe	4010×1670×1310 mm	4010×1670×1315 mm
Gewicht	835 kg (trocken)	845 kg
Höchstgeschwindigkeit	175 km/h	200 km/h

Baureihe	Porsche 912	VW-Porsche 914-4, 914-6, 916
Baujahre	1965–1968	1969–1976
Modell	912 1967	914-4 2.0 1973
Motor Konfiguration	4-Zylinder-Boxer	4-Zylinder-Boxer
Hubraum	1582 cm³	1971 cm³
Bohrung × Hub	82,5×74 mm	94×71 mm
Kraftstoffversorgung	2 Doppelfallstromvergaser Solex 40 PJJ-4	elektronische Einspritzung Bosch
Leistung	90 PS bei 5800/min	100 PS bei 5000/min
Getriebe	5-Gang	5-Gang
Chassis Rahmen	selbsttragende Karosserie	selbsttragende Karosserie
Aufhängung vorn	Querlenker, Längsdrehstabfedern, Gummihohlfedern	Querlenker, Längsdrehstabfedern
Aufhängung hinten	Längslenker, quer liegende Drehstabfedern, Gummihohlfedern	Schräglenker, Schraubenfedern, Gummihohlfedern, Teleskopdämpfer
Maße Radstand	2210 mm	2450 mm
Länge × Breite × Höhe	4160×1610×1320 mm	3985×1650×1230 mm
Gewicht	970 kg	950 kg
Höchstgeschwindigkeit	183 km/h	190 km/h

Baureihe	Porsche 911 Turbo (930)	Porsche 911 Carrera 3.0 & SC 3.0
Baujahre	1974–1989	1975–1983
Modell	911 Turbo 3.0 1976	911 SC 3.0 1980
Motor Konfiguration	6-Zylinder-Boxer, 2×OHC, Turbolader	6-Zylinder-Boxer, 2×OHC
Hubraum	2994 cm³	2994 cm³
Bohrung × Hub	95×70,4 mm	95×70,4 mm
Kraftstoffversorgung	Einspritzung Bosch K-Jetronic	Einspritzung Bosch K-Jetronic
Leistung	260 PS bei 5500/min	204 PS bei 5500/min
Getriebe	4-Gang	5-Gang
Chassis Rahmen	selbsttragende Karosserie	selbsttragende Karosserie
Aufhängung vorn	Querlenker, Längsdrehstabfedern, Federbeine	Querlenker, Längsdrehstabfedern, Dämpferbeine
Aufhängung hinten	Schräglenker, quer liegende Drehstabfedern, Teleskopdämpfer	Längslenker, quer liegende Drehstabfedern, Teleskopdämpfer
Maße Radstand	2270 mm	2270 mm
Länge × Breite × Höhe	4291×1775×1305 mm	4290×1650×1320 mm
Gewicht	1195 kg	1160 kg
Höchstgeschwindigkeit	260 km/h	235 km/h

Specifications · Technische Daten

Baureihe	**Porsche 550/550 A**	**Porsche 356 A**
Baujahre	1953–1957	1955–1959
Modell	550 Spyder RS 1955	1600 Cabriolet 1958
Motor Konfiguration	4-Zylinder-Boxer, 2×DOHC, 4 Königswellen	4-Zylinder-Boxer
Hubraum	1498 cm³	1582 cm³
Bohrung × Hub	85×66 mm	82,5×74 mm
Kraftstoffversorgung	2 Doppelfallstromvergaser Solex PJJ	2 Doppelfallstromvergaser Zenith 32/36 NDIX
Leistung	110 PS bei 6200/min	60 PS bei 4500/min
Getriebe	4-Gang	4-Gang
Chassis Rahmen	selbsttragender Verbundbau mit Bodenrahmen	Stahlblech-Kastenrahmen
Aufhängung vorn	Längslenker, quer liegende Vierkant-Blattfederstäbe	Längslenker, gebündelte Querdrehstabfedern
Aufhängung hinten	Pendelachse, Längslenker, quer liegende Drehstabfedern	Längslenker, Drehstabfedern
Maße Radstand	2100 mm	2100 mm
Länge × Breite × Höhe	3600×1550×1015 mm	3950×1670×1310 mm
Gewicht	550 kg	812 kg (trocken)
Höchstgeschwindigkeit	220 km/h	160 km/h

Baureihe	**Porsche 911 2.0–2.4**	**Porsche 904 Carrera GTS**
Baujahre	1963–1973	1963–1964
Modell	911 S 2.0 1969	904 Carrera GTS 1964
Motor Konfiguration	6-Zylinder-Boxer, 2×OHC	4-Zylinder-Boxer, 2×DOHC, 2 Königswellen
Hubraum	1991 cm³	1966 cm³
Bohrung × Hub	80×66 mm	92×74 mm
Kraftstoffversorgung	indirekte Einspritzung Bosch Sechsstempelpumpe	2 Doppelvergaser Weber 46 IDM
Leistung	170 PS bei 6800/min	180 PS bei 7800/min
Getriebe	5-Gang	5-Gang
Chassis Rahmen	selbsttragende Karosserie	Kastenrahmen, mit Kunststoffkarosserie verklebt und verschraubt
Aufhängung vorn	Querlenker, Längstorsionsstäbe, Gummihohlfedern	Dreiecksquerlenker, Schraubenfedern, Gummihohlfedern
Aufhängung hinten	Längslenker, quer liegende Drehstabfedern	Dreiecksquerlenker, Schraubenfedern, Gummihohlfedern
Maße Radstand	2268 mm	2300 mm
Länge × Breite × Höhe	4160×1610×1320 mm	4090×1540×1070 mm
Gewicht	1020 kg	740 kg
Höchstgeschwindigkeit	225 km/h	263 km/h

Baureihe	**Porsche Carrera RS 2.7**	**Porsche 911 2.7**
Baujahre	1972–1973	1973–1977
Modell	Carrera RS 2.7 1973	911 Carrera 2.7 Sondermodell 1974
Motor Konfiguration	6-Zylinder-Boxer, 2×OHC	6-Zylinder-Boxer, 2×OHC
Hubraum	2687 cm³	2687 cm³
Bohrung × Hub	90×70,4 mm	90×70,4 mm
Kraftstoffversorgung	indirekte Einspritzung Bosch Sechsstempelpumpe	indirekte Einspritzung Bosch Sechsstempelpumpe
Leistung	210 PS bei 6300/min	210 PS bei 6300/min
Getriebe	5-Gang	5-Gang
Chassis Rahmen	selbsttragende Karosserie	selbsttragende Karosserie
Aufhängung vorn	Querlenker, Längsdrehstabfedern, Dämpferbeine	Querlenker, Längsdrehstabfedern, Dämpferbeine
Aufhängung hinten	Schräglenker, quer liegende Drehstabfedern, Teleskopdämpfer	Schräglenker, quer liegende Drehstabfedern, Teleskopdämpfer
Maße Radstand	2270 mm	2270 mm
Länge × Breite × Höhe	4102×1650×1320 mm	4291×1652×1320 mm
Gewicht	960 kg	1075 kg
Höchstgeschwindigkeit	240 km/h	240 km/h

Baureihe	**Porsche 924**	**Porsche 928**
Baujahre	1975–1988	1977–1995
Modell	924 GT 1981	928 GTS 1992
Motor Konfiguration	4 Zylinder in Reihe, OHC	V8 90°, 2×DOHC
Hubraum	1984 cm³	5397 cm³
Bohrung × Hub	86,5×84,4 mm	100×85,9 mm
Kraftstoffversorgung	Einspritzung Bosch K-Jetronic	Einspritzung Bosch LH-Jetronic
Leistung	210 PS bei 6000/min	350 PS bei 5700/min
Getriebe	5-Gang	5-Gang
Chassis Rahmen	selbsttragende Karosserie	selbsttragende Karosserie
Aufhängung vorn	Querlenker, Federbeine	Doppelquerlenker, Schraubenfedern, hydraulische Teleskopdämpfer
Aufhängung hinten	Längslenker, quer liegende Drehstabfedern, Teleskopdämpfer	obere und untere Querlenker, Längsschubstreben, Schraubenfedern, hydraulische Teleskopdämpfer
Maße Radstand	2400 mm	2500 mm
Länge × Breite × Höhe	4320×1735×1275 mm	4520×1890×1282 mm
Gewicht	1180 kg	1620 kg
Höchstgeschwindigkeit	240 km/h	275 km/h

Glossary on page 462
Glossaire voir page 462

Caractéristiques techniques

Baureihe	Porsche 944	Porsche 911 Carrera 3.2
Baujahre	1981–1991	1983–1989
Modell	944 Turbo 1991	911 Speedster 1989
Motor Konfiguration	4 Zylinder in Reihe, OHC, Turbolader, Ladeluftkühler	6-Zylinder-Boxer, 2×OHC
Hubraum	2479 cm³	3164 cm³
Bohrung × Hub	100×78,9 mm	95×74,4
Kraftstoffversorgung	Einspritzung Bosch L-Jetronic	elektronische Einspritzung Bosch Motronic
Leistung	250 PS bei 6000/min	231 PS bei 5900/min
Getriebe	5-Gang	5-Gang
Chassis Rahmen	selbsttragende Karosserie	selbsttragende Karosserie
Aufhängung vorn	Querlenker, Federbeine	Querlenker, Längsdrehstabfedern, Federbeine
Aufhängung hinten	Schräglenker, quer liegende Drehstabfedern	Schräglenker, quer liegende Drehstabfedern, Teleskopdämpfer
Maße Radstand	2400 mm	2272 mm
Länge × Breite × Höhe	4230×1735×1275 mm	4291×1775×1220 mm
Gewicht	1280 kg	1220 kg
Höchstgeschwindigkeit	260 km/h	247 km/h

Baureihe	Porsche 968	Porsche 911 (993)
Baujahre	1991–1995	1993–1998
Modell	968CS 1994	GT2 1995
Motor Konfiguration	4 Zylinder in Reihe, 16 Ventile, DOHC	6-Zylinder-Boxer, 2×OHC, 2 Turbolader, Ladeluftkühler
Hubraum	2990 cm³	3600 cm³
Bohrung × Hub	104×88 mm	100×76,4 mm
Kraftstoffversorgung	elektronische Einspritzung Bosch Motronic	elektronische Einspritzung Bosch Motronic M 2.10
Leistung	240 PS bei 6200/min	430 PS bei 5750/min
Getriebe	6-Gang	6-Gang
Chassis Rahmen	selbsttragende Karosserie	selbsttragende Karosserie
Aufhängung vorn	Federbeine, Querlenker	Querlenker, Federbeine
Aufhängung hinten	Schräglenker, quer liegende Drehstabfedern, Teleskopdämpfer	Mehrlenkerachse, Teleskopdämpfer
Maße Radstand	2400 mm	2272 mm
Länge × Breite × Höhe	4320×1735×1275 mm	4245×1795×1285 mm
Gewicht	1320 kg	1175 kg
Höchstgeschwindigkeit	252 km/h	297 km/h

Baureihe	Porsche 911 (996)	Porsche Cayenne (9PA)
Baujahre	1997–2001	2002–2010
Modell	911 (996) GT3 1999	Cayenne Turbo S 2006
Motor Konfiguration	6-Zylinder-Boxer, 24 Ventile, 2×DOHC	V8, 32 Ventile, 2×DOHC, 2 Turbolader, 2 Ladeluftkühler
Hubraum	3598 cm³	4511 cm³
Bohrung × Hub	100×76,4 mm	93×83 mm
Kraftstoffversorgung	elektronische Einspritzung Bosch DME	elektronische Einspritzung Bosch ME 7.1.1
Leistung	360 PS bei 7200/min	521 PS bei 5500/min
Getriebe	6-Gang	6-Gang Tiptronic S , Allradantrieb
Chassis Rahmen	selbsttragende Karosserie mit Hilfsrahmen	selbsttragende Karosserie mit Hilfsrahmen
Aufhängung vorn	Querlenker, Federbeine	Doppelquerlenker
Aufhängung hinten	Mehrlenkerachse, Schraubenfedern, Teleskopdämpfer	Mehrlenkerachse, Luftfederung, elektronisch gesteuertes Dämpfersys
Maße Radstand	2350 mm	2855 mm
Länge × Breite × Höhe	4430×1765×1270 mm	4780×1930×1700 mm
Gewicht	1350 kg	2355 kg
Höchstgeschwindigkeit	302 km/h	270 km/h

Baureihe	Porsche Panamera (970)	Porsche Cayenne (92A)
Baujahre	2009–2016	2010→
Modell	Panamera S 2009	Cayenne Diesel 2013
Motor Konfiguration	V8, 32 Ventile, 2×DOHC	V6, 24 Ventile, 2×DOHC, Turbolader
Hubraum	4806 cm³	2967 cm³
Bohrung × Hub	96×83 mm	83×91,4 mm
Kraftstoffversorgung	Benzin-Direkteinspritzung	Common-Rail-Dieseleinspritzung
Leistung	400 PS bei 6500/min	245 PS bei 3800–4400/min
Getriebe	6-Gang	8-Gang Tiptronic S, Allradantrieb
Chassis Rahmen	selbsttragende Karosserie	selbsttragende Karosserie
Aufhängung vorn	Doppelquerlenkerachse	Doppelquerlenkerachse, Federbeine
Aufhängung hinten	Mehrlenkerachse	Mehrlenkerachse, Federbeine
Maße Radstand	2920 mm	2895 mm
Länge × Breite × Höhe	4970×1931×1418 mm	4846×1939×1705 mm
Gewicht	1770 kg	2155 kg
Höchstgeschwindigkeit	285 km/h	220 km/h

Baureihe	Porsche 918 Spyder	Porsche Macan
Baujahre	2013–2015	2014→
Modell	918 Spyder E-Hybrid	Macan Turbo mit Performance-Paket 2016
Motor Konfiguration	V8, 32 Ventile, 2×DOHC, 2 Elektromotoren	V6, 24 Ventile, 2 Turbolader
Hubraum	4593 cm³	3604 cm³
Bohrung × Hub	95×81 mm	96×83 mm
Kraftstoffversorgung	Benzin-Direkteinspritzung	Benzin-Direkteinspritzung
Leistung	V8: 608 PS bei 8700/min Elektromotoren: 129 PS vorn, 156 PS hinten System: 887 PS bei 8500/min	440 PS bei 6000/min
Getriebe	7-Gang, Allradantrieb	7-Gang, Allradantrieb
Chassis Rahmen	Monocoque mit Hilfsrahmen	selbsttragende Karosserie mit Hilfsrahmen
Aufhängung vorn	Doppelquerlenkerachse, Federbeine, Stabilisator	Mehrlenkerachse, Luftfederung, elektronisch gesteuertes Dämpfersyste
Aufhängung hinten	Mehrlenkerachse, Federbeine, Stabilisator	Mehrlenkerachse, Luftfederung, elektronisch gesteuertes Dämpfersyste
Maße Radstand	2730 mm	2807 mm
Länge × Breite × Höhe	4645×1940×1167 mm	4699×1923×1609 mm
Gewicht	1674 kg	1925 kg
Höchstgeschwindigkeit	345 km/h	272 km/h

Baureihe		**Porsche 959**	**Porsche 911 (964)**
Baujahre		1987–1988	1988–1994
Modell		959 1988	911 Turbo 3.6 1993
Motor	Konfiguration	6-Zylinder-Boxer, 24 Ventile, 2×DOHC, 2 Turbolader, 2 Ladeluftkühler	6-Zylinder-Boxer, 2×OHC, Turbolader, Ladeluftkühler
	Hubraum	2850 cm³	3600 cm³
	Bohrung × Hub	95×67 mm	100×76,4 mm
	Kraftstoffversorgung	elektronische Einspritzung Bosch Motronic	elektronische Einspritzung Bosch Motronic
	Leistung	450 PS bei 6500/min	360 PS bei 5500/min
Getriebe		6-Gang, Allradantrieb	5-Gang
Chassis	Rahmen	selbsttragende Karosserie	selbsttragende Karosserie
	Aufhängung vorn	Doppelquerlenker, Schraubenfedern, doppelte Teleskopdämpfer, automatische Niveauregulierung	Querlenker, Federbeine
	Aufhängung hinten	Doppelquerlenker, Schraubenfedern, doppelte Teleskopdämpfer, automatische Niveauregulierung	Schräglenker, Schraubenfedern, Teleskopdämpfer
Maße	Radstand	2272 mm	2272 mm
	Länge × Breite × Höhe	4260×1840×1280 mm	4250×1775×1310 mm
	Gewicht	1450 kg	1470 kg
Höchstgeschwindigkeit		315 km/h	280 km/h

Baureihe		**Porsche 911 GT1**	**Porsche Boxster (987)**
Baujahre		1996–1998	1996–2012
Modell		911 GT1/97 1997	Boxster 2005
Motor	Konfiguration	6-Zylinder-Boxer, 2×DOHC, 24 Ventile, 2 Turbolader, 2 Ladeluftkühler	6-Zylinder-Boxer, 24 Ventile, 2×DOHC
	Hubraum	3164 cm³	2687 cm³
	Bohrung × Hub	95×74,4 mm	85,5×78 mm
	Kraftstoffversorgung	elektronische Einspritzung Bosch Motronic M5.2	elektronische Einspritzung Bosch Motronic DME
	Leistung	544 PS bei 7000/min	240 PS bei 6400/min
Getriebe		6-Gang	6-Gang
Chassis	Rahmen	selbsttragende Karosserie mit Hilfsrahmen	selbsttragende Karosserie mit Hilfsrahmen
	Aufhängung vorn	Doppelquerlenker, Feder-Dämpfer-Einheiten	Querlenker, McPherson-Federbeine
	Aufhängung hinten	Doppelquerlenker, Feder-Dämpfer-Einheiten, Schubstreben	Querlenker, McPherson-Federbeine
Maße	Radstand	2500 mm	2415 mm
	Länge × Breite × Höhe	4710×1980×1173 mm	4330×1800×1295 mm
	Gewicht	1050 kg	1295 kg
Höchstgeschwindigkeit		310 km/h	256 km/h

Baureihe		**Porsche Carrera GT**	**Porsche 911 (997)**
Baujahre		2003–2006	2004–2011
Modell		Carrera GT 2005	Carrera 4S Cabriolet 2006
Motor	Konfiguration	V10, 40 Ventile, 2×DOHC	6-Zylinder-Boxer, 24 Ventile, 2×DOHC
	Hubraum	5733 cm³	3824 cm³
	Bohrung × Hub	98×76 mm	99×82,8 mm
	Kraftstoffversorgung	elektronische Einspritzung Bosch ME7.1.1	elektronische Einspritzung Bosch DME7.8
	Leistung	612 PS bei 8000/min	355 PS bei 6600/min
Getriebe		6-Gang	6-Gang, Allradantrieb
Chassis	Rahmen	Monocoque und Karosserie aus Kohlefaser-Verbundstoff	selbsttragende Karosserie mit Hilfsrahmen
	Aufhängung vorn	Doppelquerlenker, Feder-Dämpfer-Einheiten, Schubstreben	Querlenker, McPherson-Federbeine
	Aufhängung hinten	Doppelquerlenker, Feder-Dämpfer-Einheiten, Schubstreben	Mehrlenkerachse, Schraubenfedern, Teleskopdämpfer
Maße	Radstand	2730 mm	2350 mm
	Länge × Breite × Höhe	4615×1920×1165 mm	4427×1852×1300 mm
	Gewicht	1472 kg	1575 kg
Höchstgeschwindigkeit		330 km/h	280 km/h

Baureihe		**Porsche 911 (991)**	**Porsche Boxster (981)**
Baujahre		2011→	2012→
Modell		Carrera S 2012	Boxster S 2012
Motor	Konfiguration	6-Zylinder-Boxer, 24 Ventile, 2×DOHC	6-Zylinder-Boxer, 24 Ventile, 2×DOHC
	Hubraum	3800 cm³	3436 cm³
	Bohrung × Hub	102×77,5 mm	97×77,5 mm
	Kraftstoffversorgung	Benzin-Direkteinspritzung	Benzin-Direkteinspritzung
	Leistung	400 PS bei 7400/min	315 PS bei 6700/min
Getriebe		7-Gang	6-Gang
Chassis	Rahmen	selbsttragende Karosserie mit Hilfsrahmen	selbsttragende Karosserie mit Hilfsrahmen
	Aufhängung vorn	McPherson-Federbeine	McPherson-Federbeine
	Aufhängung hinten	Mehrlenkerachse	McPherson-Federbeine
Maße	Radstand	2450 mm	2475 mm
	Länge × Breite × Höhe	4491×1808×1295 mm	4374×1801×1281 mm
	Gewicht	1427 kg	1320 kg
Höchstgeschwindigkeit		304 km/h	279 km/h

Baureihe		**Porsche Panamera (971)**
Baujahre		2016→
Modell		Panamera Turbo 2016
Motor	Konfiguration	V8, 32 Ventile, 2×DOHC, 2 Turbolader
	Hubraum	3996 cm³
	Bohrung × Hub	86×86 mm
	Kraftstoffversorgung	Benzin-Direkteinspritzung
	Leistung	550 PS bei 5750–6000/min
Getriebe		8-Gang, Allradantrieb
Chassis	Rahmen	selbsttragende Karosserie
	Aufhängung vorn	Doppelquerlenkerachse, Luftfederung
	Aufhängung hinten	Mehrlenkerachse, Luftfederung
Maße	Radstand	2950 mm
	Länge × Breite × Höhe	5049×1937×1427 mm
	Gewicht	1995 kg
Höchstgeschwindigkeit		306 km/h

Baureihe	Series	Gamme
Baujahre	Years of production	Millésimes
Modell	Model	Modèle
Sondermodell	special edition model	modèle spécial
Motor	**Engine**	**Moteur**
Konfiguration	Configuration	Configuration
Boxer	flat	à plat
DOHC (doppelte oben liegende Nockenwelle)	double overhead camshaft	double arbre à cames en tête
Elektromotoren	electric motors	moteurs électriques
in Reihe	in line	en ligne
Königswelle	vertical shaft	arbre de renvoi
Ladeluftkühler	intercooler	échangeur thermique intermédiaire
OHC (oben liegende Nockenwelle)	overhead camshaft	arbre à cames en tête
Turbolader	turbocharger	turbocompresseur
Ventile	valves	soupapes
Zylinder	cylinders	cylindres
Hubraum	Displacement	Cylindrée
cm³	cc	cm³
Bohrung × Hub	Bore × stroke	Alésage × course
Kraftstoffversorgung	Fuel supply	Alimentation en carburant
Benzin-Direkteinspritzung	gasoline direct injection	injection directe d'essence
Common-Rail-Dieseleinspritzung	common-rail diesel injection	injection de gazole à rampe commune
Doppelvergaser	dual carburetor	double carburateur
Doppelfallstromvergaser	dual downdraft carburetor	double carburateur inversé
Einspritzung	injection	injection
elektronisch	electronic	électronique
Fallstromvergaser	downdraft carburetor	carburateur inversé
indirekt	indirect	indirecte
Sechsstempelpumpe	six-plunger pump	pompe à six pistons
Leistung	Output	Puissance
PS	hp	ch
bei .../min	at ...rpm	à ... tr/min
Getriebe	**Gearbox**	**Boîte de vitesses**
...-Gang	...-speed	à ... vitesses
Allradantrieb	four-wheel drive	transmission intégrale
Chassis	**Chassis**	**Châssis**
Rahmen	Frame	Cadre
Kastenrahmen	box-section chassis	châssis à caisson
mit Hilfsrahmen	with subframe	avec berceau auxiliaire
mit Kunststoffkarosserie verklebt und verschraubt	glued and bolted to plastic body	collé et boulonné à la carrosserie en plastique
Monocoque und Karosserie aus Kohlefaser-Verbundstoff	monocoque and body made of carbon fiber composite	coque et carrosserie en composite à fibres de carbone
selbsttragende Karosserie	integral body	monocoque
selbsttragender Verbundbau mit Bodenrahmen	integral floorpan-body combination	combinaison autoporteuse de plate-forme et carrosserie
Stahlblech-	made of sheet steel	en tôle d'acier
Aufhängung vorn/hinten	Suspension front/rear	Suspension avant/arrière
automatische Niveauregulierung	automatic level control	régulation automatique du niveau
Dämpferbeine	damper struts	montants de suspension
Doppelquerlenker	double wishbones	double bras triangulés
Doppelquerlenkerachse	double wishbone axle	suspension à double triangulation
doppelt	double, dual	double
Drehstabfedern	torsion bar springs	barres de torsion
Dreiecksquerlenker	wishbones	bras triangulés
elektronisch gesteuertes Dämpfersystem	electronically controlled damping system	système d'amortissement à régulation électronique
Feder-Dämpfer-Einheiten	spring-damper units	combinés ressort-amortisseur
Federbeine	spring struts	jambes de suspension
gebündelte Querdrehstabfedern	laminated transverse torsion bar springs	ressorts à barre de torsion transversaux en faisceau
Gummihohlfedern	hollow rubber springs	ressorts creux en caoutchouc
hydraulisch	hydraulic	hydraulique
Längsdrehstabfedern	longitudinally mounted torsion bars	barres de torsion montée longitudinalement
Längslenker	trailing arms	bras longitudinaux
Längsschubstreben	longitudinal pushrods	poussoirs longitudinaux
Luftfederung	pneumatic suspension	suspension pneumatique
McPherson-Federbeine	MacPherson struts	jambes MacPherson
Mehrlenkerachse	multilink axle	essieu multibras
obere und untere	upper and lower	supérieur et inférieur
Pendelachse	swing axle	essieu oscillant
quer liegend	transversally mounted	transversal
Querlenker	transverse links	bras transversaux
Schräglenker	diagonal struts	bras diagonaux
Schraubenfeder	coil spring	ressort hélicoïdal
Schubstreben	pushrods	poussoirs
Teleskopdämpfer	telescopic shock absorbers	amortisseurs télescopiques
Vierkant-Blattfederstäbe	square leaf spring bars	barres carrées de ressorts à lames
Maße	**Dimensions**	**Dimensions**
Radstand	Wheelbase	Empattement
Länge × Breite × Höhe	Length × width × height	Longueur × largeur × hauteur
mm	100 mm = 3.937"	mm
Gewicht	Weight	Poids
kg	1 kg = 2.205 lbs	kg
trocken	dry	sec
Höchstgeschwindigkeit	**Maximum speed**	**Vitesse maximale**
km/h	1 km/h = 0.621 mph	km/h

Acknowledgments · Danksagung · Remerciements

I wish to express my very sincere thanks to the following persons for their active support for this project:

Für Ihre Unterstützung des Gesamtprojekts durch Rat und Tat danke ich ganz herzlich folgenden Personen:

Je remercie vivement les personnes suivantes pour leur soutien constant au projet :

Porsche AG: Jasmin Anderson, Anke Brauns, Klaus Bischof, Michael Blaurock, Benjamin Gross, Ralf Kielgas, Jan Klonz, Dieter Landenberger, Sebastian Missel, Andreas Schönhuber, Sabine Schröder, Jan-Christian Waschek;
Uwe Biegner; Rolf Fassnacht; Ludwig Funk-Fritsch; Angie Jung; Oliver Schmidt, Thomas König, Stefan Behrend;
Achim Kubiak; Patrick Rehs; Karsten Schreyer; Chuck A. Stoddard; Jens Torner

I extend my thanks to the following for making their cars available:

Für die Bereitstellung ihrer Fahrzeuge bedanke ich mich bei:

Je remercie également pour le prêt de leurs véhicules :

Tobias Aichele, Dieter Assmuth, Dr. Helmut Bartram, Alexander Baumeister, Jiri Burda, Gaby Christensen, Dr. Burkhard Dreyer, Karl-Heinz Förster, Joachim Fricke, George Gallion, Markus Grabenbauer, Jürgen Haitz, Jürgen Heidger, Peter Hoffmann, Reinhold Joest, Heinz Jung, Dr. Wolfgang Kiehne, Bernhard Kneer, Rolf Knigge, Wolfgang Köhler, Thomas König, Klaus-Bernd Kreuz, Michael Küke, Marc-Oliver Kuhse, Lars Maisack, Jörg Manthey, Willi Marewski, Dr. Werner Mössner, Arwed Otto, Jörg D. Patzenhauer, Peter Petersson, Rüdiger Peukert, Patrick Rehs, Sven Reuter, Hans-Peter Schazmann, Heinz Schmidt, Oliver Schmidt, Thomas Schmitz, Jens Schöll, Karsten Schreyer, Karl-Heinz Schröder, Ansgar Schwind, Christian Seewald, Chuck A. Stoddard, Michael Storck, Frank Troche, Thomas Voigt, Patrick Wagner, Harald Weber, Marianne Wehlauer, Wilfried Wiesener, Ekkehard Zentgraf, Hans-Peter Ziegler

Further thanks go to:

Außerdem danke ich:

Merci encore à :

Oliver Hessmann (layout), Hartmut Lehbrink (text), Stefano Luzzatto (image editing/Bildbearbeitung/traitement d'images), Jochen von Osterroth (text); Walter Röhrl (foreword/Vorwort/préface);
management and tower staff at the airfields of / Geschäftsleitungen und Fluglotsen der Flugplätze von / le personnel des tours de contrôle des aérodromes d'Egelsbach, Michelstadt, Mainz-Finthen; Flughafen Siegerland, Luftfahrtverein Mainz.

Rainer W. Schlegelmilch

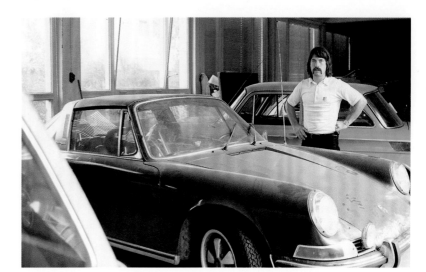

Rainer Schlegelmilch's third Porsche was stolen in 1972 by Andreas Baader, of Baader-Meinhof fame. The picture shows the slightly bewildered photographer when the authorities restored his car.

Rainer Schlegelmilchs dritter Porsche wurde ihm 1972 von Andreas Baader gestohlen. Das Foto zeigt den Fotografen bei der Rückerstattung durch das BKA.

La troisième Porsche de Rainer Schlegelmilch lui a été volée, en 1972, par le terroriste Andreas Baader. La photo représente le photographe lorsque l'office fédéral de police criminelle la lui restitue.

Bibliography · Bibliographie

70 Jahre Porsche im Spiegel der Zeitgeschichte, Wolf Strache, Halwart Schrader, Stuttgart n.d.
Augenblicke, 1948–1998, das offizielle Porsche-Jubiläumsbuch, Peter Vann, Reutlingen 1998
Auto.Biographie, Ferdinand Piëch, München/Zürich 2004
Catalogue Raisonné Porsche 1947–1993, Stefano Pasini, Milano 1993
Faszination 356, Eine Typologie des Porsche 356, Achim Kubiak, Bielefeld 2002
Das große Porsche-911-Buch, Alexander Knoll, Königswinter 2002
Das große Buch der Porsche Typen, Jürgen Barth, Gustav Büsing, Stuttgart 2005
Illustrated Porsche Buyer's Guide, Dean Batchelor, Osceola, 1982

Mein Leben, Ferry Porsche mit Günther Molter, Stuttgart 2002
Porsche – der Weg eines Zeitalters, Herbert A. Quint, Stuttgart 1951
Porsche – Geschichte und Technik der Renn- und Sportwagen, Karl Ludvigsen, München 1980
Porsche 356 1948–1965, Walter Zeichner, Stuttgart 1998
Porsche 356, Alle Coupés, Cabriolets, Roadster und Speedster von 1950–1965, Laurence Meredith, Königswinter 1999
Die Porsche 911 Story, Paul Frère, Stuttgart 2002
Porsche 924–944–968, Die technische Dokumentation der Transaxle-Modelle, Jörg Austen, Stuttgart 2003

Porsche und die Schweiz, 50 Jahre Porsche-Import durch die AMAG 1951-2001, Schinznach-Bad 2001
Das Porsche Calendarium 1931–2006, Anton Hunger, Dieter Landenberger, München/Zürich 2006
Projekt 928, Die Entwicklungsgeschichte des Porsche 928 von der Entwurfsskizze bis zur Serienreife, Julius Weitmann, Rico Steinemann, Stuttgart 1977
Christophorus
auto motor und sport
Autosport, 1967–2007
Motor Revue
Katalog der Automobil Revue, 1952–2016

© h.f.ullmann publishing GmbH

Original title: *Porsche*
ISBN 978-3-8331-4012-9

Photography: Rainer W. Schlegelmilch
Text: Hartmut Lehbrink, Jochen von Osterroth (Updates)
Design and typography: Oliver Hessmann
Reproductions: Schlegelmilch Photography
Image editing: Stefano Luzzatto
Translation into English: Hartmut Lehbrink
Translation into French: Jean-Luc Lesouëf

© for this updated edition: h.f.ullmann publishing GmbH

Special edition

Project management for h.f.ullmann: Lars Pietzschmann

Translation into English: Andrew Brown in association with First Edition Translations Ltd, Cambridge, UK;
Edited by David Price in association with First Edition Translations Ltd, Cambridge, UK
Translation into English for the new updates (pp. 6, 17, 28–29, 274–275, 332–335, 380-390, 396–455):
Ian Farrell in association with Delivering iBooks & Design, Barcelona

Translation into French: Florence Lecanu in association with Intexte Édition
Translation into French for the new updates (pp. 6, 17, 28–29, 274–275, 332–335, 380-390, 396–455):
Aurélie Daniel in association with Delivering iBooks & Design, Barcelona

Cover design: Oliver Hessmann

All photographs by Rainer W. Schlegelmilch, except pp. 5 BC+BR, 8–11, 12 T, 13–20, 21 L, 29 R, 56–59, 84–85, 108, 442–445, 454–455: Archiv Porsche

Overall responsibility for production: h.f.ullmann publishing GmbH, Potsdam, Germany

Printed in China, 2017

ISBN 978-3-8480-1141-4

10 9 8 7 6 5 4
X IX VIII VII VI V IV

www.ullmannmedien.com
info@ullmannmedien.com
facebook.com/ullmannmedien
twitter.com/ullmannmedien